GREAT
MASTERS
of AMERICAN ART

GREAT
MASTERS
of AMERICAN ART

JORDI VIGUÉ

WATSON-GUPTILL PUBLICATIONS/NEW YORK

First published in the United States in 2004 by
Watson-Guptill Publications,
a division of VNU Business Media, Inc.,
770 Broadway, New York, N.Y. 10003
www.watsonguptill.com

Original title: Grandes Maestros de la Pintura.
Maestros Norteamericanos
© 2004 Gorg Blanc, s.l.
Via Augusta, 63
08006 Barcelona, Spain
www.gorgblanc.com

Library of Congress Control Number: 2003114700

ISBN: 0-8230-2115-7

Editor-in-chief: Virgin Stanley
Collaborators: Melissa Ricketts, Xavier Agramunt
Photographic archive: Arxiu Gorg Blanc, Vegap
Graphic design: Paloma Nestares
Photographic documentation: Albert M. Thuile
Layout: Albert Muñoz
Publishing coordinator: Miquel Ridola
Translation: Bi-Cultural

Printed in Spain
Gráficas Iberia, s.a., Barcelona

1 2 3 4 5 6 7 8 9 / 09 08 07 06 05 04

Preface

The history of the United States is a unique one, its beginning full of adventure and triumph over an oppressive rule. Next came a longing to create a collective conscience; wars that defined its identity; struggles and devotion to strength as a nation; and finally the attainment of indisputable world leadership. Art, too, follows this path—reflecting life, changing as society and circumstances change.

As it corresponds to a great but young country, the path of American painting begins in the contemplation and appreciation of the nation's own landscape. In the beginning, American art was influenced by European trends. But early on, the United States began to develop and define its own indigenous art, until, by the 20th century, the country became a source for all kinds of ideas and creativity.

In this book, our goal is to offer an overview of American painting. We explain the paths taken in its history, the milestones that mark its progress, and the contributions of many great painters.

Through these paintings, the reader can observe how, at any given moment in American history, there have existed many different ideas and means of expression. The path has always been complex, divergent, and pluralistic. Schools, trends, and objectives coexist, overlap, and intertwine, but the constants are the love of country and its history. There is a need to connect with the paintings of the Old World, but also an eagerness to create an independent art form.

This volume is the result of research and investigation. We have struggled to find documentation and representative pieces. We believe that this volume offers a remarkable insight into American painting and a fine selection of the artists and works of those who define it. Great Masters of American Art *should add information and enjoyment to any museum experience. We travel the path of discovery and learning together. Please enjoy this journey through American art history.*

Jordi Vigué

Contents

Where it all began

To trace the history of American painting is to uncover and understand the United States's continuing quest for a leading role in history. If the American colonies were, at the beginning, simply a branch of a European tree, their citizens soon recognized their separate identity as a people. The United States was born from the struggle for independence, and in its wake, the first American painting set out to wrest Europe's unquestioned supremacy as the center of art.

Several elements shaped the awakening and development of American painting. First of all, the artists' environment was fascinating. Nature in this new country was so rich, pure, luminous, and imposing; it was so moving that artists felt the need to express their feelings in some fashion. This wilderness astounded people with its majestic grandeur: enormous forests, high mountain ranges, and immense plains. Clear and dazzling light prevailed, rendering colors vivid and sharpening contrasts. The painters who worked in this natural environment had nothing to envy in the serene golden light of Italy or the velvety French light; the whiteness of their light cleanly and transparently clarified forms and colors, neither hiding nor distorting them.

Second, in addition to a poor artistic infrastructure, there was a complete absence of pictorial tradition, inevitably filled by the European legacy. European art was accessible only through a long journey by land—artists could travel to American cities to study reproductions and engravings sent from the Continent—or by sea—more affluent artists crossed the Atlantic to the Old World to study in the best European schools, with direct access to works of the great masters. But because the trip was so costly, until the first scholarships were created, most American painters were able to make the journey across the Atlantic only relatively late in life.

A pragmatic spirit led painters to begin learning by teaching themselves. Many painters, therefore, embarked on a professional career in the United States long before visiting Europe; in that way they established themselves as artists or at least saved enough to live in more expensive cities such as London. American artists, guided by their innovative spirit, learned to make their creations stand out. To the Europeans' surprise, artists from the New World created their own identifiable style in their painting, becoming, over time, a model for others.

Finally, the demands of a new way of life were felt. The need for settlers to use common sense and know-how to improvise was combined with their overwhelming confidence in their own free will and the protective presence of a forbearing God. The settlers were practical; they believed more in the worth of people's talents than in a family name. This created career possibilities for those who set themselves apart by artistic merit—that is, if they had the chance to prove it. This practicality was also reflected in American painting by a marked trend toward realism.

Searching for an identity

This road was not an easy one. At first, the few artists who sought recognition found themselves in a vicious cycle around the time of the signing of the Declaration of Independence. On the one hand, American institutions encouraged them to study in Europe, but on their return, the artists had to deal with the reactionary ideas of their clients, who were highly conservative compared with Europe; most regarded painting as little more than a superfluous luxury. Faced with such a situation, the artists who had been trained in the best foreign schools at the time had only two choices: either to settle in Europe, or to return to the United States and dedicate themselves exclusively to portraiture, the only skill for which the great landowners were prepared to pay. Throughout the 18th century, only those painters who had sufficient financial support and enthusiasm for their art to make this choice could triumph as professionals.

In the last quarter of the 18th century, relations with Great Britain, the mother country, were strong. Most American painters eventually journeyed to the London studio of the painter Benjamin West (1738-1820). This American artist astounded Europe by discarding the notion of incorporating classical Roman portraiture and architecture; instead, he chose to represent contemporary events, establishing a new type of history painting. He never returned to the United States, and his studio became an improvised academy, training many of the American artists who traveled to London.

One of these artists was Charles Willson Peale (1741-1827), who became the representative of the most nationalistic branch of portraiture. He was a follower of the style and realism of John Singleton Copley (1738-1815), and he also admired Raphael and Titian. During his stay in London, Peale was already depicting American themes—portraits of politicians inspired by engravings—but only after he returned to America did he develop a less classical and anglophilic style. His approach was a mixture of the neoclassical concern for form, the colonial tradition of portraits, and genre painting, which sometimes led him to use illusion in his compositions. In his *Staircase Group*, a life-size painting that reportedly baffled even George Washington, his trompe l'oeil successfully convinced the viewer that he/she was in front of two young men climbing the stairs. After painting portraits in wealthy Philadelphia—his son Rembrandt Peale (1774-1860) followed in his footsteps—the American Revolution made Peale the first painter in the history of America who resided in his own country. Peale, a devoted patriot who had taken part in the war, recognized that his new country needed its own heroes and historic events, as well as a painter capable of representing them in both a documentary and idealistic style. After the war, his pictorial interests turned to his paleontological discoveries, which were shown in his museum, the first in the United States.

The works of Ralph Earl (1751-1801) should also be included within this nationalistic trend. His portraits go deeper psychologically, presenting the political leaders of independence in a manner that moves away from deification, toward a more realistic and simplified tone. Instead of staring into space, the people in his portraits look directly at the viewer, imparting an air of honesty and openness.

Even though he had already shown his merit as a portrait artist with an anglophile tendency, Gilbert Stuart (1755-1827) is best known today for the numerous portraits he painted of George Washington (one of which appears on the $1 bill). A man with a great talent for accumulating debts, he was incredibly

lucky to be rescued from an uncertain future by West, who appointed him as his main assistant. Despite the fact that he was valued by a London clientele, the competition there obliged him to return to his birth country. He did not, however, leave behind his unique style with soft, loose brushstrokes that highlighted his subject's face and gaze. Stuart's result was natural and realistic from the direct application of the pigment on the canvas. He was the best and fastest portrait artist in the Federal period, although he took a very long time to turn in his orders—not because of laziness, but because he overextended himself.

Thomas Sully (1783-1872) also dedicated himself to satisfying the demands of the wealthy class that survived in the first half of the 19th century. He had been trained by West in England and, as a result, leaned toward the English style. Individual patrons were very important in America, because they financed painters' training. The most significant award for a painter was neither a medal nor an honorable mention, as in Europe, but rather something desirable and practical that would broaden their horizons, such as a trip to Paris, London, or Rome. Thanks to such a trip, Sully learned to practice a type of English portraiture that idealized women and portrayed men with vigor. Although he did not completely abandon classicism, he always looked for his subject's physical similarities that would fit in with this movement, and he did not go very deeply into their psyches. In his portraits, the main subject and situation were suggested by color, producing a very delicate result.

With the signing of the Constitution in the United States, the painters who had received training in Europe thought that the upper class would develop a refined aesthetic taste. They believed that the elite would come to appreciate the value of the battle and war paintings that they kept offering. But this genre was rejected. As a result, West and other history painters remained in England, where this type of painting was greatly admired.

John Trumbull (1756-1843) came to London after starting to paint in Boston, against the will of his father, an important senator. After being saved, by West, from the gallows in London (he was accused of being a spy) and deported, he later returned to the studio of this American painter to continue learning. His style is a mix of Peter Paul Rubens's drawing, John Singleton Copley's realism, and West's colors and dramatic light. Looking to paint a more realistic and reliable history, he painted portraits of the major figures from America's most important historical events. He hoped that the administration would order large-format paintings from him, about historical events, for the majestic Capitol building. Despite little interest in this type of painting, the order finally arrived. With Trumbull, the peak of historical painting in America passed by.

Thomas Birch (1779-1851) was the only artist who was successful with his paintings of scenes from the War of 1812. His naval battles are very similar to Dutch compositions. However, America was looking toward the future at that time, and the interest in new things and progress were what stirred the national spirit.

Romantic classicism

John Vanderlyn (1775-1852) was not happy painting portraits. He went to Rome to saturate himself in the current neoclassicism and to study classical ruins. He also went to Paris to study at the École des Beaux-Arts and enjoy the paintings of Jacques-Louis David and François Gérard. Vanderlyn is the best representative of Romantic classicism in the United States, both the best trained and the most

capable. His work blends his concern for drawing and anatomy with the dramatic and with a variety of expressive elements; his compositions also boast landscape backgrounds and theatrical lighting. His *Ariadne Asleep on the Island of Naxos* was the first nude in American painting; however, it was not well received in the puritanical environment of the young nation. The beautiful anatomy and perfect drawing is similar to the way Giorgione or Correggio would have depicted the nude; however, it was not moralizing and edifying, which would have made it tolerable. This painting cut Vanderlyn's career short. However, the landscape behind the nude image was not at all indecorous, and it brought out a new period in American painting.

The great way, or the English way, introduced in England by the first president of the Royal Academy of London, Joshua Reynolds, was a type of painting that idealized reality while using classical sources such as Raphael and Michelangelo. The direct observation of the work of these great masters was essential to mastering drawing and color adequately, and so John Vanderlyn traveled to Europe to see such paintings.

Washington Allston (1779-1843) was a friend of Vanderlyn's and interested, like him, in the great way; he was one of the first painters to catch on to the new artistic trends coming over from Europe. Under the influence of West, his teacher, he added the Venetian style (in the chromatics and the lighting), the style of J. M. W. Turner and Nicolas Poussin, as well as the incipient symbolism of American painting. However, he made a change: The figures that the viewer identified with were dwarfed by the grandness of the surrounding natural landscape. The vastness of the landscapes were shaded by a serene and reflective tone, representative of the artist's own personality. On the other hand, moonlight added a touch of mystery and fantasy, making Allston's work a predecessor to Romanticism. He was very successful with his landscapes that were not real, but rather constructed from his inner emotions; the true motive of his work was an aesthetic quest more than any economic benefit.

The self-taught John James Audubon (1785-1851) traveled unexplored parts of America at this time and created his series of birds in an encyclopedic style born from neoclassicism. But the birds' proud poses and his meticulous treatment of them is reminiscent of the American taste for documentary realism, giving his work an original touch that could never be surpassed. The dramatic quality and vigor in these representations can be linked with the first Romantic trends and even with the images of Winslow Homer, far in the future.

Landscape painting, symbol of national identity

While pompous portrait painting flourished and historical painting flagged after the War of 1812, a reappraisal of landscape painting took place; it came to symbolize patriotic feeling for the new land. Romanticism was also evolving, tending toward imaginary and exotic themes. This, together with a special concept of nature as a reflection of all things divine, formed the basis of American landscape painting. Having firmly established the idea of itself as a nation, with the heroes and battles for independence now in the past, the United States looked to its natural surroundings as the West began to be settled. Before the eyes of pioneers who made their way to the promised land in wagons, vast and exuberant landscapes came into sight—a clear manifestation of God's greatness. There were no classical ruins in America, but the settlers were happy to admire the sublime and virgin lands.

Painters were quick to recognize the value of the natural setting before them and hastened to depict all of its beauty. In doing so, they made their profession respectable; before then, it had been considered little more than a craft. To produce their large and splendid works, artists would make detailed sketches and then recompose in their studios. This laborious art form was possible only through the support of patrons. Up until then, landscape painting had been a fairground attraction (Vanderlyn and Trumbull had painted panoramic landscapes) or a mere pastime.

In a more intimate context, the Americans' fondness for nature was reflected in a genre considered secondary: the still life. Raphaelle Peale (1774-1825), one of Charles Willson Peale's sons, became America's foremost still-life artist. The drawing in his still lifes is masterful, and the meticulous detail can be compared to 17th-century Dutch still lifes—which he probably never saw. However, the difference lies in his extreme simplicity and serenity, which defines the clientele to whom he catered. In fact, one of his last works was a sarcastic criticism of Puritanism. Using a trompe l'oeil effect, he covered a nude Venus with a cloth. By means of this premeditated trickery—a technique later developed by William Harnett (1848-1892)—the observer could only see one of the goddess's forearms and one of her feet. It is so well painted that it seems real. It was a way of mocking the ridiculous controversy in American society regarding nudes at a time when human anatomy was a fundamental subject for painters in all of Europe's academies. The American still-life tradition was continued by Severin Roesen (1815-1870), who, with his photographic attention to detail, catered to the many hoteliers and restaurant owners of the German colony in Williamsport, Pennsylvania, in exchange for food and lodging.

The most representative 19th-century landscape school in the United States originated in the Hudson River Valley. Most of the painters belonging to this school traveled to Europe to complete their training. On their return to America, they proved to be extremely eclectic, mixing the styles of their British and German contemporaries with the tradition of Claude Lorraine, Nicolas Poussin, or the 17th-century Dutch school. From the beginning, two styles became apparent: one used a more Romantic language, highlighting impressive, frightening, and wild elements to sublimate the landscape; and the other opted for a more classicist lyricism, employing a more distant point of view. These calm and placid tones illustrated the abundance of the new lands to be discovered, in itself a manifestation of God's destiny for the people.

The founder of the Hudson River School was Thomas Cole (1801-1848), who, in 1825, exhibited his landscapes of the Hudson River Valley in New York. Asher Brown Durand (1796-1886), painter and engraver, a landscape artist who shared the ideas of John Constable of painting directly from nature without studying the great masters first, was one of the great inspirations of Cole. He admired Durand so much that he included him in his work *Kindred Spirits*. There were no coliseums or ancient temples in the United States, but there were the Catskill Mountains and Kauterskill Falls, and Cole made sure they were immortalized. Although his paintings represented natural settings designed to entice the tourist, Cole's reinvention and enhancement of their original appearance restored their idyllic purity. This painter drew upon the techniques of British landscape painters, and so it was not unusual to find pastoral scenes in his work, dwarfed by the landscapes. Storms were another of the artist's typical subjects, purifying the sky as they make way for bright light on the horizon.

Luminism

In the middle of the 18th century, there was a tendency toward subjective representation, inherited from Asher Brown Durand, which also applied to landscapes. Culminating in the last phase of the Hudson River School, luminism began directly from a more serene study of natural phenomena, a change from the descriptive intention of the first period. Light was the main characteristic, diluted in very subtle tonal gradations, staining the neat pictorial surface where brushstrokes could barely be distinguished. The origins of luminism can also be traced back to very detailed paintings of Boston marinas.

Fitz Hugh Lane (1804-1865) came from the heart of this: He stood out for his ability to convey an incredible feeling of calmness and stillness (the calmness his clients, usually businessmen and boat owners, wanted in their ocean crossings) with scrupulous, clear details. He did not paint genre scenes—no fishing boats—and so he avoided all activity and movement whose effect he did not like; therefore, he was able to concentrate on the light and detail of his brushstrokes. Lane's painting stands in the margin of the academic world, because it is a bit more independent.

Another painter linked to luminism, although with a more naturalist appearance in his work, is Martin Johnson Heade (1819-1904), who, although he also worked on portraits, can be considered heir to Lane's luminosity. He learned about the importance of light in landscapes from his friend Frederic Church. Heade's preferred subjects were salty marshes on the coasts of Massachusetts and New Jersey. They are composed very simply but with extremely bright and colorful results, as if the scene were suspended in time. The sharpness and detail of his work give way to the use of space and silence as the main characteristics, linking him to the German artist Caspar Friedrich.

Finally, Jasper Cropsey (1823-1900), another landscape artist of the Hudson River School, was a fervent admirer of Cole and Church. Although he created most of his work in the Hudson River School, this style approached luminism due to his concentration on light. In his landscapes, man maintains a perfect harmony with nature; coexistence without exploitation is possible. His landscapes acquired a pensive and autumnal tone, and they are always quite spiritual. Unfortunately, with the start of the Civil War, this type of landscape—charged with positive energy that touches the deepest part of the viewer—progressively lost meaning, until it was forgotten.

The Hudson River School continued to rely on skilled artists who completed their training and career with long, expensive trips to Europe, especially Germany and France, removing American painting from its isolation. All the tradition and success of the Hudson River School traveled with them in their work. Though they were influenced by the detail of the German School or, later on, by the naturalism of the Barbizon School, they maintained the intimate and mystic tone in their work that was typical from the middle of the century. While these artists were working, the American frontier was expanding westward, increasing the national sense of pride in the country's landscapes.

Thomas Worthington Whittredge (1820-1910), an outstanding painter, was also concerned with light and represented the most intimate line of the Hudson River School. His lyricism is comparable only with the works of Durand, who personally encouraged him to continue his career as a painter. Thanks to his patrons, he was able to move to Germany to improve his style at the Düsseldorf Academy.

In the United States, the development of painting and of arts in general was favored, paradoxically, by the total absence of support from the government, which was always reluctant to make a statement about artistic matters; this was a question that was left for the incipient American schools. Individual patrons played a vital role; when a patron personally decided that a painter had talent, he would pay for the artist's training in Europe. This was the case with Whittredge, who eventually became president of the National Academy of Design in New York. This American institution was born of an eminently practical spirit: Because there were already very important schools in Europe as well as great art, American painters received excellent training in drawing—essential to make the leap to the other side of the ocean with certain success. New York started to become a true center for artists who were studying there, and many were housed in the Tenth Street Studio Building, built specifically for them.

Another artist who dedicated himself to travel in Europe with Whittredge was Sanford Robinson Gifford (1823-1880), whose work marked the culmination of the luminist tradition. With a solid academic education, he decided to leave aside everything he had learned to dedicate himself to the study of light and color during his numerous excursions. His work shows as much gusto for detail as emphasis on representation of light—a light that stains the air and the space, dazzling the viewer. No one knew how to depict the brightness of the American light like he did; because of this ability, he was able to sacrifice topographical details. In pursuit of light, he moved to the Egyptian desert. A great friend of Whittredge and Albert Bierstadt, he traveled with them through part of Europe, only to return afterward to the United States and devote himself to traveling the Catskill and Rocky Mountains, making sketches. After the Civil War, the virgin landscapes of America were not enough, and Gifford's work echoed the transformation that the natural environment began to suffer.

With the West conquered, the landscape was damaged by tree felling and large-scale mining exploitation, which created hefty American fortunes. The industrialists supported paintings of the landscapes that they themselves had destroyed. The old rural way of life for trappers, cowboys, and explorers was left behind, giving way to the factories and the growth of the cities. New York started to be consolidated as the artistic center around the National Academy of Design, which attracted a large number of painters.

Large natural stages

Another great representative of the Hudson River School, in its glory, was Frederic Edwin Church (1826-1900). The young painter absorbed the tradition of Cole's pristine landscapes and added meticulously descriptive symbolism and massive formats, which gave his paintings tremendous impact. Thousands of people paid 25 cents each to look at the painting *Heart of the Andes* (inspired by Church's trip to South America), with or without a spyglass. The painter invited the audience to discover the most trivial details in this painting, as if it were a window looking out on a real landscape. Encouraged by his success, many young landscape painters went to New York, but for a long time, no painter was able to match the spectacular quality of Church's landscapes.

Among the many painters who followed in Church's wake, Robert Duncanson (1823-1872) is worth drawing attention to; he was trained in Canada due to the fact that there were very strong racial prejudices against African-Americans and people of mixed race in the United States. In Canada, Duncanson learned how to

paint by copying the works of Cole and Church, and soon he felt the need to study the American landscape directly in order to capture it on canvas. The important Nicholas Longworth promptly called for him to decorate his house (today, the Taft Museum) with eight enormous murals.

The most successful artist, with the most tragic ending of all who stayed at the Tenth Street Studio Building in New York, was Albert Bierstadt (1830-1902). Trained in Düsseldorf, he traveled Europe's most famous landscapes with Gifford and Whittredge. His interest in the American West came over him when he saw the Rocky Mountains for the first time, and he devoted himself to traveling the country to make sketches that he would use to make his paintings in the studio. The details, the huge size of the canvases (adopted from Church), and the pristine appearance of his landscapes lured the rich industrialists who made up his clientele, paying astronomical sums of money for each one of his paintings. Bierstadt became the most famous, wealthiest, and most admired painter of the 1860s in America, and his career began to languish only when, with the conquering of the frontier, there was no land left to explore. In his work, Bierstadt presented the public with the first images of magnificent American landscapes—landscapes whose virginity would last only a short time longer. When the grandiloquence of his enormous panoramic paintings went out of style, Bierstadt's fame faded away, leaving the painter in poverty until he died, completely forgotten.

Toward more naturalist landscapes

After the era of the large, overworked, and exhaustively detailed backdrop landscapes, new ideas from Europe inspired artists to keep experimenting with a more subjective approach.

The first and most important of these artists was George Inness (1825-1894), who had been personally acquainted with the artists from the French Barbizon School. This was a more naturalistic school of artists who painted in the open air and were therefore more receptive to the reality of landscapes. From the artists of this group, Inness learned the importance of open-air painting, although he used it to present a more poetic and transcendental vision of the landscape. Trained in the luminist environment of the Hudson River School, his work represents a step toward the quest for the true spirit of nature. His paintings were intended to move the viewer not intellectually, but emotionally. Today, Inness is considered the father of American landscape painting.

The realism of the Barbizon School also influenced the work of Edward Bannister (1828-1901), whose landscapes have a calm and bucolic tone, as well as a descriptive one. Bannister was the first Afro-American artist to receive a prize for painting in 1876, which is particularly important considering the recent Civil War.

Another notable representative of this realism was Samuel Colman (1832-1920), who took on a different perspective from the first burst of idealism that the Hudson River School started: He focused on the fact that man's presence had invaded the natural environment. It was as if a few intruders had interfered with the painter and the landscape, and their presence made the vision of the grandiose panorama dirty and forced. Colman's work was the extreme of what Gifford had previously suggested, although the exploitation was already evident. Ecological problems were, at that time, a subject of constant controversy, although the balance always ended up tilting in favor of the industrialists and speculators. This reality, which was the origin of the great American fortunes, would also eventually give art a new momentum.

William Trost Richards (1833-1905) also adopted the naturalist style of the Barbizon School, as well as their inclination to paint more common landscapes. Nevertheless, his brushstrokes transformed these ordinary places into something unique and original. Deeply interested in lighting effects, especially on bodies of water, he devoted the final part of his career to seascapes. However, other paintings that were more vigorous and less bucolic soon replaced the placid compositions of his early work.

Homer Dodge Martin (1836-1897) began to create landscapes following John Frederick Kensett's luminist tendency, but he soon came under the influence of the Barbizon School. In his works, he combined the realism of this school with Cole's idealism, achieving some very evocative landscapes.

Alfred Thompson Bricher (1837-1908) was one of the last artists of the Hudson River School. He witnessed the decline of landscape as a subject in favor of a more modern style of painting. As if they were his swan song, his works—imbued with a sense of clearness and luminosity—transmit the spirituality and purity of nature untouched by mankind. He devoted himself mainly to panoramic seascapes (elongated, like those of Church or Bierstadt, to emphasize the horizontality) in which it is possible to discern the time of day or the season of the year, illustrating how perfectly the light and detail are captured. This was, without a doubt, the result of direct observation of nature, which had been handed down to him by the Barbizon School.

Genre scenes and folk literature

In addition to landscapes, scenes of daily life were also used to glorify the nation, in a kind of ennoblement of the common or self-made man—a reflection of American democracy. This genre is filled with an edifying intent and, at the same time, a literary tone that recalls the adventures of Huck Finn or Tom Sawyer. It emerged successfully from illustrations for novels and newspapers (hence its realist inclination, linked to the Barbizon movement in landscapes).

Although Sydney Mount (1807-1868) and John Quidor (1801-1881) had been the pioneers of genre painting, depicting barns, inns, daily life, and popular legends, it was George Caleb Bingham (1811-1879) who was the most characteristic of these artists; he was at the intersection of the taste for the exotic, the urge toward realism (quite different from the showiness of Deas's images), and the European style. It should not be forgotten that many of these images were intended not only for the American public, but also for the European bourgeoisie. After having worked as a portrait painter in Washington, Bingham returned to Missouri, where the life and customs of the boatmen and trappers became his main subjects. Although they are the leading figures, Bingham reworked reality into idyllic and peaceful scenes, using great depth in his compositions (with a zigzag perspective—very neoclassical). His work represents a turning point in American painting: It depicts these frontiersmen as the embodiment of the true American spirit, the pioneer who lives far removed from the affectation of the Eastern bourgeoisie (whose portraits Bingham had painted in Washington), and on the borders of the land with no law.

Continuing with these scenes of local customs, Eastman Johnson (1824-1906) devoted most of his work to depicting a romantic version of the Afro-Americans' everyday life. The scenes in these paintings, set on Southern plantations, show people enjoying themselves despite dire straits and wretched conditions. Although Johnson would have had the subjects for his painting close at hand, the treat-

ment that he adopted was a little exotic—very similar to Dutch painting of manners of the 17th century. His technical skill and meticulousness denote his apprenticeship in Düsseldorf, where he perfected his drawing and eye for detail.

Thomas Waterman Wood (1823-1903) also devoted part of his work to capturing the life of Afro-Americans, during and after the Civil War. After slavery was abolished, they were given their freedom, but the following period revealed the racism and marginalization to which they would be subjected. Wood's images from real life are a testimony to this situation, even though the artist tinged them with a certain pleasant tone, making him a precursor to Norman Rockwell.

But men were not the only protagonists of everyday American life, and the case of the painter Lilly Martin Spencer (1822-1902) is a clear example of this. A master of techniques, she worked with a number of genres; her intimate scenes were the ones that made her popular. The most surprising thing about her production, however, are the works that look at the role of women in society (servant, mother, lover)—works which for their audacity only received scorn from the critics.

Images of Native Americans and African-Americans

While new landscapes and natural wonders went on being discovered, there started to be more conflicts with the native peoples who were the rightful owners of the lands and forests. There were many different opinions regarding Native Americans; painting offered a fine cross-section of the degree of curiosity people had about them—the respect or rejection with which the white man regarded them. These attitudes were often determined by the white man's interest in seizing their territory. Paintings of American Indians were very successful with people in the East, who were always eager to receive news on what was happening on the frontier.

Charles Bird King (1785-1862) was one of the first artists who painted portraits of Native Americans dressed up with their ornaments, in the tradition of the "noble savage," honorable and filled with deep thoughts. The faces of his subjects resemble one another a great deal, and their ornaments are the only features that distinguish them.

George Catlin (1796-1872) was the main disseminator of the image of American Indians in art, although he did so using a more heroic tone, singling out their features and attire. Catlin was the first artist to live with the Indians, and he was able to witness their ceremonies and customs with his own eyes, which became subjects for his illustrations. One of the paintings that had the most impact on his clients showed the okeepa, a religious ceremony of the Mandan Indians, in which, as a form of initiation, youths were hung from the roof by ropes and hooks in order to test their endurance. The painter was well aware that, even then, little remained of the Native Americans' way of life.

Influenced by a visit from Catlin, Seth Eastman (1808-1875) also spent long periods of time with Native Americans on the frontier that he, a soldier, protected with his companions from the fort. A draftsman by profession, he described numerous places along the frontier and the daily life of American Indians, always depicting them as peaceful and involved in their daily tasks.

Before Catlin, Alfred Jacob Miller (1810-1874) had already penetrated the American rivers, reproducing scenes from an expedition up the Mississippi. He was Sully's pupil; Sully advised him to travel to Europe in order to complete his training,

and the fact that his scenes contain a certain amount of French neoclassicism should be attributed to this fact. He not only returned from this trip with the first representations of the Rocky Mountains, but also with a portfolio of illustrations of Native Americans, which he later reworked in oils. These very romantically represent the native people as if they were Roman sculptures, although the pictures do include certain psychological observations. In spite of this, these images were created exclusively for the enjoyment of the rich Scotsman who had arranged the expedition, and they were never published.

As the conflicts intensified, the idealized vision of painting the "noble savage" was to be succeeded by a different, more terrifying and demonic one, which reflected the conflict with the white man. One representative of this tendency was Charles Deas (1818-1867), whose early work can be compared with Catlin's documentary style. Like Catlin, Deas went deep into the wilderness and depicted Indian chiefs, reproducing their ornaments with great attention to detail. However, life on the frontier put him in contact with trappers and colonists heading for the West. Their stories about the Native Americans' hostility (one-sided accounts, of course) and about the rigors of the journeys upriver made a great impression on Deas's manic personality, and he very expressively portrayed the shocking images inspired by these dramatic tales. Attacks by savage Native Americans on innocent trappers and the burning of the prairies are just two examples of this artist's work, whose dark personality still remains inaccessible to historians.

Realism: The masters of plein air

After the Civil War, there was a change in American painting toward more powerful realism. In the wake of landscape painters, artists were drawn to Europe, especially to Paris, Munich, and Rome, but they also invented a purely American pictorial style.

A series of painters educated in Paris became responsible for combining the new European trends with American idiosyncrasy. Winslow Homer (1836-1910) began his artistic career as a watercolorist and engraver, although he also published illustrations for *Harper's Weekly*. During the Civil War, he painted scenes of the front that gave him great prestige, encouraging him to pursue his career as a painter, this time using oils. The subjects that he undertook had to do, above all, with the war and fishermen, the latter very much in Homer's line of work. In his first paintings, characteristics of his style could already be observed: the anecdotal became less important in favor of the reality at hand. There was no place for the emotional or the rhetorical. He was one of the first American painters to study Impressionist work in Paris, and he was profoundly interested in Édouard Manet and Claude Monet as well as in Japanese ukiyo-e. When he returned to the United States, he was incredibly interested in the daily life of Americans; whether they were bourgeoisie on vacation at the resorts, or poor children playing crack the whip in a rural area, he always subordinated the landscape to the figure. This increased the dramatic quality of his compositions; whether he was dealing with fishing scenes or animals in action, he was always looking at them objectively. His paintings kept absorbing the fluidity that he used for his watercolors, little by little with his brush, until he considered this technique valid for his works.

Thomas Eakins (1844-1916) represents a more scientific facet of naturalist realism—almost a perfect mirror of reality, but more self-controlled and intimate. Two tendencies can, however, be observed in his work: on one hand, in his open-air scenes, he approaches the luminism of the Hudson River School, while, in his

interior scenes, the influence of German realism can be distinguished. His style reflects the influence of the painters of the Spanish Baroque and Gustave Courbet and Édouard Manet, whose work he studied in Paris while learning at Jean-Léon Gérôme and Léon Bonnat's academy. Eakins was also a sculptor; this contributed to his careful study of his figures' volume, making them seem even more lifelike. He was in Spain in 1869 where he studied Jusepe de Ribera's violent realism and Diego Velázquez's precise technique. What he learned from them increased his desire to have absolute mastery of anatomical drawing (he had studied medical anatomy) and perspective. It should be no surprise that he used photographs to aid his direct study of daily life. These photographs, in which many of his students posed, were the reason why his position as professor (later occupied by his student Thomas Anschutz [1851-1912]) became shaky. The realism of Eakins was not well understood by the Philadelphia public, either, who were not ready for the weight of naturalism.

Impressionism and symbolism

During the last decade of the 19th century, some artistic tendencies were rein-forced, while others were abandoned. The latter was the case of the ostentatious landscape painting and genre painting, which no longer made sense in an America that was open to the world and progress. While realism was being firmly established in the United States, other artistic movements such as Impressionism found very fertile ground in a number of painters.

One of the most outstanding representatives of Impressionism in the United States was William Merritt Chase (1849-1916), who traveled to Europe after being trained in New York. In Munich, the dark, dense palette of naturalism, as well as the loose brushwork of the Dutch painter Frans Hals, influenced him. In Paris, he was interested in Manet's work. During his visit to Spain, a highly exotic destina-tion for Americans, he admired the work of Velázquez. In Chase's work, technique acquired as much importance as the subject; he therefore painted plein-air scenes in Claude Monet's style, using a vibrant palette and colors. The whiteness of the light of the American coast shines as if it were alive in a myriad of tiny brush-strokes.

Another artist who was strongly influenced by French Impressionism was Theodore Robinson (1852-1896). He met Monet personally and, like him, painted at Giverny. He influenced the Ten American Painters, thanks to his friend John Henry Twachtman.

Mary Cassatt (1844-1926) is the most important American representative of Impressionism. The dark palette of her early work would gradually drift toward lighter and clearer tones from the influence of her friend Edgar Degas. Officially a member of the Impressionist circle in Paris, she did not allow their preoccupation with technique to get in the way of deeper questions. Novel perspectives and the placement of two planes very close together convey a sensation of ambiguity inherited from Japanese prints. She used this technique to treat the subject of the feminine role in society. Cassatt not only spent most of her life in Paris, but she was also responsible for the arrival of the Impressionists in America in the form of their principal art dealer, Paul Durand-Ruel.

Durand-Ruel, to the indignation of the American gallery owners, opened a gallery in New York. Foreseeing the tremendous competition he was going to create (Impressionism had already been a great success in Europe), the gallery owners did not stop harassing him until they had forced him to close down. All

the same, thanks to the seeds sown by Durand-Ruel, a small branch of Impressionism was born in the United States, through the work of the country's own painters.

Childe Hassam (1859-1935) made his debut with street scenes using a deep, classical perspective in which the light takes on great importance. After his trip to Paris, he adopted the loose, dotted brushwork of the French Impressionists. He painted Union Square and other emblematic New York landmarks (including some views of its rising skyline) in the style of Camille Pissarro or Claude Monet. Hassam was also one of the founders of the Ten American Painters, who exhibited their work in 1895, leaving aside the Academy, which was still arguing for the maintenance of obsolete values. Artists of the stature of Weir and John Henry Twachtman formed the Ten American Painters.

Julian Alden Weir (1852-1919) conceived an energetic Impressionism, giving the surface of the painting a very pictorial treatment, although this did not take place until well into his career as a painter. Before leaving for Paris, he had begun his artistic training at the National Academy of Design in New York. Afterward, he traveled through Spain and Holland, admiring the realism of Frans Hals and Diego Velázquez, which explains his initial rejection of French Impressionism. Surprisingly, after seeing the exhibition organized by Cassatt, his painting took a turn. He organized afternoon painting sessions with Twachtman in his home outside Paris. At the same time, he was in contact with Hassam and Chase and painted work that was characterized by the study of color (influenced by James McNeill Whistler) and brushstrokes that gave the impression of an embroidered surface.

John Henry Twachtman (1853-1902) offered a more lyrical side of Impressionism, melting the ground of the compositions into symphonies of color and anticipating, like Whistler, abstract art. He was one of the most gifted and sensitive American Impressionists, judging by the pictorial quality of his canvases, comparable to the French Impressionists. Scholars such as Edgar Richardson have even compared his work to French Impressionist music.

Edward Potthast (1857-1927) should also be considered among the Impressionists. Influenced by the Spanish painter Joaquín Sorolla, Potthast was able to capture like no other the violet-white quality of American coastal light. Sorolla, whose work had been exhibited at the Hispanic Society in New York, was using his own style for the coastal area of Valencia. Potthast began painting academically, but would rid himself of that extra baggage in order to concentrate on the treatment of light and color in the Impressionist manner. Leisure scenes from the carefree middle-class lifestyle of the period known as the Age of Innocence, just up to World War I, are prominent in Weir's work.

Though symbolism had already had a predecessor in the figure of George Inness, Robert Albert Blakelock (1847-1919) is considered the heir to Washington Allston, due to the dreamlike vision with which he painted his landscapes. They have a psychic quality, and are somewhat sad and somber—the product of the painter's depressive personality, and an outlet for his own inner solitude.

Albert Pinkham Ryder (1847-1917) also abandoned realist representation in search of the externalization of his own inner anguish. His work includes elements of musical and literary origin (Richard Wagner and William Shakespeare) mixed with elements of Nordic Expressionism in all its mystery and tortuousness. The painter adopted a reclusive life on the coast in order to devote himself to the contemplation of the sea and moonlight, in a kind of mystical solitary confinement. His path would be followed by Louis Michel George Eilshemius (1864-1941),

whose style definitely links up with German expressionism. A precursor of the symbolism of the nineties was Elihu Vedder (1836-1923), an artist with a precise hand and a vivid imagination, who in his works combined allegory and mystery long before the English Pre-Raphaelites.

Frontier art

There was a group of artists who embraced the realist movement, though combined with Catlin's documentary tone and Bierstadt's love of the West. Frederic Remington (1861-1909) was the greatest of the frontier artists, along with Charles Russell (1864-1926). Yet by the time he was making his paintings, the free life of the cowboys and Indians of the Great Plains had already disappeared. To his minute description, Remington added a great sense of drama, which filled his scenes with vitality. Cowboys fleeing from Indians who pursued them, or galloping amid a stampede, are the images that have gone on to form part of the popular imagination of the West.

More centered on the life of the Indians and close to the ones he lived with in his childhood, Henry Farny (1847-1916) opted for a more realistic and descriptive, less idealized representation of Indians. What was idealized was the way of life in which he depicted these Indians, since at the time they were already confined to reservations. Although an academic influence in the treatment of anatomy can be seen in his work, he utilized loose Impressionist brushstrokes and a brilliant treatment of light.

The gilded age and the aesthetic movement

The last 35 years of the 19th century after the Civil War, the United States was in full force, with its industrial machinery dominating and with large fortunes growing by the day. This period was known as the American Gilded Age, a golden age that would end abruptly with the stock market crash of 1929. At the time, the wealthy upper middle class, lacking a legitimized past, wanted to affirm their social position through identification with models from classical antiquity as seen through the eyes of the Italian Renaissance. Just as the great Medici or Sforza families had done, the new American rich very actively patronized the arts, commissioning work from the artists of the time as dictated by the academic norms (the Academy regarded this return to the past favorably), although they could not evade the influence of new tendencies. This was the case of Thayer, Dewing, and La Farge.

Abbott Handerson Thayer (1849-1921) worked, like the Italian Renaissance artists, in groups that included other artists; the ideal was for the best architect, the best sculptor, and the best painter to create the artistic agenda. The projects in which he participated were very successful, and the images, although catering to the tastes of the upper class, were well received by the lower class. These painters projected an image of women that was an ethereal and perfect ideal of beauty, clashing with that of the symbolists. The high society wished to distance itself from the humble in an aristocratic manner, as if they belonged to an elite caste. Such idealized and distant women were nothing less than the perfect reflection of this wish.

John La Farge (1835-1910) was an authentic Renaissance man; aside from being a painter, he was also a muralist, a designer, and an illustrator. His very eclectic style has a marked influence from Japanese prints, although at the end of his career he returned to more academic subjects, inspired by the great masters.

Thomas Dewing (1851-1938) is an example of an artist who, with the patronage of a millionaire (Charles Freer, who also promoted Whistler), always painted within the refined and delicate academic taste. Although in his early work he displayed a preference for drawing, in his later work, he showed a tendency toward dissolving his figures into vaporous atmospheres, moving closer to Impressionism and symbolism. His tonal harmony, inherited from Whistler, also approaches abstraction. Almost exclusively dedicated to the women of the upper class (and the ideal of beauty) he always presented them as ideal, but with great elegance and refinement. This starkly contrasted with the daily life of American women at that time, who were beginning to demand their rights in Boston.

Edwin Austin Abbey (1852-1911) exhibited a greater presence of drawing in his work, which used Shakespearian and medieval subjects in plans for murals and decorative projects for public buildings. He began work as an illustrator for *Harper's Weekly* and later moved on to painting. Once in Europe, where he coincided with Whistler and Sargent, he came under the influence of the Pre-Raphaelites William Morris and Edward Burne-Jones.

A growing interest in forming their own private collections began to take root in the American upper middle class, which led them to start acquiring the works of the great masters and the French academics. As a result of this, the United States emerged from its cultural isolation and arrived at a convergence with contemporary European art. However, the American mentality was still not sufficiently avant-garde to be able to absorb all the ideas brewing in Europe. This caused many American painters to move definitively to the continent, changing their lives into a continual pilgrimage between cities such as Paris, Rome, or London. This was the case with Whistler.

James McNeill Whistler (1834-1903) was the principal representative of the aesthetic movement. He spent his career between the French and British capitals, studying painting in Paris, where he saw the work of Gustave Courbet and Edgar Degas for the first time. After being rejected by the Paris Salon (as with Courbet, this did not prevent him from exhibiting privately), he moved to London, where he established a friendship with Oscar Wilde, and where he had the misfortune to get involved in a dispute with the critic John Ruskin, which led to a trial that ended up ruining him. Whistler, like other American painters, was influenced by the Japanese art circulating around all of Europe at the time, as well as by the color arrangements of the English academic Albert Moore, who inspired Whistler's chromatic studies. In these studies, Whistler gave a prelude to abstraction; the only thing that really interested him was to highlight the aesthetic nature of the painting in a reaction against Victorian painting, which placed more importance on the subject. In an avant-garde display, Whistler named many of his paintings as if they were musical symphonies of colors.

The painter John Singer Sargent (1856-1925) was another independent personality, for several reasons. In the first place, although he grew up in the United States (he was born in Florence to American parents), he lived and made his career in Paris and London. Second, although his work makes use of all the artistic styles, it cannot be classified as any of them. Finally, although one can appreciate the influence of the great masters, like Diego Velázquez and Antony Van Dyck, his artistic personality was a precedent for painting of the 20th century. Sargent was

an attractive dandy, cultured and cosmopolitan. He was the archetype of the American nouveau riche of his day. He visited Spain to study the work of Velázquez, whose realism and clear rendering of all the elements of composition he admired. From him, Sargent adopted the effects of light, which distinguish some of his portraits, such as *Madame X*, which cost him his social exile to London. There, he continued to be successful as a portrait painter, especially with upper middle-class ladies. His style combines the loose brushwork of the Impressionists, the realism and rendering of detail of Velázquez, and the aristocratic pose natural to English portraits, while adding freshness and distinction. This would have a great influence on many European portrait painters. However, bored of these portraits, he began painting other subjects later in his career.

An American genre

At the beginning of the 20th century, American painting was on hold, stagnant with the traditional and European values that the Academy offered. In their search for a different and original spirit and encouraged by the audacity of the avant-garde, American painters began to organize independent exhibitions in which they rebelled. The Ten American Painters had already organized their own exhibition in New York, so there seemed to be nothing impeding other artists from doing the same. Two pictorial movements emerged then, which were based, on one hand, on the social reality of New York, and on the other, on the European avant-garde. The Eight, also known as the Ashcan School, pertained to this first category. They were given this name for painting the most sordid subjects in New York at the turn of the century. Painters such as John Sloan (1871-1951), George Luks (1867-1933), and William Glackens (1870-1938) belonged to this group. Robert Henri (1865-1929) was their theorist and he, after the Academy rejected him, organized the first exhibition in 1908, at the Macbeth Gallery of New York. These artists started with a descriptive vision of reality, like Eakins, but they added real people and places without disregarding any material—they were like documentary journalists.

At the beginning of the new century, New York became the final destiny for many European immigrants who were looking for a better future, turning the city into a heterogeneous and energetic world, full of restaurants, dance halls, and theaters. George Bellows (1882-1925) portrayed it as such in his boxing scenes. The upper class was not the subject of the painter's canvases; he focused on the middle and lower classes who were the genuine city dwellers. He dealt with subjects that were truly American, captured in the direct and sincere American way. Despite the novelty of his subject, his technique referred to the great masters: Hals, Velázquez, or Rembrandt, as well as Goya and Manet. The rapid focus of the painting and the strong brushstrokes contrasted with shadow and clarity come from these great painters.

Modern painting

Paradoxically, it was Robert Henri, a realist, who opened the doors to the avant-garde, sparking, from that time on, a conflict between realism and the avant-garde that would separate them for many years. In 1913 the Armory Show was born, without a jury or awards, as a response to the Annual Salon of the National Academy of Design of New York, which imposed excessive requirements on its participants. In the Armory Show, there was work from the Ashcan School, Marcel

Duchamp, Henri Matisse, Georges Bracque, Gustave Courbet, Édouard Manet, and Vincent Van Gogh, as well as from the Flemish masters. Although much of the work was too advanced for part of the large public that packed the armory, styles like cubism were definitely reflected, even in people's clothing. Also, some gallery owners, such as Leo Stein and Walter Arensberg, after first rejecting this work, saw that it sold well, and decided to support it by buying and proposing exchanges with European artists.

In the United States, different schools would then be created for Dadaism, futurism, surrealism, and precisionism, that would make this country the center of modernity. Many modern American artists and other Europeans who stayed in New York met at Gallery 291, run by Alfred Stieglitz on Fifth Avenue. There, years before, Stieglitz had dared to show the work of Henri Matisse, Henri de Toulouse-Lautrec, Henri Rousseau, and Pablo Picasso. Marsden Hartley (1877-1843) was an important painter within Stieglitz's circle, although he lived primarily in Europe. He participated in the gatherings in Gertrude Stein's house in Paris, which painters such as Picasso attended. Stein took in a large number of American painters who traveled to the French capital by virtue of the exchanges she made with American and European painters. Hartley also traveled to Berlin, where he mixed cubism and futurism in his paintings; these were not well received in New York, even though they were a synthesis of avant-garde European movements.

Georgia O'Keeffe (1887-1986), who started her career as a watercolorist and draftswoman, and later went on to oils, incorporated all of these tendencies. Paradigm of the liberated woman of the 1920s, she led a dissolute life that let her meet the most famous artists of the time. (It definitely helped that she was married to Stieglitz.) Her early work was in a futurist style, but later on she created very unique visions of flowers on a close first plane. At the end of her life, she went back to depicting the desert with the same modern vision of her early work and a certain dose of introspection.

Another painter in Stieglitz's circle was Charles Demuth (1883-1935), along with Charles Sheeler (1883-1965), the most well-known representative of precisionism. This style mixed the breaking of color planes of cubism with the gusto for modern cityscapes, with its chimneys and simplistic architecture typical of futurism. The result was work with a clean, almost clinical appearance, although it revealed the insipidness of this new environment.

Stuart Davis (1892-1964) was the one who connected the avant-gardists with the future of American painting, and the only one who captured the rhythm of city life with more joy, comparing it to fast and improvised jazz. In a style that brushed on abstraction, this painter reflected like no other the street sounds, colors, cars, bright lights, and advertisements that inhabited New York's skyline. When he attended the Armory Show (he showed five of his realist watercolors) ten days before its closure, he was enthusiastic about cubism, and then started to create collages like Georges Bracque. He painted numbers and letters with primary colors, which drew him closer to the aesthetic of pop art.

In 1929, the avant-garde celebrated the creation of the Museum of Modern Art of New York. Henceforth, the museum would promote abstract art.

Metaphysical introspection

Edward Hopper (1882-1967) helped the development of realism, the reaction to the advances of the avant-garde. Trained in Henri's sphere, this painter was in Germany, where he became interested in the Expressionists, futurism, and light. On his return to the United States, he started to depict the stages of bourgeoisie life silently and introspectively in small, authentic American cities; this sometimes evoked mysteriousness or nightmares. A commercial artist and graphic designer by profession, his style owed a good deal to the world of advertising. Even though he sold much of his work, he never abandoned his little bohemian apartment, and he even turned down a membership to the Academy.

The realism of these painters gradually focused on the rural zones, leaving only a small nucleus in New York, even though the city was the quintessential artistic center of modern art.

Charles Burchfield (1893-1967) started painting nature subjectively (reminiscent of the Hudson River School), but in the middle of his career, he went back to portraying rural cities. With great technical precision, Burchfield captured the empty city moments, making the viewer seem like a voyeur. For Burchfield, the city was a live body with its own eyes. In this respect, although it seems that we, the viewers, furtively spy on home life, it is true that the city also watches us through the houses' windows. This is a somewhat surrealist conception that Edward Hopper and Andrew Wyeth (born 1917) also shared, even though the latter was more deeply connected to the land than the other two.

The Great Depression also affected the painters in the big cities like New York. While abstraction was searching for an aesthetic identity, painters like Reginald Marsh (1898-1954) took in the influence of the Ashcan School (artists such as Bellows and Sloan passed through his father's studio) and sometimes studied daily scenes critically, sometimes cynically. He purposely portrayed vulgar moments that totally destroyed the myths that surrounded the city's inhabitants; he showed them as prisoners of their own routine. As a result of his trip to Paris, he saw Daumier's illustrations and adopted his critical tone and gusto for representing the most underprivileged social classes.

Eugène Delacroix, the French painter from the 19th century, also instilled Marsh with the gusto of representing anatomies in a Naturalist manner, as seen in his beach scenes. He also showed influences from the baroque period with his dark tones, ideal for portraying sordid environments. He never made a distinction between the characters; he dedicated his sarcastic and critical brush to all of them, depicting them alone, although surrounded by a crowd. Jacob Lawrence (1917-2000) did the same, although his paintings focused on African-Americans. They dealt with politically incorrect matters since they depicted a bitter disposition, far from the ethereal world that abstraction absorbed, yet deeply documentary.

The artist Ben Shahn (1898-1969) is considered the most important figure in socialist realism. From a Jewish family, he suffered deeply from the marginalization and poverty of the immigrant ghettos in Brooklyn. He gradually went from portraying an active social critique to depicting a more subjective vision of the world's problems. He had an academic background and, after traveling to Africa and Europe, where he met the avant-gardists, he was influenced by the Swiss artist Paul Klee, from whom he adopted a colored plane and defined contours. His lithographic work added an almost-naïve caricature quality to his figures

that contrasted with the seriousness of the denunciations he dealt with. Sometimes, to support the feeling of realism, he used photographs he had taken spontaneously in the streets of New York. After World War II his characters became sadder, with an increase in introspection after the explosion of the nuclear bombs in Japan. From that point on, his subjects were oriented toward the warning of biological experiments that could be used against humanity.

American regionalism

As a resistance to the entrance of European influences in American painting, a group of painters focused on America's rural areas. Categorized under the name of American regionalism, they shared a common desire of returning the focus of American painting back to more authentic values. The appearance of this group coincided with the Great Depression that struck in 1929. The government created an aid system that subsidized art, in addition to other social programs. Along with scholarships, a campaign for decorating public buildings was launched that included the creation of agencies to organize different jobs for artists. The Works Progress Administration, the Federal Art Project, and the Public Works of Art Project were born, for which painters such as Grant Wood would work.

The trip that Grant Wood (1892-1942) made to Germany helped him absorb the influences of the German masters such as Albrecht Dürer and Hans Memling. He applied his discoveries to paintings of rural America. Precise drawings, color, upward composition in his early works, the frontal view of his figures, and the introduction of allegories and even the same technique (tempera on wood), demonstrated the clear influence of the final gothic period, especially of the retables. The subjects represented, however, had to do with cornfields and local farmers and their families. The painter's subjective contribution appears in these landscapes, where he studies a field with an idyllic perspective, approaching a delicate naïve aesthetic. Moving forward to the 1930s, a colony of artists was founded that searched for a national style while leading the Public Works of Art Project in Iowa.

Thomas Hart Benton (1889-1975) was another of the best-known representatives of American regionalism. He also benefited from some government aid programs. After starting his career in the boom of modern movements, especially cubism and synchronism, he started to make figurative paintings after fruitlessly trying to show his work at Stieglitz's gallery. He started to represent the traditional values of America and his home state of Missouri, incorporating a hint of legend. The delineated forms were softened or smoothed out, the colors were strident and exuberant, and the perspectives were confusing. The characters also appeared to be arranged unstably, as if they were about to fall. Benton looked down on Stieglitz and his circle of modernists, so he created something unusual in American painting: a painting with an integral nude as the mythic Persephone, about to be raped by a Missouri farmer (Atkins Museum of Art, Kansas). Just as the Renaissance masters had done, Benton dared to reinterpret classical mythology, adapting it to the American landscape and people. Little by little his style evolved toward more compact forms, yet he maintained the same expressiveness.

With the entrance of the United States into World War II, the patriotic spirit was reflected in the paintings of Norman Rockwell (1894-1978). The traditional moral values and the affable and decisive spirit of the American people were absorbed into this artist's work, featured each week on the cover of the

Saturday Evening Post. He was an excellent draftsman, a student of Dürer; he practiced by making quick sketches of his friends and neighbors' gestures. This gave his compositions a warm vivacity that was almost photographic; he made them look real even though they were fiction. In spite of the painful circumstances of the war, Rockwell always showed the most friendly and tender side of the conflict, exalting both nationalism and patriotism. However, Rockwell began to tire of idealized images of the American dream, and by the mid-1960s he was more interested in portraying contemporary social problems, always within his characteristic photographic style.

New York, the capital of modern art

Paris gave up its place as the seat of modernism when the Nazis invaded it in 1940, and most of its talents fled to New York. Later on, once the war was over, the United States experienced an unprecedented economic growth that made it a leader in the world's economy. It was at this moment when a new, purely American artistic movement emerged, which owed very little to the European avant-garde and became in itself a model for future European trends. This movement was called Abstract Expressionism, or "action painting." A group of very heterogeneous artists are included under this umbrella; all concentrating on the expressiveness of the involuntary pictorial gesture of the painter himself.

The gestation of this movement took place during the crisis of the Great Depression, when theoretic influences were gathered from surrealism (according to which the creative act is a reflection of the subconscious) and the French thinker Jean-Paul Sartre's existentialism (the anguish of being). During World War II, the New York Museum of Modern Art gave an enormous push to Abstract Expressionism by organizing the Fifteen Americans exhibition. The birth of this movement occurred between 1947, the year in which Jackson Pollock began to use dripping as a technique, and 1956, the year he died, when the first pop works were starting to be created.

Undoubtedly Jackson Pollock (1912-1956) is the most famous figure of Abstract Expressionism, more than other painters such as Robert Motherwell, Mark Rothko, or Willem de Kooning. Pollock, who had been one of Thomas Hart Benton's students, did not work from sketches. He allowed himself to act spontaneously, dripping paint onto canvas nailed to the floor, directly expressing his feelings. However, in the muddled appearance of some of his works, a fluctuating rhythm beats that unifies the painting, generating a feeling of rejection and attraction at the same time. Pollock did not look to illustrate his feelings with figures, but rather to express himself through a technique that would inherently speak for him. He was a tormented alcoholic who died in an automobile accident when Abstract Expressionism was beginning to give way to other trends, such as the one represented by Richard Diebenkorn (1923-1993) and the Bay Area, less expressive and more focused on color, as in the style of Mark Rothko.

Two years after Pollock's death, Jasper Johns (born 1930) and Leo Castelli met for the first time; the latter was the gallery owner who would accept modern American painters from that point on. Johns was the first and youngest artist who painted differently from the Abstract Expressionists. He has used elements from daily life so that they have lost their meaning once represented on canvas. Johns has focused on numbers and letters as motifs,

with the aesthetic as the main concern. With this, a new perspective replaced the viewer's typical reaction of trying to figure out what was represented in the painting, because he or she recognized the objects automatically, without effort. It was a search for the aesthetic, a kind of contained philosophical reflection, which was a prelude to all later art. While he has been taken as a predecessor of pop art due to his use of trivial objects, he is also considered a precursor of minimalism for his geometrical taste.

Johns's reserved and concentrated attitude contrasts with the creative exuberant explosion of his friend Robert Rauschenberg (born 1925). Initiator of "combine painting," he is a totally unclassifiable artist due to the continuous research he has made on subjects, styles, and artistic techniques, always with a very expressive result. He has been capable of cleverly combining painting and silkscreen printing, figures, and gestural brushstrokes. From the beginning, he has been in contact with modern movements, actively participating in all the arts, sometimes as a dancer in Merce Cunningham's experimental ballets, other times as a lighting technician for these productions. The impressive production values of some music concerts today is, in part, thanks to him. Given the quality of integration in his work, he is permanently in search of new creative sources and also willing to contribute ideas that promote creativity in others. For this reason, he has been busy lately organizing an association for professional engineers and artists from both sides of the Atlantic.

Pop art

If these two artists represent the most abstract path through which American art moved away from the dead end Abstract Expressionism had become, the artists belonging to the heterogeneous pop art movement presented the most realistic alternative. Although this movement began in England in the 1950s, American pop art differentiated itself in that it concentrated much more on advertising in order to create a satire or to make a criticism of the consumer society, while its own stylistic doubts were gradually materializing.

Roy Lichtenstein (1923-1997) asked himself what was and what was not art when he started creating his comic vignettes. Lichtenstein's topic was the progressive vulgarization of emotions, stereotyped through mass culture. For this reason he simulated the commercial printing technique, imitating the layers of dots in comics and using a palate of primary colors, which he applied flatly, very distanced from the feelings of the Abstract Expressionists. Ironically, the figures in his comics are the only ones that seem to take the emotions that they represent seriously. Lichtenstein criticized the contemporary art that was always submerged in its own aesthetic concerns, while reality was right there, ready to be addressed.

The person who addressed this with artistic and commercial success was Andy Warhol (1928-1987). In his criticism of the consumer society, he went beyond the work of art and turned his own life into a product—a product that, of course, could be sold. His series of silkscreen prints, created by an enthusiastic group of extravagant collaborators, were the opaque and empty reflection of advertising and the star system. There is no meaning behind them, there is nothing—they are only a studied image, a pose that desire itself gives life to.

Tom Wesselmann (born 1931), on the other hand, is one of the people of a more abstract branch of pop art. In his works he represents the American

dream in a disincarnate manner, the supposed "good life" that is nothing more than a stereotype. He presents this, moreover, as if it were a dream within arm's reach, just like television portrays it. However, if you pay attention, although the objects are desirable in and of themselves, the space they occupy is flat, nonexistent, and uninhabitable. The result is a cold and almost abstract composition in which ashtrays, fruit, cigarettes, and women in vulgar and erotic poses are juxtaposed, just as in advertisements.

New ideas

Some of the many movements that emerged around painting, which passed through conceptual and minimalist movements, tried to give the power back to pictorial manifestations as a transmitter of ideas and concepts. This is the case of Judy Chicago (born 1939) who has been criticizing the androcentrism of the (constructed) history of humanity since the 1960s. Her artistic personality covers pictorial creation as well as sculpture, often using installations to organize her message. Throughout history there have been women who have contributed their knowledge and art to the world, but they have been marginalized by a history compiled from a masculine point of view. In regards to this, Chicago has shown other installations in which she denounces how society, based on the masculine concept of competition, provokes violence and war. On the contrary, the feminine principle is one of life generation and union. Far from criticizing men, with whom she often collaborates, the artist highlights the fact that they possess a feminine side they should awaken if they want to survive the next millennium.

* * * * * *

American painting has no precedent in art history, and studying it highlights the undeniable values that make it original and new, and absolutely necessary when addressing a global study of the history of painting. The environment, the vastness of the territory, and the taste for innovation (a product of its desire for progress) have led these new stimuli to provoke innovative reactions, giving rise to original, typical American proposals and themes, making it incredibly unique. If all of this is added to the great common sense inherited from the settlers, a type of painting that has been capable of absorbing as many influences as possible from Europe has emerged, adapting these influences to the American vision of the world.

It took a little less than 500 years for the United States to become a leader in modern art, a place where American painting has truly made its mark. Currently, despite the difficult circumstances, and the lack of really original figures that can overcome the present very conservative cultural policies, cities like New York are still the mirror in which artistic trends from the rest of the world look can be seen; it feeds on a plethora of cultures and a new chapter in the history of American painting is formed every day.

JOHN SINGLETON COPLEY

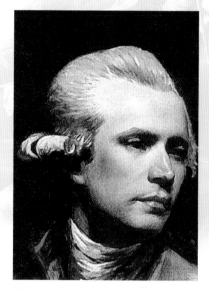

Self-Portrait, *1784, oil on canvas, National Portrait Gallery, Washington, D.C.*

Copley was one of the most successful American artists in New England during the colonial period. Originally from Boston, he was introduced to painting by his stepfather, an artist and engraver. At first, Copley was influenced by the detailed portraits of Robert Feke and Joseph Blackburn, an English Rococo painter.

In search of additional training, Copley went to London, where the portrait artist Joshua Reynolds, the president of the Royal Academy, and Benjamin West, an American artist of historical themes at the service of the English court, had invited him. His portrait art became more sophisticated there, and he became very popular among English society, who enjoyed his realism and attention to detail. His talent flourished after a visit to Italy, where he studied the works of the great masters.

Copley also began to compete with West in the field of historic painting, despite the considerable price of this type of work. Copley invented a very creative system to obtain more profit from his historic paintings: He made engravings of each one, designed to sell at a very affordable price. He also often organized exhibitions and charged an entry fee, which enhanced his reputation among his clientele.

Copley's historic work stood out because it was based on recent facts or local history and was done in a rhetorical and elegant style.

- **1738** Born in Boston on July 3, son of Mary Singleton Copley and Richard Copley, owner of a tobacco store at the port.
- **1748** His mother, who had become a widow the year before, marries the Bostonian painter and engraver Peter Pelham. Young John becomes great friends with his stepbrother, Henry Pelham, and paints him in *Boy with a Squirrel.*
- **1751** Peter Pelham dies.
- **1752** With his stepfather's tools, Copley makes engravings and commissioned portraits.
- **1755** Sees the work of Rococo painter Joseph Blackburn, whose color and light techniques influence him.
- **1759** At 21, he is considered the best portrait artist in the colonies.
- **1766** His portrait *Boy with a Squirrel* is exhibited at the Society of Artists in London.
- **1767** Benjamin West proposes, and Joshua Reynolds approves, naming Copley a Friend of the Society of Artists.
- **1769** Marries Susana Clark, daughter of Richard Clark, a well-known Boston tea merchant. The couple lives in Beacon Hill, a wealthy area of Boston.
- **1771** Moves to New York, where he paints portraits of important politicians.
- **1772** His son John is born. He will later become chancellor Lord Lyndhurst.
- **1774** Moves to London, invited by Reynolds and West. In August, he travels to Italy to see the work of the great artists. Meets Brook Watson of *Watson and the Shark.*
- **1775** Is reunited in London with his wife and three of his children. He paints them the following year in *The Copley Family.* His father-in-law, Richard Clark, is also in the painting.
- **1777** Named associate member of the Society of Artists.
- **1778** Exhibits *Watson and the Shark* quite successfully at the Royal Academy in London.
- **1779** Is elected permanent member of the Royal Academy.
- **1781** Soon after the battle of Royal Square in Jersey, a London engraver asks him to make a painting to commemorate the event.
- **1784** Exhibits *The Death of Major Peirson* in London. The king contemplates it for three hours.
- **1793** Exhibits *The Red Cross Knight* at the Royal Academy in London.
- **1815** Dies in London on September 9 without ever having gone back to America.

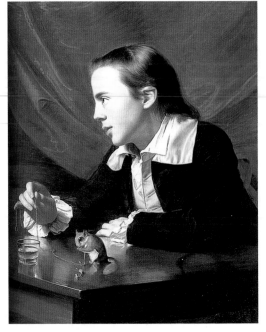

Henry Pelham
(Boy with a Squirrel)

(1765)
oil on canvas
30.3 x 25 in (76.84 x 63.5 cm)
Museum of Fine Arts, Boston

This work portrays one of Copley's stepbrothers, Henry Pelham, when he was 16 years old. Although John was 11 years older, they were great friends, so much so that Copley made this painting of him as a reflection of his esteem. The result was so impressive that Copley sent the painting to London to be exhibited at the Society of Artists. The English public and press, which had come en masse to look at this work—the first painting from the colonies to be exhibited—greatly admired the detail of all the elements.

Copley was a master in depicting the individual surrounded with many symbols that alluded to the sitter's personality and circumstances. Squirrels were a very common pet among the youth of the upper classes, who saw in this animal a reference to civic responsibility and the education that all youngsters should have. The gold chain restraining the squirrel suggests the freedom that young Henry should aspire to, as he has had sufficient learning to be able to cope with the adult world. Joshua Reynolds, president of the Royal Academy, acknowledged this painting, and through the recommendation of Benjamin West, an American artist at the service of the English court, he invited Copley to join them at the Society of Artists as honorary member. It would still take Copley some years to cross the Atlantic, but at last he accepted the offer and set sail for London.

Paul Revere

(1768/70)
oil on canvas
35 x 28.5 in (88.9 x 72.3 cm)
Museum of Fine Arts, Boston

Nicholas Boylston

(1767)
oil on canvas
49.2 x 39.2 in
(125 x 99.5 cm)
Harvard University,
Cambridge, Massachusetts

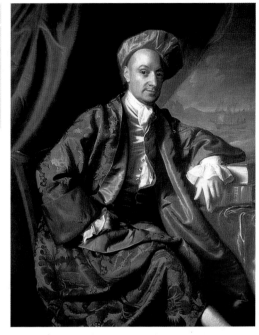

Copley's mastery, particularly his ability to convey magnificent elegance in his characters, made him sought after by individuals from the upper classes, who saw in him a determined artist capable of depicting them as gentlemen of high lineage. Nicholas Boylston was, together with his brother, among the most important merchants and ship owners in Boston.

Copley portrays Boylston luxuriously dressed, as if he were a prince or pasha, with a short Oriental dressing gown and a turban of richly embroidered silk. The subject looks at the viewer with great self-confidence, aware of the status that his high social standing gives him. Nonetheless, he is not depicted at leisure, but working at his office, as the books on which he leans demonstrate. A red curtain opens the room to a view of the sea, where a ship at anchor alludes to Boylston's merchant activities abroad.

Boylston was one of the merchants who refused to sign an agreement that banned the importation of English products; as a result, he was accused of being an "enemy of the country" by the patriot Samuel Adams in 1767. Boylston's refusal to sign began a deep division in the colonial independence movement, but his intention was to safeguard his main source of income; he was one of the two largest importers in Boston. In addition, the 1765 revolt against the Stamp Act (a new tax on publications) had resulted in dire consequences for his family's property, some of which had been burned to ashes.

Left: Copley also painted portraits of Boston's artisans and businessmen, including those who were most loyal to the colonies, such as Paul Revere. Revere, of course, is famous for his "midnight ride," when he warned colonists of the imminent surprise arrival of English soldiers on the American coast. He traveled on horseback through villages and towns around Boston, spreading the word. Revere was a silversmith, and the shining, polished teapot he holds in his hand represents his trade. It may also have been a symbol of Revere's loyalty to independence, as the English had already imposed a tax on tea, the Townshend Act. Colonists—probably including Revere himself—rebelled against this injustice with the Boston Tea Party.

In his traditional style, Copley has shown the man surrounded by symbols that indicate his profession and social status: Although he was a silversmith, his hands are clean and well cared for, and he is neatly dressed. His thoughtful expression lends him the air of a gentleman. Copley's ability to capture both the personality of his subject and the material qualities of the objects is remarkable. The surface of the table is highly polished and reflects the white shirt worn by Revere. The painter has perfectly captured the shine of the teapot, which the viewer may still visit today; it is in the collection of silver objects created by Paul Revere at the Museum of Fine Arts in Boston.

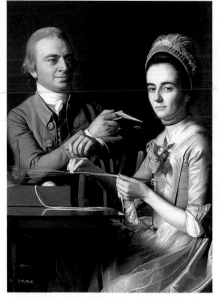

Mr. and Mrs. Thomas Mifflin (Sarah Morris)

(1773)
oil on board
61 x 48 in (154.9 x 121.9 cm)
Historical Society of
Pennsylvania, Philadelphia

This work is one of the many portraits that Copley made for Philadelphia's upper classes. It shows Thomas Mifflin, the first governor of Pennsylvania after American independence, and his wife. The married couple are shown at leisure, although they are not inactive: The governor seems to be showing his wife a passage from the book he is reading, while Mrs. Mifflin, busily engaged in a piece of needlework, looks toward the viewer. This style of representing the subjects actively engaged in hobbies or other pursuits contrasted with European paintings, where the protagonists simply appeared posing.

Copley clearly conveys the unity of the couple, whose leisure activities correspond to the traditional views on marriage, with the woman dedicated to work that is typically feminine and the man busy with a more intellectual activity befitting a politician. It is surprising that Mifflin is totally turned toward his wife—turned so far that he has to rest his arm on the back of the chair to face her more comfortably. This pose imbues the composition with vividness and movement, a quality that was required by New England's upper classes, which saw these works and the naturalness of their attitudes as a way of highlighting the differences in their social conditions from the English aristocracy. The large neoclassical column behind the Mifflins surely alludes to the governor's political personality as one of the principal pillars of American independence.

Right: This work depicts the most dramatic moment in the history of Brook Watson, a 14-year-old sailor who was attacked by a shark while swimming off the coast of Havana. Miraculously, his shipmates managed to reach him and save his life, although he lost one of his legs.

While his friends try to push the terrible monster away, Watson wears an expression of horror and shock after the animal's first attack; it is turning to strike again. The painter

Watson and the Shark

(1778)
oil on board
71 x 90 in (182.1 x 229.7 cm)
National Gallery of Art,
Washington, D.C.

has submerged the right leg of the unfortunate young man in the darkness of the sea, suggesting that he is going to lose it in spite of the efforts of his companions. One of them fruitlessly throws out a rope, while two more are on the side of the boat reaching out for Watson, another holds his friend so he doesn't fall, and the last lifts a harpoon to spear the animal. Copley has avoided representing the scene too gruesomely, including only traces of blood in the sea and on the mouth of the shark, which looks more like a sea monster.

Copley had met Watson when he returned from his trip to Italy, when Watson had already started mercantile work and was preparing for the political arena (he later became a baron, and his shield made reference to the shark attack). The old sailor commissioned Copley for this work, and the artist subsequently exhibited it at the Royal Academy in London. The painting caused a true impact with the English, bringing to mind their old Caribbean adventures. Today, it symbolizes the triumph of faith and willpower over adversity.

The Copley Family

(~1776)
oil on board
72.6 x 90.4 in
(184.4 x 229.7 cm)
National Gallery of Art,
Washington, D.C.

This work was made by Copley to commemorate his reunion with his family in London, where he went to improve his artistic education and look for new clients away from the turbulent political situation in Boston.

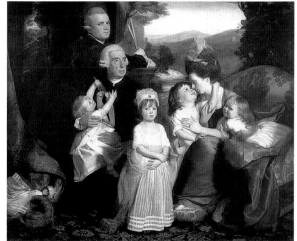

The painter had arrived in the British capital in June of 1774, leaving behind his pregnant wife and their three children, whom he would not see again until October of 1775.

Copley was in Italy when he learned that his family had already reached London, although his wife had brought only three of their children. The painter never met his fourth child, Clarke, who was born in delicate health and died when only a few months old. The three adults are easily identifiable: The painter's wife is wearing a blue dress, and her 65-year-old father is at her side, holding one of the children. Copley appears behind his father-in-law in a posture characteristic of self-portraits. The four children are, from left to right: Mary (3); John Jr. (4), hugging his mother; Elizabeth (6) in the center; and, looking at the viewer, little Susana, who had just been born in London. Elizabeth's calm demeanor, attentive and poised, indicates that she is the oldest child. She will soon start to be educated to be a young lady, as shown by the abandoned doll on the left that is dressed in similar clothes. The children are all dressed in long gowns, as that was the common attire for youngsters, regardless of gender.

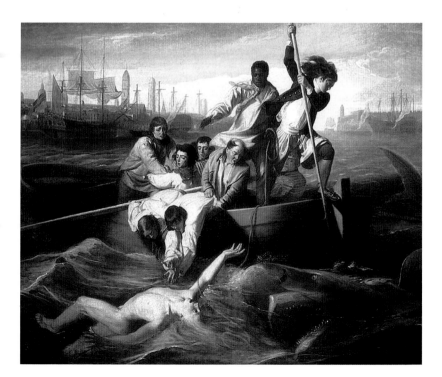

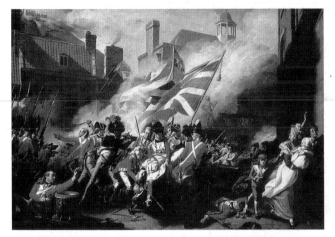

The Death of Major Peirson

(~1783)
oil on canvas
99 x 144 in
(251.5 x 365.8 cm)
Tate Gallery, London

On January 6, 1781, a battalion of French soldiers entered the island of Jersey to take the capital, St. Helier. They were stopped by English troops in a short but bloody battle in Royal Square. The French were defeated, but Major Francis Peirson, leading the British forces, was struck down by an enemy bullet and died. The news quickly reached London, where a famous engraver named John Boydell urged Copley to create a large-scale historical painting to commemorate the event.

This painting is important to the historical genre because Copley's work blew a breath of life into a genre that was still tied to old neoclassical traditions; earlier artists preferred to represent the heroes and the battles of classic antiquity. The Battle of Royal Square (also called Le Vier Marchi) was a very recent event, and people were still excited about it in England when *The Death of Major Peirson* was exhibited, even being viewed by the king of England.

The composition is extremely dynamic, and its high degree of expressiveness foreshadows Romanticism. Major Peirson lies in the arms of his soldiers while his black servant, Pompey, mortally wounds the man who had fired the fatal shot.

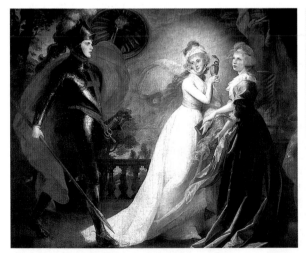

The Red Cross Knight

(~1793)
oil on canvas
47.2 x 70.9 in
(120 x 180 cm)
National Gallery of Art, Washington, D.C.

This is Copley's only work that was inspired by literature, and it was exhibited at the Royal Academy in London in 1793. The work is based on an event in the epic Elizabethan poem *The Faerie Queene*, by Edmund Spenser, published in 1590. The poem relates the story of a noble Christian knight, distinguished by a large red cross on his chest, totally absorbed and committed to the search for Truth.

Shortly after starting upon his journey, he meets the personifications of two of the virtues: Faith is dressed in white and surrounded by a mystic halo that imbues her with greater candor; in her hand, she holds a golden cup containing a threatening serpent, symbolizing her absence of fear before any adversity. The second is Hope, dressed in blue and holding a small anchor, as according to the Bible, Hope is an "anchor of the soul." Copley used his own children as the models: Junior is the knight, Elizabeth is Faith, and Mary is Hope.

CHARLES WILLSON PEALE

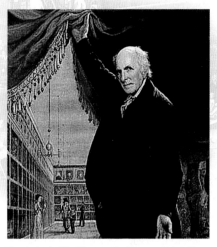

The Artist in His Museum (self-portrait detail), 1822, oil on canvas, 103.7 x 79.9 in (263.5 x 202.9 cm), Pennsylvania Academy of the Fine Arts, Philadelphia.

Charles Willson Peale's humanist dimension made him into an artist who came close to the Renaissance ideal of the scientific painter. His interest in natural science, politics, and history demonstrate Peale's intense personality and the incredible passion he put forth in all the disciplines he practiced. His pictorial style is a faithful reflection of this personal intensity.

A direct disciple of John Singleton Copley, Peale's life was divided between England and the United States. As a result, in his painting he abandoned the rigid nationalism that dominated his contemporaries' work, gradually opening up to a natural, sincere realism that allowed him to truly reflect the changing American society in the late 18th and the beginning of the 19th century.

A clear exponent of America's first portrait movement, Peale often featured the founding fathers in his work—most prominently George Washington. Peale shared this type of portraiture with Gilbert Stuart, although he did not use the same officious formality. Peale's revolutionary character led him to represent the nation's founding fathers as normal people, close to the public. At the same time, his commissioned works represent an evolution of traditionalist rococo from the mid-18th century.

An expert on the new British and French painting, nearly a realist pre-Romantic landscapist, Peale used light as a means of expression and had a free, spontaneous style through which his characters appear to be represented more naturally and with more feeling.

- **1741** Born in Queen Anne's County, Maryland, on April 15. Son of a bankrupt aristocrat.

- **1761** After working as an apprentice in a chair-making workshop, he starts a business in Annapolis.

- **1762** Shows an interest in painting and a year later begins studying with the portrait painter John Hesselius.

- **1765** Sets off for Boston, where he works for three years in John Singleton Copley's studio.

- **1766** In December he travels to England to study with Benjamin West. Stays in London for two years, thanks to the financial support of some Maryland patrons.

- **1769** Returns to Maryland, where he does his first important commissioned portraits.

- **1776** Moves to Philadelphia, where he becomes a political activist and serves in the Continental Army.

- **1779** Receives an order to paint George Washington's portrait.

- **1782** Opens a portrait gallery of leaders of the American Revolution.

- **1786** Converts the gallery into a museum where the Museum of Natural History is housed.

- **1794** The museum moves to the Philosophy Room. He is a founding member of the Columbianum Group, the first professional art academy in the United States.

- **1799** Begins a traveling series of conferences about natural history.

- **1801** Begins an expedition in order to recover two almost completely intact skeletons of mastodons near Newburgh, New York.

- **1802** Introduces the study of physiognomy in the United States.

- **1810** Retires in order to write in his country home in Belfield, Pennsylvania.

- **1812** Publishes "An Essay to Promote Domestic Happiness."

- **1818** Returns to Washington for a few years to complete various portraits.

- **1822** Once again takes over the management of the Museum of Natural History.

- **1827** Dies February 22 in Philadelphia.

Mrs. Thomas Russell

(~1784)
oil on canvas
30.3 x 25.3 in
(76.8 x 64.1 cm)
Butler Institute of
American Art, Ohio

In 1784 Thomas Russell commissioned two portraits, one of his wife and one of himself. It seems that these portraits were going to decorate his house in Cecil County, Maryland. It is no surprise that he commissioned Charles Willson Peale, since the artist dominated the Philadelphia portrait market at that time.

This painting shows the artist's interest in scientific realism. His knowledge of physiognomy led him to profoundly explore the woman's face, showing a sensibility based on a play of light and textures. For Peale, the perfect reproduction of the surface of a fabric, an object, or even human skin, was a fundamental priority. Thanks to a perfect perception of light and its reflection on the woman's skin, Peale has captured all the details down to the millimeter, representing the tiny blushes, the imperceptible wrinkles, and the light's glow on the flattest features of the feminine face. Equally, the artist has carefully represented the delicate satin of her dress, with its iridescent glows and contrasts of color in the pleats.

In this painting of Ann Thomas Russell, Peale maintains a style that recalls the rococo academicism of the mid-18th century, although the woman does not appear with the same static posture but rather with a contained dynamism, reflected through facial tension that conveys her strong character.

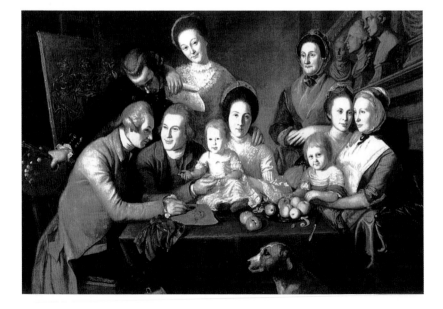

Washington at the Battle of Princeton January 3, 1777

(1784)
oil on canvas
93.3 x 56.9 in (237 x 144.5 cm)
Princeton University,
New Jersey

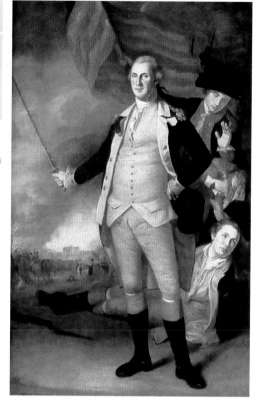

The claim could be made that portraits of George Washington constitute their own portrait genre in the United States. Aside from copies, most works produced at the end of the 18th century and based on the living first president give a fairly faithful idea of the great impact artists had on the political and social life at the time.

In the artistic world of the American revolutionary period, painters showed a remarkable intuition for reproducing scenes of major historical transcendence. At the same time, they were creating a new graphic language based on social icons such as the flag or President Washington's image.

In this work Peale has done an exceptionally modern exercise in analytic realism. His vision of the president as a living, breathing person allows him to demystify the character and truly show a human being. Peale does not highlight George Washington's political or strategic talents; rather, he shows his humanity as if it were a divine gift.

Washington appears on a plane apart from the battle. Reproducing the effect of focus by planes that the human eye does instinctively, the artist has represented a moment from the battle of Princeton, in which the protagonist appears with a natural solemnity. Peale offers an ephemeral instant in which the protagonist stops majestically and the battle continues dynamically behind him. The figure is tall, graceful, and majestic. He conveys a sense of security and grandeur, the image of a man who is never frightened away and is able to ensure victory. In a nation that was in its initial stages, the people needed such feelings of confidence so that the union of different states could gain supporters and be guaranteed.

The Peale Family

(1773-1809)
oil on canvas
56.5 x 89.5 in (143.5 x 227.3 cm)
Henry Luce III Center
for the Study of American Culture,
New York

Left: This painting's emotional implications are obvious, as the subjects are the artist's own family. Its execution was long, and Charles Willson Peale must have added members as his family grew, so the style is direct, personal, and free. Its spontaneity lies in the fact that the painter could not plan the whole painting from the very beginning, and therefore it has an almost Impressionist informality.

The work was in Charles Willson Peale's possession his entire life, first in his office and later displayed in the Peale Museum from 1812 to 1854. Almost all the painter's children appear here. Peale was the progenitor of a small dynasty of artists. His sons Rembrandt and Raphaelle were very popular, and his father called them the great classical masters. This composition recalls the style used for group portraits in central Europe during the 17th and the beginning of the 18th century, although the people's facial expressions appear with a more natural vision. The use of a chiaroscuro that develops through the entire pictorial space, contrasting with the clarity of the faces, creates a sensation of family intimacy in which all the members are comfortable in their environment.

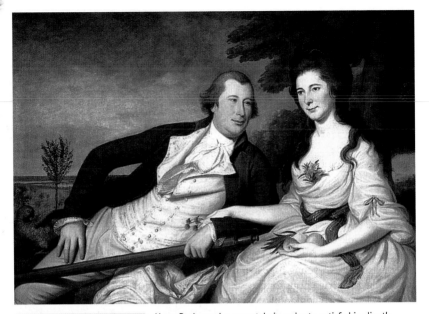

Benjamin and Eleanor Ridgely Laming

(1788)
oil on canvas
41.7 x 60 in (106 x 152.5 cm)
National Gallery of Art,
Washington, D.C.

Here, Peale used a new style in order to satisfy his client's demands. In this commissioned work for a Baltimore merchant, he composed the painting so that the local landscape is represented behind the couple. The artist has positioned the spouses in an unusual way for an 18th-century portrait. Both appear seated, and the husband leans affectionately toward his wife in a very explicit gesture for the era. This painting combines the traditional classical vision of the portrait with the new way of seeing the world that Peale proposed. The figures' expressions and gestures appear to be very natural, disregarding the traditional canons, in which the posture would be elegant and formal, clearly reminiscent of the rococo portrait style. For Peale, this naturalness is necessary in order to convey a sincere vision of his characters' personality and humanity. As a result, the artist has painted, in minuscule detail, the wrinkles of the man's clothing in this leaning position. Peale has not restricted himself with conventions or exaggerated elegance, and this painting is much more free.

The Exhumation of the Mastodon

(1806)
oil on canvas
50 x 62.5 in
(127 x 158.7 cm)
Peale Museum, Baltimore

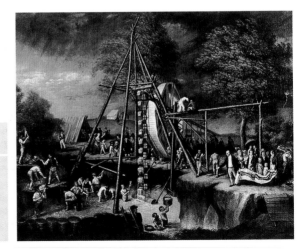

Staircase Group

(1795)
oil on canvas
89.5 x 39.4 in (227.3 x 100 cm)
Philadelphia Museum of Art

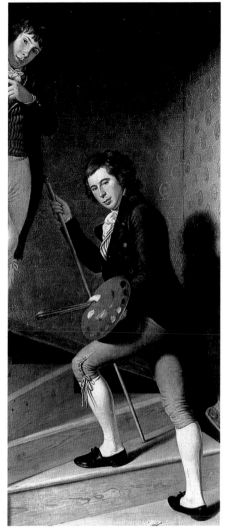

When Peale completed this portrait, he had left commissioned portrait painting behind some time before, due to his dedication to exploration and experimentation in the realm of natural sciences. From 1790 on, his portraits began to acquire such personal and political transcendence that he returned to the brush only for works of social or family importance. Peale was very busy socially, and his pictorial style took on the character of a social and historical chronicle. His work for the promotion of the arts in Philadelphia and the founding of the Columbianum Group, an association of artists based on a model proposed by the Royal Academy of London, absorbed much of his artistic dedication. The founding of a nature museum and leading scientific expeditions ended up taking up all his time, and therefore his painting became a capricious and selective discipline.

In this work, he shows his sons Raphaelle and Titian Ramsey Peale climbing stairs. The painter planned this work with the intention of achieving a trompe l'oeil effect. However, as the initial result was far from creating an illusion of real space, the artist added the two people in order to make the work more convincing by taking advantage of the false space that had been created. To increase the visual trick's sensation even more, the painter hung this picture in a doorframe of his office and built a real step in front of the canvas so that it gave the staircase three-dimensional continuity. Later, Rembrandt Peale recalled that George Washington was fooled into tipping his hat to the two painted boys.

Left: Painting was, for Peale, an excellent way to express and communicate his interests, investigations, and achievements to society. This explains why many of his works reflect his influence in the revolutionary period, his interest in science that would illustrate and enrich the national heritage, or, as in this painting, his successful expeditions in search of the remains of prehistoric animals or lost cultures.

In this painting, Peale represents a scene from his most successful exploration campaign. When, in 1801, an expedition led by Charles Willson Peale found the remains of two mastodons, it was relevant news for the whole nation. Early 19th-century American society celebrated these scientific achievements enthusiastically. The citizens saw them as a sign of cultural independence and prosperity of the new country, and they constituted a point of pride for the national consciousness. Aware of this, Peale decided to share his experiences with the American public by creating detailed accounts of the exhumation of the two skeletons. The realist quality with which Peale reproduces the water pump and the excavators' intense work constitutes some interesting working notes of great scientific and documentary value. The work knowingly combines a landscapist vision with a detailed picture of the group. The artist has used an ochre-green monotone tonality, alongside which only the intense blue sky stands out in the painting's upper left. It is a new and very interesting pictorial genre.

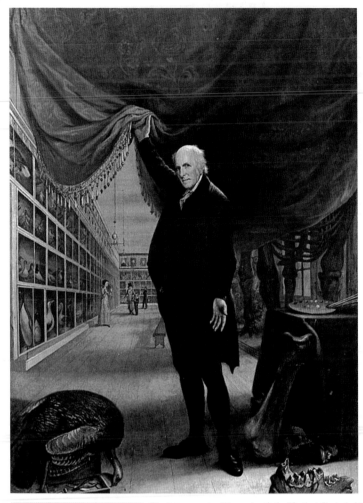

The Artist in His Museum

(1822)
oil on canvas
103.7 x 79.9 in
(263.5 x 202.9 cm)
Pennsylvania Academy
of the Fine Arts, Philadelphia

The intense scientific and artistic life that Peale led trans-
formed him into an outstanding figure in his society. The
painter knew perfectly well the social transcendence of his
actions, and therefore his behavior tended toward a certain
vanity; this can be detected in his paintings as well.

In this work he employs a pictorial style that was very
new at the time. He represents himself opening a great red
velvet curtain to unveil a room at his museum of natural
history, with an attitude that welcomes the viewer and at the
same time exhibits the magnitude of his work. From the
figure's mood, we can deduce that when he did this work his intention was to emulate Gothic
and Renaissance votive offerings. In this self-portrait, he shows himself offering a museum to
society in the same way that the portraits of medieval church patrons were included in frescoes,
as if they were offering their contributions to the saints.

Peale knew perfectly well that he communicated with his audience and that there was no
better way to get his message across than to do a painting addressed directly to the viewer.
Here, he has combined different elements in order to convey the implications of his gesture.
Seeing this picture, the viewer clearly knows that the artist is personally and very directly
addressing him. The artist appears with a solemn and reflective expression, but an under-
standing and conciliatory one as well. He also shows himself as a host, attentively lifting up
a thick, perfectly textured curtain and opening his left hand completely in a courtly gesture
that invites us to enter.

RALPH EARL

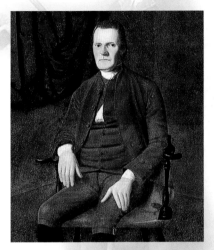

Roger Sherman, *1775, oil on canvas, 64.6 x 50 in (164.2 x 126.5 cm), Yale University Art Gallery, New Haven, Connecticut.*

Many of Ralph Earl's works depict the bourgeoisie at the height of their prosperity, people who were desirous of exalting and immortalizing themselves through portraits. The images that he left behind show a concept of morality based on civic virtue and heroism, two characteristics it would have been difficult to better express in any style but the neoclassical. The basis of this style, predominant in Europe in the last quarter of the 18th century and the first of the 19th century, is a natural and detailed treatment, as well as a compositional clarity that allows the protagonists to be identified by the attributes that speak of their virtues, their activities, and their luxuries and property, but always with a touch of intimacy, modesty, and relaxation.

Consciously or not, Earl responded to the approach that Johann Winckelmann had taken in his work *Reflections Concerning the Imitation of the Painting and Sculpture of the Greeks* (1755), a work that was considered the bible of neoclassicism soon after its publication. The "noble simplicity" and "quiet grandeur" pondered in these reflections were the same objectives that would mark Earl's work. He painted with an "intelligent" brushstroke—another of Winckelmann's sayings—as his images were always more complex than they seemed at first viewing.

A large part of Earl's relevance lies in the fact that he became, through his work, one of the best chroniclers of the new American republic. Proof of this is his portrait of Roger Sherman, a hero of American independence, and the four sketches he made of the Battle of Lexington.

- **1751** Born in Shrewsbury, Massachusetts, the eldest of the four children of Ralph and Phebe Whittemore Earl.
- **1774** Marries Sarah Gates, his second cousin.
- **1775** His first daughter, Phebe, is born. Earl sees and is deeply affected by the work of John Singleton Copley on a visit to Boston. Paints portrait of Roger Sherman, considered his masterwork.
- **1778** Loyal to the crown, he decides to abandon his family and leaves for London, where he starts painting with the support of Colonel John Money.
- **1783** Studies in London with Benjamin West and successfully displays four portraits at the Royal Academy's annual exhibition.
- **1785** Returns to the United States with his second wife, Englishwoman Ann Whiteside.
- **1786** Jailed for not paying personal debts. In prison, paints around twenty portraits of prominent families.
- **1788** Gets out of prison and returns to Connecticut, where he receives the support of Dr. Mason Fitch Cogswell, who commissions several works from him and introduces him to high society. From this point on, he and his wife and two children, Mary Ann and Ralph, will move constantly.
- **1799** With two colleagues, he becomes one of the first American artists to travel to Niagara Falls.
- **1801** Dies as a result of alcoholism in Bolton, Connecticut.

During his exile in London, he worked in Benjamin West's studio, along with John Singleton Copley, one of the most exalted artists in North America at the time. While he was never actually a pupil of West in the strictest sense, this period at his side represented Earl's maturation as an artist, as he learned many ideas characteristic of the Royal Academy and confirmed his interest in painting landscapes, country homes, and sporting events. During this same period, Earl began to exhibit his works, which quickly gained in value.

Joseph Steward (1753-1822) and Captain Simon Fitch (1785-1835) should be included among his disciples.

Ralph Earl can be classified as an itinerant artist who painted more than 180 portraits, some of which can be found in the permanent collections of the best American museums.

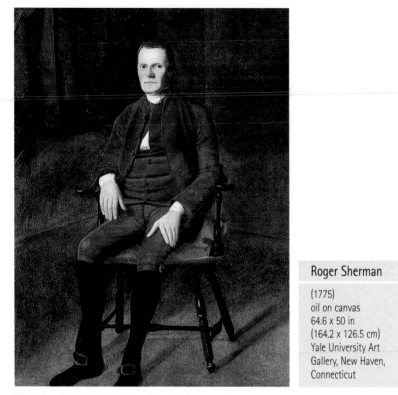

Roger Sherman

(1775)
oil on canvas
64.6 x 50 in
(164.2 x 126.5 cm)
Yale University Art
Gallery, New Haven,
Connecticut

This portrait is rightly considered the masterwork of the painter. Roger Sherman was the only American to place his signature on all of the four most important documents that permitted the birth of the United States as an independent nation: the Declaration of 1774, the Declaration of Independence in 1776, the Articles of the Confederation in 1781, and the Federal Constitution in 1788. Because of this, the work, besides having undeniable artistic value, also has significant historical value, as it is one of the best graphic documents in existence of this important man.

The portrait is exquisitely simple. The austerity, of the protagonist, the chair, and the room, shows the painter's intention concerning the image he wanted to project of Sherman: an orderly, dignified man who inspires confidence. The figure, defined with delicate yet firm lines, is dressed soberly and without luxury. He sits on a chair in a room where a curtain is the only background. This atmosphere gives the sensation that we are before an affable person, a politician devoted to the common interest, far from any superficial concerns. It is the image of someone who has sacrificed capriciousness for the good of his public and republican vocation. The work is also notable for the expressiveness in the contrast, for the clean composition, and for the care Earl took in depicting the folds and textures of the clothing.

Mrs. Noah Smith and Her Children

(1798)
oil on canvas
Metropolitan Museum of Art,
New York

Mrs. Benjamin Tallmadge and Son Henry Floyd and Daughter Maria Jones

(1790)
oil on canvas
78 x 54 in (198.1 x 137.2 cm)
Litchfield Historical Society,
Connecticut

This portrait is of a woman with her children inside the home. The way the artist has given texture to the woman's dress to suggest a tactile sensation is quite interesting. The predominance of the line in this work is clear, an effect that grants a detailed description of the folds and textures. It also aids a psychological treatment of the people posing that tries to imbue them with serenity and the appearance of nobility.

As can be appreciated in much of Earl's work, the artist has created strong contrasts between light and shadow, ensuring that the people in the foreground are brightly illuminated, while those in the background are immersed in semidarkness. The artist has emphasized the feminine world with the fan. There is also a curtain in this work, as if it were a type of backdrop in a theater, and a window through which the landscape outside can be seen. In Earl's works, secondary landscapes stopped being a representation of fact and became instead his personal signature.

In this work, as in most of Earl's paintings, the precision of the detail is an important aspect. With well-defined brushstrokes, the artist re-creates the belongings of the characters, from the furniture to the dress and jewels. They are references to explain the economic and cultural condition of the protagonists.

Left: This portrait is a good example of the expressiveness with which Earl represented his characters. It is a style that combines the techniques proposed by the neoclassical trend, basically conscious of the importance of drawing with subtle and well-defined lines, and his unique signature of using the landscape as a background. The light is treated homogeneously, and the artist makes it clear, as ideals of this era dictated, where the source of illumination comes from. The work shows a bourgeois family of the 18th century. The six members pose inside, probably in the living room of their home, where two important elements are mixed: the landscape in the background and the curtain draped behind them, on the far right side of the work. This latter element has been borrowed from the Baroque tradition to add a theatrical touch to the scene.

The family members are in the foreground—with the notable exception of the father—holding objects that act as hierarchical symbols, defining their social roles according to their age and sex. The mother, Mrs. Noah Smith, is on the far right, holding her youngest child. Her firstborn son is on the opposite side, a young man with a stately appearance; his posture, clothing, and even the cane that he holds denote his role as the "man of the house." His position opposite the mother evidences a balance of power. Next to him is a younger son with a map in his hand, a symbol of adventure and conquest, two determining concepts for North American culture. At his side is a young boy standing on a stool and holding a hat, possibly to evoke the absent father. The other family member is a little girl standing at her mother's side, holding a small doll in her arms. The expressions and glances of those portrayed in Earl's works are unusual. In this case, all of the members of the family look toward the viewer, except for the mother, who looks beyond the canvas. Scenes where the mothers, and often the children as well (except for the males), do not look directly at the viewer were frequent in family portraits of this period.

Right: Of the six landscapes that Ralph Earl created, this is the most representative. Following the common custom of the time, Colonel Thomas Denny, Jr., commissioned Earl to create this panoramic view of Worcester, Massachusetts. As the officer was going to move, he asked Earl, an old family friend, to paint the valley where he had lived since he was a child, so that he could take the work to his new home.

Looking East from Denny Hill

(1801)
oil on canvas
45.7 x 79.4 in (116.2 x 201.6 cm)
Worcester Art Museum, Massachusetts

In this representation of an afternoon landscape, Earl demonstrates his expertise in managing distance, especially with regard to scale. There are two trees in the foreground, one on each side of the painting, whose height exceeds the frame of the work. There are also some diminutive farmers, almost suggested, an empty road, and, farther away, the tops of the bell towers of the two churches in the town of Worcester. This landscape is reminiscent of solitary countryside seen through small windows, always with blue-and-pink pastel-colored afternoon skies, a cloud or two, in countryside that is depicted with a soft brushstroke. The expressiveness and detail of the landscape reflect the interest that Earl felt for this genre, as he also used it recurrently for the backgrounds of his portraits. He created these works by commission and the landscapes became a type of distinctive sign of his works. Earl was one of the first American artists to consider the landscape as a form of expression that went beyond being strictly decorative.

Right: This portrait is a good example of how, at times, the compositional elements used to capture the characters had to do with their leisure activities. The protagonist is outdoors and, considering the gesture he makes with his hat, presumably on his own property. With his posture, the hunter seems to flaunt his domain before the viewer. Throughout the 18th century, it was common for the local bourgeoisie to commission portraits that would make their status and refined customs apparent. In this case, the man, who seems to be enjoying his leisure time, holds a rifle while, at his side, two dogs stare fixedly in the same direction, searching for the prey. One of them appears foreshortened, an indicator of the degree of artistic education of the painter. The protagonist, appropriately dressed for hunting, looks toward the viewers as if demanding their attention. His posture is reminiscent of the baroque tradition, especially the portraits of the monarchs, because of the intentional disproportion of the legs, whose length is exaggerated to give the character a monumental image and make him seem more important in the viewer's eyes.

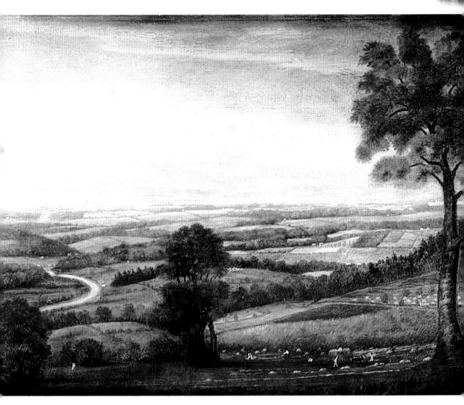

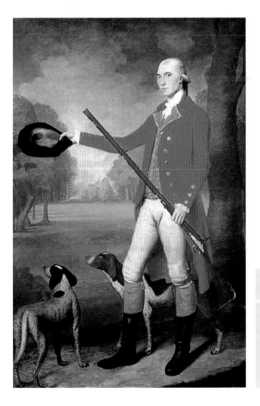

Portrait of a
Man with a Gun

oil on canvas
87 x 57.4 in
(220.7 x 145.9 cm)
Worcester Art Museum,
Massachusetts

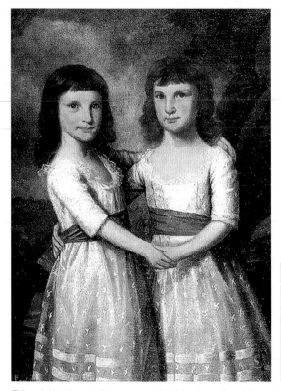

The Striker Sisters

(1787)
oil on canvas
37 x 27 in (94 x 68.6 cm)
Butler Institute of
American Art, Youngstown,
Ohio

This painting is one of twenty completed by the artist while serving a prison sentence in New York. During this difficult time of his life, the artist received the support of a charitable group; in return for their assistance, members requested paintings of wives, relatives, and friends. As a result of his talent, Earl, who at this time already had some fame among the privileged classes, was able to obtain his freedom sooner than anticipated.

This work shows the daughters of James and Mary Hopper Striker, owners of an important farm located on the Hudson River. At one time, art historians thought that the girls were twins; in reality they were not. Six-year-old Ann poses on the left, while Winifred, a year younger, poses on the right. The background is a bit unusual for an Earl piece, as it does not show a landscape at dusk, but rather a somber space without great pretension. This background gives the scene a gloomy feeling, although the semidarkness, perhaps a metaphor that reflects the mood of the artist, allows the white dresses, so wonderfully detailed by Earl, to shine in their own light.

This painting captures the intimacy of the moment: It is as if the onlooker has interrupted the dance or play of the two sisters. Their body language, mixed with mischief, reveals a close relationship between the characters. On the other hand, it is important to note the expressiveness with which Earl has enriched the flat and wide shapes of the faces, the blush of their cheeks, and the dark pink of the lips. This emotional quality is a small example of the virtuosity with which Earl describes his characters. The composition of the work is balanced because the rocky formation on the upper right-hand side is counterbalanced by a discreet leaning to the left of the central figures. This sense of equilibrium is resolved by the blue ribbon, which flows down the length of Ann's body. As in the majority of his works, Earl exhibits his characteristically delicate brushstrokes and outlines, a kind of personal signature that demonstrates his artistic experience in England.

GILBERT STUART

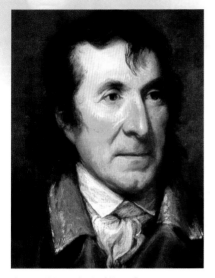

Charles Willson Peale, Gilbert Stuart, 1805, oil on canvas, 23.5 x 19.5 in (59.7 x 49.5 cm), New-York Historical Society.

Gilbert Stuart was one of the main portrait artists in American art history. His style was innovative in nature, influencing the development of American painting at the end of the 18th century. This led to the attainment of a style on a par with that of Europe at the time.

Previously, American artists had been remote in respect to style, although there were some vague imitations of the predominant European trends. Gilbert Stuart's work was a radical change in American painting, creating a distinct style in 19th-century art in which daily life and realism were fundamental.

Gilbert Stuart's European training let him perceive the Old World's cultural reality and evaluate differences in how painting was understood on both sides of the Atlantic. The rococo style, which imitated the English portrait, was predominant in American painting when the artist returned home at the beginning of the 1780s. However, a new generation of artists such as Copley, Robert Salmon, and even Stuart himself soon contributed a new, more realistic style with an added expressive perspective of light and color. Stuart's portraits of President

- **1755** Born near Narragansett, Rhode Island. Son of a Scottish immigrant who set up the first snuff mill in the United States. Studies in Newport.

- **1770** Cosmo Alexander, a Scottish painter living in Newport, gives him his first art lessons. They both live in Scotland for the next two years.

- **1773** Returns to the United States.

- **1775** Travels to Boston to board the last ship to England that was not detained by the British navy. Arriving in London in September, he works in Benjamin West's studio.

- **1778** Sets up his own studio. Travels to Ireland to paint a variety of portraits of illustrious figures of the period.

- **1786** Marries Charlotte Coats, daughter of a doctor from Berkshire, England.

- **1792** Returns to the United States, fleeing many debts in Ireland. Settles in New York.

- **1794** Moves to Philadelphia to paint a series of portraits of George Washington. Opens a studio in Philadelphia.

- **1795** Is elected member of the American Academy.

- **1803** Moves to Washington to paint President Jefferson and other notable political figures.

- **1805** Moves to Boston.

- **1827** Is elected honorary member of the National Academy of Design in New York.

- **1827** Dies on July 27 in his house in Boston.

Washington and the country's prominent citizens gave a new and original quality to American art, freeing it from comparison to English painting. A series of intimate portraits instilled with expressiveness and feeling represent this turning point and Stuart's role in creating it.

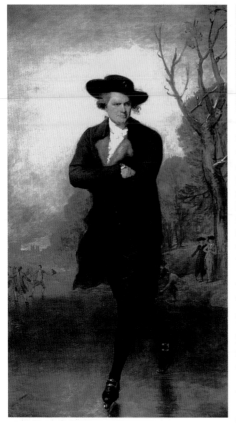

The Skater (William Grant)

(1782)
oil on canvas
96.3 x 58 in (245.5 x 147.4 cm)
National Gallery of Art,
Washington, D.C.

The painter studied under Benjamin West for five years. After several years under the tutelage of Cosmo Alexander (they were very close friends, because of their Scottish roots), he went to London, where he worked with West. This collaboration influenced Stuart's painting, and he learned a new way of appreciating objects and people from this English painter.

The Skater is Stuart's first important work. Made in West's studio, it was displayed at London's Royal Academy exhibition in 1782. When it was exhibited, critics accused Stuart of using an unorthodox style and including too many atmospheric effects in it. In this work, the young painter had already created a style that imbued portraits with a more modern and daily perspective; he stripped them of any underlying solemnity and offered greater compositional realism. At the end of the 18th century, the portrait still displayed an old-fashioned baroque style full of static images and simulated postures. Stuart, however, pioneered a more direct style where the subject himself steered the composition.

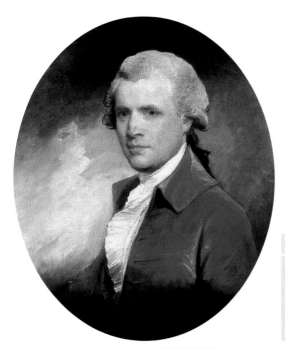

John Singleton Copley

(1783-1784)
oil on canvas
26.5 x 22.2 in (67.3 x 56.5 cm)
National Portrait Gallery,
London

Sir Joshua Reynolds

(1784)
oil on canvas
36.1 x 30.1 in (91.6 x 76.4 cm)
National Gallery of Art,
Washington, D.C.

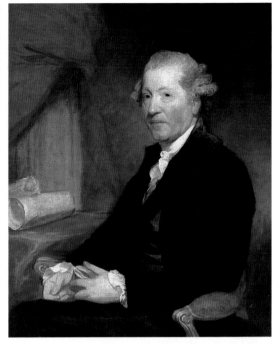

A portrait was no longer simply a painting to be hung in the living room. The portrait was now considered a valuable work of art that could be a family heirloom for future generations. This change in value influenced the portrait art of the period and created a new artistic language. Artists had to include components in the painting that represented the subject's social standing.

This painting clearly reflects Stuart's artistic style. His ability to convey metaphysical elements such as emotions or feelings lets him create a sensation of abruptly restrained dynamism. This work focuses on immediacy, because it depicts an instant in which a person poses for the portrait. Nonetheless, it also illustrates the ephemeral in that peaceful moment. Once the session is over, the person will return to his daily routine.

Stuart painted the artist Reynolds, president of the Royal Academy, at his place of work, beside a table where papers await his attention. The gentleman is soberly dressed, and his body blends into the darkness. His bright facial expression, on the other hand, steers and invites the viewer to enter his psyche. Although the portrait is very dignified, the painter has avoided everything that could dissociate the figure from his everyday life and anything that could infuse him with idealism or lavishness. Reynolds has been depicted quite naturally and close-up. However, Reynolds was offended by the way Stuart portrayed him with a pinch of snuff between his fingers.

Left: The use of an oval format is characteristic of 18th-century portraits. For many years, owning a painting had been the privilege of the fortunate few. For the most part, only the church or well-positioned patrons in the government or court could afford to commission paintings. When the Age of Reason occurred, however, a new, much more general market opened for art. In the United States, market demand prevailed in almost every type of painting from the very beginning, because American painters had far more freedom than their European contemporaries. That is why, when portraits became a social necessity at the end of the 18th century, artists found ways to stand out from the competition. They created styles and formats that became part of the new artistic vocabulary. A social statement could be made by a painting's format, its size, and the technique used. To have the desired effect, a portrait had to be painted in oil and could not be the size of an economical miniature. The oval shape represented nobility and economic power, since it appeared to correspond to a classical canon that was reminiscent of the old Renaissance tondos that ennobled the painted figure.

In this painting, Stuart experimented with the Baroque classicism of traditional portraits and the modern art of contrasting tones such as red and white. The painter has refrained from using his customary dark background to highlight the portrait's figure. This results in a more dynamic painting, featuring a wide range of colors and a somewhat romantic setting encircling the figure.

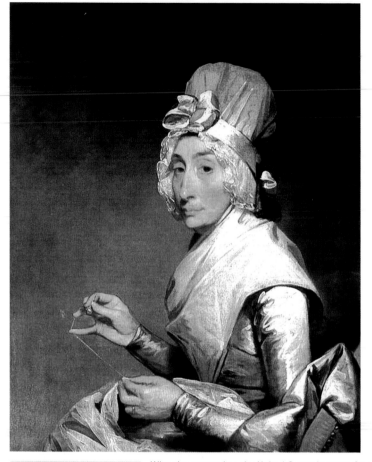

Catherine Brass Yates

(1793-1794)
oil on canvas
30 x 25 in (76.2 x 63.5 cm)
National Gallery of Art,
Washington, D.C.

When he returned to the United States in 1793, Stuart found a completely different country. Politically, a new nation had been born. Socially, a cultural mosaic opened right before the artist's eyes, and he found a wide range of themes to cultivate in his work.

This painting is one of the first the artist painted after returning from England. In it, his clever use of light can be appreciated on the woman's dress. In London, Stuart had investigated the reproduction of light reflections in depth, contrasting it with apparently dark portraits. Influenced by the style of Titian and Van Dyck, the artist chose this expressive tonal duality for his portraits. That is why he used a light tone for the figure's dress. Its silver reflection is highlighted by the background's darkness, emphasizing the woman's rosy cheeks. This makes the image very bright, dispelling nobility and making the sitter appear very human, caught by surprise as she attends to housework in a familiar environment.

Stuart subtly introduced this sensation of intimacy in his paintings. Before him, the portrait had been a symbol, a display of the model's public persona. In Stuart's paintings, on the other hand, the portraits are more realistic because they reflect the person's inner psyche, reserved for a close audience. This intimacy lends his portraits a very personal and human perspective.

George Washington and Martha Washington

(1796)
oil on canvas
47.8 x 37 in (121.3 x 94 cm)
Museum of Fine Arts, Boston

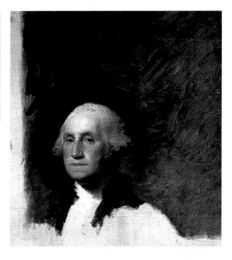

Although neither painting was finished, this portrait of George Washington is one of the most commonly reproduced paintings in the United States: It served as the source for the picture of Washington used on dollar bills. The two paintings are among the few portraits of the couple, since artists of the period preferred to paint the president only, ignoring his wife.

Stuart painted more than a hundred portraits of George Washington just after the United States became independent. This indicates the intense interest of American citizens—they wanted to see the image of the man who represented and identified the new nation. Americans have always loved patriotic symbols, and this portrait of the president can be considered the first of these symbols. That is why artists created countless portraits of the president at the end of the 18th century. Merchants, attorneys, and politicians commissioned the paintings to be displayed in their offices.

Following the style of his other portraits, Stuart worked to depict these two figures as human and dignified—qualities valued by Americans throughout our history.

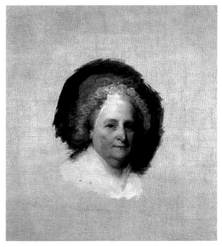

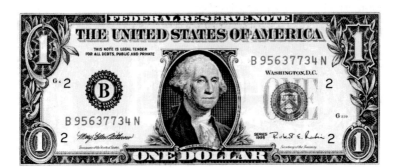

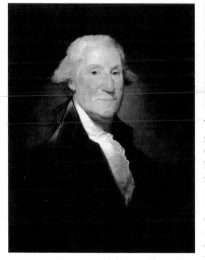

George Washington

(1795)
oil on canvas
30.2 x 25.2 in (76.8 x 64.1 cm)
Metropolitan Museum of Art,
New York

This portrait of the first president is from a series of eight very similar paintings made by Gilbert Stuart, called the Vaughan group. Samuel Vaughan, a London merchant who had settled in Philadelphia, commissioned Stuart to paint these presidential portraits. Rembrandt Peale collaborated on them with Stuart. Only one of the portraits, the first, this one, was made when the president was still alive, so the others in the series were probably based on this painting. Peale later made several copies of Stuart's George Washington portraits. This portrait became the president's official image and, therefore, is renowned. This portrait was so successful that its style was almost mandatory for the artists of the period. When a member of the general public commissioned a portrait of the president, it was on the condition that it follow the aesthetics of this portrait.

Compositionally, the work merges two very important aspects that clearly convey the idea that the public liked so much: It transmits a sensitive human expression (the president is shown as a regular person, like any other citizen, even to the point that he is depicted with rosy cheeks) with an air of distinction (the pose, the attire, and the look of great dignity). To highlight the figure and provide him with a reverential setting, Stuart created a very dark background that scarcely lets the figure's clothing be seen. It helps to focus the viewer's gaze on the face, where the artist has captured not only the model's physical features, but also his personality and character.

Mrs. Stephen Peabody

(1809)
oil on paper laid on board
33.5 x 19.5 in (85 x 49.5 cm)
Arizona State University
Art Museum, Tempe

This portrait illustrates Stuart's most authentic style. The artist's understanding of his subjects goes far beyond simple artistic expression. He usually depicted an almost psychological perspective of his figures, which he painted with an expressive realism that captured their mood, fears and hopes.
This work shows a middle-aged woman who gazes at the viewer with an avid and suspicious look. The figure appears sad because of the color tone used. Visual monotony has been avoided by giving the figure an expressive gesture, which is both strong and disconcerting. When the work was criticized, the painter commented that he was not interested in depicting romantic portraits of beautiful women but in conveying, through gesture and expression, the person's psychological manifestations. The dark background helps to create an expressive contrast. The technique used in many of this artist's paintings dissolves the figure's body and absorbs it into the artistic plane, outlining the face's clear image and, here, highlighting the fine composition of the lace on the neck and headdress.

JOHN TRUMBULL

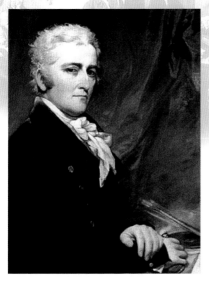

Self-Portrait.

John Trumbull was one of the founders of American art. His works are a clear reflection of the politics, society, and history of his country.

In his adolescence, he was influenced by the realism of Copley. During his war service he produced a number of maps, which won him the admiration of Washington, whom he later depicted in sixteen portraits. Trumbull then launched his period as an historical painter; eventually he moved to London to study with West. His mission as an artist was to commemorate for eternity the American Revolution and all those who had participated in the birth of this new nation.

Trumbull thought that, independent of artistic value, paintings have little impact on a viewer. However, he thought that historical works recorded forever the important moments of a nation. Many of his paintings fused both interests. He adopted a half-length seated pose, three-quarter profile painting style with a dominant color scheme of reds and blacks. Other portraitists such as Samuel Lovett Waldo and William Jewett also adopted this standard.

During his stay in Paris, when he produced his best works, Trumbull studied composition for his depiction of the signing of the Declaration of Independence. This large-scale painting represents all those who played an important role in the signing, including many not actually present.

His return to the United States marked the start of an artistic decline. Thus, when Congress commissioned him to paint murals for the four wings of the Capitol building, showing scenes from the American Revolution, contemporary

- **1756** John Trumbull is born in Lebanon, Connecticut, on June 6, into a very politically active family. His father, Jonathan Trumbull, was a successful industrialist who became governor of the colony. Very likely John Trumbull grew up listening to talk and discussion on the rights of the colonies and the problem of relations with England. While politics was everything to his father, John realizes at a very young age that his true passion is painting.
- **1771** On his way to Harvard, where he studies fine arts, he visits John Singleton Copley's studio, and is convinced to dedicate himself to art.
- **1773** He graduates from Harvard.
- **1775** When war breaks out in Lexington, he joins the Connecticut First Regiment and participates in the Battle of Bunker Hill.
- **1779** On the recommendation of Benjamin Franklin, he travels to London to work in the studio of the painter Benjamin West.
- **1780** He is jailed in England after a trial on charges of treason. Thanks to West, who asks the king to intercede in favor of the painter, he is released. In jail he does several studies of the nude form.
- **1781** Deported to the United States.
- **1784** Returns to England to continue his studies with Benjamin West.
- **1786** He completes his works *The Death of General Warren at Bunker Hill* and, shortly afterward, *The Death of General Montgomery in the Attack on Quebec.*
- **1789** Travels to Paris and strikes up a friendship with Thomas Jefferson. Begins work on *The Declaration of Independence.*
- **1804** Returns to the United States. Establishes a studio in New York, working as a portraitist.
- **1816** Congress commissions him to decorate the rotunda of the new United States Capitol with four scenes from the Revolutionary War.
- **1817** Is appointed president of the American Academy of Fine Arts, New York.
- **1843** In November 1843, he dies at home in New York. In accordance with his instructions, he is buried at the foot of his portrait of George Washington in the Yale University Art Gallery.

critics did not receive them with great favor.

Trumbull's small works in oil on fabric or wood are surpassed only by some of the miniatures of Edward Malbone, and by the best works of Charles Fraser and Benjamin Trott.

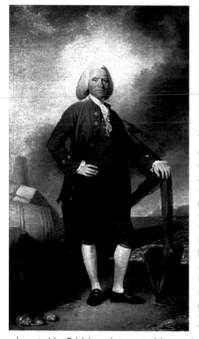

Patrick Tracy

(1786)
oil on canvas
91.5 x 52.6 in
(232.5 x 133.7 cm)
National Gallery of Art,
Washington, D.C.

This work was done during Trumbull's period of apprenticeship in London, under the tutelage of Benjamin West, and it shows the young artist's emerging talent. Apparently this picture was ordered by Nat Tracy, son of Patrick Tracy, during a business trip to London. Patrick Tracy was a ship owner and merchant who owned a warehouse in Massachusetts. For that reason, he is shown here standing on a shell-strewn beach amid crates and barrels of trade goods, resting his hand on a ship's anchor. His gray hair betrays a man of seventy-some years (a ripe age for that time), but his body, with its delicate fingers and smooth, fine hands, is that of a young person rather than an old man. Trumbull here has adopted the conventions advocated by British society portraitists such as Joshua Reynolds, who idealized their subjects' proportions, showing them as younger, stronger, and more sophisticated than they really were—hence the stylized body of this venerable older man.

Nevertheless, Trumbull's treatment of the face is very different; there, Copley's greater influence is observable. Copley had personally inspired Trumbull to take up painting, and the great admiration Trumbull felt for him is evident. The realism and honesty of Copley's faces can be seen in the portrayal of the wrinkles and direct gaze of this entrepreneur, clearly capable of great business success. This realism owes much more to the idea of the personality of the subject than to the embellishment of the figure proposed by Reynolds. This work made a very good impression on West, who subsequently began to divert commissions to Trumbull, making him his assistant.

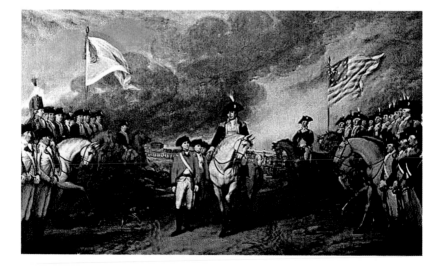

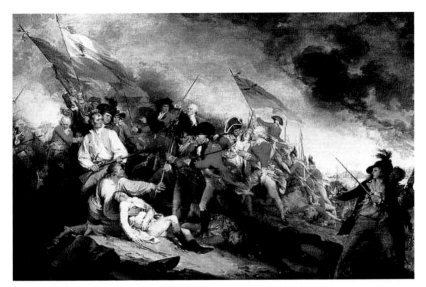

Recognized as one of the masterpieces of North American art, this work was finished in West's studio after the painter had made a systematic investigation of the events, including sketches done during visits to the historic site itself. Trumbull wrote in his diary that this work showed the moment at which the American side had run out of ammunition while British troops completely dominated the battlefield. In the final moments of action, General Warren was hit in the head by a bullet from a musket, thundering as he fell to the ground. The main group shows General Warren dying and a soldier pointing his bayonet at a British grenadier.

The Battle of Bunker Hill

(1786)
oil on canvas
25 x 34 in (63.5 x 36.4 cm)
Yale University Art Gallery,
New Haven, Connecticut

Colonel Small supports the dying man on his knees, while with one hand waves away the musket of the grenadier in an effort to prevent him from finishing off the wounded officer. The tragic moment caught by Trumbull is underscored by his use of a pyramid composition for the figures, who are crowded on the crest of the hill, submerged by the vortex of the battle. On foot is General Putnam, ordering his soldiers to retreat in the face of the imminent victory of the English, who are already raising their flags on the hill peak. Light is centered on the main group, as if Trumbull wanted to symbolize the passage of General Warren to the Mount Olympus of the heroes of the struggle for independence. Despite a studied composition, Trumbull creates a sense of documentary-like immediacy, as if he himself had been present at this tragic moment.

Left: Trumbull completed this painting in Benjamin West's studio after West had made him welcome in London. For *The Surrender of Cornwallis*, Trumbull merged the realism of a picture with the evocative capacity of an historical painting; using this style, he worked to portray the most significant moments in the history of the United States.

This scene depicts the moment when the defeated British column approaches General Lincoln to surrender, flanked by the victorious armies: the French, brandishing the flag of the house of Bourbon, and the Americans, waving their stars and stripes. All those in the picture, with the exception of the English soldiers, are perfectly identifiable, so committed was the artist to depicting a trustworthy documentary record of the moment. To the right of the viewer and advancing on horseback is Commander-in-Chief George Washington, moving toward the column of prisoners. Nevertheless, despite the interest of the painter in portraying the protagonists in the battle, the face of the central figure, General Lincoln, does not fully correspond with reality: This one was later painted in by Trumbull to replace the English officer, General Cornwallis, whom he had originally shown presiding over the group. The critics at the first exhibition of the work strongly attacked the painter, because Lord Cornwallis was not in fact present at the Battle of Yorktown. For that reason, he had to replace the head of Cornwallis with that of Lincoln.

The Surrender of Cornwallis

(1786-1787)
oil on canvas
21 x 31 in (53 x 77 cm)
Yale University Art Gallery,
New Haven, Connecticut

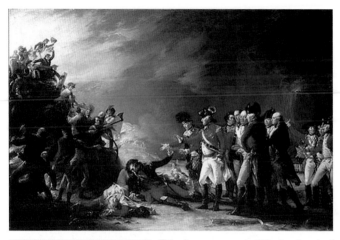

The Sortie Made by the Garrison of Gibraltar

(1789)
oil on canvas
71.3 x 107 in (180.8 x 271.8 cm)
Metropolitan Museum of Art,
New York

This gives an account of the heroic episode of November 26, 1781, in which a British garrison in Gibraltar, long besieged by Spanish troops, was able to break through after a surprise sortie. Noticing that Spanish batteries were perilously encroaching on their encampment, General George Elliott decided on a surprise attack; the Spanish soldiers fought among themselves and fled in disarray, abandoning their officer Don Jose de Barboza, who single-handedly charged the British column. He was mortally wounded, but declining all medical help, died at his post. This is the moment depicted in this work: Barboza, lying on the battlefield, makes a theatrical gesture of rejection of the offer of mercy by the enemy officers, although his life is already slipping away. Behind him, Spanish troops make a disordered retreat, in the face of the calm advance of the British forces. There are signs, nevertheless, that the battle was not an easy one: an English soldier lies dead in the dirt next to the Spanish officer.

Trumbull's style here is very rhetorical, in the tradition of grand history painting. He follows the example of his mentor West, but stresses the heroic and human aspect of history. On the one hand is the compassionate English general, extending his hand to a fellow officer; on the other is the proud Spanish officer who, having killed an enemy soldier, opts for dignity in death. For its part, the painting depicts two well-differentiated aspects: to the viewer's left, a chaotic group of terrified Spaniards, counterbalanced by the calm serenity of the English officers on the right.

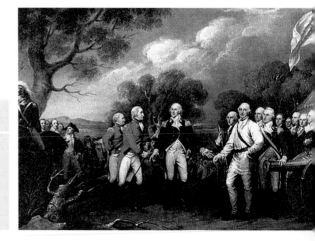

The Surrender of Burgoyne

(1789)
oil on canvas
Yale University Art
Gallery,
New Haven,
Connecticut

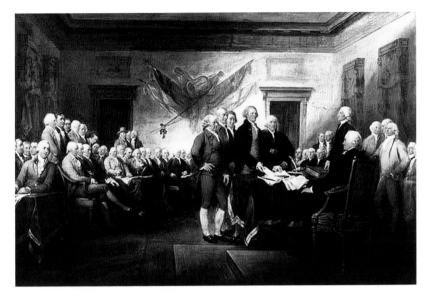

In 1789 Trumbull started work on a miniature version of *The Declaration of Independence,* designed to decorate the Rotunda of the U.S. Capitol. The painter dedicated four years of his life to finding the people who had been present during this historical event and had attended meetings of Congress prior to the signing of the Declaration.

Some accounts say on his many travels Trumbull always carried canvas and paint, so as not to miss any opportunity to portray these figures. Of the 48 subjects in the painting, 36 were made directly, some from pencil sketches quickly transferred to canvas. This fact is known because of the existence of several preparatory sketches for the faces, for example of George Wythe, Samuel Chase, and John Hancock. In 1789 the painter traveled to Paris in search of Thomas Jefferson, who provided him with a plan and detailed description of the hall in the Pennsylvania Assembly where the signing took place.

The fundamental importance of this painting resides in the fact that it is an artistic portrayal faithfully reflecting the pictures of 48 people involved in one of the most important moments in the history of the United States. Nevertheless, many students and historians have been critical of Trumbull's idea of concentrating in one place people who did not all agree at the time of the signing, although they made the necessary political gestures to ensure it happened. But, in his defense, it must be said that Trumbull's intention was to bring together all the figures who had anything to do with this significant event. In 1817 the painter produced the bigger version of this work for the rotunda of the Capitol but, due to his clear technical limitations in mural painting, the result was a little disappointing.

The Declaration of Independence

(1789)
miniature in oil
21.2 x 32.2 in (53.8 x 81.7 cm)
Yale University Art Gallery
New Haven, Connecticut

Left: According to artistic theory dating from the Renaissance, historical painting was the highest category of art. Obsessed with this idea and driven by his interest in immortalizing the high points of his country's history, Trumbull brought all his talent into play to venerate the American Revolution. In 1789, during his stay in Paris, the painter met Jefferson, who after seeing some of Trumbull's historical paintings, advised him to develop his vocation as a painter of historical subjects by depicting a series of important moments in the American Revolution.

The idea for this picture sprang from that conversation. Trumbull had made several earlier sketches for this painting, among them one in ink, entitled *Surrender of General Burgoyne,* and another in pencil, on the back of which he wrote down the proportions for the subjects, which are identical to those in this work. The painting captures the moment, on October 26, 1777, when General Burgoyne arrived at General Gates's military camp, accompanied by General Phillips and several officers. The composition is carefully balanced, the subjects united with others and different elements in the picture. As in all his historical paintings, the artist reflects the force of the situation through strongly contrasting light and shade, spotlighting the main subjects in the scene so they stand out. As always, Trumbull dedicated much time searching for trustworthy portraits of all the subjects shown, as he wanted a totally realistic portrayal.

Male Nude

(1795)
chalk on paper
19.5 x 12 in (49.5 x 30.5 cm)
Metropolitan Museum of Art,
New York

Trumbull made several studies of nude male torsos during his years in prison in England. The study of the classics and of the human figure were part of his apprenticeship in England. For this reason, his mentor, Benjamin West, gave him a book of the male nude to copy and thus pass the long hours in jail.

This later work appears to have been completed in Paris and coincided with some of the darkest moments in Trumbull's artistic development. In 1793, strongly affected by the death of Harriet Wadsworth, his beautiful young cousin whom he wished to marry, and disappointed by the little success he was having selling his work in the United States, he decided to abandon painting.

Between 1794 and 1800, his main occupation was serving in various diplomatic posts in France and England, moving away from art and, mainly, from his vocation as an historical painter. This picture is one of the few works he is known to have produced at that time; it reveals, as he himself admitted, that he had lost much of the technique he had acquired during years of study. Unlike the previous pictures, in which the influence of American or British technique, fundamentally that of West or Copley, is evident, this picture is clearly one of French inspiration. The use of black-and-white chalk on blue paper to emphasize volume was far more common in the French Academy than in those of London or the United States. However, the dynamic pose of the subject—expressing movement—harks back to Trumbull's historical paintings, where he captured a sense of war action through his subjects.

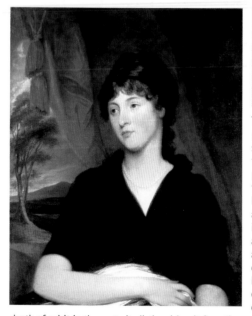

Mrs. William Pinkney

(~1800)
oil on canvas
29.3 x 24.8 in (74.3 x 62.9 cm)
Fine Arts Museum of San Francisco

Trumbull, realizing that his historical paintings were not having much success, even after his commission to decorate the Capitol, turned to producing high society paintings, in the style he had already seen during his apprenticeship in London. He adapted the suave style of Reynolds in painting this female portrait, even adding a landscape hidden behind a curtain, as was the fashion among other portraitists of the time. However, the languid glance and evident sadness of the figure, combined with a certain psychological depth of spirit in the portrait, distinguishes it from the sophisticated English style. In addition he adds much life to the face by applying a touch of pink to the cheeks, a solution already adopted by Stuart in his London portraits. Trumbull finds a practical solution to the problem of the positioning of the subject's hands, literally cutting off the left hand and placing the right one in her lap, which is then adorned with a handkerchief. In the last period of his painting life, Trumbull, who lived by exporting pictures across the Atlantic, was hampered by economic measures taken by Jefferson, who placed an embargo on trade with England.

RAPHAELLE PEALE

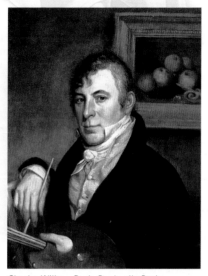

- **1774** Born in Annapolis, Maryland, on March 17. Son of famous painter Charles Willson Peale.

- **1790** For ten years he works with his father on the Peale Museum project in Philadelphia.

- **1795** Exhibits a number of works at the Columbianum Show in Philadelphia.

- **1816** Still life with fruit bowls becomes his favorite topic.

- **1817** His father censures him for his drinking habits.

- **1825** According to his father's notes he dies of extreme alcoholism.

Charles Willson Peale, Raphaelle Peale, *1822, private collection.*

Raphaelle Peale is part of a dynasty of very important artists in North American painting history. His father, Charles Willson Peale, was a naturalist painter, well known for his portraits of social and cultural leaders of the United States in the Revolutionary era. Like many great art theorists, Charles Willson Peale thought that still lifes were a minor genre, only for amateurs. In Raphaelle's father's home, only portraits and landscapes were worthy of respect and admiration. Perhaps because of this, Raphaelle Peale specialized in painting inanimate objects and explored all the compositional possibilities for creating high-quality still lifes.

In a family environment prone to artistic training, Raphaelle learned painting techniques from his father, although his family did not approve of his unusual painting style. Raphaelle Peale, who explored this genre's Northern European origins, appreciated the symbolic character of still-life painting and exploited it, creating an advanced visual language for that time.

In Rapaelle's work we can see light and color's extraordinary force as a means to construct an argument, while his compositional style and marked realism quickly turned him into the United States's first professional still-life painter.

Raphaelle Peale

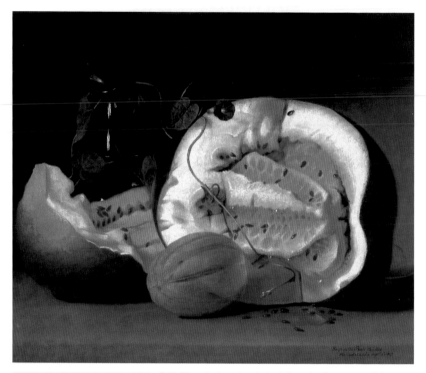

Melons and Morning Glories

(1813)
oil on canvas
20.7 x 25.7 in (52.6 x 65.4 cm)
Smithsonian American Art
Museum, Washington, D.C.

Still-life painting already had, from its European origins, some symbolic connotations that artists did not hesitate to use in order to furtively display moral, erotic, and religious subjects. This symbolism, implicit in much artwork throughout history, refers to the significance of the objects represented or to a whole set of ideas graphically represented. A symbolic corollary exists in Raphaelle Peale's work, but in this case the symbols are merely aesthetic. In Peale's work, hidden meanings or metaphysical allegories are nonexistent; rather, his work explores the effect of color and shape as a means to communicate ideas or sensations.

This composition uses a flashy chromatic range that allows the painter to play suggestively with the form in order to increase the erotic sensation. The intense red of the inside of the fruit draws the viewer's eye, and in the area, little by little, shapes are discovered that suggest a veiled sensuality. This new language of Raphaelle Peale did not receive much attention from the public at the time, but later critics perceive an explicit erotic idea conveyed by the artist, an evocation of the feminine sex.

Right: Beneath a general aesthetic simplicity, Raphaelle Peale's still lifes offer a new vision of 19th-century American society. With his mysterious light, the painter transforms simple products from the market into an exploration of the subconscious of the United States. His vision of painting implies an introspective hermeticism, in which the artist tries to make the audience reflect on the simple aesthetics of the work. For the painter, the pictorial argument is centered in his country's cultural and intellectual vision, a concept as completely new as his morbid works.

Here, the artist has turned a simple bowl of peaches into a whole dissertation on human beings. The work allows us to observe a curious lighting effect. The illumination reflected in the background is tenuous and discreet, but the peaches seem to exist in a very different light. Peale has presented these elements with great realism, even capturing the texture of the peach fuzz. The light seems unreal, emanating from the inside of the upper part of the fruit. The artist has submerged himself in a surreal symbolist and hermetic introspection, initiating a direct dialogue with the viewer.

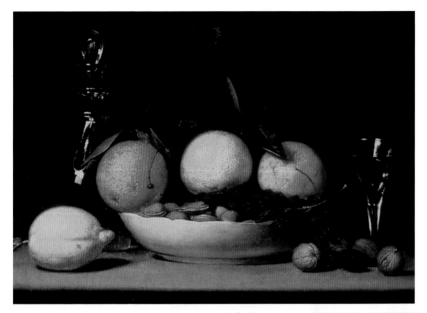

Peale's pictorial proposals stirred little interest in his family or among the general public. Still-life painting was hardly valued at all by a 19th-century American society that sought out rational modernity or classical portraits much more than splendid Flemish paintings of fruit. Nonetheless, Peale put effort into achieving an absolute technical mastery that allowed him to experiment with new artistic trends within the still-life genre.

A Dessert

(1814)
oil on canvas
National Gallery of Art,
Washington, D.C.

The artist believed that absolute realism was needed to create an expressive sense of light. With some paintings, which seem to create space out of a dark, absolute nothingness, Peale reinvented the still life.

In *A Dessert*, with his bright, realist brushstroke and an optically perfect sense of light, the artist has created a visual effect in which the pictorial space seems to grow in three dimensions. This is how he endows his paintings with depth. With this visual technique, Peale imbues this still life with a luminous quality; the light, reflected frontally, contrasts with the beckoning darkness of the background. The fruit and glass pieces seem yanked from the darkness for the viewer, who can believe that the light falling on the elements actually originates from his own viewing position. With these ingredients the still life acquires solemnity and mystery.

The Bowl of Peaches

(1816)
oil on wood with
canvas
New Britain Museum
of American Art,
Connecticut

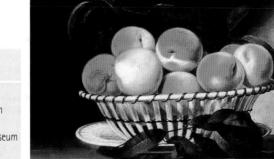

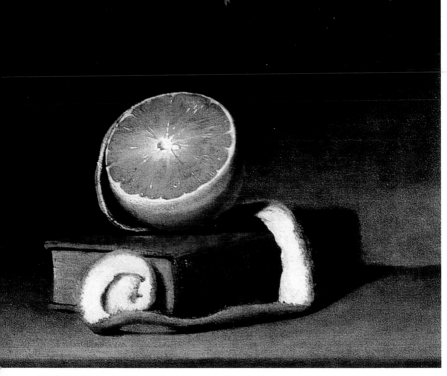

Still Life with Orange and Book

(~1815)
oil on canvas
Private collection

In the past, still lifes had usually been commissioned work. Artists, considering this a subject of the people, painted still lifes that represented the family and included the client's personal elements or characteristics. Here Peale has included certain details that characterized the period. The book exemplifies the rationalist period the United States went through at the end of the 18th century and the beginning of the 19th.

Compositionally, this is one of the artist's simplest works. Two elements emerge from the characteristically dark background beneath a specific illumination. The sense of light is a constant compositional element for Peale, who treats the objects as profoundly as a portrait painter does his subjects. The impact of light, which appears, in an undefined way, to give the objects life, is decisive for the artist; in it, he bases the painting's expressive and dramatic charge. The space remains implied, and the light does not reflect within it. The light's origin is unknown, and the closed focal effect over the orange and the book produces an unsettling atmosphere.

Right: In his experimental painting, the artist explored various methods of representation and different visual effects. His work was often far ahead of its time, its style more recognizable as something of the end of the 19th century and even more so of the 20th.

This work is one of great modernity. Traditional sketches and studies of the period sometimes include the reproduction of the folds on a piece of cloth. For years art students had done such exercises in order to study the effects of light. In this work, Peale has elevated these exercises to works of art by endowing them with their own language. The artist has used the fold lines to create a compositional argument. On this lineal framework the light disperses in various directions and brings a full shape to the cloth. The contrast between this light element and the background results in a simple yet aesthetically balanced effect. Peale has placed a simple architecture of branches in the background; the way the cloth hangs from it gives the painting a realist sense, adding space and depth. If this structure had not been included, the painting could have been considered the first abstract work in American painting.

Still Life with Oranges

(1818)
oil on canvas
18.4 x 23 in
(47.4 x 58.3 cm)
Toledo Museum
of Art, Ohio

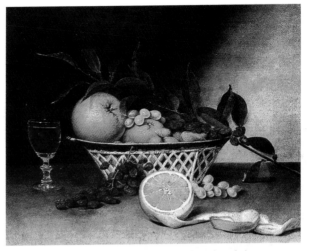

In this painting, Peale has opted for a more classical compositional sense. In an allegory for the passage of time and the transformation of the human soul, the artist has used a repetition of elements in different states as simple visual symbolism. Peale has also tried to convey this temporal quality with the color and tonal gradation of the pictorial space. Here, the elements do not appear to be in dark shadow, but the scene shows a darkness that seems to advance, trapping the glass of wine and some of the leaves on the left margin. Peale wanted his work to be understood by his audience, without being banal or boring. The impression of a slow, monotone light is broken thanks to light details scattered throughout the painting—the twinkles on the glass, the rich chromaticism of the orange divided in half, and the peel that extends dynamically to the right. There is also the green glow of the grapes, which brings a bright rhythm to the painting while harmonizing the vision of the other elements. The raisins and the darkness of the wine quantify the intensity of the light. Compositionally, the work displays a dynamic equilibrium, which seems to expand from the center. From the bowl of fruit, the different elements seem to escape into the corners of the painting, filling it with life.

After the Bath

(1822)
oil on canvas
29.3 x 24.1 in
(74.3 x 61.3 cm)
Nelson-Atkins Museum of
Art, Kansas City, Missouri

Strawberries, Nuts & etc.

(1822)
oil on wood and paper
16.4 x 22.8 in (41.6 x 57.8 cm)
Art Institute of Chicago,
Illinois

The composition of a still life requires study and design on the painter's part; the artist must decide which elements to include in the painting and how they should be organized in order to achieve a certain effect. In this work, Peale has played with different elements in order to create a very rhythmic exercise. Each object or fruit has its own color as well as its own luminous effect, which touches upon the whole picture. Peale has placed pieces of bright white porcelain at both ends in order to create a very clear frame of light, enclosing the fruits' delicate tones between the two objects. The artist has used this rhythmic sense in two directions: horizontally, the pieces are arranged following a tonal sense; in terms of depth, the chromaticism of the elements has been used to construct the space. This compositional style, which seems to oppose classical principles that specified that the tone should mark the depth, shows the artist's interest in demarcating himself from convention and creating a new aesthetic for still lifes.

Peale has used a new design for this genre, preserving the fruits' lead role but placing them in glass pitchers or on top of porcelain pieces, therefore separating himself from traditional Flemish still-life painting. The glass goblet full of strawberries that appears in the background is a great exercise in realism, showing how the painter controls space. The strawberries appear as if they were suspended in the air. Only some small twinkles of light suggest the invisible goblet.

JOHN VANDERLYN

Ariadne Asleep on the Island of Naxos
*(detail), 1814, oil on canvas, 68.5 x 87 in
(174 x 221 cm), Pennsylvania Academy
of the Fine Arts, Philadelphia.*

John Vanderlyn's portrait art brought an innovative concept to this discipline in the United States. While other painters at the time first studied in the United States and then traveled to London to complete their training, Vanderlyn traveled to Paris, where he became familiar with the neoclassical style that would influence him so much.

Due to this, John Vanderlyn's work was a step forward that his own audience did not come to understand. His style was an evolution of the French portrait tradition, which originated in Versailles, based on a transcendental view of the individual. However, the artist's attempt to transfer this historical portraiture to his own country resulted in recurrent failure, which invariably affected his economic stability.

Vanderlyn unsuccessfully tried to promote himself as a historical painter, but his style was only appreciated in Europe. That is why the exhibition the artist held when he returned to the United States in 1815 was decisive, a failure that made Vanderlyn himself acknowledge that the only way he could devote himself to painting was through commissioned portraits.

John Vanderlyn's style is pleasantly simple. It shows the progressive abandonment of the American portrait-art tradition entrenched in rococo since the mid-1800s. The artist offers a new, less superfluous style in which the individual acquires metaphysical importance and his or her personality, character, or sensitivity stands out.

- **1775** Born in Kingston, Ulster County, New York, on October 15. Son of the artist Nicholas Vanderlyn and his second wife, Sarah Tappan. After completing his education at the prestigious Kingston Academy, he moves to New York, where he works in an engraving shop and store. Studies art at Alexander and Archibald Robinson's Columbian Academy of Painting. During his studies, Aaron Burr becomes a friend and sponsors him financially for twenty years. Burr himself makes the arrangements so that Vanderlyn can study in Philadelphia with Gilbert Stuart.

- **1796** As a result of Burr's sponsorship, Vanderlyn is able to study in Paris, where he enrolls at the École des Beaux-Arts. Studies with the portrait artist and historical painter François-André Vincent. Copies masterpieces from the Louvre during his time in Paris and meets Robert Fulton, who encourages him to devote himself to panoramic painting.

- **1799** Due to financial trouble, Burr suspends Vanderlyn's stipend for that year.

- **1800** Returns to the United States, where he makes a series of engravings of Niagara Falls. Afterward, he becomes a professional portrait artist.

- **1803** Returns to Paris to sketch and acquire antique sculptures for the recently inaugurated American Academy of Fine Arts. After he settles in France, he visits London. There, he meets Washington Allston, with whom he decides to take a trip around Europe.

- **1804** Paints his first historical artwork, *The Death of Jane McCrea.*

- **1808** Is honored with a gold medal at the Salon de Paris.

- **1815** Returns to the United States and holds an exhibition of his work produced in Europe. The American public considers the exhibition scandalous due to its nude content.

- **1836** Burr dies, thus exacerbating Vanderlyn's financial situation.

- **1837** Moves to Havana to make a series of graphical studies on topography.

- **1839** Returns to Paris. His work advances slowly, and there are rumors that collaborators help him paint. After recurrent failure, the artist is forced to devote himself to painting commissioned portraits to support himself.

- **1852** Dies on December 23 in Kingston, alone and bankrupt.

Aaron Burr

(1802)
oil on canvas
22.2 x 16.5 in (56.5 x 41.9 cm)
Henry Luce III Center for the
Study of American Culture,
New York

Aaron Burr was extremely influential in John Vanderlyn's artistic career. After making a copy of Gilbert Stuart's painting of Aaron Burr, the artist, who had just completed his studies, met Burr, who would become his patron and friend. Burr himself sent Vanderlyn to Philadelphia so that he could study with Stuart, and later, in 1796, Burr provided the means for him to travel to Paris. It can be said that Colonel Burr ran Vanderlyn's career for twenty years.

The artist fully develops his classical style in this portrait, depicting his patron concisely. Any superfluous element is avoided in order to portray his friend with greater emotion. In fact, this painting's expressiveness lies in the contrast between Burr's face and the unyielding darkness that surrounds him. Vanderlyn created a setting where the chiaroscuro acquires organic connotations, producing the atmosphere that defines the painting. Burr appears in the center of this impenetrable darkness, in profile, letting himself be painted and exposing his personality. Thus, the painter endows his subject with a personality that transcends his facial expression.

Marius Amid the Ruins of Carthage

(1807)
oil on canvas
86.6 x 68.3 in
(220 x 173.4 cm)
Fine Arts Museums of
San Francisco

Robert R. Livingston

(1804)
oil on canvas
46.3 x 35.3 in (117.5 x 89.6 cm)
Henry Luce III for the Study of
American Culture, New York

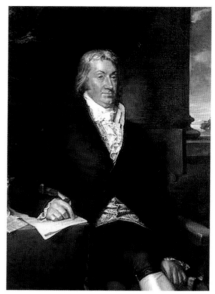

This painting portrays Robert R. Livingston, the United States ambassador to France. The National Academy of Fine Arts of New York commissioned this portrait, painted in Paris in 1804. Livingston was its first president. On his second trip to Paris, Vanderlyn decided, apart from painting historical themes (very popular in America), he would also try his hand in the neoclassical style—in fashion in Europe—in order to broaden his education. This work was completed while the artist studied a variety of themes for his first historic painting. That is why the influence of both genres can be seen here. In this portrait, Vanderlyn combined his particular sense of chiaroscuro with an elaborate background, where part of a sunset landscape appears. The artist displays his painting skills by incorporating a sense of depth and demonstrating an interest in landscape aesthetics.

The painting is clearly descriptive; the subject obviously wanted to be painted anecdotally, with personal and professional splendor. That is why Vanderlyn has to combine the darkest spaces with objects that are specifically illuminated, like the manuscript that Livingston is reviewing and his magnificently elegant clothing. The individual has a prudent expression on his face. The artist knew perfectly how to blend the rigid seriousness of a politician with a much more personal human appearance.

Left: Vanderlyn discovered a major source of inspiration in sculpture as a result of a commission he received from the American Academy of Fine Arts to study European sculpture in Paris in 1803. The artist, whose economic situation was good at the time, was able to display his true gift by depicting historical scenes of ancient Rome, which he became familiar with by visiting the ruins and statues of Italy.

This painting portrays one of the most important epic scenes of Roman culture. The war against the Carthaginians and all its legendary characteristics are depicted here under a clear sculptural influence. The artist has constructed the scene so that the interplay of light and shadow, which describes the terrible event (the destruction of Carthage) that has just occurred, predominates. The painter, allowing himself some liberty, has introduced an idealized, nostalgic Greek temple in ruins, under warm, benevolent light. The artist has also incorporated an aqueduct that appears against the twilight, evoking the first Western civilization. The artist uses all his skill in painting the realistic portrait of the main figure. The influence of sculpture blows up Caius Marius's features to help the viewer perceive him as a rough yet thoughtful man who meditates beside his weapon. Vanderlyn made the painting more dramatic by surrounding the warrior's body with a textured bright red cape.

Zachariah Schoonmaker

(1815/1818)
oil on canvas
26.1 x 22.4 in (66.4 x 57 cm)
National Gallery of Art,
Washington, D.C.

Vanderlyn's portrait style implied a new perspective for traditional American painting, which had been primarily based on English styles. In portrait art, the differences between English-style portraits and French-style portraits can be detected in the expressive quality of the painting. Vanderlyn's portraits do away with monotonous English solemnity and acknowledge the individual as a collection of gestures and expressions through which a specific character or personality can be discerned.

Vanderlyn learned a great deal from Gilbert Stuart, but it was not until he went to Europe in 1796 that his painting took on a unique style. His work changes this genre from a technical copying and reality exercise to an art that transcends the individual, opening itself directly to the individual's soul. In this painting, the artist focused the expressiveness on the individual's face. Contrasts appear exaggerated as a result of a brighter combination of colors compared to previous paintings. Vanderlyn took advantage of the model's expression, which is tough and somewhat aggressive, to use a reddish tone. The semifrontal pose makes it possible to observe the penetrating look and harsh expression produced by the sitter's closed jaw. As a result, Zachariah Schoonmaker appears almost exaggeratedly fierce and proud.

Right: Tracking Vanderlyn's professional trajectory, one is led to believe that his work depended on his economic situation, which did not allow him to explore his potential as a historic genre painter. Although this was true, Vanderlyn was, in fact, concerned with more than his financial situation. His artistic pride led him to want unconditional acceptance of his art in the United States. That is why there are some historic paintings in his art production, although they were a terrible failure for the artist when they were exhibited in the United States.

This painting, depicting the legend of Ariadne, was made a year before Vanderlyn's disastrous United States exhibition—the exhibition that determined his career as a portrait artist. The work is an example of the painter's delicate neoclassical style. Ariadne's nude body is depicted with tremendous realism and sensitivity, and the figure is set against an elaborate, elegant landscape. The organization of space and the use of light as the main expressive elements show an interest in atmospheric effects such as those on the landscape to the right, where the artist works with depth and light to depict nature as exuberant as the woman's erotic body. Vanderlyn was truly a compositional master, but portraits did not allow him to display the full scope of his abilities.

Ariadne Asleep on the Island of Naxos

(1814)
oil on canvas
68.5 x 87 in (174 x 221 cm)
Pennsylvania Academy of
the Fine Arts, Philadelphia

Mary Ellis Bell (Mrs. Isaac Bell)

(~1827)
oil on canvas
30 x 24 in (76.2 x 61 cm)
National Gallery of Art,
Washington, D.C.

After a resoundingly negative reaction from the public and critics upon his return to the United States in 1815, John Vanderlyn returned to a style more acceptable to a public accustomed to English painting. His portraits, previously focused on personality, became more decorative, and he learned to paint with a more complete background and setting. The individual is no longer depicted as himself; rather, he is contextualized and projected in a space that broadens his personality. Following this style, Vanderlyn was able to go back to commissioned portraits for the American bourgeoisie without fear of being rejected.

This is one of the artist's most decorative portraits—yet it offers a glimpse into the painter's true style. The mirror, the key element of the painting, reflects the woman's face in profile, while in the original image, Vanderlyn paints the lady frontally and slightly inclined to the right. For the mirror portrait, the artist worked with Mrs. Bell's expression, transforming a monotonous and rigid image into a strong, expressive face with distinctive features.

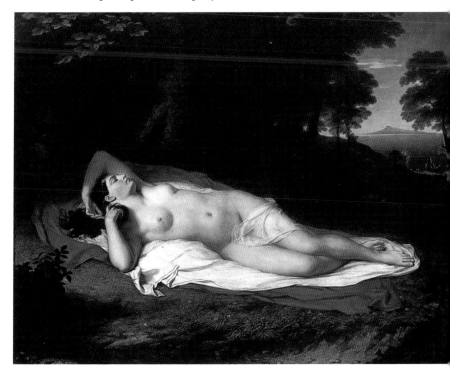

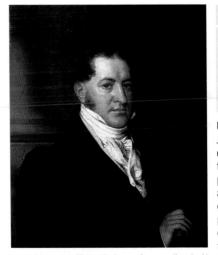

John Sudam

(1829-1830)
oil on canvas
30 x 24.9 in (76.2 x 63.2 cm)
National Gallery of Art,
Washington, D.C.

Upon his return to the United States in 1815, John Vanderlyn's professional future became quite complicated since, in addition to the fact that his work was rejected, he lost his patron, Aaron Burr, who had died in 1836. As a result, he had to reconsider his artistic career and devote himself to commissioned portraits. Since he dedicated himself completely to this genre, the painter was able to acquire some prestigious commissions in the mid-1830s. Nevertheless, after settling in New York and painting the Rotunda in City Hall Park, he was penniless. He spent several years promoting a series of panoramic landscapes that never attained success.

Portraits, however, continued to be a reliable source of income, and eventually the artist gave in to the genre, postponing his experiments and his historic painting. This is a good example of the portrait style that Vanderlyn used for his commissions. It is a simple work in which the artist demonstrates his innate ability to recognize and transmit the main features and details that make up the personality of the individual who is being painted.

In a clearly representational painting, the artist places Sudam in an inclined plane with a chiaroscuro effect that accentuates his features. The subject looks seriously at the viewer, keeping his body and head inclined while turning his expressive eyes frontward. Vanderlyn paints him with a white cloth collar, contrasting the whiteness of the fabric with the livelier and more organic tone of Sudam's skin. Thus, the artist has introduced an element of style that allows him to add texture and richness to the individual's skin, while displaying a sample of his skill as a realist painter.

Study of a Cape

(~1838)
brown and black chalk heightened with white chalk and pastel on blue board
16 x 14 in (40.7 x 35.5 cm)
National Gallery of Art,
Washington, D.C.

John Vanderlyn was a multidisciplinary artist who produced a number of projects in which the sketch was a key factor. His series of topographical studies, architectural projections, and pencil reproductions of many European sculptures is a fine example of his mastery of drawing. This sketch or study for a portrait, showing a person dressed in a classical cape, reveals Vanderlyn's skill in sketching. The artist has used the base color to give the drawing a very definite basic tone from which one can almost extract, as if in a marble sculpture, the person and the decorative elements.

With white chalk, Vanderlyn completed this study using a type of grisaille, incorporating black and brown to highlight depth and contrast. It appears to be an indoor sketch, in which the person is shown trying on a suit in front of a mirror. Vanderlyn has reproduced the reflection directly in the background without outlining the reflective surface, giving the painting a mysterious and ethereal feeling.

REMBRANDT PEALE

James Peale, Rembrandt Peale's Portrait, *1795,*
watercolors on ivory, 3 x 1 in (6 x 4 .4 cm), Yale
University Art Gallery, New Haven, Connecticut.

Rembrandt Peale became quite famous because he painted a portrait of George Washington during Washington's life. His technical precision—the result of continuous training—and his ability to depict the psychology of the individual—the product of intuition—made him one of the best portrait artists of his time. This painter was always an independent artist, although his father, the forceful Charles Willson Peale, influenced him most of his life. He oriented him toward the best way to make painting profitable.

Rembrandt Peale, who had demonstrated a gift for drawing since he was a child, was able to realize his dream of traveling to Europe to study the work of the great masters, visiting Italy and France. There, he was influenced by Jacques-Louis David's elegance. He also learned the portrait technique during his stay at the Royal Academy of London. Rembrandt's father paved the way for all these trips because he considered Rembrandt to be the most ambitious of his children.

The artist combined his work as an independent portrait artist with his management of Peale Museum branches and even with teaching. He also enjoyed literature and poetry and even wrote a small treatise for beginners about basic drawing. He is quite relevant in American painting, since he is one of the few American artists able to bolster talent with a solid educational base.

- **1778** Born February 22 in Bucks County, Pennsylvania, son of the artist Charles Willson Peale and his first wife, Rachel Brewer.
- **1791** Paints his first artwork, a self-portrait.
- **1795** Paints a portrait of George Washington.
- **1796** Begins a tour to promote his father's museum, exhibiting dozens of copies of portraits that were on exhibit in the gallery. Rembrandt and his brother, Raphaelle, had made these copies.
- **1798** Manages the family museum branch established in Philadelphia.
- **1801** Helps his father excavate mammoth bones found in Newburgh, New York.
- **1802** Organizes the reconstructed mammoth exhibit with his brother, Rubens, in London. Enrolls in courses at the Royal Academy, where he remains until 1803, receiving classes from Benjamin West.
- **1803** Returns to America and works in Savannah, Charleston, New York, and Philadelphia.
- **1809** Settles in Paris to paint French authors, scientists, and artists for his father's museum. Sees Jacques-Louis David's work, which will influence his style.
- **1810** Returns to the United States and opens a studio in Philadelphia.
- **1813** Manages the Peale Museum branch in Baltimore.
- **1820** Paints an enormous composition called *Court of Death*, where he expresses his deepest religious convictions.
- **1822** Moves to New York, leaving the management of the museum, which has serious financial problems, to his brother Rubens.
- **1825** Succeeds John Trumbull in the presidency of the American Academy of Fine Arts.
- **1827** Wins a silver medal at the Franklin Institute for a lithograph of Washington. Is honorary member of the National Academy of Design.
- **1831** Begins painting his five versions of Niagara Falls.
- **1832** The United States Congress purchases Washington's portrait for $82,000, a huge sum at that time.
- **1835** Writes a drawing manual for schoolchildren.
- **1855** Writes personal views on American art history called "Reminiscences"; the articles are periodically published in *The Crayon* magazine.
- **1860** Dies in Philadelphia in October 1860.

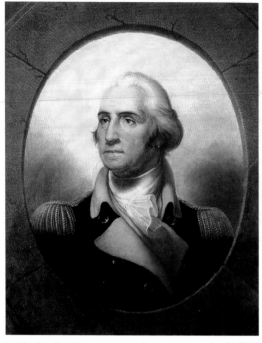

George Washington

(1795)
oil on canvas
36 x 29 in (91.4 x 73.7 cm)
Butler Institute of
American Art,
Youngstown, Ohio

Charles Willson Peale wanted to have a portrait of George Washington, which was quite difficult to obtain because the hero of American independence did not like to waste time posing for artists. Nonetheless, after much persistence, he got special permission to send his young son, Rembrandt, more skillful and faster than he was, to paint Washington on canvas. Washington disliked posing not only because it cut into his work day, but also because he suffered from very painful toothaches that became worse whenever he remained still. Eating, talking, or smiling provoked great discomfort. That is why he has his jaw clenched in this portrait.

Rembrandt was very nervous, so he asked his father to accompany him during the sessions, which lasted all through the autumn of 1795. When Washington died in 1799, Rembrandt considered making a definitive portrait of the patriot to convey a noble and authentic image of the person. The result was a series of exact portraits that, although they were not as famous as those by Gilbert Stuart (made at the same time as Peale's in 1795), were distributed throughout the United States. Their sale was one of the painter's main sources of income. It was not until 1823 that he made a copy that he was pleased with. It was called *The Porthole Portrait*, because of its shape. A stone wall frames Washington's face. His eyes gaze at infinity. This porthole is reminiscent of those on defensive walls, reminding us of the patriot's past.

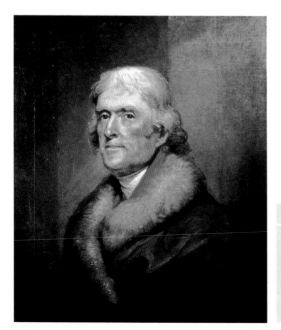

Thomas Jefferson

(1805)
oil on canvas
28 x 23.5 in (71.1 x 59.7 cm)
Henry Luce III Center for the
Study of American Culture,
New York

Rubens Peale with Geranium

(1801)
oil on canvas
28.2 x 24 in
(71.7 x 61 cm)
National Gallery of Art,
Washington, D.C.

This work was made in Philadelphia and conceived as a double portrait, since, in addition to the individual, the geranium that appears was the first one ever to bloom in the New World, a result of the care given by Rubens, the artist's brother. A scientific interest in plants and animals was always present in the life of Charles Willson Peale's children, particularly after he established his museum. In this portrait, one can observe Rembrandt's detailed work, as well as his ability to depict psychological depth. The plant's smoothness is reflected in Rubens's gentle look. There are reflections of light on his face, which travel through his glasses' lenses, while he holds another pair in his hand (perhaps they are magnifying glasses to see the flowers in more detail).

Rubens was seventeen years old when he posed for this portrait and had just started his studies in botany, after showing no interest in following in his father's artistic footsteps. The precision and clarity in this painting reflect Rembrandt's artistic maturity at a young age. His work would not linger in this spontaneous naturalism, but it would evolve toward greater confidence as a result of his European training. His precise lines would find a connection with neoclassical trends in France through David's compositions. Although Rembrandt never abandoned the sweet simplicity of his portraits, he attained great perfection in technique through rigorous study; the copying of masterpieces was his education.

Left: Again accompanied by his father, who wanted to add new portraits to his gallery of famous people, Rembrandt Peale went to Washington to paint the most important political and scientific figures in the United States. Thomas Jefferson was one of them and, just like George Washington, he had a busy schedule. Nonetheless, as a result of Charles's persistence, the encounter occurred, and Rembrandt once again portrayed the face of one of the most important men in American history.

At this time, Rembrandt had already returned from London, where he had organized the exhibit of a gigantic mammoth, found on American soil, which now belonged to the Peale Museum. In London, he found time to attend classes at the Royal Academy, where he met Benjamin West, who taught him, with the same friendliness with which he treated all American painters, the way to use light and color to achieve more realistic portraits. Rembrandt probably also saw the work of the aristocrat portraitist par excellence, Joshua Reynolds.

It is evident here how the painter used his brush with a fresh stroke; he has applied it much more freely. The color is more brilliant, making the face appear livelier. Likewise, Jefferson's contemplative character is revealed by his distant and slightly elevated gaze, which passes over the viewer as if Jefferson was concentrating on more sublime feelings. A focus of light brightens his face as if God inspired his ideas, many of which helped to create the democracy of the United States.

Rosalba Peale

(1820)
oil on canvas
Smithsonian American Art
Museum, Washington, D.C.

It was not only learning at the Royal Academy of London with West that improved Rembrandt Peale's painting technique. He resided in Europe, where copying great masterpieces and constantly painting portraits of illustrious people perfected his style. This does not mean that the artist limited himself to a specific approach, but that his skill was enhanced as a result of an extensive and solid formative base that other American artists did not even dream of. Once again, the opportunity sprang from the needs of his father's museum, which called for portraits of European figures. His father, therefore, decided to send Rembrandt, his most gifted son, to France. As a result, the young man had the opportunity to see the masterpieces of the great artists, which he cheerfully copied.

This work is evidence of how Rembrandt Peale learned the sweetness of the Renaissance's Raphael, to which he added his own smooth brushstroke. The novelty of a closeup adds expressiveness and naturalness to this portrait, a marvel of artistic quality. An anecdotal note should be mentioned: The intense focus of light, which brightens Rosalba's snow white face, may come from a gas lamp. Gaslight brightened the lives of Americans for the first time, thanks, as a matter of fact, to Rembrandt Peale, who supported its use in Baltimore in 1817; from there it spread to the rest of the country. The great portrait artist probably did not take long to test the applications that this invention had to painting, using his own daughter, who at this time was also an excellent portrait artist, as a model.

The Court of Death

(1820)
oil on canvas
133.9 x 281.5 in
(340 x 715 cm)
Detroit Institute
of Arts, Michigan

Michael Angelo and Emma Clara Peale

(1826)
oil on canvas
30 x 25 in
(76.2 x 63.5 in)
Metropolitan Museum
of Art, New York

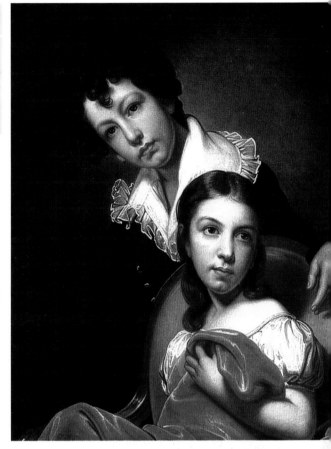

Rembrandt's children appear as if they were two adults in English-style portraits, which depicted individuals in aristocratic poses. Both are elegantly dressed in fashionable clothes, Emma Clara with a white silk dress that she covers with red velvet fabric and Michael Angelo (named in keeping with his father's awareness of the great masters and in the Peale family tradition), with a dark fitted coat and a very white shirt that brightens his face. The fact that he is dressed as a young man indicates that Michael Angelo is already an adult. As a gentleman, he has conceded the seat to his sister and protects her by placing his hand on the back of the chair. They both have a distant look, gazing away from the viewer. Still, the work is intimate in tone, distant from commissioned portraits, and closer to the artist's personal satisfaction.

Rembrandt Peale was one of the most prolific portrait artists of the United States. There are more than 1,200 finished works with his signature, among them copies and original portraits, still lifes, and landscapes. Among his enormous production, there are images of the most illustrious individuals of his time, from heroes of the Independence to the most notable European scientists.

Left: This colossal painting traveled through several American states in a traveling exhibition for which it was created. In order to sum up the essence of American painting, Rembrandt suggested this allegory about life based on a poem by an Anglican bishop. In it, man is called to a fatal quest for Death, ignoring pleas and prayers. Death's agents, which are War (represented as a soldier of classical antiquity) and its followers, are to the right of the viewer. With their swords and torches, they pass over a group of orphans and innocent widows. To the left is a group of people associated with cardinal sins. Their decadent attitude, be it laziness or lust, has led them directly to Death. Death is present but hidden in darkness, so that its terrible features cannot be seen. It is in the middle and dressed in a broad and heavy shroud that makes it appear as monumental as an ancient sculpture.

Beneath one of its feet is the body of a handsome young man; his father looks on in despair. This symbolizes the power of Death, which calls on everyone without distinction. In his last steps, this old man is helped by Faith, dressed in blue, which leads him inexorably to his final resting place. In summary, the work presents a theme from Romanticism through the rhetoric of neoclassicism, which the painter would have had the opportunity to absorb during his stay in France, when he saw Jacques-Louis David's work.

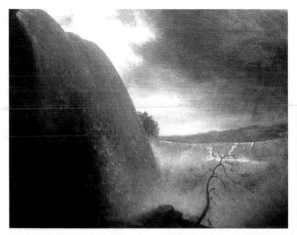

Falls of Niagara Viewed from the American Side

(1831)
oil on canvas
Mrs. Deen Day Smith
Collection

Rembrandt Peale painted five views of Niagara Falls, predating Frederic Edwin Church by more than twenty years. It is as if Peale's artistic sensitivity had noticed the importance of this natural phenomenon to the American national spirit.

This view is in autumn, which is noticeable from the dry tree that serves as a figurehead of the rocky cliff. Next to it, and to highlight the drama of the landscape that spreads before the viewer's eyes, a man leans against its trunk, looking for security. A storm is coming, announcing rain that will add to the water tumbling over the falls, magnifying their savage potential. The misty setting is so perfectly portrayed that the viewer feels the sensation of being there, contemplating the event like the man next to the tree. The effort of making these paintings, combined with the lack of commercial success they had at the time (none of the five views was sold) made Rembrandt Peale finally return to portrait art as his main source of income.

Thomas Sully

(1859)
oil on canvas
23.9 x 20 in
(60.8 x 50.8 cm)
National Gallery of Art,
Washington, D.C.

One of Rembrandt Peale's friends was the renowned painter Thomas Sully, who gave one of Peale's sisters painting lessons. At this time, the Peale family must have been quite well off, since Sully was the artist most in demand among New England's high society because of his aristocratic style. Sully taught Rembrandt all the secrets of portrait art, including a special color treatment. Rembrandt conveyed the sensation of warmth through the use of brown, orange, and yellow as dominant colors. Therefore, Sully recommended that Peale use a palette composed of three browns, two reds, a yellow-ochre, and ivory black; for cold tones, only marine blue and white. In painting Sully, Peale did not hesitate to practice these innovations.

The brown tones outline a serene face where warm tones are the base of the composition. Even the subject's gray eyes have that warmth, their liveliness increased with a minor white reflection. Some light orange brushstrokes appear on the eyelids to highlight this effect. This would be one of the last portraits Rembrandt Peale made and illustrates, through the loving psychological description, the great esteem he held for Thomas Sully.

WASHINGTON ALLSTON

Washington Allston, *Brigham Young University Museum of Art, Provo, Utah.*

Washington Allston, a writer and painter, was the finest romantic artist of the United States. Upon traveling to England, his personality perfectly fit and understood the romantic ideal William Blake and Henry Fuseli proposed. After he was accepted into the Royal Academy of Arts in London and spent years in Italy and England, Allston returned to Boston because of the death of his wife.

Afflicted with a gloominess that deeply influenced his art, the painter imported romanticism to the United States. He not only pointed out new visual aesthetics, but also a particular way of looking at life.

The birth of American romanticism can be traced to Allston's work. Its influence extends to the principal 19th-century styles. Luminism, the Hudson River School artists' aesthetic approaches, rationalist realism, and naturalism are rooted in the work of this painter.

His painting contains some religious symbolism, as the obvious biblical inspiration of his themes illustrates. However, an intense naturalist sensitivity can also be observed. His work is a blend of visual poetry, biblical sym-

- **1779** Born on the Allston plantation, Georgetown, South Carolina, on November 5. His parents send him to Harvard, where their son studies classics and practices landscapes and satirical caricatures.
- **1800** He graduates from Harvard and returns to South Carolina. Dissatisfied with rural life, he decides to sell all the land inherited from his family to pay for his art studies in Europe. His first destination in the Old World is London, where the artist stays for four years, studying at the Royal Academy.
- **1804** Travels to Paris, where he meets John Vanderlyn, with whom he studies and works.
- **1805** Travels to Rome with John Vanderlyn to study the work of Venetian artists, particularly Titian. Stays in Italy for four years, during which time he makes the acquaintance of artists and writers such as Bertel Thorvaldsen, Irving Washington, and Samuel Coleridge.
- **1810** Returns to London.
- **1818** Returns to the United States after his wife dies and settles in Boston. Affected by his wife's death, his style becomes more somber. Is named associate member of the Royal Academy in London.
- **1830** Marries again and moves to Cambridgeport, Massachusetts, the hometown of his new wife.
- **1842** Charles Dickens, the English novelist, visits him in Boston. He rekindles Washington Allston's passion for English romanticism.
- **1843** Dies in Cambridgeport, Massachusetts, on July 9.

bolism, and naturalist morality, allegorized in bucolic but very dynamic landscape painting.

A new quality that was still unknown in the United States can also be appreciated in Allston's art: The idea of sublime beauty. In romanticism, it is understood as the work of God. This painter interprets it as the composition's beginning and end: A detail can reflect all of beauty's criteria as the Supreme Being's direct representation.

Landscape with a Lake

(1804)
oil on canvas
38 x 51 in (97 x 130 cm)
Museum of Fine Arts,
Boston

A new moral idea emerged in early 19th-century European romantic painting: portraying man in the world as humble beside God's imposing work. For the romantics, the moral and religious implications of painting hinged on the depiction of human beings in relation to the world. Romantics perceived this as the artistic form of a language used between the Creator and his work. The greatest exponent of this pictorial language was the German artist Caspar David Friedrich, who, with exceptional sensitivity, knew how to depict human afflictions and hopes through small reflexive figures portrayed beside monumental landscapes.

The major American artists quickly assimilated this aesthetic code of humanity beside God's work. Luminism and Hudson River School art include an interpretation of man as the rational moral element beside and within the landscape's divine freedom.

In this painting, Allston illustrates this aesthetic ideal, depicting the human being as an imperfect and simple Arcadian who placidly integrates into nature. The artist used an unquestionably spontaneous perspective here, employing a fluid brushstroke that constantly alternates between perfect realism and an impression. The landscape in the foreground embodies lush and vigorous nature, while the figure is tiny, a simple sensation more ethereal and volatile than the landscape.

The romantic landscape, which flourished in England at the begin-
ning of the 19th century with such artists as John Constable and
J. M. W. Turner, led to the creation of scenes with great tonal
drama. These paintings illustrated how the violence of nature
reduced man to a mere anecdotal figure beside the landscape's
monumentality. This view of a wild and chaotic world where civi-
lization is secondary influenced Washington Allston's work. He
was interested in capturing the effects of light and atmosphere, as
Turner was, although Allston's light and color does not attain the
fantasy effects of Turner's work.

Storm Rising at Sea

(1804)
oil on canvas
38 x 51 in (97 x 129 cm)
Museum of Fine Arts,
Boston

Allston expressed his admiration for Turner's paintings in many of his letters. It appears that
he met him on his second trip to England. The two men were peers, Turner only four years older
than Washington, but Turner was much more prolific. That is why he quickly developed clear-cut
ideas and a maturity that Allston would only attain years later.

In this painting, Allston portrays nature's grandeur in a spectacular manner. With dark colors,
winding lines, and a daring Turner-like composition, the painter illustrates the sea's magnifi-
cence and power beside man, represented by the boat that is at the mercy of the waves,
insignificant and helpless. Although the technique and composition are not that of the British
painter, Allston does not conceal his interest in the same themes and his clear admiration for the
way Turner depicts them.

Moonlit Landscape

(1819)
oil on canvas
25 x 35 in (64 x 91 cm)
Museum of Fine Arts,
Boston

This is a mature and insightful work. Allston's style developed quite rapidly in London as he experimented with the compositional alternatives offered by light and color tone. Structurally, this work is based on the vertical course between the poetic light of the moon and its gradation to the silhouettes of the figures in the foreground. The entire painting is luminous, the atmosphere created by the brilliance and reflection in the sky and water. The composition is reminiscent of the work of the British artist John Constable. The landscape's poetic design and cultivated smoothness gain drama from the use of light and shadow.

The way the landscape dissolves away from the light, as opposed to the perfect outlines of the architectural elements and the people, produces an image with color glazes anticipating the Impressionist art that would appear in France half a century later. Although the work may not seem very colorful, Allston gives the scene subtle dynamism with contrasting tones and ideas. The radiant sky, constructed from a halo of clouds surrounding the moon's velvety yellowish silhouette, evokes a divine romantic ideal where the celestial implies a Supreme Being surveying nature. The artist creates a dialogue between the heavens and the earth, where human shadows make tiny movements that do not integrate with divine architecture.

Right: Allston was primarily a painter of landscapes and history paintings. However, he sometimes, painted portraits for people who were close to him. This is a preliminary study for a later painting, which is currently at the National Portrait Gallery in London. Samuel Taylor Coleridge was 42 when Allston made this painting of the famous writer and poet. He was Allston's close friend and promoter. The artist said that there was no other friend to whom he owed so much.

Allston created an apparently ecclesiastical gothic arrangement for his friend, placing him in a cathedral to express reverence for a man considered one of the major religious thinkers of his time. Surrounded by a somber darkness, the portrait personifies one of the major ideas of religious theory: God as a mystic organism, whose dynamic system is and produces life. It may also be that Allston puts Coleridge in a traditional Christian cathedral to evoke the friends' return to their religious roots after belonging to the Episcopalian church.

Allston produced many biblical paintings. The painter's interest in religious scenes originated from the moralizing tendency of romantic art: The artist felt the need to convey the idea of simplicity and divine nature to the viewer. However, Allston also painted this type of scene for its historical interest. Through his reading of the Bible, the artist developed a belief in history as a cyclical rise and fall of empires and kingdoms. This idea, shared by Thomas Cole, led Allston to paint battle scenes of historical armies that evoked the wars that took place in the United States during the 18th century.

Christ Healing the Sick

(1813)
oil on laminated mill board
28.7 x 40.3 in (73 x 102.4 cm)
Worcester Art Museum,
Massachussetts

 This work portrays an event from the New Testament about the miracles of Jesus; the viewer is very close to the scene. The artist did not use a traditional ecclesiastical image in which Christ displays only His divine aspect. For romantic artists, mysticism was only one feature of Jesus' character and personality, and hence the art does not have to be limited to resplendent images and crucifixes. Jesus is in the center of the painting, and his white tunic makes him stand out clearly from the crowd. He is idealized but still has a human aspect similar to the other figures in the painting.

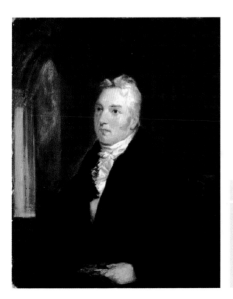

Samuel Taylor Coleridge

(1814)
oil on canvas
8.9 x 7.2 in (22.7 x 18.4 cm)
Brigham Young University
Museum of Art, Provo, Utah

The Flight of Florimell

(1819)
oil on canvas
36 x 28 in (91.4 x 71.1 cm)
Museum of American Art,
Detroit

This scene of a horse and rider is based on a passage from an epic poem by Edmund Spenser, published in 1590. Spenser's poetry inspired many American artists, including John Singleton Copley and Benjamin West, who found the ideal of morality and nature in the work of this British author. Literature was one of the main sources of inspiration for romantic painters. To them, the description of the natural and mystic world in old tales and poems offered a response to an incipient preindustrial society.

In portraying Florimell, a symbol of chastity and purity, the painter highlights the heroine's virtues as described by Spenser. The scene has a romanticism resembling the British Victorian view, which flourished in London at the beginning of the 19th century. The lush landscape infiltrating the pictorial space and a beautiful and elegant woman on a magnificent white horse approach the symbolic romanticism that would be explored years later by the Nazarenes and Pre-Raphaelites. Allston's luminist awareness can be observed in the open, sunny landscape beyond the forest in the foreground. The artist has thus created two quite distinct spaces where he explores the new vision of epic painting and the traditional landscape art of his previous work. The work of Allston describes the moment in which the knights enter the forest in pursuit of Florimell, a beautiful fairy with long blond hair, who flees in order to avoid contact with them.

THOMAS BIRCH

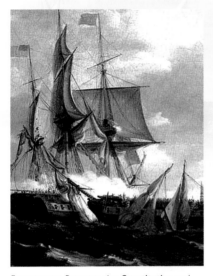

Engagement Between the *Constitution* and the *Guerriere* (detail), 1813, oil on canvas, 28 x 36.3 in (71.1 x 92.1 cm), Museum of Fine Arts, Boston.

Born in England, Thomas Birch arrived in the United States with his father in 1794. Although his most representative works were naval scenes from the War of 1812, this painter began in the art world as a miniaturist. Trained initially in Philadelphia, during his youth he served as an infantry marine, which later determined his passion for maritime themes. This was a new discipline, and he deserves to be regarded as the first naval painter in North American history.

Thomas Birch's work constitutes a visual document that is very relevant to the formation of the United States during the first third of the 19th century. His landscape paintings show the country's architectural evolution; his work brings together an important number of scenes of Philadelphia, Washington, and New York.

Thanks to the extensive art schooling he received from his father, Birch went from miniature to oil painting and watercolors and was able to create beautiful architectural views with a profound, romantic sentiment. This painter was a born observer, and as a result, his painting bears witness to his times. Birch was familiar with the profound changes the United States underwent during the beginning of the 19th century, and he reproduced

- **1779** Thomas Birch is born in England. He is the son of William Russell Birch, landscape and miniature painter of modest means.

- **1794** Thomas and his father move to the United States, where William Birch (his father) tries to establish himself as a miniaturist painter.

- **1799** Works as an apprentice to his father. They both do magnificent miniatures of Philadelphia landscapes on enamel. Thomas's father encourages him to dedicate himself to landscape drawings.

- **1806** Begins working with oils and water-colors, showing a special inclination for por-traits. Taught by various professors, Birch decides to continue with landscape painting.

- **1811** Exhibits for the first time in the Pennsylvania Academy of the Fine Arts.

- **1812** After enlisting as an infantryman in the Marines, Birch becomes an official war painter. Despite the lack of documentation regarding the painter's years in the military, it is known that he made various trips to Europe.

- **1832** Exhibits at the National Academy of Design, New York.

- **1833** Exhibits at the American Academy.

- **1834** His father dies on August 7 in Philadelphia.

- **1838** Exhibits at the Apollo Association, where he exhibits again a year later.

- **1839** Exhibits regularly until 1850 at the American Art-Union.

- **1840** Named honorary member of the National Academy of Design.

- **1848** Exhibits for ten consecutive years at the Maryland Historical Society.

- **1851** Dies January 14 in Philadelphia.

those changes in a realist way. Tradition and modernity mix in Birch's painting. His compo-sitional style is based in classicism, but his stylistic resources announce a patriotic roman-ticism.

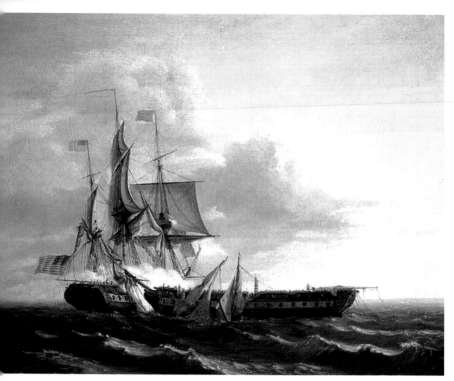

Engagement Between the Constitution and the Guerriere

(1813)
oil on canvas
28 x 36.3 in (71.1 x 92.1 cm)
Museum of Fine Arts, Boston

The passion Birch shows in his paintings of the War of 1812 reveals a deep sense of patriotism that contrasts with his British roots. In this painting of a legendary United States Navy ship, the *Constitution*, in battle against the *Guerriere*, a British ship, the painter's partial view alerts us to some patriotic details. The *Constitution*'s waving flags recall a miniature style that the artist mastered well, while the beaten British ship is represented by a jumble of masts over a defeated hull. In his naval paintings, Birch stood out thanks to his excellent training as a miniaturist, which allowed him to convey numerous details clearly.

Here, the artist combines his patriotic sentiment with the dramatic vision of the American ship, showing not only this isolated victory, but also evoking the United States's hegemonic power over the water. To convey this, Birch did not hesitate to create a romantic vision of the scene. Behind the elegant *Constitution*, Birch has placed a large, corporeal cloud that adds to the ship's starring role and creates a contrasting effect, strengthening the impact of the details. The scene presented is grandiose and epic.

Southeast View of Sagely Park

(1819)
oil on canvas
34.3 x 48.4 in (87 x 122.9 cm)
Smithsonian American Art Museum, Washington, D.C.

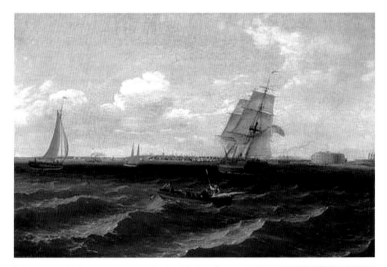

This scene, which represents a majestic ship heading out to sea with New York Harbor in the background, constitutes a new vision of naval painting in the United States. While other artists of his generation were dedicated to calm landscapes of the countryside or bucolic coastal scenes where the sun never fully sets, Birch was committed to the Navy, with whom he worked as a an official war painter.

New York Harbor

(1813)
oil on canvas
18.4 x 27.6 in (46.8 x 70 cm)
Henry Luce III Center for the
Study of American Culture,
New York

In this work, Birch presents a very neat seascape where all the different elements work together to produce a great dynamism. In his first landscapes, the artist adopted a compositional style based on a framework of lines that distribute the space. In this work, the horizon orders the whole space, which is divided into two superimposed bands corresponding to sky and sea, while the ships' masts add drama and connect both elements.

Structurally, the work is very simple. The clouds' dynamism and the rhythmic flow of the waves break any monotony and fill the pictorial space attractively. The artist has planned the work from a landscapist perspective, giving the lead role to the monumentality of the sea and the sky.

Left: Birch's work, with its scenes of daily life, gives a romantic but accurate view of the 19th century. In this painting the artist offers a view of Sagely Park, an important Philadelphia banker's mansion and the first example of neoclassical architecture in the United States. Benjamin Henry Latrobe, responsible for the United States Capitol building in Washington, D.C., designed and directed the construction of the mansion. During the first half of the 19th century, United States architecture evolved toward a monumental neoclassicism, a representation of a new free society that used ancient classical republics as a model.

This painting has an interesting documentary value in itself, and Birch has enriched that by adding a beautiful postcolonial landscape. The rich vegetation seems to hide the building and contrasts with the sky's tonalities, which reflect on the exterior of Sagely Park. Birch understood the new architecture very well, and he played with the rectitude of the classical structures contrasting with nature's formalized freedom. This way the artist shows a classical ideal of architecture based on nature.

U.S.S. *Wasp* Boarding H.M. Brig *Frolic*

(~1815)
oil on canvas
25 x 48.3 in (62.5 x 122.6 cm)
Private collection

This work, the most militaristic by the painter, contains a series of standardized entries. The technical resources for capturing a live battle scene were very limited, so the artist was obliged to work from notes, studies, and sketches. Here we see that Birch had a vast knowledge of naval ships; thanks to this, he was able to create some exceptionally precise and detailed reproductions. In his military paintings Birch combines the destructive violence of the sea with the vigor of the two navies. In this work all the elements are aggressively dynamic. The sea is angry, and the sky threatens and foretells a storm hidden among gray rain clouds. The whole painting seems to be in movement, with the exception of the American ship, abnormally deserted, while the men board the British boat, beaten and defeated.

Birch's work represents the famous battle with an accentuated romantic sentiment. Influenced by historical accounts of classical military battles, the painter did not hesitate to magnify the themes of his work. He did this by capturing the fury of the elements, as his forces victoriously roll over the enemy in the way the mythical Poseidon ruled the seas during the classical age.

Mill Grove Farm, Perk Omen Creek, Pennsylvania

(1820)
oil on canvas
14.8 x 22.6 in
(37.5 x 57.3 cm)
Henry Luce III Center f
or the Study of American
Culture, New York

After working with his father in their miniature-on-enamel work-shop in Philadelphia and completing, also with his father, a series of views of the city, Birch decided to travel to New York and enlist in the navy. This painting represents a transitional period in the artist's life. Until 1810 his artistic career was always subject to his father's interests. It is unknown how the professional collaboration ended between father and son. It is evident, however, that the relationship must not have been gratifying for Thomas: All his work, from the beginning of the century, was signed by his father.

The Narrows, New York Bay

(1812)
oil on wood
20 x 26.7 in
(50.8 x 67.9 cm)
Fine Arts Museums
of San Francisco

In this painting, Birch disconnects completely from everything he had done in Philadelphia and explores new, more free, more modern compositional techniques. In this view of New York from a distance, Birch has adopted a very classical landscapist style. The space, regulated by a large tree on the left, has a romantic, harmonized composition; within it, the artist plays with atmospheric effects. Everything seems to be covered in a mysterious light centered over the two animals in the front plane, next to the tree. Birch gained popularity with this delicate picture for having captured a landscape as the English painters did.

Left: After seven years in the United States Navy, painting on the high seas, Birch decided to get back to his roots, and he returned to Philadelphia. There he took up landscape painting once again, in a calm and quiet setting. Back in 1800 his father had encouraged him to paint landscapes of the city's outskirts. Father and son worked together on different projects, which were later exhibited under the name William Birch.

In this view of a farm, Thomas Birch has adopted a romantic style following modern criteria. Before this time, European pictorial genres had not been matched in North American painting, and some genres would not be practiced in the New World for some time. However, from the 19th century on, the artistic communication between the continents was more fluid. As a result, until the end of the 19th century, the United States did not have its own pictorial style; original American work consisted of revisions of European painting. Many artists went to Europe to get to know firsthand the works of the classical masters as well to study and adopt new ideas in the artist circles of London and Paris.

This painting is a demonstration of Birch's artistic temperament, clearly influenced by the English. Birch took the concept of romantic, idealist painting and applied it to rural America. The result still reflects Victorian taste, although the landscape's force, much more aggressive than that of the English countryside, determines this work's character.

Naval Battle Between the *United States* and the *Macedonian* on October 30, 1812

(1813)
oil on canvas
27.7 x 35.9 in (70.5 x 91.1 cm)
Museum of Fine Arts, Boston

In this painting, Birch has not painted his traditional vision of a defeated ship next to a heroic American battleship. Here, the artist has used a much more realistic and dramatic vision in which the boats are engulfed in full battle. Birch has placed both ships on the same compositional plane, and although he shows his patriotic viewpoint with details such as the proud American flag waving in the wind, the scene conveys more tension than his earlier compositions. The Macedonian is showing its first signs of defeat—a jumble of masts and sails fallen on the hull. But thanks to its proximity to the viewer, the ship still gives the impression of latent aggressiveness, which adds drama to the scene.

Birch has situated the naval battle at high sea, beneath a threatening sky, with clouds that play chromatically with the smoke from the canons. The sea is the other great dynamic element; its rough waters bring movement and fury to the work. In these naval scenes, we can appreciate the importance of the atmospheric elements in composing and distributing the space. The artist has used the ships' architecture to order the pictorial space, while in the sky and the rough sea he has created a strong framework of lines, a foundation for the work's pictorial dynamism.

THOMAS SULLY

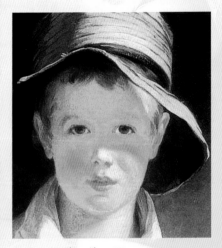

The Torn Hat (detail), ~1820,
oil on wood, 19.1 x 14.6 in (48.6 x 37.2 cm),
Museum of Fine Arts, Boston.

Thomas Sully was one of the best exponents of Romantic painting in North America. His portrait style demonstrates a British influence, although his work shows an evolution in this genre in the United States.

After years of study with different teachers, Thomas Sully decided to follow in the footsteps of his older brother, the miniaturist Lawrence Sully. However, he soon returned to portraits, the genre to which he remain dedicated for the rest of his career.

Sully's work shows his unique ability to create formal innovations in portraits. His European experiences allowed him to create a vision of the genre based on an apparent realism. He experimented with fundamental components of portraits such as personality and atmosphere. As a result, Sully renewed this pictorial genre, with all its formal possibilities. Dress, gesture, and tonality were looser and more informal, while the person was painted in his own surroundings, a complement to the artist's intimate descriptions.

Thomas Sully can be regarded as the first painter of impression in the United States. This stemmed from his reinterpretation of the romantic tendencies prevailing in England and the new portraitist consciousness emerging in France through Gustave Courbet and Honoré Daumier, who combined realism with spontaneity and dynamism.

- **1783** Born in Horncastle, Lincolnshire, England, the ninth son of two actors.
- **1792** Emigrates to the United States under the care of one of his father's brothers-in-law, a theater manager in Virginia and South Carolina. Attends a school in New York for two years.
- **1794** His mother, Sarah Chester Sully, dies. Returns to the family home in Richmond, Virginia. Shortly thereafter, he moves to Charleston, South Carolina, to train as an artist.
- **1799** After studying with different art teachers, Thomas follows in the footsteps of his older brother, Lawrence Sully, the professional miniaturist, and decides to work with him in Richmond, Virginia.
- **1804** Attracted by Henry Bainbridge's portrait style, he continues his artistic studies and even opens a studio in Richmond. His brother Lawrence dies in September.
- **1806** Accepts an offer as the salaried portrait painter for a New York theater.
- **1807** Moves to Boston to study with Gilbert Stuart, who encourages him to become a portrait painter. Later he moves to Philadelphia, his permanent residence for the rest of his life.
- **1809** Goes to London with the help of many prominent Philadelphians. In London he shares a room with Charles Bird King and studies with Benjamin West and Henry Fuseli. Enters into the circle of the most active and up-and-coming artists of the Royal Academy of Art.
- **1810** Returns to Philadelphia and quickly establishes himself as a professional portrait painter, gaining unanimous recognition from the general public and critics.
- **1812** Named honorary member of the Pennsylvania Academy of the Fine Arts.
- **1837** After working for several years in Philadelphia, Washington, Baltimore, Boston, and New York, and at West Point, as a prestigious portrait painter, an association of British expatriats called the Society of the Sons of St. George sends him to London to do a commissioned portrait of the recently crowned Queen Victoria.
- **1851** Prepares a brief guide for portrait artists called "Hints to Young Painters" and another titled "The Process of Portrait Painting," later revised in 1871 and published in 1873.
- **1872** Dies November 5 in Philadelphia.

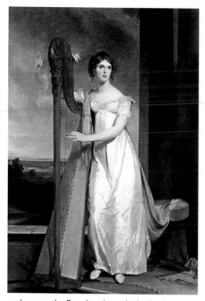

Lady with a Harp: Eliza Ridgely

(1818)
oil on canvas
84.4 x 56.1 in
(214.5 x 142.5 cm)
National Gallery of Art,
Washington, D.C.

Upon his arrival from London, Sully's fame as a portraitist led him to paint many important members of society. Sully was also recognized for his ability to portray delicate domestic scenes, in which he treated femininity in a more personal manner. In this picture, the artist shows a new vision of women in which intimacy gains a sentimental, luxurious character. Thomas Sully presents a Baltimore merchant's daughter in an elegant and distinguished way. Compositionally, Sully knew how to arrange people and objects by means of never-before-tried scenes. By structuring the work along two nearly parallel lines (formed by the woman and the harp), he created a composition both modern and romantic. Despite the painting's chromatic richness and decorative character, the artist has carried out a sublime exercise in composition, in which the colors balance into an almost narrative order. The blue veil directs the eye toward the painting's white center, and this effect is surprisingly complementary, thanks to the artist's tones. In the same way, the brown of the harp frames the monumental landscape that seems to steal the starring role from the room's interior.

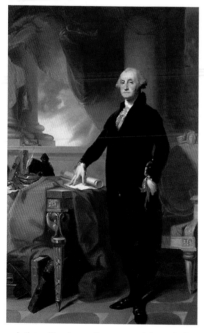

George Washington

(1820)
oil on canvas
85.6 x 54.6 in
(217.4 x 138.8 cm)
Minneapolis Institute
of Arts, Minnesota

This portrait of George Washington is part of a series completed by Sully. He copied one of portrait painter Gilbert Stuart's works. (Sully also did many copies of pictures of government buildings, and he showed a much more fluid brushstroke than Stuart, even though he worked to achieve total veracity in the copies.) This picture depicts the president surrounded by symbols representing his politics and those of the United States. His right hand rests upon a copy of the Constitution, while the saber represents his own heroism and the open window in the background symbolizes the nation's future and hope. The work, still very classical, shows a new compositional style, which Sully would also use in later paintings. The decorative sense of the painting allows for a discourse or pictorial narrative that steers the spectator through the picture and therefore constitutes a whole dissertation on patriotism in the United States.

In his indoor portraits, Sully adopted a style similar to Stuart's, whose portraits were very realistic and whose protagonists usually stood out from a profusely decorated background. Sully has followed this decorativeness faithfully, complementing this new vision of the portrait of impression and personality with an internal description of the person through the elements and props that surround him. The figure of the president, dressed in a vigorous black that reinforces the silhouette and endows him with a majestic, distinguished air, recalls many portraits of European royalty from previous centuries.

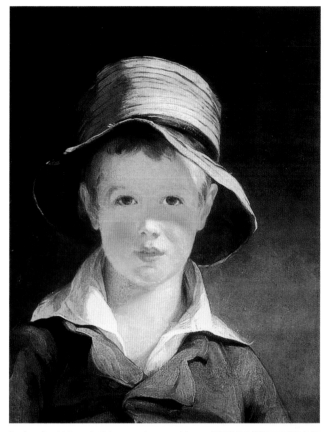

During the 18th and 19th centuries, portraits of children usually showed young people just like adults, dressed somberly in serious poses. Sully took a different approach. In this painting, he shows his son, Thomas, dressed in a more informal manner. Although the portrait maintains a certain formality, the boy's appearance is fairly realistic. This concept represents a stylistic revolution in 19th-century American painting. The modern char-acter of Sully's work brought the portrait up to date, liberating it from the rigid canons of classical asceticism and bringing it closer to the country's reality. Even though Sully did not use this style for commissioned work, the innovations he brought to portrait painting anticipated the work of John Singer Sargent and Mary Cassatt. Thomas Sully was the first American painter to practice free painting without any apparent rules, based on the spontaneity of the scene.

The Torn Hat

(~1820)
oil on wood
19.1 x 14.6 in
(48.6 x 37.2 cm)
Museum of Fine Arts, Boston

Later on, some details that the artist already shows here, such as the capacity of clothing for expression and the particular sensation of inno-cent sincerity reflected in the boy's face, would become part of the language of painting. This absolute truthfulness of personality is reinforced by the realistic light on the boy's skin. His figure emerges from an almost smooth background; the changes of light serve to texture his face just slightly, but nothing disturbs the vision of the innocent child.

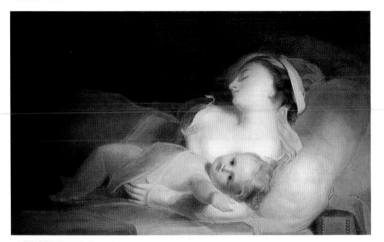

Mother and Child

(1827)
oil on canvas
26.5 x 43.5 in (67.3 x 110.5 cm)
Butler Institute
of American Arts,
Youngstown, Ohio

At the time Sully dedicated himself to the portrait, a very classical vision of painting prevailed in the United States. Stylistically, American artists followed guidelines dictated from Europe, although they interpreted them differently. In this painting Sully has adopted a slightly academic portrait style, although compositionally the distribution of space and the characters' poses appear to be free and spontaneous. The rigidity of the portraits done in Europe at the end of the 18th century and in the United States at the beginning of the 19th had disappeared, giving way to a more sincere, realist face.

In this work Thomas Sully approaches motherhood with a sentimental and tender scope. With a fairly modern vision of intimacy, the artist seems to explore a new language based on the body's expressive capacity. Surrounded by dense darkness, a luminous image of a mother appears. She is in bed, resting with her son in her arms. Her posture, very spontaneous and with mildly erotic details, captures the whole luminous sense of the painting, which allows us to appreciate the intense tones on the resting woman. The child, however, is more lively. Between the two figures, there is a balance of static and dynamic elements that leaves the work suspended in time. The colors and technical treatment give the work a vaporous atmosphere, which endows the picture with a mysterious air, as if it were an allegorical or idealized vision.

Suffer the Little Children

gouache on blue paper
10.4 x 14.3 in
(26.5 x 36.2 cm)
John Davis Hatch
Collection, National Gallery
of Art, Washington, D.C.

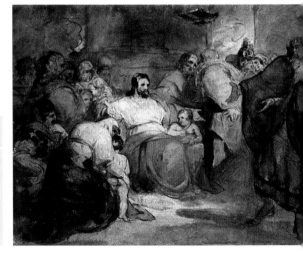

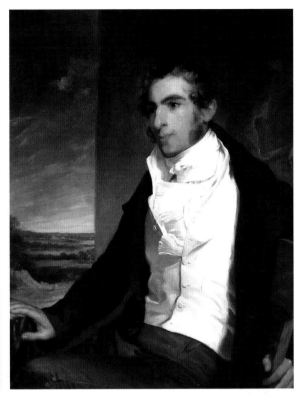

Daniel de la Motte

(1912)
oil on canvas
36.3 x 29 in
(92.3 x 73.8 cm)
Smithsonian American
Art Museum,
Washington, D.C.

Throughout his career, Sully demonstrated a talent for portraits. At the beginning of the 19th century, naturalism dominated the American art scene, revolutionizing landscape painting and country scenes. On the other hand, young painters were losing interest in portraits, while established portraitists were stuck in a very limited, formal style apparently without any glimmer of evolution. Sully was, for portrait painting in the United States, a total revolution. He renewed interest in the genre at a historical period of great stability, during which people began to demonstrate their appreciation for art. Commissioned portraits were revived, and Thomas Sully led the revival.

Here the artist has done a somber portrait, composed very traditionally, although he has included a very European landscapist detail. The shine of the figure's blouse seems to stand out for the tonal weight of the color white and because it is surrounded by dark tones. However, Sully has knowingly used the colorful landscape in order to balance the painting and break the stillness. The boy's delicate face and hands acquire spatial freedom and take on the lead role, thanks to this interplay of light and dark.

Left: In this painting, Sully demonstrates a compositional style quite different from his more traditional works. The work's religious character is a departure from his earlier paintings, which did not yet have the influence of the great European neoclassical masters. During his early years Sully adopted many genres and subject matter, through which he studied, rather basically, the classical artists.

Here, the baroque classicism accompanied by a chiaroscuro effect appears slightly disordered, taking up space toward the center of the picture. The seated figure and the child stand out dramatically from their chaotic surroundings. Sully has tried to reflect the central figure's mystical character in this work, emphasizing the harmony between the figure and the child. The imaginative profusion developed by the artist in order to compose this painting in two completely different light planes clearly demonstrates his interest in the European neoclassicists. The central color details, delicate but intense, in contrast to the dark dynamic masses around them, create a new language in American painting, showing a mix of the painterly and chiaroscuro.

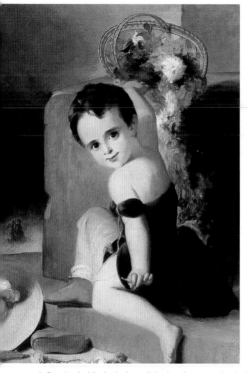

Robert Fielding Stockton

(1849)
oil on canvas
29 x 36 in (73.7 x 91.4 cm)
Smithsonian American Art
Museum, Washington, D.C.

Although North American painting from the first half of the 19th century is a reinterpretation of European stylistic trends, we can see an evolutionary line from academic naturalism at the end of the 18th century to Romantic painting in the 1850s. Sully was conscious of this pictorial tradition and evolved gradually, conserving certain characteristics of classical style and composition with modern formal approaches.

The European influence of the 18th and 19th centuries can be discerned here. The composition reveals a delicate classical character, while the formal conception of the work is modern. Sully was intrigued by the work of Francisco Goya and Rembrandt, which he saw in London. Here he adopted their particular qualities in the facial and bodily gestures. Sully also shows their influence in his depiction of the boy in a neoclassical setting, which appears disordered, while the child is forced to adopt a complex pose in order to see the viewer. Sully knew how to interpret and reproduce the gesture: the very expressive posture shows the child's interest in the basket overflowing with flowers and illustrates how he turns toward the viewer out of natural curiosity.

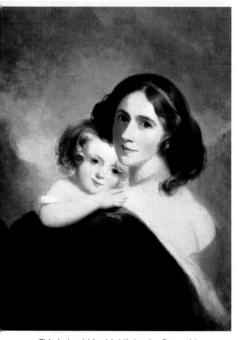

Mrs. Fitzgerald and Her Daughter Matilda

oil on canvas
30 x 25 in (76.2 x 63.5 cm)
Private collection

In this painting Sully demonstrates his new portrait style and applies it to the theme of motherhood. In these types of portraits Sully always used the component of affection between mother and child, which he emphasized with carefully studied poses and with the help of delicate gestures of tenderness to represent the close and intimate relation between the two. This new way of presenting the affectionate bond between mother and daughter brought Sully popular recognition and many commissioned works.

Compositionally, the work hinges on tonal contrasts, emphasizing the luminous warmth of the characters' faces to create an intense, familiar sensation. In all of these paintings, Sully composed degraded backgrounds in cold colors. This helped him highlight the figures' human quality as well as define a closed space for a sense of intimacy. This is a painting of impression, rebelling against the exacerbated realism that permeated American painting. Sully has created an atmosphere and expressed emotion with new chromatic approaches that utilize the relationship between color and tone as an expressive element.

JOHN JAMES AUDUBON

John James Audubon.

This artist is a legend among scholars and enthusiasts of ornithology in the United States. His work on bird species is one of the most important ornithological catalogs in history. Although he was not the first illustrator to create such a composition, he is considered a pioneer in the field because of the documentary and artistic quality of his work.

In Audubon's paintings—basically a classification of birds and some mammals—he conveys an artistic sensitivity. His work is an example of the intellectual art that was characteristic of the beginning of the 19th century.

Audubon's work, although subject to rigid scientific guidelines, has many artistic connotations because of his effort to give expressiveness to the animals. His training in France gave the artist the sensitivity to analyze the animals as if for a portrait. This made it possible to capture not only the appearance of a specific example of a species, but its lifestyle, aggressiveness or passivity, appearance when active, or the aesthetic relationship it had with its environment. Audubon portrayed his birds in a very dramatic context in order to show his viewers as many dimensions of each specimen as possible.

- **1785** Born on April 26 in Les Cayes, Santo Domingo, in what is now Haiti. Illegitimate son of Jean Audubon, a French boat captain, and a chambermaid, Jeanne Rabine.

- **1788** Moves to France with his father. During his happy childhood in Coueron, near Nantes, he studies geography and mathematics. His favorite hobby is drawing birds, eggs, and other aspects of ornithology. According to his own notes, it seems he may have studied with the neoclassical painter Jacques-Louis David, although there is no reliable documentation on this.

- **1789** His father buys a farm near Philadelphia.

- **1803** John James Audubon moves to the farm in the United States.

- **1808** Marries Lucy Bakewell. The couple moves to Louisville, Kentucky.

- **1810** Meets Alexander Wilson, whom he admires because of his ornithological studies. Ten years later, he helps Audubon create an illustrated study of natural sciences.

- **1822** Takes oil painting classes from an itinerant artist called John Stein (or Steen).

- **1824** Visits Philadelphia, where he holds an exhibition of his naturalist work at the Academy of Natural Sciences.

- **1826** Travels to England looking for a sponsor for his illustrated American bird study project. Arrives in Liverpool, where an exhibition of his work is held at the Royal Institution. Gradually receives subscriptions in London for his project. He subsequently begins a series of trips between the United States and London.

- **1838** *Birds of America* is completed. It is composed of 435 hand-colored plates of 1,065 birds, a total of 489 species. The book is published in five volumes between 1831 and 1839. It is very successful in England and the United States, so much so that the president of the United States, Andrew Jackson, encouraged Audubon to publish two more works. The first is a smaller version of *Birds of America*; the second, *The Viviparous Quadrupeds of North America*, is two volumes of hand-colored lithographs based on watercolors by Audubon and his son, John Woodhouse Audubon, accompanied by text written by the amateur naturalist Reverend John Bachman. It is published between 1845 and 1848. .

- **1851** Dies January 27 in Minnie's Land, a 35-acre piece of property near Manhattan, New York, owned by Audubon. This land, beside the Hudson River, was where the artist spent the last nine years of his life.

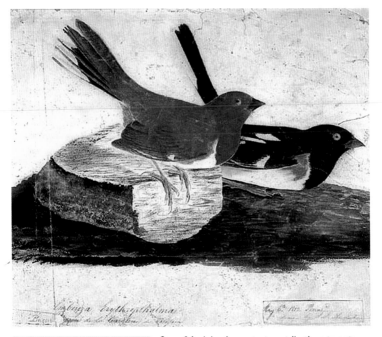

Towhee Bunting

(1812)
chalk, watercolor, pencil
and ink on paper
9.4 x 11.1 in (23.8 x 28.3 cm)
Smithsonian American Art
Museum, Washington, D.C.

One of Audubon's greatest contributions to natu-ralist painting was to develop a new way of illus-trating animal catalogs through very artistic compositions. Before *Birds of America* was made, naturalists' illustrations were mere colored sketches, showing a specific animal of a species without illustrating its habitat or behavior. Audubon, in contrast, contributed the idea of context: He also painted the landscape, character-izing the animal as an example of its species—with a personality and attitude reflected in its gestures and features. Here is a sketch Audubon made in the old documentary style. Most of the information about the bird is described in notes, and the illustration is simply supplementary. Until about 1800, most ornithological information was based on this type of classification; artistic sensitivity was considered an unnecessary luxury. In any case, even in his first notes, Audubon posed artistic questions. In this illustration, the artist used his innate sense of compo-sition to create contrast between the color of the birds and the dark tone of the paper. The artist included the bird's nest in the illustration not only to show and complete the information he had gathered, but also to introduce an element that justifies the birds' presence on paper.

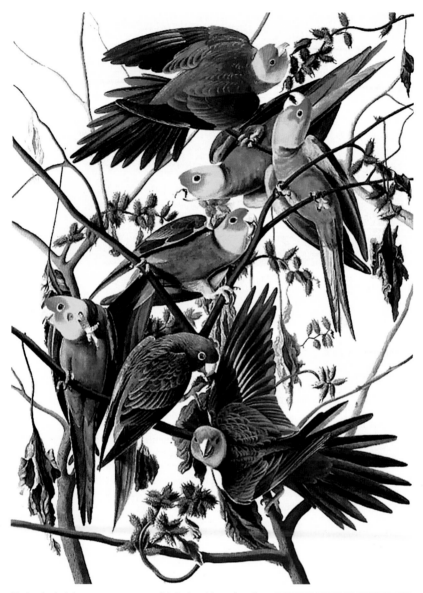

Obviously, Audubon was an expert ornithologist able to describe each species' way of life, while at the same time taking each bird's personality into account. The artist was able to recognize and distinguish the variety of forms of each bird species without depicting any individual out of its original context. A clear example of Audubon's respect for the variety of bird characteristics is this painting of a family of North Carolina parakeets, a species now extinct. These animals lived in extensive communities in the same tree or in a group of two or three trees, depending on the size of the flock of birds.

Carolina Parakeet

(1827-1838)
hand-colored aquatint
engraving on Whatman paper
38.3 x 25.3 in (97.2 x 64.2 cm)
North Carolina Museum of Art, Raleigh

Audubon painted them very realistically, portraying each individual bird's restless character. The artist here illustrates that this species' main characteristics were its social relationships and incessant activity. That is why he has depicted this parakeet community as a colorful swarm of bright colors in constant motion.

Farmyard Fowl

(~1827)
oil on canvas
28.1 x 41 in (71.5 x 104 cm)
National Gallery of Art,
Washington, D.C.

What makes an artist? In Audubon's case, the true artistic nature of his career can be questioned. His yearning to be acknowledged as an artist is clear from his notes, where he insistently expressed his pride at having studied with a painter like Jacques-Louis David. His training gradually fulfilled his need to master a variety of techniques that would make it possible for him to reproduce his bird sketches.

It was not until 1822 that Audubon decided to study oil painting and, undoubtedly, he did it to be able to give his painting a greater artistic quality.

In this work, one of the few in which the artist did not use a mixed technique, Audubon painted a classic picture of farmyard fowl. This painting is neoclassical in style, and the artist applied his recently acquired knowledge of oil painting to create one of his most artistic works. Audubon painted it using chiaroscuro, which destroys the expositional quality of his specimens. Even so, the painting highlights the color of the birds and the golden aspect of their plumage, which appears to glow as a reflection of nonexistent light.

Fox and Goose

1835
oil on canvas
21.5 x 33 in
(54.6 x 83.8 cm)
Butler Institute of
American Art,
Youngstown, Ohio

In Audubon's exhibition-style illustrations, a variety of sequences can be found where birds are carrying out a specific activity such as hunting, eating, or mating. For expert ornithologists, these illustrations are a source of vital information. From an artistic point of view, the paintings are quite interesting because of the dynamic effects the artist creates and the complex spatial design of placing the bird and its prey.

Bald Eagle

(1827-1838)
hand-colored aquatint
engraving on
Whatman paper
38.3 x 25.3 in (97.2 x 64.2 cm)
North Carolina
Museum of Art, Raleigh

Here, Audubon depicts an eagle ready to devour its prey, a river fish lying on a rock. The artist depicts not only the moment when the powerful bird awaits the fish's last breath, but the dramatic moment to come, when the eagle will devour the fish an instant after that. Audubon captured this sensation through a violent dynamism produced by the wavy outlines that surround the scene and by painting the bird with a ferocious look. The bird looks into the distance while, with one claw, it firmly holds its prey, dying dramatically on the rock. Adding to this remarkable picture is the way the artist has re-created the landscape. It is an indistinct place, almost among the clouds, where the bird calmly, but brutally, reigns.

Left: This painting, completed in England while the artist was still trying to find financial support to study ornithology, shows a more elaborate pictorial style and better structure than his later works, which contain a clearly exhibition-oriented component. Here Audubon wishes to demonstrate not only his qualities as an illustrator for a scientific project, but also his abilities as a painter. This drama in nature, in which Audubon captures a goose trapped by a fox, displays a more elaborate compositional style, with the British landscape in the background.

Here Audubon has completed an exemplary piece, unifying his traditional pictorial style, characteristic of nature illustrations where the animal in movement displays its natural features in a most efficient way, with traditional painting, where the decorative aspect fills the space with details and elements of a clearly intentional aesthetic nature. Audubon, who came from the world of scientific illustration, took oil painting classes at the beginning of the 1820s, which allowed him to practice a more artistic style for his *Birds of America* project and afterward.

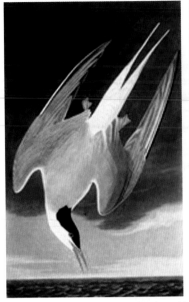

Arctic Tern

(1835)
hand-colored aquatint
engraving
National Gallery of Art,
Washington, D.C.

The particular argumentative style of painting that Audubon used for his naturalist studies is flawlessly depicted in this engraving. A bird appears in the process of hunting, rapidly hurling itself into the water with a perfectly defined expression of the survival instinct. The artist depicted this scene with a clearly fantastic element; the artist's contribution cannot be separated from the bird's behavior. Audubon was probably not able to reproduce this image directly from observation, but rather from knowledge about the bird and its physical presence, creating this speedy descent with the greatest realism that an understanding of the topic allowed. It is important to point out how the artist mixed the depiction of action with a clear display of the animal's morphology, creating a composition in which these two aspects are joined to provide the greatest amount of information to the viewer.

As a result of the color combination that the artist chose, this picture is very modern. The predominating grayish tone is probably not only a depiction of the original scene, but a conscious choice on the part of the artist, one that allows a greater sense of dynamism. The bird handles the air as if it were part of itself.

Arctic Hare

(~1841)
pencil, graphite, and black
ink with watercolor
and oil on paper
24 x 34.2 in (61 x 86.9 cm)
National Gallery of Art,
Washington, D.C.

Audubon's ornithological studies represented an advancement for the experts in those days, not only for his ability to contextualize a variety of species in their natural habitats, but also because of his special sensitivity in depicting the relationship between these animals and other species. In his important work on oviparous animals, the artist reflected an interest that went beyond a simple display or classification of birds, introducing the study of a variety of animals that, because of their feeding habits, have a symbiotic relationship with birds.

Audubon depicts a pair of animals akin to the rabbit here. They have a direct relationship to birds due to their oviparous diet. In this work, the artist displays great skill in depicting the hares, placing two specimens of different color in profile and facing forward, thus portraying them very thoroughly. Audubon's compositional style is simple. The artist bases his illustrations on a full view of the animal, which occupies most of the pictorial space. Behind it, he shows details of the natural habitat that describe the weather conditions and terrain where the species lives.

CHARLES BIRD KING

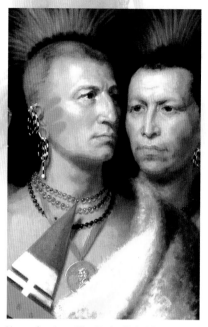

Young Omahaw, War Eagle, Little Missouri, and Pawnees *(detail)*, 1821, oil on canvas, 36.1 x 28 in (91.8 x 71.1 cm), Smithsonian American Art Museum, Washington, D.C.

- **1785** Charles Bird King is born on September 26 in Newport, Rhode Island. He is the only son of Deborah Bird and Captain Zebulon King.

- **1789** American Indians kill his father in Marietta, Ohio. He moves in with his grandparents, and his grandfather, Nathaniel Bird, gives him art classes.

- **1796** Moves in with his mother and stepfather, Nicholas Garrison, in Newport.

- **1800** Works as an apprentice with Edward Savage in New York for five years.

- **1806** Travels to London, where he studies at the Royal Academy. Meets Thomas Sully.

- **1812** Returns to the United States and settles in Philadelphia.

- **1813** Exhibits four paintings at the Pennsylvania Academy of the Fine Arts.

- **1814** Lives in Richmond, Virginia, until December, then settles in Washington.

- **1815** Lives in Washington until he moves to Baltimore in December.

- **1818** Returns to Washington.

- **1819** His mother dies in Newport.

- **1827** Elected honorary member of the National Academy of Design of New York.

- **1828** Exhibits four paintings at the Boston Atheneum.

- **1850** Sets up an art gallery in Washington, with mixed results.

- **1856** Becomes a member of the Washington Art Association.

- **1862** Dies in Washington, D.C., on March 18. He is buried in the Newport Island cemetery.

Charles Bird King had a modest art career. Most of his artistic production consisted of portraits commissioned by the Office of Indian Affairs. The work was done in Washington, where the artist's permanent studio was located.

Charles Bird King studied art in New York and London before he settled in Philadelphia to work as a portrait artist. His work shows professionalism, although artistically, it is characteristically simple. The realistic quality of his portraits led to constant work, and his paintings are a graphic chronicle of Washington's political and social life. His European training allowed him to adopt a compositional style that was quite innovative in the United States. His particular perspective on human nature, portrayed in his figures' gestures and facial expressions, gave him special recognition because he was one of the first American artists to reveal emotional qualities.

Charles Bird King was the first American artist to paint Native Americans. Although other artists had previously made Romantic explorations through Indian lands, King was the only one who painted Native American portraits from the aesthetics of a traditional portrait perspective. He portrays each Native American in a unique way, without sacrificing his own style.

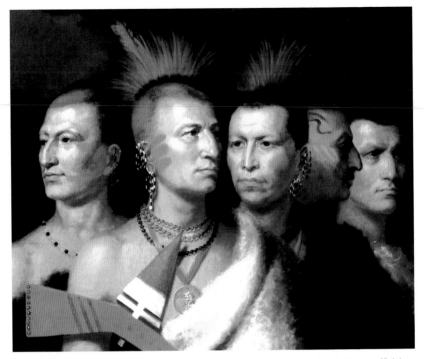

Young Omahaw, War Eagle, Little Missouri, and Pawnees

(1821)
oil on canvas
36.1 x 28 in (91.8 x 71.1 cm)
Smithsonian American Art Museum, Washington, D.C.

When he lived in Washington, D.C., King painted many official portraits. His work as a professional artist led to many commissions to paint public figures who had traveled to Washington. In this work, he painted a portrait of a Pawnee tribe delegation. Although Native Americans in Ohio had killed his father many years before, the artist painted many portraits of tribal representatives, all commissioned by the United States government, without a trace of bias or personal prejudice.

This painting does expose a Romantic curiosity for what is exotic and strange. Undoubtedly, *Young Omahaw* is one of the most comprehensive paintings the artist did on Native American themes, since it is a group portrait where a hierarchical system is displayed. The composition organizes this hierarchical system and insinuates the Pawnee tribe's customs. In this portrait, Bird King used a dark background to heighten the figures' striking character, highlighting the strength of their paint and clothing. It is interesting to see in the foreground, the chief holds a decorated ceremonial tomahawk, adding a warlike aspect to the group portrait.

Right: In this painting, Charles Bird King depicts Little Crow, one of the greatest and most honorable Sioux chiefs in history. Under his command, the Sioux people fought with the English in the War of 1812. When the war ended, he and a small group were invited to visit the British command. The English humiliated Little Crow and his people, although he kept his dignity in front of his men while he was insulted.

Little Crow, or Chetañ Wakan Mañi, heir of one of the Kapiosa band chiefs, began a long dynasty of Sioux chiefs. King painted this portrait of Little Crow based on another painting. The Sioux chief's personality and character are evident here. Thomas Loraine McKenney, an ethnographer in charge of many investigations about indigenous peoples, described this Little Crow as arrogant and theatrical, although he emphasized his splendor.

Little Crow visited Washington, D.C., in 1824, heading a Sioux delegation. King knew how to capture the dignity in his gesture and expression, but the portrait is cold and remote. It appears more like an illustration than a portrait. In spite of this, it cannot be denied that it is a good documentary testimony of this unique chief.

Shaumonekusse

(1821)
oil on canvas
26.9 x 22.3 in (68.2 x 56.7 cm)
Joslyn Art Museum, Omaha,
Nebraska

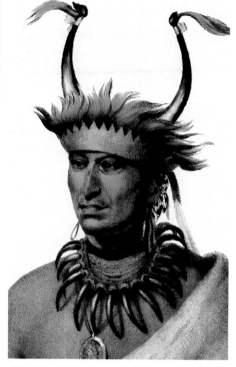

This painter's commissioned portraits of Native Americans who visited the Office of Indian Affairs in Washington, D.C., formed the foundation of the National Indian Portrait Gallery, which was owned by the government. This gallery, with several hundred portraits representing all the indigenous American tribes, was located in the U.S. War Department until it was transferred to the Smithsonian, where a fire destroyed most of the art in 1865.

Interest in this particular type of American portrait led to an English-style Romanticism that analyzed the customs and aesthetics of the country's native populations. Due to the popular interest, the government's Native American collection was also published in lithographic form in *History of the Indian Tribes of North America* by Thomas L. McKenney and James Hall in Philadelphia between 1836 and 1844.

In this work, the artist has painted his subject's most outstanding features. His exotic headdress with horns, plus his clothing and necklaces that adorn it, is quite striking. The tribal chief is in a typical portrait pose, which gives the painting an almost jarring sense of classicism.

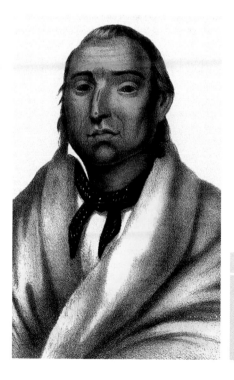

Little Crow

(1824)
color lithography on paper
19.6 x 13.5 in (49.9 x 34.3 cm)
Smithsonian American Art
Museum, Washington, D.C.

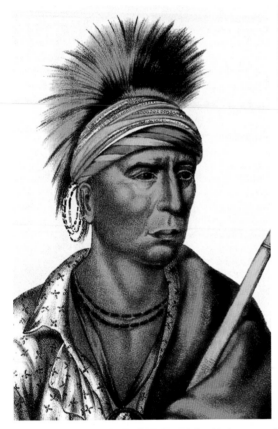

Notchimine, or No Heart

(1837)
oil on canvas
17.5 x 13.3 in (44.5 x 33.9 cm)
Smithsonian American Art
Museum, Washington, D.C.

In his work as a portrait artist, Charles Bird King also made reproductions of other portraits for the Office of Indian Affairs. This painting is a reproduction of a Thomas L. McKenney lithograph of this Iowa tribal chief.

Notchimine was a legendary Iowa warrior who desperately struggled against the U.S. Army, fighting with only 50 men. Although he lost his brother in the battle, the Iowa won because of Notchimine's heroic and ruthless behavior.

Subsequently, he was called No Heart for his ferociousness in combat. In 1837, Notchimine visited Washington to conclude the Iowa peace details of the agreement General William Clark signed a year before. King's portrait is that of the warrior McKenney described. Bloodthirsty and cruel, Notchimine personally tortured and assassinated the prisoners he captured in bloody raids on enemy camps. In his reproductions of Native American portraits, King usually used ethnographic studies such as those by McKenney to capture the individual's personality better, since he never visited Indian Territory. The artist painted this Iowa warrior with a ferociousness reflected by the aggressive tonal composition of Notchimine's tribal ornamentation.

Portrait of a Girl

(1859)
oil on canvas
15.9 x 12.3 in (40.5 x 31.25 cm)
Brigham Young University
Museum of Art, Provo, Utah

**Tukose Emathla,
Seminole Chief**

(1826)
oil on canvas
15 x 12.3 in (38.15 x 31.2 cm)
Lowe Art Museum at the
University of Miami, Florida

Although the artist never visited Indian Territory, he displays a special sensitivity to the distinctive features of different Native American tribes in his paintings. This painting, produced for the Office of Indian Affairs in Washington, D.C., made him one of the greatest Native American portrait artists of his time and the only one who captured the components of a variety of tribal delegations that visited the nation's capital from a very objective perspective.

In this painting, King has been very realistic. The Seminole chief's picturesque blend of tribal and modern style is highlighted. The surprising fusion of tradition in the headdress and adornments contrasts with elegant contemporary clothing that reconciles indigenous roots with the new American society. In this chief's face, King used a mixture of dark and light tones to reinforce expression. King painted his American Indian subjects with somewhat dark skin tones to create a contrast between brighter areas and natural features that generate an individual's facial expression. The features are quite distinct and the eyes gleaming, illustrating the artist's interest in working with expression and gesture.

Left: This portrait of an anonymous young girl was painted in Washington for a Mrs. Henry Smith. King's Romantic view is highlighted by the blend of clear and bright tones on the young girl's skin and dress. The artist portrays a sentimental and tender image of femininity in his female portraits, although his perspective is generally remote and melancholic. He eliminates all the neoclassical traits of his compositional style in this painting, although his disinterest in the feminine world does not allow him to completely exploit the girl's personality in detail. The painter never got married and it does not appear that he had relations with any woman. At a time when access to femininity only came from the family environment, this portrait becomes an almost impossible task. In spite of this, this painting is clearly Romantic in style and exalts the figure's individual spirit, capturing a reclusive beauty. The girl does not express any emotion and appears restrained to displaying her personality. That is why the artist prefers to surround her with a mysterious off-white halo.

Elisabeth Meade Creighton (Mrs. William Creighton)

(~1820)
oil on canvas
32.8 x 25.5 in
(83.2 x 64.8 cm)
Morris Museum of Art,
Augusta, Georgia

A series of trends that led to the rapid development of painting were emerging in Europe's artistic scene when Charles Bird King visited London to study at the Royal Academy. Eighteenth-century baroque and neoclassicist art made way to painting that was free and open to the public. English Romanticism and realism proposed new ways of understanding art. Aesthetics had to go hand in hand with specific rationalist considerations about the human spirit. This led to a new perspective on the individual to be painted in a portrait. Artists had to truly reflect not only facial features, but also personality. The painter experimented with this new conception of portrait art very much and, although his first portraits after returning from London did not attain the degree of perfection he wanted, his work gradually became more thorough and contemporary. In this painting, a much more mature and reflexive style than that observed in this artist's previous work can be appreciated. In it, the painter demonstrates that he has acquired the necessary observation to capture the individual's human aspect without having to recur to exaggerated formal impositions. In this painting, Mrs. William Creighton is depicted very gracefully. This makes it possi-ble to appreciate an extension of her character in the entire painting. The painter uses a dark setting, so that the viewer focuses on her face. Nonetheless, the setting is sufficiently elaborate to see that the details have been worked on with special care in a whole series of fine points that make up the decoration. This can be seen in the broad curtains behind the wo-man, in the scenery that can be made out through the window on the left, and in the parti-culars that help define this person's social status, such as the dress. This produces a unified whole, which is a high-quality portrait that highlights the woman's dignity and distinction.

GEORGE CATLIN

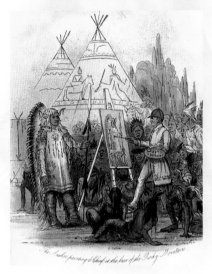

Catlin painted a self-portrait in this illustration from Letters and Notes on the Manners, Customs, and Conditions of the North American Indians, 1841.

Although George Catlin was professionally involved in lithography and the historic painting of Native Americans, it is doubtful that he had a true artistic calling. Catlin entered the art world only after studying law and becoming an attorney. At 25, he created his first graphic artwork, reproducing miniatures and illustrations until he discovered lithography in New York.

Catlin was a graphic chronicler rather than a true painter. His graphic and theoretical studies on the ethnography of American Indian culture are quite admirable and of great historic value. They are a firsthand reference about the aesthetics and customs of the American Indian.

When Catlin discovered the artistic richness of Native American life and rituals on his first trip to the Great Plains in 1830, he used his knowledge of illustration to take notes for etching. In 1832, he moved to Missouri's Indian Territory to experience and study these customs. There, he developed his own style of painting, similar to what was called Romanticism in Europe. The interests that led Catlin to this type of work were the same as those the Romantic artists in Europe experienced when they attempted to uncover the roots of popular art. Apart from painting, Catlin also collected Indian artifacts, of which he later made expositions in order to sell them. However, interest was so scarce that it almost ruined him.

- **1796** Born on July 26 in Wilkes-Barre, Pennsylvania.
- **1818** After studying law for two years in Litchfield, Connecticut, he returns to Pennsylvania. There he turns his attention to the art world.
- **1821** Settles in Philadelphia, where he lives until 1825. He works as a miniaturist.
- **1826** Moves to New York and becomes interested in painting historic scenes of American Indians. During his time in New York, he makes portraits and notes for his lithographic work.
- **1830** Moves to Saint Louis in the spring. From there, he travels around the Great Plains for six years.
- **1837** In September, he inaugurates his Indian Gallery in New York with more than 400 objects and works of art. He also begins a campaign to persuade the U.S. Congress to acquire and take the Indian Gallery under its wing. This campaign proves unsuccessful.
- **1840** Begins a series of Indian Gallery exhibitions in England, which are accompanied by a variety of paintings of American Indian rituals and scenes.
- **1841** Publishes *Letters and Notes on the Manners, Customs, and Conditions of the North American Indians*.
- **1844** Publishes *North American Indian Portfolio*.
- **1845** Exhibits his Indian Gallery in Paris, where he is asked to do two series of paintings.
- **1848** Leaves Paris and travels to London. At the end of the 1840s, he begins to work on a variety of Native American sketches.
- **1852** He is imprisoned for his many debts. He moves to Paris and sells the Indian Gallery to a North American boiler manufacturer, who relocates it to Philadelphia.
- **1854** Goes to South America for seven years, where he draws and searches for gold. He makes fleeting trips to the United States and Europe during this period.
- **1860** Moves to Brussels and publishes stories about his trips. He attempts to reorganize the original Indian Gallery.
- **1870** Exhibits a collection of drawings in Brussels.
- **1871** Exhibits the collection of drawings in New York. He moves to Washington, D.C., and sets up the drawings at the Smithsonian Institution.
- **1872** Dies on September 23 in Jersey City, New Jersey.

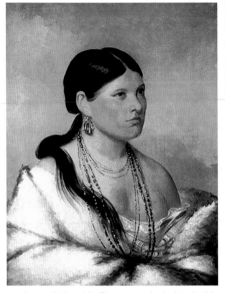

The Female Eagle Shawano

(1830)
oil on canvas
28.4 x 23.2 in (72.2 x 59 cm)
Paul Mellon Collection, National
Gallery of Art, Washington, D.C.

While Catlin was working in New York as a miniaturist and illustrator, he frequently traveled to upstate New York. His interest in American Indian customs led him to make this portrait before he moved to Missouri.

In this work, the painter shows a dependence on the classical portrait style. His compositional approach follows the norms of European aesthetics that he learned in New York. Nonetheless, the young woman's slightly leaning pose reflects an independent artistic spirit. The woman is depicted with one bare shoulder, noticeably displaying her bust. Her long ponytail flows down her body, against her rich skin. These are erotic elements that convey an alluring exoticism. Catlin conveys an interest in the American Indian that is both physical and emotional. His enthusiasm for this culture allowed him to paint intimate portraits of American Indians in a novel way, a style much more realistic and intimate than that previously produced by other painters.

Catlin painted the figure somewhat inclined in the middle plane. The light on the left brightens the blanket that covers the woman, while a small red cloth focuses the viewer's attention on her torso and adds a touch of color.

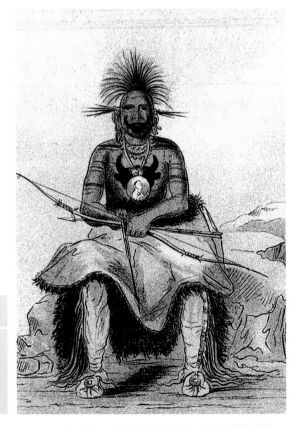

Buffalo Bull—A Grand Pawnee Warrior

(1832)
oil on canvas
29 x 24 in (73.7 x 60.9 cm)
Smithsonian American Art
Museum, Washington, D.C.

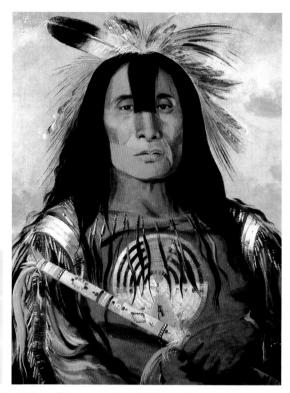

Buffalo Bull's Back Fat, Head Chief, Blood Tribe

(1832)
oil on canvas
29 x 24 in (73.7 x 60.9 cm)
Smithsonian American Art
Museum, Washington, D.C.

Although Catlin's realism in his paintings of American Indians is indisputable, the aesthetic approaches he uses reveal his perspective as an engraver. Here, as was usual in his work, Catlin created a very realistic portrait, since he had to illustrate the American Indian warrior's wardrobe and war paint with many details for his ethnographic studies. This painting is an impressive portrait of an American Indian chief.

Catlin knew how to convey his model's conviction with great skill. The warrior's aggressiveness is conveyed not only by his attitude, but also by his features and expression. The painter approaches the person from two perspectives: that of a man and that of a warrior. The ornamentation and tribal paint captivate the audience, while Catlin's personal artistic perspective uncovers the man who exists under this exterior. Distinctive tribal facial features have been depicted through a wide range of exotic colors that make the chief's gaze more expressive, a true reflection of the intense experiences he has lived through.

Catlin painted many portraits of American Indian chiefs. For all of them, he chose this same compositional style in which dynamism is suspended, but apparent in the personal character of his subject.

Left: Catlin's work reflects how the artist wavered between historic truth and an aesthetic approach to the scenes he portrayed. In this scene, a purely factual view, the painting authentically illustrates the clothing and accessories of an American Indian warrior. Catlin arranged all the compositional elements to illustrate the warrior's features in the most direct and realistic way possible. The frontal position, the full plane, and a realistic, detailed perspective illustrate the customs of these people.

Catlin's characteristic chromatic range of ochre can be observed in this painting. It is the typical color of the Great Plains, and the artist uses it to project a more authentic image, not only of the person, but also of the natural environment in which he dwells. All of Catlin's art, from the beginning of the 1830s to the end of his life, presents this characteristic color, which allows the artist to work with aggressive contrasts. The warrior appears immersed in a yellowish hue, while his torso and head have an intense reddish hue. In this case, Catlin characterizes the aggressiveness and roughness of the life of these people from a distance, without taking any trace of humanity into consideration.

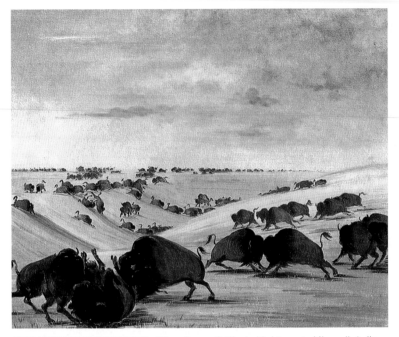

Buffalo Bulls Fighting in Running Season

(1837-1839)
oil on canvas
24 x 29 in (60.9 x 73.7 cm)
Smithsonian American Art
Museum, Washington, D.C.

When George Catlin decided to go to Missouri's Indian Territory in the 1830s, the aesthetic perspective of his paintings changed radically. He gradually discovered the intense contrasts that nature offered and adapted them to his graphic work. The artist found himself in wide open spaces where life was still harsh and rudimentary, and this was reflected in his painting.

This nature scene shows a herd of wild buffalo clashing in the Great Plains. The animals' dark bodies appear as dynamic spots of color in a dusty yellow desert, under a scorching sun. Rich combinations of ochre hues flood the whole painting with light. The buffalos appear in strangely pentagonal shapes under a broad orange sky. While traveling through the wild countryside, Catlin was able to observe the incredible tonal gradations that nature offered. In this painting, the use of these gradations allowed him to re-create a vast space of inaccessible scope, in both the land and the sky. The chromatic effects of solar light are an intense explosion of color. With this light and atmospheric setting, the painter draws the viewer into the scene so that he can understand the heat and the stifling air of the harsh summer.

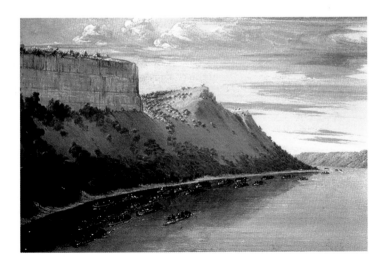

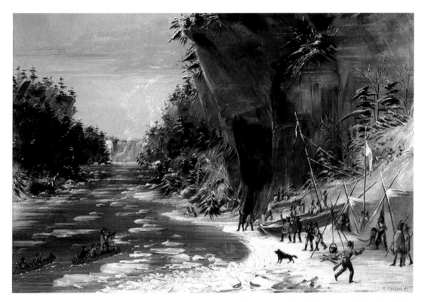

Catlin's view of nature evolved during his artistic career. This painting illustrates a classical compositional style. The view of a river with falls in the background lets the painter incorporate a very dynamic element that acts as the narrative substance. The small figures in the foreground are protected from the wild current.

Catlin used very diluted brushstrokes to depict the trees. The excessive linearity of these brushstrokes can be seen in some other areas of the painting, although the artist has disguised it as if it were a fringe of vegetation. Apparently, the painter was still not comfortable with landscapes, which led to erratic results. In 1840, Catlin began to use this more scenic compositional style, and through it he demonstrated a complete command of small human forms. His past as a miniaturist made it possible for him to give the diminutive figures great expressiveness and clarity. The figures act independently, carrying out a variety of tasks, which complement the scene.

The Expedition Encamped Below the Falls of Niagara, January 20, 1679

(1847-1848)
oil on canvas
14.9 x 22.1 in (37.8 x 56.2 cm)
Paul Mellon Collection,
National Gallery of Art,
Washington, D.C.

Father Hennepin and Companions Passing Lover's Leap, April 1680

(1847-1848)
oil on canvas
14.9 x 22.1 in (37.8 x 56.2 cm)
Paul Mellon Collection, National
Gallery of Art, Washington, D.C.

Left: The American Indian theme offered Catlin many artistic possibilities. When the artist arrived in the Indian Territory in the 1830s, his major interest was the study of American Indian customs. His tribal paintings and warrior and family portraits took up most of his time. As time went by, the painter broadened his perspective to include the landscapes that surrounded these scenes.

This work, which was painted in Europe, depicts a band of American Indian soldiers traveling by canoe.

Catlin contrasts a huge landscape with tiny figures in scenes like this, illustrating the wide gap between man and nature. In this way, the artist offers the viewer a look at the harsh conditions these travelers endured while simultaneously displaying a spectacular view of the natural paradise they inhabited. The painting overcomes the difference in scale between the landscape and figures. The static nature of the geographic fault at the left gives the figures extraordinary vitality. The intense blue sky, filled with clouds, gives the painting a more poetic aspect.

A Caribbe Village in Dutch Guiana

(1854-1869)
oil on card mounted on paperboard
18 x 24.6 in (45.8 x 62.4 cm)
Paul Mellon Collection,
National Gallery of Art,
Washington, D.C.

Catlin's work lies midway between formal painting and illustration. This work's format is characteristic of the painter. He made these oval prints as if they were illustrations for a book on wildlife. The format, the technique, and the base are repeated in hundreds of works that were part of Catlin's traveling Indian Gallery. For Catlin, they were graphic documents through which he made wildlife known in the halls where he exhibited.

This work displays a Caribbean village. In 1854, Catlin moved to Central and South America, fleeing overwhelming personal and financial problems. There, the artist looked at the possibility of continuing his Romantic ethnographic work and returned to the graphic study of native people once again. In these paintings made in the Caribbean, Catlin was attracted to the variety of hues of light, perfect for a chromatically very rich painting. The artist, who was familiar with European painting, created structured and developed compositions with magnificent color. Catlin's time in South America led to a radical change in his work. When he returned to the United States, he was able to explore the composition of landscapes with more ease.

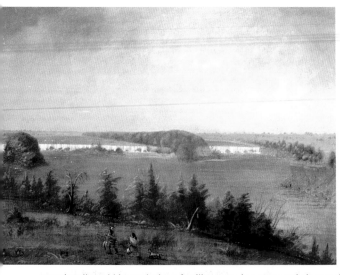

The Falls of St. Anthony

(1871)
oil on card mounted on paperboard
18 x 25 in
(45.8 x 63.5 cm)
Thyssen-Bornemisza Museum, Madrid

After his trip to Europe, Catlin returned to the United States in 1871. There he created a new series of American Indian paintings. In this painting from his later period, structural maturity allowed him to depict a familiar scene in a more artistic way. Catlin was familiar with European painting and studied the American luminists and landscape artists. He admired their naturalist perspective, which he gradually adopted in his own painting. Catlin's need to depict the documentary truth subtly persists in this work, yet, after his years of very complete studies of American Indians, he allows himself to observe them in a more distant and artificial way at last. The artist opened the plane and experimented with a monumental landscape. The figures appear anecdotal, and Catlin uses them to contextualize his painting.

In this painting, the artist made a more balanced and precise composition than in his earlier landscapes. The waterfall constructs and distributes the work. The vaultlike sky fills the upper half of the painting, while green and blue hues dominate the entire surface. Catlin timidly depicts the effects of light on water, and the meadow at the right side is also bright, painted in a hue that the artist obtained by blending blue with a good deal of yellow.

ASHER BROWN DURAND

Daniel Huntington, Asher Brown Durand, *1855, oil on canvas, 51 x 40.2 in (129.5 x 102 cm), Century Association, New York.*

- **1796** Born August 21 in Jefferson Village, now Maplewood, New Jersey.

- **1812** For five years he studies with Peter Maverick, the printer who is his partner until 1817.

- **1820** Does prints of John Trumbull's *The Declaration of Independence.*

- **1826** Founding member of the Sketch Club.

- **1830** Does prints for William Cullen Bryant's *American Landscape.*

- **1835** Does a series of presidential portraits for Luman Reed.

- **1837** Accompanies painter Thomas Cole on his trips in order to complete paintings on Schroom Lake in the Adirondacks, New York. The friends will take these trips annually for many years.

- **1840** Travels through Europe for a year, along with John W. Caisler, John F. Kensett, and Thomas P. Rossiter.

- **1855** Publishes "Letters About Landscape Painting" in the magazine *The Crayon.*

- **1869** After living in New York for more than 50 years, he retires to his family's home in Maplewood.

- **1878** Completes his last painting and decides to give up painting because, he says, his hand can no longer paint the way he wants it to.

- **1886** Dies in Maplewood, New Jersey, on December 16.

Nineteenth-century American art presented a new landscape culture. In both literature and visual arts, nature was idealized and monumentalized with the presence of human beings. This tendency to interpret the American landscape as an Eden or virginal Arcadia materialized, in painting, in the work of the Hudson River School. Asher Brown Durand is one of this group's major exponents.

His vision of the picturesque of daily life and of nature's magnificence as an ideal in the face of the industrial revolution clearly interprets the educated public's consciousness during the time. Scientists, naturalists, and explorers have been intrigued by the graphic expression of rationalist worries during the first half of the 19th century. Durand's work is full of expression and light as he interprets the landscape through a modern sense of history. The tonal effects, a principal characteristic of Hudson River School painting, determine the painting. The composition begins and ends with a magnificent tonal decline; the light regulates the distribution of space and the expressive direction and even proposes a narrative discourse.

For Durand, the aesthetic debates between compositional harmony and an honest and wild vision of nature are resolved through a specialized compositional approach in which the artist superimposes pictorial planes with varying expressive and tonal intensity.

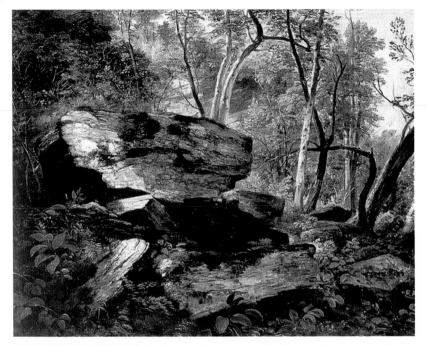

Study from Nature: Rocks and Trees

(~1836)
oil on canvas
21.7 x 17 in (55 x 43 cm)
New-York Historical Society

During the 19th century, aesthetic approaches were part of a debate over fidelity to nature versus formal homogeneity in painting. Many artists painted monumental landscapes in which dynamic natural elements were reduced in size in order to give the picture a placidly static image. Other artists, however, like Durand himself, opted for a purer, more truthful vision of nature where no sign of man appeared in the landscape.

As a result, Durand's paintings are particularly dynamic. Thanks to a constant change of elements and tones, the artist's work is rich in nuance and usually offers the viewer a visual journey through the work's different structural planes. Over the years, Durand developed a painterly vision in which the ideal of beauty demonstrates a depersonalized monumentality. Here, however, the artist presents details of the forest, showing how the different individual elements come together to form a more complex aesthetic whole. This study of nature is treated as an exercise on the forest's anatomy; the artist experiments with forms and textures.

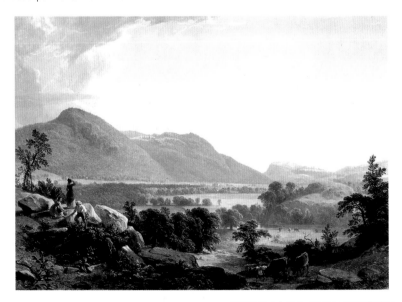

The Beeches

(1845)
oil on canvas
60.4 x 48.1 in
(153.4 x 122.2 cm)
Metropolitan Museum
of Art, New York

A dichotomy between realism and impression divides Asher Brown Durand's work. His work, full of sensations and effects, is realistic, with a magnificent sense of detail. *The Beeches* showcases the light and the monumental character of the landscape, while the more realistic elements appear in a smaller, more intimate plane. In the first plane, the painter has placed a bucolic set formed by two trees and a climbing plant that connects them. The painting acquires a personal and closed-in sense, which the artist evolves in the second plane toward an expressive, monumental landscape.

The organization of this work is based on the superimposition of different pictorial planes; each has an independent pictorial discourse. However, the artist has used the light to insinuate an immense open landscape at the end of the path, giving the painting some homogeneity and structural continuity. This path steers the viewer through the picture's different planes.

Left: For this artist, painting is a manifestation of human reason. His works are organized in a purely geometric way, and few elements remain free from a perfect spatial structure. In this painting, a simple, geometric interior architecture dominates, so that everything is subject to the firm lines that distribute the space. With a horizontal approach, a few guiding bands are enough for Durand to create spaces that are differentiated tonally and maintain the structure beautifully and discretely. Durand was interested in optical effects. The figures along the left-hand edge of *Dover Plain* are well defined, and in a reproduction of the eye's natural focus, the landscape is slightly undefined. Durand's desire to paint realistically led him to study the natural human perception of the landscape so that he could reproduce the effect in his painting. Here, the sense of realism is based on a sharply defined first plane that loses definition as it moves away from the viewer. This painting plays with this optical effect, combining it with a great sense of depth to create an infinite visual space.

Dover Plain, Dutchess County, New York

(1848)
oil on canvas
42.5 x 60.5 in
(107.9 x 153.7 cm)
Smithsonian American Art
Museum, Washington, D.C.

Kindred Spirits

(1849)
oil on canvas
46 x 36 in (116.8 x 91.4 cm)
New York Public Library

Durand's work faithfully illustrates the spirit of his time. The first half of the 19th century was very productive in terms of scientific study, exploration, and human reason in general. Among the American urban elite, it was quite usual to organize outings and trips in order to get to know the country's virgin landscapes. This custom, considered very bourgeois, was adopted by Durand. He took an annual trip with Thomas Cole, the painter and naturalist, to study landscapes. This painting is the fruit of a trip to the Adirondacks. This unusual, dynamic scene offers a very interesting argument about man's presence in nature. It reflects an intelligent way to appreciate the landscape and paint it: Man maintains his personality in the face of the monumentality of God's work.

From the 1840s on, Durand adopted this more spiritual outlook on landscapes. The artist was, without a doubt, familiar with the works of John Ruskin, the English critic who wrote that the artist, regarding God's work, should behave as a humble observer, faithful to nature, where light shines on objects so that humans can understand their own insignificance in comparison to so much natural magnificence and splendor.

Right: From the 1850s on, Durand demonstrated a realist style with a mature balance of light. The glowing scenes of his early years evolved into a series of registers and nuances that offer a more restrained expressiveness, as well as a more narrative one.

This painting offers a panoramic vision of the landscape. Its horizontalness allows the artist to experiment with the dimensions of the different elements and brings an endless depth, a far cry from Durand's earlier paintings, in which the sense of depth was created by superimposing various light planes in which the elements were placed according to their dramatic content. Here, the homogeneity and balance serve as compositional elements organized to engage the viewer slowly, surely, and in an organized fashion. For the sky Durand has used violet tones, which he had tried in earlier works to achieve certain light effects, always in a very subtle way. Here, however, Durand gives the sky a vitality that energizes his precise vision of the landscape.

Early Morning at Cold Spring

(1850)
oil on canvas
60 x 48 in (152.4 x 121.9 cm)
Montclair Art Museum, New Jersey

In the 19th century, the idea of the ideal of nature as a response to unpleasant preindustrial modernity emerged on both sides of the Atlantic with the same artistic force and intensity. The divine, pure landscape, a place where man could rediscover himself, was a popular concept among the luminists and Hudson River School artists in the United States. In England, Romantic painters adopted the same type of landscape painting while introducing borrowed elements from ancient civilizations, with the idea that the past had been better.

This image of human loneliness facing the landscape demonstrates certain European influences. At the beginning of the 1840s, Durand traveled through Europe, where he studied the work of the German artist Caspar David Friedrich, who reflected the Romantic spirit through a monumental landscapist lens. *Early Morning at Cold Spring*, influenced by Friedrich, is made up of metaphysical sensations. It represents a man's emotions as he faces the world. The mood of melancholy is created by the colors and tones as well as the contrast between light and shadow planes. Just as in European Romanticism, in this painting the light gains a new spiritual dimension. The sunlight symbolizes the divine quality; below, the small figure evokes human insignificance.

Genesee Valley Landscape

(1853)
oil on canvas
Private collection

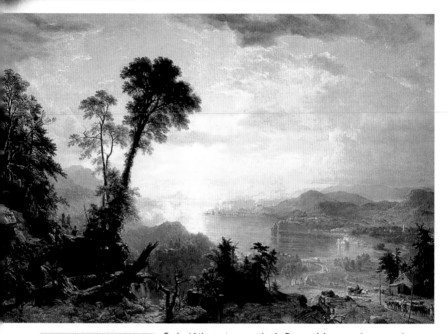

Progress (The Advance of Civilization)

(1853)
oil on canvas
Warner Collection

Early 19th-century aesthetic Romanticism openly opposed progress, civilization, and industrialization. In his paintings, Durand advocated preserving a picturesque ideal in the face of urban ugliness. It can even be said that he pleads for conservation, although his work offers an ephemeral idea of natural beauty—a vision of nature's fragileness and morality that makes his paintings attractive and magnificent.

This landscape is a open critique of modernity. In the foreground, the destruction of a once-luxuriant forest is presented as disorder, humans carelessly destroying nature's splendor. The painting is divided into two halves, with the bay separating the picture into two separate planes. In one, civilization advances threateningly, urbanizing toward the mountain. On the other side, a virgin forest is endangered by man. Durand has composed the work beneath an immensely vast, indestructible sky, under light, rich in nuances, that symbolizes nature's decline.

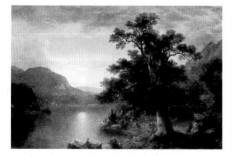

The Trysting Tree

(1868)
oil on canvas
27.5 x 42 in
(69.9 x 106.7 cm)
Butler Institute of
American Art,
Youngstown, Ohio

In 1848, after the death of his close friend Thomas Cole, Durand became the indisputable leader of the new American landscape painting. Until that point, in his work, the light as a main expressive element had never acquired the drama of Cole's work, although Durand's ability to create an atmosphere similar to what would be explored, years later, by the French Impressionists, came from a sense of modernity highly superior to his American contemporaries.

In this work the artist is in a reflective mood. The painting is less showy and more intimate than earlier paintings. The light does not flood the whole space, although it clearly defines the work's character. Durand saw the end of his career coming, and his style captures a sad, intimate, personal regret. The light is not monumental; it is just a detail, and the landscape is just as it would be at a certain time of evening. Structurally, the work does not present a very clear plan. The space has been composed from the different elements and their light arrangement, avoiding the traditional guiding lines so prominent in Durand's earlier paintings.

THOMAS COLE

Self-Portrait, ~1836, oil on canvas, 22 x 18 in (55.9 x 45.7 cm), New-York Historical Society.

- **1801** Born in Bolton-le-Moors, Lancashire, England, February 1.
- **1818** Emigrates with his parents to Philadelphia. Works as an engraver's assistant. His family moves to Ohio.
- **1819** Travels around the West in May and June. Settles in Ohio.
- **1823** Visits his parents in Pittsburgh. Returns to Philadelphia in November. Studies at the Pennsylvania Academy of the Fine Arts.
- **1825** John Trumbull and William Dunlap, two famous artists, praise his work and help to make him famous. Discovers the town of Catskill, New York, and settles in the region.
- **1826** Founding member of the National Academy of Design.
- **1829-32** Travels in Europe, visiting England, France, and Italy.
- **1834** Obtains American citizenship.
- **1841-42** Travels to Europe again.
- **1848** Becomes ill and dies of pleurisy in Catskill, February 11.

British by birth, Thomas Cole emigrated with his parents to Pennsylvania in 1818. After an introduction to the art world as an engraver's assistant and portraitist, he studied at the Pennsylvania Academy of the Fine Arts. Impressed by the landscapes of his new country, he worked to capture the essence of the yet-to-be-explored America in his paintings. John Trumbull and William Dunlap, two of the most distinguished artists of the time, praised Cole's fresh and lively perspective of the American landscape during his first exhibition in New York in 1825. From then on, his name would be linked to the history of American painting.

Cole is considered to be one of the founders and the main representative of the Hudson River School. He settled in Catskill, New York, on the banks of the Hudson River. The scenery that surrounded his house was Cole's source of inspiration. Most of the followers of the Hudson River School were European, and some of them studied in the old world. They were influenced by the Romantic movement that was in vogue in Europe in the first half of the 19th century. The nationalist ideals inherent in this movement were greatly accepted by the Hudson River School. The artists introduced events from famous American novels into landscapes that had originally been merely topographical. As a result, their painting evolved into a pseudo-historic genre, acclaimed by the public for its great patriotic message.

Although J.M.W. Turner and John Martin's incisive and spectacular scenes were originally mandatory reference points for the painters of the Hudson River School, variations in each individual's evolution can be observed. In Cole's case, a second stage, influenced by his time in Europe, is evident. Seeing Italian ruins induced the painter to introduce vestiges of the past into his majestic landscapes, to stress the transience of civilizations compared to nature's imperturbability. This metaphysical idea, similar to that of German Romanticism, led Cole to create monumental series such as The Course of Empire and The Voyage of Life, perfect embodiments of the painter's religious and moral perspective working in harmony with his patriotism.

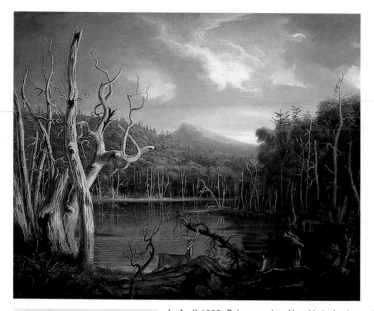

Lake with Dead Trees

(1825)
oil on canvas
27 x 33.8 in (68.6 x 85.8 cm)
Allen Memorial Art Museum at
Oberlin College, Ohio

In April 1825, Cole moved to New York. At the end of the summer, he made his first excursion up the Hudson River toward Catskill. The artist painted this work from a sketch he made on this journey, his first trip to the area that would become his home.

It is an expressive landscape, a lake with mountains in the background, tenuously lit by the twilight that leaves the trunks of dead trees in the foreground in semidarkness.

Here, Cole, largely self-taught, breaks away from the picturesque American tradition, developing a style of painting that is relatively free from academic conventions. The painter wrote in his diary, "All nature is new to art." That is how he expressed his belief in his new landscape perspective, closely related to the pantheistic conception of Romantic nature, which considered the landscape a reflection of a nation's spirit. The American public saw the painter's patriotic ideas in his admiration of Catskill's wilderness. The Erie Canal had recently opened, passing through the state of New York and heightening American pride. *Lake with Dead Trees* was one of the most appreciated works featured in an 1825 art exhibition at William Coleman's frame shop in New York. William Dunlap, an artist and writer, acquired the painting and helped make the painter famous through his complimentary articles.

Right: In a letter dated March 2, 1836, addressed to his sponsor, Luman Reed, Cole wrote that he had painted this work to exhibit and sell it. Shortly afterward, the National Academy of Design in New York held an exhibition of paintings, including this one. It seems that the painter's source of inspiration for this work was not direct observation of the landscape, but the book *Forty Etchings Made with the Camera Lucida in North America in 1827 and 1828*, published by Basil Hall.

View from Mount Holyoke, Northampton, Massachusetts, After a Thunderstorm—The Oxbow

(1836)
oil on canvas
51.5 x 76 in (130.8 x 193 cm)
Metropolitan Museum of Art, New York

Once again, the Hudson River School painter praises his adopted country's landscape. Here, he captures it through a composition that uses a chiaroscuro effect to show a storm moving away to leave a radiant sky shining over the river, exalting the landscape of a prosperous America filled with infinite resources. The countryside is reborn, illuminated by bright light that contrasts with the dark gray stormclouds.

In the middle of this indomitable landscape, the painter himself appears on a promontory as the only glimpse of civilization, drawing the Oxbow. Thus, Cole approaches the Romantic ideal of the sublime landscape where nature's forces are unleashed. He portrays himself as the prototype of humanity living in communion with nature as a result of his artistic sensitivity.

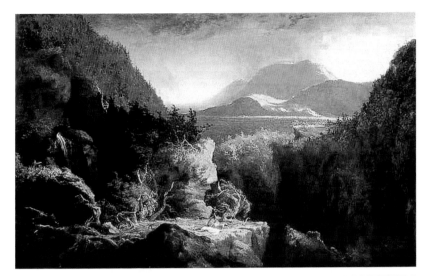

If there was a common interest among the Hudson River School painters, it was to convey the devout patriotism that all its members professed. The virginal landscapes of the Hudson River were often the starting point to acclaim the country's prosperity from imposing natural resources.

At other times, nature also acted as the backdrop of contemporary literary scenes that artists such as Thomas Cole painted. Washington Irving and James Fenimore Cooper were the most popular authors. Cole dramatized several scenes from Cooper's *The Last of the Mohicans*, published in 1826. Here, he depicts one of the novel's climactic scenes. Cole shows the moment in which Hawkeye, next to the body of his beloved Cora (who has fainted), raises his rifle to shoot Magua, who had sequestered her and now intends to escape. The painter stages the scene in a sublime natural setting that verifies the dignity of the people and consequently, the nation they represent.

Scene from *The Last of the Mohicans*

(1826)
oil on canvas
26.1 x 43.7 in (66.4 x 111 cm)
Terra Museum of American Art, Chicago

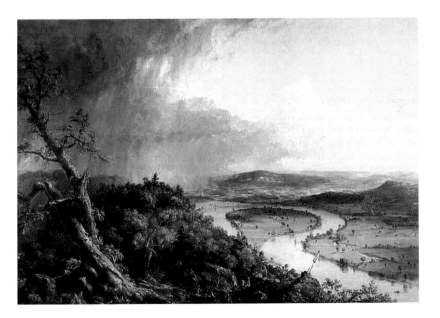

The Course of Empire

His trips to Europe in the 1830s and 1840s greatly influenced Cole's later work. Although the Hudson River School's painting originally focused on praising the natural landscape of the United States as evidence for nationalism, Thomas Cole changed its focus by enhancing its conceptual content. He traveled to Italy twice, staying at Horatio Greenough's (an American sculptor) house. There, he discovered ruins that stood testimony to a splendorous past, comparable to the prosperous period in the United States.

The painter's assessment of history's ups and downs produced his most ambitious creation: The Course of Empire, a series of five images of the same landscape over the course of time. He portrays the rise and fall of an imaginary civilization, from an initial Arcadian existence through urban magnificence to a final view of a desolated landscape devastated by war. Cole takes a pessimistic view of history: civilizations are condemned to repeat their mistakes over and over again, a direct corollary to the European historical allegorical themes of the time. Nonetheless, Cole's viewpoint can also be interpreted as an admiration of an America without ruins, without past failures, and he captured that America in his virginal landscapes that reflect prosperity.

The Course of Empire: The Consummation of Empire

(1836)
oil on canvas
51.3 x 76 in
(130.2 x 193 cm)
Henry Luce III Center for the Study of American Culture, New York

In a classical composition, the painter conveys the Empire's strength through formal and iconographic elements. The landscape is lighted uniformly and its balanced composition is a precursor to pictorial neoclassicism. Placing the landscape around a port helps to illustrate the imaginary nation's prosperity—blessed with a port, it has a thriving sea trade. Commemorative monuments and the classical organization of the buildings tell the viewer that this city is the seat of an imperial government.

The Course of Empire: Destruction

(1836)
oil on canvas
39.4 x 63.8 in
(100 x 162 cm)
Henry Luce III Center for the Study of American Culture, New York

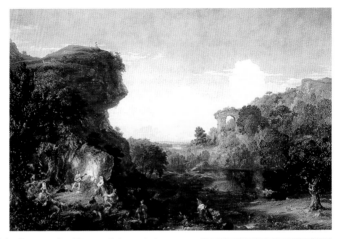

After he toured the Roman ruins, Thomas Cole used these vestiges of the past constantly in his work. This landscape is from another of Cole's epic series Desolation. Here he depicts the landscape after the defeat; a serene sunset and unique framework add to the symbolism. Wild vines cover the abandoned ruins, proving that nature is stronger than civilization. This allusion to Romantic transcendentalism contrasts with the hopeful metaphor of the column left standing in the foreground, illuminated by golden light.

Italian Landscape

(1839)
oil on canvas
35 x 13.6 in (88.9 x 34.62 cm)
Butler Institute of American Art, Youngstown, Ohio

This column, the organizing element of classical order and, by analogy, the symbol of imperial power, has withstood the downfall. *Italian Landscape* is less pretentious than other works in the Desolation series. Roman ruins, with a characteristic semicircular arch, appear in the scenery. This classical hint seems to serve purely to place the viewer in a specific geographical context and to balance the composition.

At the opposite end of the ruins, Cole has portrayed a picnic. Shepherds, travelers, and a fisherman gather, listening to a troubadour's music. Among the figures, Cole has depicted himself sketching under the shade of the trees in the lower left corner of the painting.

This work is a view of the landscape after the desolation. Humanity has survived for centuries after the fall of Rome because it has coexisted with nature; this coexistence is symbolized by the picnic scene. Cole conceives art as the link between man and nature, represented in the figures of the painter and the troubadour in this work.

Left: European trips helped the painter understand the Romantic English paintings of J. M. W. Turner and John Martin. Cole selected Turner's pictorial language to depict the warfare of an imperial power in oil painting. The smoking sky is reminiscent of Turner's storm clouds, where the forces of nature surge, disdaining human beings, which are symbolized by boats at the whim of the waves. Cole conveys the same sense of human inferiority when he portrays an angry, oppressive sky, quite different from the serene and radiant daylight he used to symbolize the height of the empire. He uses chiaroscuro here to emphasize the drama of this agitated composition.

The Voyage of Life

Cole painted The Voyage of Life shortly before his death. The series, composed of four scenes, keeps the historical allegorical slant of The Course of Empire. Here, however, Cole does not refer to the epic theme of the course of civilizations, but expresses a clear religious and moral message implicit in the description of different stages of life: childhood, youth, adulthood, and old age. Cole himself wrote about the moral interpretations of this work in his own descriptions of it.

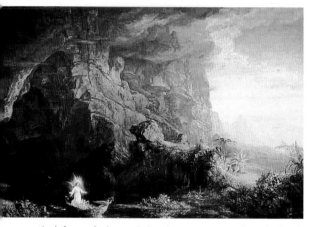

The Voyage of Life: Childhood

(1842)
oil on canvas
52.9 x 76.9 in
(134.3 x 195.3 cm)
National Gallery of Art,
Washington, D.C.

Cole uses the recurring metaphor of the river as an analogy for the course of life in this pictorial series. A sunrise illuminates a rocky landscape that symbolizes the infancy of a human being. A stream emerges from the interior of a cavern into a landscape of abundant grass and flowers; on the water, a richly sculpted boat with symbols of time glides, making a mythological allusion to the flow of time. On the boat, a resplendent angelical figure reveals the painter's religious zeal.

In the painter's own words, the flowers and grass are allegories of youthful happiness. In contrast, the closed perspective of the painting represents the lack of experience in childhood and its self-absorption. A lotus flower in the foreground completes the painting's iconography as a symbol of a new life beginning. From a formal aesthetic perspective, this painting reveals a new approach in the late work of the painter. Cole makes references to recent symbolic trends, particularly to the figurative beauty of the English Pre-Raphaelites.

The Voyage of Life: Old Age

(1842)
oil on canvas
52.5 x 77.2 in
(133.4 x 196.2 cm)
National Gallery of Art,
Washington, D.C.

Once again, Cole uses chiaroscuro to add divine significance to light unfolding from the darkness. The painter places Old Age at the mouth of the river that was emerging in Childhood. Here, the river ends, joining the sea in the same way that the body dies to join the immortal soul with God, according to Cole's Christian beliefs.

The boat, destroyed by the storm, has been stripped of the mythological allegories that adorned it, indicating that time is running out. The landscape that surrounds the scene is inhospitable and barren, with none of the pleasures of the material world. A guardian angel appears to the old man and shows him the divine light, which symbolizes his new immortal life.

FITZ HUGH LANE

Lumber Schooners at Evening on Penobscot Bay
(detail), (1863), oil on canvas, 24.6 x 38.1 in (62.5 x
96.8 cm), National Gallery of Art, Washington, D.C.

During the first half of the 19th century, American painting went through a series of changes that eventually led to luminism. The 18th century had been the age of reason, and as the 19th century approached, Copley's linearity gave way to a rationalist vision of existence. Deism took over American painting, and Charles Willson Peale was its quintessential example. But starting with the Hudson River School in the 18th century, a lineal evolution occurred in United States art. Light became painting's indisputable protagonist, and the artists of the Hudson River School used it dramatically.

Fitz Hugh Lane's work is the result of this artistic evolution. The luminists understood light as the most important element of painting, but they never forced it as a dramatic vision. Luminism's visual poetry was characterized by a realism more pronounced than any the United States had previously known. This realist vision of landscapes and waterscapes would become more pictorial and graceful thanks to the light that the luminists used as the start and finish of the artistic process.

Fitz Hugh Lane is, along with Martin J. Heade,

- **1804** Born in Gloucester, Massachusetts, on December 18 into one of the city's founding families. Originally baptized as Nathaniel Rogers Lane, he changes his name to Fitz Hugh. During childhood, he suffers partial paralysis in his legs, probably caused by polio.

- **1832** Moves to Boston to work as an apprentice in William S. Pendleton's lithography workshop.

- **1835** Makes his first etching.

- **1837** Works for Keith and Moore Publishers.

- **1840** Begins experimenting with oils.

- **1841** He is included in the Boston Almanac as a maritime painter. Shows his work at the Boston Club, where he continues exhibiting work regularly.

- **1845** Becomes partners with his friend John W. A. Scott in order to start a lithography business.

- **1847** Returns to Gloucester in the winter to spend a few months at his family's house. Visits Maine for the first time, where he will often go on outings with Joseph L. Stevens, in search of landscapes for his paintings.

- **1849** Establishes himself permanently in his native Gloucester.

- **1850** Visits New York and Baltimore, and—it is thought—also Puerto Rico.

- **1865** Dies August 14 in Gloucester.

the outstanding example of an American luminist artist. His astonishing vision of the New England coast, which he painted in many works, meticulously reproduces boats and ports as well as the atmosphere and, above all, the light on the sea.

The Fort and Ten Pound Island, Gloucester, Massachusetts

(1847)
oil on canvas
19.6 x 29.5 in (50 x 75 cm)
Thyssen-Bornemisza Museum, Madrid

This painting shows luminism's deep realist sense. With remarkable chromatic richness, Lane reproduces the entry to the port of Gloucester, the town where he was born. It is a significant painting for the artist, who had learned to love the sea along these very same coasts. Here, Lane already demonstrates a remarkable sense of light. In his later paintings he would use one intense focal point to distribute the light, while in this painting the light appears as a powerful hue on the water.

Lane has based the painting on the variation of light. The light descends from left to right, while the wharfs appear in mysterious semidarkness. In this work, Lane is somewhere between luminism and the Hudson River School, giving light the lead role but not abandoning its dramatic capacity. Here he has used the light reflected on the water to create a fleeting impression rather than a deep feeling. His melancholy view of the port of Gloucester translates into very poetic, filtered light at dusk.

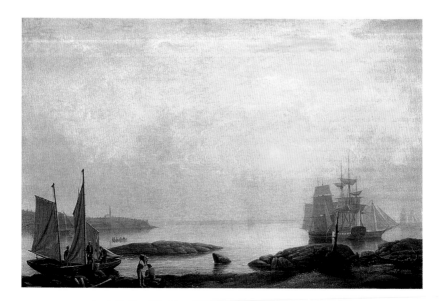

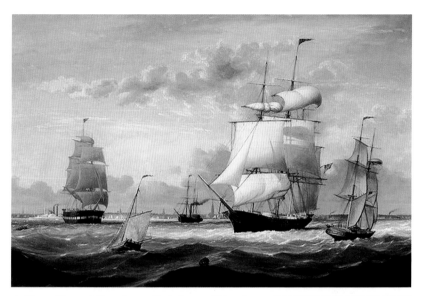

In his maritime paintings, Lane reflected many different ports and cities, and he tried to bring out the character of these places or the impression that he had of them. In New York, for example, Lane painted a lively, heavily trafficked port. Even the natural elements have extra vitality and dynamism. A group of boats sets off to sea in a fantastic array of sizes and colors, under an intensely vital sky.

In this composition he has used many elements to make a very complete picture. The sky, with its incredible chromatic intensity, catches the work's overall dynamic, while the sea is choppy and full of whitecaps that load the painting with movement. Lane has used a complete tonal range in which blue, red, and white stand out. The most surprising part of the painting is the water, which Lane has represented in all its detail. The blue-green color becomes a mass of water, very much alive, with brilliant flashes of white and a rich, luminous glow.

New York Harbor

(1852)
oil on canvas
23.5 x 35 in (59.7 x 88.9 cm)
National Gallery of Art,
Washington, D.C.

Castine Harbor

(1852)
oil on canvas
18.3 x 27.6 in (46.5 x 70 cm)
Portland Museum of Art,
Maine

Left: In this relaxing painting, Lane shows an Impressionist vision. The scene of daily life in a coastal area shows people unloading a small vessel as another group appears at the port's entry. Lane captures the daily coexistence between the local people and the great maritime personages. The boats, at times metaphors for human traits, appear here as symbols of progress and communication, while the little people continue to lead their lives in the front plane.

The work is submerged in an intimate atmosphere. The monumental parts of the landscape are buried in light mist, where only a yellowish halo of sun is able to steal the spotlight from the people. The work's static quality reflects Lane's worldview: The earth's calmness contrasts with the dynamic ferocity of the open sea. Lane's realism gives way to an intimate and poetic vision, producing a human, direct painting. The contours and defined brushstroke cannot overcome this mist of feelings, which fills the pictorial space and offers a softened vision.

Three-Master on a Rough Sea

(1856)
oil on canvas
15.5 x 23.5 in (39.3 x 59.7 cm)
Cape Ann Historical
Association, Gloucester,
Massachusetts

Lane's work usually features boats in different seas and situations. The painter compared the sea to human traits and human moods. In this image of a raging sea, a magnificent sailing ship reels back and forth at the mercy of a storm.

Lane often constructed metaphors for life; in this case, the painting reads as the story of a powerful mentality shaken by life's ups and downs. The composition, like the metaphor, is very organized. Beneath a darkened sky, the boat climbs the waves, working to ride out the storm and confront life's difficulties. The angry, aggressive sea splashes against the sides of the boat. The sky in the center of the painting apparently offers a path to smoother sailing, while the boat has its own peculiar light, a feeling of calm in the eye of the storm. The massive ship seems untouchable, although the waves—almost solid—still seem threatening.

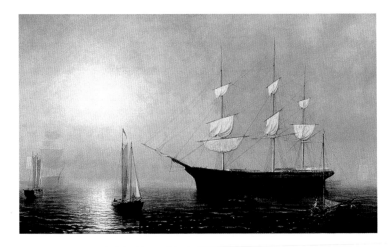

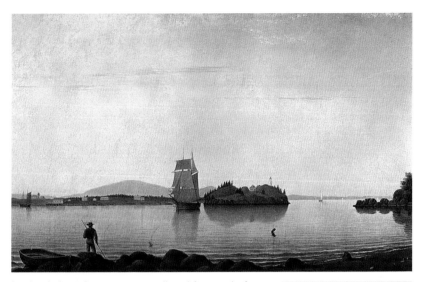

Lane's paintings often present a complicated framework of details, which are distributed across the picture to mark a prescribed visual journey. In this painting, apart from the central ship, the viewer starts in the front plane, with the sharp image of a fisherman against the light, then follows the waves toward the sea. At the same time, the rich details and reflections of light on the water pull the viewer around the island, toward the coast in the background.

Owl's Head, Penobscot Bay, Maine

(1862)
oil on canvas
15.7 x 26.1 in (40 x 66.4 cm)
Museum of Fine Arts, Boston

Lane has placed a bit of red detail in the center to attract the viewer, an intensely colored building on the island. The artist steers and controls the reading of the painting; he has created an easy and direct pictorial argument. The only important point of light is in the sky, relegating the light tonal shading to the second plane, which gently pushes the viewer, at last, toward the right of the pictorial space. Some clouds attract a bit of attention, but they do not interfere with the ideal visual journey Lane has planned.

Ship Starlight

(1860)
oil on canvas
30 x 50 in
(76.2 x 127 cm)
Butler Institute of American
Art, Youngstown, Ohio

Left: During the last ten years of his life, Lane practiced a completely luminist style of painting. This work illustrates the canons of this aesthetic, which dominated North American painting in the mid-19th century. The profile of a boat below an intense focal point becomes a mere shadow cutout against the sky. Lane specialized in portrayals of boats, and this work shows his attention to detail.

The painting bows to the sunlight's splendor, which almost hides two tiny, hardly visible, vessels. Lane uses the glow to make a series of reflections that move throughout the work, concentrating in a crescent-shaped vision around the sun. Although the ship shows up against the light, its great sails are just more of many surfaces reflecting the sunlight and contrasting with the gray sky in the background. The artist, a master of light and shadow, has created a strange scenario, where the sunlight illuminates the boats while the sea and sky remain threateningly dark.

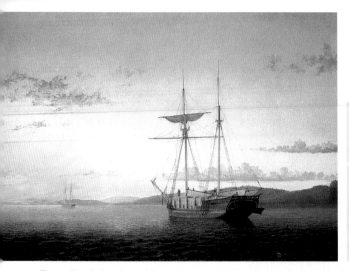

Lumber Schooners at Evening on Penobscot Bay

(1863)
oil on canvas
24.6 x 38.1 in
(62.5 x 96.8 cm)
National Gallery of
Art, Washington, D.C.

The realism in Lane's work is very intense. In this painting of a boat heading rather Romantically into the sunset, the sharply drawn details convey the real emotions of the scene to the viewer.

The artist's clarity in depicting his maritime scenes is intended to create a feeling of reality and draw the viewer into the painting. The delicate balance of the composition, and the vision of the sunset with its reddish tones extending softly along the water, produce a sense of calm. In Lane's painting, realism, along with the light, is the crux of the composition. He used miniscule brushes in order to capture each and every detail of light.

Although the vessels' excessive linearity sometimes takes away from the overall balance of the composition, the artist uses the lines to define the space naturally. Oftentimes the ships' masts function as determinants, which organize the space and build a solid, yet imperceptible, interior architecture.

Brace's Rock

(1864)
oil on canvas
30 x 21.9 in
(76.3 x 55.5 cm)
Terra Foundation
for the Arts, Daniel
J. Terra Collection,
Chicago

A year before his death, Lane completed this painting of a lonely coastal landscape. Late in his career, the artist returned to a gloomier vision of painting, and here he amuses himself with chromatic details provoked by a more dispersed light. As in his first works, Lane has created a complex play of light and shadow distributed throughout the pictorial space, which gives precedence to the light on the water. Lane returns to the Hudson River School's naturalist influence, seen here in the old, lonely boat. A perfectly illuminated landscape demonstrates the marvelous effect of reflection on the calm coastal water.

Lane is a visual poet, a master of both composition and color. The sharpness of his scenes comes from the combination of realism and tonal clarity, while his particular vision of the coastal world offers intimate yet cunning landscapes. Through his painting, starting with simple, ordinary boats, the artist conveys a whole range of sensations. Under his brush, everyday boats become organic and very humanized.

SETH EASTMAN

Seth Eastman.

Although Seth Eastman was not a professional painter, the artistic training he acquired at the military academy at West Point awakened an artistic awareness in him that merged the two quite contrasting disciplines of painting and military service. Eastman was a brilliant professional soldier who attained the highest rank thanks to working with rigorous meticulousness, something he also applied to painting. His scenes of Native Americans illustrate martial qualities although, obviously, applied to native customs.

Initially trained in topographical drafting, this artist is an interesting illustration of a documentary painter. His closeness to the Native Americans can be observed in his work, the product of the deep personal relationship he had with some tribes. Eastman lived with the Dakota tribe, where he created most of his artistic production, and even sustained a relationship with a Dakota chief's daughter. As a result, he understood their problems and customs much more than other artists. In his paintings, he illustrated the cultural richness and historical significance of this society, which he studied in depth.

Seth Eastman's work reflects the influence the Hudson River School artists had on him. During his years at West Point, he studied with two teachers who were precursors of the Hudson River School. Eastman's work is a very valuable visual document that shows deep artistic sensitivity. He never subordinates the artistic composition to the documentary value of the painting. His work is truly meaningful.

- **1808** Born in Brunswick, Maine, on June 24, the son of Robert and Sarah Lee Eastman.
- **1824** Enters the military academy at West Point at 16, where he attends his first drawing and painting classes with the French miniature painter and engraver Thomas Gimbrede.
- **1829** Graduates from the military academy and is assigned to Fort Crawford, Wisconsin.
- **1830** Transferred to Fort Snelling, Minnesota, where he works with the topographical team.
- **1833** Returns to West Point as an assistant professor. During the seven years he is at the academy, he studies landscape painting with Charles Robert Leslie and Robert W. Weir, who influence him in the Hudson River School style.
- **1836** Exhibits his work for the first time at the National Academy of Design and the Apollo Gallery in New York.
- **1837** Publishes a topographical treatise that is used as a textbook at West Point.
- **1838** The National Academy of Design names him an amateur honorary member.
- **1840** Leaves West Point and participates in the skirmish against the Seminole Indians. He makes many sketches during the conflict.
- **1841** Returns to Fort Snelling, where he remains until 1848. Studies the Dakota and Chippewa tribes, making many paintings of daily life and customs of the natives.
- **1848** Sent to Texas to defend the border from American Indian incursions.
- **1849** Makes a sketchbook of landscapes he sees in the lower Mississippi and in his trips through Texas. Shortly afterward, he is transferred to Washington, where he is commissioned to illustrate Henry Rowe Schoolcraft's *Historical and Statistical Information Respecting the History, Condition, and Prospects of the Indian Tribes of the United States*, published in six volumes between 1852 and 1857.
- **1855** Returns to Texas as the Fort Duncan regiment commander and later as that of Fort Chadbourne. During the first years of the Civil War, transferred to Maine and New Hampshire.
- **1863** Named military governor of Cincinnati, Ohio.
- **1867** Assigned to Washington, D.C., where he is commissioned to make a series of paintings about Native American scenes for the Capitol building.
- **1875** Dies in Washington on August 31.

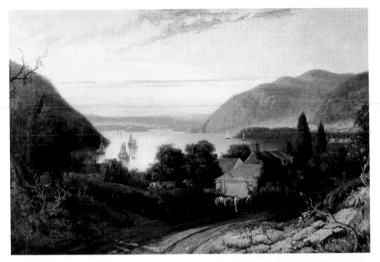

Hudson River with a Distant View of West Point

(1834)
oil on canvas
33 x 50 in (83.82 x 127 cm)
Butler Institute of American Art,
Youngstown, Ohio

The influence of the Hudson River School can be appreciated in this work, which was completed when Eastman was an assistant professor at West Point, studying under Charles Robert Leslie. This painting, mildly luminist, illustrates the traditional landscape monumentality of naturalism at the beginning of the 19th century under a very new conception of light. Although Eastman's artistic production is clearly dominated by his passion for the Native American, he was a landscape painter. The landscape quality of the richly decorated background, where natural light provides freshness and forms the artistic space, can be observed in Eastman's Native American theme work.

Here the painter illustrates his sensitivity through the landscape. Using oils, the artist has created a painting that is completely different from his usual work. Its composition is much more complex, and its sense of light reveals an interest in naturalist painting. This is quite in keeping with the Hudson River School, and many consider Eastman a precursor of that school, although he had few relationships with other painters in the movement.

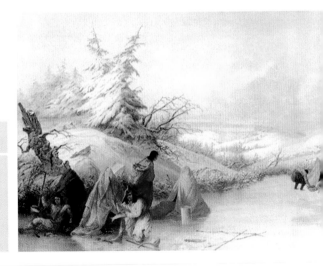

Spearing Fish in Winter

watercolor on paper
28.2 x 40.1 in
(71.7 x 101.8 cm)
Committee on
Resources,
Washington, D.C.

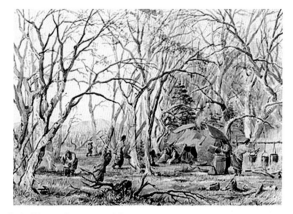

Eastman experimented with stylistically very free compositions. His painting, quite spontaneous and informal, led him to move away from the classical canons and leave the background blank.

Indian Sugar Camp

watercolor on paper
33 x 50 in (83.82 x 127 cm)
Committee on Resources,
Washington, D.C.

This painting illustrates maple sap collection. The native women's clothes, in the midst of a monotonous ochre landscape, become dynamic touches of color. Eastman had a special ability to create space. His sensitive work style allowed him to capture daily life from his own naturally picturesque perspective. This painting uses a modern compositional style: Trees and branches form a dynamic linear framework. The work is both airy and solid, as the scene is developed horizontally in the lower portion. This contrast makes the painting dynamic, with two very different areas: ethereal nature and earthbound humanity. Eastman construes light as a reflection of freedom, which has led him to use bright details in all objects. Light is seen in the figures' clothing, in the metallic cooking pots, and in the small fur-lined cabin. *Indian Sugar Camp* is a dazzling vision of a day of work under the sun.

Left: Winter scenes were artistically very appealing to Eastman. For the northern tribes, winter was a season with no game; they had to survive on fish gathered in icy rivers and lakes. The painter depicts the fishing method they used.

The fisherman made a hole in the ice. Over the hole, he built a tent with branches and blankets, screening out the light so that he could see into the water's depths.

Eastman's artistic instinct led him to explore the painting's variety of lighting possibilities. The artist liked to depict winter because it gave him the chance to paint the rich effects of light on snow. In this painting, the clarity of the ice and snow is blended with that of the sky to create a monochrome plane. The branches on the riverbank and the mountain's soft contours silhouette the landscape. In the foreground, the coloring of the figures gives a gratifying tonal contrast. Their tonal warmth is evident when compared with the landscape's coldness. The colors of their garments are reflected on the ice in realistic detail.

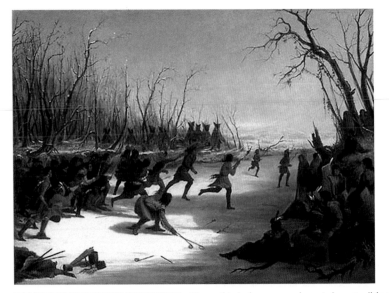

Ballplay of the Dakotas on the St. Peters River in Winter

(1848)
oil on canvas
33 x 50 in (83.8 x 127 cm)
Amon Carter Museum,
Dallas, Texas

Many of today's games and sports have traditional roots; some are of Native American origin. This scene depicts a sport on ice that is not unlike hockey.

Eastman's work can be divided into two distinct periods. The paintings completed during his years at West Point and in his first assignments at Fort Crawford and Fort Snelling reflect a more pictorial and monumentalist Eastman. In these works, the effect of light is decisive and the composition complex but classical. On the other hand, when the painter was assigned to Texas, he reused the Fort Snelling sketches and studies to paint his visual chronicles of American Indians. Most of his Dakota tribe paintings were planned before 1848, although Eastman did not paint them until years later. This painting blends the artist's two pictorial styles. The landscape's dramatic light is intermingled with the game's portraiture as dynamic figures move about in the snow.

Right: Eastman painted all sorts of scenes in the American Indians' daily life, particularly those depicting rural existence. In this painting, the artist illustrates a group of women gathering wild rice, a staple for the Dakota and Chippewa tribes.

With his fine watercolor technique, Eastman has captured a complex task. One woman steers the canoe, and the other two bend the tall stalks and remove the grain. Eastman chose prominent, daily Dakota scenes. His sensitivity and excellent artistic perspective led him to formulate the best composition. His distribution of space is based on an angular configuration created by the horizontal canoe and the vertical framework of the vegetation on the left. The artist manages space with the order and precision inherent in his military outlook and offers a harmonized perspective despite the prominence of the sky. The free brushstroke and tonal clarity give a sketchlike appearance to this painter's Native American paintings. Their drawing and color illustrate an artistic maturity independent of any style or trend.

The paintings that the Office of Indian Affairs in Washington, D.C., commissioned for the Capitol Building are not a specific type of scenery. Since Eastman had no information about the criteria the Office of Indian Affairs would use to select the work, and no information about what his submission should depict, it seems clear that it was the artist himself who decided the daily tribal custom that he would illustrate.

Indians Spearing Muskrats in Winter

watercolor on paper
Committee on Resources,
Washington, D.C.

Eastman's watercolor style has given these paintings such tonal clarity and fluidity that he has formulated a realistic and simple visual language with them. These paintings are, like his brushstroke, subtle and almost transparent. Eastman used the paper's whiteness and very diluted colors, so that blending occurred directly on the base paper instead of the palette. The detail of his watercolor technique can be observed here. The paper can be seen throughout the painting, which has been created with a variety of glazes that blend with details of greater chromatic opacity. This painting illustrates a winter scene under a gray sky, which reflects its threatening presence on the ice and snow in contrast to the warmth of the figures.

Rice Gatherers

(1867)
watercolor on paper
27.8 x 36.9 in (70.5 x 93.7 cm)
Committee on Resources,
Washington, D.C.

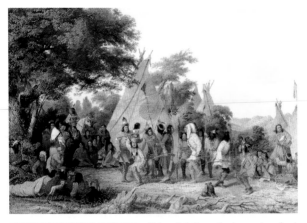

Dog Dance of the Dakotas

(1868)
watercolor on paper
28.2 x 40.2 in (71.7 x 102 cm)
Committee on Resources,
Washington, D.C.

This painter's meticulous nature is clear in the way he depicts each detail of this ceremony with absolute precision. The colorful Native American community, so appealing to many artists during the 18th and 19th centuries, is shown here with clarity and care. Eastman does not attempt to paint an impression that is dependent on flamboyant chromatic effects; instead, each color has a personality of its own and a unique expressive quality.

The work depicts a tribal ceremony in a classical angular composition. Eastman's landscape work results in a natural scene in which everything is well organized and clear in order to spotlight the events of the ceremony. Although Eastman's Native American paintings do not reflect his understanding of light, his use of a very light tonal range allows him to bond the effects of light with an unusual atmospheric impression. These paintings clearly evoke the freedom in which these societies lived. *Dog Dance of the Dakotas* captures the independence of the characters in a culture without hierarchy.

Indian Mode of Traveling

(1869)
watercolor on paper
28.1 x 40.1 in
(71.3 x 101.8 cm)
Committee on Resources,
Washington, D.C.

Although the Chippewa and the Dakotas lived in a well-defined territory, they were nomads. Periodically, family clans moved from one part of the country to another in search of better conditions. These trips were seasonal since, once the harsh northern winter was over, the families returned to their land. This painting has a melodic cadence and a slight sensation of movement. Eastman has blended the bucolic sense of traveling with the graphic record of this custom for the urban white man of his time.

The artist used a pictographic composition: Figures retreat from the foreground to walk toward the left of the painting. Eastman depicts depth, so that his figures retreat without disappearing completely. The artist alludes to a long journey, a trip that will last until the change of seasons brings the travelers home. The painter identified with his subjects, and his documentary sensitivity has led him to a perfect depiction of how these people traveled with their wrapped bundles on a wooden frame, called a *travois*, pulled by a horse.

ALFRED JACOB MILLER

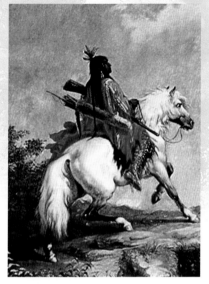

Indian Scout *(detail), Private collection.*

During the first half of the 19th century, American Romantic painting had a freedom of genre and style that allowed it to develop its own character, free from formulaic debts to European pictorial genres.

Romanticism in the United States was the country's first artistic language to develop independently and maturely. The influence of British painting constituted a starting point from which American artists were able to create a new visual language. American Romanticism was based on a pictorial nationalism; artists painted landscapes from the interior of the country and the customs of the first settlers.

Alfred Jacob Miller was definitely the most Romantic of the artists of his generation. With his own pictorial style, this artist brought together the two strains of American Romanticism, creating a new vision of painting with Native American themes. His works are

- **1810** Born in Baltimore.
- **1831** Begins his studies with Thomas Sully.
- **1833** Travels to Paris to broaden his artistic studies in the École des Beaux-Arts de Paris.
- **1834** Moves in order to live at the British School in Rome.
- **1836** Returns to Baltimore, where he sets himself up as a professional portrait painter, then moves to New Orleans after the Baltimore studio fails.
- **1837** Arrives in New Orleans. Accompanies William Drummond Stewart on an expedition along the Mississippi River as an illustrator for a newspaper.
- **1840** Moves to Stewart's Murthly Castle in Scotland for a two-year period. There he completes a number a paintings of the daily life of the locals.
- **1874** Dies in Baltimore.

not just graphic documents in the style of Catlin; Miller's painting reflects a marked interest in the most artistic aspects of the composition.

Miller presents his American Indian scenes with the same poetic and idealist vision that the Europeans used to paint epic legends from classical Greece and Rome. For Miller, his country's indigenous peoples had the same place in American historical painting as the founders of classical civilization did in British or French painting. This vision of an idealized world must have come from the artist's training in Paris, Rome, and England, where he showed a deep interest in Renaissance painting.

Deer by the River Wyoming

oil on canvas
30.5 x 25 in (77.5 x 63.5 cm)
Private collection

Left: At the same time that American Indian-themed painting was developing, a landscape style born of English Romanticism was evolving in the United States. This landscape style, popular among the luminists and the Hudson River School artists, was based on the landscape's monumentality and the light as principal expressive elements, while human beings are represented as naive and humble observers of God's work. This landscape style would give birth to its own visual language, based on compositional techniques that were repeated in many works throughout the beginning of the 19th century.

This painting uses some of these standardized stylistic resources. The composition develops from a clear center that composes and distributes the elements, dividing the painting into two fairly symmetrical planes. The subject is a wild river that brings depth and verticality to the painting while it focuses the center of the picture perfectly. The artist also uses verticality in the whole composition in order to create an expressive enclosed space that is centered by the animals in the foreground. In the background, a rocky mountain appears; in addition to building the background, it creates a contrasting effect. This juxtaposition of proportions gives the painting dynamism.

The Halt

oil on canvas
21.9 x 18. 2 in (55.5 x 46.3 cm)
Sheldon Memorial
Art Gallery and Sculpture
Garden, University of
Nebraska—Lincoln

The different artistic trends that emerged in the United States in the first half of the 19th century were clearly influenced by British Romanticism, both aethetically and theoretically. English Romanticism proposed a revision of the search for an ideal that exemplifies the perfect relationship between man as the father of art and God as the creator of nature. In the American version, Romantic painting was principally derived from two genres, landscape and American Indian theme painting. Miller was a unique artist for the American Romantic period. His style represents a new way to view the origins of the United States, which would later influence Seth Eastman's painting. Miller's compositional style was influenced by the British. In his work, he creates a monumentalized scenario where man is creation's perfect being. *The Halt* blends a classical portraitist sense with a composition that creates space and depth for a dramatic scene.

In the foreground, two men say good-bye in a friendly manner. The landscape has been represented as if it were a little allegory of the country: A seascape, a colossal mountain, and a stormy yet celestial sky appear as emblems of the nation. The two figures symbolize a deep reflection upon relations between the past and the present or just on two ways to see the world and approach life. This work's Romanticism helps to underscore the artist's thoughts on this subject. Works of this type always have a deeper meaning beyond what the eye can see. The travelers have made a halt on the trail in order to buy provisions from the Indians that live by the river. Miller presents the Indians as well-meaning helpers rather than a menace.

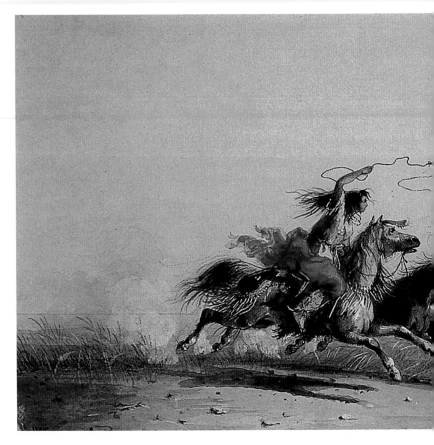

Right: For hundreds of years before the Europeans arrived in North America, indigenous peoples ruled the land and lived in harmony with nature. The relationship between American Indians and their surroundings was not completely understood by the artists who painted them, and so they generally presented these scenes as if the people were merely the embodiment of exoticism and rarity.

Miller enlisted in an expedition with the military official Drummond Stewart after the failure of his Baltimore portrait studio. He joined the campaign from professional interest, but after he saw the Rocky Mountains, which had never been painted before, the trip took on a new significance for him. He soon discovered and came to understand American Indian customs in their original context; his work presents Native Americans as Arcadians in paradise.

This was Miller's response to European aesthetic approaches. European artists had to imagine an idyllic past or settle for capturing the everyday life of rural inhabitants; Miller, on the other hand, was witness to an utterly unique civilization. Through his work, this painter makes his viewers participate in his idealized images, and he explains his Romantic theories through American Indians. This painting presents a monumentalized landscape beneath a stormy sky. In the foreground, on one side, a warrior guides the viewer's gaze toward untamed lands. Miller has captured the emotions that he himself felt after following the lead of his guide.

Indian Scout

Private collection

Lassoing Wild Horses

watercolor and
gouache on paper
8.5 x 13 in (21.6 x 33 cm)

Left: American Indian genre painting uses a very standardized series of simple compositional structures. These paintings or drawings, mostly done with watercolor or gouache, were adopted by many artists of Miller's generation who dedicated themselves to doing scenes of indigenous American peoples. The artistic style is very simple, and their value as graphic documentary images resides basically in the truthfulness and sincerity with which they were conceived.

Although Miller is the most Romantic of all the artists who worked in the genre, his work as a portraitist for a newspaper in New Orleans and as a graphic reporter on the expedition of Drummond Steward—a captain of the British army who mounted yearly expeditions in the Rocky Mountains for fun—demanded that he produce simple, accurate work. In this picture, the artist has adopted this documentary style. The compositional style is subordinate to the perfect appreciation of the scene's descriptive details: A Native American on horseback, trying to lasso the wild horse.

Paintings like this left the artist little artistic freedom. Miller was restricted by the very horizontal scene packed with action. The painting's interior distribution is poor, so the sense of a quick sketch comes through. The artist has done a perfect, dynamic, and effective drawing with many details (the manes and the red clothes blowing in the wind, the dust the horses kick up) that instill a feeling of realism. All of the energy of the painting is focused on the horses and the rider. As for the rest of the work, the road's shoulder is depicted with a few simple lines and the background is almost untouched.

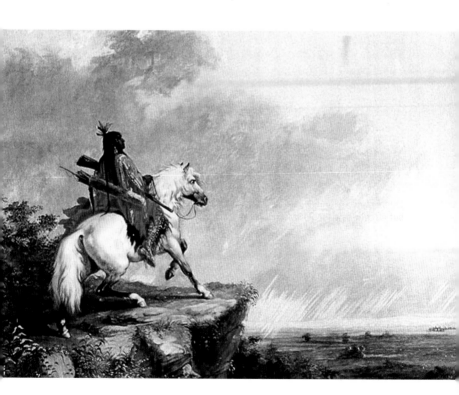

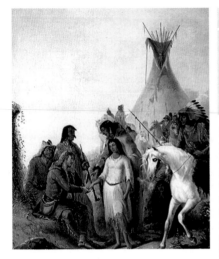

The Trapper's Bride

1850
oil on canvas
27.3 x 22.8 in (69.4 x 58 cm)
Joslyn Art Museum, Omaha, Nebraska

In 1837, when Alfred Jacob Miller embarked on the expedition headed by the Scottish military official William Drummond Stewart, a new type of narrative painting was emerging in the United States. It represented the unexplored territories in the middle of the country in a style more documentary than artistic. The paintings of George Catlin and Karl Bodmer are magnificent examples of this style of graphic ethnography. Miller is among the artists who were dedicated to representing these explorations, but his paintings show a greater interest in composition.

Miller did an artistic interpretation of what he saw, and he presented it through a poetic interpretation. Traveling salesmen, dusty everyday characters from the middle of the country, and great Indian warriors were painted by Miller as heroes in a world where the human condition is the clearest reference to God. For the artist, the vision of humble humanity standing before divine nature takes on a new sense. Miller's characters appear idealized so that they become the stars of the paintings, the natural hero of the work of God.

This work presents a wedding between a trapper and an American Indian woman. A social and festive scene, it is offered with a poetic vision, as if it were a marriage of two different worlds. The artist has used this symbolism in order to evoke symbiosis between man, nature, and the divine. Curiously, so that nothing takes the focus from the bride and groom, the painter has left out almost all other elements. The top of the tepee that appears to the right of the scene should be interpreted as a detail given in order to contextualize the scene and explain how the Indians lived.

Interior of Fort Laramie

(1858-1860)
watercolor on paper
10.6 x 12.9 in (27 x 32.8 cm)
Walters Art Museum, Baltimore, Maryland

Thanks to Miller's apparent interest in the compositional aspects of his visual chronicles, his work has a very original style that in some ways recalls photography. The conception of this painting is certainly original; the scene is presented within a very clearly delineated frame.

Miller has used this pictorial sense with two objectives: he has created an interior architectural whole to present a well-defined space, and he offers a perfect, contextualized vision of the frame where the scene takes place. Fort Laramie, built in 1834, was one of the most emblematic places of the new American history, and it became a symbol of the progress of "civilization" in the country's interior territories.

In this painting, Miller has applied a particular treatment to the light that works as the compositional core. In a carefully planned manner, the artist has placed a zone of chiaroscuro in which shadows combine with the geometric shapes of the architecture. This effect forces the viewer to enter the scene and gives the image a theatrical quality. The frame guides the viewer's gaze toward the central zone, where a space of great clarity opens up. This contrast between planes with very different lighting allows the painter to create a new and original painting that has chromatic dynamism and depth. The light, the aesthetic, and the perspective form an exceptionally attractive whole.

SEVERIN ROESEN

Still Life with Flowers (detail), oil on canvas, 16 x 20 in (40.6 x 50.8 cm), Private collection.

Severin Roesen's meticulous still-life and dining-room paintings make him this genre's major representative in 19th-century America. His work is so detailed and thorough that the viewer may think he is observing actual fruit and flowers. Roesen is considered to be a direct descendant of the 17th-century Dutch still-life tradition. In addition, experts praise his drawing skill, which could be the result of his training—unconfirmed—at the Academy of Düsseldorf and his attendance at a workshop on porcelain painting.

Originally from Germany, Roesen moved to the United States when he was already a skillful artist, as could be seen in his exhibitions at the American Art-Union in New York. He settled in the German community of Williamsport, Pennsylvania and painted still lifes that included flower vases and fruit baskets to adorn restaurants and residences of the town's merchants. These paintings would pay for his room and board.

Roesen's work creates a sensation of a completely synthesized and unified composition, even though each element has been painted individually. Sometimes Roesen used the same elements to compose various paintings in the same session, in order to earn more quickly and thus be able to satisfy his debts.

The prodigious number of still lifes, somber in tone, that he produced after his wife and children left him reflects the depression, worsened by alcohol abuse, the painter was experiencing during this period. Nonetheless, his still-life technique has been interpreted as a reflection of the abundance of resources of an America blessed by God and entrusted to humanity.

- **~1815** Born in Germany.
- **1835** Presumably trained under a porcelain craftsman in Germany.
- **1840** Presumably studied at the Academy of Düsseldorf.
- **1845** Presumably worked as a porcelain painter.
- **1847** His artistic activity is documented in Cologne, Germany.
- **1848** Emigrates to America with his family. Exhibits two floral pieces in the American Art-Union in New York.
- **1849** Marries another German immigrant, Wilhelmina Ludwig, in New York.
- **1852** The American Art-Union, where he had been exhibiting, closes down. Moves to Pennsylvania after his third child is born, leaving his family in New York. Wilhelmina decides to go back to Germany with their three children.
- **1858** Roesen travels to Philadelphia and Huntington, Pennsylvania.
- **1862** Settles in Williamsport, Pennsylvania, where the press acclaims his magnificent still lifes, despite his notorious drinking. He is very popular among the large German community and is commissioned to complete many paintings. His nickname is "the genial German."
- **1863** Exhibits his work at the Pennsylvania Academy of the Fine Arts.
- **1864** His friend, Peter Herdic, hangs some of his paintings at the Herdic Hotel in Williamsport.
- **1865** The hotel manager and brewer Jacob Flock commissions him to make a painting for his establishment. Eventually he will own about 50 of Roesen's works. Roesen will barter them for lodging and beer, his favorite drink.
- **1866** Likes to go for long walks, contemplating the region's floral diversity. He lives poorly in a small room, although he has many friends.
- **1870** Paints *Fruit and Wine Glass*, one of his last compositions. It is believed that he died in Williamsport or in Philadelphia, since there are no more documented paintings after this year. His work would be recognized only a century later, when Jacqueline Kennedy hung one of his paintings in the White House.

Still Life with Fruit

(1848-1852)
oil on canvas
29.3 x 44.3 in
(74.3 x 112.5 cm)
Main State Department
Diplomatic Reception Room,
Washington, D.C.

Roesen's great precision and meticulousness must have impressed the American Art-Union's members when he showed them his paintings for the first time. Much later, Jacqueline Kennedy, the first lady, was also impressed; this is the painting she hung in the White House.

Roesen came to the United States from Germany, where he had already exhibited his work in Cologne. His use of light to create focus and his rigor in drawing remind historians of his training as a porcelain painter and his academic schooling in Düsseldorf. This painting is one of the most exuberant compositions of the artist, created when he was still living in New York. Identifying each type of fruit can serve as a pleasant pastime for the viewer; it is delightful to contemplate the richness it offers. There are currants, cherries, and raspberries next to a small wicker basket of one of Roesen's leitmotifs: wild strawberries. There are also larger fruits such as oranges, plums, apples, and a variety of apricots, as well as a half-peeled lemon. Green grapes predominate, the length of their stems extending above the other objects, while the green vines lure the viewer's gaze. Roesen used grapes on several occasions, hinting at the idea of wine. The painting's illusion is augmented by the shelf that supports the fruit, enhancing the sensation of depth.

Still Life with Fruit and Champagne Glass

(~1857)
oil on canvas
29.3 x 63.3 in (74.3 x 160.7 cm)
Sheldon Memorial Art Gallery,
University of Nebraska–Lincoln

The oval format was quite common in 19th-century still life since it centered the composition, enhancing its decorative aspect. In fact, even though the canvas was square shaped, many frames were oval to create this form. Here, Roesen works with reddish tones that blissfully color the fruit. Currants, wild strawberries in a basket, and grapes and grape leaves are depicted in red, giving them warmth and capturing the viewer's gaze. Purple and green grapes appear once again. They are drawn with the utmost detail, to the point that each one shines.

This is the type of work Roesen exhibited at the American Art-Union, which ceased to exist in 1852. The painter then had to look for new clients in New York and the surrounding area. There, only the few wealthy people who believed this rich still life was a manifestation of America's prominence acquired his work. The still-life genre already existed in the colonial era, when popular painters made simple but expressive Dutch-style compositions without Roesen's elegance or precision. There has been much speculation about Roesen's methodology. Some say that Roesen, familiar with porcelain art, painted from memory. Others say that he collected fruit and other objects to paint them directly. What is certain, and there are anecdotes to confirm this, is that he planned the composition on his own without any client intervention. He only asked the client to indicate what still-life theme he wanted.

Still Life with Fruit

(1852)
oil on canvas
34.1 x 43.9 in
(86.5 x 111.5 cm)
Smithsonian American Art
Museum, Washington, D.C.

Roesen painted a variety of still lifes with fruit baskets and flower vases. In this work, the basket includes plums, apricots, and grapes with yellowish vines reflecting the passage of time. It seems as if the fruit has fallen out of the basket, which resembles the mythological cornucopia of abundance, pouring its contents on the table. A pineapple, a basket of fresh fragrant wild strawberries, and an appetizing slice of watermelon are the highlights of the scattered group, along with a 19th-century bell-shaped glass of champagne. Roesen's still-life work was and is an authentic feast for the senses, since a variety of nuances that juggle sweetness and acidity can be felt by simply contemplating his paintings. The champagne adds a slight touch of bitterness, heightened by the lemon, which crowns this sensual festival.

The complex emotions behind the picture make it probable that Dutch still life influenced Roesen's work; perhaps he admired Dutch paintings when he lived in Germany. The detail in the vine's autumn colors must be noted. This may reflect the difficult family situation that the artist was experiencing: His wife abandoned him and left with their three children, tired of leading a nomadic lifestyle.

Still Life with Fruit and Champagne

(1863)
oil on canvas
30 x 40 in (76.2 x 101.6 cm)
Museum of Art, Utica,
New York

The painter once again enjoys the view of fruit accompanied by a bottle and a glass of champagne, which enhance the painting's splendor and exuberance. The small wicker basket of wild strawberries has given way to a porcelain fruit tray whose shape must have been quite familiar to Roesen. Red is used once again, although in a much more intense hue. The half-peeled lemon's acid tone and the strawberries are perfect counterparts to the beverage, whose color is similar to the green grapes (from which it is produced). Small, perfect bubbles can be seen rising slowly up the middle of the glass. All the fruit flavors, particularly strawberries, are enhanced by champagne, adding a touch of distinction to the still-life painting.

Roesen's clients interpreted his still lifes as a reflection of their optimistic economic outlook. They enjoyed these plentiful and detailed compositions of fruit, more pleasant than still lifes showing game slit and hung after hunting. Roesen's still lifes were predominantly placed in the hallways and dining rooms of the homes of German immigrants and, in the case of restaurants and hotels, in dining rooms to stimulate the appetite. Only much later, when their artistic importance was acknowledged as a result of Jacqueline Kennedy, were these paintings placed in museums.

Still Life with Flowers

oil on canvas
16 x 20 in (40.6 x 50.8 cm)
Private collection

Flowers also offered Roesen a magnificent opportunity to depict sensations on canvas. This floral bouquet appears to give off an intense fragrance, primarily from the roses, which dominate the composition. There is detail even in the glass vase brimming with clean transparent water.

As was common in Dutch still life, the flowers that appear in the painting do not all bloom at the same time, but in different seasons of the year. This makes us think once again about the way the artist painted, since it was impossible for the petals of all these flowers to remain fresh during the lengthy painting. To complete the composition, the painter commonly added an object that was unrelated to the rest of the objects—in this case, a bird's nest with three eggs, which could symbolize the rebirth of nature.

In 1862, Roesen moved to Williamsport, Pennsylvania, where the German immigrant community welcomed him. His artistic ability, sociability, and culture made him quite popular. He was known as "the genial German" among friends and clients, who commented on his delight in taking long walks to contemplate the rich flora and fauna of the surrounding area. This contrasted deeply with the life that he led, sleeping on the floor of a grimy and smelly hotel room, where he lodged in exchange for paintings. Since he paid all his debts in this way, the restaurants in the area collected many of Roesen's works, which are quite valuable in today's art market.

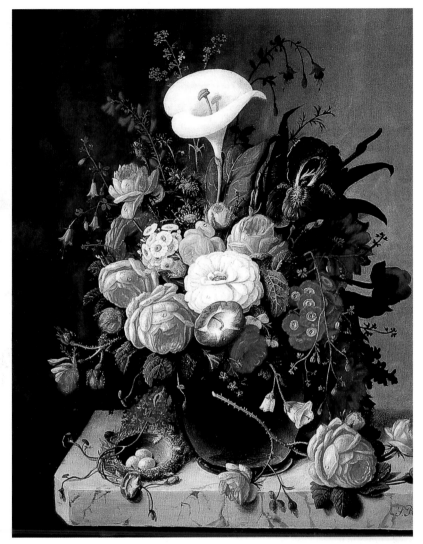

This is a delightful floral bouquet in rich pink tones, enhancing the ideas of fragrance and softness implicit in flowers. A small bird's nest with eggs is hidden in the bouquet's exuberance. The shelf the vase is on is made of streaked marble over a hazy background. The flowers and the nest are life-size, which may indicate Roesen's dependence on natural live models. However, it will never be known for sure if he made several paintings at the same time, using the same objects.

Floral Still Life

oil on canvas
24 x 20 in (61 x 50.8 cm)
Private collection

The realism is quite evident, and that is what attracted Roesen's clients. Among them was the hotel manager and brewer Jacob Flock, who accepted some 50 of Roesen's paintings in exchange for lodging. The painting themes did not vary too much over time; there were only small variations with respect to the objects' arrangement. The great variety of wild flora around Williamsport gave Roesen the opportunity to select flowers that were suitable both in appearance and in hardiness. It must be kept in mind that the artist made these paintings, not for his own pleasure, but to pay his debts.

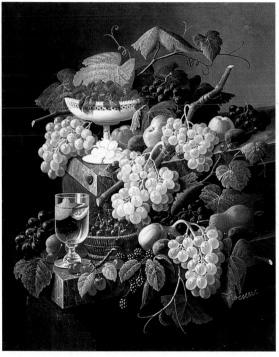

Still Life

(~1860-1865)
oil on canvas
30 x 25 in (76.2 x 63.5 cm)
Spanierman Gallery,
New York

Light brightens the fruit that appears on two slabs of gray marble. The marble lies powerless under the fruit that has taken over its surface. Wild strawberries, common in Roesen's paintings, appear in the upper portion of the composition in a white porcelain bowl, surrounded by apples, plums, and grapes, also common in the painter's work. On the lower surface, the porcelain bowl has its equivalent in a small wicker basket containing some luscious cherries still on the branch. Next to them, there are bunches of purple and green grapes, green and purple plums, apricots, blackberries, and even papaya, a tropical fruit. This summer still life also contains a glass of lemonade where a slice of the refreshing citrus floats. The original way that Roesen signed his work can be seen here: in the lower right-hand portion of the painting, he has coiled one of the tendrils to create his surname so that it is inscribed in the composition without clashing with the other objects.

Fruit and Wine Glass

(1870)
oil on canvas
New Britain Museum of
American Art, Connecticut

The artist has used the double-shelf style once again to compose another still life whose main elements are grapes and wine. The still life is a kind of bacchanal homage to his favorite beverage (which submerged him into poverty): alcohol. Although it has been documented that his favorite drink was beer, it is certain that he did not refuse high-grade schnapps. Roesen is known to have commonly added a mug of beer to his compositions, but his clients did not approve of this very much. The painter, surprised, would end up erasing it. This painting, one of the last known works by Roesen, sheds light on the life and work of this man. After 1872, he disappears from any record, and we do not know if he died at this time, as some say, in front of a public building, or in the crowded streets of New York City; perhaps he ended up returning to Germany. What is certain is that Severin Roesen was one of the most important 19th-century still-life painters in the United States.

JOHN FREDERICK KENSETT

John Frederick Kensett.

John Frederick Kensett is the most outstanding figure of luminism, a trend followed by some of the Hudson River School's second generation, which focuses on the effect of light on the landscape and atmosphere.

Kensett originally studied engraving and moved to New York to work at a bank-note printing press. He began to paint after admiring Thomas Cole's landscapes and made friends with a group of painters who encouraged him to continue painting. Kensett traveled throughout Europe for seven years with the American painter John William Casilear and Asher Brown Durand, the father of the Hudson River School. He lived in London, Rome, Paris, and several Swiss cities. While he supported himself by selling engravings, he attended art classes in London, holding exhibitions at the Royal Academy. Increasingly confident about his artistic abilities, he sent several paintings to the American Art-Union in New York, which acquired two of his meticulous Italian landscapes.

Kensett simplified his style after being influenced by the baroque landscape artist Claudio de Lorena, who enhanced his poetic landscapes with a golden mist bathed in sunlight. The English painter John Constable and the masters of Dutch baroque painting also affected his style. Kensett focused on atmospheric effects, endowing his coastal landscapes with a special sense of classical serenity and clarity that suspend time, even for today's viewer.

- **1816** Born in Cheshire, Connecticut, on March 22, son of Thomas Kensett, a British engraver who lived in New Haven.

- **1834** Alfred Daggler, a bank-note engraver, teaches him the trade.

- **1837** Works as a bank-note engraver at a New York bank.

- **1838** Sends a landscape to the National Academy of Design's annual exhibition.

- **1840** Travels to Europe with Asher Brown Durand and Casilear. Visits England, France, Italy, and Switzerland, engraving and sketching landscapes. Sees Claudio de Lorena's work at the Louvre.

- **1845** After studying in England for two years, he exhibits a landscape of Windsor Castle at the Royal Academy in London.

- **1846** Sends several paintings to the American Art-Union, which buys two landscapes.

- **1847** Returns to New York. Exhibits at the National Academy of Design. Sets up his studio in Washington Square.

- **1849** Is elected a member of the National Academy of Design in New York and the Century Association.

- **1850** Goes trekking through the Adirondacks and Newport's coast, painting in detail, almost topographically.

- **1859** Is named member of the National Art Commission to oversee the ornamentation of the Capitol building in Washington.

- **1860** Becomes interested in the role of air and light in atmospheric effects.

- **1863** Participates in the organization of the Sanity Fair Exhibition to collect funds and send medicine to Union troops.

- **1865** Helps to establish the Artists Fund Society and becomes its president.

- **1870** Is founding member of the Metropolitan Museum of Art in New York. Travels West again.

- **1871** Completes his series of 38 paintings of Long Island, which he donates to the Metropolitan Museum.

- **1872** Dies on December 16, after a bout of pneumonia as a result of plunging into a frozen lake to save the wife of a friend, who had fallen in.

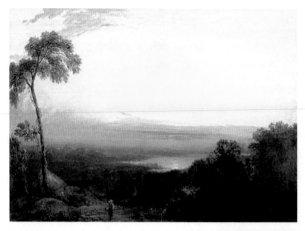

European Landscape

(1845)
oil on canvas
21 x 29 in (53.34 x
73.66 cm)
Henry Luce III Center
for the Study
of American Culture,
New York

Kensett was able to get enough money together to realize his dream of traveling to Europe to see the works of the great masters. In Paris, he lived in an apartment in the Latin Quarter, near the École des Beaux-Arts. Copying Claudio de Lorena's landscapes at the Louvre was his main activity, and this determined the lighting characteristics of his future work. He was also interested in the serenity that Dutch landscape art transmitted. Later, after studying John Constable's work in London, he traveled to Italy, where he painted landscapes that reflected this influence.

The Italian countryside appears just as idealized and bucolic in this European landscape as in de Lorena's compositions. Constable's influence is also evident in the selection of the theme, which is no more than a simple and common landscape containing three main elements: sky, water, and earth (traversed, in this case, by a farmer). The novelty here is the fourth element, light, which tints the sky and generates brightness. It is the last ray of sunlight that brightens the bluish sky, barely surrounded by clouds.

It is important to point out the way that Kensett emphasizes the sky and the significance of light over all the other elements in the composition: Water is the grayish reflection of light, while the forest is almost covered in darkness. Following Constable, Kensett did not underestimate the pictorial possibilities of a setting in any way, since he was aware of the fact that it is the hands of the painter that convert it into the sublime.

Right: Kensett met the need of the American people to see their identity portrayed in the most extraordinary landscapes. National pride was expressed in many forms of nature's strength, be it mountains, rivers, or waterfalls—especially, of course, Niagara Falls. Kensett offers a kindly, tempered view of the falls here. He depicts them from above in a close-up, barely shows the water falling over the cliff at an angle, and partially shrouds the water with the forest. Instead the artist focuses the viewer's attention on the rapids that flow into the falls, full of propelling force, and on the splendid sky that opens up before the viewer's eyes.

The horizontal emphasis underscores the feeling of serenity, later a hallmark of Kensett's work. In addition to the topographic precision that details even the abrupt transition between the two currents of the river (a calm one and a turbulent one), the painter gives the atmosphere a leading role, dominating almost all of the central composition. This has to do with the search for the sublime, considered earlier by the Hudson River School painters.

Kensett focuses on the fullness of the sky. The divine essence of a God who has accompanied the American people in their discovery of the promised land is evoked in the light emanating from the sky. There is no place for idyllic shepherds or pilgrims here, since the domestication of such a wild force of nature, the expression of an emerging America, is impossible.

Niagara Falls and the Rapids

(1851-1852)
oil on canvas
16 x 24 in (40.6 x 61 cm)
Museum of Fine Arts, Boston

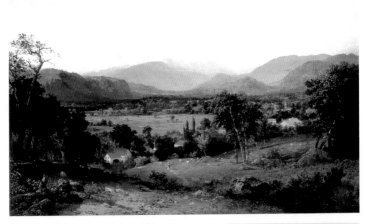

After returning to New York to the acclaim of his colleagues at the National Academy of Design, the most important art institute in America, Kensett began taking trips to the White Mountains and the Adirondack Mountains. Following in the footsteps of the Hudson River School's first generation of artists, he sketched outdoors in the summer and painted in his studio in Washington Square in the winter.

The White Mountains from North Conway

(1851)
oil on canvas
40 x 60 in (101.6 x 152.4 cm)
Wellesley College Museum, Massachusetts

The paintings from this period, meticulous and focused on details, reflect Kensett's work as an engraver. This image is one of the best paintings of the White Mountains, specifically Mount Washington. The majestic mountain rises in all its splendor at a distance of about 15 miles from North Conway, New Hampshire, where the artist sketched. A flock of sheep is tended by a shepherd, and a house next to the forest evokes de Lorena's compositions. The painting is bathed in soft light, transmitting warmth to the landscape. This idealization of renowned American regions added to Kensett's popularity at the time, since it offered an idyllic alternative to Frederic Church's spectacular landscapes and Thomas Cole's pomposity. Still, one cannot understand the development of Kensett's painting without acknowledging Cole's influence; Kensett assimilated his spirituality. Certainly Cole's paintings inspired Kensett to abandon his work as an engraver and become a landscape artist.

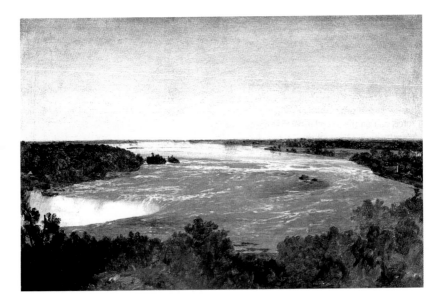

Beacon Rock, Newport Harbor

(1857)
oil on canvas
22.5 x 36 in (57.2 x 91.4 cm)
National Gallery of Art,
Washington, D.C.

The painter traveled through much of the United States, even visiting the most exotic corners of the Mississippi Valley, searching for its intrinsic aesthetics. Newport was one of the areas that Kensett visited, and it is documented by this work. References to de Lorena and Constable are adapted to the coastal landscape here. Detail as well as light stands out. Soft tonal transitions embrace all the elements of the composition. Using a magnifying glass reveals each detail: a fisherman with a red shirt and a straw hat standing on a rocky ledge, several sailboats plowing the waters at a distance. The composition is symmetrical, to underscore the idea of serenity: While the sky, clear and cloudless, is in the upper half of the composition, the water and rocks are in the lower half, adding stability to the whole. The serenity can also be detected in the peaceful appearance of the water, its surface barely stirring in the breeze. Even the sky reflects its brightness.

Although the artist painted this work using a scene popular with travelers because of its beauty and grandeur, he does not make a spectacle; instead, he scrupulously concentrates on detail and lighting. Calm waters show Kensett's preference for meditation and introspection over high drama. Over the years, this work accumulated a yellow patina; it was removed in restoration.

Right: This is a good example of the lighting that was typical in Kensett's paintings. The artist commonly primed the surface of the canvas in white before painting on it. Kensett would brighten areas that were water or sky with this first layer. He then applied fine, barely perceptible brushstrokes to blur the white color with grayish or greenish tones that heightened its brilliance. The clarity of water and sky blend together in a barely visible line on the horizon.

Kensett, always seeking an opportunity to convey atmosphere, began to display his preference for coastal areas because of the brightness of the landscape. The seashore concentrated all the purity and energy of sunlight, plus it offered the simplicity that Kensett looked for in landscapes. Dependence on de Lorena's bucolic models—this time, a fisherman and a picturesque boat—is still evident here. Constable's influence can be observed in the detail of the trees standing out from rock crevices. Gathering clouds suggest impending rain, but even so, the air collects all the brilliance of sunlight.

Beach at Beverly

(1869-1872)
oil on canvas
22 x 34 in (55.8 x 86.4 cm)
National Gallery of Art,
Washington, D.C.

This view of one of England's most magnificent sites, Langdale Pike, displays the painter's interest in detail. Far from making the place a product of an illusion, Kensett depicts it with the simplicity of Constable's landscapes. Kensett himself wrote, "Things are no more than what the mind makes them out to be."

Kensett thus displays this mountain on a slant, as if it were part of a whole and not the main image. The painter focuses on depicting the surrounding forests. The brushstrokes add a touch of freshness and thus avoid exaggeration. A complete control of technique is displayed in this work; the painter has been daring in his study of atmospheric perspective. Light and air mix and merge in the distance, barely allowing a view of the mountain's profile. The vegetation in the foreground gives way to smooth water that allows the sailboats to glide peacefully on its surface. An animal at the side of the road adds to the bucolic quality. This small and apparently harmless route has its parallel in the hills to the left of the composition, which have extensive clearings that used to be forests. It demonstrates human presence in an area that is no longer as wild as it was when Frederic Church depicted it.

The Langdale Pike

(1858)
oil on canvas
22.2 x 36 in (56.5 x 91.4 cm)
Cornell Fine Arts Museum at Rollins College, Winter Park, Florida

Lake George

(1869)
oil on canvas
44.1 x 66.4 in
(112.1 x 168.6 cm)
Metropolitan Museum
of Art, New York

Little by little, the artist simplified his compositions to the point that animals as well as people disappeared from the painting to give way to light. In depicting this lake, there is just sky, water, and mountains in tenuous grayish tones that blend together. The calm lake water barely has waves. It seems as if it is sleeping next to the rush and stones on the bank. The spectacular, if it ever existed in his work, has completely disappeared. Kensett's descriptive tone does not correspond to the meticulousness of Church's work, which would have had beams of sunlight or clouds giving warning of an imminent storm of biblical proportions. Here, all is silence and meditation, order and clarity. The simplicity of the composition of horizontal lines is barely broken by mountain profiles that are serene and placid, without arrogant monumentality.

Eaton's Neck, Long Island

(1872)
oil on canvas
18 x 36 in
(45.72 x 91.44 cm)
Metropolitan Museum of
Art, New York

The group of seascapes that Kensett made during the last stage of his life is proof of the process of abstraction that his landscapes had undergone. This is his masterpiece, because it sums up his aesthetic approach of order and simplification.

The painter's subject was an empty beach. He was able to depict the clarity of the summer light using a range of such soft colors as grays and browns. Two lines, like two masterstrokes, make up the composition: one for the infinite horizon and one for the curve that forms the deserted beach with vegetation. The seawater, greenish in color, barely highlights the foam of the waves. The sky is cloudless and has no sea birds to alter its sense of eternity. Variations can be detected in the blue and gray tones in the lower portion of the sky, as if the light reflecting from the sea had tinted it. Paintings such as this one, surprising in their abstraction, were found unfinished in Kensett's studio on the coast of Long Island after his death from pneumonia.

GEORGE CALEB BINGHAM

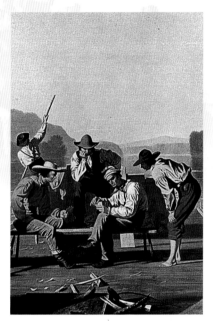

In a Quandary *or* Mississippi Raftsmen at Cards *(detail), 1851, oil on canvas, 17.5 x 21 in (44.5 x 53.3 cm), Huntington Library, San Marino, California.*

- **1811** Born in August County, Virginia, on March 20.
- **1819** His father dies and the family moves to Missouri.
- **1830** Studies with portraitist Chester Harding.
- **1834** Participates in a political coalition against President Andrew Jackson.
- **1835** Establishes himself as a portraitist. in Missouri.
- **1837** Studies at the Pennsylvania Academy of the Fine Arts.
- **1838** First exhibit of his paintings. in New York.
- **1840** Works in Washington painting portraits of army officers and politicians.
- **1844** Returns to Missouri, where he definitively begins his political career.
- **1846** Is elected to the Missouri State Legislature.
- **1862** Is elected treasurer of the state of Missouri.
- **1865** Is elected adjutant general of Missouri.
- **1879** Dies on July 7.

In George Caleb Bingham's works, we can see a modernity that is present in various artistic styles that migrated from Europe, but which, in his work, reflects a new American realism. Bingham understood how to take full advantage of the compositional offerings of the Victorian style of British Romanticism in order to chronicle the preindustrial period in his country.

This graphic testimonial to the evolution of the American character in the second half of the 19th century was useful to Bingham in rediscovering the value of daily life. His paintings capture the poetry inherent in rural scenes and gatherings of an ancestral tradition. He renders figures with great compositional frankness and places them in landscapes that call to mind the rural naturalism of the beginning of the 1800s. George Caleb Bingham combines this style of painting with classical portraiture.

Bingham's initial training as a portraitist led him to open a studio in Missouri and later in Washington, D.C., where he dedicated himself to painting portraits of leaders. Indeed, politics was the second great passion of the artist, and his collected paintings form a remarkable testimonial to the workings of American democracy at the end of the 19th century.

Bingham's paintings are dominated by a deep sense of chiaroscuro—the use of light and dark—that governs the expressiveness of his compositions. His paintings are orderly and reflect a stylistic openness unusual in American artistic circles during this period.

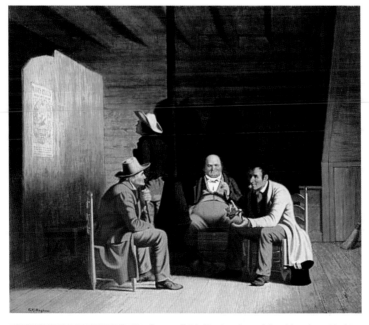

Country Politician

(1849)
oil on canvas
20.4 x 24 in (51.8 x 61 cm)
Fine Arts Museums of
San Francisco

George Caleb Bingham's work is a historigraphical treasure for studying American political history in the 19th century.

He was the only painter who represented political meetings and councils where specific moments of daily life are captured, and through these, he offers insight into human behavior. Far from feeling especially attracted by portraits of the great political leaders of his country, the artist's interest was focused on parochial paintings depicting modern American democracy through the eyes of the simple man. In this interior scene, the artist paints some type of political conspiracy.

The meeting of four notable characters seems here like a secret ceremony—a sensation that the artist emphasizes through the scene he has constructed. The lateral illumination plays a large role in this scene; it illuminates an austere room with bare walls, although it is comfortable and suitable for the meeting. The characters converse expressively, are attentive, and gesture with complicity. The artist has captured this conversation as if it were a snapshot. The modern clothing of the gentlemen contrasts with the classical composition of the work, and the architecture seems to act as a protagonist in the pictorial argument, immortalizing the moment, while the penumbra imbues the scene with a drama. Bingham has constructed the setting very formally and specifically, with a classicism that is almost manneristic. The space opens toward the viewer, while the wooden wall on the left leaves a spacious opening that allows the viewer to imagine depth beyond the room.

Right: Although there was not a true generation of historical painters in the United States, the appearance of artists like Bingham and Seth Eastman on the American artistic scene suggests the existence of a new stylistic concept based on contemporary social reality. This new pictorial vision is obviously distinct from the previous generation, the offspring of an adapted English Romanticism with signs of luminism. The use of prominent realism, demonstrated by the compositional form and style is—along with the preference for outdoor paintings that are more anecdotal and spontaneous—the principal strength of this new vision of American art. Here Bingham portrays two desolate, simple, and humble men that are resigned to their condition. Their vacuous expressions denote a demystification of art, while the landscape that opens up toward the right-hand side of the painting shows a distant splendor. Bingham thus illustrates his new artistic concept of men as independent beings that should never be submissive to any mystical creation. In this painting, the artist plays lightly with chiaroscuro. The stylistic resource, used frequently in his works, allows the viewer to appreciate the detail with which Bingham portrays his characters. The texture of the fabrics, the ground, and even the dog's fur appear as a meticulous exercise in realism.

Portrait of an Unknown Girl

(1849-50)
oil on canvas
Boonslick Historical
Society, Boonville,
Missouri

Unlike landscapes and still lifes, which were the most common styles throughout the 19th century, portraiture had lost popularity in the American artistic arena. At the end of the 18th century, portraits were so sought after that there had been a resurgence of workshops and artist studios in many American cities. But the elitist and representative nature of this genre, inherited from European painting, seemed to grow ever less accepted by the new preindustrial society. This painting was not commissioned and was most probably a private exercise by Bingham himself. The face is rendered in an extremely conservative style. The artist seems to want to mock the rococo style that had been so influential in American portraiture at the end of the 18th century.

The portrait is an original composition that lauds the poetic beauty of a young girl, while the background is quite fanciful—or perhaps a sign of early surrealism. The figure, whose torso gradually fades, gives the girl the appearance of floating upon a bed of clouds. Bingham's new vision undoubtedly came from new advertising that the artist had seen in New York; seeing them, he discovered the possibility of combining realistic elements—such as the beautiful face of a young woman—with a different background, invented to exalt and add further beauty to the person being portrayed. Although Bingham set up a portrait studio in Missouri, he was quick to realize that his artistic scope could not be confined to simple studio portraits.

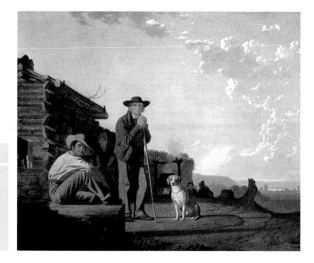

The Squatters

(1850)
oil on canvas
25 x 35 in (63 x 89 cm)
Museum of Fine Arts,
Boston

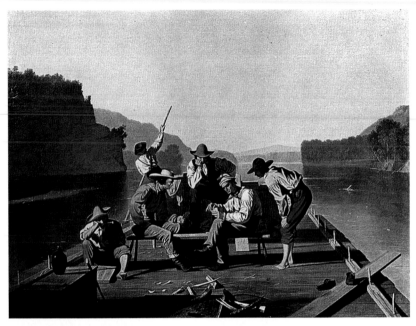

In a Quandary or Mississippi Raftsmen at Cards

(1851)
oil on canvas
17.5 x 21 in (44.4 x 53.3 cm)
Huntington Library,
San Marino, California

Bingham was always attracted by the lives of the lowest social strata. The daily life of the common man preoccupied both his political and artistic sides. This painting portrays a group of men playing cards while they float down a river on a raft. The austere compositional structure, centered around a meticulously calculated linearity, is broken by the figures. While the river descent is based on lines that converge in a distant vanishing point, the raftsmen appear free and immersed in their daily lives, although signs of preoccupation can be divined in their faces.

Bingham felt that the particular freedom of each individual was something simple yet beautiful, and this is highlighted here by the interplay between the indifference on the faces and the tranquillity of the landscape, enhanced by the calm waters of the river. The painting shows strong contrasts that surely stem from the artist's experiences with engraving. Thanks to the light and the highly contrasting colors, this painting is mildly dynamic, although it also has a sense of linearity from the excessive shadowing. As in many of his other paintings, here Bingham uses exaggerated shadowing to imprint stronger personalities upon his subjects in order to convey the worries of the time.

Right: George Caleb Bingham initiated a new genre of American painting that would become the precursor to avant-garde realism in the United States. The artist was a witness to the social changes in the United States in the second half of the 19th century. After the Civil War, and after experimenting with naturalism at the beginning of the new century, American art would undergo a resurgence by and for the common man. Finally, painting would begin to favor scenes of everyday life above all other subjects. Both rural and urban life acquired an anecdotal value, and Bingham can be considered the precursor to this movement.

This painting shows a group of young men frolicking on a boat. This work, created in the artist's most prolific period, provides us with a new vision of daily life, which Eastman Johnson would shortly emulate. The happiness of the adolescents gives this painting a carefree appearance that contrasts sharply with the severe post-Romantic landscapes still present at this time in the United States. Through skillful use of chiaroscuro, the artist imbues this dynamic and brilliant work with color and form, culminating in the optimism of the boy waving his hat. Behind him, the monotony of the river creates a background filled with chromatic nuance. Bingham planned the triangular composition carefully, arranging the characters in a sculptural way. They appear in stark relief through a clever play of light and shadow.

The Jolly Flatboatmen in Port

(1857)
oil on canvas
42.9 x 63.4 in (109 x 161 cm)
Saint Louis Art Museum,
Missouri

Landscape with Waterwheel and a Boy Fishing

(1853)
oil on canvas
30 x 25 in (76 x 64 cm)
Museum of Fine Arts, Boston

Although Bingham proposed a new pictorial trend in his art, his appreciation of English Romanticism caused him to revisit this style frequently. The identification of the environment as a protagonist and the opportunities for conveying climatic elements such as humidity, heat, or coolness were qualities he discovered through Romantic artists, including John Constable.

In this work, the artist let himself be seduced by the type of bucolic painting created by Constable, whom Bingham studied for his perception of organic energies and its later expression on canvas. In spite of this clear acceptance of British Romanticism, Bingham wanted to distinguish himself by representing typically American landscapes with a free attitude. He adopted a vision that was distinct from the landscape paintings of the luminists, where light was the main protagonist. In Bingham's paintings, light is faint and depicted through a constant play of subtle tonalities.

Here, Bingham has portrayed a humanistic landscape where a simple water mill has been substituted for Roman ruins or magnificent neoclassical architecture. The artist presents a more secluded, small-scale vision of nature that dominates the interior of the painting, except for the boy, who is illuminated by a slender, restrained ray of sunlight.

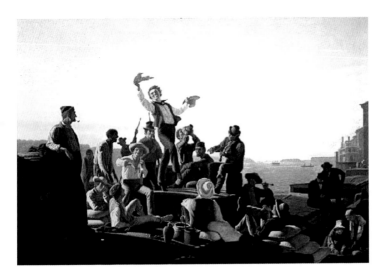

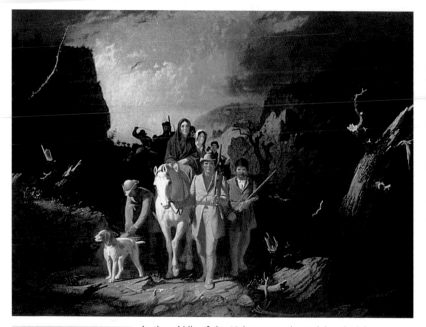

The Emigration of Daniel Boone

(1851-52)
36.6 x 50 in (93 x 127 cm)
oil on canvas
Washington University
Gallery of Art, St. Louis

In the middle of the 19th century, the social outlook in many parts of the United States inspired desperation. It was a time of constant change that trapped the common man in a dark mood, burdened by long years of stagnation and apathy. The Industrial Age was often devastating to jobs that developed near rivers or near borders. Bingham's strong political misgivings are reflected in his art and are presented as a graphic recognition of these social changes and the consequences this entailed for rural men. The artist portrays an emigration in this scene. Bingham avoids any pronounced drama, instead showing the great pioneer Daniel Boone starting his epic journey through the Cumberland Gap to Tennessee, later known as the Boone Trail and used by the settlers in the great expansion toward the West. The painting, with its deep chiaroscuro, is sentimental. Bingham created expressiveness in many of his paintings by infusing them with strong drama, achieving this through a successful use of light and shadow.

Here, the figures are illuminated by a beam of light coming from the upper left-hand corner. Shadows throw the grouped characters into relief, while the landscape, rich in chromatic tonality, fades into darkness at the edges. Boone and his entourage stride firmly and purposefully toward the viewer. The artist is working to lift public spirits and awaken hope through the protagonist's drama. Behind the group, a beautiful and majestic sky completes the image, emphasizing the virtues of the explorer.

G.C.Bingham

CHARLES DEAS

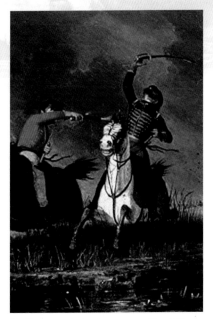

The Trooper, *1840, oil on canvas, 12 x 14 in (30.5 x 35.6 cm), Private collection.*

- **1818** Born in Philadelphia to a military family. In his youth, Deas prefers drawing outings in the Hudson River Valley to his classes at West Point. The Seminole War erupts at the Spanish border in Florida.
- **1836** Studies art at the National Academy of Design in New York.
- **1838** First exhibits at the National Academy of Design. The chief of the Seminoles is detained and shot after the bloody guerrilla war. The Trail of Tears, the forced Cherokee exodus toward the lands of Oklahoma, begins.
- **1839** Elected associate member of the National Academy of Design.
- **1840** After seeing an exhibition by Catlin, Deas decides to travel to St. Louis, on the edge of the frontier, to paint Indians, trappers, and travelers. Also visits his brother, an officer at Fort Crawford, in Prairie du Chien, Wisconsin. Navigates the Mississippi and Missouri Rivers and travels through the Platte River region.
- **1845** His works are regularly exhibited at the National Academy of Design, the Boston Athenaeum, and the Pennsylvania Academy of the Fine Arts. Prints of his works are made, which help make him more widely known.
- **1850** Confined to a psychiatric hospital due to mental illness.
- **1867** Dies at the psychiatric hospital.

Currently, Charles Deas is best known for his paintings of American Indians and the dangerous frontier lives of pioneers. These paintings are filled with openly hostile feelings toward the Native Americans—shockingly different from the descriptive and documentary sense imparted by other painters such as George Catlin.

We must remember that Deas's works were created at the same time that the United States was expanding and moving westward. Indian tribes had occupied this territory until the arrival of the "white man." That is why Deas's dramatic, propagandistic works, depicting Indians as evil assassins and the white man as their defenseless victim, were accepted. His views were shared by both the general population and the authorities. They saw this reasoning as justification for genocide and the exodus they subjected the Indians to. In reality, these actions were provoked by the hunger for new lands, as well as the discovery of gold on Indian lands.

Deas became interested in the Indians after seeing one of Catlin's exhibitions. Deas had studied painting first in Philadelphia and then in New York at the National Academy of Design, where he later became a member. Recognized for his domestic genre scenes, and very skilled as a painter, he traveled West, visiting Fort Crawford in Wisconsin and later braving the upper Mississippi, the Missouri, and the Platte Rivers. He eventually established himself in Saint Louis, and from there he sent a constant flow of his paintings to exhibition halls in the East.

His career was cut short by mental illness that left him confined in a psychiatric hospital for the rest of his life.

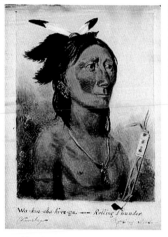

Rolling Thunder, Wa-kon-cha-hi-re-ga

(~1840)
oil on canvas
8.2 x 6.2 in (20.9 x 15.8 cm)
Private collection

This portrait belongs to the same series as the following one, and shows an important member of one of the Indian tribes on the frontier, the Winnebago. Since the first colonists had arrived on American lands, the fight against the Indians had been ferocious and without limits, and the truth is that, besides the confrontations, the diseases imported from Europe had notably diminished their numbers. One of the ways the army decimated the Indians was to sell them blankets infected with smallpox.

The Americans had not forgotten that the majority of Northeastern tribes had allied with England in the revolution, but the real reason for their expulsion from their lands was the discovery of gold. In the Southeast, where Deas made his explorations, tribes such as the Seminoles, Apaches, Cherokees (the most numerous), and Alabamas lived, although Deas tended to depict the Sioux and the Winnebago more in his portraits. All these tribes survived by collecting wild fruits and harvesting vegetables. The remains from this period are few, and thus, artists' graphic descriptions are invaluable historical documents for anthropological studies about American Indians.

In these portraits, Deas showed the descriptive spirit found in a Catlin, whose works showed a documentary angle in representing the Indians, starting from the idealized version of the noble savage, a perspective displayed by previous artists such as John Trumbull and Thomas Cole. In contrast, Deas's viewpoint would follow American public opinion that had begun to see the Indians as an ominous threat in their advancement toward the West.

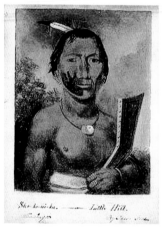

Little Hill, Sho-ko-ni-ka

(1840)
oil on canvas
8.2 x 6.2 in (20.9 x 15.8 cm)
Private collection

Like Catlin before him, Deas's only goal in venturing into Indian Territory was to visit the tribes and make portraits of their members. The comparison of these works with Catlin's paintings and drawings is inevitable, as these portraits show the same perspective, using three-quarter and frontal views, although the glance of his subjects is generally not so direct as this of Little Hill. However, while Deas's documentary and descriptive objectives may have run parallel to Catlin's, the anatomical sensibility of the drawing is inferior, particularly with respect to the proportions of the head compared to the rest of the body. It would bear investigating if Deas made these portraits directly with oil or finished them later in his studio.

It is interesting to see how Deas uses elements that would become characteristic in his works: the stormy, troubled skies and the figures characterized by aggressiveness—note how he portrays the Indian proudly wielding his weapon. However, Deas was also concerned with representing the other accoutrements of the figure, from the feather on his head to the necklace, the bracelet, the rings, and the face paint. These elements must have been truly exotic to people in the East, whose only information about the tribes that inhabited the frontier came from these types of works. In the general American population, the predominant feeling about Indians was a visceral fear of their hostility.

The Trooper

(1840)
oil on canvas
12 x 14 in (30.5 x 35.6 cm)
Private collection

This is a characteristic scene showing Deas's style. Two soldiers on different sides fight, one on a white horse and the other on a black horse. Deas captures the dramatic moment when the man on the black horse has managed to shoot his enemy. The author could not resist representing military subject matter, as his family descended from illustrious officers, and his own brother was a decorated leader at Fort Crawford. Ralph Izard, a hero of the American Revolution, was among their ancestors.

The influence that his visit to Fort Crawford may have had on his somewhat Manichean vision of the relationship between the Indians and the white man has been speculated on. However, if we add together the beliefs of the era, the experiences of the artist himself, and what he must have heard from travelers passing through Saint Louis, part of the puzzle comes together about the artistic and stylistic personality of Charles Deas. The dark side of this important figure in American art history has been largely clarified thanks to the efforts of art historian Carol Clark, who has been able to unravel many of the mysteries surrounding his artistic biography. More concretely, she has managed to bring a large part of his work to public attention; before her studies, Deas's work had not earned the attention it deserves.

Winnebago Leader

(~1842)
oil on canvas
Saint Louis Mercantile Library,
Missouri

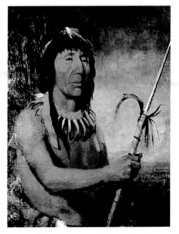

In this portrait of a member of the Winnebago tribe, Deas has made a greater effort to represent the figure with anatomical correctness. We no longer see the disproportion between head and body of his earlier works; quite the opposite, as he seems to use all his artistic resources to make the model truly lifelike. The skin color, the depiction of the muscles—especially in the hand—and the study of the quality of the cloth around the figure's waist are all very realistic.

If there is one thing that characterizes American art, in its short but intense history, it is its tendency to realism. While European trends infiltrated American art, the artists themselves reinterpreted it in their own style, always looking for a practical application or a way to add some meaning to the work of art. Works like this were virtually the only visual information for people in the East until the arrival of photography, and for this reason, the maximum realism possible was highly important.

However, it is clearly evident that some works were not completely faithful to reality, and some elements of compositions were manipulated. In this case, for example, the Winnebago Indian is portrayed with dignity and a classical, but threatening, demeanor, wielding a sharp spear that takes on a sense of foreboding danger here. The anatomical realism would impress contemporary viewers, who would take it as documentary truth.

The Death Struggle

(1845)
oil on canvas
30 x 25 in (76.2 x 63.5 cm)
Shelburne Museum, Vermont

Most of the time, Deas presented the Indians as evil beings, dark and instinctive, who would do everything in their power to destroy the white man, who was the innocent victim. Although there was some tolerance, this was the common view held throughout America about the indigenous tribes. Of course, the territorial wars would favor the white man in the end.

In this scene, perhaps the best-known painting by Deas, a white trapper riding a white steed is attacked by an Indian wearing a dark and terrifying expression on a horse as black as his malevolent evil. The expressions of the figures are distorted, their white teeth gleaming while their eyes bulge from their sockets. The black horse of the Indian breathes red fire—attributed to demonic beings—while the rider embraces the white man in a delirium of hate and death. Brandishing knives, both have jumped into the depths of the abyss, and we see a horrified expression on the trapper's face and the savage decision written on the face of the Indian warrior. With his killer's urge, the Indian is capable of taking the white man's life with him.

After seeing this type of image, it is not difficult to understand why Deas would end up in an insane asylum. The brutality of the expressions and the subject matter of the scene, which he would later repeat in subsequent works, suggest insanity. The ravine, the dark and stormy sky, and the frightening drama expressed in the protagonists' faces are all an important part of the artistic legacy of this artist.

Right: Deas had moved to Saint Louis, a city that was almost the portal to the Mississippi Valley, with the objective of representing life on the frontier. One of his greatest interests was creating portraits of the Indians, and he uses the full range of his artistic skills here to represent this warrior. The scene is filled with tranquillity and silence. The Indian, totally serene, is seated comfortably on a large rock, secure despite of the danger inherent in the situation. The warrior has surely used this stony seat many times before to survey the horizon and alert his tribe to the presence of enemies. Outwardly calm, he is watchfully alert against attack.

This painting is a metaphor for the Indian situation. At this time, Native Americans had seen their numbers reduced from around ten million populating North America in the 17th century, to seven million by the middle of the 19th century. Deas's choices in this work show influences of two different artistic styles: the Indian's face does not show many traces of his race and is idealized, along Thomas Cole's lines, and the stormy landscape is extremely and dramatically Romantic.

To this must be added the presentation of the protagonist in an extreme location, at the edge of an abyss. The rocks are highly detailed, as well as the soft and near classical body of the Indian, reflecting Deas's academic training. The sun between the black storm clouds illuminates the heroic figure of this warrior dramatically, along the line of the most Romantic representations. Deas's later works would all display a much more extreme dramatic tone.

Deas's works demonstrate the movement from the neoclassicism of his first traditional scenes filled with balance, represented also by Bingham, to the purely Romantic and extremist scenes of the second half of the century. The comparison of this work with George Caleb Bingham's *Fur Traders Descending the Missouri* is inevitable. This comparison, however, only has one point of common ground: Both paintings show travelers on a boat. While Bingham's overall tone is friendly and peaceful, the current of the river silently accompanying the raft and its passengers, in Deas's painting, we sense a more thrilling and excited tone. Each element

The Voyageurs

(1846)
oil on canvas
13 x 20.2 in
(33.02 x 51.43 cm)
Museum of Fine Arts,
Boston

in the composition transmits a lack of balance and a sense of high drama, emphasizing the insecurity of the moment. The tilt of the canoe is the only axis; the compositional rhythm itself of the figures is jagged. The forms in the background are barely discernible as they blend into the black and troubled sky. It seems like, from one moment to the next, a bolt of lightning may split the canoe in half, putting a tragic end to the adventures of the men. The Indians were not the only threat to the trappers and pioneers in the South who Deas saw passing through Saint Louis; weather and environmental conditions, at times extreme, could also endanger their lives.

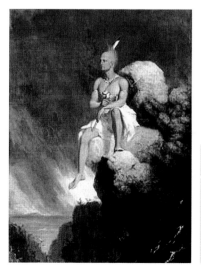

Indian Warrior on Precipice

(~1847)
oil on canvas
36.5 x 27.6 in (92.7 x 70 cm)
Museum of Western Heritage,
Los Angeles

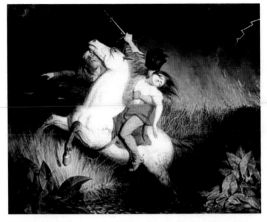

Prairie Fire

(1847)
oil on canvas
73.4 x 91.6 cm
Brooklyn Museum of Art,
New York

The subject matter that appealed to Deas was the struggle for survival—and his interest in this subject is understandable, considering the extreme conditions the pioneers of the frontier had to deal with. The dangers of the new lands were many. The mission of the pioneers was to tame huge areas of prairie land and establish cores of populations, but prairie fires and the dry climate often meant their efforts were doomed to failure.

At first, artists made an effort to represent the plains as a pleasant and manageable place, signaling the edge of the plains with a distant, but not too distant, mountain. Deas, however, drew attention to the dangers of the prairies and showed their tough and threatening character as fodder for flames. The enormous plains are not a paradise, perfect for starting a new life; rather, the land is one of the obstacles that pioneers will have to fight and overcome.

This painting shows a heroic pioneer who has rescued a youth from certain death by fire, caused by a lightning strike. The rampant white steed is the Pegasus of this hero, who rides with an old man who signals the way to him. A highly dramatic focus of light illuminates the equestrian figure, a white blaze in the composition. The perfect drawing and anatomical rendering of the horse, together with the detailed representation of the plants, speak of Deas's great artistic skill, perfected at the Academy. Dramatic excess is characteristic of Deas's works; he always chose situations at the limit to represent in his works. These images were often what people in the East saw when they received their first news of the frontier.

MARTIN JOHNSON HEADE

Cattleya Orchid with Two Hummingbirds
(detail), ~1880, oil on canvas, Newark
Museum, New Jersey.

Originally from a rural area, Martin Johnson Heade traveled all his life and hardly ever lived in the same city for more than two or three years. As a result, he got to know a large part of the United States, visited South America several times, and satisfied his interest in European painting during stays in Italy, France, and England. This restlessness continued until he moved to Florida and married at the age of 64.

He learned his trade painting portraits, genre scenes, and copies of European and American masters. At the age of 30, he became interested in landscapes, encouraged by members of the Hudson River School. Although he adopted technical elements from this school, he developed his own style, mostly painting luminous scenes of salt marshes along the East Coast.

The exotic landscapes and paintings of plant life and fauna of South America, which he completed during various stays there, are an important aspect of his work. His mature work includes seascapes, landscapes, and floral still lifes that he exhibited in prestigious institutions such as the National Academy of Design in New York, the Pennsylvania Academy of the Fine Arts in Philadelphia, and the Royal Academy in London. Nevertheless, his contemporaries soon forgot him after he left New York.

His art was rediscovered with the renewed interest in the Hudson River School during the 1940s. Since that time his work has been considered very significant.

- **1819** Born in Lumberville, in Bucks County, Pennsylvania. He is the oldest son of Joseph Cowell Heed, farm owner and sawmill worker. He is taught by his neighbor, the folk painter Thomas Hicks (1780-1849), and probably by his younger cousin as well, the portrait painter Edward Hicks.

- **1838** Travels to Europe to study. Visits England and stays two years in Rome.

- **1841** With the acceptance of his portrait of a little girl (now lost) in an exhibition at the Pennsylvania Academy of the Fine Arts in Philadelphia, he makes his professional debut.

- **1843** Lives In New York and exhibits at the National Academy of Design. Soon after, he moves to Brooklyn. Changes the spelling of his name from Heed to Heade.

- **1847** Moves to Philadelphia.

- **1848** Travels to Rome again and probably to Paris as well. When he returns, he exhibits regularly and lives for almost in year in St. Louis.

- **1852** Over the next three years lives in Chicago, Trenton, and Providence.

- **1859** Returns to New York. Rents a studio in the Tenth Street Studio Building, along with other artists, mostly Hudson River School landscape painters. This experience and especially his friendship with Frederic Church seem to move him to paint more landscapes in his personal style and begin his interest in panoramic landscapes with subtle atmospheric effects.

- **1861** Lives in Boston for two years and paints marine landscapes. Begins to experiment with floral still lifes.

- **1863** Travels to Brazil, where he stays until March 1864 to illustrate a series of South American hummingbirds, *The Gems of Brazil* (1863-1864, Manoogian Collection, Detroit).

- **1866** Travels to Nicaragua. Lives in New York until 1879 and keeps his Tenth Street studio.

- **1870** Travels to South America for the third time, visiting Colombia and Panama as well as Jamaica.

- **1872** Discovers British Columbia's beauty on a trip West.

- **1875** Stays in California.

- **1883** Marries Elizabeth Smith and moves to St. Augustine, Florida, where he paints landscapes and floral still lifes. Paints dozens of works over the next decade for his patron, Henry Morrison Flagler.

- **1904** Dies in St. Augustine.

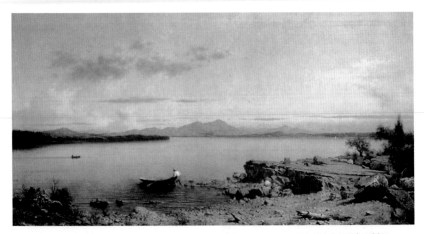

Lake George

(1862)
oil on canvas
26 x 49.8 in
(66 x 126.4 cm)
Museum of Fine Arts,
Boston

This peaceful, relaxing lake scene presents a man moving his boat. Mountains in the background and a wide sky are illuminated by warm light. Lake George, in the Adirondack Mountains of upstate New York, was a popular motif for the Hudson River School. This group of realist landscape painters, whose work was inspired by the beauty of the American landscape, was active from 1820 until 1880 in New York. They frequently painted scenes of the Hudson River Valley and mountains close to New York, such as the Catskills and the Adirondacks. Important members of this school were Thomas Cole, Asher Brown Durand, and especially, Heade's friend Frederic Church. This painting by Heade is different from the usual Hudson River School motif. He did not use the group's preferred point of view or the cold colors they typically selected. As a result, this is an unusual view of Lake George, with a color range that seems more appropriate for an arid desert than the exuberant greenery of the Adirondacks.

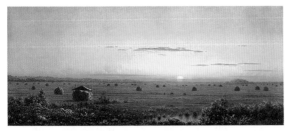

Ipswich Marshes

(1867)
oil on canvas
12 x 28 in (30 x 71 cm)
New Britain Museum of
American Art, Connecticut

This panoramic picture depicts a marsh in Ipswich, Massachusetts, in the northeastern part of the United States. The flat, wide landscape is bathed in the soft, romantic light of sunset. The protagonist of the painting is the sun, which, about to disappear, is still split between the flat land and the blue-magenta sky, decorated by elongated clouds. A few haystacks stand out against the light and steer the viewer through the composition.

Heade had begun painting marshes in 1859 and continued to do so until his death 45 years later. In total, he painted more than 150 marshes, which represent a fifth of his total work. While other painters like Frederic Church and Albert Bierstadt specialized in dramatic landscapes of spectacular places such as the Rocky Mountains or Niagara Falls, Heade was known for his marsh paintings. For him the salt marshes offered a peaceful, familiar landscape that he enjoyed. They allowed him to study light and its various combinations of color and intensity, depending on the time of day and time of year.

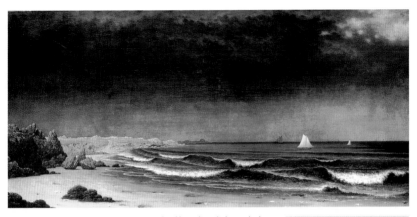

This is one of Heade's best-known works. He painted these dark, melancholy seascapes, which constituted an important part of his work, during the 1860s. Beneath a huge, dark gray, and threatening sky, breaking waves rush toward a rocky beach. We can still feel the calm before the storm. Two sailboats head to shore in these last few moments.

The sandy beach opens the panorama to the viewer, and the composition steers the view from the boats' small sails toward the lightest part of the sky, above the horizon at right. The journey ends at the white cloud in the upper right-hand corner, creating an opening in the sky and reflecting the last rays of the sun.

Heade has captured a familiar, disturbing atmosphere through a sophisticated composition of darks and lights. The picture's vision is unsettling and compelling.

Approaching Storm, Beach near Newport

(~18667)
oil on canvas
28 x 58.2 in
(71.1 x 147.9 cm)
Museum of Fine Arts, Boston

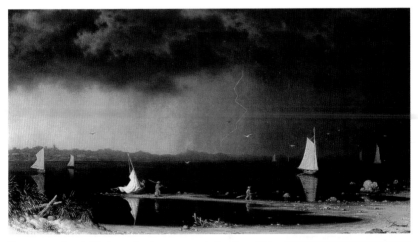

The protagonist of this dramatic, stormy scene is the sky, split by a lightning bolt. Heade has captured the moment that it strikes. The lightning bolt is between the dark and the lightest of the clouds. An intense rain appears in the background, and to the right, boats head toward the safety of the shore. The epic vignettes of people on the beach and the sailboats on the water recall 17th-century Dutch seascapes, and Heade's brown tones allude to this era as well.

Thunder Storm on Narragansett Bay is key to understanding Heade's work. The artist was almost totally ignored by his contemporaries and largely forgotten by the art world. In 1943, professor Theodore Stebbins discovered this painting. He was so impressed that he started a collection, in order to allow Heade's work to be appreciated by the public.

Thunder Storm on Narragansett Bay

(1868)
oil on canvas
32.3 x 54.3 in (82 x 138 cm)
Amon Carter Museum, Fort Worth

Orchids and Hummingbirds

(1875-1883)
oil on canvas
14.1 x 22.1 in (35.88 x 56.2 cm)
Museum of Fine Arts, Boston

As if taking a close-up photograph, Heade has painted, in detail, a yellow-and-red orchid with two beautiful, blossomed flowers growing along a tree branch. This exotic, splendidly beautiful plant stands out in this South American landscape not just because of its extremely unusual size, but especially for the leading role it takes in the composition. Despite its small size, the hummingbird, which appears opposite the orchid on the branch, also catches the viewer's attention with its iridescent red plumage. The luminous flowers stand out from the misty, verdant background.

Although an attractively integrated painting, the picture is actually an accurate botanical and zoological portrait of plants and birds in their natural environment. This combination of science and art should be understood in the context of artistic interest in this subject, which began to bloom around the middle of the 19th century. Heade, who began painting hummingbirds in 1863, during his first stay in Brazil, started adding tropical flowers to enrich the paintings during the 1870s. He continued to paint such scenes until the end of his life.

Right: In this picture, Heade presents a pink orchid with an intensely red calyx, a palm tree, two hummingbirds in a tree, and in the background, a mountain covered in tropical mist. The birds are small compared to the bright flowers. The artist placed the female, with her simple gray plumage, in the center of the composition. The showy red-headed male forms a triangle with the flowers that echoes the mountain in the background.

Cattleya Orchid with Two Hummingbirds

(~1880)
oil on canvas
Newark Museum,
New Jersey

Heade's interest in painting hummingbirds and orchids in tropical South America is rooted in two motives: his fondness for these beautiful birds, and the fascination with the wildlife and environment of these tropical countries shown by 19th-century artists like John James Audubon and William Gould. Heade adored hummingbirds from childhood, and his enthusiasm continued for more than 50 years. These pictures of hummingbirds and flowers should be understood as part of a long tradition of still lifes painted in tropical settings.

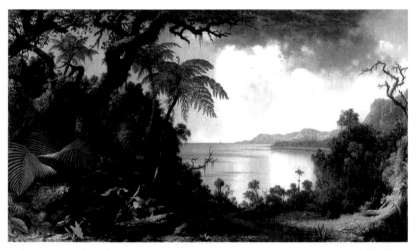

Heade's relationship with the tropics originated in 1853 when, after reading Alexander von Humboldt's *Book of the Cosmos,* he traveled to Colombia and Ecuador. Heade was attracted to the exuberance and virginity of the forests in this humid enviroment, which to him evoked the beginnings of human civilization. He kept this fascination for the rest of his life and traveled several times to Central and South America in the 1860s and 1870s.

This picture was painted much later for Henry Morrison Flagler, Heade's patron. It shows a typical tropical landscape, with abundant foliage and trees in the first plane leaning toward a path. The tallest trees on either side of the path come together beneath a dark cloud, allowing the viewer a telescopic view of a peaceful bay and soft, white clouds. With no indication of human life, this landscape becomes an image of paradise. Heade has planned the painting so that all the edges are painted in dark, dense colors. With these colors, which contextualize the landscape and define the elements, he forces the viewer toward the center of the painting, where the horizon opens and the colors lighten to offer a relaxing, fascinating vision. This is one of Martin Johnson Heade's greatest and most mature works.

View from Fern-Tree Walk

(1887)
oil on canvas
53 x 90 in (134.6 x 228.6 cm)
Manoogian Collection, Detroit

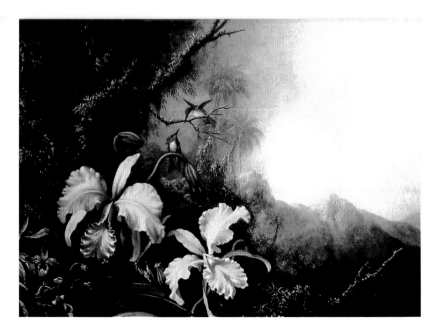

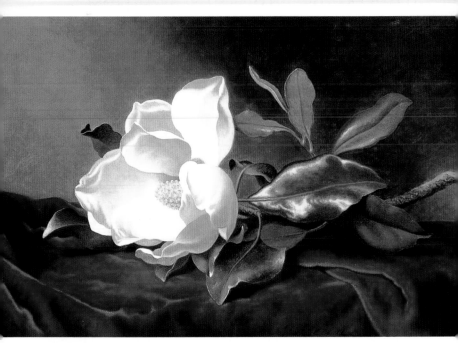

Giant Magnolias on a Red Velvet Cloth

(~1890)
oil on canvas
15.1 x 24.2 in
(38.4 x 61.5 cm)
National Gallery of Art,
Washington, D.C.

The beauty of this magnolia on red velvet defines this still life. The picture is one of the last Heade painted in Florida. His final paintings were variations on still lifes with flowers. *Giant Magnolias on a Red Velvet Cloth* is a horizontal composition in which Heade plays with the contrast between the white flowers and the dark background as well as the varying textures.

This work shows, once again, Heade's technical mastery. The artist controls the brush so well that the work has an almost hyperrealistic appearance. During his last years, the painter was very close to his patron, Henry Morrison Flagler, a wealthy businessman. (He was John D. Rockefeller's partner at Standard Oil.) Heade and Flagler discovered St. Augustine at the same time, and Flagler decided to turn it into the Newport of the South. The Ponce de Leon Hotel, which opened in 1888, five years after Heade's arrival in St. Augustine, had seven studios reserved for artists. This sparked the guests' interest in art. Flagler gave Heade one of the studios and encouraged and supported him at all times until Heade died six years later. During his years in St. Augustine, Heade painted more than 150 pictures, most of them landscapes and still lifes.

THOMAS WORTHINGTON WHITTREDGE

Emanuel Leutze, Whittredge, *1865, oil on canvas, 15 x 21 in (38.1 x 53.4 cm), Reynold House, Museum of American Art, Salem, North Carolina.*

Thomas Worthington Whittredge was essentially a self-taught and independent painter. He never had any formal schooling, not even at the outset of his professional career. Even when he traveled to Europe, he never had a very close relationship with the Academy, because he found it more rewarding to take private classes with his teachers than to attend a general art class.

Nevertheless, in addition to careful training from his teachers, Emanuel Leutze and Karl Friedrich Lessing, he also established close friendships with other American painters, such as Sanford Gifford and Albert Bierstadt, who were his companions on a Grand Tour of Switzerland and Italy.

In Rome he separated from his friends and set about earning a living there as a landscape artist for five years. These landscapes, which sold well to tourists in Italy, were not very popular in the United States because they were too European. Once installed, starting in 1859, in the Tenth Street Studio Building in New York, Whittredge radically changed his subject matter and began to paint American landscapes, which were far better received.

His style is very variable. It fluctuates between his own highly detailed approach, similar to that of the German Academy, to the intimate style of the Hudson River School, particularly that of Durand. He was also influenced by the light and color studies of the

- **1820** Born on a farm near Springfield, Ohio.
- **1837** Moves to Cincinnati, where he works as a painter and daguerreotypist.
- **1840** Focuses on portrait painting.
- **1843** Begins painting landscapes.
- **1845** His works reflect the influence of Thomas Cole and Asher Brown Durand, who had personally inspired him to continue his career in landscape painting.
- **1849** Subsidized by his Cincinnati sponsors, he travels to Düsseldorf, Germany. There he studies independently with two Academy teachers: Emanuel Leutze and Karl Friedrich Lessing.
- **1854** Travels to Switzerland, where he makes some studies of the Alps. Moves to Rome, where he stays for five years.
- **1859** Austria invades the Italian Piedmont. Frederic Church exhibits very successfully in New York. Whittredge returns to the United States and moves into a studio in the Tenth Street Studio Building.
- **1861** Elected a member of the National Academy of Design in New York.
- **1866** Embarks on a series of trips to the West Coast, accompanied by Sanford Gifford and John Frederick Kensett.
- **1865** Elected president of the National Academy of Design.
- **1870** Travels with Kensett to the American West, making sketches.
- **1871** Visits the Platte River.
- **1874** Elected president of the National Academy of Design for the second time. Along with Kensett and Gifford, he accompanies General John Pope on an expedition from Kansas to New Mexico. He is greatly impressed by the vast plains.
- **1880** Moves to Summit, New Jersey. His landscapes are filled with color tones. He starts his autobiography.
- **1896** Goes to New Mexico to make sketches with Church.
- **1910** Dies in Summit, New Jersey.

Barbizon School, though he would later reject the tendency to introduce figures in the midst of a work about nature. As much for his studies of color and light as for his supple touch, his works are considered pre-Impressionist, except that, for Whittredge, nature has a more intimate character, where an atmosphere of silence and mysticism reigns.

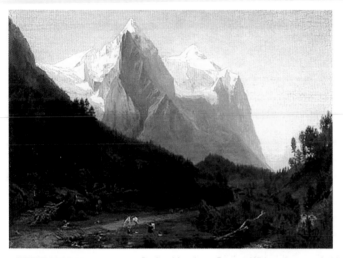

The Wetterhorn

(1858)
oil on canvas
39.5 x 54 in
(100.3 x 137.2 cm)
Newark Museum,
New Jersey

During his trip to Europe, Whittredge traveled in Switzerland, where he did some sketches of the Alps. He always carried a sketchbook to draw landscapes as he saw them, and he recorded detailed accompanying notes for each sketch.

While his traveling companion, Bierstadt, was comfortable drawing the enormous alpine landscapes, Whittredge preferred close-ups so that he could portray an air of intimacy in his works. It could be said that while Bierstadt moves the viewer back from the landscape, emphasizing the grandiose, Whittredge draws the viewer in, stressing natural values. Thus, without idealizing it, the artist portrays the mountainous landscape at a distance, flooding the peaks with light, while in the forefront he depicts a landscape in the shades of the late afternoon, where there are two elements: a man and his horse. Silence reigns, broken only by the twitter of birds and the gurgling of the river.

The palette is dark in the front and uses bluish shades in the background, all designed to ensure that the mountains remain distant for the viewer. The attention to detail, acquired during years of study with Leutze in Düsseldorf, is present in the perfectly drawn contour of the peaks and in the faithful representation of nature in the small, intimate foreground landscape. Whittredge is very careful with perspective, bounded by the path into the forest and the aerial view of the mountains.

The Old Hunting Grounds

(1864)
oil on canvas
36 x 27 in (91.4 x 68.6 cm)
Reynold House Museum of
American Art, Salem, North
Carolina

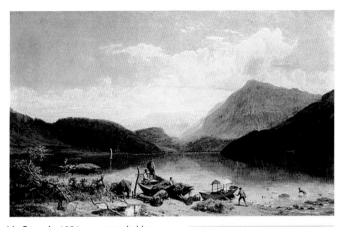

Whittredge arrived in Rome in 1854, accompanied by Sanford Gifford and Albert Bierstadt. This Italian city was the highlight of the Grand Tour of Europe popular among artists and students, basically due to its fame as the cradle of the arts—it was a kind of learning tour. Whittredge decided to remain in Rome longer than his companions since the city was a comparatively inexpensive place for an artist and offered landscape painters a good source of income. The city's surroundings were full of useful inspiration for foreign painters, who portrayed them on canvas and then sold the landscapes to tourists. This was Whittredge's source of income for the five years he stayed in Rome.

Landscape near Rome

(1858)
oil on canvas
33 x 54 in (83.82 x 137.16 cm)
Butler Institute of American Art,
Youngstown, Ohio

This is one of the colorful vistas he made during this period. It closely resembles his Swiss work. Although it was painted during a summer he spent near Lake Albano and the Sabina Mountains, this work has nothing to do with these landscapes; rather, it is a typical scene from Northern Italy. The landscape, the men's attire, and the boats are all suggestive of those used in the North. The figures add color to the picture and are typical of European landscapes. At this time, Whittredge did not feel very secure in painting mountain grandeur, so he kept the peaks at a safe distance in the background, showing them from an aerial perspective.

Left: By 1859, Whittredge had returned to the United States and established himself in the Studio Building in New York, on the north side of Tenth Street on Fifth Avenue. The building had been sponsored by millionaire James Boorman Johnston, whose brother served as the first president of the Metropolitan Museum of Art (Whittredge had played a part in its founding). Johnston understood the importance of providing artists with suitable working rooms at reasonable rents, as well as a congenial atmosphere for them to exchange ideas. In 1857, Johnston commissioned architect Richard Morris Hunt to design the building to include more than 20 studios and an exhibition room that later became the studio of painter William Merritt Chase.

After its opening in 1858, Frederic Church exhibited his *Heart of the Andes* work there with outstanding success, so much so that Whittredge was encouraged to move back to New York. He returned to the United States laden with tourist sites of Rome and Switzerland, ready for sale. These European landscapes did not gain much success in New York, and Whittredge turned to drawing American landscapes. The artist was never comfortable with vast landscapes, always preferring to show the detail and diminutive views that give his work its highly intimate character. This piece is representative of this style. It even has a sense of mysticism, developed by the way the light filters through the trees. This view focuses on the silence of the forest; a quiet stream and an abandoned boat add to the atmosphere.

View of Kauterskill

(1868)
oil on canvas
19.5 x 15.5 in (49.6 x 39.4 cm)
Private collection

One thing that characterizes Whittredge's work is his capacity to absorb European influence. He took some elements, rejected others, and created his own style in accordance with his understanding of landscapes. This work exemplifies Whittredge's highly personal style. Surprisingly, here he leaves behind his precise academic brushstrokes to produce one of the most innovative landscapes ever done by any of the many American landscape artists. The very loose finishing touches, almost brushstrokes, suggest Impressionist influences. Whittredge, like the Impressionists, was affected by the same basic influence—the Barbizon School, which fostered remote and academically precise touches. With this approach, this school fragmented tonality, as Whittredge had observed in Paris.

In this work, Whittredge uses the technique to depict Kauterskill Falls in New York State, heightening the warm colors of the landscape and applying the sketchy treatment even to the clouds in the sky. The high vantage point enables the viewer to take in, in a single glance, the entire landscape. However, the details are so completely eliminated by Whittredge's brush style that the trees in the foreground cannot be distinguished individually. Even the rocks in the foreground are quite sketchy. They are, perhaps, together with the trees, the white thread of the waterfall, and the mountains, the only recognizable elements in the landscape. Whittredge, who belonged to the second generation of Hudson River School painters, discards any established style here to impose his own view.

Right: Whittredge saw nature in a mystical sense, as a means to attaining spiritual salvation. This sense was shared by other Hudson River School painters, such as George Inness. These men agreed that nature shows her beauty and fascination to all people equally, not to an elite group. Furthermore, nature symbolized the pioneering spirit of Americans, their present and future, in the face of a lack of historical tradition. Landscapes from this group are often filled with smooth light filtering through the trees, as seen in this work. This forest scene is perhaps the most characteristic of Whittredge's works. The painter draws the viewer toward the landscape, inviting him to drink directly from the waters of the river, just as the musk deer do. But while in *House by the Sea* the composition is more open, here two trees frame the light that is central to the composition. This light symbolizes the presence of the essence of God in nature and the protection this gives the American people.

Whittredge, who traveled to Rhode Island, also painted landscapes showing the American coast. Here, a sudden about-face for the painter can be seen. The painting shows a more horizontal and open landscape than his interior scenes in American forests. Once again, Whittredge uses attention to detail to depict rural scenes, this time coastal farms. The perspective drops into the horizon with blue-and-white tones—to the point that boat sails in the background are visible only through a curtain of haze.

House by the Sea

(1872)
oil on canvas
36.2 x 54.2 in (92 x 137.6 cm)
Addison Gallery of American
Art, Andover, Massachusetts

This is a humanized landscape that lacks the wild strength of the first generation of Hudson River School scenes. The sea is very calm; both earth and water have clearly been domesticated by man. The academic influences of Whittredge's early days are seen, creating a strong contrast with his previous work. Perhaps the presence of his early teacher, Emanuel Leutze, in the Studio Building reignited Whittredge's concern for line and drawing. On the other hand, it was to the tradition of the Hudson River School that he owed his interest in shaping vegetation in great detail. Nevertheless, the painting is not without a very human, very day-to-day and intimate character. An old lady is seen at the door of the house with geese crowded around her. To the right are chicken coops, hidden by the shade, and in the background, crops and farmers tilling the soil. Although the scene appears picturesque and idealized, it includes a very realistic depiction of its subject.

Deer Watering

(~1875)
oil on canvas
19.8 x 15 in (50.2 x 38.1 cm)
Kennedy Galleries, New York

Along the Delaware

(~1875)
oil on canvas
12 x 15.5 in
(30.5 x 39.4 cm)
Brigham Young
University Museum
of Art, Provo, Utah

Whittredge was always traveling and making sketches in his sketchbook. His style evolved from the detail and clarity of his early study in Düsseldorf toward a more free brushstroke style using soft colors and subdued tones to represent the landscape. This was the result of the influence of the French Barbizon School of landscape painting, whose works Whittredge studied in Paris. While he was very attracted to Paris as an artist, he never thought about staying there because of the high cost of living. The artist, who had earned his living on the frontier as a hunter and later as a painter, preferred to establish himself in Rome.

Although miniaturist in scale, this work reflects man in harmony with nature and thus draws the viewer to the landscape and the river. Both the man and the dog with him are part of the landscape. This conciliatory view probably stems from Whittredge's happy childhood memories of frontier life.

Woodland Glade

(~1895)
27 x 34 in
(68.6 x 86.4 cm)
Brigham Young
University Museum
of Art, Provo, Utah

Once more the painter portrays a scene inside a forest. This time, the influence of the Barbizon School is clearly reflected in the naturalist aesthetic, at that time a growing influence in American painting, replacing the waning impact of the Hudson River School. However, Whittredge also still remains faithful to Durand's intimate perspective. This painting—similar in composition to earlier works such as *The Old Hunting Grounds*—has little aesthetic pretension; the artist is working simply to capture the freshness of the moment.

The fact that the composition centers on the point of light in the sky indicates that Whittredge, despite his advanced age, had not yet abandoned a fascination with the light-filled landscape studies that always intrigued him. Whittredge, who became an important member of the Hudson River School when he arrived in New York, served two terms as president of the National Academy of Design, although he never abandoned the nomadic personality that made him travel and explore new corners of the United States. His focus, however, was not on the great landmarks, but rather on the meticulous recording of naturalistic details in small forests and rivers.

LILLY MARTIN SPENCER

Self-Portrait, *1841, oil on canvas, 25.5 x 30 in (64.8 x 76.2 cm), Ohio Historical Society Collection, Columbus.*

Educated in a liberal environment and trained with the best portraitists in Ohio, Lilly Martin Spencer was one of the few women of her time who dared to develop her artistic career in a world dominated by men. Although she successfully worked in genres such as still lifes, she was best known for her interiors, imbued with a cozy spirit of love for the home. They perfectly captured the pleasure of intimacy held by bourgeois families, but they were really nothing more than a reflection of her own marital happiness (the models for these works were members of her own family).

The precision of her drawing, together with a technique that revealed her interest in Renaissance art, made her worthy of the attention of the critics and public alike, who started to hire her for portraits. The painter's portraits manage to add a special symbolism to the idealized appearance and studio poses of her sitters, so that her art shows the distinct characteristics of the person being portrayed. Each portrait was much more personal than a simple decorative image or object of luxury. This symbolism reached its zenith in her series depicting different women in the kitchen. Many considered these images an ironic mockery of the reigning social system of the time, which relegated women to limited and servile roles. Despite the harsh criticism these works received when they were first shown, they are today considered the most visionary paintings of Spencer's entire collection.

- **1822** Angélique Marie Martin is born on November 26 in Exeter, England, daughter of Giles and Angélique Martin, two followers of Charles Fourier's theories.
- **1830** The family emigrates to the United States to found a utopian colony, determined to support the fight for abolition and women's rights.
- **1832** Educated by her parents at home with the help of a substantial library.
- **1839** Makes numerous portraits and family scenes in charcoal.
- **1841** The family moves to Marietta, Ohio. Exhibits at a local church, charging 25 cents per person to fund her education. Travels to Cincinnati to look for a patron who will defray the costs of her studies.
- **1842** Meets Nicholas Longworth, a patron of the arts who makes his collection of paints and paintings available to her and introduces her to the portraitists James Beard and John Insco Williams. The latter will later give her painting classes.
- **1844** Marries Benjamin Rush Spencer, who will support her thereafter.
- **1845** Sells prints of her paintings for five dollars apiece.
- **1848** Exhibits at the National Academy of Design and the American Art-Union.
- **1849** Moves to New York with her family.
- **1850** Works as an illustrator for different books and magazines, as well as painting commissioned portraits.
- **1851** Starts her series of kitchen scenes.
- **1852** At an American Art-Union exhibition, some of her work sells for more than the paintings of John James Audubon, George Caleb Bingham, and William Sidney Mount.
- **1854** The Western Art-Union buys one of her paintings to reproduce on lithographs and prints.
- **1858** Moves with her large family to New Jersey.
- **1860** Rents a studio in New York.
- **1869** Refuses to sell one of her works for the weighty sum of $20,000.
- **1876** Exhibits her series of small "cabinet-sized" paintings at the Philadelphia Centennial Exhibition.
- **1902** Dies in New York on May 22.

Domestic Happiness

(1849)
oil on canvas
55.5 x 45.3 in
(140.97 x 114.94 cm)
Detroit Institute of Arts,
Michigan

When this work was exhibited for the first time, the painters that viewed it praised the technical genius of the artist for tackling such a difficult composition. *Domestic Happiness* was based on drawings of Spencer's two sons, asleep in each other's arms. The parents (the mother is a self-portrait of the artist) watch the boys with tenderness and pride, lit by a gentle light that accentuates the homey feeling. The husband's features are soft and sweet, in high contrast to the masculine image of this time, which was invariably stronger and more vigorous and never so gentle. Spencer's admiration for Renaissance works can be seen in the triangular composition, with its base along the children's bed.

Spencer gave birth to 13 children, although only seven of them would reach adulthood. Maternal themes would be one of the artist's most recurring subjects, whose work supported her family. Because of this, many critics were disparaging and ridiculed her distinct lifestyle and by extension her painting as well, although they could not stop her overwhelming public success. The truth is that, besides being a talented artist, Lilly Martin Spencer was also an intelligent marketer of her work. From the time of her first exhibition at the church in Marietta and the prints for the lottery in Cincinnati (which was declared illegal by the authorities) through the large New York exhibits, she struggled long and shrewdly for artistic recognition.

The painter sought exactitude in her representation of the home in this work, which may seem strange as she was not the one who actually took

Conversation Piece

(1851-1852)
oil on canvas
28.3 x 22.6 in (71.9 x 57.5 cm)
Metropolitan Museum
of Art, New York

care of her own home. Spencer often used family members as models in her works to increase their credibility. She is the protagonist of this family scene, holding her third child in her lap with her husband behind, who plays with the infant by dangling cherries above him. The artist is elegantly dressed in a yellow silk skirt and a white blouse, while her son is swathed in the typical dress of this time for boys and girls alike—bows and lace. Benjamin Spencer wears a formal dark suit, but his posture is warm and affectionate. The scene contains a natural tenderness, with none of the characters paying attention to the viewer, absorbed as they are in mutual contemplation. This is surely the family room of the Spencers' apartment in New York, whose decorations reflect the painter's European origins. There is a screen, a Limoges ceramic compote from France, a French-inspired lamp, and a doll typical of Suabia in Germany, near the French border, which has been cast onto the floor by the child, entranced by the new vision being offered by his father. The cherries and the small Venus sculpture on the shelf by a mirror have been interpreted as symbols of the pleasures of home life. Spencer's works always contained these types of symbols; without them, the composition might have had a stuffy appearance.

Young Husband, First Marketing

(1854)
oil on canvas
29.3 x 24.8 in
(74.3 x 62.9 cm)
University of Michigan,
Ann Arbor

Fortunately, Lilly Martin did not have to renounce her artistic profession when she married Benjamin Spencer. Here we see Benjamin struggling to keep his market purchases inside the basket, beneath the jeering glance of the gentleman passing behind him. The social prejudices Spencer's husband had to put up with were enormous throughout his life, as it was most unusual for a wife to embark upon such a dishonorable career-oriented path. Lilly Martin Spencer pays a humorous homage here to the steadfast and sensible nature of her husband, perhaps depicting a scene that she herself lived. The man, dressed in an elegant suit, with umbrella and hat, tries to balance the basket overflowing with market foods. Some of the contents have spilled to the ground, and the eggs have broken. The man tries to keep the rest from falling. The chicken is about to slip from between his fingers as he tries to hold the load on his knee without losing his balance.

The painter shows a new vision of the 19th-century man, far from the myth of the traveler or the dandy, which were products of cultural codification that told men and women how they should act and feel. Her paintings encompassed the virtues of small daily acts of heroism. Her vision shows great modernity, framed as a comic episode, although it contains nothing of the ridiculous. The man grimaces with true effort, and his stance portrays a great deal of determination to master a task that for him is an arduous one.

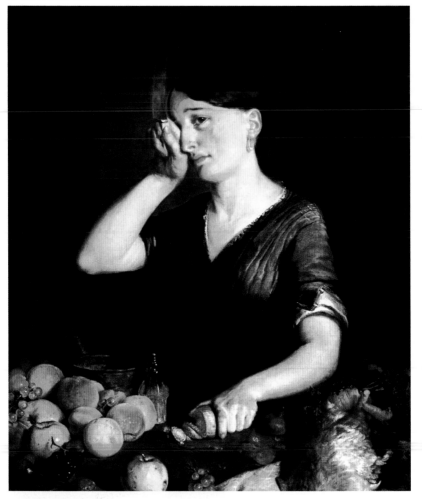

Peeling Onions

(1852)
oil on canvas
36 x 29 in (91.44 x 73.66 cm)
Memorial Art Gallery, University
of Rochester, New York

During this period, Spencer started a series of paintings that had household chores as their main theme, but were principally centered around the kitchen. Within this domestic setting, a certain sarcastic air is noticed that is representative of the second half of the 19th century. The painter shows a woman who is crying while peeling and slicing an onion, along with a splendid still life made up of fruits, a chicken, and earthenware pots. These "false" tears may be Spencer's response to those who criticized her work by denouncing a woman who had abandoned her natural place: the kitchen. It was interpreted to mean something like "Look how I am crying not to be in front of the hot stove in my home." However, this series was not successful with her clients, as the representations were not very endearing.

The artist would next turn to more commercial subjects still centered on domesticity, but emphasizing the virtues of the housewife. The American bourgeois mentality, while more advanced than the European in some ways—for example, women were allowed to enter art academies—was still not prepared to admire the type of personal statement made in *Peeling Onions*. They preferred to acquire work that represented themes more in keeping with society's approved feminine roles, such as maternity or marriage. In her later, more commercially successful works, Spencer portrayed women as angels in the home, caring mothers and loving wives.

Kiss Me and You'll Kiss the 'Lasses

(1856)
oil on canvas
30 x 25 in (76 x 64 cm)
Brooklyn Museum of Art,
New York

The title of this work plays with the words kiss and lasses, a paronym of ashes. A kitchen maid in a green dress stares at the viewer with mischievous complicity. Her smile invites the viewer to discover the title's play on words—it alludes to the furtive flings between a maid and the man of the house. The servant is near the fire—a symbol of awakening the dormant desires of secret lovers, although the fire will later turn to ash.

There is incongruous irony in the fact that the girl wears an attractive, billowing silk dress with a crinoline, short sleeves, and a low-cut neckline, not a practical choice for cooking over the fire. This image is from a series that Spencer made about women in the home, and despite inspiring affection in the public, the works did not convince buyers of their sincerity. These paintings were intended to decorate the houses of the moneyed upper classes of Ohio, who saw in them an indulgent reflection of their private lives.

The history of women in the United States is very different from that of Europe. Because of this, there were several women artists of the stature of Lilly Martin Spencer. The artist began to enjoy the fruits of her success about this time, working on canvas on the small cabinet-sized paintings like those in the pages of weeklies such as *Godey's Lady's Book*.

This Little Pig Went to Market

(1857)
oil on wood
16 x 11.9 in (40.64 x 30.1 cm)
New Britain Museum of
American Art, Connecticut

The painter's interest in Italian Madonnas can be noted here in the technique, the composition, the subject matter, and the format of this work, which reproduces the idea of the Renaissance's religious tabernacle with an American twist. It is an oil painting done on a wood panel, whose upper border is the curve of the wood, imitating the wooden boards of the great masters. The mother (who is Spencer herself) and son play in the morning light as if they were the Baby Jesus and the Virgin Mary. The curve of the mother's back and head and the shape of the child's bedchamber, which is disorderly, heighten the triangular composition.

This Little Pig Went to Market reflects a mother's love; she wants nothing more than to spend time with her son. The little boy, with his tangled curls, and looks happily at the viewer, removing any solemnity from the work. His mother plays a familiar game with him while caressing his toes and foot. This painting legitimizes the relationship between a mother and child, imbuing it with an almost religious appearance. There is an air of intimacy that brings to mind the interiors of the rococo period. Spontaneous touches can be noted in the mother's feet, resting on the footstool, and the child's shirt.

War Spirit at Home

(1866)
oil on canvas
30 x 32 in
(76.2 x 81.3 cm)
Newark Museum,
New Jersey

Here the painter shows the consequences of the Civil War. There are no men in this dining room, only women and children. The mother reads about Grant's victory at Vicksburg in the newspaper, which meant a shift in favor of the North. The children play soldier, and the maid sets the table while trying to read the expression on her mistress' face.

This work depicts more than a simple household scene: It is an almost documentary portrait of the catastrophe wrought by the war upon families as fathers, sons, and brothers left for almost certain death. The atmosphere has lost the clarity of Spencer's other representations, turning dark and cold. The war forced many women to move forward alone in a world that until then had been organized and dominated by men. From this time on, American women would take take up a struggle for their rights, while European women continued to carry the weight of many centuries of cultural baggage.

We Both Must Fade

(1869)
oil on canvas
72 x 53.7 in (182.8 x 136.3 cm)
Smithsonian American Art Museum, Washington, D.C.

Lilly Martin Spencer also created portraits, adding the characteristic symbolism of her other work. Here her model, Mrs. Fithian, is depicted almost life-size, dressed in a spectacular blue silk dress with a sweepingly low neckline. One of her diminutive feet can be seen under the folds of her skirt, stretching toward the viewer, in an almost rococo style. The rose in the young woman's hand alludes to the meaning of the title. During the second half of the 19th century, European paintings depicting "decadent" subjects enjoyed success among the American upper class, who enjoyed reflecting some form of European tastes. The progressive loss of beauty was one of the topics that most worried the well-to-do society of this time, and it is symbolized here by the rose Mrs. Fithian holds in her hand that will soon lose its freshness. The extraordinary detail apparent in the fabrics demonstrates Spencer's outstanding talent. She was one of the first women who dared to express herself in the arena of American painting.

ROBERT DUNCANSON

W. A. Notman, *The California African American Museum.*

- **1823** Robert S. Duncanson is born in Seneca County, New York. His mother is a black woman from Ohio and his father a white man of Scottish ancestry from Canada. (The date of Duncanson's birth is very uncertain. During the 19th century in the United States, birth registry for people of color was practically nonexistent.) Because of racial tension in the United States, his father decides to take him to Canada, where Robert begins his art studies and copies landscapes by the masters of the Hudson River School.

- **1841** Returns with his mother to Cincinnati, where he holds a short exhibition of his paintings.

- **1846** Starts the most productive period of his career, introducing neoclassic elements into his landscape painting.

- **1853** With the support of Nicholas Longworth, a prominent Cincinnati citizen, he travels to Europe, where he makes contact with the works of the classical masters. During the Civil War, he lives in England and Scotland.

- **1872** Falls ill with a mental breakdown while preparing an exhibition in Detroit, Michigan. He dies shortly thereafter.

Robert Duncanson is the first black painter in the United States to be considered as such during his own lifetime. At a time when slavery and racial discrimination were still burning realities, Duncanson exploited the European origins of his father to get an education that would enable him to work as an artist.

Although a little-known painter, his work, mainly preserved in Washington's Smithsonian American Art Museum, breathes a singular sensitivity, born of a union between classical form and the landscape painting of the Hudson River School. Although his work shows clear differences from that of the Hudson landscape artists, the way he handles light and the expressive quality of his nature paintings perfectly reflect the depth of the landscape. Duncanson was clearly one of the last expo-

nents of luminism. His painting has vivid and quivering compositional vision, combining a sense of the monumental with classical architectural elements. Robert Duncanson mingles the American naturalistic tradition with an aesthetic neoclassical pictorial sense, giving rise to a style that can reasonably be labeled as a post-Romantic reminiscence. Duncanson played with natural effects to create a lyrical and expressive atmosphere.

Roses Still Life

(1842-1848)
oil on canvas
10.8 x 15.2 in (27.4 x 38.5 cm)
Smithsonian American Art
Museum, Washington, D.C.

During his early years as an artist, Duncanson was a solitary figure. His artistic training in Canada gave him unique opportunities, but his efforts to integrate with other artists were not always successful. Seeking acceptance and a wider audience, his first steps in painting were reproductions of landscapes by painters of the Hudson River School, and years later this time would prove critical in his artistic development. In this work, a departure, the artist indulged in an exercise in realism and sensitivity. Still lifes on natural subjects were seldom seen in the United States; most stemmed from the painting of 18th-century central Europe. Duncanson here shows a new vision in painting such still lifes. With a remarkable sense of proportion and space, the artist experiments with intense colors that contrast with the smoothness of the flowers. Thus, leaves and stems are painted a very dark greenish color and the background is filled with an intense hue, so that the flowers contrast strongly for a very original luminosity. Duncanson plays with darkness and brightness, while carefully defining the spaces between the light and the dark.

Pompeii

(1855)
oil on canvas
21 x 17 in (53.3 x 43.2 cm)
Smithsonian American Art
Museum, Washington, D.C.

Contrary to what might be have been supposed, the Afro-American origins of Robert Duncanson did not present a barrier for the artist, despite the political and cultural atmosphere of the United States in the mid-19th century. Thanks to his education outside the country, Duncanson was able to maintain tight control of his incursions into the American art scene. He contacted a very selective public and befriended people such as collector Nicholas Longworth. Thanks to the financial backing of this Cincinnati benefactor, Duncanson was able to travel to Europe, where he became acquainted with Renaissance painting and studied landscapes filled with the classical ruins that would later inspire him to create a neoclassical series of his own.

In these paintings Duncanson created a Romantic vision of the ruins of Pompeii. His interest in monumental landscapes appears in some of his works, and he created spaces that defeat depth, where architectural elements arranged in linear fashion are used to control the pictorial space across the whole canvas. Here, the column that stretches into an exquisite sunset sky gives the picture a verticality that is repeated in the column of smoke rising from Vesuvius.

Mount Healthy, Ohio

(1844)
oil on canvas
27.9 x 36 in (70.8 x 91.4 cm)
Smithsonian American Art
Museum, Washington, D.C.

Left: On his return to Cincinnati, Duncanson rediscovered American neoclassical architecture. He arrived at a time of urban splendor and major architectural projects in a country that, committed to making great symbols of all its institutions, had found inspiration in the classical style. In this painting, Duncanson produced a work of contrasts in which he uses light expressively but also as a main directive element for the composition.

Dividing his pictorial space into two well-differentiated areas, the artist has developed a realistic language in which simple details complement the still-lively blue light of a sunset. Duncanson paints the shades of night that already hang over the fields, while a luminous white emphasizes a new vision of the period represented by the neoclassical mansion in the center of the painting. The painter draws the architecture with special clarity, centering the building and raising it as if it were a modern feudal castle, surrounded by its own land and properties—a romantic image that shows the European influence on the development of a new country.

Freeman Cary

(~1856)
oil on canvas
43.4 x 35.2 in (110.2 x 89.5 cm)
Smithsonian American Art
Museum, Washington, D.C.

While details of Robert Duncanson's career are very scarce and often appear manipulated for or against the idea of Afro-American art in the United States, his paintings seem not dissimilar to those produced by the white-dominated art world. In the United States, as in Europe, portrait painting was an exercise in representation. A portrait was not only proof of the artist's skill; it also improved the artist's social standing if he painted a person of high status. The portrait of Freeman Cary, one of his rich benefactors, shows the still very classical conception of American portraiture. The composition, which assumes some modernity thanks to its expressive use of coloring, reflects the influence of late 18th-century American portraiture traditions. This is illustrated by the central positioning of the subject. He has been placed under a delicate light, against a background of light and shade, to give greater expressive force to the face. The subject's expressive body pose and the window add a sense of openness and light that contrast with the room's claustrophobic atmosphere.

Right: Starting in 1865, Robert Duncanson's art became melancholy. His paintings, often showing nostalgia for his country, were generally simple, luminist landscapes. Then, after a season traveling in Europe, the artist went through an artistic dichotomy: He showed pictorial euphoria for European culture and landscape *and* American nature in a Romantic and bucolic fashion.

This work belongs to the painter's last artistic period. In the 1870s, Duncanson began to concentrate on monumental landscapes where nature was shown in all its savage strength. The artist adopted the criteria of luminism, reverting to a very pure, almost spiritual Romanticism and introducing elements of civilization to echo Ruskin's theories that man and his landscape are the work of God. Perhaps already affected by the depressive anxieties that would make him critically ill just two years later, the painter became overwhelmed by nature's magnificence and began to portray himself as a little man in the face of divine force.

This painting is a return to the most classical canons of luminism. The use of the river as an axis in composing the painting and the luminosity that emphasizes the ochre tones echo the European Romantic movement, giving the work a melancholy air that captivated the artist.

Mountain Pool

(1870)
oil on canvas
11.1 x 19.9 in (28.3 x 50.6 cm)
Smithsonian American Art
Museum, Washington, D.C.

The evolution of Robert Duncanson's painting can be seen in the progression from traditional monotone luminism to this generously colored landscape, which joins several different spaces in the work and plays with them. The artist confers his own personality on the individual elements of the picture, equipping each with its own light and tonality. Natural and architectural elements facilitate the reading of the work and add vivacity.

In this work, Duncanson depicts a sparkling landscape, divided by the rainbow. Thanks to this natural element, the artist creates an imaginative vision with a very novel layout; the entire work is subordinated to the optical effect of the rainbow. The viewpoint is set at a slightly elevated site, so that the landscape seems to emerge right at the feet of the viewer. From here, an effect of depth leads the eye into the painting, toward a distant view of a romantic copse.

The Rainbow

(1859)
oil on canvas
30 x 52.2 in
(76.3 x 132.7 cm)
Smithsonian American Art
Museum, Washington, D.C.

On the St. Anne's, Canada East

(1871)
oil on canvas
29.7 x 50 in
(75.4 x 127 cm)
Smithsonian American
Art Museum,
Washington, D.C.

After several trips to Europe, Duncanson returned to the United States with new ideas that seemed to exile the traditional landscapes that had filled his paintings. In Europe, the painter had firsthand contact with the forerunners of the Impressionists, discovering in France the works of the Barbizon School of artists. This offered Duncanson a new source of inspiration, since it allowed him to fuse his luminism with this new style of colorful shades and intense tones. These new concepts would gradually be incorporated into Duncanson's work; this painting, completed in Canada, is an example.

The artist used a very simple composition based on a river in the center that flows leftward, out of the painting, surrounded by trees and undergrowth. Having established his composition, Duncanson proceeded to unfold all the new ideas he had absorbed from British and French painting. Tonally rich and compositionally dynamic, the whole picture depicts moderate but unceasing movement, bursting with an organic vitality.

Scotch Landscape

(1871)
oil on canvas
29.8 x 50 in (75.6 x 127 cm)
Smithsonian American
Art Museum,
Washington, D.C.

The Scottish origins of Robert Duncanson's father greatly influenced the artist, thanks to the frequent trips he made to the British Isles. Here, Duncanson produces a vision of old Scotland, endowing it with a melancholic and monumental image that harks back to the works of artists in the Hudson River School. This vision of the Scottish landscape depicts an idyllic and peaceful image of the country's central highlands.

It is curious to see how Duncanson painted American scenes and made them look Scottish, even when he was practically on top of spectacular mountains and coastal scenes. Clearly, the artist was suffering from a strong dose of nostalgia for Scotland, the land of his birth. At the beginning of the 1860s, Duncanson suffered from constant depression that would culminate in 1872 with a transitory mental illness. Here the artist depicts a landscape in the tradition of the Hudson River School. The autumnal light characteristic of this kind of scenery emerges here as a reflection of the artist's own melancholy, which he is trying to mirror in his work. In fact, it is very likely that most of this work is a product of the painter's imagination.

SANFORD ROBINSON GIFFORD

William Henry Jackson, Gifford Sketching, *(1870), black-and-white photograph, George Eastman House, Rochester, New York.*

Sanford Gifford was one of the most popular American landscape painters in the last quarter of the 19th century. His work is luminist, part of the last phase of the Hudson River School.

His childhood on the banks of the Hudson, combined with his admiration for Thomas Cole and his trips to the Catskills and the Berkshire Mountains, must have influenced his love of the countryside, enough to sway him from the career as a portraitist that he first started.

In the same manner, the detailed works of the French painters of the Barbizon School, the Englishman J.M.W. Turner's use of color, and the special lighting found in the European and African towns that he visited also motivated him to experiment with landscapes. He tended to stray from dramatic, traditional representations. Instead, he turned to a sensitive and peaceful style, softened by unifying transcendental light.

Gifford's paintings are characterized by how he highlighted the effects of light—distinctly American light—in such a way that it became an outstanding part of the work. His forms are defined precisely and almost photographically, using practically invisible brushstrokes. The compositions themselves use few elements, which are treated as volumes and areas.

His style is based on details, balanced composition, and above all, the representation of light. Even topographic details may be sacrificed for the sake of light's leading role.

- **1823** Born on July 10 in Greenfield, New York, the son of a rich industrialist and fourth of eleven children.

- **1842** After spending his childhood in Hudson, starts his studies at Brown University.

- **1845** Shortly after finishing college, moves to New York to begin his artistic studies with drawing professor and human anatomy specialist John Rubens Smith while attending the National Academy of Design.

- **1846** Visits the Catskills and Berkshire Mountains for the first time and dedicates himself to painting landscapes.

- **1850** Becomes an associate member of the National Academy of Design.

- **1853** Visits the White Mountains along with other painters such as Benjamin Champney and Richard W. Hubbard.

- **1854** Is elected full academician of the National Academy of Design.

- **1855** Makes his first trip to Europe to complete his training and visits England, France and Italy, coinciding with Albert Bierstadt's travels.

- **1858** Returns to New York and sets up a studio in the Tenth Street Studio Building, a building designed specifically for artists.

- **1859** Is elected member of the Century Association. Travels to Europe again.

- **1860** Enlists with the Seventh Regiment of the National Guard in the state of New York, after the attack on Fort Sumter in April. He will defend Washington a total of three times.

- **1861** The Civil War begins.

- **1865** Toward the end of the war, he has the opportunity to visit the White Mountains again.

- **1866** Exhibits his work at the Universal Exhibition in Paris.

- **1868** Travels to Europe again, where he will stay until 1870.

- **1870** Expresses interest in the American West, and begins to explore the Rocky Mountains with Thomas Worthington Whittredge and John Frederick Kensett.

- **1874** Makes a second trip to the West, but this time travels the coast from California to Alaska.

- **1880** Dies on August 29 in New York, after making a final trip to the Colorado Rockies.

The West Riverside

(1856)
oil on canvas
9.4 x 14 in (24 x 35.6 cm)
Private collection

Gifford had the opportunity to travel to Europe, thanks to being elected an academician of the National Academy of Design. For American artists, to culminate their training in Italy, the mother of fine arts, was to put a crowning touch on their education. Because of this, it was no surprise that the artist met and traveled with other artists, including Albert Bierstadt and Thomas Worthington Whittredge, on legs of his journey. This work is still strongly influenced by academia, although the personal characteristics of Gifford's own style emerge as he places ever-greater importance on light.

The artist's idyllic vision of the daily life of the farmer is represented here through the perfect order and the careful equilibrium of all the elements, each rendered with stunning detail and unified in the luminous atmosphere. The horizontal landscape conveys a feeling of calmness. Two trees with interlaced tops open the path toward a scene filled with brilliant Mediterranean light. The calm water is filled with small boats that reinforce the horizontal composition, while the crops and other plants are alternated with buildings, including a Roman church, that speak of a humanized landscape. Gifford's ability to reproduce the bark and leaves of the trees with meticulous precision and barely perceptible brushstrokes is a legacy of landscape artist Thomas Cole and the influence of Barbizon School painters such as Jean François Millet and Jean-Baptiste-Camille Corot. Still, the true protagonist of the scene is not the figures, nor nature, but the all-enveloping light.

Mount Mansfield

(1859)
oil on canvas
10.5 x 20 in
(26.7 x 50.8 cm)
National Academy of
Design, New York

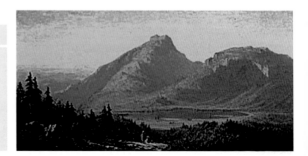

Kauterskill Falls

(1862)
oil on canvas
48 x 39.8 in (122 x 101 cm)
Metropolitan Museum of Art,
New York

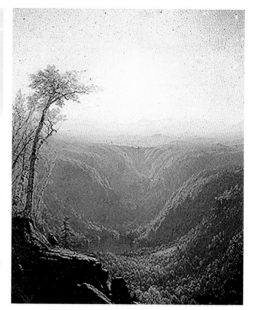

Although Gifford enlisted in the Seventh Regiment of the National Guard of the State of New York in 1860, he never abandoned his painting. He always recalled the Catskills as a beautiful place that had inspired him to become a landscape artist, and he traveled there even during his period in the army.

The waterfall shown in this work was very popular with American landscape artists, who, like Asher Brown Durand in his work *Kindred Spirits*, chose it for its great beauty. In this case, however, Gifford was more concerned with capturing the brilliant light filling the scene than with showing the fine details of this natural enclave. The sunlight is so intense that it nearly hurts the eyes.

The composition presents two planes separated by a large open space occupied only by the luminous air. The atmosphere masks the topography and blurs the forms, although the thin thread of a waterfall is still visible in the distance. Everything is bathed in a light that impregnates nature and its colors, bestowing brilliance and effervescence. The upper half of the canvas is sky and light, and the lower half is landscape and forest, imparting a calm and serene balance to the work. The sense of silence and tranquillity is a reflection of the artist's personality. He was a man of deep spiritual peace who, nevertheless, served as a soldier.

Left: When Gifford created this work, he was already living in the Tenth Street Studio Building in New York, a building designed specifically for artists, where Bierstadt and Whittredge, among others, also had studios.

When he worked, Gifford first made small-scale pencil sketches in the open air. He then created a second sketch with oil paints in his studio, and finally, after resolving his compositional problems, went to work on the final canvas. This way of working was very slow, but the result, a perfect balance between extraordinary detail and the encompassing atmosphere of light, made his paintings unique.

For *Mount Mansfield*, Gifford applied several layers of varnish to the finished work in order to achieve this lighting effect. The composition depicts a rocky hill with figures in the first plane and a lake at the foot of the majestic mountain, hazy because of the brilliant light in the air, filling the space between the two planes. Gifford used these empty spaces in his works to represent the luminous atmosphere caused by the reflection of light in the air. These reflections gave rise to zones of chiaroscuro that present grayish shades.

The small size of the contemplative figure contrasts with the monumentality of the mountain and gives it more weight. Gifford's detail is remarkable, in the textures of the outlines of the figures, in the surfaces of the rocks and the mountain itself. Even the leaves on the trees are represented in meticulous detail.

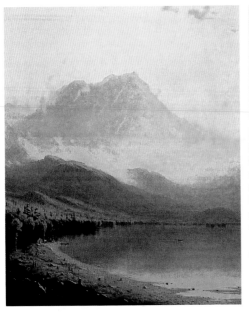

Morning in the Adirondacks

(1867)
oil on canvas
50 x 41.7 in (127 x 106 cm)
Spencer Museum of Art,
Lawrence, Kansas

Landscapes were one of the main symbols of the American artistic identity. The country's unique and dramatic elements were represented in all their splendor, highlighting their untamed, virgin character. Gifford inherited this love of detailed, idealized, and organized panoramic compositions representing the perfection of nature—God's work—from Thomas Cole. Like Cole, Gifford pushed his landscapes beyond pure representation to add moralizing content. Gifford even went one step further by representing the light as the true protagonist of the landscape, making atmospheric effects and warm colors a major characteristic of his style.

The composition of this work shows the water, which, like a mirror, reflects the mountain and the sky. The enormous mountain seems to float over the clouds, in contrast to the small house located under the shelter of the red, autumnal trees. The boats (whose course intensifies the peaceful horizon of the composition), the clouds, the house, and the forest are all highly detailed. Gifford used an intense palette, applied with imperceptible brushstrokes, to create this effect. There is a strong contrast between the reddish colors of the forest and the bluish shades of the water and the sky, counterbalanced by the warm morning light, which plays the most important role in this work.

Gifford presents the two sides of the humanization of the wild, the inherent order of destroying first before constructing later. The tree stumps that pepper part of the setting show evidence of the felling of the forest. The two boats on the lake, however, are dedicated to the rustic task of fishing. In the mid-1860s, an interest in the conservation of nature arose, and Gifford, as a nature lover, shows this concern for the environment. But *Morning in the Adirondacks* also idealizes the life of the pioneers; in wartime they symbolized the American hero. At times it seems as if Gifford's deep interest in depicting light is a protest against the industrialization of his pastoral ideal.

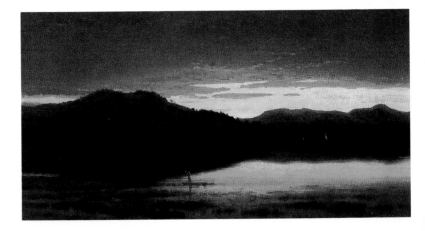

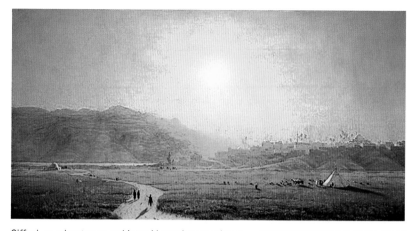

Gifford, an adventurous and intrepid traveler, was always eager to explore new landscapes. After traveling through such countries as England, France, Italy, Germany, Switzerland, and the Netherlands, he decided to visit Africa to see firsthand the characteristics of the exotic light of the desert.

Siout, Egypt

(1874)
oil on canvas
21 x 40 in (53.3 x 101.6 cm)
National Gallery of Art,
Washington, D.C.

The diffusing power of the bright light of Egypt inspired Gifford to make numerous sketches. This one shows an idealized version of the town of Siout. The light radiates from a focal point, the sun that centers the horizon, between the hill on which the buildings are placed and the mountains. The detail of the objects is clear; their outlines are clearly defined by the artist's precise brushstrokes. Some, like the white tents, have slight touches of lighting.

The human figures are dwarfed by the magnificence of the landscape that both absorbs and reflects the sunlight. The desert hills and mountains show only the faintest hints of grain and details through the veil of the air. The symmetry of the composition is organized starting from the radial point of the bright, glowing sun. The colors are alive and intense: the white, the dark yellow of the undergrowth, the light gray of the stony mountains. The city atop the hill recalls Gifford's theme of man as colonizer of the land, even if it is a tough and uncompromising land like the desert.

Left: American mornings were not the only ones that could offer stunning light spectacles. Italian dusk and sunsets also held great luminosity—in this case the light is so intense that it almost appears incendiary. In his travels through Italy, Gifford made numerous sketches of coastal landscapes, paying special attention to atmospheric phenomena that, because of their brevity, posed a challenge to all painters. Gifford would travel to Italy a second time in 1868, where he would once again be dazzled by the Mediterranean light.

This work is a characteristic composition, balanced and organized through three horizontal strips: the water, the land, and the sky, with the light bringing them all together. The boats reinforce this calm horizon, as well as alluding to the presence of people nearby. The golden twilight, characterized by intensely brilliant reddish tones, shows the last glimmers of the sun exploding in the clouds, which are then reflected on the water. This creates a highly balanced, compositional symmetry over the silhouette of the hill, which is also reflected in the water. In spite of the darkness, the picturesque sailboats, typical of fishing boats in the Mediterranean, are clear.

Twilight at Mount Merino

(1867)
oil on canvas
10.7 x 20 in (27.3 x 50.8 cm)
Sotheby Parke Bernet,
New York

The effect of the light is quite intense, due to the contrast between the dark earth and the burning sky after the sun has dropped over the horizon. As in all of Gifford's work, it is once again the light that monopolizes the viewer's attention, while the other elements are subordinated to this unique protagonist. The light here is nearly the only thing that has life and color, as the other pieces of the composition remain in near-darkness.

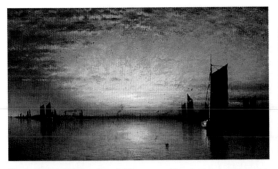

Sunset, New York Bay

(1878)
oil on canvas
23.8 x 40.7 in
(60.4 x 103.5 cm)
Everson Museum of Art,
Syracuse, New York

The balance and serenity of this composition inundate this scene, composed of two horizontal elements—the water and the sky—filled with the rosy light of sunset over the bay. The blue sky, framed by clouds that reflect the last glimmers of the day, is reflected in the calm water. The painter has emphasized this light as a focal point and the protagonist of the picture. He has framed the luminosity with the clouds. The light fills two-thirds of the canvas in the sky, and impregnates the rest of the elements with the last rays.

Gifford's meticulous brushstrokes are still used in the objects, but his interest in representing the light has increased. A famed painter and an academician of the National Academy of Design, certainly comfortable and successful in New York, he never lost his fascination for landscapes and the phenomenon of light. In his last years he traveled to the American West, attracted by the majestic Rocky Mountains, which he visited with Whittredge and Kensett. The sunsets on the West Coast also dazzled him, and as a result he traveled from California to Alaska seeking this brilliant lighting, unique to the American shores.

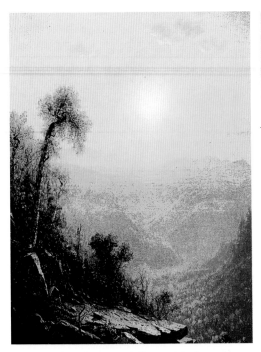

October in the Catskills

(1880)
oil on canvas
36.3 x 29.2 in (92.2 x 74.2 cm)
Los Angeles County
Museum of Art

This work demonstrates Gifford's path toward perfecting his representation of light values, and depicts the same setting he used in his 1862 work *Kauterskill Falls*. The location is identical, but this time the focal point is the sun, whose brilliance penetrates the viewer's vision. Painting light was Gifford's fundamental goal throughout his career, and he most certainly achieved it.

The entire composition draws the viewer's glance toward the point of light. The autumn sun reflects even in the clouds that break up the sky. The sensation of the serenity, calmness, and silence of the forest are conveyed through this atmospheric and luminous representation— rather than through the minuscule detail of the landscape, partially masked by the aerial perspective tinted with light. On the other hand, there are no human inhabitants: this Garden of Eden remains intact in its original and divine representation, a sublime vision.

One year after Gifford's death in New York on August 29, 1880, the Metropolitan Museum of Art organized a retrospective of all his work, hailing him as one of the most important American painters.

Jasper Francis Cropsey

Edward L. Mooney (1813-1887), *1854, oil on canvas, 31 x 26 in (78.7 x 66 cm), Private collection, Connecticut.*

Trained at first in decorative art and architecture, this painter was the only American landscape artist capable of understanding the scale of English Romantic painting, in all its aesthetic and philosophical dimensions.

During his early years, Cropsey composed his paintings from the specific viewpoints of form and volume. In this early stage, his paintings show an almost mathematical balance in proportion and tonality. But it was not until 1856, when the artist settled in London, that his work acquired a clear aesthetic. Thanks to his friendship with the critic John Ruskin and his frequent visits to museums to contemplate the painting of John Constable and J.M.W. Turner, Cropsey was able to fill his art with metaphysical language where wild and realist nature captured humankind. His work was characterized by remarkable landscapes containing rich tonalities of luminosity, although without a monumental quality. Cropsey's canvases render ephemeral moments in a small corner of the forest, alongside the vastness of late afternoon landscapes tinged in autumnal light.

Cropsey was a descendent of the American luminists and was influenced by the Hudson River School. This was seen in the two different visions of the world that he captured before and after his "conversion" to English Romanticism. There are virtually two Cropseys: the American

- **1823** Born February 18 on his father's farm in Rossville, Staten Island, New York. He is the oldest of eight brothers of a French and Central European Huguenot immigrant family.

- **1837** At 14, he wins a certificate from the Mechanics Institute Fair, New York, for a model scale house he designed and built. Some months later, he starts formal studies in drawing and watercolor with Edward Maury, a British teacher. During his artistic beginnings, he receives support and advice from American painters such as William T. Ranney and William Sidney Mount.

- **1843** Exhibits for the first time at the National Academy of Design in New York.

- **1844** Becomes an associate member of the National Academy of Design.

- **1847** Marries fellow artist Maria Cooley in May. After the wedding, the Cropseys take a long trip to Europe.

- **1848** After a stay in London, Cropsey and his wife settle in an American artist colony in Rome.

- **1849** On his return to the United States, Cropsey visits the White Mountains and later sets up a studio in New York.

- **1851** Becomes full plenary member of the National Academy of Design.

- **1856** In June, the Cropseys travel to England, where he sets up a studio in Kensington Gate, London.

- **1863** Returns to America where, after visiting Gettysburg, he receives a commission to decorate several railway stations. Later he works on architectural designs and spends time painting his house in Hastings-on-Hudson, New York, while his work is shown with some regularity at the National Academy of Design.

- **1900** Dies on June 22 in his house in Hastings-on-Hudson.

responsible for his main body of work, and the Cropsey from 1856 through the beginning of the 1860s, an artist entirely influenced by British Romanticism.

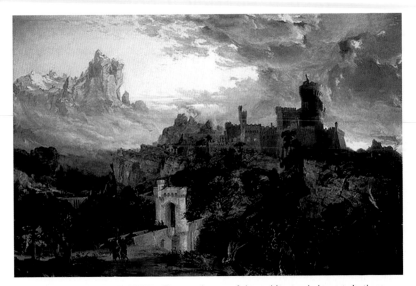

The Spirit of War

(1851)
oil on canvas
43.6 x 67.6 in (110.8 x 171.6 cm)
National Gallery of Art,
Washington, D.C.

The prominence of the architectural elements in the painting of this artist must be attributed to the memory of his time as an assistant in an architectural practice in New York. For some years, Cropsey dallied between architecture and painting, finally choosing painting. Throughout his career he cultivated (although only occasionally and without doing any major projects) the decorative arts and architectural design. This work, a landscape allegory of war, shows the artist's outstanding ability to create volumes and arrange them on a pictorial plane as a fantasy, but in an exact way.

This painting shows an imaginative stream of color and form, where the different elements appear isolated, although the way they are placed gives the image a brutal dynamic—the mountains and clouds seem capable of devouring the work of man. The compositional style is very original, locating three protagonists in three different planes. The three structures that focus the attention of the viewer are static, while the clouds and the reddish color of dusk threaten the work of man to become the dramatic arguments of the painting.

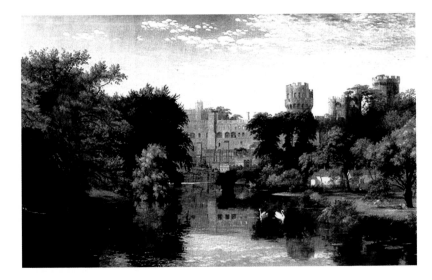

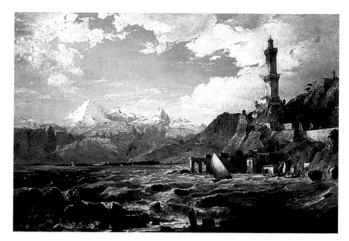

During his early years as a painter, Cropsey traveled from one coast of the United States to the other searching for an identifying language that would allow him to unite the Romantic vision of medieval architecture with a strongly moralistic naturalist sense. His own position as a landscape artist ensnared him in a contradiction—while he fervently admired God's natural work, he also had an architectural passion that led him to draw unreal castles and buildings in his paintings. At the end of 1840, he traveled to Europe and became acquainted with the ideas of Romanticism. At last he was able to unite both aesthetics.

The Coast of Genoa

(1854)
oil on canvas
48.2 x 72.5 in
(122.4 x 184.2 cm)
Smithsonian American Art Museum, Washington, D.C.

This painting is a compositional exercise dominated by an intensely dynamic sea and sky. The merger between natural monumentalism and human achievement becomes compatible with a moral message about man's reverence for the miracle of God's handiwork. Cropsey played off the different elements to create a unifying composition; nature and architecture become complements as the artist contrasts volume and form but homogenizes tone and color. This way, the tower on the coast is represented as a continuation of the irregular shape of the cliff, while on the sea and in the sky, the dark shadows on waves and clouds seem vaguely human.

Left: After his second visit to England, Cropsey's painting took on a completely British character. In his own particular way of imagining the world, the artist displayed a vision of architecture that evoked medieval history and legend. Thus, the first paintings the artist did in London were generally of magnificent castles surrounded by greenery under an autumnal sky; his training in the importance of luminosity was evident.

In this painting the artist presents a formal architecture. In terms of composition, a castle can be painted much like a portrait of a distinguished person. A frontal viewpoint, a regal yet realistic image, and luminosity that slightly dramatizes the scene are characteristic of traditional painting, and all are used here by the artist to represent, in full admiration, a noble English building.

Warwick Castle, England

(1857)
oil on canvas
31.9 x 52.1 in
(81.1 x 132.3 cm)
National Gallery of Art, Washington, D.C.

But given Cropsey's American landscape vision, the amount of shade in this painting can be gauged from the light on the plants, the water, and the stone, which shows a carefully illuminated sky behind the castle, further enhancing the bucolic image of the building. This backlighting allows the artist to transmit an atmosphere of warmth and vitality.

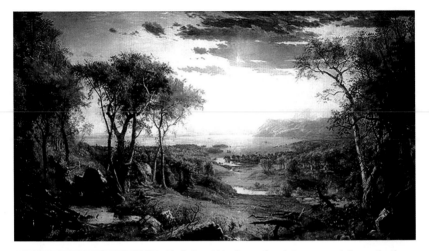

Autumn on the Hudson River

(1860)
oil on canvas
59.8 x 108.2 in (151.8 x 274.9 cm)
National Gallery of Art,
Washington, D.C.

Until the 1860s, Cropsey's painting was post-Romantic: the concept of man and nature converged, encouraging him to create colorful scenes where the influence of Turner is clear. However, with his return to the United States after his first European tour, Cropsey discovered a new artistic panorama, where dramatic or quiet luminosity evolved into new naturalist styles. The artists of the Hudson River School totally dominated the American artistic scene, and Cropsey knew how to adapt his painting to the style of the new American landscape tradition. *Autumn on the Hudson River* was done from memory, after the artist's second stay in London. The composition, completely in keeping with the style of the Hudson River School artists, is a view of the Hudson River from a distant viewpoint, looking to the southeast of Storm King Mountain, seen in the background. This placid scene, where the slow flow of the river convinces the viewer that this late afternoon sunset will last forever, is executed with the artist's usual delicate tonal combinations. Cropsey always showed a special sensitivity to tonal shades, finishing his clouds with fine intense bursts of colors that he repeats throughout the rest of the painting, rather like scattered notes in a musical composition.

The Old Mill

(1876)
oil on canvas
48.5 x 84.3 in
(123.2 x 214 cm)
Chrysler Museum,
Norfolk, Virginia

During his second stay in London, Cropsey discovered a new concept of landscape painting. But he also experienced personal growth; he was in contact with different artistic and intellectual groups where his aesthetic sense found acceptance. In his landscape painting, he did not seek a break with human creation; rather, he sought a new communion between nature and works by the hand of man. His ideas became an evolution of Romantic painting in which Gothic and Renaissance ruins merged with verdant architecture and gave rise to a fantastic universe full of mystery.

Richmond Hill and the Thames, London

(1861)
oil on canvas
8.7 x 16.3 in
(22.2 x 41.3 cm)
Private collection

In this fluvial image of London, the artist used his harmonizing vision to offer a rich image of shade and verdure. Through constant chromatic changes and the interplay of light and shade, the painter pushes the landscape slowly toward a luminous horizon. The pictorial pace gives this work an expressive and Romantic character. Cropsey combines a sense of depth with a rhythmic pictorial narration; the viewer enters the landscape and travels back and back, slowly and gently.

Left: All of Cropsey's art expresses his intense admiration for the English landscape tradition. Like his British colleagues, the painter looked for and carefully selected subjects for his paintings, with an emphasis on leafy vegetation, a calm brook, and, as in this painting, picturesque architecture.

In this canvas, the artist again unites and harmonizes architecture and nature. Although the building is old and rundown, the landscape sets the pace, showing enough dynamism to let us imagine that the house is still inhabited. The same occurs with the chromatic combinations. The artist uses lively and brilliant colors that are filtered by the dappled light, and the picture is capped with a very clear sky that seems to be fused with the original white of the canvas. Thus, the artist suggests an unreal space created totally by his imagination to offer a poetic vision, a fantasy of nature.

Looking North of the Hudson

(1890)
watercolor
15.9 x 25.9 in
(40.6 x 66 cm)
Private collection

At the start of the 1880s, Cropsey gradually returned to his roots in his artwork. During this period, the measured Romanticism of the Hudson River School dominated his work. Following in the footsteps of many of his artistic contemporaries, Cropsey moved to a small town, Hastings-on-Hudson, New York. He kept in touch with the most commercial artistic circles as he painted very conservative, tranquil landscapes.

This painting illustrates what the last years of his life meant to the artist. He presents a classical composition showing a natural landscape close to his home, a view of the eternal Hudson River. Yet despite the traditional form, Cropsey uses a very modern treatment of light and color. The artist's fruitful years in Europe had influenced his eye. He organized this painting around a central point formed by the river, choosing a horizontal viewpoint that allows him to play with different pictorial planes. This lends dynamism to the painting. The lines of the different planes guide the viewer, to the horizon and across the sweeping landscape.

Sailing: The Hudson at Tappan Zee

(1883)
oil on canvas
14 x 24 in (35.56 x 60.96 cm)
Butler Institute of American Art, Youngstown, Ohio

At the end of his artistic career, Cropsey returned formally to the pictorial vision of the Hudson River School. His palette returned to ochre tones and, compositionally, his painting became more classic and static, usually showing a huge and virginal landscape. This painting illustrates this type of composition. From the beginnings of his professional career in the United States, the painter's teachers and friends tried to persuade him to adopt this style. Finally, after his constant trips and study, the artist returned to this calm and somewhat familiar theme.

Despite this, *Sailing* shows a new vigor in the brushstrokes. Cropsey had discovered Impressionism in Europe, and in some of his last paintings he uses an impulsive brush to disturb the intense color of the rich shades that skirt his clouds and horizons. Here, this looser brushstroke is used to render a traditional landscape as a modern image. Luminous ochre acquires a new life, mixed with bright yellows and whites.

THOMAS WATERMAN WOOD

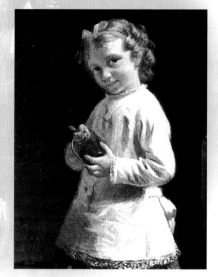

In the Jelly Jar *(detail), 1879, oil on canvas, 24.6 x 36.4 in (62.5 x 92.5 cm), Brigham Young University Museum of Art, Provo, Utah.*

Thomas Waterman Wood's paintings bear a striking resemblance to American Impressionist works from the end of the 19th century. Nevertheless, his unique vision of the man on the street, and his sharp perception of the social changes being experienced in his country during the most difficult years of the industrial revolution, made him the first painter to represent realism as it began to appear in the United States at the beginning of the 20th century.

Waterman developed this realism thanks to his special perception of reality, a viewpoint that no artist had ever had before. He captured the anonymous men and women of the street, his brushstrokes elevating them to the status of heroes of everyday life, earning, in the process, a reputation as a modern painter. In the United States, his work acquired considerable worth and significance. It is still relevant if the totally radical subject matter that Wood proposed is kept in mind. Nevertheless, he also received his share of harsh criticism from critics who did not believe that his themes could ever be worthy of an interesting painting.

- **1823** Born on November 12 in Montpelier, Vermont, where he would work in his father's store.

- **1846** Moves to Boston to begin his art studies with Chester Harding.

- **1850** Establishes himself as a professional portraitist.

- **1858** Travels to Paris and Düsseldorf to study and work with Hans Gude.

- **1862** Returns to the United States, where he begins a series of professional trips to paint portraits. He travels to a number of cities in Alabama, Louisiana, Kentucky, and Tennessee.

- **1867** Returns to New York, where he opens a studio. Founds the New York Etching Club.

- **1871** Is elected a member of the National Academy of Design in New York.

- **1878** Becomes president of the American Watercolor Society.

- **1890** Becomes president of the National Academy of Design.

- **1903** Dies in New York on April 4.

The artist's paintings and etchings use very simple compositions, based on effects of chiaroscuro that let him describe with great nuance the features and gestures of the characters. These images became authentic allegories of a concrete era and lifestyle in the United States at the end of the 19th century.

His paintings normally focus on a single person, appearing in the center of the image, in a pose that suggests a story. For Waterman, the clothing and the attitude of the person depicted were fundamental elements, as his painting was based on the character of the individual. He worked to portray an impression without worrying about the repercussions that it could provoke.

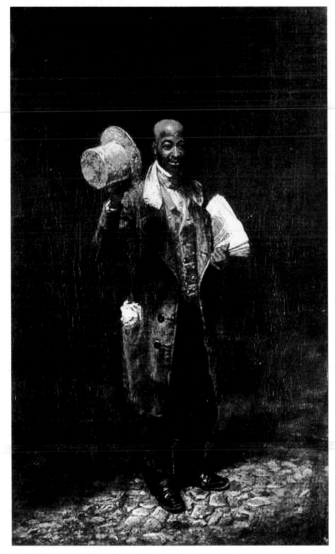

Moses, the Baltimore News Vendor

(1858)
oil on canvas
24.1 x 15 in (61.3 x 38.1 cm)
Fine Arts Museum
of San Francisco

Thomas Waterman Wood was one of the first artistic chroniclers of everyday American life in the 19th century. During this period, in Paris, London, and other European cities, artists turned to the theater, public parks, and popular streets packed with cafes in their search for individuals exuding the joy of living captured by the Impressionists. In the United States, Waterman followed the same path to represent modern life in the big cities. However, his perspective was more journalistic and documentary, and he preferred to depict a cruder and harsher reality: that of the lowest classes. He depicted these individuals as authentic heroes of the industrial revolution, resisting the consequences of progress with heroic strength.

Faithful to Wood's particular view of the people from the most humble ranks of society in modern American cities, this painting shows a newspaper hawker in Baltimore. Waterman Wood borrowed from his favorite, well-known technique, etching, to use a lively chiaroscuro, where the most intense tones become an urban mist that invades the scene and overwhelms the protagonists. The painter used this particular stylistic resource to represent a new phenomena of the modern industrial city: the invisibility of its residents. Newspaper sellers, shoeshine boys, and beggars are invisible, unnoticed by modern man that thinks of them or takes notice of them only at the precise moment when they need their services.

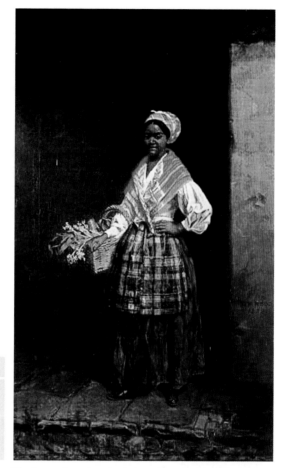

Market Woman

(1858)
oil on canvas
23.5 x 14.5 in (59.4 x 36.8 cm)
Fine Arts Museums
of San Francisco

In the middle of the 19th century, Wood started a series of paintings about the life of blacks in his country. He was very sensitive to social evolution in the United States, and his art is an exceptional testimony that reflects, in a way that seems to anticipate American realism at the beginning of the 20th century, a poetic but objective vision of the small daily changes in the lives of the "anonymous" beings of the period. This series about the lives of Afro-Americans is the first existing pictorial chronicle with an artistic sense that could also be considered documentation of historical value. Despite his innovation, Wood was the object of harsh criticism for daring to elevate the lives of poor, working-class people to the level of art.

This painting emphasizes the vitality of an Afro-American woman going to the market. In the course of the 19th century, American society changed radically, and black people in the United States began to differentiate themselves in a more independent and personal way. The artist has used this woman's vital coloring in order to contrast, with his unique sense of chiaroscuro and with remarkable ingenuity, the struggle between the monochromatic daily tedium with the happy and joyful individuality of the character.

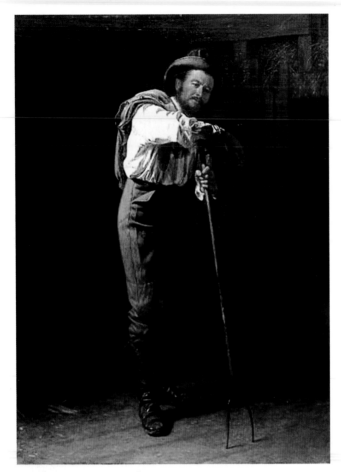

Cogitation

(1871)
oil on canvas
30 x 27 in
(76.2 x 68.6 cm)
Fine Arts Museums
of San Francisco

Thomas Waterman Wood's works demand that we accept the individual as the axis of social change. His simple compositions, in which the protagonists appear wrapped only in their personality and perhaps some trait of their profession, are sufficient for Wood to illustrate the life of cities such as New York, Baltimore, and Philadelphia, without needing to turn to landscapes or panoramic views of the city.

In Europe, this vision of daily life was sweetened by artists who purposely omitted any traces of ugliness in their paintings. But Wood created more open and sincere works, where his subjects are represented as they truly are, within their world full of problems and complexity, and with an intrinsic and diverse beauty arising from their own uniqueness.

Wood knew how to capture this interior beauty through extremely simple compositions, such as this monotone ochre-colored work of a man in shirtsleeves. The scene is imbued with theatrical lighting on the protagonist, creating a highly illuminated area that, little by little, blurs into an anonymous darkness to which the man will soon return. With this illumination, the painter can show the dusty wooden floor that the man seems to belong to in a metaphysical and incomprehensible, yet clear, way.

Shine, Sir?

(1877)
wood engraving
13.1 x 9 in (33.2 x 22.9 cm)
Achenbach Foundation
for Graphic Arts, San
Francisco

During his early days as an etcher, the artist discovered that the simplicity of this technique could be applied to painting. In this work, the quality of the wood engraving is notable due to the application of a dense and organic chiaroscuro. In the type of etching that Wood made, the chiaroscuro is the principal expressive element, creating a dark and pessimistic view, through which the dark tones seem to overwhelm the personalities.

In this work, the interior organization has been structured by rectangular stairs that cross the work. On these, a routine daily scene is shown: Humble shoeshine boys offer their services in the street. Wood gives this scene a dense urban atmosphere. The picture is filled with dust, and the shoeshine boys seem like creatures native to this dirty, abandoned world. It is precisely the artist's ability to re-create scenes like these cityscapes, with the same vision as the artists that went on nature expeditions 50 years earlier, that makes the painter stand out as an observer of everyday American life in the 19th century.

Sick Man Measuring Out a Dose of Medicine

(1883)
etching
11.9 x 8 in (30.1 x 20.2 cm)
Achenbach Foundation for
Graphic Arts, San Francisco

For Wood, portraits represented the opportunity to capture different aspects of the human condition. At the same time, he always respected the personality of the individual. Portraits allowed the artist to show a specific lifestyle, with some attractiveness, or to simply create a faithful reproduction of the person posing. This etching clearly shows the artist's intention of describing a specific lifestyle. Illustration and etching were often used in the United States as a graphic means of explaining the life and work of unexplored segments of society. This work is obviously documentary; in fact, it is probably the most informational of Wood's many etchings. The stylistic complexity leads the viewer to wonder if this was a commissioned work or if the artist acted on his own, challenging himself to depict the most complete character possible. He used all the available space in an almost metaphysical way and let the character of the protagonist truly fill the space.

In the Jelly Jar

(1879)
oil on canvas
24.6 x 36.4 in
(62.5 x 92.5 cm)
Brigham Young University
Museum of Art, Provo, Utah

While normally practicing a decidedly social pictorial style, Wood's training as a portraitist allowed him to create works of formal and stylistic complexity, like this delicate portrait of a little girl. Reverting to the Baroque portrait style popular at the beginning of the century, the painter has used his characteristic chiaroscuro, this time to achieve contrast and a greater range of tonal shades to portray the face of this girl and her charming childlike smile. The painting focuses on these facial gestures and the capricious expression of this child, to imbue the work with the same argumentative capacity as the everyday individuals in the artist's urban images.

The composition is simple and natural, allowing the artist to play with nuances for greater emotional effect. The child's expressive face is dulled by the white brightness of her dress, which draws the viewer's attention. The dress suggests volume; combined with the complexity of the sideways glance of the little girl, it makes *In the Jelly Jar* a superb portrait of a child.

EASTMAN JOHNSON

The Maple Sugar Camp, Turning Off (detail), 1865-1873, oil on wood, 10.1 x 22.6 in (25.7 x 57.4 cm), Thyssen-Bornemisza Museum, Madrid.

Eastman Johnson, a member of the Civil War generation, was the first American artist professionally trained equally in Europe and the United States. This differentiates his thematically diverse work from the rest of 19th- century American painting. Up to that point, the main pictorial genres had been portraits and landscapes done under a classical influence, but Johnson's work reveals a modernity that would reach its prime along with Winslow Homer, John Singer Sargent, and James McNeill Whistler.

A tireless worker and very receptive to new pictorial genres, Johnson examined various subjects that, in retrospect, seem to follow 19th-century American history in chronological order. His training in Germany was very influential in this area. His teacher, Emanuel Leutze, the master of historical painting, instilled in him a new vision in which everyday scenes became a fundamental part of history. Johnson embraced this idea, and he painted convincingly, describing the life of his country and its people through his figures' expressions and gestures in scenes of children, social portraits, and even in a controversial series of portraits of African slaves working on plantations.

Around 1860, Johnson became one of the most acclaimed artists in New York; his domestic scenes were particularly renowned. He dedicated his final years to commissioned portraits of important public figures.

- **1824** Born on July 24 in Lowell, Maine., although he grows up in Fryeburg and Augusta. His father works in different capacities for the state government.

- **1840** Works in J. H. Bofford's print workshop in Boston.

- **1842** Leaves the workshop and travels as an itinerant portraitist in New England and Washington, D.C. In the capital, he prepares a series of portraits of national political leaders.

- **1846** Moves to Boston as a portraitist.

- **1849** Moves to Düsseldorf, Germany, in order to study at Düsseldorf Kunstakademie.

- **1850** Sends two works to the American Art-Union.

- **1851** Having finished his studies at the Academy, works in the studio of Emanuel Leutze, a German-American who specializes in historical painting. In the summer he travels to England for the International Exposition. In the fall he moves to The Hague, where he stays for four years, studying with different teachers.

- **1855** Moves to Paris, where he studies briefly with Thomas Couture, and by October he returns to the United States.

- **1861** Works as a portrait artist for the Union battle camps during the Civil War.

- **1870** From this year on, he spends every summer on the island of Nantucket.

- **1890** During the 1890s he travels to Washington and Cincinnati, and does some folkloric portraits about Indians.

- **1899** Opens his own studio in New York.

- **1906** Dies at home in New York, where he had become an important public figure and a successful portrait painter.

Feather Duster Boy

(1860-1870)
oil on canvas
22 x 16 in (55.88 x 40.64 cm)
Butler Institute of American
Art, Youngstown, Ohio

Because of the subject matter he chose and the style he used, we can say that Johnson reinvented American painting. His ability to find new pictorial genres where before there had just been routine subjects led him to represent 19th-century society in a new and more complete way.

In this work, which could easily be defined as a pre-Impressionist painting, Johnson captures a humble traveling salesboy. Portraits of anonymous figures would become popular later, during the Impressionist period. Johnson's work touches on an urban human reality, showing a nameless character who poses cheerfully, as if he were happy to be painted, caught in this moment.

In this painting we can appreciate the new style that Eastman Johnson proposed. Having left behind the classical aesthetic of the era, he has planned a very European work here. The figure appears strange, almost grotesque, because of his shabby appearance, while the compositional style denotes a restraint that gives the work veracity. Before a woven background that adds seriousness, Johnson has placed the youth, loaded down and balancing his wares as he observes the painter. The boy's posture gives the work a dynamic quality; the simplicity and openness awake the viewer's sympathy and interest. Instantaneous and alive, the painting is fresh, with the quality of a snapshot.

Right: Johnson's compositions were an innovation. In this work, the artist coincides stylistically with Sargent, although their aesthetics were formed and developed in very different geographic places. Like Sargent, Johnson gives an intimate look at people in a group portrait. He has distributed the figures to convey familial coziness.

Compositionally, the scene is made up of various planes in which each space acquires its own personality. The inclusion of different light planes gives the painting a dynamism that extends over the whole surface of the painting instead of limiting the focus to the figures before the fireplace. Light and shadow play here, so that some well-lit spaces stand out, especially the fireplace and the faces next to the darkly shadowed areas. The space, painted decoratively, seems modern because of the little girl's blue dress, which breaks the stylistic monotony and reflects a new vision of the child portrait. In this picture the painter has, once again, created a sense of immediacy and spontaneity. As a result of this, and despite the stuffy decoration, the work breathes freshness.

The Brown Family

(1869)
oil on paper mounted
on canvas
23.2 x 28.5 in (59 x 72.4 cm)
National Gallery of Art,
Washington, D.C.

The Tea Party

(1873)
oil on canvas
Phoenix Art Museum,
Arizona

In this work Johnson has combined a classical vision of child portraits with a happy and dynamic proposal. He uses a close-up viewpoint that makes it easy to understand and enter the imaginative world of children. This scene takes place in classically decorated surroundings, but the vision of the little girl playing with dolls placed around a table at teatime evokes the childhood games in which children imitate their parents. Therefore it is both a portrait and a social commentary in which we see games, not so different from those of today, as well as the refined decoration and habits of the 19th century. The Victorian aesthetic is presented here in a playful form.

In the light from the window, Johnson has composed the scene in a decorative way, creating a guiding frame with intense colors on the rug and curtains. In these homey scenes, the artist often included elements, like the rug, which add to the composition while enhancing the perspective. Using an open angle such as this allows the painter to unravel the scene in a natural manner.

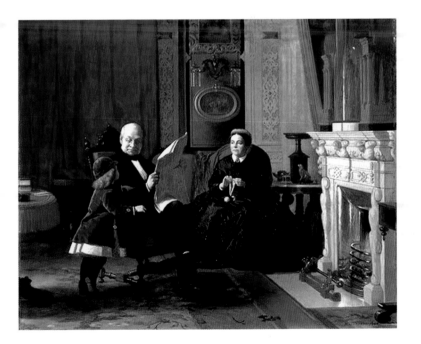

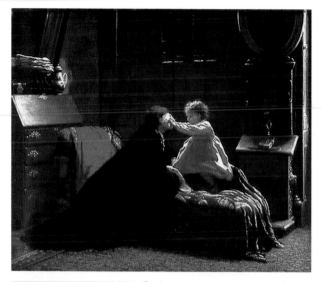

Bo-Peep

(1872)
oil on wood
Amon Carter Museum,
Fort Worth, Texas

Tenderness, games, innocence, and emotions—these are the aspects of Johnson's paintings of children that created the new aesthetic of child portraiture in the Victorian era. During this period, an aesthetic and moral reassessment of children took place, and youngsters were perceived and presented as treasures of innocence and charm. Childhood was no longer regarded merely as a transitional period on the way to adulthood, but rather as an independent state in which children formed their own imaginary world of fun and games. New schools, new children's fashions, and new ideas emerged, and new themes were explored through literature in books like Lewis Carroll's *Alice in Wonderland*. This new consciousness translated into a new artistic interest in childhood.

In this work, Johnson presents a tender scene between mother and son. The sense of intimacy, in which the feelings show without being held back by social conventions, comes from the delicate light and shadow. Beneath a gentle light that enters on the right, the mother and child play on the bed. The brightness of the child spotlights him as a rich treasure. Behind the woman, a red cloth directs the viewer's eye toward the space of intimacy in the center of the room. The dark background emphasizes the figures and adds volume and rhythm.

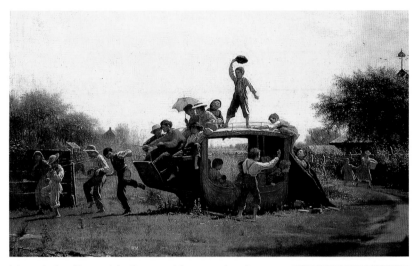

Johnson had a wide repertoire that ranged from everyday urban scenes to paintings in a Victorian-style domestic genre. One of his less-popular subjects during the 19th century was the rural portrait, or scenes of the country's interior. Starting in 1870, the year he began his cross-country trips, the painter explored this theme, which included country scenes, portraits of children, and domestic scenes on farms.

The Old Stagecoach

(1871)
oil on canvas
36 x 60 in (92 x 152 cm)
Milwaukee Art Museum,
Wisconsin

This image of an old stagecoach provides a look at Johnson's exploration of rural subject matter. Here he has adopted a narrative style in which, with a group of children, he has evoked the passing of years and his country's evolution. An old stagecoach, like those that traveled the frontier, lies now without wheels, totally useless. It is a reminder of the past. An energetic group of children play on the stagecoach. This painting is part of a new concept of children in the 19th century; Victorians adored children playing at being adults. Here a child, high up on the stagecoach, waves his hat euphorically while the others act out their favorite characters, really enjoying the game.

Johnson has done a composition that combines the children's dynamism with the abandoned coach's static desolation in the countryside. In the first plane, a bit of grass alludes to civilization's proximity, while toward the back the woods grow wildly under the harsh sun. Chromatically, the picture combines, excellently and illustratively, two color ranges that evoke two worlds: the green that goes with the landscape, and the warm one that refers to the heat of the season and the happiness of the children lost in their game.

The Cranberry Harvest, Island of Nantucket

(1880)
oil on wood
24.92 x 49.72 in
(63.6 x 126.3 cm)
Timken Museum

Left: From 1870 on, Johnson went to Nantucket regularly. Each year he spent a short time on the island, painting magnificent rural portraits of harvests or just amusing himself by drawing landscapes. This work shows locals picking cranberries. It is certainly something new to see how the artist painted elegant women on their knees in the grass alongside children and farm-women. The delicate class system of the 19th century attracted Johnson aesthetically; he reflected social imbalance and inequality in his work. Here, Johnson has created a painting full of chromatic details in which the sun's tonal effects stand out. The whole work has a yellowish tone that contrasts with the realism of the people. In the center of the painting, the artist has placed a woman standing, staring toward an undetermined point to the right. In all his compositions with groups of people, Johnson used figures or objects that, because of their position, seem to center or frame the painting.

The Maple Sugar Camp, Turning Off

(1865-1873)
oil on wood
10.1 x 22.6 in
(25.7 x 57.4 cm)
Thyssen-Bornemisza
Museum, Madrid

This scene of a sugar camp where the workers rest during a break from their hard day is an unusual style for Johnson. The composition has been done very linearly, almost horizontally. This painting was completed after the painter had worked as a portraitist for the Union troops during the war, and he was trying a new compositional style that allowed him to leave behind the strict commissioned portraits.

This sugar camp was one of his first rural works, and his pictorial character had yet to be developed. During his early years as a professional artist, after returning from Europe, Johnson's works showed some artistic confusion; his style was undefined. Here the artist wanted to show the character of a group of people united by their work. The painter often showed that he enjoyed painting people connected by family, love, or just friendship. These paintings would reach their peak toward the end of the 1870s. However, in this work, the artist still shows himself to be somewhat unsure, and it would take eight years for him to reach his artistic prime.

More diffuse, less precise than his later works, this painting does not have his mature sense of realism. This could be seen as an exercise in European-style Impressionism, where the artist is experimenting with knowledge he acquired in the Old World, but surely it is primarily an attempt by the artist to find his own style.

GEORGE INNESS

George Inness.

George Inness was one of the first American landscape artists to seek out new subjective formulations at a time when classicist and monumentalist concepts from the beginning of the century were in decline.

Inness was first influenced by the painters of the Hudson River School, since he was trained by them. Soon he had the opportunity to travel to Europe. There he studied the works of J.M.W. Turner, John Constable, and Jean-Baptiste-Camille Corot. He also observed firsthand, in Fontainebleau, the painters of the Barbizon School, whose members practiced open-air painting with the objective of faithfully reproducing nature. Although Inness's first landscapes are extremely detailed and naturalistic, in the style of this French school, little by little he would abandon his dependence on the physical world to present his own unique vision of the natural world.

Through his loose, soft brushstrokes, the artist continued to blur the outlines of his work in harmonious blends of color, air, and light, forming hazy visions within a poetic atmosphere. These compositions were a true reflection of the author's ideas about the spirituality of nature—transcendental ideas very close to the reflections of the Swedish philosopher Emanuel Swedenborg.

His creative impulse would make him the most brilliant figure in landscape painting in the mid-19th century, and he is considered the father of American landscapes.

- **1825** Born in Newburgh, New York, the fifth of 13 children of a shopkeeper.
- **1829** The Inness family moves to Newark, New Jersey.
- **1839** His father places him in charge of one of his grocery stores, attempting to dissuade him from his artistic interests.
- **1841** After receiving his first painting classes in Newark, he starts as a print-shop apprentice at the New York cartography shop of Sherman and Smith.
- **1843** Receives artistic training at the studio of Regis François Gignoux, a Hudson River School painter.
- **1844** Exhibits his paintings at the National Academy of Design for the first time, where he will continue to have shows regularly.
- **1846** Exhibits one of his works at the yearly show of the American Art-Union.
- **1849** Meets art patron Ogden Haggerty, who finances a 15-month stay in Europe for him.
- **1853** Member of the Academy and already a notable figure in the Hudson River School, he makes a second trip to Europe, where he meets the Barbizon School painters. From them he learns outdoor painting.
- **1860** Leaves New York to set up a studio in New Jersey, next to the Eagleswood artist colony. Strikes up a friendship with William Page (1811-1885), who introduces him to the philosophy of Swedenborg.
- **1869** Wins gold medal at a Paris exhibition.
- **1870** Travels to Italy, where he stayed for four years painting landscapes in Campania, the Alban Mountains, southern Rome, and Florence.
- **1875** After a brief stay in France, returns to the United States.
- **1876** In an interview, expresses his desire to visit the American West.
- **1878** Meets art dealer Thomas B. Clarke, and sets up studios in New York and Montclair, New Jersey. Becomes a devotee of Swedenborg's philosophy.
- **1884** John E. Sutton promotes a large exhibition for him in New York, leading him to be considered as the most important American landscape artist.
- **1890** Travels to California and San Francisco, where he meets his fellow painter and friend William Keith.
- **1894** Receives numerous American honors. Dies on August 23 at Bridge of Allan, a small Scottish town, while touring to make sketches of nature.

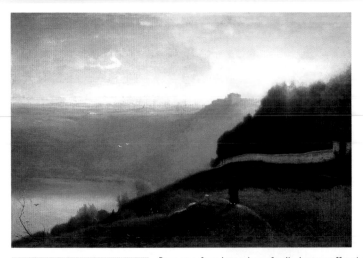

Lake Nemi

(1872)
oil on canvas
30 x 56.8 in (76.2 x 144.3 cm)
Museum of Fine Arts, Boston

Born on a farm into a large family, Inness suffered epileptic attacks from infancy. But he had a remarkable artistic gift, and his creative fever, along with his extremely emotional character, led him to work incessantly to capture the spirit of nature on canvas. His interest, as he himself stated, was not so much to attract people to his work intellectually, through detailed representations, but rather to bestow upon others the same emotional impression that the original scene had left on him. This objective produced landscapes that were highly intimate and subjective, and quite far from academic rules that placed importance on faithful drawings.

After this transcendental search, the painter traveled to Italy, staying there for four years. He completed *Lake Nemi* there. It gives an idea of his great technical abilities, acquired through the iron-clad learning systems of the Hudson River School. In this work, characterized by his use of perspective and depth, he has abandoned detail to focus on his technical concerns regarding light and color, to create an introspective atmosphere of peace and reflection. The almost mystical nature of Inness's artistic reflections are undoubtedly one reason why he felt such a strong connection with the Swedish philosopher Swedenborg, who maintained that the spiritual world was much more real than the material one.

Only a few years later, Inness would have the opportunity to increase his prestige; he met the renowned collector Thomas B. Clarke, who was very interested in the originality of Inness's work.

Right: It is said that Inness presented this work to the director of a school in Batavia, New York, to pay for his daughters' education. The artist constantly worked to render the energy of different weather conditions upon his canvas, without presenting them as his contemporaries did—wild and fearsome. Rather, he wanted to show nature reconciled with man, civilized and humanized. Nature here is depicted in harmony with humanity, who, in turn, respects and uses the resources that she offers.

While the clouds, heavy laden with rain, approach threateningly over the valley, a farmer, who is aware that life is a cyclical process, continues working and is not afraid. His flock grazes peacefully; at the distant farmhouse, the smoke from a chimney can be made out. This fundamental regenerative cycle can also be seen in a visual metaphor in the bottom right-hand corner, where there is a tree stump at the base of a sapling. The man here is presented as one more element in the world, living in harmony with nature.

The ideological and deeply ecological perspective shows the artist to be ahead of his times. He would surely agree with the American Indians' views regarding the responsible use of resources and respect for the cycles of nature. The details and structural weighting show the continuing influence of the Barbizon School, although realistic representation is already losing importance for Inness, in favor of the spiritual and poetic concept of nature as a whole in which humanity is integrated. This connection between the spiritual and the natural would deeply influence 20th-century art.

The Coming Storm

(1878)
oil on canvas
26 x 38.5 in (66 x 97.8 cm)
Albright Knox Art Gallery,
Buffalo, New York

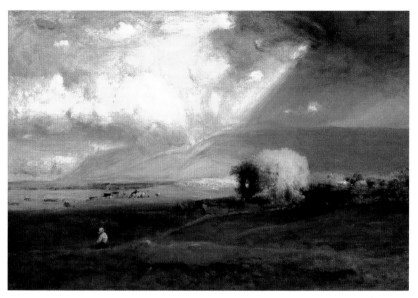

In his European travels, Inness dedicated himself to observing and drafting the essential characteristics of various landscapes, storing a rich multitude of scenes in his mind's eye. Later, back in the United States, he would develop these images. When he was returning to America, he had to travel through France. By coincidence, he arrived in Paris at the time of the Impressionist exhibitions. He never felt attracted by this style, as he thought that Impressionist art was only focused on portraying the physical world through lighting effects. Inness went much further than strict reality, as he always sought the emotions produced within each person when contemplating scenery. He did not simply represent the landscape; he made it leap from the canvas in its full splendor.

Passing Clouds

(1876)
oil on canvas
20 x 30 in (50.8 x 76.2 cm)
Private collection

One of the artist's favorite subjects was landscapes with clouds, which let him explore how outlines dissolve in hazy or misty weather. Clouds also demonstrated the living energy of nature. Here, the effect of dense clouds blocking the light and breaking the landscape in two gives rise to a chiaroscuro that adds academic profundity to this work, in contrast to the almost dramatic tone of the subject matter. The horizontal composition conveys tranquillity. The focal point is the yellow tree centering the scene. The harmonization of color is perfect, and the contrast between the cold colors, provoked by the threat of rain, and the hot colors, brightened by the light, create balance that is menaced only by the rainclouds.

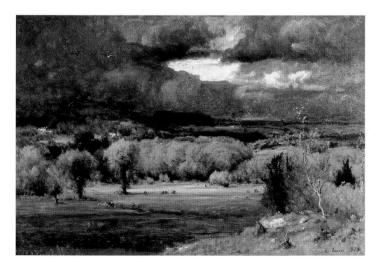

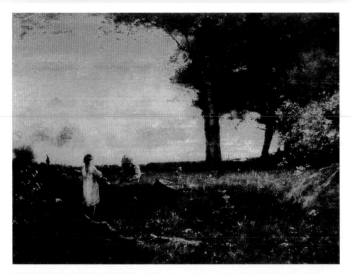

Sunset at Montclair

(1885)
oil on canvas
30 x 40 in (76.2 x 101.6 cm)
Columbus Museum
of Art, Ohio

Inness's working methods were based on his great capacity for observation. Once he had captured the essence of a landscape, he shut himself in his workshop and literally attacked the large canvases with violent sweeps of his brush to define the shapes and volumes. Only then would he begin to delicately fill in the details. His never-ending search for perfection often made the artist lose patience, and he would take the half-finished painting out of his sight to begin again. Later, he would return to these abandoned canvases to finish them, although he always felt like he stood at the portal of what he had truly hoped to achieve. The year this painting was made, Inness had recently set up shop in Montclair, New Jersey, and he was already a well-known figure both in and outside the United States. His presence in Montclair attracted many other artists and turned this town into a true cultural center.

During this period, Inness concentrated on color tonalities and transitions, and he had many followers. His relationships with other artists were difficult, due to his strong personality and habitual straightforwardness. Certainly his demanding character, which made him eternally dissatisfied with his own work, also provoked severe criticism from others. He could be friendly and accessible at times, but when he came into contact with mediocre painters or felt overwhelmed by his patrons, he could be egocentric and distant.

In this painting, the composition shows a clearing in the woods in the first plane. Two children are rendered in intense greens, contrasting with the golden, almost orange, color of the sky at sunset. To create great depth, Inness placed elements such as the hunched figure, almost a shadow, and a distant chimney. The last glimmer of the sun reflects on the clouds, and the tones move from orange to golden in barely perceptible transitions. The outlines of the figures are blurred, defined only by the air and the light, not by the drawing.

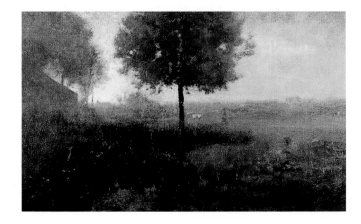

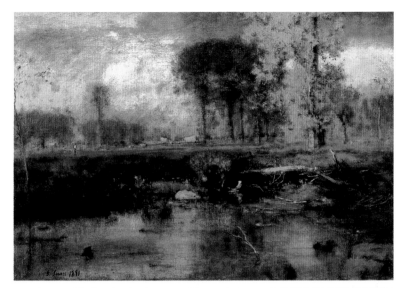

Inness was interested in American landscapes, and he traveled to California with his wife to meet up with his friend and fellow painter William Keith. Both men made studies of the rugged coast-lines and inland forests. In his rush to capture the spirit of the countryside, Inness would elaborate upon his rough sketches in Keith's studio, even at times changing the species of trees, such as drawing oaks instead of cypresses.

His friendship with Keith backslid when Inness stated that no one had ever been capable of painting the landscapes of Yosemite well, but that he, Inness, could do it. After making this declaration—bordering on an insult to artists like Albert Bierstadt or Keith himself—Inness tried to capture the essence of Yosemite in order to prove his point. He failed to obtain satisfactory results. He had to admit to Keith that he was unable to succeed.

Inness offended Keith once again when he gave him his palette as a gift, intending it as an honor. Keith gave it away to an artist in need. Once the friendship had been restored, Keith admitted to Inness's influence both in his own work and on other, later Californian painters.

The full maturity of Inness's style can be appreciated in this work. It is the air and light that create the landscape and give it color and life. The composition starts from a first horizontal plane, very peaceful, filled by the river, which reflects the surrounding colors like a mirror. This horizontal section is balanced by the verticality of the tall trees. The trees deeper in the background have less definition and lack even an outline.

Spirit of Autumn

(1891)
oil on canvas
30 x 45 in (76.2 x 114.3 cm)
Private collection

Left: This work perfectly captures Inness's ideas about how the transcendence of nature should be represented on the canvas. The material world fades, leaving in its wake only the pure essence, the poetry of the lived moment and the transfer of an artist's inspiration to a work of art. A mysterious mist, as in a dream, creates a mood that goes beyond what is seen. The most suggestive elements of this world are contained in this remarkable work. The color, background, air, space, and light work together to capture the spirit of what was thought and seen in a moment of contemplation of nature. The green tones melt into the foggy morning, and volumes are established through a gradation of tones.

Hazy Morning, Montclair (New Jersey)

(1893)
oil on canvas
30 x 50 in (76.2 x 127 cm)
Butler Institute of American Art, Youngstown, Ohio

Although the artist's strength was dwindling at this time, making him decrease the speed of his production, Inness never abandoned his search. His research prompted him to make a final trip to Europe to work toward an understanding of the essence of new landscapes so he could develop them on canvas. One year after painting this picture, he died in a small town in Scotland while he was researching and making sketches of nature.

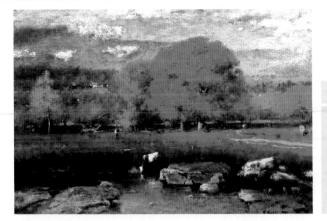

Red Oaks

(1894)
oil on canvas
35.4 x 53.5 in
(89.9 x 136.5 cm)
Santa Barbara
Museum of Art,
California

Inness was a famous artist by this time in his life. His talents and the many exhibitions of his work attracted several patrons, who afforded him the opportunity to travel to Europe in 1849 to perfect his art. He used this trip to Europe to finish the training he had received in the United States, an achievement that was not within every artist's grasp. To be able to view the works of French painters such as Jean-Baptiste-Camille Corot, Théodore Rousseau, and the Barbizon artists exercised a great influence over Inness, but he went beyond them, and adapted these teachings on technique and motif to the American spirit.

Since he added his own particular vision to the objective of art—to evoke emotions and give form and shape to the essence of nature—he created a very original artistic reformulation, drawn, no doubt, from European sources. But through his genius and artistic talent, his work became his own expression, far from academia.

This painting demonstrates how the American landscape presented Inness with his principal character. He captured all the strength of a group of oak trees to represent permanency. The human figures blend with the undergrowth that is composed starting from tonal gradations, defined without outlines. The brushstrokes here are extremely light, and color is the only protagonist. The horizontal planes, constructed from basic elements such as water, the field, and the cloud-filled sky, are broken by a line of trees in the warm colors of autumn.

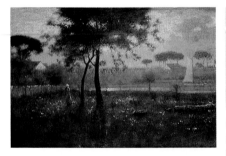

Rosy Morning

(1894)
oil on canvas
30 x 45 in (76.2 x 114.3 cm)
Hunter Museum of Art,
Chattanooga, Tennessee

Completely different from the dark palette he used at the beginning of his career, this work shows Inness's great skill in managing light. This light does not directly attack the viewer's eyes, but appears screened through the leaves of the trees or the clouds that often split the sky lines in his works, as here. Twilight and dawn, because of their fleeting nature, were exceedingly interesting to the artist, since capturing their poetic essence on canvas was problematic. Jean François Millet, for example, would draw inspiration from these same moments of the day, without ever being able to represent the farmer's life in all its harsh reality.

The horizontal composition presents different elements that add to the sense of depth: the meadow, the trees, the river and the boat, the houses, and finally the blurry trees. All are lit by the golden light, which contributes to the creation of this perspective, from the semidarkness of the meadow and the backlit trees to the soft illumination of the other elements. (The air becomes a visible presence.) Thus, glimmers of golden light can be made out behind the treetops, and even reflect upon a part of the river. A figure crosses the grass, which seems to be filled with diminutive flowers, while in the background a sailboat glides peacefully down the river. Everything in this scene suggests peace and harmony, in an atmosphere pregnant with the feeling of well-being and idyllic poetry that Inness captured in nature.

FREDERIC EDWIN CHURCH

Frederic Edwin Church.

One of Thomas Cole's finest pupils, Church is the most important member of the Hudson River School's second generation. He distinguished himself for his extraordinary use of color and drawing, as well as for applying and improving on his teacher's views on the use of landscape painting as a national language.

Church's painting was strongly influenced by Alexander Von Humboldt's *Cosmos.* Like Humboldt, he believed that a physical description of nature did not have to be a literal portrayal. That is how he understood the landscape—as a revelation of a specific place's national character. He believed that an intimate study of nature was essential to understanding an essential truth: the universe is a great whole animated by internal forces that tend toward harmonious unity.

During his first artistic period, Church's landscapes had much depth and were topographically exact. He used independent elements in very detailed scenes.

Between 1860 and 1870, the artist stopped painting detailed scenes of the tropics and opted for sunlit landscapes of the United States. The paintings of this period are quite different from his earlier ones, not only in style, but also in atmosphere. The objects at a distance are not detailed but seem rather implicit. Like many painters at the end of the 19th century, Church began to give more importance to the poetic unity of the painting than to the detailed description of its elements.

- **1826** Born in Hartford, Connecticut, to a wealthy family that encourages him to develop his artistic skills at an early age.

- **1844** Begins to study painting with Thomas Cole.

- **1848** Inaugurates his studio in New York; takes on William James Sillman as his first pupil.

- **1849** Exhibits at the National Academy of Design in New York for the first time with his painting *West Rock, New Haven.*

- **1853** A year after reading von Humboldt's book, he leaves for South America to travel through and paint the places described in the text. Travels from Barranquilla, Colombia, to Guayaquil, Ecuador, to the northern Andes, where he sketches rivers, waterfalls, and volcanoes. Upon his return, he visits Niagara Falls several times. Travels around Nova Scotia. Travels extensively through Maine, New Hampshire, and Vermont.

- **1860** Buys a farm in Hudson, New York, and marries Isabel Carnes.

- **1866** Their son and daughter die from diphtheria.

- **1867** Visits Europe and the Middle East for the first time. There he captures new exotic themes that he depicts in his work.

- **1869** Travels to the Middle East.

- **1870** Starts to suffer from rheumatism in his right hand. This makes it difficult for him to continue with large paintings. Nonetheless, during his last years, he is able to paint some small oil paintings of Olana, Mexico, where he spends winters, and Lake Millinocket in Maine.

- **1900** Dies.

Humboldt's geological and physical harmony was transformed into the poetic unity that Darwin presented as the vital process of survival of every living being.

Ironically, despite having earned so much fame and money as a painter, Church's work lost popularity before his death. As a result of a study by David Huntington, Church became appreciated once again and assumed his rightful place as an important figure in American painting.

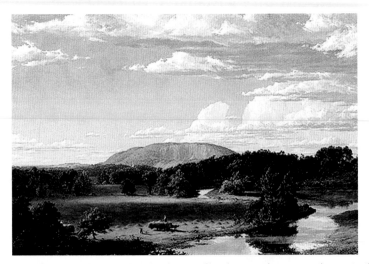

West Rock, New Haven

(1849)
oil on canvas
John Butler Talcott Foundation
New Britain Museum of American
Art, Connecticut

In 1849, Church won a place among the great artists of his time when he exhibited this painting at the National Academy of Design in New York. *West Rock, New Haven* not only shows the bucolic charm of the American landscape and displays it as a unique geological monument, but it evokes a specific event in Connecticut's colonial history that made the place a symbol of the nation and of the struggle for independence from England.

In 1649, a group of judges condemned King Charles I to death for crimes he had committed against the British. Once the monarchy was restored in 1660, Charles II looked for and executed the judges who had participated in the sentence. Two of them were able to flee to the United States. During the time the authorities searched for them, they hid, protected by local people, in a the West Rock cave. Years after, the following phrase was carved into the rock to commemorate the historic event: "Opposition to tyrants is obedience to God."

Apart from the historic event it represents, this work is exceptional. West Rock rises in the landscape's background as an enormous rising sun, symbol of the nationalism that was prevalent at the time. The composition of the elements creates a sense of balance and absolute peacefulness in nature. Human presence is almost imperceptible, and what signs of it there are merge with the landscape to become part of nature. The river water, completely still, acts as a mirror that reflects the sky and surrounding trees. It joins the elements into a whole that helps illustrate the peacefulness of the place, enhancing the bucolic sensation of the work.

This painting also has a second "mirror." Look at the top half of the picture. It is all sky and clouds. At first it seems as if the clouds have been randomly placed—but on closer inspection, it is evident that they reflect the clearing and trees below. There is a green esplanade between the trees and the stream where the men work; that same clear patch opens up in the sky.

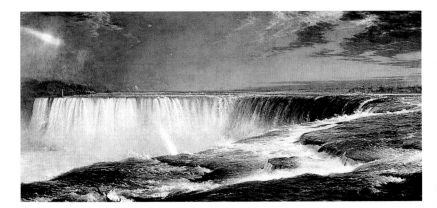

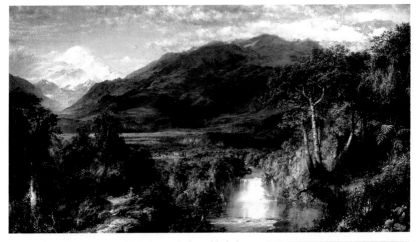

This is one of Church's most important paintings. Made in his early period, it was viewed by more than 12,000 visitors during a three-week exhibition in New York. After reading Humboldt's *Cosmos*, Church traveled to the Andes with the idea of painting the magnificent places described in the book.

This painting is based on observation, but also on Humboldt's words. He described the place as "a large space, moved and animated by internal forces." With this idea, Church captures an instant where it appears that veiled nature opens its drapes to reveal its most intimate places to the viewer. Like all the paintings from the painter's first period, this one is characterized by minute botanical detail, by great depth combined with a surprising sense of unlimited space, and by the light that covers everything and that can be interpreted as an indication of divine presence.

The elements are very balanced. In the foreground, the trees hold the road back from the river. The forest opens to show the hidden center of a spectacular region. Clouds are swept by the wind toward the right, contrasting with the clear sky that opens up in the sky on the left, where a snow-covered volcano balances the landscape emphasized on the right. Church was impressed by the great variety of settings and climates that could be observed from one site. Thus, in this image, he links a tropical river bordered by dense vegetation, the plains, the savanna, and at a distance, a very high mountain and the snow-capped volcano, in a spectacular demonstration of what one region could contain geographically and climatically.

Technically brilliant in its details, this painting features water in its many forms—liquid, snow, ice, fog, steam, clouds—to symbolize that natural diversity is part of a divine plan, and also to demonstrate constant change in the elements.

Heart of the Andes

(1859)
oil on canvas
66 x 119.3 in (168 x 302.9 cm)
Metropolitan Museum of Art,
New York

Left: After this work's exhibition, Church's reputation began to skyrocket. Here he depicts one of the most impressive natural wonders of the American landscape in panoramic dimensions and in great detail. The elevated viewpoint reveals a desire to dominate the earth and hints at patriotic pride.

A gleam of light is reflected in the spray of mist produced by the falls, as if it were a divine signal addressed to the pioneer. Manifest destiny, or the belief that America had a divine mission in the world, had its echo in these landscape paintings that detailed each crevice in the ground, each plant, and each drop of water. Vigorous, strong, these landscapes were a true reflection of the pioneer spirit. Church portrayed the remarkable American landscape as a divine trophy.

Once he achieved success, Church became interested in more exotic landscapes. This work is typical of the paintings the artist made on his trips throughout the Americas; later, his curiosity sent him to the Mediterranean, where he prostrated himself when he saw the beauty of the Palestinian and Greek landscapes.

Niagara

(1857)
oil on canvas
42.5 x 90.6 in (108 x 230 cm)
Corcoran Gallery of Art,
Washington, D.C.

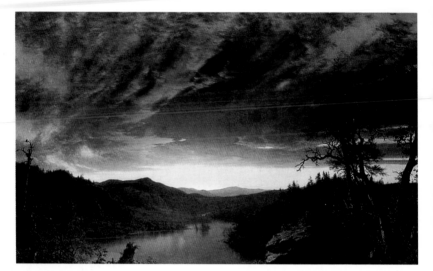

Twilight in the Wilderness

(1860)
oil on canvas
40 x 64 in
(101.5 x 162.6 cm)
Cleveland Museum of Art,
Ohio

Most of Church's paintings depict a specific place in minute detail. Faithful to reality, he preferred to portray the landscape that he observed as exactly as possible. This painting, however, does not show a specific place. The painter created it from a variety of sketches he had made here and there in Maine, as well as in New York. When he exhibited this work for the first time, there were many interpretations from the public and critics. Some believed it was an allegory for the divine presence over the country. But Church made this painting when the Civil War was starting; it is probably a metaphor for this charged political situation.

The painting has two contrasting elements: the sky, covered with violent, moving clouds, and the earth, peaceful, with mountains and river bathed in red light filtered by the clouds. Only the pines cut through both fields. They rise from the earth to the sky, joining the light with the darkness. The tops of the trees blend with the red clouds, obscuring the sky and creating shadows. The dramatic use of light, based on sketches Church made of sunsets from his studio in New York, gives the work an apocalyptic quality. The panoramic splendor created by the brilliant, dense clouds insinuates the coming of a storm. There is light only on the horizon, and it is shedding light on the landscape. This reflects Church's optimism about the coming events and contrasts with the somber work *Twilight: Mount Desert Island*, which he painted five years later.

Right: Church captured many different views of Cotopaxi volcano in Ecuador. The painter had become curious about this volcano when the German naturalist Humboldt said of it, "The Cotopaxi has the most beautiful and regular shape of all the colossal peaks of the Andes. It is like a perfect cone covered with a thick layer of snow that shines with such a brilliance at sunset that it seems to detach itself from the sky's blue." At the time Church visited it, he witnessed the volcano's magnificent and dangerous eruptions, which appear smoky and menacing here. Only a radiant sun penetrates the curtain of gases that the volcano spits out, hazing over much of the sky.

This painting was exhibited in a novel way. It was hung in a small room dimly lit with gas lamps, so that it seemed like a magical window to an unknown and remote world. Telescopes were positioned so that the painting could be examined in detail. Visitors thronged in long lines, eager to travel to this exotic location for the modest sum of 25 cents per person. The exhibition was so successful that Church repeated this entry-fee system many times. As a result of his self-promotion and publicity, the price of his paintings quickly increased, and Church was able to devote himself to his favorite pastime: traveling.

Cotopaxi

(1862)
48 x 85 in
(122 x 216 cm)
oil on canvas
Detroit Institute
of Arts, Michigan

After making several trips to the tropics in 1859, coinciding with the publication of *The Origin of Species* by Charles Darwin, Church traveled by boat for one month to explore the coast of Newfoundland and Labrador. Seasickness and rough seas did not prevent him from enjoying the impressive. During the trip, he sketched icebergs as they became visible on the horizon. He later made several amazing paintings bases on these sketches.

Although he works with a variety of depths, this painting does not express nature's geographic determinism; it is a sample of its crudeness. In the painting, Church depicts his thoughts as icebergs appeared, each with its own structure, but also as part of an unending trail of icebergs. On the left, in the foreground, a large block of ice rises toward the sky. On the right, in the middle plane, another iceberg bounds the right side, leaving just a narrow ocean canal in the middle. In the background, in the middle of the composition, there is an enormous third iceberg. A bit to the left, farther back, a small iceberg is lost in the horizon. The minute detail of the ice boulders, as well as the ocean and sky, stresses the sensation of inclement weather. Small waves make their way among floating islands.

The icebergs' balanced composition makes the painting a poetic work where ice, light, and water create a raw sensation, which illustrates that the northern frontier of the United States is a place of irresistible but terrifying beauty. This is one of the most important paintings made of icebergs, as well as one of the most valuable works of the American 19th-century landscape genre.

Icebergs

(1861)
oil on canvas
64.5 x 112.5 in
(163.8 x 285.8 cm)
Dallas Museum of Art,
Texas

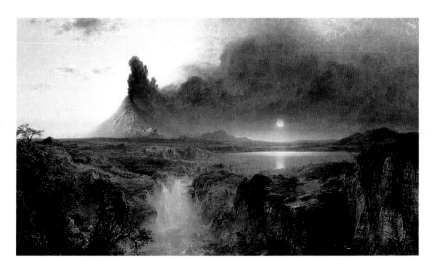

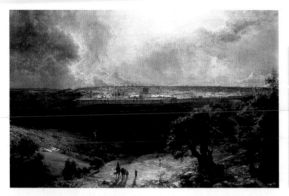

Jerusalem from the Mount of Olives

(1870)
oil on canvas
54.3 x 85 in
(137.8 x 215 cm)
Nelson-Atkins Museum of
Art, Kansas City, Missouri

This painting belongs to Church's second artistic period, when he was no longer influenced by Humboldt but by Darwin. It is one of his last monumental oil paintings.

In 1869, the painter traveled to the Middle East to sketch exotic landscapes. Darwin's theories created great religious controversy right from the start. Several biblical explanations, particularly creationism, were tottering. Church, a strong believer, may have used this painting as a reaffirmation of his religious faith. Painting a timeless image of Jerusalem could be a portrayal of the place where biblical events occurred—or in some way an expression of his concern for the theological debate.

As in many of Church's paintings, light is essential here. The contrast between light and shade is the main mechanism of this painting. The light bathes the horizon in a radiant tone that contrasts with the more shaded surroundings to produce an extraordinary sense of depth. Church follows several of his tropical compositions: The trees in the foreground, in contrast with the more distant elements of the painting, emphasize the sense of spaciousness and immensity. At a distance, small olive trees appear, their shadows extending over the ground. Almost on the horizon, the viewer sees a glimpse of Jerusalem, much brighter than the rest of the landscape, as gray clouds approach the city. Church portrays the most important elements of the painting in the foreground and background: In the foreground, the olive trees are practically green shadows, except for the tops of the trees, whose leaves are spattered with light and, in the background, the lit-up city, white and brown houses barely visible.

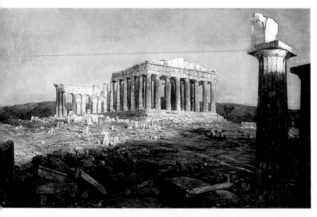

The Parthenon

1781
oil on canvas
44.5 x 72.6 in
(113 x 184.5 cm)
Metropolitan Museum
of Art, New York

Church traveled through Europe for almost a year and a half, first visiting London and Paris and then continuing on to Alexandria, Constantinople, and Jerusalem, where he became fascinated by desert landscapes. His love of ancient civilizations took him to the coasts of Italy and Greece, where he made many sketches of the Parthenon.

Church did not use a high perspective in this view, so impressed was he by the majesty of the Greek temple. It rises above the irregular ground in all its greatness, despite being just a ruin. The sketches that Church made have served to bury the myth of the resplendent whiteness of ancient Greek architecture. A close study of this image reveals that the columns of the temple are reddish; this color is the remains of the protective polish once used on the building. A special painting technique, based on the direct application of hot wax mixed with pigments, was used to apply this finish. It gave the building a very colorful appearance.

EDWARD MITCHELL BANNISTER

Edward Mitchell Bannister.

Edward Mitchell Bannister, a prominent 19th-century New England painter, was the first Afro-American artist to receive a national award. His decision to settle in Boston, a tolerant city, center of the abolitionist movement where great opponents of slavery lived, benefited his devotion to painting. He completed and sold several paintings there.

Bannister never studied painting formally. He always attributed his talent to his religious beliefs. Perhaps that is why many of his paintings from his earliest period depict biblical themes, although he also painted portraits, landscapes, and historical scenes. In 1865, Bannister took classes with the sculptor William Rimmer. He learned technical principles that influenced his style from this point on.

That same year, William Morris Hunt returned to the United States after a stay in France, bringing a new style of painting with him from the Barbizon School. Bannister adopted this style in subsequent paintings, since it allowed him to express his admiration and reverence for nature. His paintings during this time depict nature as quiet, passive, and beautiful. Unfortunately, Bannister's landscapes are small and have darkened considerably with time.

Moving to Providence, Rhode Island, brought him closer to nature, allowing him to paint landscapes and forests constantly. His paintings evolved during this period, and he stopped painting biblical themes to focus on landscapes and coasts; these new paintings featured several layers of paint and few details.

- **1828** Born in St. Andrews, Canada, son of a Scotswoman and a native of Barbados. His father dies when the boy is six years old.

- **1844** His mother dies, and he goes to live with a family in New Brunswick.

- **1848** Works as a cook on a boat, traveling to Boston and New York and visiting libraries and museums in those cities. Finally settles in Boston. In 1840, the daguerreotype had opened a new market in pictures. Persons with artistic talent were needed to tint the pictures, the precursors of photography. Bannister finds a job in this field, which is compatible with his work as a barber. Meets his future wife.

- **1850-60** Actively works in abolitionist circles in Boston in favor of Afro-American rights.

- **1857** Marries Christiana Babcock Carteaux, a Native American from Narragansett, Rhode Island.

- **1870** Settles in Providence, Rhode Island, with his wife. Devotes himself to contemplating the surrounding landscape.

- **1871** Sets up the Providence Art Club with other Rhode Island painters.

- **1876** Wins the bronze medal, the highest award given to an oil painting by the jury at the U. S. Centennial Exposition in Philadelphia, for his painting *Under the Oaks* (now lost). This is the first national exhibition in the country in which great American artists, such as John Singleton Copley and Frederic Church, also participate.

- **1901** Dies of a heart attack in Rhode Island on January 8 while attending an Elwood Avenue religious service.

Although he had sparse technical knowledge of painting, Bannister was one of Providence's most renowned painters. After his success at the Centennial Exposition, he had a greater reputation and, because of the many commissions he received, he was able to devote himself entirely to painting.

Gradually, the Barbizon School and with it, Bannister, went out of fashion, giving way to the Hudson River School. Bannister started to have memory lapses, and this affected his activities. Nevertheless, he continued painting with brushstrokes of broken color that are reminiscent of the Impressionists' technique.

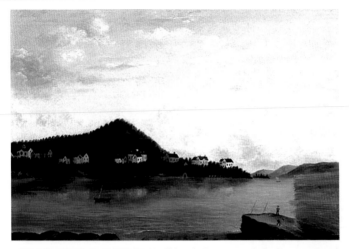

Dorchester

(1856)
oil on canvas
14.1 x 20.1 in (35.9 x 51.1 cm)
Smithsonian American Art
Museum, Washington, D.C.

This painting was made in the same year that William Morris Hunt returned to the United States with the new Barbizon School landscape painting style, a style that Bannister adopted in his first period as a painter. The composition and elements of *Dorchester* are reminiscent of the style of Jean-Baptiste-Camille Corot (1796-1875), for whom the most important part of painting was to express a balance among elements. As in most of Bannister's work from this first period, the human figures are so small that they seem to function only to reveal the harmony between man and nature. The painting depicts the peacefulness of a small sailing town. Two sailboats, one in the middle of the painting and another small one on the right, sail peacefully through serene water. Two people quietly do their chores.

The ambience is largely created by the colors and the lack of deep shadows in the painting. The pearl tone in the grayish blue and the cold, soft colors produce a sensation of imperturbability, evoking nature's peacefulness and calm. Bannister does not capture much depth in the landscape. Although there are several planes in the painting, the lack of strong color contrasts, the absence of shadows, and the emotional neutrality make the painting reminiscent, to a great extent, of xylographs, lithographs, engravings, and even the first photographs. Although Bannister's style here is based, in part, on some of Corot's painting, he was probably influenced by his early years working in daguerreotype as well.

Right: In the 19th century, most newspapers were sold by children. These children—"newsies"—called out the latest news to passersby, working to entice buyers. They were generally children from poor families that needed another wage earner to make ends meet. Artists began to depict this situation as child labor rose in the United States at the end of the century. Several painters of the time, such as William Hahn and Winslow Homer, began to produce art that depicted children in their daily work, performing adult jobs.

Newspaper children were a particularly recurrent theme. Paintings, engravings, and photos depicted the reality of children who struggled every day on the street to earn a living. This is one of the best examples of the child-labor genre, although it is one of the few Bannister paintings with social content that has survived and perhaps one of his few urban works. It was painted in Boston, a city seething with tensions: former slaves, recently arrived from the South, competed with Irish immigrants looking for work.

Like many paintings that deal with the theme of newspaper children, this one depicts a healthy and robust boy, but in contrast to other paintings, Bannister illustrates a mixed-race child full of self-confidence. Bannister did not feel comfortable painting people, and perhaps that is why, while he uses fine brushstrokes on the boy's face to depict it in detail, he has opted for thick brushstrokes in the rest of the painting. On the boy's hand, particularly, the stroke is much coarser than in the rest of the painting. The social symbolism in the work places Bannister in a distinctly American genre, and the brushstroke makes it clear that this painting is from the artist's quasi-Impressionist second period.

Bannister's *Approaching Storm* is one of his most emotionally charged paintings. In most of his work, nature is represented as bucolic, calm; here, the force of the wind produces movement and exaltation. The branches and the leaves of the trees curve with the wind, while dense clouds cover the sky. There is a strong sense of movement; it almost seems that the color and brushstrokes are being erased by the wind.

Although the approaching storm, wind, and light are the painting's central elements, the small figure walking on the

Approaching Storm
(1866) oil on canvas 40.2 x 60 in (102 x 152.4 cm) Smithsonian American Art Museum, Washington, D.C.

trail, trying to keep his hat from being blown away by the wind, plays a central role. Although he is small and wearing dark clothes, this man is in the middle of the composition, the only element moving against the wind. He carries an ax, which implies that the storm has surprised him at his chores. He is walking on a clearly marked path. Bannister probably wanted to illustrate how an ordinary rainy day was for someone working in the field.

Like the artists of the Barbizon School and the Impressionists, Bannister responds to nature from a sensory point of view, using flat tones in vibrant autumn colors. Here he uses green and yellow tones to make the earth's brown color stand out. The clouds are full of turbid gray tones that help create the sensation of an approaching storm. In the manner of Gustave Courbet, Honoré Daumier, and Jean-François Millet, he tends to blur or attenuate shapes by using wide brushstrokes of paint that, in this case, heighten the sensation of strong wind.

Newspaper Boy
(1869) oil on canvas 30 x 25 in (76.2 x 63.5 cm) Smithsonian American Art Museum, Washington, D.C.

After the Shower

oil on paperboard
8.5 x 10 in (21.6 x 25.4 cm)
Smithsonian American Art Museum, Washington, D.C.

Before 1880, painting outdoors was not popular among artists. Although it became common among Corot and artists of the Barbizon School in general, these painters seldom completed entire paintings outdoors. Later, the Impressionists also painted outdoors to capture the colors of light.

Bannister, influenced by both schools during his time in Rhode Island, began to paint outdoors more. *After the Shower* was painted toward the end of the painter's life. The thick brushstrokes that avoid fine detail and the color strokes that organize space and volume are reminiscent of the Impressionists' style. This new way of painting, based on the direct experience of light and color, required Bannister to change his perception of shapes. Nonetheless, although the style is completely different from his earlier periods, his paintings continue to evoke a sense of peacefulness.

This painting is reminiscent of the moment right after a shower, when the clouds are bright red and are reflected on the whole setting. The supremacy of color over details produces an image based on sensations, and the validation of the impression comes from the real world. Bannister wanted to show the harmony of nature and convey its peaceful essence in landscapes. He achieved this with this new style, sacrificing detail and forms to convey an accurate impression.

Right: When Bannister completed this work, luminism had already triumphed at the hands of artists such as Sanford Gifford. Luminism gave landscapes a certain air of mysticism, emphasizing the lighting of large natural areas over the rest of the elements. Bannister was able to use this mysticism in the most common and simple countryside.

In this small canvas, he displays great delicacy in portraying the twilight that brightens the sky. The diagonal composition, with the lower segment dominated by the terrain, is surprisingly reminiscent of Goya's *The Dog*, although there is no evidence that Bannister ever saw that painting. The artist's mastery is based on giving importance to ordinary landscapes, rather than exalting large natural scenery, as members of the Hudson River School did. A hill where cows descend—to go to water? To return to the barn for the night?—comes to have the same importance as the depiction of Kauterskill Falls, giving the viewer the feeling that he is participating in a beautiful and magical moment. The work's small dimensions, which make it easy to transport, reflect the artist's taste for painting outdoors. Likewise, the loose brushstroke proves his skill in depicting the essence of the landscape.

Untitled (Cows Descending Hillside)

(1881)
oil on canvas
11.1 x 12.1 in (28.3 x 30.8 cm)
Smithsonian American Art Museum, Washington, D.C.

This is a typical painting by Bannister, a bucolic landscape based on a contemplative and realistic approach to nature. The landscape becomes an excuse to express the idea of perfect harmony in a setting that Bannister depicts in detail.

Bright Scene of Cattle near Stream

oil on canvas
22.2 x 36.3 in
(56.5 x 92.1 cm)
Smithsonian American Art
Museum, Washington, D.C.

The cows grazing in the middle of the painting are in a kind of islet formed by the yellowish green pasture. This space is bordered in the lower part by bushes and a stream, and in the upper part by leafy trees. This makes it seem that the cows are grazing in a peaceful, protected space. The white clouds that practically cover the entire sky are made with thick brushstrokes that give the impression that the landscape is moving.

Significantly, in all of Bannister's work, the artist gives all of the elements and all of the painting's angles the same value. The upper and lower corners, as well as the center of the landscape, have been painted with the same artistic interest. Although he plays with the islands of color and the space, the clouds, bushes, and trees are just as important as the cows and the stream. By creating bucolic and peaceful settings, Bannister was able to make paintings that were not literary, political, scientific, philosophical, or moral. His paintings appear to be only an interesting experiment in color and shapes that blend on the canvas. This produces the harmonious sensation that the pigments are part of the canvas. They are colors with texture.

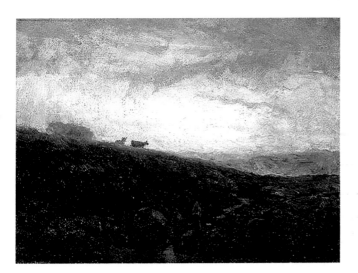

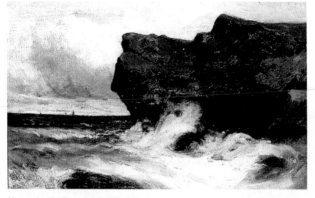

Ocean Cliffs

(1881)
oil on canvas
10 x 16 in
(25.4 x 40.7 cm)
Smithsonian
American Art
Museum,
Washington, D.C.

Not only did Bannister paint the American countryside, he also occasionally depicted the coast of the United States on canvas. Though his first years of life coincided with the abolition of slavery, the early death of his parents forced the painter to find a way to make a living. Combining his fondness for painting along with his need to support himself, Bannister found work as a sailor based at Boston Harbor, sailing close to the coast from Connecticut to New York. There he met his wife-to-be, a brilliant businesswoman by the name of Cristiana Babcock Carteaux, who encouraged him to dedicate himself fully to painting. The couple moved to Rhode Island, and the artist took long walks on the coast.

This work is one of the few seascapes the artist painted. His talent for observation is evident in the way he illustrated the force of the waves. It is even more commendable if the viewer takes into account that it is by a totally self-taught painter.

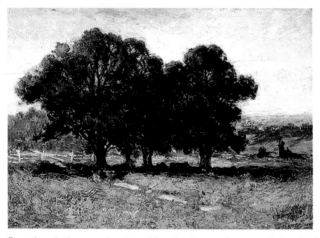

Landscape

(1899)
oil on canvas
14 x 20 in
(35.5 x 50.9 cm)
Smithsonian
American Art
Museum,
Washington, D.C.

Even though the exact location of Bannister's most famous painting, *Under the Oaks*, which won first prize at the Centennial Exhibition in Philadelphia, is still unknown, other works are a testimony to his skill in capturing nature. Here, the protagonists are three trees situated next to a small trail leading toward the edge of a farm. Animals rest under their shade, while the sky shines with the clear blue of a summer day.

The brushstrokes here are loose, vibrant, and descriptive, in line with the French painters of the Barbizon School. However, as a result of all the details that he sees and captures, Bannister's painting has a bucolic, tranquil tone, reflective of a calm and contemplative spirit. The appearance of Bannister in American art signaled the acknowledgement by the public and the institutions of the abilities of Afro-American artists. Before his time, these artists had been looked upon with prejudice—prejudice that lingered well into our own times.

ALBERT BIERSTADT

Albert Bierstadt.

Albert Bierstadt was one of the most successful American artists between 1860 and 1870. His enormous panoramic paintings capturing the monumentality and beauty of the American West were bought by the most powerful politicians and industrialists of the time for extraordinarily high prices. Railway, mining, and wood magnates all wanted these glorious images of the countryside that they themselves were gradually domesticating.

In Bierstadt's style, we can see the influences of the history painter Emanuel Leutze, as well as the German Romantic landscapists who were characterized by their heroic tones and highly detailed compositions. Bierstadt also traveled through Europe with American landscape painters such as Thomas Worthington Whittredge and Sanford Gifford, with whom he made studies of the Alps and the Rhine.

His deep love of the West began during a trip to the Rocky Mountains and, throughout his travels, he took numerous photographs and made many sketches, which he then developed into oil paintings in the Tenth Street Studio Building in New York. He also painted landscapes of California and Alaska. Bierstadt always went beyond recognized boundaries in order to portray America's virgin territories.

During the last decade of the 19th century, new trends arriving from Europe—such as Impressionism and the Barbizon School—began to take the limelight, and Bierstadt ended up declaring bankruptcy. He died completely forgotten in 1902. Today he is considered the greatest landscape painter of the West.

- **1830** Born on January 7 in Solingen, Germany.

- **1832** Emigrates to the United States with his parents, settling in New Bedford, Massachusetts.

- **1850** Works as a drawing teacher; spends time with local painters and daguerreotypists.

- **1852** Visits the White Mountains.

- **1853** Travels to Düsseldorf, Germany, to study painting. Travels to Italy and Austria with Gifford and Whittredge.

- **1857** Returns to New Bedford and organizes an exhibition of 150 paintings. The Boston Athenaeum purchases one of his works, guaranteeing his success.

- **1858** Exhibits one of his works at the yearly exhibition of the National Academy of Design. Shortly after, becomes an honorary member.

- **1859** Makes an expedition through the Rocky Mountains and Wyoming led by Colonel Lander.

- **1861** Acquires a studio in the Tenth Street Studio Building in New York. Exhibits at the Brooklyn Art Association.

- **1862** Joins the Century Association.

- **1863** Makes a second trip to the West by train with writer Hugh Ludlow, whose widow he would marry several years later.

- **1865** Builds a house with 35 bedrooms on the shore of the Hudson, near New York. He calls it Malkasten, German for "box of paints."

- **1867** Visits Europe again. Has audiences with Queen Victoria in England, Napoleon III in France, and the czar in Russia. In London, he exhibits at the Royal Academy, in France he is awarded the Legion of Honor, and the czar presents him with the Order of St. Stanislaus.

- **1871** Travels to California. Makes many trips to the White Mountains.

- **1872** Visits California's Farallon Islands.

- **1876** Accompanies his wife to Nassau, due to her delicate state of health.

- **1882** His Hudson River house burns down with many of his works inside.

- **1889** Paints in Alaska and British Columbia. Presents his work *The Last of the Buffalo* at the Universal Exhibition in Paris, but it is declined.

- **1890** Continues painting landscapes and also creates designs for train cars.

- **1902** Dies in New York on February 18.

The Roman Fish Market

(1858)
oil on canvas
28.5 x 37.5 in (72.4 x 95.2 cm)
Fine Arts Museums
of San Francisco

Bierstadt had traveled to Düsseldorf to study painting, There he met up with other American painters, including the landscapists Whittredge and Gifford. He traveled with them along the German Rhine and through the Alps and Italy, making many sketches that would later be developed into paintings.

This is one of the paintings he made, inspired by scenes of Italian daily life, which must have seemed extremely picturesque to the artist. Although such scenes are not characteristic of his typical work, they do show his tendency toward meticulously detailed descriptions, learned from Leutze, and his preference for monumental elements that dwarf the human figure. The enormous mouth of the arch opening onto the passage could easily swallow up all the characters taking part in different market activities. A fishmonger watches over his wares, sniffed at by a cat and surrounded by ducks, while others examine the fish on an improvised table that is held up by pieces of classic columns. A gentleman mixes among the general rabble, watched by one of them. In spite of the detail, the people in the second and third planes are roughly sketched, not a feature of later work, which always showed great visual clarity.

Upon returning to the United States, Bierstadt, always a man with initiative and a strong commercial character, organized an exhibition in New Bedford with 150 works, including many by the great artists of the day. Shortly after this, the Boston Athenaeum acquired one of his pieces, marking the beginning of a successful career.

Ruins of Paestum

(1858)
oil on canvas
22 x 36 in
(55.9 x 91.5 cm)
Minneapolis Institute of
Art, Minnesota

Bierstadt impressed critics at the annual exhibition of the National Academy of Design in New York with this work portraying Lake Lucerne, at the base of the majestic Swiss Alps. New York critics were moved by the technical perfection and, within weeks, had proposed his entrance into the Academy as an honorary member. This moment marked the beginning of a career filled with triumph.

Lake Lucerne

(1858)
oil on canvas
72 x 120 in
(182.9 x 304.8 cm)
National Gallery of Art,
Washington, D.C.

Viewers responded to this work with great emotion, due to several elements. First, the panoramic format captures all the splendor of the lake and the monumentality of the Swiss Alps, rising magnificently to the blue sky above and crowned by clouds. Second, the representation of these immense mountains dominating the narrow green strip of the lake provokes a sublime sensation, a characteristic of painters such as the German artist Caspar David Friedrich, who used these resources to place the viewer within the work.

Finally, Bierstadt has created a sense of distance through a careful study of aerial perspectives, covering the farthest peaks, and his use of cold colors in the middle ground to make them seem more distant. Bierstadt consistently used the effect of alternating shadow and light to increase the depth of his landscapes. He had learned these techniques while studying in Germany, and he would use them repeatedly in his works. Although he was working with well-known techniques, the beauty of his work comes from his talent for combining all of them in one expressive painting: the representation of the sublime.

Left: Landscapes with classical ruins were very attractive to 19th-century painters interested in depicting a romantic vision of ancient times. These particular ruins are part of the famous temple of Paestum, constructed by the Greeks in Italy during the colonization of the Mediterranean in the 6th century B.C.

This work was a learning exercise for Bierstadt, who was starting to teach himself to capture natural scenes using aerial perspective. While his traveling companion Gifford worked to represent light in his landscapes, Bierstadt showed greater interest in the clarity of the drawing and the detail of the representation. In this composition, totally horizontal and balanced, the remains of enormous columns from the Greek temple occupy the foreground, while in the background the silhouettes of majestic mountains can be seen. Two trees add perspective, more distinct in the effect of the shadow that crosses the landscape.

The study in tonalities in the transition from the upper area of the blue sky to the lower part, colored by the sun, shows Bierstadt's mastery in capturing chromatic changes. In the same way, his perfect finishing touches reflect the countryside with an almost photographic faithfulness. Unlike contemporary painters who were heavily influenced by academia, Bierstadt daringly represents the scene without framing it with other elements, such as trees on both sides. In this way, he achieves a more panoramic and relaxed vision.

The Lander's Peak

(1863)
oil on canvas
73.5 x 120.7 in
(186.7 x 306.7 cm)
Metropolitan Museum of
Art, New York

When he was 29, Bierstadt accompanied a government expedition led by Colonel Frederick West Lander to the West. The objective of the journey was to find a new route for crossing the Rocky Mountains toward Wyoming. But for Bierstadt, the journey meant the discovery of what would become his favorite subject matter: the virgin landscapes of the American West.

With a mule loaded down with his canvases, sketchpads, and brushes, Bierstadt made numerous sketches and took many photographs of the lives of the Indians and the magnificent land-scapes of the Rocky Mountains. When he returned to New York, he acquired a studio in the Tenth Street Studio Building, where he created the enormous panoramic vistas of natural American marvels that the public loved.

This is one of the most beautiful views ever made of the Rocky Mountains, which at this time were considered the American Alps. Bierstadt already had gained experience with representing the Swiss mountains. The detailed depiction shows how photographs helped the artist, and indeed, Bierstadt was one of the first painters to use this technique to finish his works. However, it is not merely photography that gives the painting its grandness, but rather the mastery of the painter. In the foreground, the lives of the Indians, not without a certain idealism, are presented in an Eden-like paradise dominated by a waterfall and lit artificially by a ray of sun. The hot colors in the foreground give way to the cold tones of the middle ground, where we can see the silhouette of Lander's Peak, fuzzy because of the aerial perspective.

These were the scenes that Bierstadt's Eastern public raved about; they longed to know what existed at the edges of the frontier. Bierstadt gave them the savage and majestic images that they clamored for, and because of this, he earned much success. In exhibitions throughout the United States, the public would pay simply to see this work.

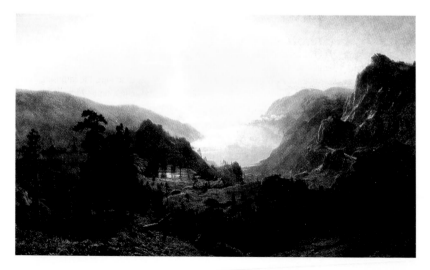

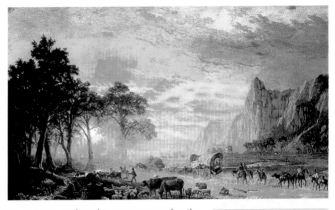

Bierstadt's paintings were a top-notch tool to encourage emigration to the recently conquered lands of the West. His idealized vision of the Rocky Mountains and the American prairies encouraged pioneers from the East to depart for the new lands.

This work, smaller than Bierstadt's panoramas, shows a caravan on the road, headed toward the Promised Land. A resplendent sun points the way, as if it were God himself guiding them and protecting them in his golden light. However, the journey is not without its perils and, in the distance, we see an Indian camp threatening the peace of the path West. Similarly, the travelers who never reached the West cannot be forgotten, and a cow skull announces the difficulties these voyagers will need to confront. However, the presence of other, well-fed animals ensures that they will overcome difficult times.

> ### The Oregon Trail
>
> (1869)
> oil on canvas
> 31 x 49 in
> (78.74 x 124.46 cm)
> Butler Institute of American Art, Youngstown, Ohio

State representatives were delighted with these works of an almost biblical nature, seeing them as a way to promote expansion toward the West. Bierstadt had already experienced travel by caravan to unknown territories, and the notes he had made on that trip helped him in this work. He had journeyed with the young writer Hugh Ludlow (whose widow he would later marry). They met a caravan of Prussian immigrants, and this trip surely inspired him to create this splendid painting.

Left: Bierstadt's paintings were in great demand from industrialists working in mining and lumber, or on building railroads. The vice president of the Central Pacific Railroad ordered this work, planning to exhibit it throughout America to promote the construction of the Transcontinental Railroad.

The elevated perspective places the viewer in a privileged place, to admire the imposing and somber rocky cliffs and the morning sun shining in the sky and reflecting on the pristine waters of Donner Lake. Wild stands of sequoias, the largest trees in the world, grow abundantly on the left-hand side, appearing small before the monumental landscape. A train, so small it is barely discernible, crosses the mountains on the right-hand side.

> ### Donner Lake
>
> (1867)
> oil on canvas
> 72 x 120 in
> (182.9 x 304.8 cm)
> New-York Historical Society

This work, used on publicity posters, imparts important information to the viewer: First, that Donner Pass, where the tragedy of the Donner Party had occurred several years earlier, was not only not dangerous, but could be traveled in safety, thanks to the railroad. Second, it told viewers that the train would not damage nature and demanded little space in the abundant landscape. Finally, it showed that the train was the ideal viewing platform for anyone who wished to contemplate the beauty of this natural wonder.

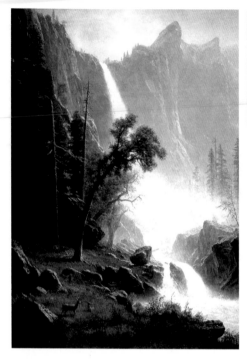

Bridal Veil Falls, Yosemite

(1873)
oil on canvas
36.1 x 26.4 in (91.7 x 67 cm)
North Carolina
Museum of Art, Raleigh

Bierstadt was at the peak of his career when he created this work, which coincided with the business boom in the West. Astronomical figures were paid for his works—around $15,000 at this time (about $1.5 million today), although he would never become as famous as the landscapist Frederic Church. Bierstadt had already visited California's Yosemite Valley, and like many of his contemporaries, he saw it as a veritable Garden of Eden.

Ironically, this divine vision was what attracted large numbers of tourists to the site and forced the painter to look for new settings. This is a sublime landscape, creating the aesthetic emotion felt upon contemplating something of both beauty and grandeur. Yet the painting does not seem as excessive as some of Bierstadt's enormous previous works. The magnificent waterfall plunges from above as if falling from the heavens, spraying the surrounding vegetation as it strikes the rocks below. Two deer watch the show offered by the torrent of water rushing between the rocks.

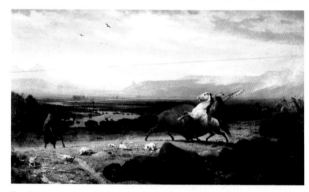

The Last of the Buffalo

(1889)
oil on canvas
71.2 x 119.3 in
(180.9 x 302.9 cm)
Corcoran Gallery,
Washington, D.C.

The West, mostly settled by the time this work was painted, would end up being disfigured by the felling of trees, mining, and the railroads. American Indians would suffer tragically, confined on reservations, witnessing the destruction of their primary food source—the herds of buffaloes. Here, Bierstadt attributes the near-extinction of the buffalo to the Indians, as did the rest of the American population—when in reality the crisis was due to the white man and his massive hunts.

Although this work retains all the characteristics of the painter's style, Bierstadt no longer enjoyed the same reputation as before. His idealized visions no longer found acceptance with the public; once the West was conquered, they were able to see for themselves the places that Bierstadt represented in his works. Furthermore, new trends such as Impressionism and the Barbizon School were arriving from Europe, proposing new languages that made Bierstadt's grandiloquent works obsolete.

When he presented this work to the committee in charge of selecting the paintings that would represent the United States in the Universal Exhibition in Paris, it was rejected for being old-fashioned. Bierstadt would die ruined and forgotten in New York on February 18, 1902.

SAMUEL COLMAN

Solomon's Temple, Colorado *(detail), 1888,
casein on paper, 20.5 x 26 in (52 x 66 cm),
Private collection.*

- **1832** Born in Portland, Maine, son of an art history editor. The family later moves to New York, where his father opens a bookshop on Broadway.

- **1860** Travels to Europe, where he visits Italy, France, and Switzerland. He is one of the first American artists to portray Spain and Morocco.

- **1862** Named a member of the National Academy of Design.

- **1866** Founder and first president of the American Society of Watercolor Painters.

- **1867** Interested in engraving technique. First landscapes.

- **1870** Begins his voyage to the American West, whose landscapes are depicted in panoramic paintings.

- **1871** Visits Spain, France, Italy, and Morocco during his second trip to Europe.

- **1877** Exhibits his engravings at the inauguration of the New York Etching Club.

- **1881** Decorates the house of Mark Twain together with his friend Louis Comfort Tiffany.

- **1920** Dies in New York.

Samuel Colman's artistic career is characterized by constant development and change, parallel to the evolution of American artistic society in the second half of the 19th century.

Trained by the painter Asher Brown Durand, Colman is considered a second-generation artist of the Hudson River School, although this classification is not exactly correct. His constant work and graphic experimentation allowed him to follow the European artistic evolution in the years before Impressionism. His frequent travels to Europe and northern Africa put him in contact with fine art from the Old World, and because of this his art acquired a transitional character that united the luminist trends of the middle of the century with the new art of the 20th century.

Colman experienced this gradual, moderate movement in different disciplines. By the end of his pictorial career, the artist had embraced the idea of total art proposed by Charles Rennie Mackintosh and Louis Comfort Tiffany, and had also become interested in decoration. Toward the end of the century, he worked in decorative arts with Tiffany and John La Farge.

Samuel Colman was an art collector and expert in art and Asian ceramics, an engraver and a painter. In his art, he created original transitional painting that reflects the American artistic character of the second half of the 19th century.

Off the Maine Coast

(~1860)
oil on canvas
28 x 45.1 in (71 x 114.5 cm)
Brigham Young University
Museum of Art, Provo, Utah

The influence of Asher Brown Durand is quite evident in Samuel Colman's work. Durand, who was Colman's teacher, guided him with his passion for luminism and the aesthetics of the Hudson River School, as well as his respect for Romantic landscapes. In these, the vision of man and his relationship with the work of God acquires a moral language where the humility of the human being before the grandeur of nature is exalted.

In Asher Brown Durand's work, this depiction of human humility before divine creation is represented perfectly in the painting *Kindred Spirits*, completed in 1849, which inspired Samuel Colman to create this painting of the coast of Maine. Here the artist has followed the guidelines of his teacher to give his picture dynamism through his organization of pictorial planes; the areas of light and dark impart a rhythm to the composition.

The sense of depth in the painting, which is extreme due to the darkness of the central space, acquires a moral quality that invites the viewer's introspection. It must be noted that this work is not a faithful representation of a real landscape. The artist has intentionally added certain elements to his works to give them greater energy and life. His composition here interlaces vertical lines with the clear horizontal direction of the painting. As if portraying classical architecture, Colman has placed a vertical framework of trees along the side, which supports the composition and meaning of the work as it develops from a distant and romantic horizon.

The Harbor of Seville

(1867)
watercolor and gouache
12.4 x 27.6 in (31.5 x 70 cm)
National Gallery of Art, Washington, D.C.

During the 1860s, Colman's painting reflected new styles coming from Europe. In the first half of the century, landscapes in the United States tended to be faithful reproductions of nature, drawn from the perspective of Romantic morality exported from England at the beginning of the century.

However, starting in 1850, the American art world experienced a renewal, thanks to artists who were involved in the new trends of Paris and London, but who did not want to adapt them to monotonous American luminist aesthetics. James McNeill Whistler, Mary Cassatt, and John Singer Sargent are examples of this new artistic ideal; they sought the creation of a genuinely new American style. Colman, however, still retained the teachings of Durand. While his extensive travels opened his eyes to new interpretations of painting, his work continued to be influenced by Romanticism.

This painting shows a classic interior composition, centered on a river landscape of well-defined lines and contrasts between depth and volume. Colman did break with convention in the way he handled color. In a clear, bright atmosphere, the reflection of the water offers the illusion of vertical continuity. Colman also introduced an element of modernity through the smokestacks and the steam, clearly alluding to the Industrial Age in the middle of this work of classical Romanticism, depicting the wildness of nature. The steam, the symbol of an uncertain future, is diffuse and surrounded with a mysterious halo, while at the same time the luminosity of the whole painting suggests hopefulness. The integration of the steam with the naturalist landscape shows the artist's character: He keeps the conservative elements of Romanticism, yet recognizes in the industrial era a secret beauty, almost organic in appearance.

Storm King on the Hudson

(1866)
oil on canvas
32.1 x 59.8 in (81.6 x 152 cm)
Smithsonian American Art Museum, Washington, D.C.

Left: Samuel Colman was one of the first American painters to break away from the confines of Anglo-American influence to travel the world searching for new landscapes and painting styles. He moved from the luminism of American landscape painting to entirely new scenes, becoming fascinated by the exotic Moorish forms found in architecture in the south of Spain and Morocco.

This vista of the city of Seville confirms the strong influence of the style of the Hudson River School. Here he shows, in a poetic light, the architecture along the Guadalquivir River in the Andalusian capital. The Tower of Gold, which the Arabs constructed on the riverbank during their occupation of the Iberian Peninsula in the Middle Ages, is perfectly recognizable, even though it lies in the distance.

A gentle depth combines with the verticality of the architecture to form a poetic play of shadows that gives a feeling of transcendence. Using shadows that imbue the ships and port with energy and life, the artist has played with the sensation of corporeality. At the level of the water, the boats and port appear dark and solid, drawing the viewer toward the tangled horizon, while the forest of masts and rigging dissolves toward a beautiful Andalusian sky.

Dusk

oil on canvas
7 x 11.5 in (17.8 x 29.2 cm)
Private collection

In this work, the painter shows his great expertise in rendering landscapes; *Dusk* is compositionally strong and aesthetically pleasing. This work depicts a row of backlit trees, which divide the landscape into two broad planes and increase the effect of depth; they also add a sense of chromatic play to the scene. The glowing twilight defines the clouds in the sky and the distant mountains and draws attention to the contrasting silhouettes of the trees. Like a backdrop, this light defines boundaries and focuses attention on the water. Here Colman's short, energetic brushstrokes offer a symphony of color enlivened with a rich range of tonalities, in the style of the works of the French Impressionists. The reflection of the trees on the water increases the expressiveness of the composition, making the landscape more evocative.

The painter cannot conceal his deep knowledge of nature in this type of composition, nor the influence of the works of the French and English landscape artists. To this he added the characteristics that make the American landscape unique. Colman's landscapes pay homage to nature, praising and magnifying it. The painter shows himself to be a great nature lover through his representations, but he also demonstrates his extraordinary ability to capture spectacular images. *Dusk* is a great act of recognition of the perfection and glory of the work of God.

In American painting, landscape artists were in many respects historians, and on many occasions were the first graphic witnesses to events and territories. Samuel Colman was the first painter to represent the landscapes of Nevada, although the graphic veracity of his work remains in doubt due to his incredible improvisational skills with his paintbrush. In many of his paintings, he altered reality in order to create a stronger composition. This work shows a view of the Colorado River, fascinating because of the rough shapes on the reddish rock walls. The artist

Solomon's Temple, Colorado

(1888)
casein on paper
20.5 x 26 in (52 x 66 cm)
Private collection

plays with a monochromatic range of earth tones that are softly broken by the horizontal shape of the river and the sky. An interesting study in volume is created here; the directional lines are authentic structural protagonists.

From the river, the succession of vertical lines emphasizes the treatment of color and move the viewer's eyes toward the enormous boulder outlined against the sky. In this work, depth has been achieved, not through visual continuity into the distance, but through the creation of volume. Vertical lines cut the first plane directly to open the landscape toward an aerial background. In this way, the artist has reinvented a visual sequence of different planes drawn from nature.

Beach Scene

(1886)
oil on canvas
Peabody Art Collection,
Baltimore, Maryland

Toward the end of his career, Samuel Colman accepted changing artistic trends that granted him greater artistic freedom. The rigid structure of the artists of the Hudson River School dissipated, and light acquired a different, more truth-to-life quality; it no longer determined an expressive quality, but a mood.

This painting, one of the most modern of Colman's works, has a degree of Impressionism. The artist uses more lively and intense colors that are distributed over the surface of the painting in large and apparently static spaces. He has composed the work starting from large horizontal strips, one of which forms the sky and the other the sand on the beach. In this way, Colman adopted a free simplicity that contrasts with the meticulous style that dominated his work until the end of the 1860s.

In this painting, the brushstrokes are expressive and the lack of definition of the figures creates movement; the painter has achieved a work of sensations. Without doubt, this piece demonstrates that by the 1880s, Colman already had an understanding of the new European aesthetics. The luminosity and the quality of the brushstrokes clearly show that the artist was working with Impressionist ideas. The composition is still formal, a bit timid, anchored firmly in landscapes from the middle of the century. However, the play of light and the complementary contrasts between the sand and the figures on the beach show Colman's interest in modernizing his style to keep up with new European influences. From this time on, artistic ideas were dominated by the French art world rather than the British one.

WILLIAM TROST RICHARDS

William Trost Richards and his grandaughter Edith Ballinger Price in Conimicut, Rhode Island, (1899).

William Trost Richards was self-taught from a very young age, acquiring most of his knowledge through practice and observation. He became one of the most successful landscape artists both in the United States and England, recognized above all for his magnificent seascapes.

Richards's work should be considered within the field of landscape painting that tries to impart an aesthetic experience by using a wide range of formats and techniques. Richards created both large-scale paintings and ones the size of a postage stamp, depending on what was most useful or suitable, and worked with watercolors and gouache to increase the expressiveness of his paintings. Thanks to this, he was skillful at emphasizing the beauty in apparently common daily scenes like the sea or tree-filled landscapes without needing to introduce grandiloquent subject matter.

What he did do was saturate most of his landscapes with luminosity, something he achieved by selecting the perfect and exact moment when the light caressed and touched the land, transforming it into something beautiful. The artist displayed great technical skill in his sketches, as it is very difficult to depict light, which is always changing throughout the day; the same is true of the waves in the sea. The sketches Richards made were later organized in the studio, where the artist selected the format and technique he would use for the final work.

His finished paintings are characterized by enormous realism; they were intended to delight the viewer. Richards's attention to realism is a direct result of his interest in artistic techniques and drawing, which he had the opportunity to develop during his trip to Europe.

- **1833** Born on November 14 to a Quaker family from Philadelphia.
- **1846** Works at a local store to support his family after his father's death.
- **1851** Works at a company that adorns and finishes advertising illustrations, a job that requires a great mastery of drawing.
- **1852** Starts to paint on his own accord. Sends a landscape painting to the Pennsylvania Academy of the Fine Arts, and it is exhibited at the Academy's yearly exhibition.
- **1853** The Pennsylvania Academy exhibits three of his works, two of which sell quickly.
- **1854** Travels to Europe on a scholarship from the Philadelphia Art Union. Spends long periods of time in Düsseldorf.
- **1865** Starts creating seascapes.
- **1876** Wins a medal at the Centennial Exposition in Philadelphia.
- **1878** Visits the Cornish coast of England for the first time, to paint seascapes to be sold on the American market and to establish himself in the London artistic market.
- **1879** Exhibits two of his English works at the Royal Academy in London, which sell quickly.
- **1880** Returns to the United States.
- **1882** Builds a house on Conimicut Island in Narragansett Bay in Newport, Rhode Island. Is at the peak of his success.
- **1885** Travels to the Pacific Coast and England, looking for new landscapes. Receives a medal at the Pennsylvania Academy of the Fine Arts.
- **1889** Wins the bronze medal at the Universal Exhibition in Paris.
- **1892** United States borders expand to the Pacific Coast.
- **1905** Dies on November 8 in his house in Newport, having belonged to such illustrious artistic societies as the National Academy of Design, the American Watercolor Society, and the Pennsylvania Academy of the Fine Arts.

Lake Squam from Red Hill

(1874)
watercolor, gouache,
and pencil on paper
8.9 x 13.6 in (22.5 x 34.6 cm)
Metropolitan Museum
of Art, New York

Richards's father died in an accident, and Richards had to work from a young age. His work experience gave him the chance to enter a company that retouched advertising posters. His job was to create the ornamental filigree that surrounded the promotional material, work he found extremely disagreeable because of its highly mechanical nature. However, the precision he needed to employ later made it possible for him to develop his enormous ability in drawing.

Works like this are a direct result of the artist's talent for describing pictorially, in an almost botanical manner, the trees and other plants that make up a picture. To this must be added his skill with watercolors, a discipline that allows no room for error. The colors he used impart a great feeling of unity in the landscape—here in violet tones—with the brilliant American light also adding to this feeling. For the composition, Richards has used a classical system in a zigzag perspective that places plants closest to the viewer in a detailed foreground. Meanwhile, the middle and backgrounds move progressively farther away through the aerial perspective that tints the atmosphere in violet tones, imparting the mood of a daydream. The lake in the middle ground, reflecting the sunlight from a single focal point, gives the scene an even greater feeling of distance. This is a work that, in spite of being created with what today are considered minor techniques, totally achieves the standing of a work of art, with the depth and expressive quality showing true mastery.

Right: Newport was one of Richards's favorite places to paint landscapes. The contrasts produced by the gray rocks and the green prairies must have powerfully affected him. Here, he worked to convey a feeling of unity and harmony. He achieved this by staining the air with a soft light that gives the painting an almost misty aspect. The artist has used gouache to enhance the solidity of the enormous boulders in the foreground and middle ground, as well as the rock formations in the background. The aerial perspective, washed with light, is another protagonist here, leaving the grand rock formations slightly blurred.

Richards's work *Paradise, Newport,* is remarkable because he was able to give an idyllic appearance to a rocky, harsh environment. Some delightful sheep on the right-hand side of the composition add to the dreamlike quality. The skillfully painted ominous clouds that threaten a coming storm show different hues of grays that connect them to the rocks. The clouds allow a small fragment of sky to be seen on the left, where the sun peeps through. One ray of sun has managed to pass through this cloudy gap, and it crosses the green prairie from left to right. Here, Richards has used a very Romantic theme—the approaching storm—yet, curiously, it gives the painting an idyllic quality, almost pastoral, far from the drama-filled scenes common to this period.

Paradise, Newport

(1877)
gouache
27 x 37.1 in (68.58 x 94.14 cm)
Private collection

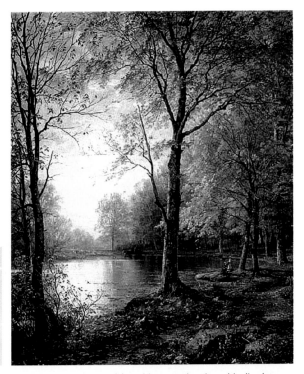

Indian Summer

(1875)
oil on canvas
24.1 x 20 in
(61.28 x 50.8 cm)
Metropolitan Museum
of Art, New York

This work makes it clear that Richards was not only a magician with watercolors, but with oil paints as well. This autumn landscape depicting the banks of a river presents a unity, enhanced by the brown and green tones of the figures. Extraordinary detail was used to render the trunks and leaves of the trees, and the water serves as a mirror for the atmospheric light. Various elements make up the scenery: vegetation, earth, water, and sky, with only the occasional appearance of people. Of all of these, the most difficult to represent is plant life, as it requires patience and good powers of observation.

Despite the apparent simplicity of some of his works, the author did create highly complicated color combinations. One clear example is this painting, where the figures in the foreground are rendered with high detail. The sky is a study in tones, changing from light blue to whitish yellow in the lower part, where it is bleached by the last rays of sun.

The representation of the calm water of the river and the use of aerial perspective suggests distance. The figure of a young girl in a white dress adds a picturesque touch.

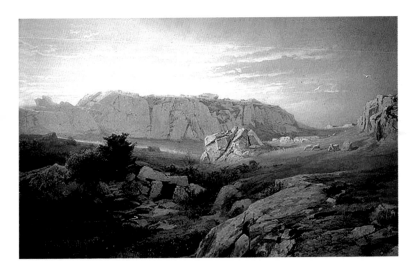

Salt Marsh by the Sea

(1877)
watercolor and gouache
22 x 36 in (55.9 x 91.4 cm)
Private collection

Here we see all the elements that characterize Richards's works. First is a classic zigzag composition, filled with the elements that are typical of all landscape work: plant life, land, sky, and water. A country cart and several cows peacefully grazing have been added to the work, giving it a picturesque air. A harmonious sensation has been achieved through the use of bright, vivid colors throughout the painting—an especially bright yellow defines the central zone. Second, the artist has paid precise attention to detail in representing the plants, especially where the vegetation is closest to the viewer. The corn and the cut stalks, in the lower right corner, are realistically dry. Third, light plays an essential role in adding harmony and unity to the composition. The sunlight comes from the side to illuminate the amber countryside and the green fields, as well as to create elongated shadows in all planes, which adds volume. Last, the water must be mentioned in its own right: It has been rendered meticulously, in spite of the great difficulty inherent in capturing it on canvas.

Water would always intrigue Richards, and it made coastal scenes and seascapes his favorite subject matter. Small ripples formed by waves and tiny foaming crests as they near the shore were the objects of exhaustive study by the artist. In *Salt Marsh by the Sea*, he has created an impressive work filled with depth and detail using gouache. This technique allows the artist to make impastos, but, problematically, the tones lighten as they dry. This has not been an obstacle to Richards, as he worked equally dexterously in many different techniques.

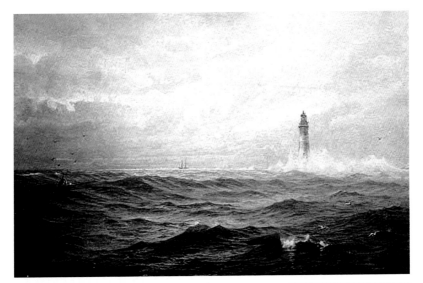

This work is an example of Richards's favorite subject matter: seascapes. For landscapists, there is almost nothing more challenging and difficult to paint than water, because it is in constant motion. Further complications include its transparent qualities, changing color depending on the effect of the light, and the fact that background objects can be viewed through water. Water also acts as an unstable reflecting mirror. Richards was always fascinated by seascapes, due to the challenge they posed: How to depict water realistically and with detail?

From the time he started his artistic career in the 1870s, mastering this skill was his constant concern. He traveled to Germany for this reason, as according to him, this was the homeland of the greatest draftsmen, and he spent long periods of time in Düsseldorf, site of the famous Academy.

Richards's ability to represent the waves of the sea is undeniable. This seascape is the proof: Through his drawing and the apt selection of elements, the artist has managed to convey the sheer force and power of the water. It feels like we are in the middle of the sea, suffering from the pounding of the waves, just like the buoy and the lighthouse. A distant sailboat is probably using the lighthouse as a reference point in this angry sea. The color of the water is amazingly realistic, as bluish traces can be glimpsed in the crests of the waves, like the sandy, rock-filled bottom, shown in the ochre hues that appear blurry through the water.

Eddystone Light

(~1885)
watercolor and
gouache on paper
23.2 x 36.2 in (59 x 92 cm)
Kennedy Galleries,
New York

Left: Country landscapes never lost their appeal for Richards, who depicted them often, and they were also in high demand on the market. Richards had enjoyed success as an artist from the time he was 20. His technical skills and the attractiveness of his compositions, with their approachable and pleasant beauty, made them highly desirable among collectors. Once he felt sufficiently secure with the landscape discipline, he sent one of his works to the Pennsylvania Academy of the Fine Arts. It was so well received that the institution purchased the painting. From that time on, the artist's course was set, and Richards set out to travel it without doubts, meeting with success after success in both national and international markets. His landscapes continue to be popular today.

Country Road

(~1886)
oil on board
10 x 20 in (25.4 x 50.8 cm)
Private collection

This work exemplifies the painter's skill in imbuing the most commonplace scenes with beauty—here, a simple country road. The light that saturates the landscape, coming from the right-hand side, imparts a special harmony to the composition, with slightly darker tones chosen for the trees and bushes in the foreground. The blue sky in the background, streaked with white clouds, also reflects the daylight.

Land's End, Cornwall

(1888)
oil on canvas
62 x 50 in (157.5 x 127 cm)
Butler Institute of American Art,
Youngstown, Ohio

This is one of the largest paintings made by this artist. In his search for new subject matter to broaden his repertoire, Richards visited England and was thrilled with the stunning cliffs on the Cornwall coast. These enormous, towering blocks of granite are scored by the horizontal and vertical fissures characteristic of the stone. Two different bodies of water—the Bristol Channel and the English Channel—meet here in a spectacular and forceful display. The author places the viewer dangerously close to the heaving waves. The tops of the cliffs cannot be seen; they are hidden behind blowing mist that blends with the intense light and highlights the verticality of the composition. This was uncommon in Richards's descriptive paintings, but he was always experimenting with new styles, and each one had its own peculiarities.

The fundamental elements in this seascape are the force of the collision of the two currents and the extreme luminosity of the sunlight, and he pays great attention to these values, without neglecting the representation of the water.

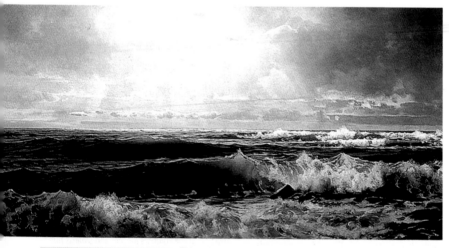

The Sheepfold

(1890)
oil on canvas
20 x 40 in (50.8 x 101.6 cm)
Private collection

This painting surely must have been painted for a sea lover, and it must have seemed like an ideal assignment to Richards. By this time, the artist was already famous, and he painted more for his own pleasure than to reap the financial rewards from the many orders that he received. Here, he has captured the exact moment when the waves rise with their foamy crests to break, in the water or with anything that crosses their path. The sun brilliantly illuminates the water, including the transparent waves as they strike the underlying layers of water. Richards probably made several sketches extraordinarily quickly in order to capture the detail of the seawater's foam, as the movement of the waves never pauses. Once he completed the drafts, the painter closed himself in his studio, where he assembled the composition and created the definitive version of the painting.

JAMES MCNEILL WHISTLER

Gold and Brown: A Self-Portrait, *1895-1900, 37.7 x 20.3 in (95.8 x 51.5 cm), Hunterian Art Gallery, University of Glasgow.*

James Abbott McNeill Whistler, who was born in the United States, studied art in Russia, and voluntarily became an expatriate in the United Kingdom, was the most charismatic American painter of the 19th century. His strong character and cosmopolitan outlook make him unique.

His style reflects his ability to reinterpret the variety of trends that dominated 19th century European art. After promising studies in print-making and illustration, Whistler arrived in the Paris of the Impressionists. There he absorbed new influences for his painting. Ukiyo-e, the Japanese woodblock prints greatly admired by the Impressionists, allowed Whistler to alter the spatial organization of his paintings using a compositional balance based on the very simple distribution of the artistic space.

This artist's restless nature led him to travel constantly around the European continent to work on his etchings and paintings. When he got to London, he decided to settle there. He quickly established contact with the city's artistic circles, and soon he had reinvented himself as a dandy, a very Victorian figure of a man, sophisticated and somewhat eccentric. Whistler mingled with the most progressive and revolutionary personalities in British culture. He was a close friend of Oscar Wilde; friends in France included Gustave Courbet and Henri Fantin La Tour.

His painting is far more subtle and discreet than his public persona. His new conception of art, based simply on aesthetics and not on morals, also made him an art theoretician.

- **1834** Born in Lowell, Massachusetts. His father's job soon takes the family to Russia.
- **1845** Takes drawing classes at Saint Petersburg's Academy.
- **1849** His father dies, and the family returns to the United States.
- **1851** Enters the military academy at West Point; expelled three years later for "deficiency in chemistry."
- **1855** Starts studying art in Paris.
- **1856** Visits Charles Gleyre's studio, where he meets Fantin La Tour and Courbet.
- **1859** Rejected by the Paris Salon, he moves to London.
- **1860** Exhibits *At the Piano* at the Royal Academy.
- **1876** Works as an interior designer in the Peacock Room, the London house of ship owner Frederick Leyland. There, he anticipated art nouveau with his attenuated decorative designs and Asian influences.
- **1877** He is involved in a libel suit with the critic John Ruskin, who accuses him of "flinging a pot of paint in the public's face" with his work *Nocturne in Black and Gold*.
- **1879** The Ruskin lawsuit leads to Whistler's bankruptcy. He moves to Venice.
- **1884** Exhibits in Brussels's Les Vingts, in the Paris Salon, in Dublin, and in London.
- **1885** The Ten O'Clock Lecture conference is held; he expresses his aesthetic convictions. Stéphane Mallarmé translates the lecture into French.
- **1886** Presides over the Society of British Arts, which has the crown's support and becomes the Royal Society of British Arts.
- **1890** *The Gentle Art of Making Enemies*, consisting of Whistler's correspondence and notes, is published.
- **1891** The Corporation of Glasgow purchases his Thomas Carlyle portrait and, shortly afterward, the French government acquires *Portrait of the Painter's Mother* and awards him the Legion of Honor.
- **1892** His private exhibition is a great success at the Goupil Gallery in London. He moves to Paris that same year.
- **1898** Named president of the International Society of Sculptors, Painters, and Gravers.
- **1899** Exhibits in the first World of Art exhibition, held in Saint Petersburg, Russia.
- **1901** Named honorary member of the Académie des Beaux-Arts of Paris.
- **1903** Named *doctor honoris causa* by the University of Glasgow. He dies in London.

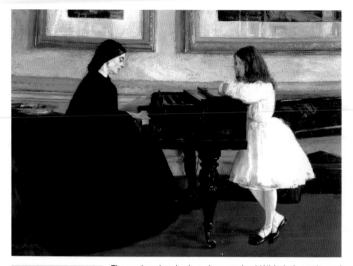

At the Piano

(1858-59)
oil on canvas
26.4 x 36.1 in
(67 x 91.6 cm)
Taft Museum,
Cincinnati, Ohio

The enclosed style that characterized Whistler's work can be observed in this painting. Here, the artist composes a closed and longitudinal space, where the background architecture stands out; it is painted in bright colors that contrast with the darkness of the elements in the foreground. This dominance of dark colors in Whistler's painting, as well as his linearity, is attributed to his training in printmaking. For the painter, the contour lines are the compositional axis from which he presents his artistic discourse.

This painting is introverted, mournful, and contains little sense of movement. It is excessively simple in its compositional and chromatic presentation. It is quite different, of course, from what was prominent in Paris at the time. Whistler was severely criticized for his excessive use of black, so remote from the brilliance and chromatic liveliness that was cherished by the Impressionists. These criticisms led Whistler to leave Paris in 1859 and settle in London, where he would exhibit this painting a year later at the Royal Academy. There, he received a good response from the public and critics and went on to the most productive period of his life. He developed as a painter and also experienced a deep personal transformation that led him to become a controversial figure in London society.

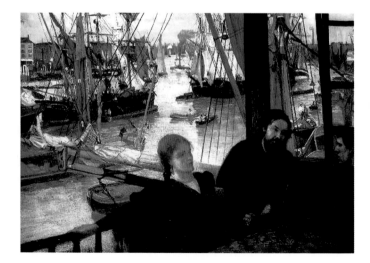

Purple and Rose

(1864)
oil on canvas
36.2 x 24.2 in (92 x 61.5 cm)
Philadelphia Museum
of Art, Pennsylvania

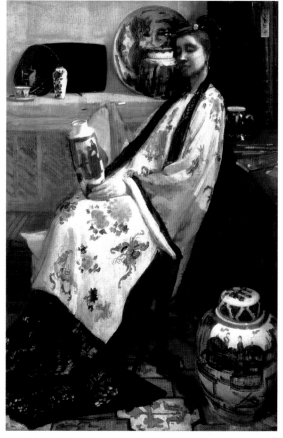

Although Whistler was considered self-taught and unaffected by the aesthetic trends of the late 19th century, his work, like that of the Impressionists, shows the influence of the Japanese. Whistler discovered Japanese Ukiyo-e because of his close relations with Impressionist artist circles. During his time in Paris in 1855, the artist was able to admire these woodblock prints and began to incorporate their compositional style in his art. The importance of the line, the defined contour, the organizational structure of the artistic space, and even the range of color used by Japanese artists were quickly adopted and reinterpreted by the painter, who depicted unmistakably Asian motifs in much of his work.

This painting is a classic portrait of a woman surrounded by many Asian elements. The woman's kimono, the bright and colorful space, and the pleasant composition make this a highly decorative work. The shape of the jar in the foreground is echoed in the pose of the languid young woman. Whistler has composed a scene in which time stands still. The viewer cannot tell if it is a contemporary image or if it is an evocation of the past. This ageless quality comes in part from the woman's Western features; Whistler has used the aesthetics of Ukiyo-e in a modern context.

Wapping

(1860-1864)
oil on canvas
30 x 40 in
(71.1 x 101.6 cm)
National Gallery
of Art,
Washington, D.C.

Left: In this painting, Whistler illustrates his capacity to capture an instant and reflect on the entire social setting. Here, the artist depicts the Thames docks and calls to mind the social connotation of London's seediest area through the expressions of the people.

With an almost photographic perspective, Whistler has divided the composition into two very specific areas. In the foreground, two people appear in the darkness of a terrace bar, dominated by an unsettling chiaroscuro. In the center, a women sits upright with an absent expression, obviously very distant from the man beside her. She is probably a prostitute from London's seamy area; by depicting her, the artist has given the characters greater social meaning. The man looks bored and is apparently killing time in the best way he knows how, in the company of a "friend" and a prostitute, possibly negotiating the price for the woman's favors. Behind them are the landscape and the busy life of the Thames.

This painting is a reflection of the estrangement that is part of this particular place. Traveling was one of Whistler's great passions, and he often represented the port, the point of departure, in his paintings. Whistler has captured the magical and mysterious sense of this place through the contrast of light and dark and the atmospheric effect of the many lines of the boats. Masts, ropes, and rigging allow him to create a whole thick linear framework that covers much of the work. What lies hidden within and behind those boats?

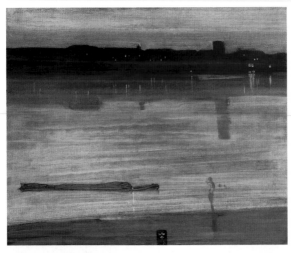

Nocturne: Blue and Silver—Chelsea

(1871)
oil on canvas
19.8 x 23.9 in
(50.2 x 60.8 cm)
Tate Gallery, London

In this work, the artist experiments with a variety of effects of light on water, in a manner very different from the Impressionists. In Paris, painters wanted to scientifically decompose light to re-create its reflection on rivers and lakes.

Here, Whistler has only painted an impression, homogenizing the reflection to make it the predominant element. The artist used this simplicity in a number of "nocturnes," a name the artist created, which originally related to trends in Romantic music. It allowed him to compose chromatically harmonized art pieces.

In this work, horizontal lines form four very different areas: the sky, the city, the river, and the riverbank in the foreground. In the mid-1870s, Whistler began to experiment by superimposing subtle layers of paint. The effects of glaze and shade he attained give his work an appealing air of mystery. Here, Whistler used this effect to give the water vitality. With a log floating adrift, the artist focuses the viewer's attention on the surface of the water. There, reflections lead the eye toward the dark and intriguing vista of the city in the background, immersed in fog.

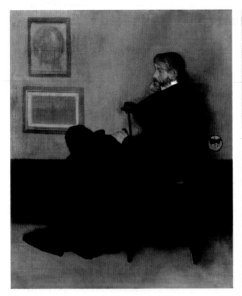

Arrangement in Grey and Black, No. 2: Portrait of Thomas Carlyle

(1872-1873)
oil on canvas
67.4 x 56.5 in (171.1 x 143.5 cm)
Glasgow Museum and
Art Gallery, Scotland

Thomas Carlyle (1795-1881) was a famous English critic, historian, and essayist who frequently corresponded with Goethe. In this portrait, Whistler used the same compositional approach he did with the painting of his mother. The subject, placed in the center, appears in dark colors. His shape takes up a significant portion of the painting, and the lighter background highlights his silhouette, although the entire painting is dominated by a dark, subdued tone. The artist also used these dark colors to give the person substance, making the figure aesthetically heavier than his surroundings. Whistler often used this technique to make his portraits more realistic. Somber clothing and decoration, as well as claustrophobic space, offer a visual contrast to bright faces.

Whistler was knowledgeable about composition and used a variety of techniques to drive the viewer's gaze to the inner recesses of his paintings. His fluid brushstroke traverses the painting horizontally in these portraits. His particular artistic style also led him to improve color mixtures. The artist prepared his own palette and used his own custom-made range of colors, which came already mixed in tubes. His aesthetic uniqueness is showcased in this particular style of work.

Harmony in Grey and Green: Miss Cicely Alexander.

(1872-1874)
oil on canvas
74.9 x 38.5 in (190.2 x 97.8 cm)
Tate Gallery, London

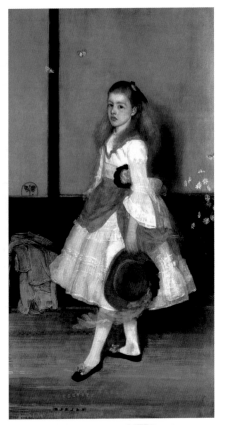

In this painting, Whistler has completely changed his perspective and made a classic portrait. The girl's delicacy and intelligence are heightened by the contrast between her white dress and the grayish background. Whistler has also deliberately increased the plane's distance so that the girl appears smaller. The 1870s were the painter's most productive period. At this time, he embraced a more Romantic figurative art, approaching that of Dante Gabriel Rossetti, although he retained a realism like Gustave Courbet and Edouard Manet. For this commissioned portrait, the artist has put dark colors aside and made a painting similar to his 1878 *Symphonies in White*, which he worked on for many years. Whistler, not very fond of these types of themes, based this painting on traditional compositional approaches. The girl faces the viewer, turning slightly to model her pretty dress. The artist has placed his subject in front of a grayish green wall, a typical color for this painter. It reflects the ambiguity between his personal view of painting and the execution of a professional portrait. In this work, the painter reveals that he is working with an unfamiliar theme; the result is a split between his own style and the rules of formal portraiture.

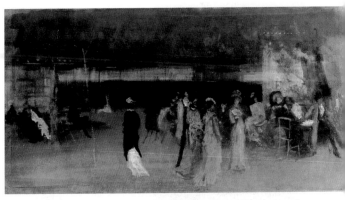

Cremorne Gardens, No. 2

(1872-1877)
oil on canvas
27 x 53.1 in
(68.5 x 134.9 cm)
Metropolitan
Museum of Art,
New York

In this scene of the Cremorne Gardens in London, Whistler blended his atmospheric style with a more realistic view of the human figure. Here, the artist used the feeling and impression of his nocturne work to make a group portrait in which the people are quite defined. When Whistler made nocturne scenes, he used glazes of paint to create a more dramatic atmospheric sensation. His technique of painting in layers allowed him to compose the whole scene in a conventional way and, afterward, cover it with very long and diluted brushstrokes to create a mood. Here, the scene becomes a mere impression, where there is neither joy nor despair. This painting is not open to any metaphysical interpretation; it simply offers a weary and lusterless view of the end of a festive day. The artist did not intend to focus attention on any outstanding element, but only to depict anonymous people as simple elements of the scene. This "glazed" view of the world has something in common with his unusual personality. His work is often whatever the viewer wants to see.

Whistler loved Venice. He made many paintings and a series of etchings there. In this work, St. Mark's Basilica appears ghostly in Whistler's distinctive fog. Here, the artist used an etchinglike style. The church is painted with brilliant strokes under a black layer. Whistler covered the whole space in near-total darkness, and only small touches of color are seen.

This delicate painting clearly illustrates the artist's characteristic style.

Nocturne: Blue and Gold—St. Mark's, Venice

(1879-1880)
oil on canvas
17.5 x 23.5 in (44.5 x 59.7 cm)
National Museum of Wales, Cardiff

He was a fervent admirer of musical composition and tried to reproduce the effects of notes as small flashes of light in his paintings. He compared his way of working and understanding painting to that of a Romantic composer. According to the artist, he composed a very harmonized melody on canvas, where necessary touches of color stood out to achieve the desired effect. The viewer, he explained, should simply see his painting as one simply listens to music, without interpreting or looking for hidden messages. This assertion, based on Whistler's theory of art for art's sake, is perfectly illustrated in his nocturnes, where, taking advantage of the dark background, Whistler uses small strokes of light in the same way notes are placed on a staff.

Red and Black: The Fan

(1891-1894)
oil on canvas
73.8 x 35.4 in
(187.4 x 89.8 cm)
Hunterian Art Gallery, University of Glasgow

In his last years, Whistler made a series of very malleable portraits. This painting has a fully defined artistic character. The figure is completely facing the viewer. In earlier portraits, the people are often in profile or turned, but in his later work, they appear defiant, looking directly at the viewer. Here Whistler demonstrates his experience and creates a modern painting. The aggressive mixture of black and red shows a very self-confident painter who did not subject his art to aesthetic concepts imposed by the changing trends of the times. Diego de Velázquez also influenced this painting, which Whistler worked on for three years. He constantly touched up the portrait, as Velázquez would have done. The determination the subject shows in the painting, and the confidence Whistler expresses in the composition, bring the Spanish artist's paintings to mind.

A dark background appears to engulf the subject. The phantasmagoric quality of the portrait—a quality also seen in Whistler's self-portrait—is the result of the constant retouching. The brightness of some of Whistler's paintings has gradually waned, reflecting a gloom that intensifies as time goes by.

JOHN LA FARGE

John La Farge, *1859, oil on wood, 16.1 x 11.5 in (40.8 x 29.2 cm), Metropolitan Museum of Art, New York.*

Although probably better known as a creator of stained glass than as a painter, John La Farge was one of the most versatile American artists of the second half of the 19th century. Considerable technical mastery of oil painting and watercolors can be observed in his work, where he created a new perspective in floral theme painting and displayed a modern sensitivity in landscape art, which in many cases predated the French Impressionists.

Because his family was French, La Farge became familiar with the new aesthetic trends that were developing in France in the mid-1850s, which would give rise to Impressionism. His new conception of landscape painting had the same roots as the work of Edouard Monet and Edgar Degas, but La Farge also had a very refined knowledge of the American naturalist tradition, and a fusion of both styles can be observed in his work. His work is outstanding for its delicate compositional balance and new treatment of light and color, as they are much more expressive and vital.

In this new idea of the landscape, La Farge also introduced the compositional style of Japanese illustration. The great influence that Asian art had on the artist can be observed in his paintings.

- **1835** Born in New York City, son of a French immigrant family, whose tradition leads him to study French literature and Catholicism. His grandfather gives him his first painting lessons, and he studies watercolors with an unidentified English artist. These art lessons were simply recreational when he was not studying at Mount Saint Mary's College in Maryland. Afterward, he studies law in New York.

- **1856** Travels also to England, Holland, and Belgium, in order to study the great masters.

- **1857** After attempting to establish himself as a lawyer, he opens a studio in New York in a building designed by Richard Morris Hunt, the architect.

- **1859** Travels to Newport, Rhode Island, and studies painting with Richard Morris Hunt's brother.

- **1860** Marries Margaret Perry; the couple moves into the family home in Rhode Island. Begins studying Japanese art, still life, and outdoor landscape painting.

- **1869** Is named academic of the National Academy of Design in New York, after six years as associate member.

- **1870** Publishes an essay on Japanese art.

- **1875** Following the advances in industrial techniques closely, he discovers his passion for stained glass windows and, a year later, he leads the Trinity Church of Boston project, designed by the architect H.H. Richardson.

- **1876** Is entrusted with the decoration of the Trinity Church in Boston and, the following year, of the St. Thomas Church in New York.

- **1886** After traveling to Europe many times, he goes to Japan to study the country's traditional culture.

- **1890** Travels through the South Pacific for a year with his friend Henry Adams.

- **1910** Dies in Providence, Rhode Island, after a long illness.

ΘΕΡΕΟΣ ΝΕΩΝ
ΙΣΤΑΜΕΝΟΙΟ

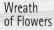

Wreath
of Flowers

(1866)
oil on canvas
24.1 x 13.1 in
(61.1 x 33.3 cm)
Smithsonian American
Art Museum,
Washington, D.C.

One of the first painting motifs that La Farge incorporated in his work was flowers. Rather than following the traditional monumentalist landscape art of the United States, the artist worked in an area that was underrated by the artistic world of the first half of the 19th century: still life. Many considered it to be amateur and dilettante painting. But La Farge saw the painting of floral themes as an opportunity to create a palette of imaginative color where expressiveness did not center on large lighted planes, but on meticulous and concise details that concentrate, through highlighted contrast effects, all the argumentative power of the painting.

This painting is a novelty in American art. Its extremely simplified composition had a special meaning for La Farge who, beginning in the 1860s, showed the influence of Japanese aesthetics in his work. Thus, a simple wreath of flowers with a somewhat macabre appearance acquires its own meaning against a plane of diffuse color. The contrast is tenuous but efficient. A simple view, this painting basically depicts the dull color of the wall and the organic greenness of the wreath, but the tones of the flowers and the leaves stand out as the viewer concentrates on the whole floral arrangement.

John La Farge was one of the American artists who best understood the Impressionist movement as a concept. For him, this new painting style implied a rediscovery of the everyday as an artistic subject; in this sense, he was one of the great innovators of this

The Golden Age

(1878-1879)
oil on canvas
35.6 x 16.5 in
(90.5 x 41.9 cm)
Smithsonian American Art Museum, Washington, D.C.

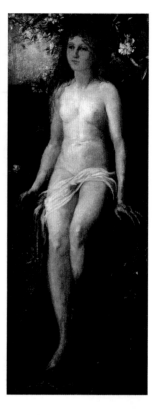

style. Through his work, this painter introduced seemingly insignificant details as basic elements for the perfect under-standing of this new art. His brush converts flowers and vegetables into strong supporting details that enhance the meaning of his paintings.

The innovative quality of La Farge's work can be appre-ciated here. Although there seems to have been a loss of interest in the nude during the mid-19th century, artists such as John Singer Sargent and La Farge revisited the genre with a view similar to that of Jean Auguste Dominique Ingres (1780-1867). Through a kind of erotic halo that surrounds the nude, both artists make the warm, textured feeling of the model's body evident as the main expression.

In this work, the artist portrays this young woman's body in a classical way, adding a modern natural setting and a simple gesture. Rich color and sensitive brushstrokes combine to create a realistic effect.

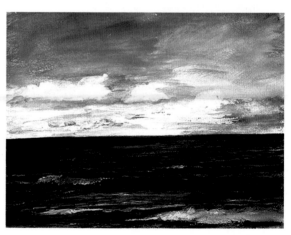

Lesson Study on Jersey Coast

(1881)
watercolor and gouache on wove paper
8 x 10.9 in (20.4 x 27.6 cm)
National Gallery of Art, Washington, D.C.

Although this artist's work includes feverish production of exotic landscapes where fantastic color contrasts with tedious American luminism, La Farge also tried his hand at monumen-talist work, where he let himself be led by traditional American painting. The tonal richness of his Samoan scenes and his floral compositions disappears, making way for the homo-geneity of light that appears monotonous.

To dispel this sense of boredom, La Farge used a series of expressive brushstokes that are reminiscent of French Impressionist painting. In this study, the artist explores the compositional possibilities of depth and volume in a seascape. He adopts a naturalist language that lets him reflect on American art. Therefore, for La Farge, the typical bucolic autumn sky is transformed here into a dynamic stormy sky. Likewise, the calm sea acquires vitality that move the paint horizontally from one side to the other without becoming subordinate to the static composition.

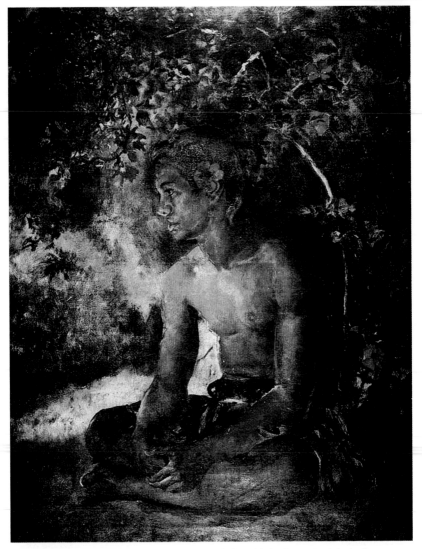

Maua, a Samoan

(1891)
oil on canvas
47.5 x 38.3 in
(120.7 x 97.2 cm)
Addison Gallery of American
Art, Andover, Massachusetts

In Paris during his first visit in the 1850s, John La Farge already displayed an unusual interest in exotic cultures beyond his Impressionist passion for Japanese woodblock prints. Later, the artist became a tireless traveler, visiting the most remote areas to study diverse and unusual customs through his work.

In this painting, the artist displays his ability to constantly renew his creative process with new compositional solutions quite different from the limited artistic resources of contemporary American painting. La Farge suggests a new perspective for portrait art in this painting, based on realistic poses not governed by social convention or by traditional representational art. The artist studies the face and gesture of the individual to depict an anonymous history and convey it to the viewer—without forcing that viewer to acknowledge the individual or praise his beauty. For the first time, the painter has attempted to paint the soul and character of his subject without following a particular style or adhering to strict realism.

John La Farge offers a full perspective of his conception of painting in this depiction of an everyday scene between two women from a Samoan town. For La Farge, it is very free art that portrays daily moments representing a specific lifestyle, which in this case is exotic and remote. It also reflects the way the people in the painting understand life.

Portrait of Faase, the Taupo of the Fagaloa Bay, Samoa

(1891)
watercolor
19 x 15.1 in (48.3 x 38.4 cm)
Private collection

Based on a central axis, the work has great color and visual richness. The constant change of color and tone allows the artist to incorporate a dynamic rhythm that appears to stop just as the two women meet. It is an everyday scene: They chat intimately, offering a more liberated perspective of women in another culture. These social contrasts, which greatly interested the public and critics of the 19th century, gave La Farge the opportunity to create a rebellious and nonconformist argument using great realism. In this painting, he used very bright colors that stand out, intense and pure. The colors are not very mixed, conserving a primary character that exaggerates the impression of exoticism.

A Rishi Calling Up a Storm, Japanese Folklore

(~1897)
watercolor on paper
13 x 15.9 in
(33 x 40.4 cm)
Cleveland Museum of Art, Ohio

John La Farge's work was greatly influenced by Japanese art. When, at the beginning of the 1880s, Japanese prints became an essential for Parisian Impressionist painters, La Farge was far ahead of his colleagues; he already knew woodblock prints well and had a deep understanding of them that allowed him to integrate the stylistic doctrines of Japanese illustration in a much more homogeneous way. Other American artists, such as Mary Cassatt and James McNeill Whistler, who lived in Europe at the time, included the Japanese compositional model in their painting; La Farge, on the other hand, completely incorporated aesthetic proposals from Asian art in his paintings. Here, La Farge depicts a seascape, portraying it under the aesthetic precepts of Chinese art, but using an Impressionist chromatic palette. His use of a linear brushstroke, reminiscent of the firm outlines of print figures, displays the artist's adaptation to both artistic traditions.

Kwannon Meditating on Human Life

(1908)
oil on canvas
36 x 34 in (91.44 x 86.36 cm)
Butler Institute of American Art, Youngstown, Ohio

John La Farge was one of the first American artists to collect Japanese art. His trip to Paris in 1856 was decisive, as the artist witnessed the beginning of the influence of Asian art on Impressionism. His family contacts allowed him to meet the prominent figures in Paris's cultural life; through them, the artist not only became familiar with the culture, but also with Japanese traditions. La Farge was particularly attracted to mysticism.

In this painting the artist appears to merge Asian meditation with traditional Christian iconography. An exotic woman sits in a meditative posture; behind her, La Farge places a nature scene with a waterfall, an unreal and an almost surrealist landscape. La Farge makes an allegory of the relationship of spiritual man with nature and other beings. The work has a religious yet fantastic quality.

HOMER DODGE MARTIN

Homer Dodge Martin, *Albany Institute of History and Art, New York.*

- **1836** Born and raised in Albany, New York. Encouraged by sculptor Erastus Dow Palmer to dedicate his life to painting. First studies with James McDougal Hart, although he will later prove himself to be a self-taught artist.

- **1865** Moves to New York City, where he studies with John Frederick Kensett.

- **1874** Made a member of the National Academy of Design.

- **1876** Travels to Europe. Studies Camille Corot and the artists from the Barbizon School.

- **1877** One of the founders of the Society of American Artists.

- **1882** Moves to Normandy, spending many seasons in Brittany.

- **1886** Returns to the United States.

- **1893** Moves to Minnesota. Sets up in Saint Paul, where he struggles with cancer.

- **1897** Dies in Saint Paul, Minnesota.

In the American artistic scene in the middle of the 19th century, there were a series of artists whose works fell somewhere between luminism and the Romantic landscapes of the Hudson River School. They showed early signs of a strict positivism that already pointed toward Impressionism. Homer Dodge Martin is a perfect example of this transitional style, which put the luminist legacy under a clearly French-influenced aesthetic.

Similar to what occurred in the United States, there was also a transitional period between two distinct artistic trends in France. After the classicism and realism of the first part of the century, the advent of landscape paintings by such artists as Jean-François Millet and Jean-Baptiste-Camille Corot signaled the beginning of the Barbizon School. From a historic point of view, this landscape trend in France completely opened the artistic arena, and heralded what would later become Impressionism.

Homer Dodge Martin was the greatest exponent of American landscapes inspired by a new vision of painting as an expressive means and not only as an imitation of nature. Although his style was influenced by luminism and the Barbizon landscapes, his personal style led him to create melancholic, reflective paintings. He incited a minor stylistic revolution defined by modern brushstrokes within the context of his monumental natural vistas.

The Iron Mine, Port Henry, New York

(~1862)
oil on canvas
30.1 x 50 in (76.5 x 127 cm)
Smithsonian American Art Museum, Washington, D.C.

Martin's pictorial style shows the strong influence of the Hudson River School. His manner of shaping the landscape evolved quite differently from movements prior to French Impressionism. His brushstrokes seem somewhat modern, but his compositional evolution seems slower and more thoughtful than the changes that were happening in France. There the style of the Barbizon landscapists showed changes that became more radical and pronounced fairly quickly.

In this rendition of an iron mine, Martin worked with a classic compositional style. The interior distribution of the work is carefully planned and balanced, still following the premises of the Hudson River School. The brushstrokes, however, have greater emotive strength, while conserving a naturalist interpretation. This work is notable for its sensation of volume and space. Although the painting remains governed by a horizontal linearity, the mountains and vegetation appear to tilt toward the viewer. To achieve this effect, Martin used subtle lighting borne in the soft color contrasts between the dominant green and the calming ochre chromatic notes on the slope of the mountain.

In Romanticism, the representation of nature was used as a means of projecting values. Poetic viewers frequently confused this with a moralistic vision of God's infinite order.

Storm King on the Hudson

(1862)
oil on canvas
Albany Institute of History and Art,
AIHA Collection, New York

In contrast, in Romantic and post-Romantic landscape painting, scenery is treated as a poetic idea. Landscape painting centered on specific elements in each artistic period, like a projection screen containing ideas and values, and during the second half of the 19th century, all moralizing intention was gradually abandoned.

Before the end of the 18th century, there were many different treatments of landscapes, both in Europe and in the United States. Not until 1835, with Carl Grass's interpretation, did landscape painting acquire its own and personal character. Grass created introspective and sentimental landscapes, through which viewers individually absorbed the effect of the work. Martin, however, was influenced by the work of John Frederick Kensett, who had his own unique vision of landscape painting, demonstrating a mathematical and rigidly conservative style.

This work, which the artist painted in the lower regions of the Hudson River Valley, shows the continuing influence of luminism. The composition is organized through highly structured pictorial levels. This structural rigidity obliged the artist to base his expressiveness solely on the effects of atmospheric light. Naturalist traditions and the new visions of Martin's landscape paintings collide in this somewhat forced painting; the artist struggles with realism rather than suggesting and insinuating natural forms.

Evening on the Thames

oil on canvas
18.3 x 30.1 in (46.4 x 76.6 cm)
Smithsonian American Art
Museum, Washington, D.C.

Left: Homer Dodge Martin's artistic trajectory was as irregular as his pictorial style. The influences of European painting and his deep-rooted faithfulness to the only two artistic styles indigenous to his country—luminism and the Hudson River School—held equal sway over his paintbrush. His work oscillates between the two pictorial styles.

In this painting, the artist is freer and shows close ties to the Barbizon style. Martin cultivated two completely distinct landscape styles that were never completely reconciled in any of his work. Following Jean-François Millet's aesthetic, he has composed the light over the river in a highly personal style, freely expressing himself with long, thick lengthy brushstrokes. In this type of painting, Martin freed himself from the restrictions of the Romantic realism of American landscapes, letting his own brush guide and organize the painting.

The work appears as a set of longitudinal brushstrokes that acquire volume as they distribute the space, resulting in an immense and open vista. In the end, the expressiveness resides not in a single luminous point, but in the brushstrokes as well. They are a dramatic element adding a dynamic and changeable effect to a static landscape.

Adirondacks

(1879)
oil on canvas
24.6 x 36.4 in (62.5 x 92.5 cm)
Brigham Young University
Museum of Art, Provo, Utah

Toward the end of his career, Martin returned stylistically to his Hudson River School origins. He seized once again upon the realistic details of his first works, although he still used a vigorous brushstroke dominated by color. Martin used his brush more freely and intuitively to create a mixture of colors that blended perfectly with the background while achieving a high-contrast optical effect.

Here the artist organized the interior of the painting through different pictorial planes. Starting from each of these different levels, Martin split the painting into different spaces, in which light, color, and the atmosphere are layered along rigid guidelines, although the final result appears quite homogeneous. This is due to the perfect planning of the painter. He first organized the forms, playing with their depth and size. Once the work was formally structured, he distributed the colors for a completely organic appearance, as if a living mantle were covering the shapes of the mountains. Lastly, Martin used luminist-style lighting, which added delicate but powerful expression. The overall effect is one of great contrast and chromatic play, of great realism and an interpretation of the landscape, where light, color, and depth go hand-in-hand with the masterful technique of the painting.

WINSLOW HOMER

Napoleon Sarony, Winslow Homer, (~1880), Bowdoin College Museum of Art, Brunswick, Maine. Gift of Homer's Family.

Nature and solitude were very important elements for Winslow Homer's life as a painter. He traveled extensively to paint outdoors. In the summer, he chose places where he could observe fishermen or hunters. He would often go south to places such as Florida, the Bahamas, or Bermuda to spend the winter.

Homer was always close to his family and never married. He preferred a quiet life devoted to painting in his secluded house on the coast of Maine.

Homer began his artistic career as an illustrator for prominent magazines. He then became a freelance artist, selling his paintings at art galleries. He discovered watercolors in the 1870s and developed a very sophisticated technique influenced by English and Japanese watercolor.

While he used oil, especially in his later work, to represent insightful and timeless themes, he frequently used watercolors to capture his visual experiences on the spot and summarize images linked to a place and time that were familiar to him.

Although this great watercolor and oil artist mainly painted figures in genre scenes in his earlier work and, later, landscapes, he also worked with same-theme series in which he would invest two or three years. Today, his seascapes are perhaps his best-known works.

- **1836** Born in Boston, Massachusetts, one of three brothers. Son of Charles Savage Homer, a businessman, and Henrietta Benson Homer, a watercolor painter.
- **1857** After an apprenticeship as a commercial illustrator, he is successful as a freelance illustrator. His work is published in *Harper's Weekly*, an illustrated magazine based in New York.
- **1859** Moves to New York and works as an illustrator for *Harper's* until 1875. Studies at the National Academy of Design and shortly after that in the University Building.
- **1862** During the Civil War, *Harper's* sends him as a special artist to the front in Virginia. He produces his first oil painting.
- **1867** Lives in Paris for almost a year.
- **1874** First watercolor exhibition, which is quite successful.
- **1875** Retires from commercial illustration.
- **1880** Exhibits more than 100 watercolor paintings and drawings.
- **1881** Sails to England in March. There he paints in an artists' colony in Cullercoats. He stays there until November of 1882.
- **1883** Moves to the secluded family house in Prout's Neck on the coast of Maine, where he lives and works the rest of his life when he is not traveling.
- **1884** Makes his first etching. After his mother dies, he travels with his father to the Bahamas and Cuba for the *Boston Herald*.
- **1889** Goes to the Adirondacks twice and paints almost three dozen watercolors of hunting scenes and landscapes.
- **1890** Paints fishing scenes in Enterprise, Florida.
- **1893** After a stop in Quebec, he is in an exhibition at the Chicago World's Fair and receives a gold medal. He returns to Quebec several times through 1902.
- **1898** His 89-year-old father dies. He spends the next winter in the Bahamas and in Enterprise, Florida.
- **1900** Exhibits in the Paris World's Fair, where he receives a gold medal. It is the last year that he paints in the Adirondack Mountains.
- **1904** Paints his last watercolor paintings in Florida in the winters of 1903/04 and 1904/05.
- **1909** Completes his last painting, *Driftwood*, at the end of the year.
- **1910** After spending the summer in the Adirondacks, he dies in October in his studio in Prout's Neck, with his brothers Charles Savage Homer, Jr., and Arthur Benson Homer at his bedside.

The Sharpshooter on Picket Duty

(1863)
oil on canvas
12.2 x 16.5 in (31.1 x 41.9 cm)
Portland Museum of Art,
Maine

This symbolic image about the Civil War was Homer's first oil painting. It was painted in his University Building studio after he observed sharpshooters during the Civil War in 1862. The painting is based on several sketches he made during his second trip to the front during the Civil War, when *Harper's Weekly* sent him as a special artist. Sharpshooters were one of two units of elite soldiers during the war; the other was the Zouaves. Sharpshooters stood out because of their uniforms and special duties. The sharpshooter illustrated sits in a tree, ready to fire. He looks through the scope to focus on a distant enemy with cold precision. Homer wanted to paint this scene because of the novelty of this war theme.

The striking thing about this work of art is its modern style. It illustrates just the sharpshooter and an essential part of the tree; the surroundings and the sharpshooter's target are not shown. Such a constrained motif is an unprecedented innovation. It is far from the traditional war scene painting, which is much more spectacular and epic. Perhaps influenced by the idea of reporting about the war as if it were a news item, the artist creates a composition that suggests instantaneity and immediacy, as if it were a photograph.

The Veteran in a New Field

(1865)
oil on canvas
24.1 x 38.1 in
(61.3 x 96.8 cm)
Metropolitan Museum
of Art, New York

Right: Homer painted this picture shortly after the end of the Civil War. Its bright colors and composition are striking. It shows a man harvesting in a wheatfield. With the uniform jacket strewn on the ground in the lower right-hand corner of the picture, Homer reveals that the farmer is a former soldier, recently discharged from the army. Homer altered this painting, which was in his studio when he died, three times: slightly after he finished it in 1865, then in 1867, and finally, shortly before his death, 50 years later.

Homer often revised his work. In this case, he eliminated some elements, such as the branches of a tree, and substituted a scythe for a single-blade sickle, still partly visible. This was done not only for formal reasons, but probably to provide symbolism to the painting. The discharged soldier reaping with a scythe becomes a symbol of death. It brings to mind the biblical quotation (Isaiah 2:4) that says that the warriors "shall beat their swords into plowshares, and their spears into pruning hooks"; thus the former soldier becomes a symbol of peace. The painting has also been interpreted as referring to the death of Abraham Lincoln on April 15, 1865, through the story of Cincinnatus. Cincinnatus left his farm to be Rome's dictator and vanquish its enemies. After he had achieved this, he returned to his peaceful rural farm life.

The Sick Chicken

(1874)
watercolor, gouache,
and pencil on paper
9.7 x 7.8 in
(24.7 x 19.7 cm)
National Gallery of Art,
Washington, D.C.

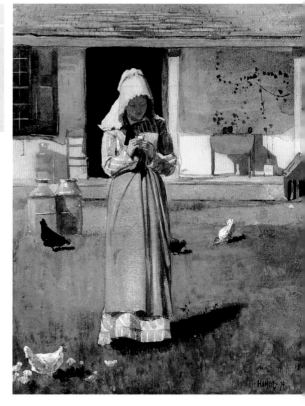

From the summer of 1873, when he painted in Gloucester, Massachusetts, Homer began to work intensively with watercolors. He was inspired by a grand exhibition he saw in New York in February 1873 of European and American artists who used gouache and watercolor techniques. Shortly afterward, Homer stopped working as an illustrator and devoted himself to watercolor painting.

This painting was exhibited with other works of art in 1875 in the eighth Watercolor Painters' Association exhibition. It depicts a young peasant woman standing in front of her house, surrounded by hens. The sun brightens the young woman, and her silhouette stands out from the dark doorway of the house's entrance. She wears a long gray dress and a tan apron with a white bonnet on her head. In her hands, she holds a feeble chick that she broods over with distress. This delicate watercolor is very detailed, as the blades of grass illustrate. Homer mainly used gouache, a technique similar to oil, in early paintings like this one. Bright and semi-bright colors can cover dark hues, so an image can also be created from darkness to brightness with gouache. Here, after letting the first layer of paint dry, the artist added shade and light. Still, the grace and confidence of the artist's later work is not yet evident here.

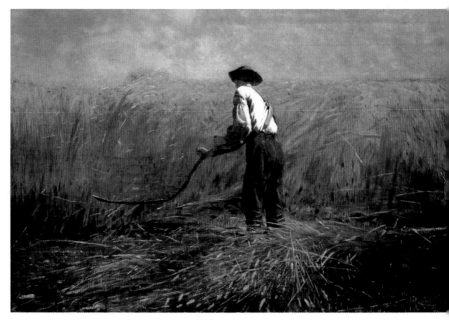

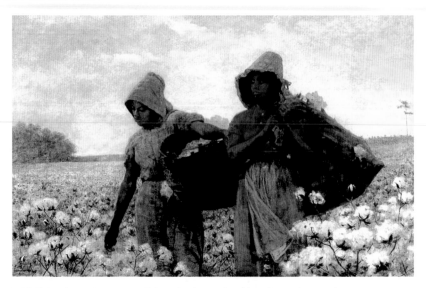

The Cotton Pickers

(1876)
oil on canvas
24 x 38 in (61 x 96.5 cm)
Los Angeles County
Museum of Art

This work of art, painted in soft pastel colors, depicts two cotton pickers in a large field. Homer painted this scene outdoors and thus captured the atmosphere typical of natural dawn light. The women are black and dressed in simple work clothes. To hold the cotton they pick, one carries a basket, the other a sack.

Cotton pickers usually worked in pairs and sang work songs that recalled the time of slavery—at this point just ten years in the past. Under large sunbonnets, the women's beautiful faces have melancholic expressions, a mixture of sadness and resignation. This work of art is part of a series of paintings and watercolors made by Homer between 1875 and 1877 that portray themes of blacks on Virginia farms. However, it cannot be ascertained that Homer was in the South during this time. Nevertheless, it seems that these paintings are based on his own observations. The backlight in this painting produces a very bright background that throws the two women into semidarkness. This gives a more dramatic effect, probably one of the painting's most significant qualities. Homer sold *The Cotton Pickers* shortly after he exhibited it at the Century Club, where it caught the eye of an English cotton spinner. Just four days later, the painting sailed on a steamship to England.

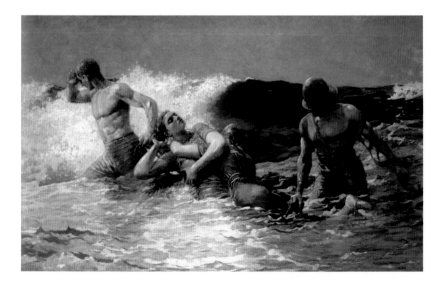

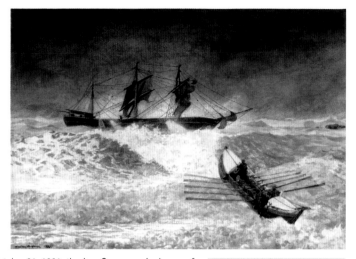

At dawn on October 21, 1881, the *Iron Crown* was in danger of being wrecked near Tynemouth, the victim of a storm. Before the ship sank, Tynemouth's rescue party was able to save the crew. Homer witnessed the event, and here he portrayed the most dramatic moment of the rescue in this watercolor: The rescue boat attempts to reach the shipwreck, courageously struggling against the strong swell. According to eyewitnesses, this battle lasted more than an hour.

Wreck of the *Iron Crown*

(1881)
watercolor on paper
20.2 x 29.4 in (51.4 x 74.6 cm)
Private collection on loan to the Baltimore Museum of Art, Maryland

This watercolor is based on Homer's drawings and notes. The painter has only illustrated the essential elements—he shows the two boats, while excluding onlookers on the beach. In order to heighten the suspense, Homer added a small figure to the *Iron Crown*, desperately signaling for help. He also highlighted the intensity of the waves. The sky, dark and menacing, was created with several layers of transparent color, predominantly gray and black. The sea, agitated and wild, is almost white.

Due to the large size of this watercolor painting, its composition and motif, this work of art should be considered part of the so-called exhibition watercolors, which were quite popular in England and which acquired an importance similar to that of oil painting. This painting is among the watercolor paintings that the artist painted in Cullercoats, in northeastern England. In this fishing town, he developed a technique inspired by English watercolors, based on applying several layers of transparent color that can be easily manipulated over pencil sketches. The paint can be separated, making it possible to scrape the base or apply more color.

Undertow

(1886)
oil on canvas
29.8 x 47.6 in (75.7 x 121 cm)
Sterling and Francine Clark Art Institute, Williamstown, Massachusetts

Left: With epic power, this painting depicts lifeguards rescuing two young women from the sea. As the title indicates, on a stormy day with menacing waves, the water has swept them seaward. The scene takes place in an ominous setting under a gray sky and dark curled waves. The two lifeguards haul the two women, who are hugging each other. The women lie exhausted on a large cloth pulled by the lifeguards. The muscular men show the signs of their struggle against the force of the sea. One of them, in the foreground, has a torn shirt, and the other, with a bare torso, wipes his forehead with his hand as a sign of pain and exhaustion. Apparently, three years before Homer completed the painting, he witnessed a similar rescue in the summer of 1883 in Atlantic City.

To paint this picture, Homer studied the effects of the sun on skin and the appearance of wet clothes, using models on the roof of his studio. Several pencil sketches and studies for this painting illustrate the development of this composition. This painting is in the historic genre, full of tension and suspense. The color, gesture, and attitude of the people, the tension of the waves, and the setting in general help to underline the suspense of the scene and to make the image more remarkable.

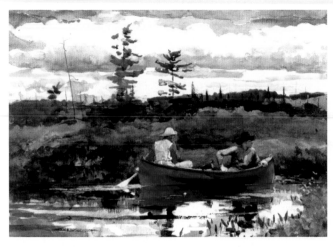

The Blue Boat

(1892)
watercolor
12.2 x 18.5 in
(31 x 47 cm)
Museum of
Fine Arts,
Boston

This exquisite watercolor, with two men fishing in a river from a small blue boat, demonstrates a new development in Homer's technique in the 1890s. The landscape on the far side of the river is worked with great style, washed with undulating brushstrokes of transparent layers in shades of green. A fine layer of matte reddish brown is interwoven and softened among the greens. The horizon is broken by the trees; they stand against the light sheer clouds reflected on the water.

Homer's work here illustrates a much more refined and spontaneous style of painting. The change in Homer's watercolors in the 1890s is related to his interest in Japanese watercolors and ink on silk and paper. Several important collectors exhibited Japanese artwork at the Museum of Fine Arts in Boston and other sites in 1890. For a while, Homer painted motifs in formats similar to decorative painting from the Edo period, but what he used in his artwork were new ideas from Japanese watercolors. Homer was able to fuse traditional techniques from East and West in his artwork as of 1892, such as in this watercolor painting. He used Asian methods such as washing, dripping, and the mixture of colors on washed layers with methods derived from English watercolor painting, such as pencil drawing and the subtraction techniques of tearing and staining.

Key West, Hauling Anchor

(1903)
watercolor and pencil on paper
14 x 21.9 in
(35.5 x 55.5 cm)
National Gallery of Art,
Washington, D.C.

This work of art is among the last watercolors that Winslow Homer painted in southern Florida. It is evidence of the skill of this mature painter, who succeeded in mastering watercolors as none of his contemporaries were able to do.

Such immediacy and spontaneity is certainly difficult to achieve, even with oil paint. The moment the crew of a fishing boat sets sail is depicted here. With the sails taken in, the wind and waves appear to be moving the boat, making it sway. The painter used very few colors: blue for the water and sky, white for the boat, sail, and rigging, two specks of red for the shirts and floating line, and a little ochre and black. He left large portions of paper without paint, filling the painting with tropical light. Since this watercolor appears so simple, at first glance, the observer does not notice the great skill that was needed to represent the milky blue water. With very few brushstrokes of washed color, Homer captured, with great ease, an instant in time on a sheet of paper.

ELIHU VEDDER

Elihu Vedder.

Elihu Vedder's work can be considered a predecessor to 19th-century symbolism: At an early point in his career, he mixed fantasy, allegory, and mystery with an academic preoccupation for perfect drawing.

Vedder trained first in his birthplace, New York City, with a learned professor from Long Island, who taught him history and mythology, subjects that would enrich his work. After working with his drawing skills at an architectural firm for a time, he moved to Europe to live in Paris, London, and Rome. Although he spent seven months studying in Paris, it would be Rome where he established permanent residency. He met the Macchiaioli group there, thus called for the light brushstrokes used by its members, which subsequently influenced the painter's *plein-air* landscapes.

His style, emerging from an alchemy of aesthetics and philosophy, had a parallel in the works of the Pre-Raphaelites and William Blake, whose illustrations he saw when he visited the English capital. Vedder's preferred subject matters were similar to those of the English symbolists, being a combination of precise and well-proportioned academic drawing and visionary representations. These images, arising from the depths of his mind, included Egyptian sphinxes, allegories, and exotic evocations of feminine beauty. All of these elements can be admired in his most famous body of work, the illustrations he created for *The Rubaiyat*, a recompilation of the verses of the medieval poet Omar Khayyam.

- **1836** Born in New York on February 26, third child of Dr. Elihu Vedder and his wife, Elizabeth.

- **1851** Studies on Long Island with Parson, who teaches him history and mythology.

- **1852** Works in the New York studio of architect T.H. Matterson.

- **1855** Sells his first work for $19.

- **1856** Studies in Paris for eight months.

- **1857** Travels to Italy, visiting Florence and Venice. He meets the Macchiaioli group in Rome, studies under Raffaello Bonaiuti, and attends classes at the Galli Academy.

- **1861** Works in New York as an illustrator for *Vanity Fair* and other magazines.

- **1863** Exhibits at the National Academy of Design in New York.

- **1864** Introduced into Boston's intellectual circles, where he meets painters such as Morris Hunt and John La Farge.

- **1865** Named academic member of the National Academy of Design. Returns to Paris and rents a studio in Montmartre.

- **1869** Marries Carrie Rosenkrans.

- **1870** Goes to London, where he meets the Pre-Raphaelites. Returning to Rome, befriends George Inness.

- **1876** Travels to London and discovers William Blake's work.

- **1878** Exhibits at the United States Fine Art Exhibition.

- **1881** *Century* magazine in New York hires him to make several drawings.

- **1882** Elected member of the Society of American Artists.

- **1884** *The Rubaiyat* of Omar Khayyam, which he had illustrated for Edward Fitzgerald's translation, sells the 250 copies printed for sale in Boston in six days.

- **1889** Exhibits his work at the Universal Exhibition in Paris.

- **1893** Exhibits at the Columbian Exhibition in Chicago.

- **1900** Stops painting and starts writing his autobiography and two volumes of poetry.

- **1923** Dies in Rome on June 29.

Dominicans; A Convent Garden, Near Florence

(1859)
oil on canvas
11 x 9 in (29.5 x 24.1 cm)
Fine Arts Museums of
San Francisco

This scene shows three religious men at the edge of a road, dressed in their habits and black capes to protect themselves against the cold, or perhaps from the threat of rain looming over the fields of Tuscany. One monk carries a book, reminding us that one of their main activities, apart from prayer and farming, was copying manuscripts, especially the classics, which they exchanged with other monasteries. In the painting, Vedder idealizes the contemplative life. To the artist, monks led lives far removed from the frenetic activity of modern society, in a state of permanent serenity of spirit that Vedder himself would have liked to enjoy. He has perfectly captured the mountainous landscapes of Fiesole, a small village close to Florence, famous for this monastery; the dark and stormy skies are characteristic of Romanticism. Behind the three figures rises a steep hill where the religious buildings nestle. A road bordered with cypress, trees that are linked to spirituality because of their name, connects these buildings. The path winds down to the stone-paved road where the three monks stand. In the background immediately behind them is the entrance gate which also restricts access to unsavory visitors.

This work was exhibited years later at the National Academy of Design in New York, where it was admired by the members and received special praise for the detail in the drawing.

This painting, where a man listens attentively to what the sphinx half-buried in the desert sands is telling him, is Vedder's best-known work. The world of magic and oracles, especially in remote times and exotic locales, fascinated the painter, who captured them in their full romantic glory.

Listening to the Sphinx

(1863)
oil on canvas
36 x 41.7 in (91.5 x 106 cm)
Museum of Fine Arts, Boston

This scene seems suspended in time, as if it were a sacred ritual and the man a priest consulting the stone divinity. The enormity of the colossal head is in sharp contrast to the shrunken figure of the man, which may be a representation of one of Vedder's principal concerns: the path to knowledge. The head of the sphinx would come to symbolize the grandeur of wisdom and the enigmatic way it is revealed to man. The man tries to find the meaning of his life in it, without being able to untangle its confusing language, formulated in unintelligible whispers.

Vedder painted this work long before ever visiting Egypt and seeing the Nile, although he already had the foundation he needed in mythology and history to tackle this type of subject matter. The work, carried out almost 20 years before European symbolists started to exhibit their work, reflects the painter's love of themes related to the East and the ancient, as well as his interest in archeology as offering a poetic discourse. To understand this, the viewer only needs to see the ruins of the temple scattered upon the sand, the monumental head the only witness to its ancient splendor.

Left: Vedder was drawn not only to the most picturesque places in Italy, but also to those that were inaccessible and so remained off the beaten path of traditional tourist routes. He liked abandoned and arid landscapes, which offered a multitude of tonal nuances as the daylight changed.

Once, when he had started to journey around these areas to sketch, he befriended Nino Costa, a member of the Macchiaioli, a group of young painters so called for their characteristic light and soft brushstrokes. Costa offered his company, showing Vedder the least-known views of Tuscany, where they both made *plein-air* sketches and later compared their work. It was inevitable that the American painter would be influenced by his new friend's style, and he created a series of paintings that stood out for their total freedom of their execution. These landscapes were quite different from those of his American colleagues, which were much larger, clearer, and more detailed.

Cliffs of Volterra

(1860)
oil on board
12 x 25 in (30.48 x 63.5 cm)
Butler Institute
of American Art,
Youngstown, Ohio

In August of 1860 Costa took Vedder to admire the cliffs of Volterra, a small medieval village southeast of Florence. In this scene, the painter highlighted the monumentality of the cliffs by the way he framed the picture—cutting the sky off in the upper part and showing the grassy countryside at the bottom. The point of view is quite low, which emphasizes the rocky, dry surfaces of the mountain's crags, very different from the damp, fertile valleys of Tuscany.

Dancing Girl

(~1871)
oil on canvas
Reynold House Museum
of American Art, Salem,
North Carolina

This image depicts an Asian dancer—although her features look decidedly European and her attire is quite incongruous, as it is more characteristic of a Renaissance princess than an exotic dancer. The woman is portrayed with an extremely sensuous expression, with parted lips, glancing toward another point in the room, allowing the viewer to gaze upon her sumptuous outfit and delicate beauty.

The myth of the dancer gave rise to many works throughout the Romantic period. Vedder, who studied Renaissance attire at the Galli Academy in Rome, adapted this myth with his own peculiar symbolism, the fruit of his personal reflections about the meaning of life. The way that the painter has represented the quality of the fabric—the shine of the silk and the rough texture of the brocades—is outstanding. Nonetheless, there are certain details that could be confusing to the viewing public, like the babuchas (a pointed Arab shoe) and the tambourine and other musical instruments on the ground, which bring the Moors to mind.

This painting clearly stems from the English aesthetic movement, which repudiated the vulgarity of naturalism and declared the decorative as its protagonist (it was "art for art's sake"). Vedder would have seen Albert Moore's works, which usually celebrated attractive and suggestive youth and which reigned supreme in the imagery of 19th-century English painters. In *Dancing Girl*, however, Vedder not only imitates aesthetic paintings; he imbues his work with a meaning dealing with mankind's eternal questions. In this, he followed the moralizing style typical of American painters. In the lower left corner, a wheel of fortune points at a skull, warning the viewer about the instability of human destiny.

Right: This work shows a woman between a bearded man and a blond woman with wings and a halo. It is the soul flanked by Doubt, a man who reflects the knowledge of his experience in his face, and Faith, with angelic features illuminated by a golden light. Vedder's vision here is the closest he came to the Pre-Raphaelites, and the one that gave him the greatest satisfaction. The painter had visited London and befriended John Everett Millais; they discussed Vedder's idyllic conception of women.

A sobbing and distraught woman covered by a cloak and darkened by the shadow of her doubt represents the soul. She stares into the distance as if seeking an answer to her uncertainty. Two opposite attitudes can be appreciated in the other two figures. The bearded man, like a Greek Poseidon, looks at her inquisitively and with great impatience, his arms crossed in negativity. Faith, however, is completely the opposite. Her youth, confidence, and optimism reveal positive energy, which inundate her with light as a soft breeze refreshes her face. This symbolism is related to theosophy, a doctrine that maintained that the soul had the freedom to choose to return to Earth to be reincarnated or rise upward to an eternal and superior world.

The Sorrowing Soul Between Doubt and Faith

(1884)
oil on canvas
7.2 x 10.5 in (18.29 x 26.67 cm)
Herbert F. Johnson Museum
of Art, Cornell University,
Ithaca, New York

The Greek Actor's Daughter

(1875)
oil on canvas
44.1 x 20.1 in (112 x 51 cm)
Private collection

This work shows an idealized vision of a woman in ancient Greece—a product of the wildly rich fantasy of the painter. Vedder found an inexhaustible source of inspiration in history and mythology, which he then transferred into the most popular subject matters of 19th-century painting. Among these, the figure of the woman stands out as one of the most important, represented above all in her idealized form, as seen in the works of the Pre-Raphaelites and academics such as Albert Moore.

This young woman is dressed in clothing of old, with a Greek tunic that falls in folds to her feet, which could be a reference to the striated shafts of Ionic columns. She does not look directly at the viewer, but languidly stares to the side with parted lips and a seductive posture. A bronze musical instrument, used to enliven theater productions with parts that were sung, is in her hand. Her left hand rests upon an anachronistic pile of parchment. Another musical instrument rests delicately at her feet, partly draped by cloth that spills over the side of the marble table. A collection of masks, essential for portraying the characters in the theater, is distributed behind her. One of them looks like the face of the beautiful young woman, which is one of Vedder's habitual symbolic elements: Masks allude to the deceit of beauty, which hides misery and inner ugliness.

The Cup of Death

(1885)
oil on canvas
44.5 x 20.9 in (113 x 53 cm)
Virginia Museum of Fine
Arts, Richmond

The most important work that Vedder was commissioned to do were illustrations for *The Rubaiyat,* a collection of poems by the Persian poet Omar Khayyam (1048-1131), who tried to prove the powerlessness of the sciences and religion to determine the meaning of life. In 1859, the English aesthete Edward Fitzgerald had translated the work for the first time, but his translation had not been as successful as he had hoped. Vedder was then given the task of illustrating the book, with total freedom in his execution. He combined unique lettering with a series of exotic drawings recalling symbolism, and he showed a particular predilection for classical anatomies.

The book was so successful that Vedder transferred the images to canvas. One was *The Cup of Death,* which became extremely famous. It refers to stanza 49, where the Angel of Death finds Man and offers the dark contents of his cup, inviting the soul to abandon the body.

The Last Man

(1891)
oil on canvas
36 x 14.4 in (91.44 x 63.50 cm)

The influence of classical anatomies is evident in all of Vedder's work. Here we see the figure of the last man on Earth in a pose reminiscent of ancient Roman statues, which the artist had seen in Rome. This is the same type of idealized anatomy represented by painters like Edward Burne-Jones, exquisitely drawn and contoured.

The young man looks into the distance, resigned to an uncertain future dominated by loneliness. An angel lies at his feet, showing the man's utter lack of defenses. They are surrounded by the dried-out skulls of all the other humans.

Vedder has related this representation to the biblical figure of Adam, who condemned himself when he accepted the serpent, which appears wrapped around the post in this barren wasteland. The colors are earthy and dark, increasing the sense of gloom accentuated by an overcast sky. The artist had fallen into a severe depression after the deaths of several of his children; the effects of these losses can be seen in the subjects dominating his last creative stage.

ALFRED THOMPSON BRICHER

Alfred Thompson Bricher.

- **1837** Born on April 10 in Portsmouth, New Hampshire, son of English immigrants. Shortly after, the family moves to Massachusetts.

- **1851** Studies at the Lowell Institute in Boston for seven years.

- **1856** After experimenting with different genres, devotes himself to landscape painting.

- **1858** After finishing his studies in Boston, he becomes a professional painter and a member of the American Watercolor Society and the Boston Art Club.

- **1860** Awakening interest in the landscapes of the White Mountains, a frequent topic of the painters of the period.

- **1868** Moves to New York. Presents his first exhibition at the National Academy of Design, where he will exhibit continually until 1890.

- **1870** Exhibits at the Boston Athenaeum and the Brooklyn Art Association. At both, he exhibits without interruption until the mid-1880s.

- **1874** Becomes a member of the American Society of Painters in Watercolors. Exhibits for the first time at the Boston Art Club, where he will regularly exhibit for the next 20 years.

- **1879** Becomes an associate of the National Academy of Design in New York.

- **1890** Moves to Staten Island, where he gives in to his passion for the sea and coastal landscapes.

- **1905** Exhibits his oil and watercolor paintings on Bailey Island near Portland.

- **1908** Dies in New York.

One of the second generation of Hudson River School painters, Alfred Thompson Bricher was a spontaneous and realistic landscape painter. At times he allowed himself to be captivated by the luminist perspective on dramatic light. However, the style of his most personal works approximates that of the Barbizon School landscape painters.

Bricher's paintings have higher-quality lines than those of the luminists. The energy of his brushstrokes contrasts with the apparent simplicity of his paintings, which achieve an atmospheric effect that is expressive, but maintains an overall aesthetic simplicity. Bricher did not use complex, confusing compositions. His painting, rather, is continuous and flows through the pictorial space in a simple and coherent manner.

Bricher was a steadfast and methodical artist, who started his artistic career with carefully planned training that included short periods with landscapists and portraitists. Similarly, his first exhibitions gave him the chance to show his work alongside Hudson River School artists such as Asher Brown Durand and John Frederick Kensett, which demonstrates that, even though he was still quite young, he was already part of the American landscape tradition.

Sunset in the Catskills

(1862)
oil on canvas
30 x 46 in (76.2 x 116.84 cm)
Brigham Young University
Museum of Art, Provo, Utah

In 1859, Alfred Thompson Bricher opened a professional studio in Boston. In this same period, the artist discovered landscape painting that was more expressive than the moralizing naturalism that had dominated artistic circles until then. Bricher went outdoors to make studies and sketches of nature, following the example of the Barbizon School painters, whose influence can be seen in this work. As in Barbizon works, the impression of the light at sunset drapes a warm veil over the work, starting from the background and reaching outward.

However, the spatial composition of the painting seems closer to the Hudson River School. The interior layout is classic, presenting a central space where the viewer enters the scene and the field of vision seems infinite. Similarly, Bricher plays with the directionality of the work to make it more dynamic. The large tree on the left-hand side helps break the horizontal plane and enhances the feeling of depth.

Bricher belongs to the second generation of the Hudson River School painters, and thus a classic style—bordering at times on tedious—appears in his paintings. However, sporadically, some element can be observed, a brushstroke or a compositional suggestion, that shows the artist's contained desire to explore new painting styles. Fortunately for

Lake George

(1868)
oil on canvas
Private collection

Bricher, the Hudson River School style remained popular throughout the 19th century, although most of the later artists followed a luminist perspective, creating more vivid and lively paintings that were more accessible to the viewer.

This painting is an example of Bricher's most academic style. It depicts a landscape, where couples and families come to enjoy their leisure time. A scene like this, showing urban families enjoying natural settings such as parks and gardens on the outskirts of the city, is influenced by the Barbizon School painters, who frequently painted such pictures. The viewpoint of this painting, with a monochrome ochre tone that drifts lightly toward green in the lower part of the work, clearly shows Bricher's horizontal concept.

Left: The aesthetics of the Hudson River School artists were very different from Bricher's preferences. This work illustrates how the artist developed his own style in which simplicity was predominant. It portrays a simple seascape with perfect linearity. The artist has not resorted to superfluous elements to construct the space or to accentuate expressiveness or movement.

Starting with a rock as an allegorical element of loneliness and reflection, the artist contrasts the rock's verticality and the sea's horizontality. Likewise, the artist depicts a dynamic and striking sea that, when it breaks against the land, expresses its energy in the white foam against an intense blue background.

Seascape

(1878)
oil on canvas
10 x 14 in (25.4 x 35.6 cm)
Private collection

Seascape is a work that portrays opposing concepts. There is a view of human nature in the coarse monumental landscape. With the silhouette of the boat in the background, man is reduced to a simple detail.

Harbor

(1880-1883)
watercolor heightened
with white on paper
14 x 20 in (38.8 x 51.9 cm)
Brooklyn Museum,
New York

Life on the docks has been a great source of inspiration for many artists. These locations offer an abundance of different socially marginalized characters, who possess something that attracts the attention of an artist eager to find interesting faces that tell a story. Whistler, for example, created some of his best works on the London docks, compositions of great expressiveness made with simple splashes of color on a dark background or depicting a balcony of a seedy bar on the Thames.

The harbor scenes in American painting reflect a clear modernity. Strangely, many Romantic painters depicted the ports of their cities as if they were the center of the industrial revolution. This painting depicts the port of New York from a Romantic point of view, where modern elements such as a steamship are not avoided. However, Bricher was a landscapist, and because of this, the painter focused his attention on the reflections and glimmers of the light on the water. The work basically consists of a horizontal plane that extends toward the horizon, as if it were a mirror in which Bricher could re-create all the hints and subtleties of light and color. To add context and break up the horizontality, the artist has placed boats on the right-hand side, their vertical masts pointing toward the sky.

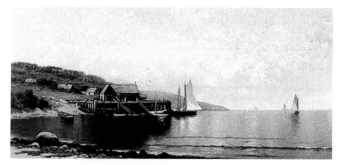

Bricher's interest in coastal landscapes originated in 1864, when he had traveled to New Jersey. He continued painting marine motives later in Maine. For more than 40 years, the painter carefully observed nature scenes throughout the region and tried to capture all its moods and effects in an extensive series of paintings about coastal villages and the beaches of New Jersey and, later, Maine. In these works, Bricher experimented with the effects of broad panoramas and materials such as pastel and chalk. It can even be said that he created a new visual language for the region.

The Landing at Bailey Island, Maine

(~1907)
oil on canvas
15 x 32 in (38.1 x 81.28 cm)
Butler Institute of American Art, Youngstown, Ohio

This landing on Bailey Island shows Bricher's great calm and patience. He truly enjoyed creating this painting and capturing all the nuances of daily life as if they were something unique and unrepeatable. The optimism generally inherent in the artist's works can be seen in the meticulous reproduction of light over a perfectly textured cloak of water, where the glimmer and brightness draws the viewer's eye toward the open sea. Without a doubt, this painting is one of Bricher's best, boasting a generous repertoire of compositional resources and playing with a complex chromatic range distributed across the work with fluid and realistic brushstrokes.

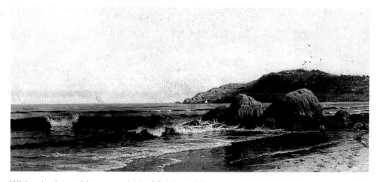

With a horizontal layout typical of Bricher, this painting perfectly captures a rugged beach, wild and full of life. In a continual form that stretches to the horizon, this painting develops with a dynamism based on the tonal changes and the white foam of the waves breaking onto the sand. Here, Bricher shows certainty and confidence with a personal painting. The artist has given free rein to his style, without the limitations of a commission or a painting designed for sale. *Breaking Surf* is a simple exercise that the artist has done for himself.

Breaking Surf

oil on canvas
15 x 33 in (38.1 x 83.8 cm)
Private collection

Here, Romanticism is a dramatic narrative that hovers in the air, without settling concretely on any one element. The chromatic combination is original as well. Using a palette of ochre and yellows for a seascape, and almost entirely rejecting blue, illustrates the special character of this work. American landscapists imbued works with expression emanating from the light; this tonal combination plunges the work into a melancholic and introspective chromatic silence.

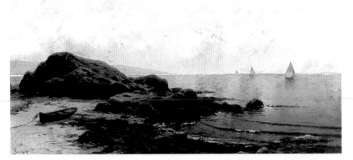

Low Tide, Bailey's Island, Maine

oil on canvas
17 x 36 in (43.2 x 91.4 cm)
Private collection

While the luminism of the last Hudson River School artists was as original as that of their predecessors, their naturalism also continued to evolve. They began to explore the new perceptions of art proposed by the French Impressionists and the English symbolists.

Bricher understood this transformation of the artistic world, and, without rejecting the traditions of naturalist painting, he proposed a new visual language in his work. This painting represents a more complex and structured composition than he had used previously. Starting from the rocks, the artist narrates two different "stories" distributed in two related planes. In one, in a calm sea under a sky of very fluid brushstrokes, the artist places three diagonally aligned boats, which offer a solid impression of depth. These boats create a line that ruptures the work's horizontal shape, dividing the space and making the viewer follow the horizon. In the other plane, another small boat shelters behind the rocks, alone and lonely. It seems as if this small boat will never touch water. This is a comment on the changes occurring in American society in the last quarter of the 19th century.

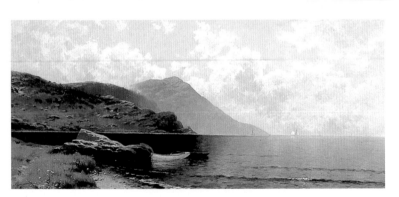

Rippling Sea, Manchester

oil on canvas
15 x 33 in (38.1 x 83.8 cm)
Private collection

Bricher's way of capturing seascapes illustrates the artistic evolution of American naturalist painting. Monumental views of mountains, where exuberant greenery creates a new Romantic language, give way in Bricher's work to distant views of shorelines. They speak directly to the human conscience instead of creating a vaguely divine reference. In this scene of the coast of Manchester, Maine, Bricher evokes the natural sense of the great luminists. However, his view goes through a transformation of monumentalism that, like the mountain in the background, becomes distant and dissipates, opening horizons where light no longer concentrates on a single point. Color and light in Bricher's work shine throughout the artistic space, enriching a well-organized interior with subtle shades that lead to new freedom. This painting exemplifies this evolution: It starts on the left side, where nature descends from a leafy height to the sea. The artist invites the viewer to board the small, empty boat in the foreground.

THOMAS EAKINS

Self-Portrait, *1902, oil on canvas, 27.3 x 22.8 in (69.3 x 57.8 cm), National Academy of Design, New York.*

- **1844** Born July 25 in Philadelphia. His father is a calligrapher and schoolteacher and Eakins grows up comfortably well off.

- **1861** Studies drawing at the Pennsylvania Academy of the Fine Arts. Combines his artistic studies with anatomy at the Jefferson School of Medicine.

- **1866** Moves to Paris to study at the École des Beaux-Arts under the guidance of Jean-Léon Gérome and, later, Léon Bonnat. He also takes an interest in sculpture, while studying with Augustín Alexandre Dumont. Discovers Rembrandt, Ribera, and Velázquez.

- **1868** Spends six months in Spain finishing his artistic studies and studying Velázquez's work.

- **1869** Returns to Philadelphia and moves into his family home, where he would live until his death.

- **1874** Begins to teach drawing at the Pennsylvania Academy of the Fine Arts.

- **1884** On December 19, marries Susan Hannah Macdowell.

- **1886** Due to a scandal related to his insistence on nude studies in painting, he is dismissed as professor and director of the Pennsylvania School of the Fine Arts.

- **1903** John Singer Sargent visits Philadelphia and meets Eakins, who is impressed by his talent.

- **1916** On July 25, the artist dies at home in Philadelphia.

Thomas Eakins is, along with John Singleton Copley and John Singer Sargent, one of America's major portrait artists and one of the most important artists of the 19th century. Although some of his training took place in Paris, his painting never showed European influences; rather, he created his own style based on everyday scenes in his country. Eakins would never achieve the popularity of many of his contemporaries, but his influence on American art and teaching is undeniable.

Eakins's aesthetic approaches are based on a thorough knowledge of the Renaissance masters. When he was appointed director of the Pennsylvania Academy of the Fine Arts he made anatomy, dissection, and scientific perspective mandatory subjects, thereby revolutionizing art education throughout the United States. This interest in science led him to study psychology in the last years of his life.

Since Eakins believed that a person's face perfectly reflects his personality and character, his late 19th-century portraits loyally, and with great realism, depict friends, musicians, and scientists as if they represented a whole range of emotions, moods, and frustrations. The people in these portraits have been, in a way, sculpted so that a slight movement of the head can spark a sense of vitality for the viewer.

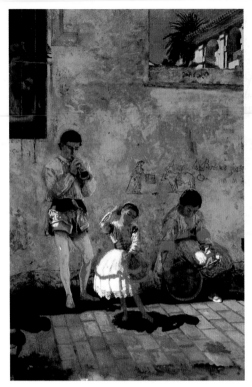

A Street Scene in Seville

(1870)
oil on canvas
57.1 x 38.4 in
(145 x 97.5 cm)
Private collection

After spending three years studying in Spain, Eakins returned to Philadelphia, where he painted this picture. His method of working, quite unorthodox at that time in the United States, allowed him to bring together enough notes and sketches to create one of his first important paintings.

This work shows an interesting vision of Andalusian life. Eakins's scientific eye redeems him from the stereotypical white walls and bright sun that frequent the paintings of his European contemporaries; instead, he takes an objective, urban approach. The color gray, the work's indisputable protagonist, influences the character of the three figures as well as the overall atmosphere of the work. At this time, Eakins still practiced an undefined style of painting with signs of spontaneity, although his approach to perspective was very calculated. While studying in Europe, the artist discovered a new, free pictorial style, which, without overly influencing him, led him to experiment with a fast, undefined brush.

The painting shows the sadness behind scenes of a fiesta. The little girl's Andalusian dress seems static, and harsh sunlight governs the people's moods. Even with its vivid colors and flashes of light, this work has a melancholy quality.

Starting Out After Rail

(1874)
oil on canvas
24.3 x 19.8 in (61.6 x 50.3 cm)
Museum of Fine Arts, Boston

In painting this seascape, Eakins's photographic vision allowed him to produce a very modern composition. The strange luminosity of this picture, which appears in each element of the composition, comes from the studied mixture of color. The artist has not followed any preestablished rule in order to compose his pallet; he has experimented with various possibilities, unorthodox for the time. As a result, his painting is intuitive and offers new luminosity and colors.

The view of the boat from behind, just as a photographer would capture the image from shore, presents a whole new approach to the subject. Eakins shows, as well, a poetic vision here, in which the vision of the boat is a look forward, toward the horizon and toward the future. The artist has emphasized the luminosity of the whole picture, which is balanced by the sky's intense blue tones and the wonderful light and shadow play on the ripples that spread like a green blanket along the blue water.

The Biglin Brothers Racing

(1873)
oil on canvas
22 x 32.9 in
(55.8 x 83.6 cm)
National Gallery of
Art, Washington, D.C.

Sports were a perfect subject for Eakins. They gave him the opportunity to show his knowledge of anatomy and science. Perfect bodies in movement, with flexed muscles, twisting and turning, allowed him to depict a reality impossible to find in a classroom. This was his great pictorial passion. This work shows the romantic way in which Eakins contemplated sports as a combination of concentration, effort, and beauty. The artist thought that spectators could see an athlete's personality. His other artistic passion, photography, helped him to capture those personalities, although Eakins preferred painting, considered more noble in those days.

In this picture, two young brothers in a scull row beneath a display of intense colors. Great observer that he was, Eakins was able to reproduce perfectly the effects of light on moving water from a realistic and scientific viewpoint. The water's ripples are perfect and steady, just like the rowing movement. One of this painting's great merits is that it connects the figures to the landscape—the characters to their surroundings. This does more than just make the picture more attractive; it joins the oarsmen's effort and strength to the peacefulness of the landscape.

Baseball Players Practicing

(1875)
watercolor on paper
9.8 x 11.7 in
(25 x 29.7 cm)
Museum of Art, Rhode Island School of Design, Providence

This painting is an excellent illustration of Eakins's pictorial style. His rational personality led him to experiment with various techniques—in this case, watercolors. Even though he never felt as comfortable with watercolor as with oil, he has achieved a very notable level of realism. Here, he has combined an impression with his scientific realism. The two players appear in very different positions, which allows us to appreciate their gestures and expressions. But Eakins has also depicted their clothing with the same veracity, giving it mass. The folds of the clothing and the weft of lines and shadows on the white cotton have been captured perfectly.

However, Eakins left the painting unfinished, showing the light color of the paper support on the margins. It seems that Eakins is experimenting here with photography, reproducing its effects in a watercolor. Oftentimes photography, still in its early stages, produced low-quality results, where the image faded at the edges. Imitating this effect, Eakins has composed a work with a great graphic quality. The painting is divided by two horizontal strips, one a dazzling color for the players, and the other a darker strip of stands where the spectators function merely as extras.

Baby at Play

(1876)
oil on canvas
29.3 x 44.1 in
(74.6 x 111.9 cm)
National Gallery of Art,
Washington, D.C.

This work is the last of a series of portraits of families and friends that the artist did between 1870 and 1876. Here he has painted an up-close and personal portrait immersed in a family environment. For a portrait of a baby the chiaroscuro approach might seem strange, but with this approach Eakins created a peaceful and intimate atmosphere. Eakins has planned a detailed painting in which the child's independence takes the lead role. The clearly festive, happy feeling that scenes of children tend to convey has been filtered and converted into a series of details of light, which convey the child's happiness. The intense colors of the baby's socks and toys show this childish joy, which contrasts with the serious tone of the work.

Eakins has not settled for a simple child portrait in which an unmeasured happiness pervades the pictorial space without any order. He is a rationalist, and his painting presents a well-organized, realistic structure. To accomplish this, he has used a moment in the daily life of this child, playing on the patio, absorbed in what he is doing; Eakins does not need any special scenery to satisfy the audience. It is precisely this sober aspect that reflects the individuality of a child at play.

An Arcadian

(~1883)
oil on canvas
12.8 x 16.4 in
(32.5 x 41.6 cm)
Spanierman
Gallery,
New York

Miss Amelia Van Buren

(~1891)
oil on canvas
40.9 x 29.1 in
(104 x 74 cm)
Phillips Collection,
Washington, D.C.

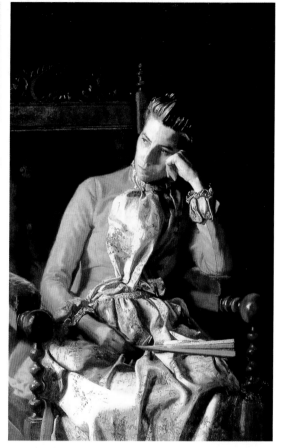

Even though Eakins's pictorial production covered many different subjects, he stood out as a portrait painter. His scientific working method, both criticized and praised by 19th-century America, allowed him to produce works, such as this portrait, of an almost exaggerated realism, which could be called organic realism due to the glow of the skin, eyes, and hair. Eakins had an excellent understanding of human anatomy, and he used this knowledge in portraits to achieve a more powerful effect. This realism, which we see here in the highlighted glow of the model's eyes, allowed the artist to paint following scientific guidelines. He depict the elements of the human body with great precision. Eakins's painting is the result of complex study, almost like the studies required in medicine, and his work can only be understood from a similar point of view. Eakins encountered enormous distrust from the public when he made his medical paintings, because his viewers were not willing to follow his scientific arguments.

This work, a perfect study and excellently executed, not only presents the figure's physical appearance but also her personality and mood at the time. As in classical paintings, in order to emphasize the figure, the painter has planned a dark background against which the colors adorning the figure shine in splendor.

Left: Eakins's classical vision of painting is illustrated in his working method. The artist discovered Renaissance painting while he was in Europe and observed, with great pleasure, that scientific painting could be applied even to classical subjects.

This painting is a mix of Romanticism and realism, which creates an unusual vision of the classical subject matter. The artist has composed this painting following classical canons, presenting a young Arcadian dressed in a tunic. The spatial structure of the work is balanced, thanks to the light on the green area, where the figure stands out sharply in a typical studio pose. The line defines the bright grassy area as it horizontally crosses the picture. From this element, Eakins has designed the scene's interior in a very studied way, creating areas independent enough to still be dynamic but leaving the lead role to the blue-and-green chromatic base. The brighter area of grass constitutes the real scenery, the background for the main figure. This area's sense of volume and realism is extraordinary; the fine grass is almost tactile.

Eakins has incorporated a darker shadowy area just above the central axis, enclosing the scenery and eliminating the horizon so as to avoid an excessive deepness that could diminish the subject's importance. The artist limits the space to center the viewer in a small, natural frame. The scene is bucolic, elegant; it is among the best images of academic classicism.

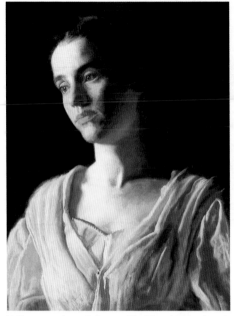

Maud Cook

(1895)
oil on canvas
21.9 x 18.2 in
(55.5 x 46.3 cm)
Yale University Art Gallery,
New Haven, Connecticut

Eakins did this picture during his last pictorial period, which we can label psychological. Its beauty resides in the ease with which he captures the personality and experiences of his subject and uses attractive details to draw the viewer's attention.

This painting is the result of great compositional maturity, thanks to which the space has been distributed with remarkable simplicity. In the style of the European masters, this portrait plays with chiaroscuro. Although he never openly admitted it, Eakins adored Velázquez and was influenced by his color play in paintings with chiaroscuro. The artist uses this effective resource here to make the girl stand out against the dark background and project a tender vision with her glowing pink camisole, which, aside from illustrating her femininity, evokes sensuality. Her face seems to disappear into the surrounding darkness, but it is expressive nevertheless. It is easy for the viewer to imagine a thoughtful young girl beneath the fragile appearance. Eakins has incorporated some evocative details: the slender, glowing neck, the soft skin, the full, red lips, the listless expression, the lost look.

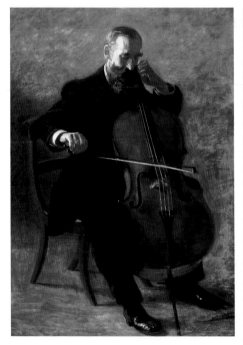

The Cello Player

(1896)
oil on canvas
58.7 x 44.1 in
(149.2 x 112 cm)
Pennsylvania Academy of the
Fine Arts, Philadelphia

During the last years of his life, Eakins had a predilection for painting scientists, doctors, and musicians. His character and scientific interest led him to explore a new field, with the idea of capturing the features that described his subjects' talents and wisdom. This psychological painting brought the artist to increase, if possible, the realism and expressiveness of his portraits.

Here we see a cellist playing his instrument. Every aspect was of interest to Eakins, from the musician's arm movements to his ability to concentrate, from the force and tension exercised on the cello to the expressiveness extracted from the musical instrument. To capture all this, the musician is positioned against a smooth wall that completes and balances the composition without the use of a dark background. Eakins put the only beam of light on the cellist's face in order to attract the viewer's attention and give the portrait a divine air. His clothes appear insignificant next to the cello, whose wood adds a serious and dignified air to the whole work.

MARY CASSATT

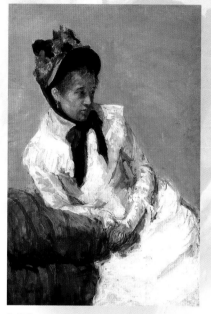

Self-Portrait, *gouache on paper, 23.7 x 16.2 in (60.1 x 41.2 cm), Metropolitan Museum of Art, New York.*

As a young woman, after making prints and illustrations on a professional level, Mary Cassatt traveled to Paris. She quickly entered into the circles of the avant-garde painters of the time, and met Renoir and Degas, whose influence caused Cassatt to shy away from the naturalism that prevailed in the United States at that time. Together they would go out to the countryside to paint in the open air, and Cassatt was first invited to present her works in an Impressionist exhibition in 1874.

Impressionism was much more within reach for Cassatt than for her French counterparts. In the second half of the 19th century, there was some significant progress in the way women painters were perceived, but Impressionists generally continued to treat women as secondary artists. Voluntarily limited to acceptable everyday domestic scenes that extolled femininity and motherhood, Eva Gonzalès, Marie Bracquemond, and Berthe Morisot were the foremost women representatives of Impressionism.

However, her male counterparts made an exception for the American Cassatt, and their acceptance allowed her to create more complete works than other women artists of the time. Her cosmopolitan viewpoint was advantageous in painting spontaneous street, theater,

- **1844** Mary Cassatt is born on May 22 in Pittsburgh, into an affluent family. Her father, a Pennsylvanian banker, is descended from French immigrants of the 18th century. Shortly after her birth, her family moves to Paris.
- **1858** The family returns to the United States and Cassatt enrolls in the Pennsylvania Academy of the Fine Arts, in Philadelphia, specializing in etching.
- **1873** Her painting *Offering the Panal to the Bullfighter* is accepted at the Paris Salón. This work was painted in Spain, a country that Cassatt visited on one of her many trips. During this period, she works as an illustrator for a newspaper.
- **1874** She moves to Paris to pursue the study of art and meets Pierre-Auguste Renoir and Edgar Degas. Degas invites her to participate in her first Impressionist exhibit with her painting *The Redhead Girl.*
- **1879** At the fifth Impressionist Salon, together with Degas and Camille Pisarro, she exhibits a series of prints completed for a magazine but never published.
- **1881** In the seventh Impressionist exhibit, she receives great critical acclaim..
- **1883** Exhibits in the Durand-Ruel Gallery in London.
- **1891** Commissioned to paint a mural for the Women's Building.
- **1895** Exhibits in the Durand-Ruel Gallery in New York.
- **1898** She returns again to the United States, where she promotes the works of the Impressionists among Americans; she acquires numerous works from members of the group.
- **1912** Cassatt's eyesight begins to fail.
- **1926** She dies in Château Beaufresne, Beauvais, France, as a result of a grave illness.

and open-air scenes. She was able to capture ephemeral moments, adding Impressionist light and color to these scenes along with a tender perception of gestures and expressions.

Cassatt also concentrated on domestic paintings but with a greater degree of realism and distance than her fellow female Impressionists.

Cassatt's works form the greatest American contributions to Impressionism. No other painter from the United States participated as actively in this movement.

Two Women Seated by a Woodland Stream

(1869)
oil on canvas
Private collection, Paris

When Cassatt was barely 23 years old, she painted this open-air scene in which the influence of American naturalism is clearly present. Her background in etching led her to experiment with oil paints. This painting, which belongs to her first artistic period, when she was still living in the United States, is very different from the Impressionist works she would create in the 1870s. However, her interest in the effects of light and color is already evident.

In a thick, damp forest, two young women sit by a stream. The artist was careful to capture all of the details of the scene. The background is quite saturated and totally decorated, without missing even the smallest detail. With its constant variations in hue, the painting is very lively. The brushstrokes are rather drawn out, although Cassatt does not depend on the more fluid strokes she would come to use in later years. The illumination and naturalism of this forest scene give no hint of the Impressionism that would characterize Cassatt's paintings just a few years later. However, the two figures, depicted using two white dashes in the center of the painting, do show the artist's pictorial nature. Cassatt is clearly inclined toward Impressionism, although in this case she relies on the formal realism characteristic of the period.

Mary Cassatt

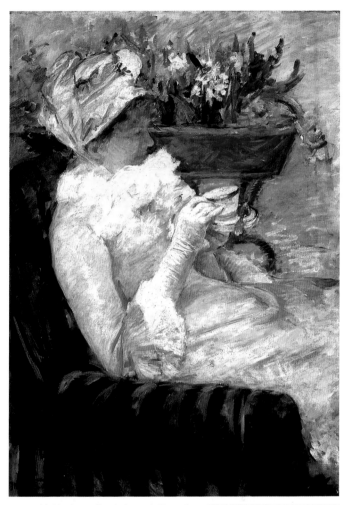

The works of Cassatt are highly decorative. In her paintings, the surroundings constitute a fundamental part of the scene. The artist does not put weight solely on the subject matter represented in the painting or the person represented in it. Rather, the subject matter forms part of a balanced unit where gestures and expressions are the main focus of attention and become the real protagonist.

In this picture, gestures are extremely detailed. The artist, a specialist in representing women and children in everyday situations, centers her work on delicate scenes in which she portrays the spirit of the subject, represented from an intimate viewpoint. Here we see the profile of a woman, dressed in an elegant orange-colored dress and seated in a relaxed attitude, holding a cup of tea. (The woman is Lydia Simpson Cassatt, the artist's sister.) Cassatt's exquisite perception of detail and of the psychology of the subject is described with great observation. The woman's attentive look at the hot drink and her expression of concentration while carefully holding the cup are perfect examples.

The Impressionist brushstrokes, generous and spontaneous, do not hide the importance Cassatt gives to portraying gestures realistically. In her scenes representing social activities, Cassatt shows her understanding of the life of women toward the end of the 19th century, especially those who belonged to a well-to-do social class. Her works frequently show women in gatherings around a table at tea, at the theater, or out with friends. The artist reflects the private world of the woman from a personal view. Women are always treated with dignity and respect. The home, decoration, and motherhood are part of Cassatt's feminist vision, although the gestures of her subjects sometimes seem to hide a certain melancholy—perhaps because, despite their social class, the women still feel imprisoned.

The Cup of Tea

(1879)
oil on canvas
36.4 x 25.7 in (92.4 x 65.4 cm)
James Stillman Collection,
Metropolitan Museum of Art,
New York

Young Woman Sewing in the Garden

(1880-1882)
oil on canvas
32.8 x 23.2 in (83.5 x 59 cm)
Musée d'Orsay, Paris

In this domestic scene, Cassatt already shows a mature style that is completely her own, although the influences of the Impressionists can be seen. On this occasion, the decorative composition of the space presents an Impressionist garden in which the intense tones contrast with the green mantle of leaves and grass. The red spots of the flowers on the background add vibrancy to the scene.

Cassatt centers this work on the face of the woman, who looks down, concentrating on the work she is doing. Attention, candor, elegance, and youth are characteristics perfectly described in this scene. Full-face portraits were a novelty for the artist, and the pose gives the work a formal sincerity. The sense of friendliness, conveyed by the face of the young girl, contrasts with the serious expression in her eyes. The linearity of the subject matter carries the viewer's sight vertically over the picture; the way the woman's head is inclined leads the eye to the work she has in her hands and to the brilliant details of her dress. This contrasts with the rich hues around her, which give the picture a notable brilliancy and spontaneity that complement the youth of the protagonist.

Right: Motherhood was a recurrent theme in the works of the women Impressionists. The relationship between mother and child appears so frequently in the paintings of Cassatt, Marie Bracquemond, and Berthe Morisot that the subject came to be considered solely for women painters. The contrast between the modern version of urban social life offered by the male Impressionist and a subject matter as classic as motherhood, embraced by the women Impressionists, is a good example of how female painters of the 19th century were really treated. Although these women were well received in exhibitions and could show their works in the same places as men, the critics referred to their works with a paternalistic and contemptuous air as nice homely scenes or amusing domestic exercises, which the women did to keep busy. In spite of this, the field of painting was definitely open to women, and there were, in many countries, women painters who fought for their place among the men.

In this painting, Cassatt has painted a magnificent scene of a mother with her son at his bath. The quality of detail, especially in the expressions of the two subjects, conveys the affection and tenderness between them. The viewer clearly perceives this bond. Cassatt did not use any special technique to portray these feelings; instead, she used direct realism to capture these expressions. The drawing is excellent, with bold lines outlining the subjects and bordering the different-colored areas.

Woman in Black

(1882)
oil on canvas
39.6 x 29.1 in (100.6 x 74 cm)
Private collection

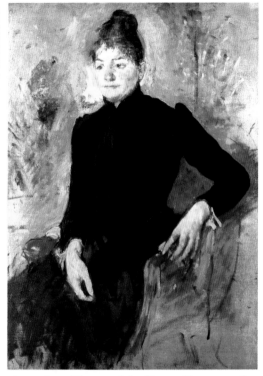

In her paintings of domestic settings, Cassatt's personal and feminine vision, always sharp but subtle, is evident. It permitted her to portray her subjects' state of mind—their feelings, desires, or fears—with unique insight. However, in this painting Cassatt lets herself be led by a more intuitive and spontaneous vision of this woman. Using a fully Impressionist type of aesthetics, resembling that of Renoir, the artist here has used a looser brushstroke and a mixed technique that increases the emotional weight but at the same time loses definition. More than a mixture of realism and Impressionism, it is a free painting or an impression. A woman, dressed in black, adopts a modern posture, sitting on a chair with one of her arms resting on the back. Cassatt demonstrates the woman's confidence using gestures, which have been exaggerated by the lesser-defined Impressionist brushstrokes. In this work the artist is totally free from conventions and creates free art based on feelings. To further center attention on the figure, the decorations in the room have been left incomplete and the pictorial space is dominated by wide, drifting yellowish brushstrokes. Because her interest lies in achieving a picture of impression, Cassatt has used strongly contrasting colors. The black of the dress brings out the chromatic brilliance of the wall, while the whitish hue of the woman's face gives her life.

This is perhaps the most aggressive of all of Cassatt's paintings. Normally, femininity and infancy, full of delicacy and candor, predominate.

The aesthetics of this work are strikingly different from her other paintings.

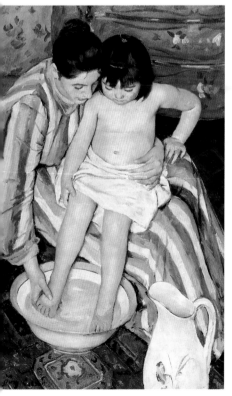

The Child's Bath

(1891)
oil on canvas
36 x 21.1 in (100.3 x 66 cm)
Art Institute of Chicago,
Illinois

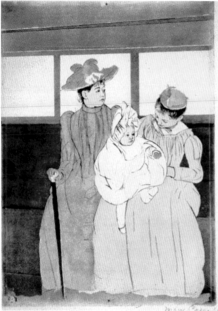

In the Omnibus

(1891)
drypoint and aquatint
17 x 11 in (43.2 x 27.9 cm)
Portland Art Museum, Oregon

From the moment she began in the art of prints, Mary Cassatt experimented with different visions and techniques for her work. Her first lithograph etchings were classical in style, very far from this elaborate scene of two women holding a child. Cassatt's relationship with Berthe Morisot and the love they both had for Japanese prints influenced Cassatt's etchings strongly. Cassatt became an important collector of Japanese prints and studied the techniques of ukiyo-e. During the 1890s, she presented a series of color prints done using only Japanese techniques. Her intention was to create a composition in an Asian style, using an Impressionist's vision of everyday scenes. This resulted in a long list of works, which merited an individual show in Paris.

Although the critics were not very favorable toward these experiments, the artist was rewarded by the approval of Degas and Pisarro, who encouraged her to continue her work in etching. The application of color on the different plates gave a new vision to this art form even as it revolutionized the technique of color prints. The hues in this work are flat and even, giving the same light to the entire picture. The colors are organized in large planes to make the painting more dynamic.

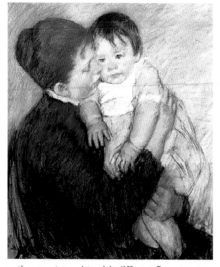

Agatha and Her Child

(1891)
pastel on paper
26 x 21 in (66.04 x 53.34 cm)
Butler Institute of American
Art, Youngstown, Ohio

In the Paris of the Impressionists, opinion was divided on Cassatt's pastel work. For some critics, she did not sufficiently dominate this technique and her works lacked force and dramatic tension. On the other hand, for the public, these portraits in pastels constituted magnificent allegories of motherhood and femininity, carried out with the same perception as her work in oil. In the 1890s, Cassatt's work increased tremendously in popularity, which led her to exhibit in her native country and to visit different European countries. The artist, who had already demonstrated her mastery of oils as her principal technique, experimented during these years with different techniques for prints and paintings.

This work represents something new in aesthetics because of the quality of the strokes Cassatt attained with pastels. The artist saw the possibility of combining pastels with the lines of an etching and the spontaneous brushstrokes of Impressionist painting. Pastel would become a favored medium for Cassatt in the last years of her artistic career, because it permitted her to draw a bold and definite line like that of a print or to blur freely, imitating a fluid brushstroke. In this painting, the artist presents a defined vision, especially in the child's face, where she demonstrates her mastery of the technique by giving the baby's skin a beautiful delicate texture. In contrast, the lines of the mother's dress are more aggressive, bolder and repetitive.

HENRY FARNY

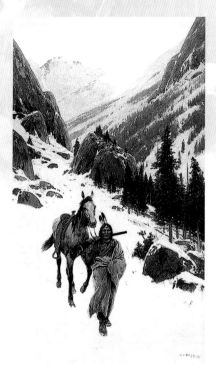

Through the Pass, Winter (detail), 1897,
gouache, 28 x 17 in (71.1 x 43.1 cm),
Private collection.

- **1847** Henry François Farny is born in Alsace, France.

- **1853** Fleeing the Napoleonic wars, his family emigrates to western Pennsylvania, where they settle near an Iroquois reservation.

- **1859** Moves to Cincinnati, Ohio, where he studies lithography.

- **1865** Receives his first commission as an illustrator for *Harper's Weekly* of New York.

- **1866** Travels to the prestigious Düsseldorf Academy, where he begins his art studies. Also visits Rome and Vienna. Shares a studio in Munich with John Henry Twachtman and Frank Duveneck.

- **1869** Returns to Cincinnati, where he begins work as an illustrator on circus posters and for books such as *McGuffey's Readers*.

- **1878** Completes a 1,000-mile canoe trip on the Missouri River.

- **1881** Visits the Sioux reservation of Standing Rock for the first time.

- **1883** The final buffalo hunt takes place— the animal is on the verge of extinction.

- **1890** Sitting Bull is assassinated at Standing Rock reservation.

- **1893** Visits Montana for the inauguration of the Northern Pacific Transcontinental Railroad.

- **1894** Visits Oklahoma, where he stays at Fort Sill.

- **1907** Marries.

- **1916** Dies in Cincinnati, having been adopted by the Sioux under the name of Long Boots.

Henry Farny is known for his magnificent illustrations of American Indians. While his training was in traditional drawing techniques, he made a living and dedicated himself to illustration, never abandoning it—artists in this field were highly sought after by newspapers and advertising.

Farny's triumph is to have elevated each of his gouache or watercolor works to the level of artistic creation, along with many of his oil paintings. On the other hand, his work is stylistically different from that of others who painted the West—such as Frederick Remington or Charles Russell—because it portrays the Indians in a much more friendly and direct fashion. Farny focused on descriptions of dress and adornments more than on scenes of battles against the white man.

The artist became acquainted with Indians as a child, because his family lived near an Iroquois reservation. Later, he was adopted by the Sioux tribe and given the name Long Boots. Endowed with considerable powers of observation, fed by a tremendous interest in Native Americans and great drawing skill, Farny gave his illustrations a remarkable quality of silence and introspection. Even scenes with a more dramatic tone, such as his early work, reflect calm and tranquillity. Furthermore, his works have a snapshotlike freshness, although in fact they were carefully elaborated in his studio at 126 West 4th Street in Cincinnati. The work he produced there was highly successful at the time, a success that has continued through to the present day.

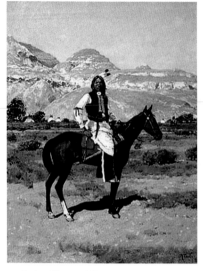

Indian Scout

(1896)
gouache on paper
Private collection

George Catlin depicted Indians so as to show the dignity of their bearing by echoing the classic canons—hence he painted them in a classically handsome style. Farny, however, drew them in their surroundings without recourse to the easy exoticism of a military painting. This image is almost like a photograph. The Indian, on his horse, has paused for a moment to stare at the viewer—and this instills a sense of instantaneousness in the work. The model is portrayed in a direct, streamlined fashion. His dress, immaculate and intensely sparkling white, is depicted in great detail. In sum, this is a very descriptive rendering. The model's facial expression, with its fixed stare, is detailed. Farny drew Indians in an idyllic style, divorced from their true suffering. In reality, they were subject to recurring humiliation from the government.

Farny's drawings were immediately successful and were understood by the residents of the Eastern seaboard as evidence that the Indians lived in perfectly happy conditions on their reservations—although the reality was harshly different. Indian reservations were frequently despoiled, and many of their chiefs systematically assassinated. Little by little, Indian tribes were driven apart to prevent them from uniting to fight the white man, although in later years, the Indians had already lost their power over the lands that once belonged to them.

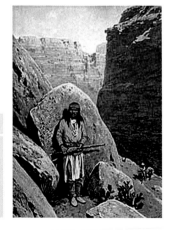

Apache Indian

(1901)
oil on canvas
8.3 x 11.5 in (21 x 29.2 cm)
Ohio Historical Society Collection

Through the Pass, Winter

(1897)
gouache
28 x 17 in (71.1 x 43.1 cm)
Private collection

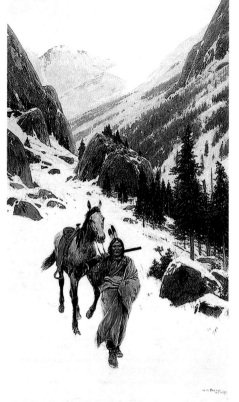

Farny's realism appealed to the Easterners—newspapers, magazines, or individuals—who bought his illustrations and wanted to have a trustworthy image of the "savage" tribes of the West. The photographic quality of his artwork, which he enhanced during his studies at the Düsseldorf Academy, added to the sense of realism.

Nonetheless, the free life of the Indians had been smothered in the suffocating reservations long before, so much so that many tribes had been forced to change their customs radically. That is why it must have been difficult for Farny to actually see a scene such as this one in the middle of the mountains in winter. Despite its apparent realism, this image is part of an idealized and romantic view; it is the fruit of the artist's own sympathetic imagination, longing for the Indians' old lifestyle. A meditative silence reigns, which for the Indian is a silent protest. Only the howl of the wind can be heard, and the footsteps of the man and the animal. (The saddle with stirrups is more typical of a cowboy than an Indian.) There are many possible interpretations for the viewer: Perhaps this is a Sioux scout who has surprised a white man spying and has overpowered him, or simply a hunter crossing the mountains in search of game. The artist's technical prowess is shown not only in the development of the two figures but also in the treatment of the landscape. The snow is light and powdery; the sun reflects off it, and the rocks are rough and textural.

Left: Farny's education did not end with the Düsseldorf Academy, but continued in the United States, where he absorbed all the innovations of new artistic styles. Indeed, he went even further given that his work as an illustrator offered even more liberties than traditional styles.

He experimented with oil on canvas, even if only in small formats. This work is almost miniaturist in style, judging by the detail in the work and the tiny size of the canvas. The assimilation of new stylistic developments can be seen in the way Farny depicts shade—as he does in this painting—setting aside the green and black tones he had learned at the Academy. Indeed, if there is one notable characteristic of American landscapes, it is the brilliance of the light, something artists such as Farny did not ignore. The shades seen here have bluish, almost violet, tints that reflect the sky and the air surrounding the objects. Farny's colors are alive and warm: clear green for the grass, clear blue for the sky, and salmon pink for the Indian's jacket.

This Indian, who seems to have been caught as he stands guard, is surrounded by a rocky landscape that was probably a product of the imagination and interpretation of the artist. Farny made many sketches and took photographs, then reorganized the elements for his artwork. In his studio in Cincinnati, he followed his imagination and placed the Indians in nomadic locations similar to those they had once occupied. Farny's works were highly romantic and idealized visions, but they have elements that make them important anthropological documents: The handkerchief knotted around the forehead, the shirt, the apron, and the skin boots are true to life.

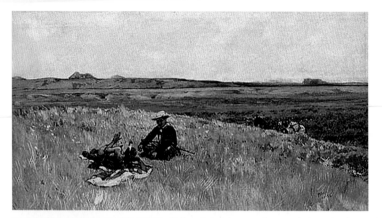

Swapping Lies

(1906)
watercolor and gouache on paper
9.9 x 17.9 in (25.1 x 45.4 cm)
Smithsonian American Art
Museum, Washington, D.C.

Although it is in gouache, a technique that is considered easier than oil painting, this painting reveals Farny's mastery of the light of the sunny prairie. The study of brilliant color is adapted to the composition, which highlights the vastness of a free territory that the Indians and whites will fight for. The open prairie contrasts with the concealed look of the soldier, who appears to be negotiating the use of a travel route with the Indian.

While the white man listens attentively and thinks about the deal, the Indian, comfortably lying on the blanket, animatedly explains everything that he is interested in concerning life on the plains.

Nonetheless, they are both lying. Even after signing many treaties, the white man never respected the agreements, always resorting to violence. As a result, Indians often delayed conversations with whites, confusing the enemy's movements, fooling them with theirs, particularly because they knew that behind every treaty there was a fatal trap. The tone of the painting is quite different from the rest of Farny's work. Here, the silence is a pause, the silence of vain words before an act of injustice. The enormous horizontal line that extends before our eyes, dotted by mountains, highlights this. The brushstroke is perfect once again for the figures. For the landscape, the artist applies the paint more freely. The prairies, once wild, have now been tamed with the arrival of commercial routes that soothe the white man's insecurity in these immense lands.

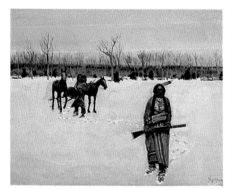

Indians with Travois

(1914)
gouache on paper
9.1 x 11.8 in (23 x 30 cm)
Spanierman Gallery,
New York

During his visits in Indian Territory, Farny gained first-hand knowledge of the utensils the Indians used in their day-to-day existence. It is this that makes his paintings so realistic. The cart shaft was formed by two strong poles set parallel with their ends fitted to either side of the horse. On these, cargo was placed in such a way that the poles could also be used for other needs, such as, for example, supporting tepees or tents.

Farny's interest in the Indians became a brotherly one to the point that the Sioux allowed him to become a member of their tribe. The Sioux referred to themselves as Dakotas, which means friend, rather than Sioux, which means serpent or enemy. With time, the tribe divided into three different branches, the Sante, the Dakota, and the Teton, which all adapted to their circumstances and influences.

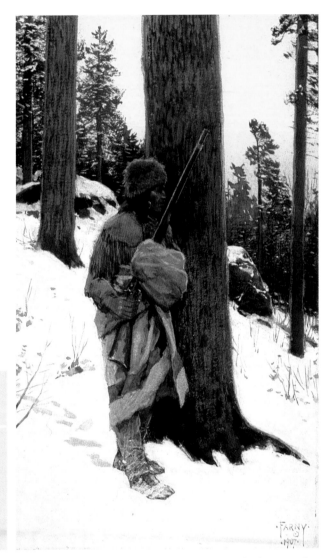

Indian Brave on the Lookout

(1907)
opaque watercolor
and glaze
5.1 x 8.5 in
(13 x 21.5 cm)
Rockefeller
Collection,
New York

Opaque watercolor, more commonly known as body color, is a type of watercolor mixed with glaze. Very similar to gouache, it is used in drawings done on inked paper. The results resemble those obtained with oil, but as opaque watercolor dries, the tones lighten. Because of its specific brilliance, it is used mainly for illustration.

Farny was very much at home with this technique, since from the outset of his career he had done posters and illustrations for children's books. Later, he used opaque watercolor to make sketches of Indians, some of which he would complete in his studio.

This work is striking, not only because of the detailed characterization of the figures, but also because of the tonal quality of the ochre in the twilight sky. An Indian soldier stands guard, silent and soundless, by a tree in the forest. His winter clothes consist of long trousers, a soft doublet, a cap, and boots, all made of skin, and a heavy blanket to stave off the winter cold. The artist has depicted the moment when the Indian stirs, alerted by some strange noise, perhaps. It was common among the Indians to set a guard to warn of any attack on the tribe. The scene is silent and nothing more than a gentle breeze is seen in the trees.

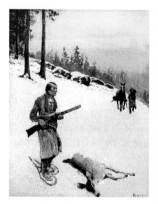

Bringing in the Firewood

(1912)
opaque watercolor on paper
6.1 x 8.5 in (15.5 x 21.5 cm)
Fine Arts Museums of San Francisco

Although Farny depicts the Indians in their daily activities here—gathering wood with the help of a travois—the truth is that these Indian customs did not survive. The nomadic lifestyle of some tribes was unsustainable in the limited territories of the Indian reservations. The landscape here shows how the plains have turned into a desert of snow, with few trees. Everything is horizontal and quiet. The only active element is the horse that pulls the travois.

The Indian lifestyle is once again presented idyllically, in a painting steeped in emotions that must have formed during Farny's childhood. Farny's romantic idea contrasts with the truth—but in the United States, realism had tremendous power as a truly American style, particularly after the Civil War. These images of the Indians, sought after today by museums because they reflect the spirit of an age, were quite popular when they were first created. Even then, they were collector's items, and many remain in private collections.

Peace and Plenty

(1915)
gouache
9.1 x 7.1 in (23 x 18 cm)
Bozeman Trail Gallery,
Wyoming

Following the ban on buffalo hunting, the Indians' main sustenance turned to smaller game, red deer, and the harvesting of wild berries. The period of peace and abundance suggested by Farny in the title was over, and in its place were left only humiliation and defeat. This scene shows how an Indian hunter approaches a downed animal on the snow-covered mountain slope. Wearing snowshoes, he moves toward the deer with his rifle. Again, the study of Indian dress and survival techniques is present, flooding the scene with a realistic and almost documentary tone, mixed with the air of legend so characteristic of Farny's works.

In fact, Farny had traveled across much of Europe and was among the most cosmopolitan of United States artists of his time. His subject matter shows his independent spirit; he chose to depict Native Americans as part of United States history, without wavering toward traditional themes suggested by the Academy.

ALBERT PINKHAM RYDER

Albert Pinkham Ryder.

- **1847** Born in New Bedford, Massachusetts, and soon begins to take an interest in painting in a practically self-taught manner.

- **1870** His family moves to New York, where he studies at the National Academy of Design.

- **1873** Exhibits for first time at the National Academy of Design.

- **1877** Visits the Netherlands and London. Founds the Society of American Artists with Louis Comfort Tiffany, John La Farge, George Inness, Levi Warner, and Julian Alden Weir.

- **1882** After becoming an artist of the symbolic and decorative movement, he travels to northern Africa in the summer.

- **1887** Visits London.

- **1901** Is awarded the silver medal at the Pan-American Exposition in Buffalo.

- **1906** Is elected member of the National Academy of Design.

- **1908** Is elected member of the National Institute of Arts and Letters.

- **1913** A selection of his work is included in the New York Armory Show.

- **1915** After his first heart attack, moves to Elmhurst, Long Island.

- **1917** Dies of cardiac arrest in Elmhurst.

An enigmatic artist who was ahead of his time, Albert Pinkham Ryder was one of the top painters at the end of the 19th century in the United States. While his American colleagues were still debating between traditional landscapes and modern Impressionism, Ryder's work was already foretelling the symbolism that would dominate European artistic circles at the beginning of the 20th century.

The highly unorthodox nature of the artist's training allowed him to dabble in new pictorial styles emerging in the United States—as an answer to, or, more correctly, a continuation of artistic movements that had appeared in Europe. Unfortunately, much of his art has not survived because of the unconventional materials he used to achieve his effects.

Ryder's friendship with artists in the modernist movement, such as Louis Comfort Tiffany and John La Farge, caused him to adopt a style in which the geometric forms and flowing shapes of his compositions became accepted as a new perspective in decorative art. While being implicitly symbolic, they were both more subtle and showed greater sincerity than the paintings flourishing in France and England, rife with complexity and pseudoliterary messages.

Despite this contrast, Albert Pinkham Ryder owes much to his English colleagues; thanks to them he discovered monochromatic paintings as a source of controversy that could be used to introduce forced contrasts, troubling viewers and provoking them to look inward.

Mending the Harness

(~1878)
oil on canvas
19 x 22.5 in (48.3 x 57.2 cm)
National Gallery of Art,
Washington D.C.

Although Ryder used dark, heavy brushstrokes in most of his works, reminiscent of rural scenes woven by Jean-François Millet, some of his paintings show a different style, a rendering of people and animals carried out so meticulously as to be almost illustrative.

Working this way in *Mending the Harness*, the artist has placed an allegorical white horse in the midst of a fearsome, dramatic web of dense, undulating brushstrokes. This grabs the viewer's vision and drives it in a dynamic horizontal path around the interior of the painting. The white horse—a symbol of honor and purity—is centered like a point the viewer can cling to. But this is a characteristic Ryder ploy: The servile horse is trapped by the surrealistic desert.

This is the type of technique the painter loved playing with, as he could control viewers through his whims. A spiral of lines and shapes was used to trap his audience and reveal his most basic symbolic universe, based on geometric shapes. In later years, Gustav Klimt and Edvard Munch would also use this controlling style.

The Race Track

(~1895)
oil on canvas
28 x 36 in
(71 x 91.5 cm)
Cleveland Museum
of Art, Ohio

The symbolist movement, which encompassed modernism, art deco, and symbolic painting, flourished almost spontaneously in all art forms. After folklore was reborn in the guise of Romanticism, the collective whole of this material that sprang forth in this age led to a new genre of literature, a movement that re-created popular traditional stories and legends, presenting the stories in a new dramatic light. The paintings that sprang from the stories illustrated the fantastic land-

Siegfried and the Rhine Maidens

(1888-1891)
oil on canvas
19.7 x 20.5 in (50.5 x 52 cm)
National Gallery of Art,
Washington, D.C.

scapes that the new authors had invented. Likewise, in the musical world, new compositional styles appeared; the objective was to make the human soul quake with a new resonance, to allow listeners to submerge themselves in a magnificent and fascinating world. The highest expression of this new musical language was in opera, a perfect synthesis of expressiveness, literature, and music, and its best representative was the German composer Richard Wagner.

In this work, Ryder eschews contemporary painting and instead merges a Wagnerian perspective from *Götterdämmerung* (The Dawn of the Gods) with exaggerated and disturbing symbolic lines. This painting of an opera has a strong theatrical element; the representation of a small human figure, surrounded by thick lines expanding outward, vibrates almost musically toward the divine light. The work heralds an almost futurist pictorial style where the color seems to acquire physical movement and drama.

Left: The symbolist movement, which originated in Europe at the end of the 19th century, involved a continuous search for themes where the mysteries of religion and the life of man were an issue. Thus, death became a recurrent artistic theme through which artists could offer a more or less placid view of their beliefs about life.

In this work, Ryder portrays an almost ironic allegory about life, interpreted as a race where the winner is unavoidably death. The artist offers the macabre outlook that art is part of the deadly race, and he implicitly suggests an afterlife. Based on his view of painting as a flow of brushstrokes and tones, the artist here creates a work that produces fear and yet simultaneously soothes fear. The composition leads the viewer through the artistic space toward a series of contrasts where the mystical horseman predominates. He appears static, which makes him even more recognizable, while the rest of the painting is submerged in movement that is sometimes chaotic, sometimes rhythmic, according to the viewer's subjective eye.

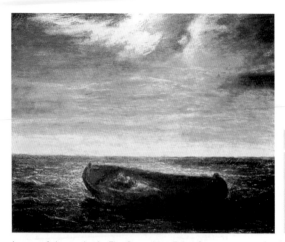

Constance

(1896)
oil on canvas
28 x 36 in (71.1 x 91.4 cm)
Museum of Fine Arts, Boston

In one of the stories in *The Canterbury Tales*, Constance was the daughter of a Roman emperor and wife of the king of Northumberland. Abandoned to chance in a drifting boat, she miraculously arrived in Rome five years later.

The painting, a symbolic illustration, stems from classical mythology and the fantastic literature that sprang forth in the European Romantic era. Stories of heroic female warriors were prominent in Western culture at the end of the 19th century, and through them, symbolists suggested a modern view of femininity as a complex and desirable trait.

In this painting, the artist has opted for a coarse monochrome, a powerful contrast to the colorful spirit of Impressionism. The thick brushstrokes and deep contrast help maintain the tension in this painting, which depicts a fragile boat practically enveloped by a cruel sea. Compositionally, this work shows an imaginative spatial challenge: While the sea appears as an element with infinite depth, the sky opens vertically, defying both the space itself and the viewer. The shapes of the clouds are simple silhouettes rendered with strong lines, very characteristic of Ryder. The work hints at some type of sinister sea monster or an incipient raging storm that will surely leave the craft shipwrecked and forsaken.

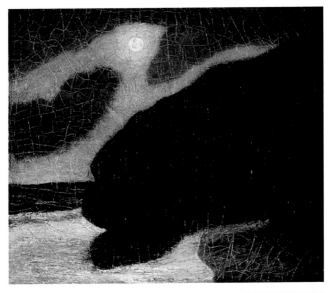

Unlike Impressionists, symbolic artists liked to use optical effects to play with the viewer's perspective. In this work, the scene of a simple beach is presented as something dark and mysterious due to the unique rendering. Here, Ryder has created a composition of open space where the moonlight clearly prevails, but the viewer "hides" in a dark space where he is forced to look at the scene that the artist has painted. These paradoxical arguments are common in Ryder's works, and he enjoyed developing novel pictorial perspectives in which the real protagonist is actually the viewer, who is at the mercy of the painter.

Moonlit Cove is a very original work, although the characteristic linear and undulating outlines that create the space, distribute it, and even insinuate some monstrous, almost subliminal animal become somewhat repetitive. The scene appears to be covered by a dark stain that makes the painting seem unfocused, as if there were an element in the immediate foreground blocking the view of the beach. This new type of trompe l'oeil, invented by Ryder, brings viewers into the scene and involves them directly in the world of the painting.

Moonlit Cove

(~1911)
oil on canvas
14 x 17 in
(35.5 x 43.2 cm)
Private collection

Left: In the same way that literature inspires fables and allegories about modern life, Greek mythology was used by symbolists to represent the virtues and vices typical of human nature. Here, Ryder depicts Pegasus, the last of the winged horses of Zeus, which managed to escape the herd's destruction at the hands of the Titans. According to this fantastic story, the winged horses, the divine creation of the father of all the Hellenic gods, were destroyed by the most earthly elements, and this portends that the human soul can be destroyed by the most mundane of vices.

Ryder belonged to the first generation of symbolic painters; reading his allegories is generally simple and direct. For an artist creating a new language, this simplicity was good; it caused his works to be received by the public with uncommon interest. Critics, however, were evidently perplexed.

The image of Pegasus is diffuse in this work. While the artist wanted to make a figurative work, he also worked to increase the discomfit of the viewer by blurring the winged horse, as if it were an intangible image like a dream or an apparition.

Pegasus

(1901-1918)
oil on canvas mounted
on fiberboard
14.1 x 17.2 in (35.8 x 43.7 cm)
Smithsonian American Art
Museum, Washington D.C.
Gift of John Gellatly

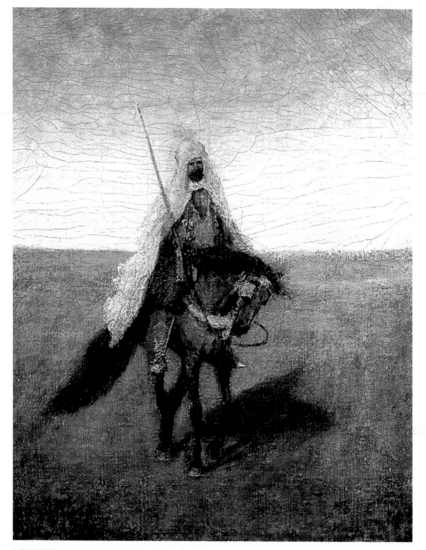

The Lone Scout

(~1880)
oil on canvas
13 x 10 in (30.5 x 23 cm)
Fine Arts Museums of San
Francisco

While Ryder's symbolic vision of the world was often direct and cruel, his work includes fairly orthodox portraits and landscapes that, in certain compositional aspects, follow American traditions of the 19th century.

The artist uses a very classic style of portrait in this painting, where perhaps the most notable feature is his choice of subject matter. This work, surely made during Ryder's preparation for his travels to Africa, presents a dichotomy between the landscape and the figure, which is resolved through the painter's compositional lines. Positioned slightly off-center and tilted somewhat to the left, the rider breaks the balanced monotony of the composition to convey spontaneous movement, as if the painting had been created at the last moment. The imbalance gives the work a casual, instantaneous quality, photographic and very modern.

Similarly, in the spatial distribution of the painting, Ryder develops the painting using curved brushstrokes that hint at imaginary and surreal surroundings, instead of basing the image on complete realism.

Ralph Albert Blakelock

Moonlight, Indian Encampment (detail),
1885-1889, oil on canvas, 27 x 34.2 in (69 x 87 cm),
Smithsonian American Art Museum,
Washington, D.C.

- **1847** Born in New York City, son of a homeopathic physician.
- **1866** After completing his high school education, Blakelock decides to study art in a more informal manner.
- **1868** Makes his exhibition debut at the National Gallery of Design with a landscape called View of White Mountains.
- **1871** Dedicates some time to traveling through Kansas, Colorado, Wyoming, Utah, Nevada, and California. After living in Mexico for a short time, he returns to the United States.
- **1872** Takes his second long trip through the eastern United States, where he discovers one of his great pictorial passions, the life of the Native American tribes.
- **1877** Marries Cora R. Bailey and starts a family; they will eventually have nine children. Begins to go through a period of hardships, mainly economic.
- **1891** Suffers a nervous breakdown and stays in a psychiatric hospital for a short time.
- **1899** Because of his mental problems, Blakelock becomes progressively more eccentric and finally provokes a serious argument with a collector. After this, he is diagnosed with paranoid schizophrenia, and his delicate condition forces him to spend most of the rest of his life in the Middletown (New York) State Hospital for the Insane. His works begin to increase in value, and in 1913 and 1916 two of his works reach record-breaking prices in the American market.
- **1919** Dies in New York.

After rejecting the career in medicine that his father wanted him to pursue, Ralph Albert Blakelock explored the artistic world through very traditional landscapes, where light still had a leading role.

Blakelock was, undoubtedly, the last representative of the Hudson River School landscape style. In his paintings, it is clear that he repeatedly tried to blend this style with more modern formulas that reproduce the effects of the landscape's atmosphere, rather than being limited to a realistic representation. In this way, from the very beginning of his artistic career, Blakelock demonstrated his own original style, dominated by chiaroscuro and the structural simplicity of his paintings.

His view of nature as subjective to the twilight, characterized by picturesque, pastoral sunset landscapes, led him to create scenes full of contrasts. In them, the image of a man always appears to be slightly in relief against the sky, or in some simple piece of architecture. Blakelock's highly personal style caused a tonal and organizational confusion that is similar to the abstract style. The simplicity of his works and the way he played with contrasts made his paintings a prelude to the nonfigurative styles that emerged in the beginning of the 20th century.

Unfortunately, Blakelock's delicate mental health forced him to retire early. At the same time, confusion was created in regard to his works. The paintings fell into the hands of art speculators, who took advantage of the fact that Blakelock's works were mounting in value. Consequently, while the artist was institutionalized, many works of questionable authenticity were attributed to him.

The Artist's Garden

(1879-1889)
oil on canvas
16 x 24 in (40.6 x 61 cm)
National Gallery of Art,
Washington, D.C.

In this image of the artist's garden, Blakelock's vision of the world is clearly revealed. Coming from an artistic background as strict as the Hudson River School, which still preserved the same compositional style used at the beginning of the century, Blakelock modernized this landscape using structural simplification and making color a purer and more direct protagonist.

Here, the artist still relies on a very classical composition in which the landscape is so orderly that one could say it was done with pinpoint accuracy. The organization of this painting, where the garden and building are placed in the foreground, plays with perspectives. The garden has been completely manipulated by human hands. On the second plane, there is a row of trees that divides the image in the same way as the horizon. Behind these trees, the sky appears, an authentically divine and free element.

The artist constantly plays with the brushstrokes, blending blue and yellow hues to contrast with the darkness of the terrain. In this way, he is able to create a contrast in light, as is characteristic of his paintings. However, he goes even further in this painting, arguing that human craftsmanship is clearly antagonistic to the work of God.

At Nature's Mirror

(~1880)
oil on canvas
16.1 x 24 in (40.9 x 61 cm)
Smithsonian American Art
Museum, Washington, D.C.

The traditional view proposed by those painters who concentrated on light, as well as by the Hudson River School painters, was of a landscape in perfect order, with a few animals to lend a picturesque and dynamic character.

In this painting, Ralph Albert Blakelock presents a landscape that completely coincides with these Hudson River School ideas. Using a traditional structure, the artist has placed a small pond extending through the center of the painting and heading into a forest with little foliage, dominated by the yellow light of the sunset.

Landscape with Cows

(~1870)
oil on canvas
Butler Institute of American
Art, Youngstown, Ohio

Blakelock uses uniform hues, allowing him to stray from strictly realistic landscapes and fill his paintbrush with a Romantic view. His passion for sunsets and for the ochre hues commonly used in this type of setting allowed him to achieve a good command of the shades of the color. This work, far from requiring the tedious placement of hues, acquires a meaning of its own thanks to the light that appears to come naturally from each and every element. The artist has placed a herd of cows drinking from the lake on the left side of the painting. The center of the painting acquires a depth that invites the spectator to enter.

Left: Like artists in previous generations of the Hudson River School, Blakelock studied the relationship between the individual and the landscape in his paintings. In this painting, one of the most complex attributed to this artist, the chiaroscuro characteristic of Blakelock's work is still preserved. However, in this case, he uses this technique only to play with light and enrich the background, while the foreground is converted into an allegory of the human relationship with the work of God. The Romantics and post-Romantics were constantly contemplating the presence of human beings in their pictorial portrayals of nature in two very clear ways: There was a trend that portrayed man as an essential part of the work of God, perfectly integrated, and in perfect symbiosis with the natural landscape. Then there was another, more naturalist trend, presenting man as a constant threat to the ideal world conceived by the Creator.

Here, Blakelock wanted to demonstrate that humans are conscious of their roles in the world, as Arcadians in the face of divine creation. In this ideal world proposed by the artist, humans form a small but strong part of the landscape. Their role is to respect it, dominate it, and give it form.

Moonlight

oil on canvas
22 x 27 in (55.9 x 68.6 cm)
Sheldon Memorial
Art Gallery and Sculpture
Garden, University of
Nebraska—Lincoln

Ralph Albert Blakelock can be considered the last Hudson River School painter. His unique painting was the result of blending a landscape style based on the absolute expressive prominence of light with new trends in composition prevalent at the end of the 19th century. This painting, a landscape filled with light and color based on premises of absolute simplicity, is a good example of this type of composition. Superfluous elements are left out as much as possible, to such an extent that light is the only element and reason for the work.

Using an exaggerated chiaroscuro, the artist creates an extremely atmospheric painting filled with densely textured substances and an organic environment, which makes the scene seem very real. Blakelock has created a complex space based on the graphic quality of the work rather than the presence of other objects, which would make the painting harder to interpret. This simplification is one of the most modern features of Blakelock's painting. The artist worked to completely decompose the painting so that the chiaroscuro color contrasts become the sole protagonists and color is converted into the painting's narrative core. In this work, the artist starts with a classic composition and develops a painting that is on the verge of being a very simplified abstraction.

Twilight

(~1898)
oil on canvas
20 x 30 in (50.8 x 76.2 cm)
Butler Institute of American
Art, Youngstown, Ohio

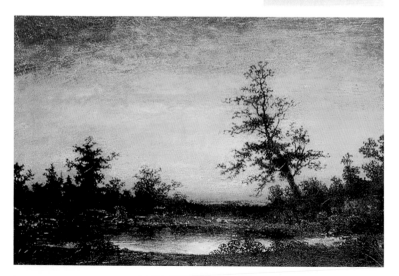

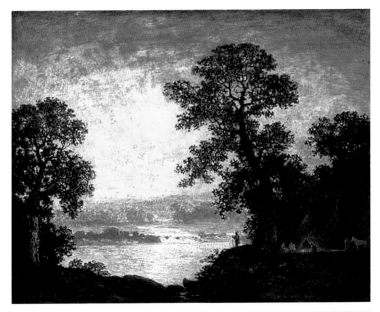

As of 1872, Ralph Albert Blakelock discovered new pictorial themes in the Indian territories of his country. His view of the American Indian is very Romantic: He portrayed free and pure men inhabiting an Eden of monumental landscapes and infinite sunsets. In this painting, the artist presents a sunset contemplated from an Indian camp. Blakelock simplified the composition as much as possible, using his deep chiaroscuro. The landscape appears to be divided against the sky, under the intent stare of a solitary figure.

Moonlight, Indian Encampment

(1885-1889)
oil on canvas
27.1 x 34.2 in (68.8 x 86.8 cm)
Smithsonian American Art Museum, Washington, D.C.

The simplicity of Blakelock's compositions, which were formed by two superimposed planes, was a constant in the works of the painter, who based his pictorial style on the use of contrast. In the foreground, the objects included in the landscape are silhouetted against the light. In the background, however, there is an explosion of color, and the artist creates points of light that extend throughout the entire painting. The figure, perhaps an Indian observing the land, forms the narrative core of the painting. The figure also provides a point of reference that allows the viewer to give order to the illuminated background, where a pond reflects the sunset. The use of a singular chromatic range to paint the lighted lake and sky creates confusion, and so the artist included an element—the lone figure—to direct and organize the space.

Left: Between 1883 and 1893 Ralph Albert Blakelock painted a series of nocturnal scenes in which he used chiaroscuro to compose very picturesque works of pastoral settings. This painting is an example of these landscapes, which the painter filled with light effects based on a Romantic perspective of twilight and its divine meaning. During this period, Blakelock created a number of paintings full of expression and energy from the contrast of colorful light, descending from the sky like a spiritual gift, with the dark and earthy landscape.

Here the artist relied greatly on the effect of the light over the water and the foliage. His meticulous details allow the viewer to follow the light's path through the plants. In the foreground, these plants appear their natural color, but as the eye travels into the painting, the leaves begin to lose their green hues and become submerged in darkness. In the background, there is an explosion of color, and the image is filled with brushstrokes of warm reddish hues. These strokes extend throughout the sky and over the water, so bright that the painting almost appears to be on fire.

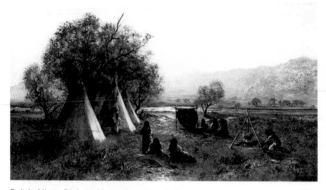

Cheyenne Encampment

(~1873)
oil on canvas
18 x 32 in
(45.7 x 81.3 cm)
Private collection

Ralph Albert Blakelock's landscape style is very individualistic. His art matches his own Romantic character, solitary and melancholic, and through art, Blakelock found a way to express his subjective impressions. As a result, the artist's work shows continuous investigation of technique as well as style. His painting was constantly evolving. Yet his compositional style almost always remained bucolic, with the landscape serving as the protagonist.

In *Cheyenne Encampment,* Blakelock uses only one tone, even for the figures. The freely painted people are completely integrated with nature, in a Romantic atmosphere. If Blakelock's naturalist outlook is too traditional, the panoramic view in this painting, guided by a central axis, is a backdrop to a rich diversity of elements in the foreground. They fill the artistic space, providing dynamism and an interesting perspective. The artist uses the linearity created by the tents and tree to lead the viewer to the painting's interior.

Untitled (Sunset Landscape)

oil on wood
8 x 8 in (20.3 x 20.3 cm)
Sheldon Memorial Art Gallery
and Sculpture Garden, University
of Nebraska—Lincoln

Blakelock is a magnificent example of how art evolved in the United States at the end of the 19th and the beginning of the 20th centuries. The intersection between American landscape traditionalism and the new European trends that emerged from Impressionism can be observed in this work. This mixture of figurative Expressionism and the omnipresent American luminism would give way, years later, to vanguard American realism, the first genuinely American art trend. Here, Blakelock uses the naturalist style that was predominant in America during the 19th century. Very simple rules organize the artistic planes with a candid simplicity that makes the painting easy to view and pleasant to see.

However, this simplicity acquires a completely different character due to the masterful use of tone. Blakelock based this work on a system of complementary contrasts similar to those Georges Seurat proposed in his theories on optic art. Although the chromatic palette is lively and almost aggressive, the artist's deliberate adaptation of the space allows each one of the expressive brushstrokes of the painting to fall into place, creating a homogeneous visual voyage. The artist introduces a compositional rhythm, formulating harmonic combinations that contrast with the primary character of the colors used.

WILLIAM HARNETT

William M. Harnett in Peto's Philadelphia Studio *(detail), 1870, Peto Family Albums, New Jersey.*

William Harnett's still-life painting is an example of the American realist trend of the mid-19th century. His work is characterized by exhaustive detail and great meticulousness in depicting textures.

Diverging from the rest of his still-life colleagues, Harnett rejected the portrayal of fruit and flowers, which were considered more delicate and feminine themes. Nonetheless, he did depict them in his earliest paintings. In general, though, Hartnett's work is masculine, filled with dark colors and objects such as pipes, hunting gear, and guns, all from the world of men.

There is a basic structural system in Harnett's work: In a balanced composition, almost always in a dark palette, several objects hang on a small door with copper or iron hinges. They all allude to a bygone era, characterized by the conquest of the West, the hard life on the frontier, and the Civil War, which still produced nostalgia in the effervescent times of the Gilded Age.

Three periods can be distinguished in Harnett's work: His study of oil painting, between 1874 and 1880, where he arranged objects on a table; his life in Germany between 1880 and 1886; and his New York period until 1892, the year he died. In each period, Hartnett worked toward a greater perfection of his technique. His remarkable realism made him very famous among the American public,

- **1848** Born in Clonakilty, Ireland. His father is a shoemaker and his mother is a seamstress.

- **1849** The family moves to Philadelphia.

- **1858** To help the family, he runs errands and sells newspapers.

- **1865** He is hired as an apprentice in a silver engraving shop.

- **1867** Attends night classes at the Pennsylvania Academy of the Fine Arts.

- **1869** Moves to New York to continue his education.

- **1870** Works as an engraver and attends classes at the Cooper Union and the National Academy of Design. Takes classes for a short time with portrait artist Thomas Jensen.

- **1875** Begins working with oils. Sends a painting to the National Academy of Design. It is not exhibited, but it sells anyway.

- **1876** Returns to Philadelphia to study more at the Pennsylvania Academy, where he meets John Peto.

- **1880** Visits London, Frankfurt, and Munich, where he stays for three years.

- **1881** Sees the work of photographer Adolf Braun in Munich. It depicts several utensils on a vertical board.

- **1882** Sends work to the United States to be exhibited and sold. He is not accepted at Munich's Academy.

- **1886** Returns to New York. The police arrest him and accuse him of forging money. Released without being charged.

- **1887** Goes to Hot Springs because of a liver ailment.

- **1889** Retires to Wiesbaden, Germany, for some time because of his liver ailment.

- **1892** Dies in a hospital in New York.

unaccustomed to seeing illusions.

Most of his work, although it can be seen in museums today, was destined for taverns and restaurants.

The Banker's Table

(1877)
oil on canvas
8 x 12 in (20.7 x 30.8 cm)
Metropolitan Museum of Art,
New York

After working as an apprentice engraver in Philadelphia for many years, William Harnett decided to take up a career in art, even though his work at the time offered him economic stability. The artist began painting still lifes in oils, since it was an inexpensive technique and a style that was easy to sell. Harnett said on one occasion that he had chosen still life simply because he did not have enough money to pay a model; he never imagined that it would become his trademark.

This is one of the artist's first still-life paintings to show several objects on a marble table. It is a banker's small table, judging by the money, the stamped envelope, the pen, and the inkwell, as well as the books. Harnett was one of the first artists to depict money so prominently in still lifes. Far from the tradition created by Severin Roesen or Raphaelle Peale , which alluded to the abundance in America by depicting fruit and flowers, Harnett ironically refers to a new nation characterized by industrial growth and political and financial corruption of which the banks were the main culprits. The artist does not refer to the spirituality of nature here, but to the obsession for material goods and the ambition for wealth that plagued the new bourgeoisie of the Gilded Age.

Memento Mori

(1879)
oil on canvas
24.1 x 32.1 in (61.3 x 81.5 cm)
Cleveland Museum of Art, Ohio

Harnett was intrigued by somewhat crude themes—in this case, he was inspired by Shakespeare, in an acknowledgment of the Romanticism that prevailed in Europe. Hamlet's words about the death of Yorick, the jester, are written on the book's cover. They are the famous verses that the Dutch prince recites when he encounters his favorite jester's skull, buried in the cemetery, which he speaks to as if it were alive and asks for his beloved Ophelia without knowing that she has committed suicide. "To be or not to be, that is the question, whether it is nobler in the mind to suffer the slings and arrows of outrageous fortune." (Hamlet, Act V, Scene I). Here, Harnett is the direct descendant of such baroque still-life artists as Valdés Leal, who presented somber themes on the passing of life.

During this period, Harnett began to codify what would become his trademark: the illusionist style of his depictions, seen in details, such as the open book, that fool the eye. The precision of his drawing was so perfect that, proud of his skill, he drew a regular-size $5 bill of that time, which ended up decorating a New York tavern. The state treasurer confiscated the painting and accused Harnett of forging money. The judge set him free but prohibited him from portraying any legal tender. Harnett never did so again, preferring to collect authentic bills to pay for his longed-for trip to Germany.

Left: Once he had saved up enough money by selling paintings, Harnett set sail to Europe, visiting London, Munich, and Paris. In Munich, he tried to study at the Academy, but he was rejected and had to make do with participating in the rich cultural and artistic life of the city, exhibiting with German painters. His still lifes of objects continued to be on horizontal surfaces, such as the wooden table that appears in this image.

In Munich, Harnett became familiar, perhaps for the first time, with photography, which had begun to catch the public's attention as a novel way to capture reality. Nonetheless, there were also photographers, such as Adolf Braun, who made photography an art. Braun's images consisted of still-life hunting elements and weapons, hung on nails on a wooden board.

Munich Still Life

(1882)
oil on canvas
24.6 x 30.3 in
(62.48 x 76.84 cm)
Dallas Museum of Art

Harnett imported this idea, along with that of photographic hyperrealism, to a country that barely considered photography an amusement park attraction.

In this painting, the brushstroke is imperceptible and the objects' outlines and textures are detailed. The mug's porous surface, the bread, the matches' wood, and the smoker's utensils are only a few examples. To increase the trompe-l'oeil illusion, Harnett painted a folded newspaper, directing the point outward as if it were entering the viewer's space.

After the Hunt

(1885)
oil on canvas
71.5 x 48.5 in
(181.6 x 123.2 cm)
Fine Arts Museums of
San Francisco

This is one of Harnett's most famous works, and, because of its size, one of his most ambitious. It consists of several objects associated with hunting, hanging from a door with iron hinges. A hat, a hunting horn, and a water bottle, among other elements, are accompanied by hanging game.

In speculation about the meaning of the work, it has been pointed out that this door with rusted hinges could symbolize the vicissitudes of life and how one must pay a price to live. From a much more practical perspective, the wooden door allowed Harnett to arrange a clear view of a series of old objects from an era remembered only through nostalgic reminders.

This still life was so successful that the artist made different versions. The public was fascinated by the illusion of reality Harnett created. He was graciously compared to the cardsharps of the Old West who tricked their opponents. Those who attended his successful exhibitions crowded together around each work to be seduced and deceived by its tricks. Critics were less enthusiastic than the general public and always considered Harnett a simple creator of visual illusions. He was never allowed to enter the prestigious circle of artists in the National Academy of Design, although he was able to sell many of his works through it.

Right: It is common to see the same elements used again and again in different compositions in Harnett's work. In this still life, the music for *Hélas, Quelle Douleur*, which was used in *The Old Violin*, appears once again. Here, the artist has assembled several of his favorite objects, including a flute, a pipe, sheet music, an inkwell, a mug, a bronze lamp, and several books. They all refer to his passion for music and reading, or, like the beer stein, to his period in Munich.

This painting proves Harnett's skill in depicting any kind of texture. The smooth surface of the pipe, flute, mug, and bronze, and the rough book covers, can almost be felt. The old, worn sheet of paper is folded toward the viewer, which enhances the perspective. The models are carefully placed and depicted in detail without any noticeable brushstroke. This skill was the result of Harnett's training as an engraver, which required absolute control in drawing and which helped him work in his hyperrealist style.

The Old Violin

(~1886)
oil on canvas
38 x 23.6 in (96.5 x 60 cm)
National Gallery of Art,
Washington, D.C.

The trompe l'oeil effect in this work was so successful that, when it was exhibited, a security guard had to be posted to prevent viewers from trying to touch the the violin—the painting had already been damaged once by a viewer who was convinced the instrument was real.

The center of this work is the violin and a musical score of the operas *La Sonnambula* by Bellini and *Hélas, Quelle Douleur*, both popular for music lessons among the middle classes. The violin, a 1724 Cremona, belonged to Harnett and was one of his most prized possessions. Otherwise, the pieces that appear in Harnett's work are not treasures. They are worn old objects, junk hidden in the deep recesses of a closet, put aside as they are replaced.

The composition is completely vertical and is so balanced that any change would affect its equilibrium. It is like a musical symphony of elements that, in turn, refers to the world of music. Harnett's work is considered to have abstract qualities: To see this, one only has to look at how the tilt of the blue envelope matches that of the music, or how the handle's round shape matches the violin's curves. Likewise, the bow is parallel to the instrument, which is in the center of the composition.

Another element that surprised early viewers was the blue envelope that appears to be stuck on a hinge as if it were just about to fall. It made viewers want to stretch out their hands and take it.

My Gems

(1888)
oil on canvas
18 x 13.8 in (45.7 x 35 cm)
National Gallery of Art,
Washington, D.C.

The Faithful Colt

(1890)
oil on canvas
22.5 x 18.5 in (57.15 x 47 cm)
Wadsworth Athenaeum,
Hartford, Connecticut

The artist depicted a Colt when over 20 years had passed since this gun was in use. The gun's worn ivory handle indicates that it has been very useful to the owner. The wooden surface is green, although the table's joints, chipped by aging, display the result of the passage of time. The rusted nails driven into the wood also show the years. One of the nails holds the old Colt, this composition's sole protagonist, by the trigger. An old newspaper clipping, at the bottom of the painting, complements it. Harnett's taste for hanging objects distances the artist from the influence of Dutch still-life painters. They preferred to place fruit and flowers on a horizontal surface, as did Peale and Roesen.

By this time, Harnett already had an enviable economic position and fame, although his health led him to make constant pilgrimages to European and American spas and hospitals.

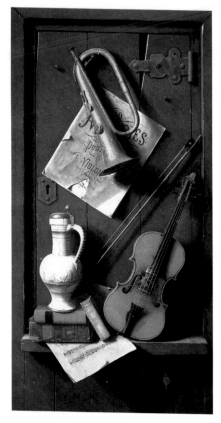

Old Models

(1892)
oil on canvas
54.4 x 28.3 in
(138.1 x 71.8 cm)
Museum of Fine Arts, Boston

This composition, one of the artist's last works, pays homage to the elements that accompanied him throughout his life and inspired his work: his old violin, accompanied by a worn musical score, some books, and a German beer mug. The small, aged door has a shelf where there are several objects, consistent with the artist's balanced style. The usual rusty hinges and lock are also depicted. The musical score's fold invites the viewer to page through the booklet. All the objects display signs of use, of how useful they have been to their owner, who is giving them this last exhibition.

Before Harnett, still life had been limited to fruit and flowers. His appearance on the American scene initiated a period of art for art's sake. His direct successors were the Pop artists such as Andy Warhol and Roy Lichtenstein. His commercial success encouraged other contemporary artists, such as John Peto, to paint still life with objects suspended on a board.

WILLIAM MERRITT CHASE

Self-Portrait: The Artist at the Studio, *1916*,
oil on canvas, 53 x 63 in (134.6 x 160 cm),
Richmond Art Museum, Gift of Warner
M. Leeds and Art Association Purchase.

- **1849** Born in Williamsburg (now Ninevah) on November 1; son of Sarah Swaim Chase and David Hester Chase.

- **1861** The Chase family moves to Indianapolis.

- **1867** Against his father's wishes, Chase begins to study painting with the artist Barton S. Hays.

- **1869** Continues to study art at the National Academy of Design in New York.

- **1871** Moves to St. Louis to become a professional still-life painter.

- **1872** After succeeding professionally in St. Louis, major personalities there decide to support him economically to promote his artistic career. As a result, Chase is able to continue his studies at the Royal Academy in Munich, where he meets Franck Duveneck and John Twachtman.

- **1878** After traveling with Duveneck and Twachtman to Venice following in the footsteps of the great classical painters, he returns to New York where he begins his career as an art teacher at the recently inaugurated Art Students League.

- **1880** After an intense period teaching at several art institutes and associations, he is elected president of the Society of American Artists, which he himself establishes.

- **1886** Marries Alice Gerson.

- **1916** Dies in his house in New York.

William Merritt Chase, the son of a women's shoes salesman, rejected his father's plans for him to go into the shoe business and became a still-life painter at a time when small paintings for modest art collectors was a trend in the United States.

This artist obtained patronage in St. Louis, as a result of his impressively realistic still lifes, created with brilliant effects that perfectly conveyed light reflected on vases and metal objects. This patronage allowed him to travel to Europe, where he discovered Impressionism.

In contrast to the great American Impressionists such as James McNeill Whistler, William Merritt Chase never abandoned his American roots; rather, he imported this style to his own country. Because of this, Chase can be considered one of the major vanguard artists of American painting. He merged the new European perspective, based on very free and atmospheric painting, with the artistic tradition of the United States, which began to discover the importance of everyday simplicity. That is why his work represents an important development in American painting: It proclaims the new realism that would appear at the beginning of the 20th century.

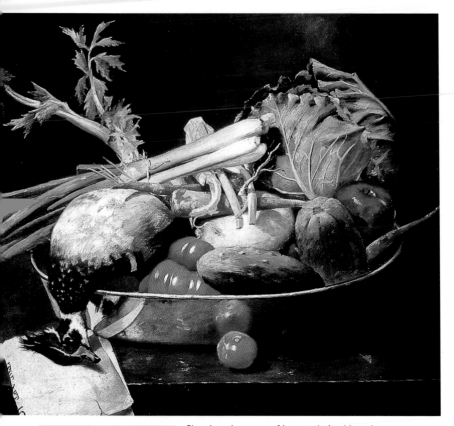

Still Life with Vegetables

(1870)
oil on canvas
20 x 24.3 in (50.8 x 61.6 cm)
Private collection

Chase's main source of income during his early years as an artist came from still-life painting. This type of art, usually in small format, made a comeback in the second half of the 19th century because members of the bourgeoisie wanted to own reasonably priced originals. Nevertheless, still life was considered a lesser art by many serious painters of the time, more fitting for a craftsperson than a real artist.

William Merritt Chase completely renewed still life's classical perspective by creating an atmospheric sensation that takes over the pictorial space. In this painting, the artist worked with common kitchen vegetables to give a modern effect to a classical still life. Breaking away from the traditional chiaroscuro inherited from Dutch still life, he used a wide range of colors. The vegetable tray's layout is also unusual; the elements do not appear to be arranged capriciously. Yet Chase captures an ephemeral moment: The vegetables have been purchased, but they have not yet been cooked.

For this still life, Chase adopted a photographic perspective. He captured the image from an elevated plane where all the elements can be appreciated independently and in a disorganized way. He based the painting's expressive force on small, delicate touches, such as the tomato's reflection on the copper tray in the lower part of the painting.

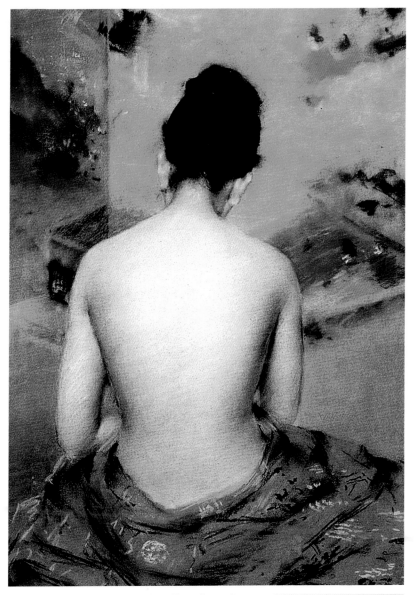

William Merritt Chase and John Singer Sargent's paintings have several things in common that clearly indicate their intention to create a new pictorial style, one that would significantly influence future generations. One was the admiration they had for Ingres's sophisticated eroticism, based on the perfect texture of the skin and the meticulous depiction of light on the nude model. Like Ingres, William Merritt Chase explored the compositional possibilities of the posture and shape of the body. Although it does not have the sophistication of Sargent's *Nude Egyptian Girl*, *Back of a Nude* showcases how Chase based an erotic image on an atmosphere, on decoration and environment, rather than on feminine nudity itself.

The artist has placed the model in the center of the painting, with an ornamented background and great color effect. Light from above falls on the young woman's delicate back, exaggerating her paleness, then glides over her skin toward the cloth covering her lower back. The piece of cloth allows the viewer to observe the perfect curves of the woman's body, and in this insinuation lies much of the image's eroticism.

Back of a Nude

(1888)
oil on canvas
18 x 13 in (45.7 x 33 cm)
Collection of Mr. and Mrs.
Raymond J. Horowitz

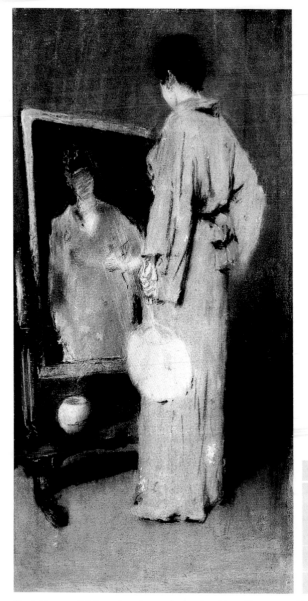

Making Her Toilet

(1889)
pastel on paper mounted
on canvas
19 x 9.6 in
(48.3 x 24.5 cm)
Frank S. Schwartz
and Son, Philadelphia

The influence of Asian art on Impressionism is evident. The compositional approaches of Japanese ukiyo-e were decisive for the new painting that Edgar Degas, Édouard Manet, and Auguste Renoir proposed. This influence was particularly evident in American artists who were seduced by Impressionist painting. Whistler, Mary Cassatt, and John Singer Sargent captured Japanese simplicity in their paintings. They acquired a passion for the detailed color of the floral prints, the extreme volumetric simplicity of outlines defined by delicate drawing lines, or simply the depiction of attitudes and clothing of the Far East.

In this painting, William Merritt Chase displays his particular interpretation of this Japanese influence. Like Whistler, Chase was surprised and seduced by the way of life of the Japanese, which elevated the aesthetic simplicity of art to a whole lifestyle. Thus, the artist portrays a scene in a very simple bathroom, where a woman dressed in a mauve kimono looks at herself in the mirror. In this somber and organized space, the simple human presence is the only colorful element, a striking contrast with the intrinsically lonely setting.

Lilliputian Boats in the Park, Central Park

(1890)
oil on canvas
16 x 24 in (40.6 x 61 cm)
Private collection

The internal organization of pictorial space is one of the most significant characteristics of Chase's work. This painting's pictorial planes have a strict order that creates spaces with very different features: There is an empty space in the foreground, which introduces the viewer into the park. On the right, there is a pond, which is much more lively. This contrast between the vitality of the water and the sobriety of the dirt path can be observed in several of the artist's paintings. It is a good example of how this artist invites the viewer to enter a work. In his paintings, Chase develops an organized route for the viewer by using color and light as the leading elements.

This painting, reminiscent of the work of Sargent, blends the American classicism popular at the end of the 19th century with the expressive tonal softness of French Impressionism. The painting is not dramatic or tense; the image simply spreads out before the viewer as an open and peaceful urban space. Likewise, in the background, the artist created a landscape of soft shapes that extends horizontally without eliminating a view of the sky.

Terrace at the Mall, Central Park

(1890)
oil on panel
11.5 x 16.5 in
(29.2 x 41.9 cm)
Collection of
Richard M. Scaife

During the early 1890s, Chase made several paintings of New York's Central Park—in fact, he practically discovered this space, so important for the 20th-century art world, just as the French discovered the Fontainebleau forests and the gardens around Paris for Impressionist art. Urban life had a special meaning for the Impressionists, especially on weekends, when city dwellers went to natural public spaces to practice the new exercise philosophy that emerged at the end of the century.

In this painting, the artist works with perspective and volume. In a striking composition, Chase has captured an open vista on the right, displaying the earth's soft curves and taking advantage of the landscape's architecture to design a dynamic and lively work. From a high perspective, the artist developed his painting by creating space toward the right and downward, completely unlocking the compositional possibilities. Chase uses a palette of greens blended with complementary colors to achieve better texture and volume.

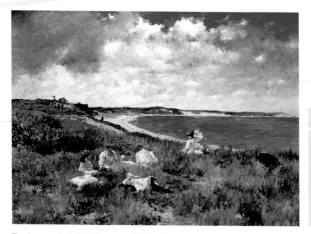

Idle Hours

(1894)
oil on canvas
25.5 x 35.5 in
(64.8 x 90.2 cm)
Amon Carter Museum,
Fort Worth, Texas

The Impressionist landscape painting that arose from the Barbizon School completely rejected monumentalism. Nevertheless, in this painting, the artist depicts a distant view and captures a coastal scene with depth. Without renouncing the foreground's detail, it portrays the distant magnificence of nature.

Chase used a very severe perspective in this painting, converting the curve of the beach to create an impossible view. The contrast between the figures in the middle plane and the vast coast that capriciously extends toward the right of the painting contradicts the Impressionist circle's principles of scale and size. Nonetheless, Chase has painted an impression in which only color and expressiveness are truly important—hence his intensely colored palette. Here, the mixtures appear almost casual, and the tone is the result of natural contrasts that exaggerate the colors of the sky and sea. Although Chase overstates depth in this painting, the work balances itself with the delicate study of beachgoers on a sunny afternoon.

Gondolas Along Venetian Canal

(1913)
oil on panel
8 x 11 in
(20.3 x 27.9 cm)
Private collection

Starting around 1890, Chase adopted his own artistic language, which explored the expressiveness of brushstrokes. This work shows how the realistic figurativeness of the artist's earlier paintings had dissipated, giving way to a much more Impressionistic style and creating a composition based on light distributed throughout the painting.

The artist went beyond Impressionism in this painting and romantically explored a calm expressiveness—far calmer than the Post-Impressionism that was appearing in Europe. Here, Chase exaggerates the Impressionist brushstroke to the point that it is the main attribute of the work. With a long, very fluid brushstroke, he creates dynamic effects that capture the gleaming canal water. The color palette is completely broken down on the canvas. The landscape creates context, but what is really important to the artist is the quality of the brushstroke and the effects that it has on the viewer.

ABBOTT HANDERSON THAYER

Self-Portrait, *1920, oil on paper.*

Descended from one of the oldest and most distinguished Boston families, Abbot Handerson Thayer looms as a unique figure in American art at the end of the 19th century. Although he was highly respected by his contemporaries, the passage of time relegated him, undeservedly, to second rank. He studied in the United States and Paris, and his early output reflects a syncretism that would be translated into an unusual personal style throughout his life.

Thayer's work is considered part of the American Renaissance movement, a school that supported a return to classical and Renaissance art as a response to the incipient technological advances of the Gilded Age. As a result of this approach to the classical canons of beauty, Thayer stood out for producing idealized female portraits. But it was not a simple classical revival that fed the creativity of this painter. A cultured, restless man and a devotee of Ralph Waldo Emerson and Henry David Thoreau, he absorbed American transcendentalism and filled his works with spirituality stemming mainly from the mystical evocation of his winged figures and his exaltation of primitive nature.

After the death of his first wife, who he adored, a somber veil dropped over Thayer's work. From then on, his paintings were more contrasting and introspective, with ominous black backgrounds.

His landscapes reflected a recurring theme: a Romantic vision of Mount Monadnock. The

- **1849** Born into a wealthy family in Boston. Because his father was a doctor, the family, during his childhood, moved first to Keene, New Hampshire, and later to Brooklyn.

- **1875** Marries Kate Bloede, daughter of an intellectual German émigré. In the next ten years, five children are born, three of whom survive beyond childhood.

- **1879** Sets up his studio in New York, where he becomes a popular painter of portraits and traditional landscapes.

- **1887** His wife's health deteriorates. Thayer's work is surrounded by a halo of mysticism. He produces his first winged figure— *Angel.*

- **1891** His wife dies. Shortly afterward he marries the artist Emma Beach, an old friend of the family. They settle in their summer home in Dublin, New Hampshire.

- **1898** Family trip to St. Ives, England.

- **1909** Publishes *Concealing-Coloration in the Animal Kingdom*, with his son Gerald. His theories on animal camouflage in natural surroundings were applied to camouflage used by soldiers during World War I.

- **1917** Produces his work *Monadnock*, a paradigm that interested Thayer because of the expressive force seen in primitive nature. In his final years he becomes a passionate conservationist, establishing programs to protect natural spaces along the East Coast.

- **1921** Dies. His son scatters his ashes on Mount Monadnock.

painter's studio and home were located at the foot of the mountain.

In addition, Thayer explored new painting techniques that made him a precursor of vanguard art: He experimented with ways of applying paint and deliberately left canvases unfinished. He concluded that the key to understanding his art lay in the creative process, a vision rediscovered in the ideas of Abstract Expressionism in the 1950s.

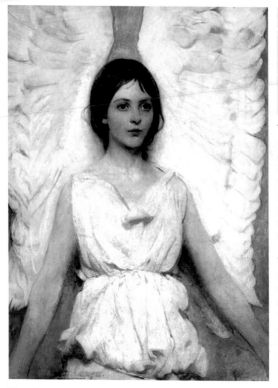

Angel

(~1889)
oil on canvas
36.2 x 28.1 in (92 x 71.5 cm)
Smithsonian American Art
Museum, Washington, D.C.

This luminous and enigmatic portrait shows the painter's daughter Mary, age 11. The beautiful figure becomes ethereal through the brilliant use of light. The angel is not illuminated by exterior light; rather, she herself seems to be the source of light.

This is the first winged figure Thayer ever painted. He may have been inspired by the mysticism that infused his thoughts and work after the illness of his first wife, Kate. The daughter of a German intellectual, she had brought the painter close to German culture and the spiritualism and idealism of German philosophy. This was allied to Thayer's own transcendental thinking, absorbed from Emerson and Thoreau. The mysticism that is seen in the painter's winged figures is a reflection of how he took refuge in idealistic philosophies to numb the pain of watching his wife's illness. Although Thayer never wanted to explain the meaning of his work, he did say that the wings of his figures served to remove the trivialities of the earthly world, that is, to help viewers escape from reality and seek refuge in idealism. After 1887, angels would become a constant feature in Thayer's works. In the last years of his life, he painted them as protective beings flying across the natural landscapes that he wished to preserve.

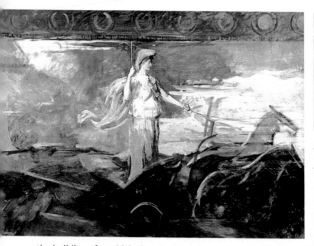

Minerva in a Chariot

(1894)
oil on canvas
38.1 x 53.7 in
(96.7 x 136.4 cm)
Smithsonian American Art
Museum, Washington, D.C.

As a star of the American Renaissance movement, Thayer received many commissions for paintings with classical themes to grace various public buildings. These Roman mythology paintings added prestige to the buildings for which they were destined. Between 1894 and 1895, the painter was commissioned to do a number of different murals. The only one he finished was *Florence Protecting the Arts*, for Bowdoin College in Maine. For this commission, intended for the Boston Public Library, and for a commission for the Library of Congress, the painter proposed to do representations of the goddess Minerva, the personification of the arts and of wisdom. Although he did not complete these murals, studies like this one show his intentions.

Virgin Enthroned

(1891)
oil on canvas
72.5 x 52.4 in
(184.3 x 133.2 cm)
Smithsonian American Art
Museum, Washington, D.C.

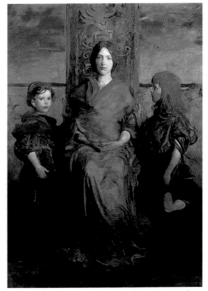

Painted after the death of his wife, this panel features the painter's daughter Mary. She was also the protagonist of *Angel*, which he had painted four years earlier. Here Mary appears as a Madonna, keeping watch over her younger brothers. The repeated comparison of the artist's elder daughter to sacred figures implies that the painter took purity as an ideal within the parameters of his idealistic thinking.

Thayer was a very devoted husband and father. This painting is a deeply felt tribute to his children, a homage to Renaissance paintings of the Virgin Mary flanked by saints. But it must also be understood as a celebration of his deceased wife. Certainly he alludes to her by showing his children against a twilight horizon, a reference to their loss of maternal protection. As in *Angel*, here, too, the light seems to emerge from the face of Mary, and then extend uniformly from there. The three figures, shaped like sculptures, complete a balanced triangular composition.

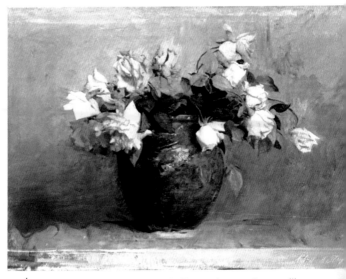

Roses

(1896)
oil on canvas
22.3 x 31.4 in
(56.6 x 79.7 cm)
Smithsonian
American Art
Museum,
Washington, D.C.

His stay as a student at the École des Beaux-Arts in Paris brought Thayer closer to the prevailing Impressionist aesthetic of the day. When he returned to the United States, he re-created Impressionist art in his still lifes. Of the few still lifes by this painter that have survived, *Roses* is probably the best known. These works, which try to capture the improvisation and inspiration of a specific moment in time, were done quickly, with fluid strokes, a technique very different from Thayer's painstaking works of idealized beauty, which often took years to complete. Thayer used this fast technique to draw flowers, sometimes in a bowl, sometimes as a table centerpiece.

The diffused light creates a palette of very subtle colors here. Against a neutral background of pastel tones, the petals of a very light rose stand out as the true protagonist of the painting. Flowers, with their ephemeral beauty, are an allegory of the transitory nature of the moment, a key concept in the Impressionist aesthetic.

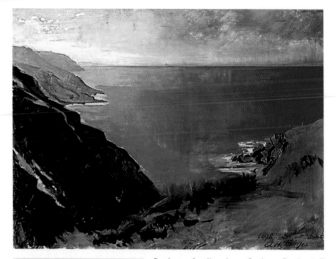

Cornish Headlands

(1898)
oil on canvas
30.4 x 40.1 in
(76.5 x 101.8 cm)
Smithsonian American Art
Museum, Washington, D.C.

During a family trip to St. Ives, England, Thayer painted this picture. Unlike his laborious idealized representations, which could take years to complete, the painter finished this landscape of the Cornish coast in a matter of hours.

Paradoxically, Thayer described it as his favorite work because "there was no Abbott Thayer in it." Perhaps because it was done, very spontaneously, during a family vacation, this panel conveys a serenity difficult to reconcile with the artist's daily life in Dublin, New Hampshire. Despite the painter's remarks, it is difficult to conceive of a work that does not reflect the imprint of its creator. And surely it is in *Cornish Headlands* that Thayer is closest to the landscape of his picturesque romantic soul.

The artist showed the Cornish coast in all its sharply pitched reality. There are no signs of civilization, and the viewer enters a timeless void; the calm sea conveys an echo of deafening silence. Cold colors reflect a weak, dying light that wanes on the landscape's horizon, intimating the harsher personality of the painter in the final decades of his life.

Right: In his youth, Thayer's artistic sensibility was sparked by a passion for nature drawings, particularly animals. The landscapes of his native New England would become a constant in his work. When, after the death of his first wife, Thayer made his home in their former summer house in Dublin, New Hampshire, his innate passion for nature was emphasized in his new rural life. The Thayer family lived in harmony with their surroundings, adopting wild animals from the forest as if they were domestic pets. Fleeing from social conventions, the painter became hardened and eccentric, spending much of his time studying nature. His exhaustive observation of New Hampshire flora and fauna, along with his academic acquaintance with color, led him to develop theories about animal camouflage used as protection against predators. These theories were published in *Concealing-Coloration in the Animal Kingdom* (1909). Thayer noted that animal markings on zebras or giraffes imitated the landscape of their natural habitats, giving them camouflage. When the book was published, it provoked a storm of criticism, especially from President Theodore Roosevelt, an amateur naturalist and friend of the painter. Nevertheless, Thayer's camouflage theories were adopted to protect soldiers and airmen during World War I.

Copperhead Snake on Dead Leaves

(1903)
collaboration with Rockwell Kent, Gerald H. Thayer, and Emma Beach Thayer, water painting
9.6 x 15.6 in (24.3 x 39.7 cm)
Smithsonian American Art Museum, Washington, D.C.

With paintings such as *Copperhead Snake on Dead Leaves*, the painter exemplified his reasoning brilliantly, fusing background and form in a direct imitation of nature. This painting shows the collaboration of members of the painter's family , the husband and his niece (Rockwell Kent, Gerald H. Thayer, and Emma Beach Thayer). Produced after a meticulous study of reality and designed to prove Thayer's camouflage theories, it is a skillful game where the viewer is invited to discover, among the leaves, the camouflaged figure of the serpent.

Stevenson Memorial

(1903)
oil on canvas
81.5 x 60.1 in
(207.2 x 152.6 cm)
Smithsonian American Art
Museum, Washington, D.C.

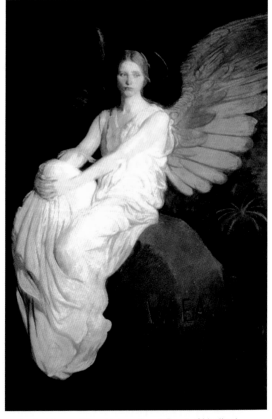

Abbott Thayer was an outstanding figure in the social and cultural life of the United States. He kept up a prolific correspondence with important figures like Samuel Clemens (Mark Twain) and President Theodore Roosevelt. At home in New Hampshire, he entertained artists like Cecilia Beaux and Rockwell Kent. But his intellectual restlessness transcended the borders of his own country. He was a great admirer of the Scottish writer Robert Louis Stevenson (1850-1894), author of *Treasure Island* and many other works. In 1903, Thayer completed this painting, after previously finishing different works in honor of the author.

This is one of Thayer's more complex works. It is composed along classical lines with a shining winged figure of idealized beauty, dressed in white. The angel appears against a black background, suggesting angelical goodness opposing the forces of evil and death. These were recurring themes in Stevenson's writings. The author's name and coat of arms were, at first, shown in the foreground, but Thayer later replaced them with the word VAEA, a reference to the mountain in Samoa where the writer is buried. The angel, seated on a rock, frames the distant grave. The image is sensual, attractive, and graceful; despite its simplicity, it conveys spirituality. This work was one of Thayer's most celebrated, both by the public and the critics, and was exhibited in the most prominent museums of the country.

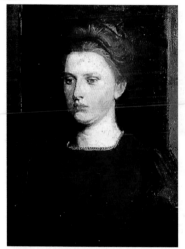

Meditation

(1903)
oil on canvas
24 x 19 in (61 x 48.3 cm)
Butler Institute of American
Art, Youngstown, Ohio

Abbott Thayer's academic training dates from his studies at the Brooklyn Academy of Design and his years at the École des Beaux-Arts, Paris. In the French capital, where he and his first wife moved shortly after their marriage, he learned about the classical ideals of Renaissance beauty, under the guidance of Jean-Léon Gérome.

When he returned to the United States in 1879, Thayer established himself in New York, where he launched a successful career as a painter of idealized portraits for high society; among his models were the Stillman sisters, daughters of banker and art collector James Stillman. Thayer created splendid figures of idealized beauty. However, the composition of his paintings from this era suggests something beyond pure, classically handsome perfection. Little by little, Thayer moved away from the frivolous nature of his early pictures, designed to please ostentatious patrons. His work became rich in shades, and he began to introduce disquieting elements that draw the viewer closer to the psychology of the person. In the 1890s, using a visual language derived from John Singleton Copley, Thayer made portraits of young women dressed in strongly illuminated colors contrasting with sinister, dark backgrounds.

This trend toward introspective portraits is also clearly seen in the painter's self-portraits. In his youth, Thayer clearly judged himself as a worthy and magnificent person. After the death of his wife and his move to the country, his self-portraits show him becoming ruder and more sullen. An excellent example of Thayer's evolution toward introspective portraiture is *Meditation*, where he eliminates any allegorical meaning to focus on the reality of the figure. Bessie Price, his favorite model, is shown in a rigid pose, with a severe expression. Her somber expression is emphasized by a dark palette and russet tones. This portrait of a graceful woman, in Thayer's own words, was designed to evoke an image of the human being's moral integrity.

Mount Monadnock

(1917)
oil on wood
48.4 x 60.6 in (123 x 153.8 cm)
Jordan Fine Arts

Mount Monadnock, the mountain standing in front of the Thayer home, was a permanent focal point for the painter's militant defense of nature. Mount Monadnock had impressed Emerson and Thoreau, who in their writings had focused on the transcendental impact of this majestic mountain. In the final years of his life, the painter tried to capture the sublime vision of nature at different times of the year. He painted the mountain in each season of the year, like a faithful reflection of his own moods.

His first landscapes were traditional and colorful, lacking in metaphor. In the new century, Thayer enriched his work with more agile techniques. Starting with a thin brushstroke, he sought to create an illusion of great distances in his paintings. His final landscapes, centered on Mount Monadnock, are imbued with the idealistic philosophy that influenced him. Re-creating nature drew out his inner nature. Of all his views of the imposing mountain, this one of the sun setting in winter and lighting up the snow-covered peak was one of his favorites. Perhaps the painter found in this majestic twilight vision the perfect representation of his most vital moment.

THOMAS ANSHUTZ

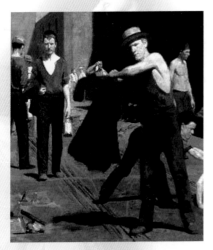

The Ironworkers' Noontime (detail), 1880,
17 x 28.9 in (43.2 x 60.6 cm). Fine Arts
Museums of San Francisco.

Thomas Anshutz's work may be considered a continuation of the realist line of American painting inaugurated by Thomas Eakins, but also a bridge between this realism and the later anti-academic style.

A professor at the Pennsylvania Academy of the Fine Arts, Anshutz's production was oriented toward landscapes, portraits, and figurative subject matter, where his ample knowledge of human anatomy can be seen. Although his best-known work was created with oil, he was also highly skilled with watercolors.

Anshutz's work displays differences in his brushstrokes depending on the technique. While there is more detail in his oil paintings, his brush-strokes are looser and he takes more care with the light in watercolors. However, in all his work a great concern for shape and volume, over drawing and contours, is obvious. His sensation of depth and three dimensions is masterful. While his portraits display psychological depth, the land-scapes convey serenity, even sentimentalism.

After a first formative stage at the National Academy of Design, which he abandoned after three years of studies, he registered to study at the Pennsylvania Academy of the Fine Arts, where Thomas Eakins taught him. Eakins greatly appre-ciated Anshutz's talent, and Anshutz became his personal assistant in his dissection class, increas-ingly trusted and valued by Eakins. When Eakins was forced to resign, Anshutz took his position.

While he was an official professor, Anshutz traveled to Europe, where he remained for a year

- **1851** Thomas Pollock Anshutz born on October 5 in Newport, Kentucky, son of Jacon Anshutz and Abigail Jane Pollock.
- **1873** Encouraged by one of his uncles, who works for the *Brooklyn Gazette*, goes to New York to study at the National Academy of Design, where he takes classes with Lemuel Wilmarth.
- **1875** Leaves the National Academy of Design because he considers it antiquated.
- **1876** Enters the Pennsylvania Academy of the Fine Arts.
- **1877** Studies anatomy with Thomas Eakins, who uses dissection of cadavers as a teaching method. Becomes Eakins's main assistant.
- **1879** Starts using photography as the base of his compositions.
- **1880** Creates his work *The Ironworkers' Noontime*.
- **1881** Becomes professor of anatomical drawing at the Pennsylvania Academy.
- **1882** Finishes his notebook of graphite sketches.
- **1886** After Eakins's forced resignation, becomes official painting professor. They never speak to each other again.
- **1887** Gives classes to Robert Henri.
- **1892** Travels to Paris to study at the Académie Julian. Works with French academic artists such as William-Adolphe Bouguereau.
- **1893** Returns to the United States.
- **1894** Joins the Philadelphia Sketch Club, created by several painters to meet the educa-tional needs of the Academy.
- **1900** Founds the Philadelphia Watercolor Club with other artists.
- **1909** Appointed director of the Pennsylvania Academy of the Fine Arts. Receives the gold medal. Starts a series of por-traits of academics for the Sketch Club library.
- **1910** National Academy of Design names him an academic. Travels to Bermuda. Becomes president of the Philadelphia Sketch Club.
- **1912** Dies on June 16 in Fort Washington, Philadelphia.

to reinforce his academic work. He was also inter-ested in modern painting, which was unusual among realist painters. His generosity, tolerance, and ease in sharing his knowledge made him very popular among his students, including Robert Henri (the founder of the Ashcan School), Charles Demuth (a precisionist), and Edward Redfield (an Impressionist).

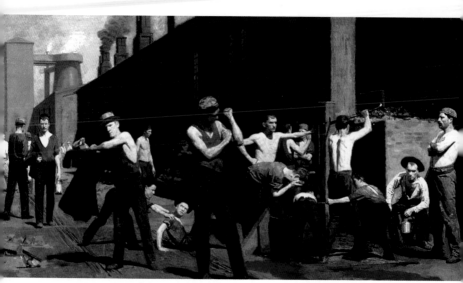

The Ironworkers' Noontime

(1880)
oil on canvas
17 x 23.9 in (43.2 x 60.6 cm)
Fine Arts Museums
of San Francisco

This painting shows metalworkers outside their factory (in fact, it was a real nail factory in Wheeling, West Virginia) at lunchtime. This painting was an authentic anatomical exercise, with men of all ages, from boys to adults, figuring in the work, some with naked torsos. Like Eakins, the painter used photographs and studies to help him compose this work, which he later set in an industrial environment. Some of the figures even contain classical references, like the man rubbing his arm in the foreground, whose pose is identical to a character from the Parthenon. The colors used are somber, reproducing the gray and rust tones of iron and smoke. Even the combined postures of the men seem to fit together like the machinery they operate in the factory. However, Anschutz does not show the workers as social victims—as was common in Romanticism—but simply as professional ironworkers resting after a long, hard morning. The energy of the emerging America was embodied in the realism of their vigorous bodies. Their light-colored torsos rise out of the dark surface, demanding their space on the canvas. This work was a novelty; no one had ever shown a group of workers so directly before, especially because the subject matter was not pleasing to the wealthy. Ironically, this work was acquired by the grandson of one of the greatest anti-union industrialists, John Rockefeller III, who later donated it to the museum.

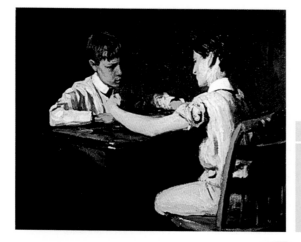

Checker Players

(~1895)
oil on canvas
16.1 x 20.1 in (40.8 x 51 cm)
Smithsonian American Art
Museum, Washington, D.C.

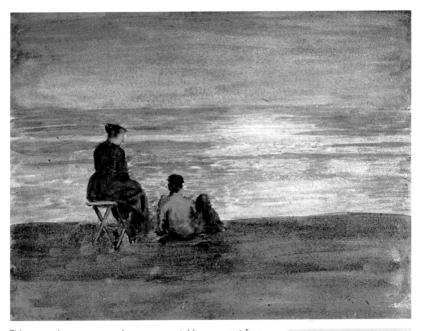

This scene shows a man and a woman watching a sunset from the beach. Both are dressed in street clothes, and the woman is seated on a small stool, while the man nearly reclines on the sand. When working with oil paints, Anshutz took pains to achieve volume and define perspective above all else; his watercolors, on the other hand, highlight sentimentality and introspection. A relationship, perhaps love, is hinted at between the two figures as they share the luminous sunset. It is a bucolic subject that is very characteristic of the painter's personality—yet his work was associated strongly with industrial settings, even though he only painted one piece featuring that subject.

Man and Woman on the Beach

(~1890)
watercolor on paper
10 x 13 in (25.4 x 33 cm)
Fine Arts Museums of
San Francisco

In this beach scene, the horizon, with its light from the sun, must have been a challenge for the painter. To capture the effect, he uses a series of blue tones mixed with yellows and the white paper to represent sky and sea, while darker colors are reserved for the woman's backlit clothing and the sand.

This search for serenity in his work could have been a product of the rupture of the artist's friendship with Eakins. Eakins's educational methods, including using naked male models in his exclusively female anatomy and drawing classes, caused a great scandal. After the academy director was flooded with letters from outraged parents, they forced him to resign and offered his position to one of his collaborators, Thomas Anshutz. After this event, Eakins never uttered another word to Anshutz.

Left: We can glimpse Anshutz's tenderness through his images of children, although these works are also always academic exercises. This work depicts two children playing checkers on a varnished wood table. Its brilliant shine and texture have been represented by capturing the effects of light on the surface. Without doubt, the painter was a great observer. There is a relationship between the two children, and one glances furtively at the other, as if impatiently awaiting his next move. Anshutz's difference from Eakins is made clear here, because he imbues his scenes with affection and sweetness, even while seeking realism above all else. While it would never have occurred to Eakins to portray children, Anshutz shows them in a large portion of his work. In comparing the styles of the two artists, it is important to note that Eakins's work often represents the absence or suspension of time; Anshutz's work, in contrast, is filled with life. This is indicative of their personalities: Eakins seriously concentrated on work that would never be recognized, and Anshutz happily developed his artistic vocation and teaching, well aware of the restrictive walls that society had placed around him, and of how best to free himself from those restrictions.

Pennsylvania Scene

(~1893)
watercolor on paper
12.8 x 8.7 in (32.5 x 22.2 cm)
Fine Arts Museums of
San Francisco

For Anshutz, watercolor was mostly a way to create rapid studies of different landscapes, but he sometimes included urban elements, such as this house in Pennsylvania. The painter has perfectly represented the sizes of the elements in the composition. The perspective is enhanced by an angular composition that directs the viewer's eye toward one of the corners of the house. Several different perspectives can be seen in this small piece: linear, created by the lines of the road moving toward the viewer; geometrical, giving the house a three-dimensional appearance through the trick of viewing a cube from one of its edges; and finally, depth from chiaroscuro, coming from the shadows of the house and the trees on the road. Anshutz's preoccupation with volume reaches a unique solution in the treetops; he depicts them with almost gestural brushstrokes.

Perhaps this is indicative of the tolerance with which Anshutz accepted the different styles of his students. Among them, John Sloan, William Glackens, and Robert Henri deserve mention; all became members of the Ashcan School, characterized by great freedom of their brushstrokes. During the years he was a professor of anatomical drawing, Anshutz used teaching methods similar to Eakins, without ever reaching, of course, the extreme nature of his mentor. Always remaining somewhat in the background, he became a painter of renown in Pennsylvania, though he dedicated his efforts to academic pursuits. His merits were later recognized when he was awarded the gold medal of the Pennsylvania Academy, an honor that John Singer Sargent and William Merritt Chase also received.

Right: Anshutz went to Paris to finish his studies at the Académie Julian, as well as to see the works of the great masters housed at the Louvre. It is possible that he had the opportunity to admire the works of Paul Cézanne, whose interest in volumes would most definitely have surprised and pleased him. In this watercolor, it is easy to imagine the square houses of the French painter. It looks like the view from a window, perhaps a studio rented by the painter in a small village. There is a series of walls, chimneys, and rooftops, and, in the background, a tall and narrow shape that could be part of a church.

Despite his obvious focus on composition, in this work Anshutz managed to represent the textures of the different objects. For example, the chimney in the foreground and the smoothness of its orange-colored tiles contrast with the roughness of the cement, black from smoke. Branches with abundant green leaves caress its sides, leading us to deduce that it is summer. At the bottom, the painter has represented the mass of bushes on the patio with a mixture of freely applied black and green tones. In contrast, as the viewer's gaze jumps from roof to roof toward the background, the figures turn into more geometrical cubes and other forms, each shape barely defined with a splash of color. It is possible that the painter experimented with Cézanne's style during his stay in France, which would explain his respect for his students' personal styles at the Pennsylvania Academy.

This watercolor reflects another of Anshutz's great themes: *plein-air* landscapes. Under a cloudy sky, a cargo boat and a rowboat rest on the shore next to a granary. The cargo boat, designed to navigate rivers and salt marshes, holds enormous bales of hay tied and ready to be transported. At its side, creating a strong contrast in size, a small boat awaits the arrival of its owner, rocking to the rhythm of the weak current.

Boats by the Shore

(~1894)
watercolor on paper
13.8 x 20.3 in
(34.93 x 51.44 cm)
Adelson Galleries,
New York

Again, academic elements are combined with details emphasizing the artistic freedom of the painter. Anshutz takes obvious pleasure in representing the volume of the objects, in both the boats and the granary, and the use of a soft brushstroke to represent the sky and the vegetation. The granary is similar to the objects in Cézanne's work, because of its geometrization, while the boats have more curved lines.

Note how Anshutz draws the viewer's eye toward the larger boat through the elongated bow and the light falling on the end. Anshutz's freedom of expression is evident in the way he portrays the vegetation at the shore, both by adding more water to the color and his ease with the brush. His mastery in capturing light and using it to define sizes and shapes are another important aspect of his work. With soft touches of color, the subdued tones of twilight caress the figures so that, without needing exact outlines, he conveys the magnitude of the objects in the foreground.

Rooftops, Saint Cloud

watercolor and
pen on paper
10.1 x 7.6 in (25.6 x 19.2 cm)
National Gallery of Art,
Washington, D.C.

A Rose

(1907)
oil on canvas
58 x 43.9 in (147.3 x 111.4 cm)
Metropolitan Museum of Art,
New York

The same realism reflected in the rest of his work governed Anshutz when he did portraits. These are characterized by the artist's ability to transmit, in a glance, the personality of the subject without omitting aspects that could be deemed negative or unpleasant—such as the woman's arrogance, in this case. However, Anshutz makes these characteristics attractive, changing the person into a mosaic of adjectives that, taken together, define his subject.

Here, the title alludes to both the color red and to the model, indicating a woman both daring and willing. On the other hand, her distracted stare makes her seem arrogant and proud. The relaxed posture could point to a bourgeois woman who is obliging and complacent—a woman who everyone wants to be with, despite feeling uncomfortable with her distracted and haughty attitude. Like the objects in Anshutz's work, the figure comes out of the work toward the viewer, who has no option but to appreciate her lifelike sense of dimension. With the color, the painter creates a tonal symphony, starting with the dress and the rose on the table, repeated in the mahogany chair and the carpet.

View of Bermuda, South Shore

(1910)
oil on wood
7.5 x 9.5 in
(19.05 x 24.13 cm)
Private collection

In his last period, it is as if the artist had finally shed himself of all academic habits and dedicated himself, at the pinnacle of his career at the Academy, to painting with total freedom. The color is freely spread upon the canvas, without any attention being paid to the outlines (he had never cared for them, and this painting offers an idea of his openness toward the future).

This work shows a beach on the island of Bermuda, a paradise where the painter had withdrawn to paint *plein air*. Anshutz was doubtless inspired by the sun-drenched beaches, lapped by profoundly blue waters. The painter had just received two great artistic honors in the United States: the gold medal from the Pennsylvania Academy and his appointment as academician at the National Academy of Design in New York, an entity that certainly must have criticized his interest in French forms and lines.

THOMAS DEWING

The Musician *(detail)*, ~1910, oil on canvas,
24.2 x 18.1 in (61.5 x 46 cm), Musée d'Orsay, Paris.

Thomas Dewing's painting represents the arrival and acceptance of European artistic values, adapted to American tastes. His paintings of languid and ethereal women, adorned with Greek and Roman dresses, are an example of the refinement and academic taste prevailing in the United States under the influence of the National Academy of Design in New York, which, borrowing from the classical European aesthetic, sought new styles and encouraged young painters to direct their creativity in this direction.

The increasing wealth of the American bourgeoisie, and the fact that the United States was a new and progressive country, encouraged it to look to Europe and, above all, to the Italian Renaissance for a cultural base, a complement to the flourishing economy. This period was to come to an end with the United States intervention in World War I.

Dewing's work on canvas and his decorative art were directed at high society. In fact, his main patron was the millionaire Charles Lang Freer. Freer's collection forms the basis of one section of the National Gallery of Art in Washington and the Freer Gallery in Detroit. Dewing's intentionally decorative paintings were inspired by Venetian artists of the Renaissance—Titian or Paolo Veronese—whose works the painter had admired on his trips to Europe. Whistler's influence can also be seen in the artist's tendency toward abstract, clear green and blue tonal exercises, and his work also reflects the aesthetics of the Pre-Raphaelites and their dreamlike depictions of women.

- **1851** Thomas Wilmer Dewing is born on May 4 in Newton Lower Falls, Massachusetts.
- **1872** Begins his career as a lithographer.
- **1873** Studies painting at the Museum of Fine Arts in Boston.
- **1874** Finds work in Albany, New York.
- **1875** Goes to Paris, where he studies anatomical drawing and volume with William Merritt Chase.
- **1879** On his return to Boston, he takes up a lecturing post at the Art School of the Museum of Fine Arts. He begins to exhibit in the city.
- **1880** Sets up his studio on 57th Street in New York and is elected a member of the American Artists Society. Takes up a post as professor with the Art Students League. He marries artist Maria Oakey, who introduces him to the world of artists and patrons of the elite.
- **1884** Visits the artist's colony in New Hampshire. Works with architect Stanford White on a decorative mural for railroad tycoon Robert Garret.
- **1885** Moves to the Washington Circle Studio Building in New York while mounting numerous exhibitions of his work. Wins the National Academy of Design's Clark Prize for his work *The Days*.
- **1886** New Jersey banker Edward Adams buys one of the artist's works, thanks to the recommendation of Dewing's patron, Stanford White.
- **1887** Starts to paint decorative and monochromatic portraits of women—whom he considers a lower order—and landscapes of hazelike mists.
- **1890** Meets Charles Lang Freer, a Detroit millionaire who becomes his most important patron.
- **1895** Acquires a studio in Paris, but, affected by many ailments, soon returns to New York.
- **1896** Organizes, along with other painters, the Ten American Painters, which counts among its members Impressionists who have nothing to do with his style. Resigns from the Society of American Artists.
- **1897** Stages a retrospective of his work in Boston. The Ten's first exhibition takes place in New York.
- **1922** Works exclusively in pastels.
- **1923** The Freer Gallery of Art opens in Washington, D.C., with one room entirely dedicated to Dewing.
- **1924** Suffers a nervous breakdown.
- **1930** Stops painting.
- **1938** Dies in New York on November 5.

The Spinner

(~1878)
oil on canvas
42 x 54 in (106.7 x 137.2 cm)
Brigham Young University
Museum of Fine Arts, Provo, Utah

This painting shows the talent for drawing and modeling that Dewing harnessed at the Académie Julian in Paris. The profile of the figure is perfectly delineated and defined, far removed from the exercises in tonality seen in Dewing's later work. Painted shortly after he returned to Boston, this decorative study was, according to the painter in a label he wrote on the back, done for a Boston publisher obsessed with traditional values. The protagonist in Dewing's work is a beautiful, delicate woman; she does not work, nor does she actually spin—she is not paying the spinning wheel the slightest attention. The use of the spinning wheel is no whim; it stems from the American interest in colonial culture, heightened by the recent Philadelphia Centennial Exposition. At the end of the century, spinning was not a daily task for the women of Boston, who, on the whole, were very emancipated and working at many jobs. In his eagerness to divorce himself from reality, Dewing turned his gaze back to the days when women knew their place in the home, and, in doing so, he produced a picture that coincided perfectly with the tastes of the publisher who had ordered the work. The viewer does not get a feeling of being confronted by a spinner, but rather of standing before a cautious, refined woman surrounded by colonial references and posing for a painting.

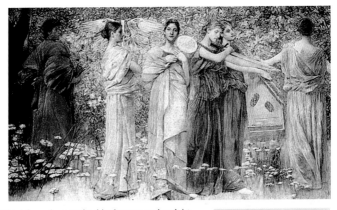

During America's Gilded Age, characterized by its economic might, society imitated European culture and favored classical art in the style of the Italian Renaissance. Local millionaires joined in this spirit and, like the Sforza in Milan or the Medici in Florence, they encouraged art inspired by Renaissance classicism, as adapted to American tastes.

This included the removal of the female nude from the repertoire; the dominant American puritan moral code disapproved of it. For this reason, Dewing's female protagonists, despite the perfection, elegance, and beauty of their classical anatomy, are coyly covered in clothing of the kind seen on Greek or Roman sculptures. However, they retain some eroticism by showing the viewer the smooth white skin on the nape of their neck and shoulders.

This painting, inspired by a poem of the same name by Ralph Waldo Emerson—who had died four years earlier—was made by Dewing and his wife, the painter Maria Richards Oakey, in Dewing's studio. The two began to make joint efforts often, just as Renaissance artists had done. While Dewing drew figures in line with academic tastes and his personal vision of ideal feminine beauty, Oakey painted the flowers and surrounding ornaments.

The predominantly horizontal composition reflects the special care used in the drawing and this study of smooth tonalities, diffused in a dreamlike atmosphere. All of this, along with the relaxed attitude of the figures and their musical instruments, conveys a feeling of peace and distance, encouraging the viewer to see the world of the muses. Thanks to this painting, which so perfectly reflects academic ideals, Dewing won the Clark Prize, presented annually by the National Academy of Design in New York. This opened the door to his artistic career.

The Days

(1886)
oil on canvas
43.2 x 72 in
(109.7 x 182.9 cm)
Wadsworth Atheneum,
Hartford, Connecticut

Left: From 1885 on, Dewing and his wife spent their summers at their Cornish, New Hampshire, residence to escape the city's suffocating heat. Dewing, who never stopped working over the summer, found the atmosphere of the artist's colony there very stimulating. It was surely here that he developed the mistlike atmosphere that characterizes his works of that period—a smoothness in depicting nature that almost suffuses the viewer in a sleepy atmosphere. All the landscape elements are fused in greenish tones, and it is almost impossible to recognize where background begins and figures end. The pastel sky presages afternoon.

These landscapes, populated by nonmaterial, ethereal feminine figures, were sought after by the artist's wealthy patrons. Green and pastel tones are mingled by the eye of the viewer, who notices the girls walking in a garden thanks only to the color of their dresses. Their faces, treated blurrily, cannot be recognized, but the figures can be seen, diluted as they are, against the hazy, poetic landscape of mistlike shrubs, grass, and trees. Because of the emphasis on the mist, these works have often been compared with those of the Impressionists. A very shallow background is again evident and, together with the monochrome palette, clearly reflects the influence of Whistler. The whole composition speaks to the purely decorative nature of the work. In this year, Dewing became acquainted with the millionaire Freer, who was to become his main patron.

Summer

(~1890)
oil on canvas
42 x 54.3 in (107 x 137.8 cm)
Smithsonian American Art
Museum, Washington, D.C.

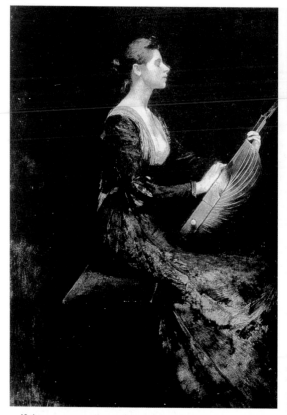

Lady with a Lute

(1886)
oil on wood
20 x 15.7 in (50.8 x 40 cm)
National Gallery of Art,
Washington, D.C.

The feminine world of Dewing's paintings contrasts sharply with the day-to-day reality of American women at the turn of the century. Since the tragedies of the Civil War, women had been active in public life. In Boston, the census showed there were 75,000 more women than men, and they were, on the whole, independent and socially active.

In contrast, the women whom Dewing displays are representations of a feminine ideal of beauty, languid, ethereal, full of elegance and refinement. Most of his women are also distant, posed without apparent involvement in any activity, as if they were mere decorative elements. Certainly this painting was intended to be decorative.

The distant gesture of this lady examining her lute is reminiscent of the languid maidens in the medieval dreams of the pre-Raphaelite painter Dante Gabriel Rossetti, except that, in Dewing, some of the women he painted are clearly no longer adolescents. Whistler's influence and his monochromatic palette can be seen in this painting. However, Dewing's academic training is evident in the emphasis he places on the hands and the face, along with the woman's sensual chest, through the use of directed light, leaving the rest of the composition in shade. The perfection of the drawing and the beauty of the totally idealized woman place the viewer on a plane outside the real world.

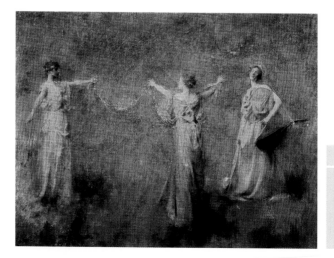

The Garland

(1899)
oil on canvas
31.5 x 42.2 in
(80 x 107.3 cm)
Private collection

The Musician

(~1910)
oil on canvas
24.2 x 18.1 in
(61.5 x 46 cm)
Musée d'Orsay, Paris

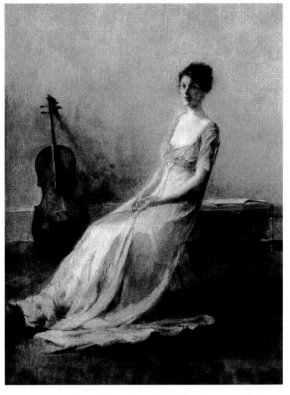

As a child, Dewing had felt a call to art as well as an interest in music; as a youngster, he had learned to play the violin. For this reason, musical instruments frequently appear in his pictures—both antiques, like the lute, or contemporary instruments such as the violoncello seen in *The Days.* This composition includes all the characteristics of a Dewing painting. The center is occupied by a young woman, resting on a chair, while the musical instrument on the wall in the background balances the composition and suggests an activity to which this young person is or will be dedicated. In the lower part of the picture, the artist has used a mass of dark shade, leaving the light to the upper part and bringing weight and balance to the painting. The background tone and the woman's dress employ the same chromatic tones—somewhere between yellow and pale green—indicating a very sparse palette and suggesting an interior scene flooded by such a warm quality that the figure and its surroundings merge. The contour is smooth, giving the sketched face a quiet and contemplative air. Finally, the atmospheric effect helps to veil the image slightly, resulting in Dewing's typical mistlike quality.

The artist's character, introverted and tending toward spirituality, is reflected in his works, which aspire to represent an ideal beyond the reach of mortals—except for the American upper classes. Herbert Spencer's social theories were very much in line with this way of thinking. In his writings, he maintained that society was evolving toward more spiritual and higher forms, and the upper classes were those that inevitably reached this peak of evolution.

Left: Great fortunes were built in the United States at the end of the 19th and the early 20th centuries. These nouveau riche—businessmen, bankers, and industrialists—wished to surround themselves with an aura of aristocracy. They looked to art as a way to achieve a sought-after high social status, characterized by elegance and refinement. Charles Lang Freer (1854-1919), a Detroit businessman, sponsored Dewing for most of his career. He was a typical example of a man of America's Gilded Age, cultured, refined, an art lover, and extremely wealthy. In 1890, he became acquainted with Dewing at a social gathering of artists and patrons. Because of these, many of the works of the artists of the time were to be found in private collections. Freer's collection forms the basis of one section at the National Gallery of Art in Washington as well as the Freer Gallery in Detroit.

Dewing's monochromatic and mistlike background is here taken to the extreme. No shapes are seen, and the viewer gets no signposts as to whether he is looking at a natural landscape or an unreal dream world. The three young women are drawn in a circular composition, united by a garland of flowers. They wear togas, in line with the classical taste of the time and always taking into consideration the conservative and puritanical morals of the time. For a while, Dewing trained intensely in anatomical drawing during his schooling in Paris; here he fails to provide detail in the faces of the young women, whose cheerful and distracted activity aims to reflect the lack of concerns of the American Gilded Age millionaires.

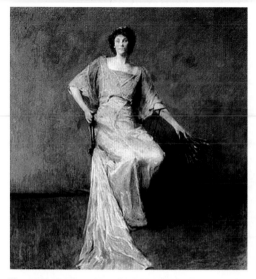

Lady with a Fan

(1911)
oil on canvas
23 x 21 in (58.5 x 53.4 cm)
Peabody Art Collection,
Baltimore, Maryland

The sophistication of America's high society at the beginning of the century is represented in the figure of this woman, sitting in an indolent and almost contorted fashion on a barely visible chair. In her left hand, she holds an open Spanish fan; the hand other leans on the armrest. It was not usual to represent figures in positions of such abandonment and insta-bility, but here Dewing has tried to incorporate an exercise in composition, using the minimum elements required for decorative purposes.

In this way, the woman portrayed, Gertrude McNeill, occupies the center of the canvas and stands out through the use of clear and golden colors on her dress against an opaque background with diffused reddish chrome hues on the wall and dark bluish tones on the floor. These bluish tones give the painting that feeling of distance so characteristic of this painter's works, intensified by the subtle way in which he blurs the drawing of the woman's face. The folds of the luxurious dress indicate that this is the portrait of a high-society lady.

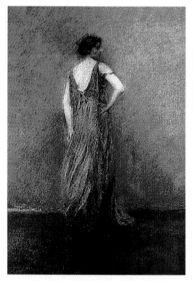

Green and Gold

(1922)
oil on canvas
24.3 x 22.5 in (61.6 x 57.2 cm)
Metropolitan Museum of Art,
New York

At this time, Dewing again began to use pastel in his works. The blurred and sketched tone that this technique makes possible can be seen in works from this last period of his artistic life.

During his apprenticeship in Boston, the artist had made numerous studies in this technique of the works of the French painter Chardin, acquiring great skill. Few Dewing oil paintings have survived preserved from this last part of his career; this is one of them. The influence of Whistler is clearer here, not only from the name of the work, which alludes to color and not to a scene or a picture, but also in the monochromatic nature of the palette. The golden tones on the wall fuse with the dress of a woman whose pale, smooth body appears to emerge from the background. A mistlike atmos-phere surrounds the figure and totally dilutes the face. The sense of distance, obtained with minimal elements, supports the decorative nature of the work.

In his later years, Dewing's health began to deteriorate, and he underwent several nervous breakdowns that prevented him from pursuing his painting career. He died in 1938, but not before seeing the Freer Gallery in Detroit open with a wing entirely dedicated to his work.

THEODORE ROBINSON

Self-Portrait, 1884-1887, oil on canvas, 13.3 x 10.3 in (33.7 x 26 cm), Collection of Margaret and Raymond Horowitz, National Gallery of Art, Washington, D.C.

- **1852** Born in Irasburg, Vermont. His family soon moves to Evansville, Wisconsin, where he grows up.

- **1869** Studies drawing and painting at the Art Institute of Chicago although, due to chronic asthma, he only goes to the institute for a year.

- **1870** Due to his chronic illness, the Robinson family moves to Denver.

- **1874** His health improves, and Robinson moves to New York to study at the National Academy of Design.

- **1876** Moves to France, where he lives for two years. In Paris, he studies with Émile-Auguste-Carolus Durand and later with Jean-Léon Gérôme.

- **1877** Moves to Grez-sur-Loing in the sumer.

- **1879** After several trips to Venice, he returns to the United States.

- **1881** Moves into a studio in New York, where he becomes a professional painter and art teacher.

- **1884** Returns to France.

- **1888** Moves to Giverny and devotes most of his time to working with Claude Monet.

- **1892** Returns to the United States. Lives in New York, where he teaches at the Brooklyn Art School. Afterward, he also teaches at the Pennsylvania Academy of the Fine Arts in Philadelphia.

- **1895** Exhibits his Impressionist work at the Macbeth Gallery. It is his first individual exhibit in the United States. The work obtains very good reviews from the public and critics.

- **1896** Dies from the chronic asthma that has plagued him all his life.

Although several American artists played a major role in Impressionism, most of the painters who visited Paris during the late 19th century were quite cosmopolitan, even distant from their national identity. James McNeill Whistler, Mary Cassatt, and John Singer Sargent are examples of American artists who chose to paint in Europe without seeking a defined artistic union with the United States. Theodore Robinson studied in the United States. When he arrived in Paris in 1876, he already had a strong artistic identity. His work shows remarkable artistic sensitivity; it reflects the influence of Claude Monet's style as well as landscape themes reminiscent of the American tradition. The link between the outdoor painting that evolved from the Barbizon School and the Impressionists' dramatic view of argumentative lighting that goes beyond simple optical effects can be grasped in his work.

In his studies in the United States and Paris with Émile-Auguste-Carolus Durand and Jean-Léon Gérôme, Robinson displayed special skill in organizing the landscape based on a calm and peaceful vision that is perfectly conveyed to the viewer. His work is an eloquent example of clarity and order, where the original artistic tradition of the United States acquires new argumentative strength. Even when he worked with Claude Monet, whom he greatly admired, Robinson did not renounce that distinct quality in his painting.

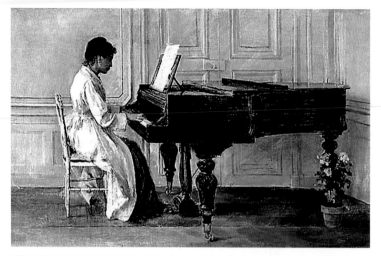

At the Piano

(1887)
oil on canvas
16.5 x 25.3 in
(41.8 x 64.2 cm)
Smithsonian American Art
Museum, Washington, D.C.

Art in France during the last quarter of the 19th century covered a variety of well-defined themes, which the majority of painters devoted themselves to with greater or lesser luck. Thus, Mary Cassatt was, together with Eva Gonzáles, one of the greatest exponents of Impressionism relating to feminine themes, while Claude Monet dealt with light effects and Pierre-Auguste Renoir captured Parisian life at the end of the century. Although each specialized in a certain theme, all the Impressionists painted landscapes, parties, or, like this Theodore Robinson painting, delicate interiors with exquisite decoration. This painting reflects great sensitivity to a specific lifestyle. Somewhere in a house, there is a corner where a woman sits in front of a piano. This is a painting made up of sensations: Loneliness and beauty are connected by the artist's sense of intimacy. Thus, all superfluous content has been discarded; the only decorative detail is the boxlike molding on the walls. *At the Piano* is a clear, organized, and realistic painting but also a work that describes the isolation of art as a need and a condemnation. Robinson expresses his own emotions through the woman playing the piano; it is surely a reflection of the artist in front of his easel.

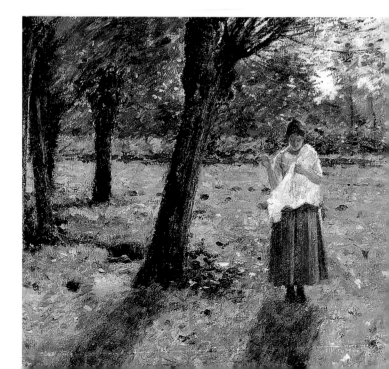

In Giverny, Theodore Robinson went through artistic growth that made him suddenly abandon the realism that had been predominant in his painting until the mid-1880s. In his work with Claude Monet, the artist slowly learned to forget all the issues that surrounded a specific piece and completely focus on its expressive power. Thus, Robinson was able to forget the American

Old Church at Giverny

(1891)
oil on canvas
18 x 22.1 in (45.8 x 56.1 cm)
Smithsonian American Art
Museum, Washington, D.C.

public, which often criticized American artists who worked in Europe, and use his own style to express himself freely. This image of the Giverny church shows a turning point in the artist's work. The painting's structure, more complicated than the landscapes he had made when he first arrived in Europe, shows many planes with a variety of structures. In the background, the linearity led by the horizon breaks up little by little with the wavy shapes of the fields and hills, while in the foreground the hillside creates a diagonal structure that is divided by the vertical of the church. Likewise, Robinson's brushstroke indicates an evolution in his painting; he depicts the grass with fluidity, while the more luxuriant vegetation has a freer and more expressive brushstroke.

Left: Theodore Robinson's work developed and deepened when he lived in Giverny. This transformation in his artistic style owed much to Claude Monet; working with him, Robinson acquired a new perspective on using a canvas as a fully expressive space. Thus, Robinson learned to paint the landscape and the human figure with a depersonalization that allowed him to focus on the quality of light and the decomposition of color as a means of expressiveness. Although his painting never reached Monet's expressive levels, Robinson's perceptions as an American allowed him to contribute a new perspective to Impressionism. In this work, Robinson merged several basic concepts of classical Impressionism. By painting nature, an individual model, and that model's dynamism in her environment, Robinson creates a painting that is somewhere between the still-realistic American art and a decomposed image leading toward the depersonalization of the model and her surroundings. Thus, Robinson has re-created a moment; in his impression, the young woman becomes part of nature in a simple way. This conceptual simplicity was one of the artist's greatest gifts.

Woman Sewing

(1891)
oil on canvas
18 x 21.5 in (45.7 x 54.6 cm)
Private collection

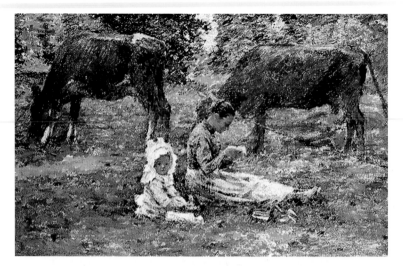

Watching the Cows

(1892)
oil on canvas
16 x 26 in (40.64 x 66.04 cm)
Butler Institute of American
Art, Youngstown, Ohio

During the time that Robinson lived in Giverny and worked with Claude Monet, he became an Impressionist painter who identified himself as such. His life in the country was quite similar to that of the French master: The days went by peacefully as he went to the countryside to paint. Thus, during this time, Theodore Robinson made his simplest but most sensitive paintings. They are everyday scenes where the artist displays a special predilection for landscapes with luxuriant greenery and picturesque farm animals. This work is a typically Impressionist scene. Its style, simple and natural, has an Impressionist logic, and the dramatic light of his landscape art has disappeared. It is a peaceful painting with a young woman and a child sitting on the fresh grass while they watch over the grazing cows. Only the young child, with a white bonnet that softly contrasts with the intense colors of nature, is aware of the artist. The painter uses an indefinite, almost abstract brushstroke; its expressiveness contrasts with the tranquil scene.

Right: When Theodore Robinson went back to the United States in 1892, the public there acknowledged the originality of his paintings as a logical progression from the typical American landscape painting to the new European trends. Shortly afterward, the first genuinely American styles would emerge (beginning with vanguard realism such as that used by Edward Hopper, some a reinterpretation of Robinson's proposals.

In this painting of a rural house in Virginia, Robinson returns to a more American artistic style. Although the painting's organization is simple and the landscape is presented under a dull, claustrophobic light, the colorful building and its placement reflect the Impressionist influence on this artist's work. Robinson plays with proportions and perspective here to create a painting where depth is blocked by the house. Thus, the ochre landscape is broken up as a result of the bright background, which in turn destroys the work's internal organization. That is why this painting is very modern. The artist develops the work from the traditional foreground to a new structure that gives the painting its own visual rhythm.

House in Virginia

(1893)
oil on canvas
18.7 x 22 in (47.5 x 55.9 cm)
Private collection

The influence of traditional American art is not evident in Robinson's compositions. Instead, the use of light filled the artist's production with bucolic sunsets under autumn skies where American Romanticism takes on a new meaning as a result of a completely expressionist brushstroke. In this sense,

Robinson is a unique painter, able to actually blend both artistic styles without succumbing to either of them. Thus, his painting acquires a new connotation as a convergence between American art and the first modern style trend in Europe.

This painting is quite American, although its defined internal organization is reminiscent of European landscape scenes. The panoramic view of the landscape that displays monumentalist qualities through a sense of depth and space amplified by light manifests the artist's Romantic sensitivity. Nonetheless, the use of a thick and quite undefined brushstroke, similar to Monet's, shows Robinson's characteristic Impressionism.

This landscape is well structured, with a canal that shows reflected light in the Parisian style and takes the viewer deep into the work, suggesting an idea of continuity that goes beyond the painting's margins.

Port Ben, Delaware and Hudson Canal

(1893)
oil on canvas
18.3 x 22.2 in (46.4 x 56.5 cm)
Sheldon Memorial Art Gallery and Sculpture Garden, University of Nebraska—Lincoln

Low Tide, Riverside Yacht Club

(1894)
oil on canvas
28 x 24 in (45.7 x 61 cm)
National Gallery of Art,
Washington, D.C.

Theodore Robinson arrived at Impressionism after having studied at the National Academy of Design in New York for two years. As a result of his studies in this prestigious American academy, he acquired a compositional approach similar to that of the Hudson River School artists. Here, as in other works, he shows a sense of monumentalism in the landscape. Light, which became an essential force for Robinson during his time in Paris, is the expressive protagonist of the piece. When the artist made this painting, he was experimenting with Asian techniques. The passion for Japanese art, which had a tremendous influence on French Impressionists, also affected Robinson—although for him, it contributed to his compositional technique rather than pushing him toward new aesthetics.

The artist used color in an organized way; he disperses slight touches of color that give rhythm and sensitivity to the painting. Here, Robinson's art acquires a new shade of simplicity where his Impressionist brushstroke has greater fluidity without losing expressiveness.

In the Orchard

(1895)
oil on canvas
18.7 x 22 in
(47.5 x 55.9 cm)
Private collection

In this work, one of the last Theodore Robinson made before his first individual exhibition in the United States a year before his death, the painter can be seen as mature and experienced, able to synthesize, through brushstrokes and light, what Impressionism was for him. It was this personal assimilation of the French movement that made him quite successful in the United States, since he did not approach the Impressionist perspective as a rupture of tradition; rather, he presented it as an evolution toward expressionism. Here, Robinson plays with light in a lively and brilliant way, which appears to stem from his initial landscape training at the National Academy of Design in New York.

The artist's fluid stroke, rich in shades, is transformed under the light into an effect that is full of personality in a clearly Impressionist piece. The painter has used a simple theme and a classically formal approach, drawing a descending diagonal line from right to left. Light and color flow in a clean, calm framework, without losing vitality from the pleasant color contrast of the woman.

EDWIN AUSTIN ABBEY

John Singer Sargent, Edwin Austin Abbey, 1888, pencil, 14 x 10 in (35.6 x 25.4 cm), Yale University Art Gallery, New Haven, Connecticut.

Thanks to frequent trips between the United States and England, Edwin Austin Abbey became the top American painter representing English symbolism in the last quarter of the 19th century.

The roots of his style, very common among British illustrators, lie in Victorian painting: delicate scenes where stylized young people are made into heroines of allegorical mythological scenes—the pagan evolution of paintings made by English Nazarenes or Pre-Raphaelites of the mid-19th century.

In fact, Abbey's painting shows the same aesthetic that dominated English Pre-Raphaelite symbolists, although Abbey's ability to create landscapes of great realism and sensitivity gives his work a new narrative interest.

Abbey also made historical genre paintings, helping mural painting evolve from a compositional structure and establishing a style of clearly understandable linear narration. As a result, his major commissions were designing and decorating official and institutional buildings. His murals were ideal for these settings, as they blended with neoclassical architecture.

Abbey showed a great passion for William Shakespeare's plays, since they allowed him to unite the aesthetic symbolism of British tradition with historic genre painting.

- **1852** Born in Philadelphia, where he spends his childhood and studies at the local school.
- **1866** Begins his artistic studies with the Philadelphia portrait and landscape painter Isaac L. Williams.
- **1868** Studies painting and drawing at the Pennsylvania Academy of the Fine Arts in the afternoons under the tutelage of Christian Schussele.
- **1869** He works as an apprentice in the Van Ingen and Snyder publishing house in Philadelphia.
- **1870** Works with New York magazine publishers, particularly *Harper's*, as an illustrator.
- **1871** Moves to New York, where he begins to earn a reputation as an illustrator.
- **1877** Is a founder of the Tile Club, to which the architect Stanford White and the painter Winslow Homer belong.
- **1878** *Harper's* sends him to England to work on an illustrated edition of poems by Robert Herrick.
- **1880** Returns to the United States after spending two years traveling through Europe. His stay in his native country is very short, since he moves to England permanently.
- **1889** Paints his first oil paintings.
- **1890** Settles down as a freelance painter in Morgan Hall, Fairford, and marries. He is commissioned, along with John Singer Sargent and Pierre Puvis de Chavannes, to paint murals in the new Boston public library.
- **1895** Exhibits murals from the Boston library in London and enjoys great critical acclaim.
- **1898** Elected a member of the Royal Academy, London.
- **1902** Commissioned to plan the decoration of the Pennsylvania State Capitol in Harrisburg.
- **1906** Suffers a mental breakdown.
- **1908** Charged with supervising the execution of paintings in the corridors of the east wing of the palace of Westminster.
- **1911** Dies in England.

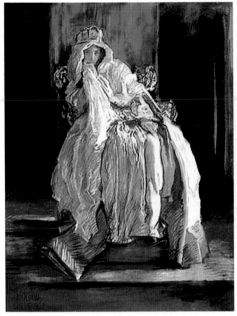

The Queen in *Hamlet*

(1895)
pastel on paperboard sheet
70.8 x 55.6 cm
Smithsonian American Art
Museum, Washington, D.C.

Abbey's art was born directly from his illustrations for poems and novels based on medieval legends. Even though his talent for illustration was often detrimental to his artistic career, the artist continued translating epic tales into visual language, especially the plays of William Shakespeare. Like many other artists, mainly British, Abbey found in this dramatist's literature all the allegorical ideals of beauty, nobility, and value, personified in magnificent descriptions of personalities as well as scenery and landscapes. For that reason, in numerous paintings, the artist portrayed whole play sequences. This painting, part of a series of works the artist did as a summarized sequence of *Hamlet*, is focused on Hamlet's mother, who marries the man who has assasinated her husband—his own brother. Her drama is perfectly captured by Abbey, who offers an allegory of luxury and splendor, but also of solitude and melancholy. The Queen of Denmark appears totally alone here, adorned in splendid attire and sitting on a golden throne; but her gestures are sad, overshadowed by an atmosphere of culpability that closes in over her.

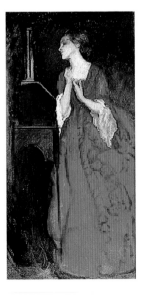

The Lady Anne

(1899)
oil on canvas
48 x 24 in
(121.92 x 60.96 cm)
Butler Institute of American
Art, Youngstown, Ohio

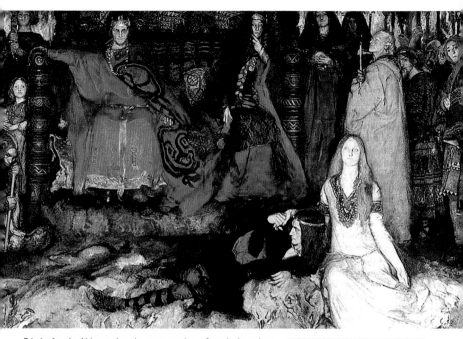

Edwin Austin Abbey painted a vast number of works based on the drama of William Shakespeare. Never before had an American painter shown so much interest in artistically portraying a body of literary work, American or European. Abbey's clear and linear style was the reason for his success with this project. In this scene, Abbey used a linear format, somewhat reminiscent of the compositional style of the retables of the early middle ages. Starting from a conception of

The Play Scene in *Hamlet*

(1897)
oil on canvas
Yale University Art Gallery,
New Haven, Connecticut

the work as a theatrical stage, the artist has adopted a clear perspective, where each character has enough space to act and establish a series of specific hierarchies according to *Hamlet*.

Thus, Ophelia, in the foreground, has Hamlet reclining on her lap as they watch the play-within-the-play. The space is not limited by architectural elements, but by a luminous halo of stage lighting. The lovers in the foreground have a very different light from that surrounding the king and queen in the background of the scene. Thus, Abbey explains two quite different situations, two conceptually different love stories: one, pure and chaste, closer to the viewer; and another of dark shades, with diabolical characters. Hamlet's mother and the murderous king are represented in a violent red color.

Left: This painting was originally intended to be part of a mural; Abbey designed it as a scene from Shakespeare's *Richard III*. In this composition, the artist heightens dramatic sense with a delicate contrast between light and shade, perfectly combining these two elements, avoiding any visual fracture and creating an aggressive effect. The work is based on a clear verticality where expressiveness seems to move quietly between light and shade. The artist obtained this effect by using a very intense chromatic palette, and color becomes the true protagonist in the painting. The composition is structured on the transition between clarity, in the lower part of the painting, and darkness, in the upper part. In this way, Abbey directs the viewer's glance along a visual route over the woman's body, creating a symbolist effect that dignifies her youth and beauty while still following a Pre-Raphaelite aesthetic.

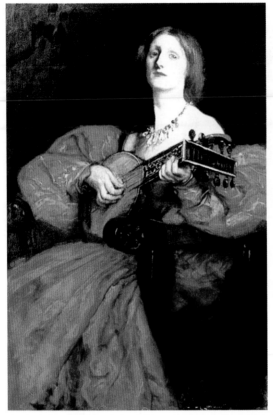

A Lute Player

(1899)
oil on canvas
30.3 x 20.1 in (76.9 x 51.2 cm)
Private collection

For post-Romantic artists, the concept of woman as an allegory of beauty was much more complex than in other periods. Never in the history of painting has a movement managed to saddle femininity with so much symbolism. For these painters, woman was a mystical beauty with the power to make sublime all aspects of divine purity that the Romantics reflected in nature. Thus, in early symbolist painting, woman appears as a personification of the divine ideal, presented before the eyes of an almost anonymous and insignificant man—the viewer. But the post-Romantic symbolists also sought to represent the cultivated woman, powerful and self-assured, claiming her true importance in a still male-dominated world. Abbey imbued this particular painting with just such an ideal of femininity. Thus, the work shows a fulsome young woman practicing the lute and arrogantly observing the viewer. The artist employs a somber chiaroscuro to emphasize her facial expression, but also to make a contrast between the intense red color of the dress and the dense darkness of the dwelling. The model's position, inclined slightly to the right of the picture, further reinforces this contrast, organizing the work into two major areas of color and darkness.

O Mistress Mine, Where Are You Roaming?

(1899)
oil on canvas
61.3 x 97 in
(155.6 x 246.4 cm)
Walker Art Gallery,
Liverpool, England

This work illustrates a song from Shakespeare's play *Twelfth Night*. The song refers to the Latin phrase *carpe diem*—"seize the day"—associated with the idea of living and enjoying life. Here it is used by a man trying to convince a lady to yield her favors. Abbey clearly favors the transcendental life of the soul; the lady does not appear to be giving in, or even to be remotely tempted. This type of allegory is firmly post-Romantic; these artists identified depersonalization of the soul as a clear characteristic of modernity.

For this painting, the artist adopts a realistic aesthetic where the colored intensity of previous paintings totally disappears. The artist displays a moment of tension between the characters. The atmosphere is dense and the range of tones used generates a deathly illumination that destroys all idea of hope or redemption. Abbey describes a serious situation: The purity of the body and the soul of a lady may be overcome by a dark masculine presence.

Left: The Victorian-style painting practiced by Abbey stemmed directly from English Romanticism. Thus, his paintings and portraits reflect a decorative sense, based on exuberant landscapes that fill the painting with a mysterious atmosphere. In this painting, the artist uses this vision of Romantic scenery to create a picture showing the simplicity and elegance of past times. Like the Pre-Raphaelites, the artist shows his rejection of the industrial ugliness sweeping Europe and the United States. For post-Romantic artists, modernity not only meant a rupture with nature, but also a loss of individual personal values. Their paintings are filled with dignified figures and elegant gestures. In keeping with this idea, the painter here shows an idealized moment in which a human being, surrounded by virgin nature, may enjoy beauty and the arts without fear of contamination by modernity. The compositional style reflects the artist's mastery of form and proportion: Abbey creates a circular space around a tree, where he places the lute-playing lady and her companion. But he also paints into the landscape behind them, creating sufficient space to allow the light to produce the painting's expressive feelings.

Fair Is My Love

(1900)
oil on canvas
Harris Museum and Art
Gallery, Preston, England

The Penance of Eleanor, Duchess of Gloucester

(1900)
oil on canvas
49 x 85 in (124.5 x 216 cm)
Carnegie Museum of Art,
Pittsburgh, Pennsylvania

This picture of the Duchess of Gloucester is probably one of Abbey's best-known paintings. The idea of the painting is rather modern, due to the way the figures are distributed and the solemn way they are portrayed. The whole work has a meticulously calculated aesthetic presence, as if a hidden scene were suddenly revealed to the viewer. The young Eleanor appears in the foreground, adorned in a dazzling white cloak that covers her almost to her feet. The luminosity of Eleanor's cloak contrasts with the assertive red clothing of the two men. In this way, the artist describes the nature of man and woman as a contrast between sensitivity and force, divinity and earthliness. The composition reflects a fragile balance between color and form, emphasizing the unreal feminine body through an abrupt change in tonality. All the elements and characters of the scene seem homogenized, except for Eleanor, a beautiful fragile woman with red hair, holding a candle in her hands as she turns her head to show her neck and face. In the same way, Abbey leaves the lower part of her legs uncovered, enabling us to appreciate the double sense of a mystical yet earthly beauty, slightly erotic.

JULIAN ALDEN WEIR

Julian Alden Weir in his summer residence.

Julian Alden Weir, a descendent of a family of American painters, took a long time to rid himself of the baggage of the academic training that he had received at West Point, the National Academy of Design in New York, and the École des Beaux-Arts in Paris. He traveled to Europe, where he admired Diego Velázquez's dark palette in Spain and Frans Hals's realism in Holland, and was influenced in France by the detailed rustic scenes of landscape artist Jules Bastien-Lepage. However, he clearly stated his profound disagreement with Impressionist ideas that were completely opposed to academic postulates, placing importance on drawing and composition to give a protagonist's role to brilliant colors and scenes of daily life.

After working as a landscape painter in Europe, he moved to New York, where he worked as a portraitist. He found the scenes of daily urban life interesting subject matter. It was then that he began to spend time with the most modern of painters, such as Childe Hassam and William Merritt Chase, and participated in organizing new artistic societies, including the Society of American Painters. He painted in the open air with John Twachtman. With these artists and others, he held group shows under the collective name of Ten American Painters.

While he may have rebelled against modernity in the early part of his artistic career, his style slowly began to reflect the influences of the techniques and motifs of Impressionism. This shift was due, above all, to his relationship with the American Impressionists, which resulted in his works being extremely daring for the period.

- **1852** Born on August 30 in West Point to a distinguished family of painters. His father is a drawing teacher at West Point, where the first part of his artistic training takes place.
- **1867** Studies at the National Academy of Design in New York until 1868.
- **1873** Studies at the École des Beaux-Arts in Paris with Jean-Léon Gérôme, thanks to the economic assistance of a family friend. Travels to Holland and Spain.
- **1874** Spends the summer in Brittany, where he meets painters of rustic scenes like Robert Wylie and Jules Bastien-Lepage.
- **1875** Exhibits in the Paris Salon.
- **1877** Sees Impressionist works in Paris and is horrified. Moves to New York, where he works as a portraitist and art teacher at the Cooper Union Women's Art School and the Art Students League.
- **1880** Works with art collector Erwin Davies, whom he advises in his acquisitions.
- **1883** Marries Anna Baker, and they spend their honeymoon in Europe.
- **1884** Spends long periods of time at his farmhouse in Branchville, Connecticut, where he often meets with American Impressionists.
- **1889** Exhibits with John Twachtman at the Ortgies Gallery in New York. Exhibits at the Paris Exhibition and at the American Artists Association.
- **1891** Solo exhibit at the Blakeslee Gallery in New York.
- **1893** Group show with Impressionists Twachtman, Claude Monet, and Paul Besnard.
- **1897** Founds Ten American Painters with Twachtman and Childe Hassam, to break away from the Academy and exhibit more freely.
- **1900** Wins a bronze medal at the Paris Exposition Universelle.
- **1906** Exhibits at the National Academy of Design.
- **1910** Exhibits at the Pennsylvania Academy of the Fine Arts.
- **1911** Traveling retrospectives of his works are organized.
- **1913** Exhibits at the Armory Show. Is elected president of the Association of American Painters and Sculptors.
- **1914** Exhibits at the Corcoran Gallery of Art.
- **1915** Is elected president of the National Academy of Design in New York.
- **1919** Dies on December 8 in New York.

The Oldest Inhabitant

(1876)
oil on canvas
65.5 x 32 in (166.37 x 81.28 cm)
Butler Institute of American Art,
Youngstown, Ohio

During his training in Europe, Weir greatly admired the detail and rich palettes of rustic scenes by painters such as Robert Wylie and Jules Bastien-Lepage. Because of this, he traveled to the outskirts of Paris to portray country life. This is his best painting from that period, and the one he worked the most, as he wanted to present it at the exhibition at the end of the year in the French capital.

An anecdote illustrates the artist's love for this painting: On one occasion, when he was traveling to the Academy in Paris, Weir discovered that he had forgotten this painting in his hotel room. Without a moment's hesitation, and knowing he would miss the train, he ran back to the hotel room to get it. At the hotel, he asked for their best horse, and with the enormous canvas under his arm, he galloped off to be able to catch the train at the next station. It was market day, and Weir's steed crashed into merchants' stalls, to the cries and shouts of his fellow artists, who applauded his efforts from the train—which Weir succeeded in catching.

The dark palette, broken only by the blue-and-white of the woman's bonnet and apron, as well as the perfect finishing touches and the shaping of the figure through chiaroscuro, shows this painting to be very much a product of the Academy. All of the compositional elements have their roots in great masters like Jan Vermeer and Rembrandt. The woman appearing in the painting, with great psychological depth, was an 82-year-old who had lived through the French Revolution. She posed for Weir during the two years it took to complete the work. This painting was exhibited at the National Academy of Design, as a foretaste of his return to New York, where it met a warm welcome.

Portrait of Anna

(~1886)
oil on canvas
34 x 26.5 in (86.4 x 67.3 cm)
Adelson Galleries, New York

In the Sun

(1899)
oil on canvas
34 x 26.8 in (86.4 x 68 cm)
Brigham Young University
Museum of Art, Provo, Utah

Painters like Mary Cassatt and John Singer Sargent had laid the groundwork for the French Impressionists, and thanks to the interest of the Parisian art dealer Durand-Ruel, they were able to exhibit in the United States in 1886. Although the American public gave them a warm welcome, the critics—mainly from academic circles—and the New York art merchants, fearful of the arrival of a new competitor, did everything possible to make their efforts fail. Enormous taxes were imposed on Durand-Ruel; in the end, they forced him to open a permanent gallery in New York. However, due to the increasing number of Impressionist exhibitions in the city, Weir and other American painters began to experiment with loose brushstrokes and bright colors.

The girl in the work is Weir's daughter, Dorothy, at nine. She is seated in the open air, holding a flower in her hand. This work is more than just a portrait; it is a study in the decorative possibilities of color. White empowers the entire composition, imparting a brilliant luminosity that envelops the figure. The rock, the girl's dress, and even the flower melt together to form a mass of color that frames the face, which is completely turned toward the flower.

Weir surely had James McNeill Whistler's studies of white in mind during the creation of this painting. Among American Impressionists, there was a preference for this color—natural, considering that American light is extremely white and brilliant. The brushstrokes, with their small splashes of color, give the surface a special texture, as if it were embroidered. These strokes are characteristic of Weir's work and differentiate it from other Impressionist paintings. Here, Weir was gradually assimilating his new style. He had previously done his portraits indoors, with dark backgrounds; now his work was set in the open air, giving color the principal role.

Left: Weir was horrified the first time he saw an Impressionist exhibition, which is not so strange, considering his rigid academic education. However, once he returned to the United States, he began to spend time with a group of modern American painters, while exhibiting at the National Academy of Design, a paradigm of academia.

From the beginning, Weir's paintings swung between academic training and the new artistic styles, but his experimental fervor would end up leaning more toward the new ideas. This work is of his wife, Anna Dwight Baker, shortly after their marriage, and is a good example of his period of artistic transition. The dark tones and defined contours in the background of the portrait are purely academic and totally neutral; so is the well-drawn figure of the woman that places emphasis on her hands and face. However, loose brushstrokes, created by directly applying color without mixing, are used to depict the texture of the dress and the shadows of the hands. The shadows of the folds in the dress use the same tones as the background. The hair is rendered with broad brushstrokes, which creates a hazy sensation quite different from Weir's earlier creations.

The white in the dress accentuates the decorative intention of the work, which captures the sweetness of the model's personality. Weir, an expert portraitist, surely chose the portrait for his stylistic experiments because he was comfortable with the genre.

The Barns at Windham

(~1905)
oil on canvas
24.4 x 33.3 in
(62 x 84.5 cm)
Private collection

Before getting married, Weir had acquired a 153-acre farm in Windham, close to Branchville, Connecticut, in exchange for one of his paintings. There, Weir would meet with other painters to work on landscapes; as a result, there are many paintings of this village. Childe Hassam, Albert Pinkham Ryder, and John Henry Twachtman were among the guests who found the farmhouse an ideal place for painting landscapes. Many works depict the granaries of the farm. The farm is now a national historic site, and many people visit to compare the paintings to the real place. Weir developed his own style, while at the same time adopting the characteristics of his contemporaries' work, and began to exhibit his work with theirs under the name of Ten American Painters. In the last decade of the 19th century he had already had solo shows that met with great critical success, and at the beginning of the 20th century, he was respected in the New York art circles and had won a bronze medal at the Paris Exposition Universelle.

This work is an example of the landscapes he painted at his farm. The colors are applied directly to the canvas, with his characteristic brushstroke, which evokes embroidery and lends a textured quality to the surface of the painting. The contours of the figures and the shadowed surfaces have been made starting from these points of color, without lines. The true concern of the painter was to capture the lighting effects and represent these on canvas and, for this, he used blue to reflect the shine on the roof of the red barn. The leaves on the trees are pure dabs of paint, while the blue sky stands out in stark contrast to the red barn. However, the academic influence can still be discerned in the artist's placement of two elements to frame the composition: a tree on the left side and the side of a wooden shed on the right.

Right: Julian Alden Weir is an example of a self-made artist who evolved from academic ideas to become a reference point within the art world. A family friend, Mrs. Bradford Alden, made his first trip to Europe possible; there he was able to study at the prestigious École des Beaux-Arts in Paris. (To show his gratitude, Weir used Alden as a first name instead of Julian.) Back in the United States, he began to earn a living as a portraitist, even though he had already gained a certain level of success among academic critics. Weir evolved from being completely dedicated to drawing and psychological representation, typical of the great baroque masters he admired, toward portraits with a purely decorative and technical intent, as what he truly desired was to test his own artistic capabilities.

Here, the dark background, used by academics to emphasize the figure, has been created with very loose brushstrokes that leave oil impasto over the surface of the painting, which went against academic painting. The sketched air of the girl's face lends freshness to her expression; interior portraits were more concerned with psychological depth and realism than any decorative intentions. The texture of the dress has been created with broad, free brushstrokes, subjugated to the drawing of the contours at some points. A point of light illuminates the girl's face, a technique used often by baroque masters such as Rembrandt.

Moonlight

(~1905)
oil on canvas
23.4 x 20 in (61 x 50.8 cm)
National Gallery of Art,
Washington, D.C.

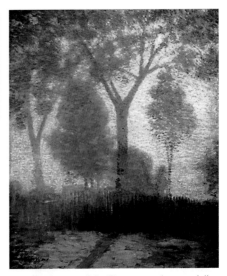

One of Weir's greatest influences was the French Impressionist Claude Monet, whose works were characterized by hazy atmospheres and diluted outlines. Weir, with his experimental fervor, saw the dissolution of academic drawing as a technical exercise. That viewpoint, together with the opportunity offered by his picturesque farm, made the creation of interesting works like this possible. Weir left his own personal stamp on his works with his characteristic brushstroke; here, it is used for the soft greens that represent the moonlight. The tree trunks, especially of the trees in the background, are created by quick dabs, so daring that they do not even touch one another; as a result, the trees appear to dematerialize. The brushstroke is widely and openly applied to the foreground, depicting the colors of the earth. The misty result reflects the clear luminosity of nights under a full moon; the glow backlights the small grove of trees and a fence. Weir's light touch with the brush owes much to Twachtman, who in turn admired Monet's brushstrokes. At a group exhibition at the American Art Association, Weir and Twachtman were compared to Monet. Nevertheless, Weir's painting would always oscillate between his academic training and Impressionist influences.

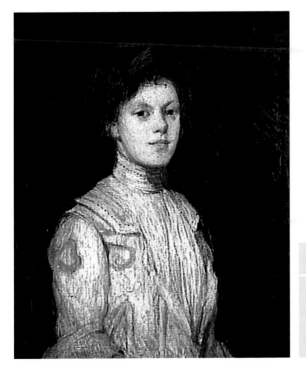

Portrait of a Girl

(~1909)
oil on canvas
28 x 23 in
(71 x 58.5 cm)
Musée d'Orsay, Paris

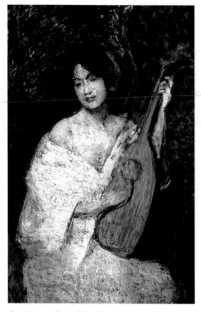

Lady with a Mandolin

(~1909)
oil on canvas
Brigham Young University
Museum of Art, Provo, Utah

Japanese culture and art had spread through ukiyo-e woodblocks, and it also came to the United States at the hands of the French Impressionists. This exoticism affected portraits, and Weir was not outside this influence. His work here is a symbiosis of academic painting, Impressionism, and Japanese exoticism. Academic influences are seen in the neutral background that makes the figure of the woman stand out, although the fluidity is broken because the artist uses two different colors: dark green and brown, separated by a jagged line. He has also made a study of the shadow produced by the musical instrument, which covers the chair where the model is seated. Impressionism is seen in the sketchy quality of the brushstroke and the choice of subject matter, a feminine portrait with decorative intent, perhaps one of the most sensual that Weir ever created. Weir was quite daring in his treatment of eroticism, especially considering the moralistic mindset in the United States at this time. The woman directs her vacant glance to a point outside the picture, while she plucks the strings of the mandolin. Her hands are sketchy, to the point where the fingers of her right hand cannot be distinguished. Similarly, the folds in her dress cannot be seen; they appear as a stain of white color that frames the model's face and upper torso, continuing the custom of American painters in experimenting with the possibilities of adding light with this color.

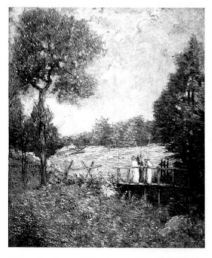

The Fishing Party

(1915)
oil on canvas
28 x 23 in (71.2 x 58.5 cm)
Private collection, Washington, D.C.

Weir enjoyed the freedom of absorbing a variety of influences in order to develop his own style. The painter knew that once he had dominated the basics of artistic creation—drawing, composition, and color—the rest could be his own interpretation. Impressionism, with its free and colorful style, gave him a new language. The great artistic variations offered at different times of the day encouraged him to greater experimentation. Painting in the open air, without having to rework in the study, was a breath of fresh air for Weir, who already felt suffocated by academia. The year he painted this work, he was already at the peak of his career. Since 1913, he had been the president of the Association of American Painters and Sculptors, and he would also be elected to the top position at the National Academy of Design in New York—which would not hinder his development of a final artistic stage.

His moments of leisure became the subject matter for landscapes where the effects of the bright American light were represented through his characteristic loose brushstrokes, bordering on an embroidered look. As his work progressed, his colors became even brighter and more luminous, and he used the aerial perspective that blurred figures in the distance. In this work, three people carrying fishing equipment stand on a small bridge to have an animated conversation. The figures are barely discernible. The brushstrokes reproduce the movement of the breeze through blades of grass and the leaves of the trees.

JOHN HENRY TWACHTMAN

John Henry Twachtman.

John Henry Twachtman may be the painter most representative of American Impressionism. After embarking on his artistic career in Cincinnati, his city of birth, he traveled to Europe, where he was deeply influenced by the Munich School. He would soon adopt their techniques of rapid and energetically drawn lines and dark-toned palette.

Shortly after, he returned to Europe again, attending classes at the Académie Julian in Paris, where he perfected his technique and saw the work of James McNeill Whistler, who would influence his production during these years. His landscapes from this period were applauded by critics, although today his best-known works are those created in the 1890s at his country home in Greenwich, Connecticut.

Once settled in the countryside, he painted different features of the farm—the granary, the waterfall, the garden—as well as his wife and children. He adopted the Impressionist technique during this period, with works that abandoned the somber tones of his first artistic period in favor of lively and bright colors. To represent reality, he fled from the empirical vision of other Impressionists, and more closely reflected Claude Monet's poetic style.

Toward the end of his life, he spent his summers in an artists' colony in Gloucester, Massachusetts, a New England fishing town. The peaceful serenity of family life in Greenwich

- **1853** Born in Cincinnati, Ohio, on August 4, the son of German immigrants.
- **1867** Attends classes at the Ohio Mechanics Institute.
- **1871** Registers at the McMicken School of Design, where he meets Frank Duveneck. With him, he makes his first trip to Europe.
- **1875** Studies under Ludwig von Loeftz at the Royal Academy of Fine Arts in Munich.
- **1877** Travels to Venice with Duveneck and William Merritt Chase.
- **1878** Returns to the United States. Professor at the Women's Art Association in Cincinnati.
- **1879** Becomes a member of the Society of American Artists.
- **1880** Returns to Europe as professor at Duveneck's school in Florence.
- **1881** Marries Martha Scudder. Returns to Europe, where he studies at the Académie Julian in Paris. Spends summers in Normandy and Holland. Influenced by James McNeill Whistler's work.
- **1886** Returns to the United States and spends most of his time in New York. In the winter, he paints scenes of the Civil War for a cyclorama in Chicago.
- **1889** Teaches at the Art Students League in New York and does illustrations for *Scribner's*. Buys a country home in Greenwich, Connecticut. Peak of his Impressionist stage.
- **1893** Wins a medal at the World's Columbian Exposition in Chicago.
- **1894** Receives a commission to paint a series of landscapes of Niagara Falls and Yellowstone National Park.
- **1897** Founding member of the American Impressionist group, the Ten.
- **1900** Paints at the artists' colony in the fishing village of Gloucester, Massachusetts, in New England.
- **1902** Dies in Gloucester of a brain aneurysm.

disappears in his paintings from this period, and while he did not abandon his bright Impressionist tones, he returned to the rapid and energetic strokes of his beginnings with powerful pieces.

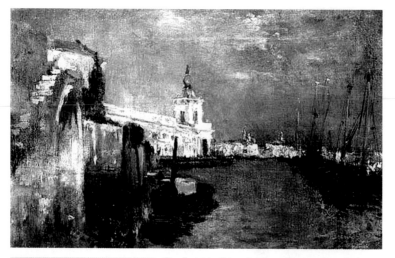

Canal Venice

(1878)
oil on canvas
10.2 x 16 in (26 x 40.64 cm)
Mr. and Mrs. Allen P. McDaniel
Collection

The first trip this artist from Cincinnati made to Europe was in 1875, when his friend and professor, Frank Duveneck, invited him to accompany him to Europe. The influence of Munich's school of fine arts became evident in the painter's earliest works. He quickly adopted the school's dark colors and rapid brushstrokes. Not even his stay in Venice before returning to the United States lightened up the painter's palette. In this work, one of several views of the great canal, the sky is depicted with somber tones that contrast with the whiteness of the buildings in the background. It shows an unusual perspective; the composition gives the work an air of innovation.

Right: Twachtman was very proud of his winter landscapes. Most of them were done at his country home in Connecticut. Fascinated by the changes in nature with the passing of the seasons, he painted this landscape of his garden covered in snow. In the interest of representation, he did it in *plein air*, despite the freezing temperatures. According to Twachtman, nature is never as attractive as when it is snowing; for the artist, snow provoked a special mysticism. This work shows a scene that he could probably see from a window of his house. The granary of his farm is in the background, and a cloak of snow covers the surface of his garden in the foreground.

The use of whites and grays tends to dissolve the shapes of individual elements in the scene, bringing them together in a fine range of colors with subtle contrasts. The predominance of a central color in the painting, with slight transformations over the surface, recalls Whistler's influence. The silence and solitude conveyed by Twachtman's snowy landscapes distance him substantially from other 19th-century interpretations, where snow was seen as a threatening element. Twachtman's scenes, however, are imbued with peace and calm, a reflection of the painter's neverending delight in this winter wonder; for him, snow bestowed a certain magic on the landscape.

Snow Scene

(1890)
oil on canvas
10 x 14 in (25.4 x 35.6 cm)
Hunter Museum of American Art,
Chattanooga, Tennessee

After marrying Martha Scudder, Twachtman traveled to Europe with her and his firstborn son. He attended classes at the prestigious Académie Julian in Paris, where his drawing techniques would mature and his knowledge of composition would notably improve. His paintings from this stage show the clear influence of the American painter

Arques-La Bataille

(1885)
oil on canvas
60 x 83.1 in (152.4 x 211 cm)
Metropolitan Museum of Art,
New York

James McNeill Whistler. Twachtman adopted his somber palette, coating his works in a grayish light, which created a dense atmosphere. This imbued his landscapes with a surreal, other-worldly quality. This sense of the ethereal is the fundamental characteristic of Twachtman's paintings from the period when the artist moved between France and Holland. The disturbing serenity of these landscapes has been greatly appreciated by art historians.

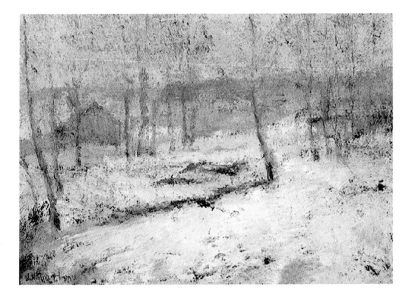

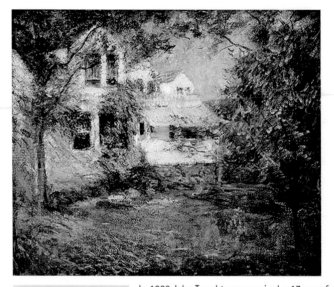

September Sunshine

(1895)
oil on canvas
25 x 30 in (63.5 x 76.2 cm)
National Gallery of Art,
Washington, D.C.

In 1889 John Twachtman acquired a 17-acre farm on Round Hill Road in Greenwich, Connecticut. The property was crossed by a stream, Horseneck Brook, that fed into a bucolic pond called Hemlock Pool. The center of the property was a farmhouse where Twachtman settled with his wife and seven children. From this time on, the painter focused on representing the different elements that surrounded him in his new home. This work is his personal vision of the farmhouse just before autumn settled in.

His brushstroke is light and superficial and strays from pictorial exactness, because his interest is focused on representing the weather and the characteristics this gives to nature.

The parallels that can be drawn between Twachtman and Claude Monet are obvious. In their personal lives, each established a family home in the country and made it into a source of inspiration. From an artistic point of view, they shared a similar concept of Impressionist painting. Unlike the strictly scientific talent of some painters, Twachtman, like Monet, followed ideas closer to symbolism and imbued his works with his own subjective ideas. Twachtman's affinity with French Impressionism and Japanese culture—he collected Japanese prints—made him one of the most modern artists in the United States. His modernity, however, was not warmly welcomed by those with a more academic concept of painting—something that had also happened to French Impressionists in their day.

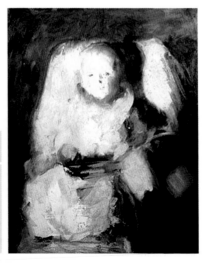

Infant Portrait of Godfrey Twachtman

(1897)
oil on canvas
30 x 25 in (76.2 x 63.5 cm)
Spanierman Gallery,
New York

In the middle of the 1890s, the painter received his only artistic commission from the elderly William Wadsworth: a series of paintings of Yellowstone National Park in Wyoming. Before Twachtman, other painters had already illustrated expeditions made to this park during the 1870s. These were descriptive works, emphasizing America's grandeur by praising its topography. Although Twachtman knew about the magnificence of the park from the works of his predecessors, he was nonetheless overwhelmed and stunned by the beauty of the landscape when he arrived.

Edge of the Emerald Pool, Yellowstone

(1895)
oil on canvas
25 x 30 in (63.5 x 76.2 cm)
Spanierman Gallery of Art, New York

The painter stayed at the Grand Canyon Hotel, where he enjoyed a privileged view of Yellowstone Canyon and was extremely close to both the Upper and Lower Falls. These elements, along with the geysers and lakes of the park, captivated the painter. This work is a paradigm of the painter. This representation of the lake, located in Black Sand Basin, centers around the colors of the water, rather than on strictly topographic details. The name Emerald Pool refers to the green tone of the lake, a result of the combination of the yellow color of the algae and the blue of the water.

The painter visited Emerald Pool three times, and this is the most abstract of the works he created there. The work draws the viewer's attention toward the spectrum of the lake's blue and turquoise colors from its framework of a strip of orangish earth. The modernity of this composition rests in its compositional asymmetry and flat layout, typical of the Japanese prints that so greatly influenced the Impressionists. Without doubt, this abstract composition reveals Twachtman as a radically innovative painter, an artist who advanced the concept of the emotional impact of color.

Left: After settling at his farm in Greenwich, Twachtman's family life was enriched, especially since the family had never had a fixed residence before. The Connecticut farm was an ideal environment for raising his children. During this stage, Twachtman's children and wife were the only figurative models in all his works. Over the years, the painter tried to capture the spontaneity of family life through portraits of family members in informal poses, painted both inside and in the open air, at first in pastels and oils.

Like the rest of his siblings, Godfrey Twachtman was portrayed several times throughout his childhood. This is the first of these portraits; it shows the child seated in a high chair, with a dark background that recalls the dark palette of the German school. However, the figure of the child is boldly lit. To do this, the painter uses a fluid brushstroke, which imbues the clothing with lightness and adds great expressiveness to the baby's face, with light touches of pink on his cheeks.

The Cascade

(~1900)
oil on canvas
30 x 30 in (76.2 x 76.2 cm)
Spanierman Gallery,
New York

In 1889, one of Twachtman's exhibitions on Fifth Avenue in New York was such a success that it brought his work great recognition. Sales were so strong that the artist was able to acquire his country home and land in Greenwich. He would never tire of representing the farm, the garden, and the bodies of water surrounding them.

This waterfall was located behind the house; Twachtman's representative interest centers around the rhythm of the falling water. The painter's approach to nature is Impressionist, and he conveys the vitality of his environment by capturing the water as it flows, an unrepeatable moment that shows the many nuances presented by reality.

This closeness with nature has nothing to do with the Romantic landscape tradition tied to allegorical national exaltation. The afternoon light in the work creates a shiny, twinkling effect on the wavy surface of the water, where the last rays of sun shine. To achieve the effect of movement of the water, the painter mixed textures: Thin brushstrokes alternate with thicker and stronger ones. The rocks, in shadow, are depicted by using a dark palette applied directly to the canvas, returning to the method learned in his early days in Munich.

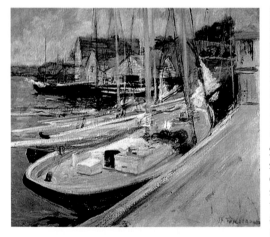

Fishing Boats at Gloucester

(1901)
oil on canvas
25.1 x 30.2 in
(63.7 x 76.7 cm)
Smithsonian American Art
Museum, Washington, D.C.

Starting in 1900, Twachtman spent summers (three, until his death in 1902) in Gloucester, a small New England fishing village that was developing into an artists' colony. During this final period of his life, the artist returned to the wide brushstrokes of his stage in Munich to create the most aggressive compositions of his entire career.

Setting up his easel on the Gloucester docks, he captured images of the hard life of the local fishermen. However, the painter did not use the somber colors characteristic of the German school. Twachtman's turn-of-the-century paintings reveal a bright, varied palette with a mixture of textures. In this work, he used sandy pigments to create blue and violet, green and brown, to evoke the subdued light of a cloudy day. Compared to his earlier works, the compositional structure is surprising, stressing the diagonal lines of the dock against the horizontals of the roofs and the verticals of the masts. All of this contributes to an architectural structure similar to the work of the French artist Paul Cézanne, a precursor of the new cubist interpretation of space, already in the vanguard of the 20th century.

JOHN SINGER SARGENT

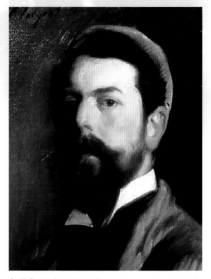

Self-Portrait, *1892, oil on canvas, 19.1 x 15.6 in (48.6 x 39.5 cm), National Academy Museum, New York.*

Although this artist was born in Florence, he has always been considered one of the greatest American artists of all time. His paintings are based on the pictorial traditions of the English and the French. Originally known as a portrait painter, his work was so wide ranging that he frequently stepped into entirely new interpretations of classic genres.

John Singer Sargent cannot be classified as an Impressionist artist. His enormous talent permitted him to reinvent painting genres, well ahead of trends. Sargent was a tenacious and steadfast worker, who never allowed himself to be classified as an Impressionist. Besides, his work was clearly influenced by the paintings of Diego Velázquez, Jean Auguste Dominique Ingres, and classical paintings. His portrait techniques brought him international fame and Sargent came to be considered one of the greatest portraitists of his time—indeed ever.

In Sargent's paintings, his view of the subject is very clear. The artist relied greatly on figurative realism, but the concept of reality took on a new meaning in his art. His paintings did not merely portray a figure or present a countryside scene; rather, each perfectly depicts an instant in time, with all of its accompanying details.

This new narrative painting approach, which anticipated the vision of art prevailing in the twentieth century, made Sargent a renowned artist who would be widely imitated and honored for generations to come.

- **1856** John Singer Sargent is born on January 17 in Florence to an expatriate American family living in Europe.

- **1874** After spending his younger years traveling through Europe, he decides to study at the École des Beaux-Arts and begins to work in the studio of E.A. Carolus-Duran, where he specializes in portrait art.

- **1876** He visits the United Status for the first time. He gains American citizenship and visits the Centennial Exhibition in Philadelphia.

- **1877** He exhibits for the first time in the Salon de Paris.

- **1879** He exhibits his portrait of Carolus-Duran in the Salon. This moment marks the beginning of Sargent's professional career. The same year, he visits Tangier and Spain.

- **1881** He takes his first trip to England. This decade proves to be the artist's most creative period. His continual trips throughout the entire continent are reflected in his works.

- **1884** After the hostile response to his portrait *Madame X*, presented in the Salon, Sargent settles in England, where he meets numerous artists of the aesthetic movement.

- **1886** He moves into a London studio once owned by James McNeill Whistler.

- **1887** He goes to the United States to paint many different portrait commissions.

- **1890** He travels to the United States to prepare a mural for the Boston Public Library and, in the same year, takes the first of many trips to Greece and Egypt.

- **1902** He settles in Venice for a year to paint a series of canals.

- **1904** He exhibits at the Royal Academy of London.

- **1905** He participates in the Nouveau Salon in Paris.

- **1909** He participates in the Fair Women Exhibition, in London.

- **1910** He begins painting landscapes, which replace his portraits in the Royal Academy.

- **1918** He moves to France and becomes an official artist of World War I.

- **1925** He dies on April 15 at his home in London. After his death, there are a number of retrospective exhibitions in his memory, both in the United States and in Europe.

Fumée d'Ambre Gris

(1880)
oil on canvas
54.8 x 35.7 in
(139.1 x 90.6 cm)
Clark Institute of Art,
Williamstown,
Massachusetts

The extremely modern aspects of this painting contrast with its Romantic elements. In the 1860s, the French culture looked to its colonies and the African continent for new and exotic references (landscape, architecture, ambiance, and customs) with which they could nurture their new artistic tendencies. This painting of an African woman is the result of Sargent's own search for sources.

Sargent takes us to Tangier, where a woman stands on a patio, dressed completely in white. She inhales smoke from burning ambergris, a guard against evil spirits. The women's figure blends with the whitewashed walls behind her. The intense light of the African continent, reflected and heightened on every white wall in the city, had a great impact on Sargent. The Romantic view of Moorish palaces—a reminder of the way Romantics viewed Italy—led to the upsurge of a fantasy that was totally new to European art of the 19th century. When Sargent traveled to Tangier, he also visited Spain, where he saw a collection of works by Maria Fortuny. Fortuny also went to Tangier, and represented this continent in some of his paintings. Both artists collected examples of humble people, lost in the huge desert spaces or the royal palace, and converted these into an almost unreal oasis.

In this particular painting, the composition of hues is extremely original. White totally dominates, contrasting only with the colored detail on the rugs and the silver incense burner. The woman, who is covered with a strange headdress, almost takes on the shape of the burner, as if she were a replica of the object. Both are the only lively elements in this almost surrealistic painting.

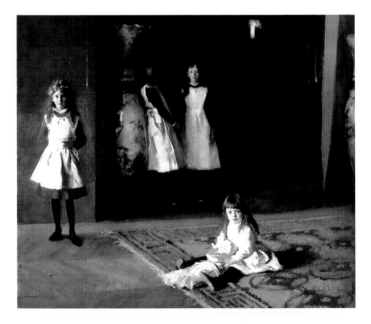

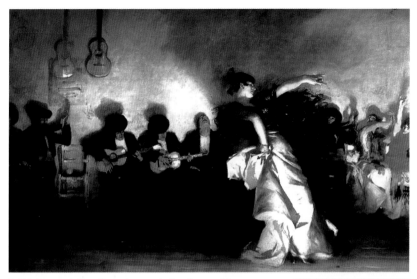

In this large painting, Sargent presents the viewer with an extremely unusual and realistic glimpse of a flamenco dance—especially if one keeps in mind that the artist was an American living in France. The painting re-creates a scene that the painter had witnessed in Spain in the winter of 1879, when he took a five-month trip to Madrid, Seville, and Granada. He was especially fascinated by Andalusian folklore and treated this subject as much more than a tourist attraction, lending it respect while capturing its true meaning. The presentation of this painting in the Salon de Paris in 1882 coincided with Europe's rediscovery of the Spanish culture.

> ## The Dance
>
> (1882)
> oil on canvas
> 93.3 x 138.6 in
> (237 x 352 cm)
> Isabella Steward Gardner
> Museum, Boston

Five years before, the opera *Carmen* had been presented in Paris, and many painters, including Edouard Manet, Thomas Eakins, and Mary Cassatt traveled to Spain to contemplate the works of Velázquez and Francisco Goya.

The Dance faithfully portrays the essence of Andalusian flamenco. In this painting, Sargent presents a very authentic view of this Spanish custom, without falling into the same trap as other artists of the 19th century, who offered a clichéd, sweetened version of this theme. Sargent made a habit of exploring all the concepts surrounding the theme to be painted. This enabled him to give content to the elements he represented with a new language of details, which he used as a narrative complement to the painting. He employed light in a sensational, theatrical way, but this helped him create both a serious environment and a sense of mystery—both inherent in this profoundly Andalusian dance.

> ## Daughters of Edward Darley Boit
>
> (1882)
> oil on canvas
> 87 x 87.6 in (221.1 x 222.6 cm)
> Museum of Fine Arts, Boston

Left: When Sargent exhibited this work in the Salon in 1883, its enormous size and unusual format surprised the public and caught the attention of critics. The composition of this painting is very modern: It combines the portrayal of children with wide-open spaces.

The painting relies on a novel idea: Create several individual portraits to form a group, then balance the painting through the use of interior architecture within the pictorial space. The painting is made up of three well-divided spaces. Sargent places a conventional child portrait on the left. Here the front of the child remains subordinate to the subtle natural light falling on her. In the lower part of the painting, another child, illuminated by the same ray of sunlight, plays on the rug. Meanwhile, in the background, which receives almost no light, two older sisters stand in a more adult pose. The dramatic lighting adds to the spectacular painting. Posing the children in different ways lends action to the painting. The result is a truly imaginative compositional rhythm. Meticulous composition, the use of perspective, the sense of an instant being captured realistically—all are clearly evidenced in this painting. For a viewer of the 19th century, there was no artistic precedent for such a composition, which explains why the work was not received with great enthusiasm.

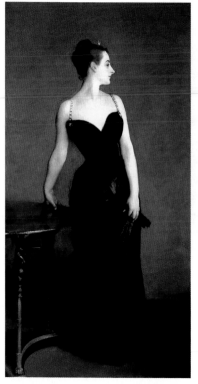

Madame X

(1884)
oil on canvas
82.1 x 43.3 in (208.6 x 109.9 cm)
Metropolitan Museum of Art,
New York

The exhibit of this painting in the Salon in 1884 marked a definitive rupture with the critics and the Parisian public who had so admired Sargent for the classicism of his art. It was the response to this painting that led Sargent to abandon Paris and move to England, where his new ideas would be better received.

Portraying Madame X, who in reality was Madame Virginie Gautreau, represented a challenge for the painter. Despite the huge dimensions of the painting, Sargent provided the portrait with a totally new underlying sensuality. The general elegance, perfect lines, exact colors, and delicacy in both shapes and textures, such as the woman's skin, made this underlying sensuality even more incisive and intense. For the first time, painting ceased to be erotic and actually became sensual, due to the effects produced by the woman's dress and the way her figure was silhouetted, accentuating the shape of her body. The artist neither exploited explicit sexuality nor erotic symbolism in this painting; rather, he relied on a new language. This language foresaw the mentality of the 20th century, in which eroticism implied a game that was almost metaphysical. This eroticism was portrayed through insinuation, which gained intensity by showing less and less.

In order to paint this portrait, Sargent was forced to argue with Monsieur Gautreau, to convince him to allow his wife to be portrayed. He embarked on the painting with great interest and worked on it constantly. Then, when the painting was finally exhibited in the Salon, the Gautreau family wanted it removed and destroyed. Sargent was confronted by many detractors, headed by Gautreau himself; they were not satisfied until the painter was driven from Paris.

Paul Helleu Sketching with His Wife

(1889)
oil on canvas
23.8 x 29.3 in
(60.5 x 74.3 cm)
Brooklyn Museum,
New York

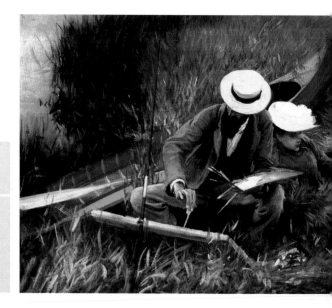

Nude Egyptian Girl

(1891)
oil on canvas
73 x 23 in (185.4 x 58.4 cm)
Private collection, on loan to
the Art Institute of Chicago

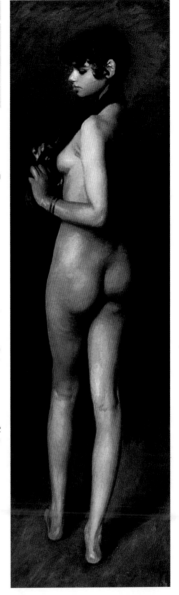

Throughout his artistic career, Sargent tried many different themes in his paintings. Regardless of whether he was painting a portrait, a landscape, or a nude, the artist always demonstrated his capacity to innovate, sometimes by using his study of the European old masters of painting.

This work, in which the influence of Ingres can be observed, presents a nude painted in a novel way. The erotic nudes painted by Ingres, based on a contextual view of the woman, are presented here as a sensual view of the woman's body itself. Sargent does not rely on an opulent, exotic setting; rather, he simplifies this scene as much as possible. He uses a smooth background and paints only the body of this girl, concentrating on her posture and gesture. These two elements are enough for the artist to create erotic tension. Sargent portrays the women's slender, smooth form slightly twisted to the left, so that the viewer is able to see the profile of her breast. Turning the woman's body produces a dynamic effect, giving the work a higher degree of realism and allowing the viewer to see the girl's face.

The artist has made the image more suggestive by making it ambiguous. Sargent evokes a moment in time that is a fantasy; the young woman stands in an empty space, against a background more suggestive than real. Her delicate skin, the exotic beauty of her face, and the lines used to define her figure increase the sensuality of the nude.

Left: The painter Paul Helleu (1859-1927) was one of Sargent's closest friends. Their friendship was sealed in 1878, when Helleu was financially ruined and close to abandoning painting altogether. Sargent visited him at one of his galleries and offered him 1,000 francs for one of his paintings. From that moment on, the two painters were inseparable.

In this painting, Sargent presents Helleu and his wife, Alicia Louise Guérin, in the woods. It was composed outdoors. The painting combines great realism and spontaneity in its portrayal of the couple. Helleu, seated, is seen from the front, his head hidden beneath a white hat. He is working on a painting that we cannot see. Meanwhile, his wife, painted from a side view, offers a more conventional portrait.

In group portraits, Sargent often assigned a defined area to each figure in order to give the viewer a clearer look at each model. In this painting, however, the artist allowed himself to be influenced by the Impressionists and by working outdoors, and he has painted the pair together within a small pictorial frame. The brushstrokes are blurred and the work is almost abstract, a contrast to the realism of his earlier works. When Sargent met the Impressionist painters of Paris, he was fascinated by the techniques they used in their outdoor paintings. Although he was not convinced to switch completely to this new, spontaneous type of art, the marvelous lighting effects that the Impressionists achieved in their paintings seduced him.

The Grand Canal, Venice

(1902)
watercolor over
graphite on white
wove paper
9.8 x 13.9 in
(24.9 x 35.3 cm)
Harvard University
Art Museums,
Cambridge,
Massachusetts

At the beginning of the 20th century, Sargent's painting took a turn that would eventually lead him to abandon portraits. His growing interest in landscapes and outdoor painting led him to Italy, where he painted a series of works on Venice. The beautiful and beloved Grand Canal is the subject of this relaxed watercolor, in which Sargent demonstrates his own particular concept of Impressionist painting. The artist, a close friend of Monet, did not completely share his pictorial ideas. For Sargent, Impressionism was innovative, but he believed that the exaggerated spontaneity and the use of light as a dictatorial protagonist minimized realism and serenity.

This painting is aesthetically similar to French Impressionism, but the strokes and the colors are more defined. The painter used a mixed technique to achieve the lighting details Monet attained using a diluted brushstroke. The slightly undefined buildings and boats evoke a very appealing, calm scene.

Muddy Alligators

(1917)
watercolor over
graphite on paper
13.5 x 20.5 in
(34.3 x 52.1 cm)
Museum of Art,
Worcester,
Massachusetts

With this painting, Sargent's talent in watercolors equaled that of his fellow American, Winslow Homer. Both artists shared a great passion for watercolor during the last years of their lives.

These alligators—a very modern theme for this time—allowed Sargent to explore all of the possible watercolor techniques in order to achieve great perfection and innovation. In this one work of art, the artist experimented with watered-down colors, glazes, and the different color mixtures possible with watercolors. He approaches this painting in a very different way than his earlier paintings. The brushstrokes are more spontaneous and the composition more homogeneous, relying on a variety of lighting effects.

In his final years, the painter experimented with other techniques and approaches. In Europe, Impressionism gave way to expressionism and the first avant-garde painters, who experimented with cubism. Sargent could not identify with this new stylistic age. Instead he concentrated on more intense hues and more relaxed themes. In this painting, the artist continues with his portrait approach, but the richness of hues allows him to adopt more carefree aesthetics.

EDWARD POTTHAST

Cold Feet *(detail), 1917, oil on canvas,*
12 x 16 in (30.5 x 40.7 cm), Private collection.

Edward Potthast used his academic background and the influences of the new Impressionist techniques to great advantage in developing his own personal style.

After initially studying in a Cincinnati art school, his early artistic vocation and drawing ability led him to work at quite a young age as a commercial illustrator for a lithographer. Later, after obtaining sufficient funds, he moved to Europe to finish his studies at the Munich Art School, which was popular among young artists from Cincinnati, where many artists were of German descent. There he learned to paint using chiaroscuro and drawing, academic resources that he would gradually abandon as he became more involved with Impressionism. The painter studied Impressionist works by the Irish painter Roderic O'Conor and later, in the United States, the Spaniard Joaquín Sorolla; both undoubtedly influenced his technique and subject matter.

Already established in New York as an independent illustrator, he could now dedicate himself full-time to painting. His style mixes the unique realism of American art with Impressionist techniques based on using soft brushstrokes and applying color directly in the open air. In New York, he would discover his greatest subject matter. Women and children strolling through the park or escaping the summer heat at the beach became the artist's trademark, a reflection of the carefree happiness of the American bourgeoisie at the turn of the century.

- **1857** Edward Henry Potthast born in Cincinnati, Ohio, on June 10, to a German working-class immigrant family.
- **1870** Studies art at the McMicken School in Cincinnati.
- **1873** Works as an artist at Strobridge Lithography Company in Cincinnati.
- **1882** Perfects his artistic techniques in Munich, Germany.
- **1883** First French Impressionist exhibition, in Boston at the International Exhibition of Art and Industry.
- **1885** Travels to Europe again, visiting Paris for the first time, where he studies at the Acadèmie Julian. Receives a medal from the Royal Munich Academy.
- **1886** Durand-Ruel brings Impressionist works to New York for a large exhibition.
- **1891** Joins the Cincinnati Art Club.
- **1892** First solo exhibition at Barton's Art Store in Cincinnati.
- **1895** Moves to New York, where he works as a freelance illustrator for magazines like *Scribner's* and *Century*.
- **1897** Becomes part of the Society of Western Painters.
- **1898** Member of the Philadelphia Art Club. The American Impressionist group Ten American Painters holds its first exhibition, with the support of the Academy.
- **1903** Has his first solo exhibition in New York at the Montross Gallery. Wins the Inness Prize, which he will be awarded again in 1906.
- **1904** Wins the silver medal at the University of Saint Louis Exhibition.
- **1906** Joins the National Academy of Design.
- **1908** Rents a studio in the Gainsborough Building in New York, offering views of Central Park.
- **1909** Attends a show by Spanish Impressionist Joaquín Sorolla organized by the Hispanic Society in New York.
- **1910** Starts a series of beach scenes. Travels to the Grand Canyon at the invitation of the Santa Fe Railway.
- **1911** Becomes a member of the group Men Who Paint the Far West. Starts to exhibit paintings made with his nephew under the same signature, as the two have the same name.
- **1912** Travels to Europe again. Becomes member of the League of American Artists.
- **1914** Wins the Hudnut Prize.
- **1927** Dies of a heart attack in his studio.

In the Park

(~1910)
28 x 22 in
(71.12 x 55.88 cm)
oil on canvas
Private Collection

After moving to New York, the painter found an inexhaustible source of inspiration in Central Park. From his studio in the Gainsborough Building, he could watch the activity of people and families, which motivated him to start making *plein-air* sketches of the street below.

This work presents the three consistent elements appearing in Potthast's work: children, water, and play. In this scene of two children feeding the ducks in a pond, his academic influence can be appreciated in the importance he places on the drawing and volumes, but his timid first attempts at the Impressionist technique can also be seen. He needed this free, loose technique to quickly capture on canvas the scenes that developed in the park.

Here, the loose Impressionist brushstrokes are free only in the ground in the foreground, not in the figures, nor in the representation of the small landscape around the pond. The landscape conveys calmness, and the dark colors that animate it are fairly academic, although Potthast's intimate nature already leans toward French mannerisms. Potthast was a master at representing sunlight on the water; here, he uses small splashes of color, applied directly to the canvas. The painting gives a mixed sensation: It is as if the lower part of the painting, which is more Impressionistic, is gradually taking over the scene—but without obtaining enough force to affect the background, still governed by convention.

Right: Potthast painted many scenes of different natural locations in the West, including the Rocky Mountains and the Grand Canyon. Other American painters had also felt great interest in these natural landmarks, so representative of American landscapes, and because of this, Potthast participated in founding the Society of Men Who Paint the West. The Santa Fe Railway invited Potthast to visit the Grand Canyon, and this work is the product of that trip. The darkness and mystery with which he depicted the scene stand out. The shape of the canyon is traced through the reflection of the sunset along the edges that sink into the depths. The horizontal sensation, common in landscapes of this era, is dramatically broken here by the depths of the canyon, which is like an enormous gaping mouth.

The dark palette contrasts with the golden strip of the sky in the distance. Potthast's use of dark colors to represent the moment just before nightfall, and his perspective, which makes the dark emptiness the main protagonist—is quite interesting, especially in contrast to the playful, clear, free, and color-filled brushstrokes he used for his coastal scenes, full of life and vibrancy. His academic influences can be seen here in the dark tones and the energy in representing the monumentality of the location.

However, what the artist truly loved was working with the light of the beach, capturing small, everyday moments of freedom—images of an age of innocence.

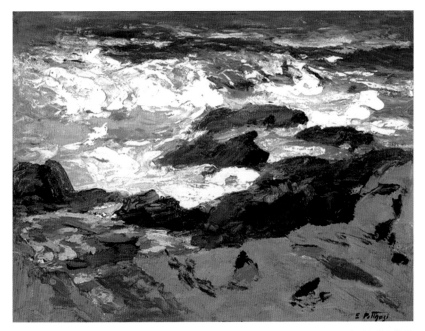

In this work, the strong surf seems to have flooded Potthast's painting with force and freedom. The broad brushstrokes spread the color directly over the canvas, without mixing them in the palette, adding vigor to the image. There is also a harmonious balance between the three colors—brown, blue, and white—as the artist avoids gradual tonal variations and instead offers high contrast.

The pure white of the waves breaking on the rocks imparts movement to the work, giving the impression of a wild sea rushing toward the viewer. Potthast had already done landscapes during his European journeys, but here he encounters the forcefulness and clarity of the Atlantic Ocean. Representing these waters in all their different states had to be an interesting exercise for the painter; over time, he discovered scenic reefs to further develop. Coney Island was a favorite tourist destination for New Yorkers at this time, but Potthast was terrified of going through the tunnel that provided the only access to the beach. Instead, he traveled with groups going to beaches near New York or heading north to the Maine coast.

Wild Surf

(1910)
oil on canvas
12 x 16 in
(30.48 x 40.6 cm)
Spanierman Gallery,
New York

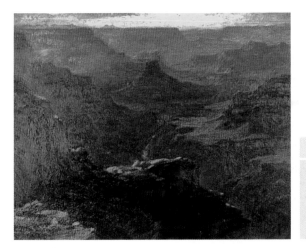

Grand Canyon

(1911)
oil on canvas
15 x 19.5 in
(38.1 x 49.5 cm)
Private collection

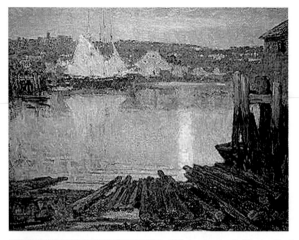

Twilight in Gloucester Harbor

(~1915)
oil on canvas
24 x 30 in (61 x 76.2 cm)
Private collection

This landscape is filled with the unique colors and brushstrokes of Impressionism, but adapted to Potthast's academic influences. The technique used is close to pointillism, as the colors are applied in small, very controlled touches, only mixing in the viewer's eye. The drawing has greater detail in the foreground, which gradually dissolves toward the horizon. However, this feature of French Impressionism does not overpower the work and dissolve the shapes of the figures. The composition is balanced: The dock with logs in the foreground is counterbalanced by the buildings on the other side of the lake. The wooden building on the pier reflects the afternoon sun, and the artist represents the volume through academic chiaroscuro. Upon this compositional balance, the Impressionist brushstrokes of pure color add brilliance and splash light onto the figures. The logs in the foreground are touched with lavender, and light floods the tranquil waters. The calm water is a mirror, reflecting the sky, the sunlight, and the silhouettes of the lighter-than-air boats.

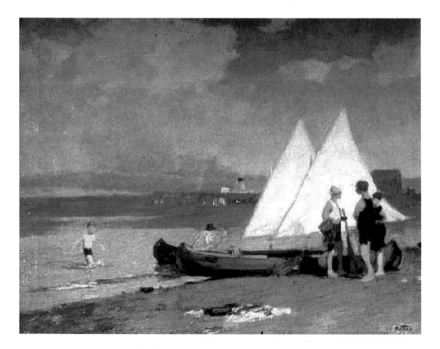

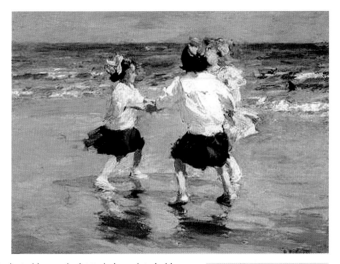

Although Potthast adopted Impressionist techniques late in his career, his paintings show the best of American Impressionism. He was applauded by both critics and the public during his lifetime, and collectors loved his beach scenes, with figures sitting on the sand, playing on the seashore, or swimming with carefree abandon. The influence of Impressionism did not come only from France. It had been more widely accepted in the United States than in Europe, and because of this—in time—shows were held of American Impressionists, such as Maurice Prendergast, or Europeans, such as Sorolla. In 1909, the New York Hispanic Society organized an exhibition of the work of Sorolla, showing scenes of the Valencia coast in Spain, washed in brilliant Mediterranean light. Potthast, a restless man interested in European art, surely attended, and the influence of these images on his work is still a subject of speculation.

Ring Around the Rosy

(~1915)
17.5 x 14 in
(44.5 x 35.5 cm)
oil on canvas
Private collection

In this work, which portrays three little girls playing near the sea, enjoying the last moments of the afternoon sun, the treatment of light is very similar to that of the Spanish artist. The same can be said of the color effects that create a mirror in the wet sand and the subject matter of the work. Loose brushstrokes outline the faces. However, the warm colors used by Potthast reflect the last rays of afternoon sun, while Sorolla usually preferred the brilliant morning sun. The happiness and lack of worry of the moment captured here are clear.

Left: Potthast's personality—shy, reserved, entirely focused on his work—belied the enormous popularity of his work with the New York bourgeoisie. Many of his works remain in private collections. The painter's works invariably impart sensations of friendliness and happiness; they reflect his own fortunate life, as he met with great success. Recognized by critics, acclaimed by the public, and full of love for his art, he was able to paint until the last days of his life.

This work depicts what would be most common in his work until the end of his career: relaxing days of fun and entertainment on the beach. Two bathers chat with the owner of a boat who has just stepped onto the sand, and a boy, perhaps the son of the couple, plays in the waves by the shore, waiting for his parents to finish their conversation.

The composition is coordinated by the two boats and the dock in the background, which lend balance to the scene. (A volumetric approach, based on free brushstrokes, was used to create the person in the boat.) Potthast also creates balance by contrasting the light and dark hats of the men on the boat, the brown skin of the couple and the off-white of the child, and the white and black shirts of the adults in conversation. But the first thing that attracts the viewer is the enormous triangular sails, which add emphasis to the group of people. Then the eye slips to the left, passing along the side of the boat to rest upon the child. Broad, Impressionistic brushstrokes create the sand and the spacious sky, as well as coating the skin of the bathers with brilliant light.

The Conference

(~1915)
oil on canvas
24 x 30 in
(61 x 76.2 cm)
Private collection

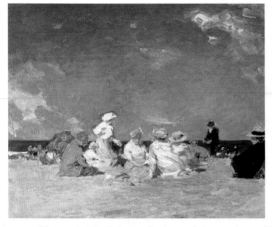

Afternoon Fun

(1915)
oil on canvas
24 x 30 in (60.96 x 76.2 cm)
Butler Institute of American Art,
Youngstown, Ohio

This work is an excellent example of Potthast's mature style. Although it appears to be a casually portrayed beach scene, in reality it is the controlled product of advance planning on the artist's part. Potthast has calculated the composition so that the balance of colors and shapes, along with the tidy details and the choice of a specific viewpoint, serve as a base for Impressionistic brushstrokes.

The group in the foreground first draws the viewer's attention, which then moves toward the bathers in the background that balance the setting. The contrasting colors of the white blouse of the kneeling woman and the dark suit worn by the man sitting on the sand lend counterbalance to the scene. The dark blue tone is echoed in the figure of the other man and, finally, on the horizon of the seascape. Within this structure, the broken, Impressionistic brushstroke distributes the lilac reflections of the light on the white sand, while broader strokes are used on the clothing and the clouds. The way Potthast treats the figures and his use of intense bright colors are reminiscent of the work of Prendergast.

Open-air painting was a great discovery for the Impressionists, as it allowed them to capture spontaneous moments and essential elements in quick, dynamic sketches. Certainly this colorful painting captures the essence of a casual picnic by the sea with friends.

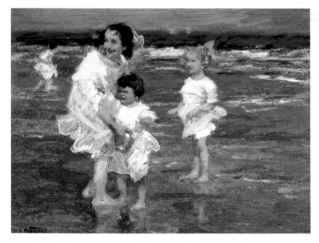

Cold Feet

(1917)
oil on canvas
12 x 16 in
(30.5 x 40.7 cm)
Private collection

Children were one of Potthast's favorite topics, as they were the living representation of playfulness, happiness, and well-being, and the works they appear in tend to have an innocent, sweet tone. This scene captures the moment when a group of children approach the sea to wet their feet. The water is cold, and the smallest child cries with displeasure. The girl holding her glances, smiling, toward someone outside the picture, probably an adult.

This instant appears to have been captured with a quick sketch, and Potthast did spend long periods of time at the seashore, watching the activity and making rapid outlines directly with his oil paints. This mastery came from his earliest training, which emphasized drawing. With his excellent draftsmanship, he could capture these brief moments and later transfer them to canvas.

Potthast started creating this series of coastal scenes in 1910, and they continued to be his favorite subject matter until the time of his death. His use of pastels for the girls' clothing imparts delicacy to the figures. Even here, a hazy sensation is conveyed, a product of the free, Impressionistic brushstrokes. The reflection of the figures in the wet sand is achieved through direct application of color, creating perfect balance: The three young girls in the foreground are connected to a fourth figure, as well as with the white surf and the white sails of the boats on the horizon.

CHILDE HASSAM

Self-Portrait, The Etcher, *etching and drypoint,*
National Portrait Gallery, Smithsonian
Institution, Washington D.C.

Among American painters, Childe Hassam best
assimilated the new ideas proposed by the French
Impressionists. He developed these concepts in a
truly American spirit.

Because he worked as an illustrator while
completing his studies in Boston, he was able to
have his own studio at a young age. He devoted
his time to observing the city and then repre-
senting it in his paintings.

Even in his earliest works, Hassam demon-
strated tremendous interest in representing
everyday scenes of life in the city under different
weather conditions. To do this, he used a dark,
opaque palette and relied on a profound and
academic perspective.

After three years in Paris, where he studied the
work of French Impressionists, he settled in New
York. Once there, he portrayed the city in the same
way that Claude Monet and Camille Pissarro had
portrayed everyday life in Paris. However,
Hassam's work was original; he added a bit of the
optimistic sprit that characterized American art.

In the same way, his use of toned-down and
pastel colors, as well as his fancy for emphasizing
the pictorial area and structure of objects, due to
his strong academic influence, distinguishes his
works from those of French Impressionism. In fact,
they even distance him from the influences of
post-Impressionism.

Hassam, who was a very prolific artist, painted
not only city scenes, but also landscapes and still
lifes. Today, his paintings can be admired in more
than 100 museums throughout the world.

- **1859** Born in Dorchester, Massachusetts, into
one of the most important families in Boston.
Family members include the painter William Mo-
rris Hunt and the architect Richard Morris Hunt.
- **1872** The family business, in Boston, is lost in
a fire. Hassam begins to work in the accounting
department at Little, Brown and Company.
- **1877** Takes classes at the Boston Art Club, and
at the same time receives private instruction from
other artists, including William Rimmer and
William Morris Hunt.
- **1883** Takes his first trip to Europe and begins
by visiting England. Upon his return, he exhibits a
group of watercolors that are very well received
by the public. He sets up his own studio in Boston
and begins to paint scenes of the city.
- **1886** Moves to Paris to take painting classes,
and his paintings are accepted at the Salon de
Paris and in the Exposition Universelle, where he
wins a bronze medal.
- **1889** He settles in New York and paints differ-
ent views of the city. His work is shown in an
important exhibition in Boston.
- **1890** Visits the island of Appledore, near
Portsmouth, New Hampshire, and begins work on
a series of landscapes, which he would paint over
a 20-year period.
- **1898** Along with other painters, he founds
Ten American Painters.
- **1900** Presents his first individual exhibition
and is acclaimed by critics as the painter who
brought Impressionism to America.
- **1902** Enters the National Academy of Design
as an associate member.
- **1904** Begins a series of train trips through the
American West.
- **1906** He is elected academician of the
National Academy of Design.
- **1913** He exhibits twelve paintings in the
Armory Show, but is skeptical about many of the
works presented.
- **1917** The United States enters World War I,
and Hassam paints a series of flags.
- **1918** He stops doing joint exhibitions with the
Ten American Painters.
- **1919** He moves to East Hampton, Long Island,
already recognized as one of the most important
American painters. He begins to do engravings
and illustrations once again, and at the same time
begins his Window series.
- **1933** A catalogue raisonné of his works,
which includes 376 pieces, is published
- **1935** Dies on August 27 in New York after a
prolonged illness.

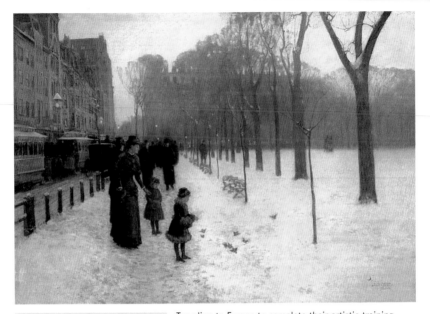

Boston Common at Twilight

(1886)
oil on canvas
42 x 60 in (106.68 x 152.4 cm)
Museum of Fine Arts, Boston

Traveling to Europe to complete their artistic training was a common goal for American painters, who were anxious to study firsthand both the novelties stirring in the French capital and the works of the old masters.

Hassam's first paintings, such as *Boston Common at Twilight*, were strongly influenced by what he had learned in Boston under Rimmer and the German artist Gaugengigl. Both the profound perspectives and the importance given to sketches, which he drew with extraordinary ease, were evidence of the weight that his academic studies and the teachings of William Morris Hunt had on his works. Hunt taught the artist to concentrate on details, like the French painters from the Barbizon School.

However, his first tour through Europe, which took him to England, France, Italy, and the Netherlands, also had a great impact. He was impressed by the characteristic light of each country, and he had the opportunity to see the works of William Hogarth and J.M.W. Turner and to study the great masters of the 17th century. From these experiences, he developed his soft palette filled with ochre and grays, which he used to illustrate his first city scenes. By 1885, Hassam had already achieved great success as a watercolorist and illustrator, but he wanted to develop his career as a painter. Every day he observed life in the city from his Boston studio. His interest lay in representing the city's incessant activity on canvas, without revealing the volume and structures of figures or objects.

The Little Pond of Appledore

(1890)
oil on canvas
16 x 22 in
(40.6 x 55.8 cm)
Walter M. Schulze Memorial Fund, through prior acquisition of the Friends of American Art Collection, Art Institute of Chicago

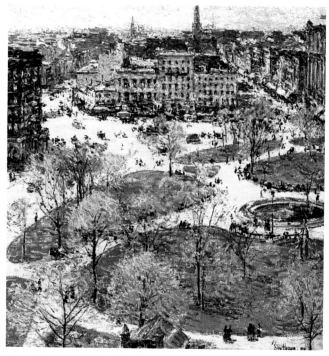

This is one of Hassam's most famous paintings. The artist portrayed New York City in much the same way that the French Impressionists reflected life in Paris, but with an added touch of lively optimism that was uniquely his own. Pedestrians, streetcars, and horse carriages are distributed through the long wide avenues and enormous buildings, which served as proof that New York was an exciting new metropolis.

Details are gradually eliminated so that in the distance, only large blue brushstrokes of sky can be seen. In the foreground, the artist starts with an enormous square, which breaks off into two avenues, packed with businesses, pedestrians, and plenty of activity. Hassam found it difficult to abandon the need to give perspective to his painting, as he had been taught. More people stroll around the pond and through Union Square, adding to the hubbub. This painting offers a remarkable look at New York, already a center of culture and power, at the turn of the last century. Americans were interested in what was happening in Europe, but they were committed to their own art scene and economic growth.

Union Square in Spring

(1896)
oil on canvas
21.5 x 21 in
(54.6 x 53.3 cm)
Smith College Museum
of Art, Northampton,
Massachusetts

Left: Hassam arrived at Appledore, a small island off New Hampshire, looking for new locations to paint en *plein air*, a technique that he had already adopted when studying in Paris. On the island, he found a crystal-clear atmosphere, full of bright light that flooded the landscape. While his use of loose and visible, yet controlled brushstrokes was evidence of the Impressionist influence on his technique, his use of white and pastel hues reflected the power of the brilliant light on Appledore scenes. This work shows how Hassam employed the French painters' findings to represent the purity of American light. Here, he was able to create a genuinely original Impressionist work. Studying nature was still not common in America, and Hassam was one of the first artists to go to the place he wanted to portray, easel in hand. He was so impressed with the landscapes on the coast of New Hampshire that he returned a number of times over the next 20 years to recapture their brilliance.

Social changes produced by industrialization permitted the middle classes to enjoy more free time and to escape from the city. Therefore, painters often illustrated beautiful tourist landscapes, places that travelers might like to visit. When he painted this, Hassam was already well known in the United States market and had settled in New York with his wife after major success in Paris in the Salón and in the Exposition Universelle.

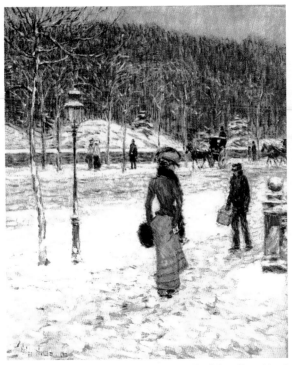

New York Street

(1902)
oil on canvas
23.5 x 19.5 in
(59.7 x 49.5 cm)
Art Institute of Chicago

Hassam did not always paint from the windows of his New York studio. He also came down to the street to capture moments of everyday life in different weather conditions. He was most interested in the winter, because the light of the snow created interesting reflections.

Here, the familiarity of the scene, with the woman gathering her skirt to keep it dry, brings the viewer closer to the people on a winter day long ago. The shaded and sad ochre color contrasts with the brilliant white light reflected by the snow, which, like the other elements, is defined with very free brushstrokes.

The perspective shows Hassam's strong academic influences. Yet in 1898, he had separated from the Society of American Artists because he disliked the way they presented exhibits—they included too many works in a space that was too small. Besides, the prizes awarded to the winners of these shows were not the sales of their works, as there were few buyers interested in works chosen by Academies. Instead, they awarded scholarships and other prizes that neither Hassam nor any others in his group desired.

Setting a precedent in the history of American art, he founded the society Ten American Painters in 1898, along with other painters who had studied in Paris, including Thomas Wilmer Dewing and John Twachtman. Through this organization, they were able to hold independent exhibitions without having to pass through Academy filters. Later, William Merritt Chase joined the group after Twachtman died, the same year that Hassam painted this work. The Ten American Painters exhibited annually until 1918 and set precedents for the epoch-making Armory Show of 1913.

Hassam's brushstroke became freer as he explored landscapes under different weather conditions. The fleeting instant of twilight on the coast allowed Hassam to free his paintings from the limits set by painting figures. Instead he concentrated on the large color masses of clouds in the landscape. His brushstrokes can be tracked in this painting, where the sea's apparent calm hides an unusual force; its energy is portrayed using wide brushstrokes to give a sense of volume. The colors were applied directly to the canvas. The pure colors create contrasts that make the light in the landscape stand out, accentuated by the effects of sunset. The sea, without pounding waves is totally calm, and looks like a mirror reflecting the last rays of the sun as they come from the horizon; a sailboat plying the waves catches the viewer's attention. The landscape is relaxed because of the horizontal composition created by the sea line and the boat. The distant coast, dwarfed by the clouds above it, also adds to this effect. Beautiful colors and contrasts make the seascape particularly appealing.

Isles of Shoals at Dusk

(1906)
oil on panel
Art Complex Museum,
Duxbury, Massachusetts

Left: This painting, created in Hassam's studio on West 67th Street, is one of the first representations of New York's characteristic skyline. On this occasion, Hassam set his daytime scenes aside to concentrate on the city at sunset. The painting has a mysterious tone, along the same lines as James McNeill Whistler's views of the Thames or the photographs taken by Alvin Langdon Coburn and Alfred Stieglitz to portray the contemporary city.

Hassam's image is intimate and poetic, showing a city in transition toward new values, set against the sunset of old traditions. Hassam's vision illustrates the changes in New York at the beginning of the 20th century. It had become a model of industrial and economic development, here defined by the outline of the buildings cutting into the sky. The East River reflects the last flashes of light as nighttime approaches and hides the face of the buildings. The sun descends upon the city, creating a foggy effect on the opposite shore. The outlines dissolve into light-colored brushstrokes, while the shaded shapes of the buildings still give some hint of life.

The volumes in this painting, following a broken line, are depicted by very free brushstrokes. The artist uses a gray palette for the buildings in the second plane and a darker ochre palette for the hidden faces of the buildings in the dark foreground. Hassam distributes the lighted areas produced by the sun to decorate the sky, using pastel hues applied with large strokes.

Manhattan's Misty Sunset

(1911)
oil on canvas
18 x 32 in (45.72 x 81.28 cm)
Butler Institute of American
Art, Youngstown, Ohio

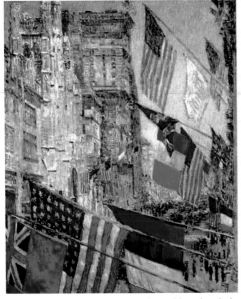

Allies Day in May 1917

(1917)
oil on canvas
36.8 x 30.2 in (93.4 x 76.8 cm)
National Gallery of Art,
Washington, D.C.

When the United States entered World War I, Hassam developed a patriotic spirit and began work on a series of New York scenes, which he called Flag Series. These paintings show New York City decorated with the flag of the United States and its allies.

Ancestors of Hassam's had been heroes of the American Revolution. This, along with the festival of colors, surely motivated him even more to paint these works, which were enormously successful with the American public. The view of the New York streets filled with color is very similar to Monet's painting *Rue Montorgueil in Paris* (1878). Here, the chromatic explosion provokes a sense of vitality and optimism. France, the Impressionists' ally as well as the United States', is also represented by its flag. Hassam emphasizes the red, white, and blue of the allied flags to show that the two nations are united.

The light is so bright that the shadows are blue and not green, as taught by academicians. The brushstrokes are evident but controlled and the figures of the pedestrians are no more than brief blurred touches of color. The light takes on life and vibrates as it collides with the buildings, presented as a singular unit. These works would be the last Impressionist paintings created by Hassam, who ended the series in 1919.

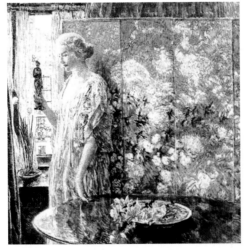

Tangara

(1918)
oil on canvas
58.7 x 58.7 in (149.2 x 149.2 cm)
Smithsonian American Art Museum, Washington, D.C.

Hassam also painted inside spaces, and he created a whole series of paintings whose principal theme was a window. In these intimate scenes, a woman always appears, either seated or standing in a relaxed position, in a silent atmosphere that contrasts with the hubbub of Hassam's portrayals of the city. Women were a recurring theme in Impressionist paintings; in many, sensuality was emphasized by attitudes that were sometimes apathetic. Exotic themes also interested Hassam; here, he includes a Japanese-style folding screen and Chinese irises on the windowsill. As they ascend, they reflect the angle of the woman's arm, holding a small sculpture symbolizing the city's growth. Her other hand rests on the round table, where a still life of a bowl with flowers balances the composition. The golden light entering through the window is reflected onto the woman's clothes and gathered hair. At the same time, it reveals her absent expression, perhaps to show that she suffers from the melancholy that is characteristic of life in the city.

After painting this cycle of paintings, Hassam moved to East Hampton, Long Island, where he began to work on etchings and watercolor illustrations once again. When he died, he had become one of the most famous and prized American painters.

FREDERIC REMINGTON

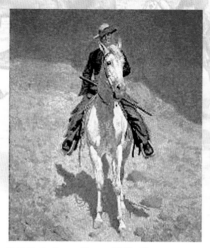

Self-Portrait on a Horse, *1890, oil on canvas, 29.1 x 19.6 in (74 x 49.8 cm), Sid Richardson Collection of Western Art, Fort Worth, Texas.*

Frederic Remington was the most famous artist to portray the American West. This uncivilized and wild world, characterized by danger and adventure, populated by Indians and cowboys, bandits and ranchers, was already passing into history when Remington began drawing his illustrations.

He had grown up in the country, surrounded by horses and enlivened by the stories of war and adventures told by his father, a former cavalry colonel who worked as a newspaper editor. His father had much to do with Remington's early interest in the West. After the young man had attended a military academy and then the Yale School of Art, he traveled to see the intriguing world that he had heard so much about.

His inspiration came from the combination of his direct experience as a painter who spent long periods of time in the West and his artistic ability. Although the scenes that he portrayed were considered to be truthful testimonies, they were, in truth, largely products of his imagination. However, the elements that composed them were not invented, and they have come to form part of our popular culture.

Remington's representations were very exact and highly dramatic. His talent for illustration also made it possible for him to enter into the world of journalism as a war correspondent working for William Randolph Hearst.

His career lasted a little less than 25 years, but he produced a great numbers of works related to the West, including paintings, sculptures, and illustrations. His portfolio is made up of a total of almost 3,000 works.

- **1861** On October 4, Frederic Remington Sackrider is born in Canton, New York.
- **1873** The Remington family moves to Ogdensburg, New York.
- **1875** Enrolls at the Vermont Episcopal Institute.
- **1876** Enrolls at the Highland Military Academy in Worcester, Massachussets.
- **1878** Starts attending the Yale School of Art, where he becomes involved in football and boxing. He lasts three semesters.
- **1880** His father dies. He leaves Yale and returns to Ogdensburg.
- **1881** Travels to Montana to get his first personal impression of life in the West.
- **1882** *Harper's Weekly* publishes one of his first illustrations.
- **1884** Invests in a saloon and store in Kansas. He marries Eva Caten, in New York. They settle in Kansas.
- **1885** The couple travels to Brooklyn, New York.
- **1886** Attends classes at the Art Students League in New York and begins his journalistic career.
- **1887** Travels to North Dakota, Montana, Wyoming, and western Canada. He exhibits for the first time at the American Watercolor Society and the National Academy of Design.
- **1888** His illustrations accompany articles written by Theodore Roosevelt for *Century*.
- **1889** His work earns a silver medal in the International Exposition in Paris.
- **1890** Moves to New Rochelle, New York. Exhibits alone for the first time at the American Art Association.
- **1891** Becomes an associate member of the National Academy of Design in New York.
- **1895** Meets the sculptor Frederic W. Ruckstull, who encourages him to sculpt in bronze. He writes and illustrates *Pony Tracks*, his first book.
- **1897** Sent as a reporter by William Randolph Hearst to cover the Spanish-American War in Cuba. He exhibits 40 works in Boston.
- **1898** His book *Crocked Tails* is published.
- **1899** Begins to draw illustrations for *Collier's*.
- **1900** Acquires a summer house in Ingleneuk, New York.
- **1901** Publishes a portfolio of lithographs in color called *A Bunch of Buckskins*.
- **1906** Writes and illustrates *The Way of an Indian*.
- **1909** He dies on December 26, of appendicitis. In less than 25 years, he created more than 3,000 works of art.

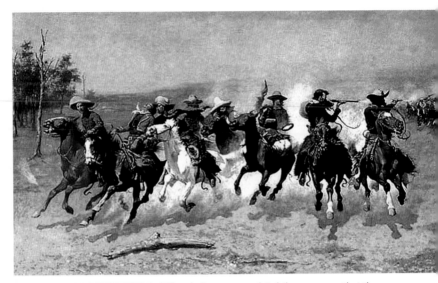

A Dash for the Timber

(1889)
oil on canvas
48 x 84.1 in (122.6 x 213.7 cm)
Amon Carter Museum, Fort Worth, Texas

This painting was completed the same year that the painter won the silver medal at the Exposition Universelle in Paris. By this point, Remington had already stopped studying at the Art Students League in New York and had become a well-known illustrator, appearing in such publications as *Century* and *Harper's Weekly*. His skill at instilling dramatic intensity in the scenes he re-created, in addition to his extensive knowledge about the American West, caused a great public demand for his illustrations. People wanted to know more about the life of the Indians and cowboys on the other side of the continent. His scenes were interpreted to be faithful representations of real-life events, even though they were surely products of his imagination. However, he had certainly observed the objects and people that appeared in his works, and they give his works great historical value.

This painting is one of the most brilliant examples of Remington's work. Beneath a blue sky, eight riders gallop to escape an Indian attack. The horses, at breakneck speed, head for the woods. Some of the riders turn on their mounts to shoot—but suddenly, one of the men is hit by an enemy bullet and falls back. The rider next to him tries to rescue the wounded rider, while another stares directly at us. Remington's characters, alive and dynamic, convey the tenseness of the moment, while the exact description of the scene adds a great deal of energy to this composition.

The Scout: Friends or Foes

(1890)
oil on canvas
27 x 40 in (68.6 x 101.6 cm)
Clark Art Institute, Williamstown, Massachusetts

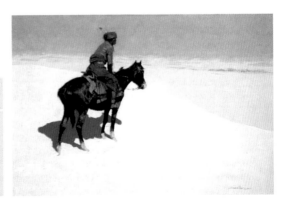

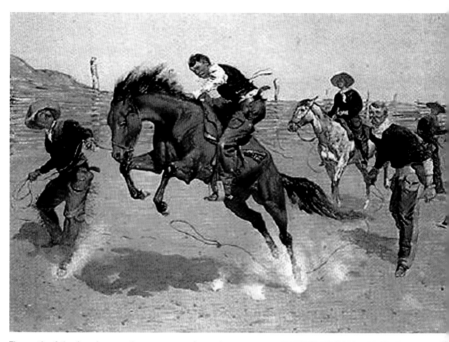

The myth of the American cowboy was created, to a large extent, by Remington's paintings. The Stetson hat, the revolvers, the boots and spurs, and the inseparable horse became part of the legend.

One of the most dangerous cowboy activities was breaking horses; a fall or a kick could cause serious injury or even death. There is no doubt that the painter had seen scenes like these years before, when he left for Kansas and tried, without success, to become a rancher. The main protagonist in this painting is the

Turn Him Loose, Bill

(1893)
oil on canvas
25 x 33 in (63.5 x 83.8 cm)
Anschutz Corporation,
Denver, Colorado

horse, who jumps and writhes, trying to throw the rider. Meanwhile, the rider holds on with all his strength. The vigor with which the artist treats the rider's anatomy and musculature is reinforced by the loose brushstrokes on the horse's mane. A shadow on the ground intensifies the sense of movement. The coarse brushstrokes, used to apply a range of warm and earth colors, help to reflect the tough daily life of the hardened Western man. The description is so exact that the viewer can almost hear the horse neigh and the men shout to cheer on their friend. The details, like the dust lifted into the air by the figures, help to convey the tension of the moment; the viewer enters the action.

Left: Remington used color to create atmosphere and fill his scenes with emotion. His compositions are always based on one dominant color. In this painting, Remington illustrates the full moon on a wintry night: It brightens the sky just as if it were daytime. Here, the painter was concentrating on the effect of moonlight on the pure white snow, causing the figure to stand out.

The painting depicts a Blackfoot explorer, who stays alert despite the extreme cold of the wintry night. The portrait of this scout, who observes the faraway arrival of an intruder, is almost heroic. The immaculate white snow is broken only by the horse tracks, which reveal that the horse has not moved an inch. The horse's frozen breath gives a sense of spontaneity. The way the Indian scout is characterized, with winter clothes and a leather hat, emphasizes the moment. In this way the artist conveys a sense of realism, as if the painting were a true report of the times.

Remington showed the Indians a great deal of respect and was very close to them on various occasions. He also witnessed their fruitless fight to keep their lands. He watched the hostilities between Indians and frontier troops being played out, realizing that even though the Indians were in the right, they were destined to lose.

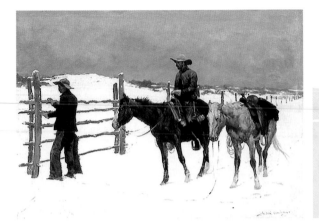

**Fall
of the Cowboy**

(1895)
oil on canvas
25 x 35.1 in
(63.5 x 89.2 cm)
Amon Carter Museum,
Fort Worth, Texas

Remington's vision of the West had been influenced by his father's stories and by his childhood in the country, where he was surrounded by horses. But his vision was shattered the first time he crossed the frontier. The proliferation of settlements, encouraged by the improvement in communications thanks to the railroad and the relative security provided by the decline in Indian resistance, had changed the way of life. The adventurous cowboy, living a wild, free life as he drove cattle across the plains, was doomed to disappear.

Remington expresses his sadness in this painting. Times were tough for the cowboys, who had to move on when winter came. The gray palette and brushstrokes that blur the edges and the faces accentuate the melancholy mood. The battered horses share the silent scene, which is no more than a farewell.

Nevertheless, the author maintained the spirit of the West in his creations, whether they were pictorial or sculptural. In 1895 the artist began to create his first bronzes, encouraged by the sculptor Ruckstull, a neighbor. Although Remington led a comfortable life thanks to his illustrations, he wanted to have his art acknowledged critically. His sculptures have the same dramatic quality and feeling found in his painted scenes. The West offered Remington an unexplored world, purely American, full of unusual situations that required the vision of a truly American artist, free of European influences and capable of directly capturing the essence of this world. Theoretical guidelines did not serve for portraying the West. Only an artist with the American spirit, a pioneer, innovator, and active observer, could portray this untamed world.

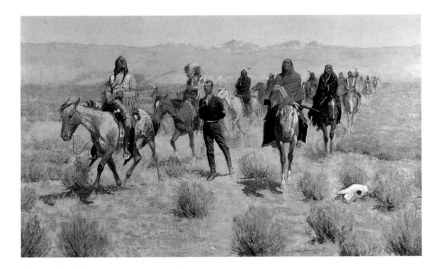

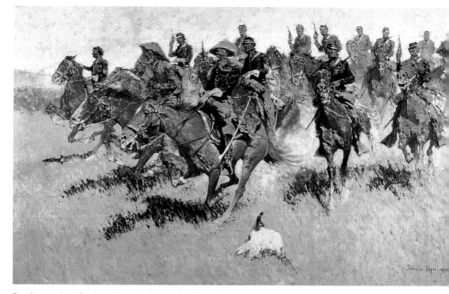

Remington had firsthand knowledge of the life of United States cavalry soldiers; he had joined them on campaigns through the Southwest on numerous occasions. Skirmishes with the Indians, which had been the main focus for these men for a long time, were becoming less frequent.

The Cavalry Charge

(1907)
oil on canvas
30.2 x 51.2 in (76.6 x 130 cm)
Metropolitan Museum of Art,
New York

In this painting, Remington re-creates one of these scenes, acting as both an artist and a historian. The sense of place and the authenticity of the details give tremendous historical value to this work. The soldiers come charging in from a high ridge at lighting speed, pistols ready, spurring their horses on. The artistic value of this painting lies in Remington's ability to adapt Impressionist technique to his own rough, vigorous style.

The artist, who had become discontented with being an illustrator and then had great success as a sculptor, returned to painting in 1900. He was well aware of the fact that the West had died, and he concentrated on exploring new techniques in order to abandon his illustration style. To this end, he looked to American Impressionism, and especially his good friend Childe Hassam, who was his main source of ideas. The fruit of his research can be seen in this painting. Here, he concentrates on the study of color and light, as opposed to the drawing or lines, giving the scene a dreamlike atmosphere. The animals and figures are simply brushstrokes; Remington accentuates the aggressive moment and abandons definition and clarity.

Left: This painting recollects a moment in which a group of Indians is guarding a prisoner, an American soldier. This scenario captures the drama and the insecurity of both the settlers in Indian territory and the Indians themselves. The Indians look out into the horizon, always on guard. The setting is distinctively the American West. Nothing is missing from the background— not the mountains, the bushes, or the cow's skull on the dusty earth. The brushstrokes are free and almost look like splashes of color, blurring the faces of the figures. The sun reddens the prisoner's face, as though it were a warning, but the prisoner does not look desperate; he has accepted his fate. The Indians, on the other hand, have remarkable dignity, with their fixed stares and raised chins. Rich, warm colors are used, giving life to the scene.

Missing

(1899)
oil on canvas
29.5 x 50 in
(74.9 x 127 cm)
Gilcrease Institute,
Tulsa, Oklahoma

William Randolph Hearst sent Frederick Remington to Cuba as a war correspondent. He was to cover the Spanish-American War there, and his job was to send illustrations of the atrocities the Spanish committed against the prisoners. However, Remington soon abandoned the battlefield, informing Hearst that there was no war going on there. Hearst famously replied that there would be, and proceeded to invent stories to fill the pages of his newspapers. Remington's disenchantment with newspapers and journalism compelled him to devote himself to his bronzes.

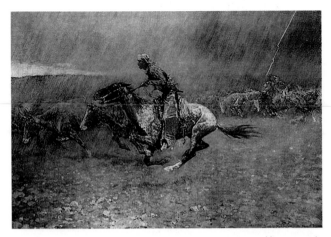

The Stampede

(1908)
oil on canvas
27 x 40 in
(68.6 x 101.6 cm)
Private collection

Remington was a master at making expression come through in his paintings, whether he was using illustrative methods or Impressionist techniques. He was always able to join all of the composition's elements to convey a sense of movement and vigor rarely seen in the history of art. In Remington's paintings, the realism so characteristic of American art finds the energy to fill the moment being portrayed with life. The originality of this work comes from using the compositional horizon, normally employed for restful situations, to heighten the sensation of speed. The composition also serves as a frame for this dramatic scene.

The protagonist of this work is the galloping rider, who seems to be suspended in air, captured at just the moment when his horse's feet lift off the ground. The horse's racing speed is reflected in the fleeting brushstrokes used by Remington to represent the animal's mane and tail. The rest of the figures blend into the background, beaten by the rain and threatened by the lightning. The light under the cloudy mass is painted with a greenish palette, which mixes grayish hues with blue shades and pale yellows for the rocky terrain. The cloud-covered sky blends with the stampeding herd, terrified by the storm.

The Herd Boy

(1908)
oil on canvas
27 x 45 in
(68.6 x 114.3 cm)
Museum of Fine Arts,
Houston, Texas

Many American artists of the 19th century had reflected the garments, weapons, and habits of the Indians, but only Remington knew how to add dramatic quality and scenography to his documentary works. This painting is the culmination of the painter's career. With it, he is able to convey the great emotional charge of the scene without relying on the movement and dynamism found in his earlier works.

The snow's white color blends with the gray sky on the horizon, creating the background for the figure of the Indian boy with his horse. These are the indisputable protagonists of this work; with their remarkable detail, they are entirely real. Here the loose Impressionist brushstrokes are reserved for the brush on the ground and the tepees lost in the snowy background. The silence and calm, together with boy's hunched position and the representation of the tired, thin horse, convey the harsh cold. The freezing wind lifts some snowflakes onto the animal's mane, while the boy watches the grazing horses, hardly sketched. The free life of the plains is coming to an end.

ROBERT HENRI

Self-Portrait, *1903, oil on canvas,*
32 x 26 in (81.28 x 66.04 cm), Sheldon
Memorial Art Gallery and Sculpture Garden,
Lincoln, Nebraska.

Robert Henri's work is considered both the culmination of the realism proposed by Thomas Eakins, and the start of a more independent painting that reflects the real world. From the canvas, as well as from his teaching positions in academies and schools, Henri always encouraged his students to go beyond the academic rules—which he considered obsolete and excessively European.

After he studied at the Pennsylvania Academy of the Fine Arts with Thomas Anshutz, who admired Eakins's realism, Henri left for Paris to study at the Académie Julian, famous for its liberal educational methods. There, he studied the work of the great masters. He was drawn to the Impressionist's loose brushstroke and the skill of Édouard Manet. Henri also traveled to Italy and Spain, where studied the work of Diego Velázquez. When he returned to the United States, he moved to New York, attracted by the vitality of a vibrant, modern city that welcomed immigrants of all nationalities. He founded the Eight, later called the Ashcan School because of the realism of its members as they portrayed the dark side of life in the slums.

Robert Henri also played a major role after World War I, when America's doors opened to the artists of the European vanguard who settled in New York, inspiring the creation of the International Exhibition of Modern Art, also known as the Armory Show.

- **1865** Robert Henry Cozad born in Cincinnati, Ohio, on June 25, the son of John Jackson Cozad and Theresa Gatewood. When the boy is eight, his father founds Cozad, Nebraska.

- **1882** His father, a businessman and professional cardsharp, is accused of murder and the family flees. His father changes the boy's name to Robert Henry, later Henri.

- **1886** Takes classes at the Pennsylvania Academy of the Fine Arts with Thomas Anshutz.

- **1888** Studies at the Académie Julian of Paris with William-Adolphe Bouguereau and Joseph Nicholas Robert-Fleury. One of his paintings is accepted at the Salon.

- **1891** Admitted to the École des Beaux-Arts in Paris. After traveling to Spain and Italy, returns to Philadelphia to teach at the Philadelphia School of Design for Women.

- **1895** Travels to Europe with William Glackens. Studies the work of Frans Hals and Édouard Manet and the Impressionists; he admires their loose brushstrokes.

- **1897** Holds an individual exhibition at the Pennsylvania Academy of the Fine Arts.

- **1902** Settles in New York and gathers around him a group of young painters who share his rejection of the stagnant posture of the Academy.

- **1903** Member of the Society of American Artists.

- **1906** Academic member of the National Academy of Design of New York.

- **1908** Founds the Eight, which exhibit at the Macbeth Gallery of New York for the first time. Among them are Everett Shinn, George Bellows, William Glackens, John Sloan, and Henri.

- **1909** Founds the Henri Art School.

- **1912** Goes to Madrid, where he rents a studio. Makes sketches of surrounding areas.

- **1916** Elected member of the Society of Independent Artists.

- **1923** A student, Margery Ryerson, publishes extracts of his classes in the book *The Art Spirit.*

- **1925** Teaches at the Art Students League.

- **1929** Dies of cancer on July 12 in St. Luke's Hospital in New York City.

Night, Fourteenth of July

(1895-1897)
oil on canvas
32 x 25.8 in (81.28 x 65.41 cm)
Sheldon Memorial Art Gallery and
Sculpture Garden, Lincoln,
Nebraska

When Henri painted this work, it was the second time he had visited Paris. He had gone to the French capital ten years before to study at the Académie Julian, known for its liberal educational methods. There he became familiar with the latest aesthetic trends, such as Impressionism. Its influence can be seen in this portrayal of an evening party. The mastery with which Henri depicts the red Chinese lanterns reflected on the Seine stands out. Despite the darkness, several figures can be seen. They appear with their backs toward the viewer, watching the celebrations for Bastille Day. The women in the center of the composition are barely lit by a beam of light that makes their dresses visible. The lady, at the left, is defined by the two white brushstrokes that make up the blouse's collar and the edge of the petticoat under her skirt. The lady is accompanied by a young woman; from her hat and apron, she could be a housekeeper, or a nanny. She holds a baby in her arms, but only the shawl covering the baby can be seen.

This work, which evokes the Impressionist brushstroke, is also reminiscent of the chiaroscuro of Baroque painters, which Henri had admired on his visit to Spain and Italy. *Night, Fourteenth of July* is also reminiscent of James McNeill Whistler's *Nocturne*.

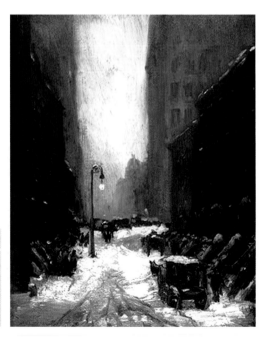

Snow in New York

(1902)
oil on canvas
32 x 25.8 in (81.3 x 65.5 cm)
Private collection

Salome

(1909)
oil on canvas
77 x 37 in (195.6 x 94 cm)
Mead Art Museum,
Amherst College,
Massachusetts

The National Academy of Design rejected this work for its annual exhibition, although Henri had been an academic member for three years. His friend John Sloan commented that it might have been rejected because the dancer's bare legs can be seen through the veil. Henri had always hated the conservative attitudes of his academic colleagues, who, time after time, rejected the innovations of their students in favor of mediocre works in the traditional spirit the institution upheld (Henri called it "the cemetery"). Gradually, Henri distanced himself from the Academy to focus on organizing alternative exhibitions, perhaps like those he had seen at the Salon de Paris.

This work depicts one of the many dancers who worked in shows uptown: vaudeville, theater, and the nickelodeon—cheap entertainments where the working class with time and money went to have a good time. The Academy did not understand that this was a portrait, and it focused instead on the scandal that the suggestive legs of this Salome would incite. Her exotic figure stands out from the dark background as if illuminated by a bright light. She is dressed in an emerald green bodice and a veiled skirt that lets her legs show through. Delicately, she lifts her veils, about to begin a sensual dance.

Left: New York was Henri's greatest source of inspiration, whether it was street scenes or portraits of people from the slums, characterized in his works by sweetness and tenderness in their faces. This scene shows a New York street completely covered with snow. There are several houses on the street, which is lit by a lamppost. Despite the cold, there are horse carriages and some people walking on the sidewalks. The sky is overcast and snow threatens again. Despite the dense fog, the viewer can see a few of the office buildings that were being constructed to unfathomable heights, the result of the city's great activity.

Gray and somber colors are predominant in this view of the city, ever growing from immigration. These rapid changes would define Henri's urge to experiment, which in turn he conveyed to his students at the Art Students League. Young men such as Bellows and John Sloan would visit him at his New York studio, adopting all the innovative ideas of their teacher. They would turn Henri's free brushstroke into violent and impetuous strokes with equally forceful themes. As a result of his rejection of norms, Henri was and is considered an insurgent and an emancipator, exalting the realist values of American art.

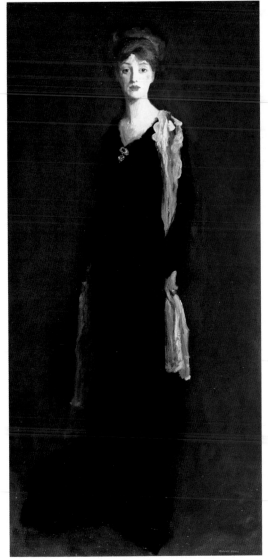

O in Black with Scarf (Marjorie Organ Henri)

(1910)
oil on canvas
77.2 x 37 in (196.2 x 94 cm)
Fine Arts Museums of
San Francisco

One of Henri's favorite models was his wife, Marjorie Organ, who was also an artist and exhibited and signed work independently. Here, she is elegantly dressed in black, holding a light-colored scarf and posing for the artist. She stands in front of a black background, and her hands, face, and bright red hair attract the viewer's attention and define her figure. The relief created with the light and brushstroke are reminiscent of Henri's teacher Anshutz and his interest in volume. Here, they mix with the style of baroque painters, and with echoes of John Singer Sargent.

Organ, an illustrator and watercolor artist, glows with self-confidence. Henri made many portraits of his wife in different costumes and settings. Here, she is depicted as a high-society New York lady. This portrait displays the artist's ease in depicting the personality of the person being painted, the result of attentive observation of physical and personal qualities. He has used a natural-size vertical composition to capture her loveliness. The dark background spotlights her figure; no other element appears to distract from her beauty.

Right: Henri painted this portrait on one of his many trips to Madrid, a city where he spent most summers sketching and contemplating the work of Velázquez. This girl from Segovia, a city near Madrid, displays the artist's preference for Frans Hals's loose, fresh brushstroke and for Édouard Manet's intensity of colors. These are the two painters Henri admired the most. He liked to paint people of all nationalities and ethnic groups; it was a challenge for him to capture the diverse features of each.

Here, Henri depicts a self-possessed model, focusing on her intense gaze. The young woman is dressed in typical regional attire: a yellow dress, a white blouse, a richly embroidered large red shawl that covers her shoulders, and an apron in the same red tones. The young woman does not look directly toward the viewer, and she keeps a Spanish-style fan open.

The Little Dancer

(1916-1918)
oil on canvas
40.5 x 32.5 in (102.87 x 82.55 cm)
Butler Institute of American Art,
Youngstown, Ohio

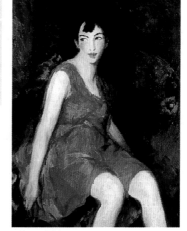

The warm colors of this portrait contrast with the gray and dark tones of the rest of the painting. The same can be said about the soft brushstroke, more characteristic of Henri's friend William Glackens, who had begun experimenting with Pierre-Auguste Renoir's Impressionism. Henri was also interested in the way Renoir painted, so this work may be an homage to him.

Like Renoir with his sensual women, Henri depicts a young woman with a very short, flamboyant dress, sitting in an armchair in a suggestive position. This work is thought to be a portrait of Isadora Duncan, a dancer known for her modern and original interpretions of music through dance; Henri admired her. He fell in love with this model's expression. He himself said that she was not beautiful, a model, or a professional dancer, but she had such a charming face that he could not resist painting her.

The dancer looks the other way, as if to avoid the viewer's gaze with an innocent gesture. Her oval face has deep blue eyes and red lips the same color as her dress. The dress is actually the center of the composition. Its volume is defined by a few brushstrokes of yellow and red that create texture. The background is painted in opaque green and brown colors so that the young woman's body is the center of attention.

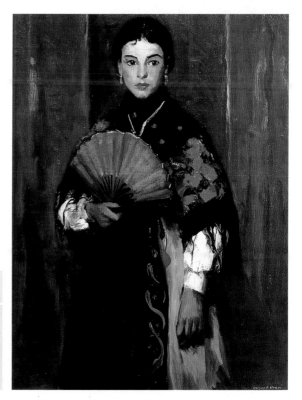

Spanish Girl of Segovia

(1912)
oil on canvas
40 x 32 in (101.6 x 81.3 cm)
New Britain Museum of
American Art, Connecticut

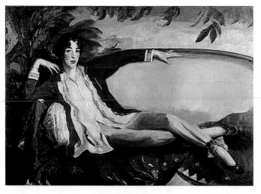

Gertrude Vanderbilt Whitney

(1916)
oil on canvas
50 x 72 in (127 x 182.9 cm)
Whitney Museum of
American Art, New York

Gertrude Vanderbilt Whitney was born in an enormous, luxurious mansion on Fifth Avenue, decorated with European works of art and antiques. Her wardrobe came from Parisian haute-couture shops; she ordered all of her clothing during her many trips to the French capitol. Her shoes never touched dirty streets. Yet despite this, she decided to go to the studio of an Ashcan School artist to get a portrait made of herself. Whitney had been educated to be a good mother and loving wife, but she rebelled, fleeing conventionalism to enter the world of art, particularly modern art.

Through this rebellion, she met Henri, who painted her dressed in pants (because of them, she was prohibited from hanging the painting in the family mansion and had to leave it in her studio in Greenwich Village). Whitney's posture highlights her elegance but does not overshadow her renowned vitality. From the very beginning, she endorsed the work of vanguard artists. Henri, whom she asked to paint her portrait, was her favorite. Her art collection, particularly that of American artists, became the foundation of the Whitney Museum collection.

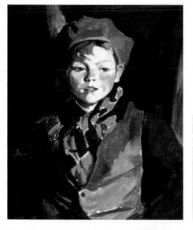

Jimmy O'D

(1925)
oil on canvas
27.5 x 20 in (69.96 x 50.8 cm)
Montclair Art Museum,
New Jersey

The natural expression seen in Frans Hals's paintings can be seen in the face of this boy, outlined by opaque colors in the navy blue background. He has a large hat turned back, a gray vest, a long red kerchief, and dark trousers. This Irish boy was one of the many who worked on the streets of New York, selling newspapers and running errands to help their families. Henri liked to paint children; their gaze was not superficial, and he felt their enormous vitality. The brushstroke here is fast and adds spontaneity to the boy's slightly sad expression, looking beyond the painting.

This work is a summary of the ideas Henri conveyed to his students: It is important to forget the details in order to capture the essence and freshness of the gesture—in other words, the emotion the face expresses. The Academy focused on drawing and outline, paying particular attention to technique. Henri used all his power to prevent these academic standards from obstructing the development of American art toward its true identity.

EDWARD HOPPER

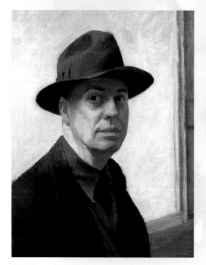

Self-Portrait, *1925-30, oil on canvas,
19.1 x 18.6 in (48.6 x 47.2 cm), Whitney
Museum of American Art, New York.*

Edward Hopper is the foremost representative of American realism of the 20th century. Born in a small town on the banks of the Hudson, Edward Hopper was, from an early age, solitary and melancholy. Early on, he showed a talent for painting and printmaking. After attending high school in Nyack, Hopper moved to New York City, where he studied with Robert Henri. He would be known as a printmaker until 1908, when he traveled to Europe to complete his studies. This trip sparked a rejection of his country's urban ugliness—a feeling that would stay with him for the next ten years, until he discovered a pictorial narrative style that would allow him to explore the American mentality.

Hopper shaped, and captured, the image of his time. In a very profound way, the painter witnessed the daily lives of his characters, in which he reflected his own mood. A sense of existential emptiness appears again and again in his work, through a simple approach based on geometric shapes.

This type of American painting is linked to the period between the world wars, when realism dominated painting, music, and literature. F. Scott Fitzgerald wrote The Great Gatsby, which describes this era in a very realistic way. Jazz seized the streets of New York and, correspondingly, Hopper painted this new society. These monochromatic planes manage to dehumanize the figures and their setting, with the intention to depict an anonymous and frozen universe. Hopper exercised great influence over later artists, such as Mark Rothko or the pop painters, partly because he get close to the abstract through the use of colored surfaces, partly due to his way of capturing the progressive banalization of modern American culture.

- **1882** Born on July 22 in Nyack, New York, to Garret Henry Hopper, a salesman, and Elisabeth Griffiths Smith.

- **1900** After graduating from Nyack High School, he studies at the New York School of Illustrating. He moves to New York City.

- **1906** Moves to Paris. Over the next two years, visits London, Amsterdam, Brussels, and Berlin.

- **1908** Exhibits with his friends Robert Henri and John Sloan. Works as an illustrator for newspapers and advertising.

- **1913** Participates in the Armory Show. That same year, his father dies. Moves to what will be his studio for the rest of his life: Three Washington Square North in New York City.

- **1915** Studies etching and gains a reputation as a painter. Guy Péne du Bois publishes the first article about Hopper in the *New York Evening Post*.

- **1920** Gertrude Vanderbilt Whitney, founder of the Whitney Studio Club, asks Hopper to hold an individual exhibition. He exhibits numerous drawings, etchings, and oil paintings, which receive favorable reviews.

- **1923** After exhibiting in Chicago, Los Angeles, and New York, he stops making etchings. He renews his friendship with the painter Josephine Nivison, once a fellow student.

- **1924** Hopper and Nivison marry. Jo encourages Hopper to dedicate himself to watercolors.

- **1925** Leaves the world of illustration.

- **1926** Until 1940, Hopper and Jo travel throughout the United States, painting landscapes.

- **1927** Holds an individual exhibition in Frank Rehn's gallery. He is recognized as an important artist on the American art scene.

- **1931** Whitney Museum of American Art opens; Hopper will hold many exhibitions there.

- **1941** The Hoppers visit southern California and Mexico in search of new landscapes.

- **1945** Named member of the National Institute of Arts and Letters.

- **1950** The Whitney Museum organizes an extensive retrospective. Hopper is ill and cannot attend.

- **1960** Follows a group of artists and intellectuals who, in the magazine *Reality*, oppose the growing abstract art movement in the United States.

- **1965** His sister dies in Nyack. Paints his last important work, *The Two Comedians*.

- **1967** After years of illness, he dies in his studio on May 15. Jo donates his work to the Whitney Museum.

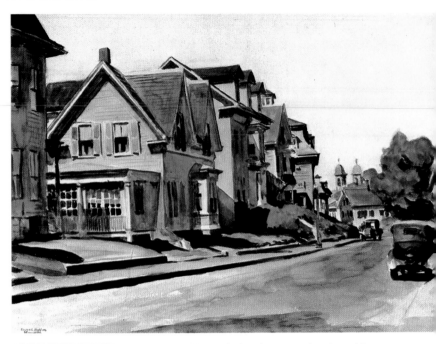

Prospect Street, Gloucester

(1928)
watercolor on paper
12.8 x 18.2 in
(32.5 x 46.3 cm)
Private collection

In this painting, Hopper depicts the street where he and Jo spent their honeymoon. This small city was meaningful to Hopper, as it was the place where he met his wife. This watercolor, one of the artist's first important works using this technique, shows his compositional maturity as he bridges watercolors and oils with ease. Although Hopper always based his work in oil painting, his watercolor landscapes were relaxed, with a style that recalled the etchings he had done in New York.

Here we can see the whole range of watercolor techniques that he explored. The gouache and glaze are a departure from his opaque city works, and they let Hopper compose with more free, less calculated brushstrokes. The artist felt that this type of painting allowed him to enjoy his art in a leisurely way, free of pretensions. The scene depicts a quiet street, which, although empty, does not have the lonely tension of the city. The long, very diluted brushstrokes seem to mix the colors right on the paper. Although undefined, the artist's stroke appears geometric; this painting offers a glimpse at the artist's watercolor technique.

Right: In his paintings of New York, Hopper explored different ways of observing reality. Objectivity was a central theme in his work, leading him to depict urban scenes in which anonymous figures acted out Hopper's own thoughts and impressions. After his trip to Europe, Hopper became a wise observer of the city, which he artistically reproduced through what seem like scenes in a play or a movie. This type of composition is characteristic of the artist. His framing technique, similar to that of a stage designer, the details of light and their effect on the figures, and the spatial aspects of the composition demonstrate a careful study of the elements that, gradually, the artist relates to one another.

Chop Suey

(1929)
oil on canvas
29.3 x 41.5 in
(74.5 x 105.5 cm)
Barney A. Ebsworth
Collection, St. Louis,
Missouri

The leading role of the female figure dressed in green is evident in this painting. She is based on Jo, the artist's wife, who would go on to pose for the majority of his female portraits. Hopper has made her face stand out by using a very pure white. Although the natural light illuminating the scene is yellowish, Hopper has re-created the figure's charm and candor. Although Hopper is known for solitary scenes and sad, dark colors, *Chop Suey* is a lively, bright departure.

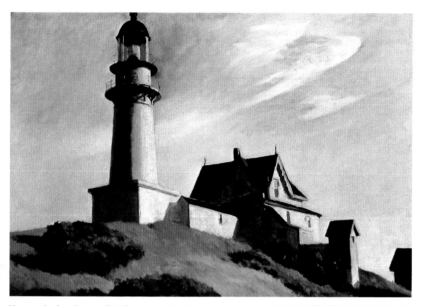

Hopper depicted many lighthouses during his career. His fascination with these coastal buildings is linked to his constant quest to show human loneliness in a meaningful way. The lighthouse represents the artist himself, who even came to identify physically with these towers. Very tall and skinny, he was nicknamed Grasshopper by his classmates.

In this painting, the lonely lighthouse stands on a hill, looking sadly out to sea. Hopper also looked out to sea, remembering his European experiences, which were present in all his work. The light is dramatic. The reflected light is white and shies away from the sun's warmth, giving a chilling effect. This is how Hopper shows the social impermeability of an urban citizen. The elements are all distinctive and individual, yet they combine to create a fascinating equilibrium. The sky and landscape contain lively blue tones that create a visual poem; through it, the artist reveals himself.

The Lighthouse at Two Lights

(1929)
oil on canvas
29.5 x 43.3 in (74.9 x 109.9 cm)
Metropolitan Museum of Art, New York

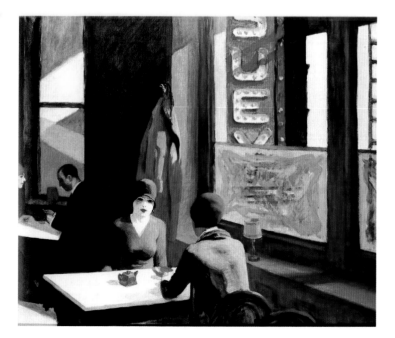

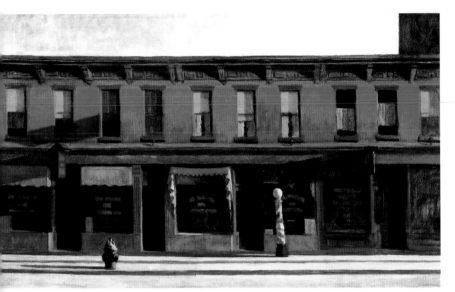

Early Sunday Morning

(1939)
oil on canvas
31.9 x 54.3 in (81 x 138 cm)
Whitney Museum of
American Art, New York

This painting, which, according to the artist, represents a section of New York's Seventh Avenue, evokes a lonely mood, defined by the empty streets and the shadows on the walls of the buiildings. According to his wife's notes, Hopper originally placed a figure inside the barbershop that could be seen through the glass, then decided to remove it so as not to interfere with the painting's mood.

The composition of this painting was challenging for Hopper. In all of his work, the architecture seems quite real, thanks to his particular style. Hopper never used a completely frontal point of view in these representations, so that the buildings would look three-dimensional. However, in this painting the buildings make a horizontal line, which excludes any sort of unevenness that might lend depth, such as a corner or an angle. One of Hopper's few architectural foreshortenings appears here, as he corrects the linearity by including some spectacular colors. The work develops from several horizontal bands of color placed freely in the composition. In juxtaposition to the classical drawing, Hopper uses intense colors in the upper section, which brings the buildings closer to the viewer.

Right: This painting, possibly the artist's most popular, conveys Hopper's thoughts about his time. The new idea of a hyper-populated city as a social center clashes with the inhabitants' distressing solitude. From a very young age, Hopper was a loner. In his hometown, he was shy and, often, it was his parents who made him play with schoolmates or neighbors. In this work, a cheap diner expresses Hopper's view of urban solitude. Here, the light plays a decisive role in creating the mysterious atmosphere that characterizes the work.

In the foreground, a man is sitting on a bench in a cinematographic and intriguing pose, his back to the street, holding a cup in his hand. Down the counter, a couple appears, lost in their own worries. The woman, in a red dress, with a very feminine gesture, examines her fingernails while the waiter works, busy and attentive. Quietness, typical of Hopper, dominates the scene and shapes the dramatic view of the city. The painting has the immediacy of a photograph. The figures are placed theatrically so the viewer easily recognizes their gestures and expressions. The viewer's eye is drawn toward the center, where there are no figures; the streets are abandoned, empty, almost naked; the scene is dark; the diners are isolated—*Nighthawks* is a remarkable expression of Hopper's perceptions of urban life.

Nighthawks

(1942)
oil on canvas
27.4 x 54.6 in
(69.5 x 138.7 cm)
Art Institute of
Chicago

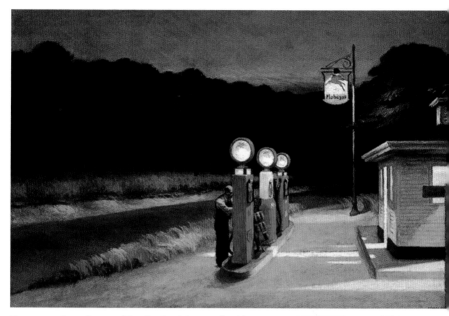

Hopper spent months searching for the right spot for this painting. When he failed to find one, he decided to paint a fictitious gas station based on real-life sketches. Hopper presents, in this painting, his own view of the contrast between modernity and pure nature. The painter, perfectly familiar with the rural mindset, thought that gas stations constituted the first signs of modernity in some deserted places where time seemed to have stopped. The gas station exemplifies the arrival of modernity in rural America, while the sumptuous forest in the background appears virginal and rustic. Hopper also used this contrast in his treatment of light. In a darkening night sky, some flashes of a dusklike glow still remain; the gas station is flooded with artificial light. Hopper based this simple composition on contradictory factors in order to represent the dynamics of change in the United States.

Gas

(1940)
oil on canvas
23.8 x 36.7 in
(60.5 x 93.2 cm)
Museum of Modern Art,
New York

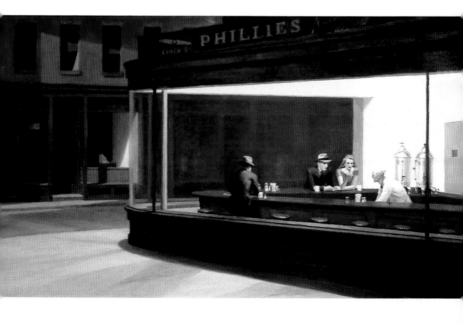

High Noon

(1949)
oil on canvas
25 x 36 in
(63.6 x 91.5 cm)
Dayton Institute
of Arts, Ohio

In this painting,
Hopper explores one
his great passions:
the female body.
A woman stands
in the doorway of
a house. The
surroundings are
surrealistic. Solitude appears again and again, in different ways, in all of Hopper's work. In this
painting, urban solitude appears in a semirural environment, where the sophisticated, modern
woman clashes with the simple farmland. The woman's plain house keeps her locked in a prison
of feelings. The windows are closed and the curtains drawn—except for one, which allows us to
make out a room lit by the noonday sun. This room symbolizes domestic reality, in contrast to the
woman's sensuality, represented by her high heels and low neckline. The woman has a dreamy look,
as if she is yearning for a less oppressive world. In this painting, the painter demonstrates the ideas
that feminism would expound in the 1960s. The artist combines his characteristic loneliness with
the idea of a social prison that holds women against their will.

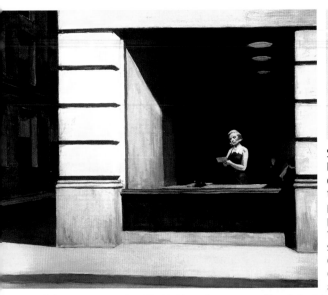

New York Office

(1962)
oil on canvas
40 x 55 in
(101.6 x 139.7 cm)
Blount Collection,
Montgomery Museum
of Fine Arts, Alabama

Starting in the 1950s,
Hopper displayed a thor-
oughly geometricist
tendency. His interest in
providing space for the
purest shapes is evident in
this work. He allows the
shapes to show their three-
dimensional quality and
exaggerated size using light
and shadow. Through a
windowpane—a recurring object in his work—we see an office at street level and a suggestive young
woman looking outside. Hopper, in a very organized way, has created various planes in the composi-
tion. The young woman is framed by a rectangular space and remains submerged in the semidarkness.
In the same scene, Hopper has included some undefined figures.

The artist used an almost photographic perspective. Although the figures represent an everyday
situation, the scene seems somehow suspended. The woman is on display as in a shop window with
the subtle eroticism characteristic of Hopper; she demands the viewer's inspection. A series of details
create the eroticism: her revealing clothing and the corporal sense of her body. In this painting
Hopper's woman is sophisticated, bared shouldered, and wearing a tight dress. In keeping with the
social milieu of the 1960s, she possesses a more explicit sexual connotation than women in Hopper's
earlier paintings.

GEORGIA O'KEEFFE

Arnold Newman, Georgia O'Keeffe at the Ghost Ranch, *1968, Museum of Fine Arts, New Mexico, donated by the photographer.*

- **1887** Born on November 15 in Sun Prairie, Wisconsin, daughter of Ida and Francis O'Keeffe, the second of seven children.

- **1905** Enters the Art Institute of Chicago.

- **1906** Attends Art Students League of New York classes. Assiduously visits the 291 Gallery, owned by photographer and businessman Alfred Stieglitz; discovers European art there.

- **1908** Obtains the Chase still-life scholarship, which allows her to continue the League's outdoor courses in Lake George, New York.

- **1912** Works as a teacher and supervisor at a public school in Amarillo, Texas.

- **1917** First exhibition at the 291 Gallery, organized by Stieglitz without the artist's permission.

- **1924** Marries Stieglitz.

- **1925** Inaugurates the Intimate Gallery in New York with Stieglitz.

- **1926** Participates in the National Woman's Party Convention in Washington, D.C.

- **1929** Travels to New Mexico for the first time. She is fascinated by its landscape.

- **1943** A retrospective of her work is held at the Art Institute of Chicago.

- **1946** Retrospective at the Museum of Modern Art in New York.

- **1947** Returns to New York, where she lives until 1949.

- **1949** Three years after being widowed, she moves to New Mexico to paint its figures and desert objects.

- **1950** Travels around South America.

- **1953** Travels to Europe.

- **1970** Receives the gold medal of the National Institute of Arts and Letters. The Whitney Museum of American Art in New York organizes its first retrospective exhibition of O'Keeffe. Begins to have serious vision problems, which force her to stop painting.

- **1985** Receives the National Medal of Arts.

- **1986** Dies March 6 in Santa Fe.

An artist ahead of her time, Georgia O'Keeffe was one of the pioneers of American modern art. After working as a commercial artist, teacher, and art supervisor in Virginia, she refocused her career, painting Texas landscapes and scenes.

Although O'Keeffe used a variety of styles to depict the many different settings and landscapes she discovered during her artistic career, her work focuses on experiments with the shape of objects. Her abstractions, based on simple motifs, and her cubist-realist style created a new style distinct from constructivism. O'Keeffe did not base her work on simple abstraction; she studied the possibilities offered by the shapes of flowers or urban landscapes, then interpreted those elements that most interested her.

Flowers, observed in abstract detail and depicted in an exaggerated manner with explicit reference to female genitalia—although this was always denied by O'Keeffe—became her foremost and outstanding theme in the 1940s.

O'Keeffe developed a new perspective on the object-model, painting her subjects with a unique delicacy. By decontextualizing flowers, skulls, or another object, she turned them into abstraction. She moves toward abstractism in a purist form, far from the European vanguard, which had become a hitherto insurmountable obstacle for American artists.

Blue Nude

(1917)
watercolor on paper
17.7 x 13 in (45 x 33 cm)
Estate of Georgia O'Keeffe

This painting belongs to a series in which O'Keeffe painted a Texas art teacher with watercolors. The paintings are based on a variety of human poses, and in them the artist illustrates her interest in simplifying forms. In this series, the painter uses basic strokes to evoke, rather than describe, the form of a female nude.

Years before beginning her series of flower abstractions, the artist painted her surroundings to experiment with the possibilities of using figurative art as a basis for abstraction. This work's composition reflects this idea, and also O'Keeffe's pictorial nature, quite early in her career. The prevalence of blue in this watercolor and the female figure depicted so simply proclaim one of this artist's future characteristics: chromatic simplification. She would work with one color many times, experimenting with monochrome painting. These first watercolors already illustrate the interrelationship between the main element and the background. In contrast to the work of the Victorian painter Marianne North, who also used vegetables as artistic motifs, O'Keeffe did not attempt to reproduce the element's natural environment. Instead, she decontextualized it, placing it in a surrealist landscape where it could develop a completely different pictorial discourse.

Right: O'Keeffe was interested in the shapes of New York skyscrapers and made many drawings and paintings of them. She used natural aspects and elements because they helped her to attain a perspective to study forms and, above all, capture the city's atmosphere.

In this work, the artist uses the sun to create a special effect on the skyscraper. By alternating between urban and rural themes, O'Keeffe learned to paint from very different perspectives. In her New York paintings, the modern style of O'Keeffe's floral paintings gave way to more traditional art. Her linear landscapes, filled with skyscrapers and dark tones, illustrate a figurative style, which the artist uses to capture the city's atmosphere.

This painting shows the urban landscape with a large gray building, the Shelton Hotel, in the foreground, backlit by the sun. An air of mystery, created by the backlighting and the yellow and red reflections, envelops the painting. The lines of the central building control the scene and the skyline that appears in it, but the mood submerges it all. From this angle, the viewer feels tiny and overwhelmed by architecture and atmosphere, a contrast that is a leitmotif of this type of pictorial work by O'Keeffe.

New York with Moon

(1925)
oil on canvas
48 x 30 in (122 x 76.2 cm)
Thyssen-Bornemisza Museum,
Madrid

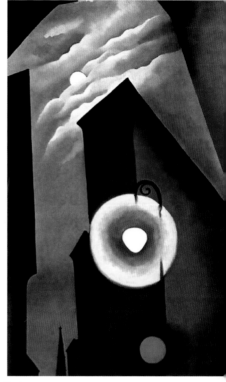

In this painting, the first that O'Keeffe made of New York City, she wanted to capture the city's character and atmosphere. She would paint New York at various times in her career, depicting it according to the pictorial style she was using at the moment. Before starting this work, the painter, who had moved to the city in 1925, studied a variety of paintings of the city, but she decided that none of them was realistic. Here she captures the architecture from a more intuitive and original perspective, based on the complex linear framework made by the city's skyscrapers. In this series, the city appears like a completely homogeneous element that the artist captures in a series of simple forms.

New York with Moon is unique among O'Keeffe's urban paintings and is reminiscent of constructivism's formal primitivism. It is based on a combination of geometrical elements that form the landscape, appropriately decorated with contrasted colors to achieve a wonderful, dramatic effect.

For her urban paintings, the artist looked for a new language. This led her to study European painting and, quite obviously, the work of Soviet constructivist artists, where she found a very direct aesthetic narrative.

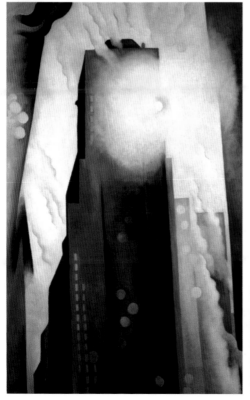

The Shelton with Sunspots

(1926)
oil on canvas
48.8 x 30.7 in (124 x 78 cm)
Art Institute of Chicago,
donated by Leigh B. Block

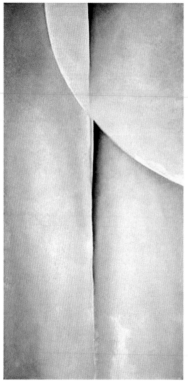

Line and Curve

(1927)
oil on canvas
32 x 16 in (81.3 x 40.6 cm)
Alfred Stieglitz Collection,
National Gallery of Art,
Washington D.C.

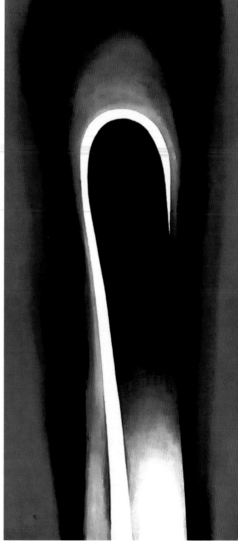

Above: Georgia O'Keeffe made paintings
such as *Line and Curve* to affirm her prin-
ciples. The use of curved lines became a
structural element of most of her work.
Throughout her career, O'Keeffe created
different series: on architecture, land-
scapes, and independent elements such as
flower abstractions or pelvic bones. Each
series has a specific style and is defined by
a specific type of line. While the paintings
that O'Keeffe did in New York consisted of
geometric exercises based on architecture,
her floral paintings are structured around
suggestive curves that fill the pictorial
space completely. Here, the painter places
a vertical line that cuts the canvas in half,
while the curve in the upper right joins the
two halves in an utterly flat way. Despite
its formality, the composition does not
have a monotonous linearity. The vertical
line gives the effect of volume, insinuating
a depth that becomes the protagonist of
the painting.

The artist, therefore, illustrates two
perspectives of art as different vital expe-
riences. The sophistication of her urban
theme work is complemented with a surre-
alist, abstract interpretation of rural life.

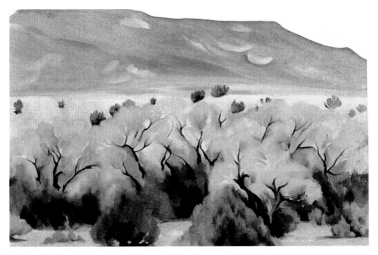

In 1929, the Taos Artists Society invited Georgia O'Keeffe to visit New Mexico. She was impressed by the brightness of the landscape. In this painting, the artist uses a variety of elements familiar from her flower abstractions, blending them with a very particular landscape style. A variety of planes of light are horizontally distributed to incorporate a variety of elements. A pair of round bushes in a dark green occupy the foreground; the next plane is a small forest, bathed in light. O'Keeffe works with the forest's brighter green tone to lead the viewer's eye toward the background, diluting the green gradually until the mountain is reached. The background is made with light brushstrokes that blend the grayish blue of the mountain with the green of the trees. This mixing produces a homogeneous impression that balances the entire work.

Cottonwood III

(1944)
oil on canvas
19.5 x 29.3 in (49.53 x 74.3 cm)
Butler Institute of American Art,
Youngstown, Ohio

Jack in the Pulpit No. VI

(1930)
oil on canvas
36 x 18 in (91.4 x 45.7 cm)
Alfred Stieglitz Collection,
National Gallery of Art,
Washington D.C.

Left: O'Keeffe made a series of Jack in the Pulpit paintings; in them, she depicts a variety of exaggerated floral details that become abstract in her interpretation. The use of these abstractions, based on reality, was characteristic of the artist's work; work on plant elements was one of the main themes of her artistic career. In the Jack in the Pulpit series, O'Keeffe focuses on the same part of the flowers, which she replicates again and again, increasing the size and presenting those elements that allow her to convey her own decontextualized perspective, independent from the painted element itself.

In this painting, a flower's suggestive forms are transformed into something dark and mysterious, allowing the viewer to let his imagination run free and form his own idea of what is being illustrated. Using this artistic approach, O'Keeffe experimented with the morphology of plants, without subordinating her art to any figurative rule or perspective principle. Her floral creations have their own aesthetic—which gave rise to some very harsh criticism. Despite this, these paintings gave the painter recognition. Many viewers felt that these paintings have a strong erotic component, and they assumed that the painter had made the images in order to depict female genitalia explicitly. O'Keeffe always denied this interpretation.

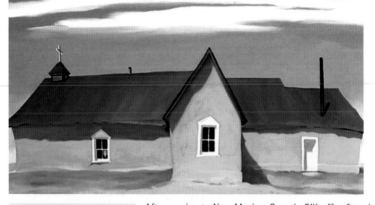

Cebolla Church

(1945)
oil on canvas
20.1 x 36.2 in (51.1 x 92 cm)
North Carolina Museum
of Art

After moving to New Mexico, Georgia O'Keeffe often drove through the small town of Cebolla. In this work, she depicts the town's Church of Santo Niño. In it, the artist captures the loneliness and aridness of the area. In a painting entirely different from O'Keeffe's characteristic aesthetic approaches, flat, opaque colors have been applied in large areas to illustrate the church's architecture. They are horizontally superimposed to create a pictorial space that covers almost the whole surface. O'Keeffe commonly covered most of the canvas with her principal motif, but here she experiments with aesthetic approaches reminiscent of Edward Hopper. The feeling of loneliness, much like that found in his work, suggests a romantic view that blends with the architecture and color. Unlike Hopper, O'Keeffe places the geometric structure in the foreground, but the compositional approach is directly related to Hopper's solitary rural buildings in arid fields. O'Keeffe was familiar with Hopper's painting, and both had the same concept of pictorial space as a relationship between the protagonist and the metaphysical void.

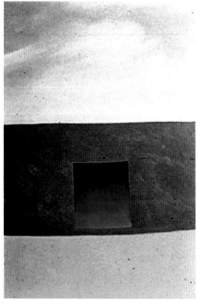

Green Patio Door

(1955)
oil on canvas
27.3 x 18.2 in (69.3 x 46.2 cm)
Albright-Knox Art Gallery,
Buffalo, New York

O'Keeffe made this sober painting in 1955. It shows the patio door of her house in Abiquiu, New Mexico. There are three horizontal spaces. While a smooth band of paint depicts the ground, the wall that surrounds the patio is highlighted by the door, which is the center of the work. The use of horizontal bands in some of her work led O'Keeffe to approach Mark Rothko's Abstract Expressionism. The main abstractionist features of O'Keeffe's work are the simplified versions of the main pictorial elements. Light is insinuated and color is distributed throughout the composition, resulting in harmonized geometric planes. Here, the artist has used straight lines to define bold blocks of color, turning a figurative painting into an abstract one.

GRANT WOOD

Self-Portrait, *1932, oil on masonite,*
14.8 x 12.4 in (37.5 x 31.5 cm), Davenport
Museum of Art, Iowa.

Along with John Steuart Curry and Thomas Hart Benton, Grant Wood was a major exponent of the American regionalism that arose as a reaction against European artistic trends in American painting. Wood disapproved of the gradual introduction of art forms like cubism and abstraction; to him, these forms represented the loss of national identity. As a result, he insisted on painting that focused on native, rural American values.

Atypically cosmopolitan despite his love of the regional, Wood, who was never interested in traveling to the East Coast, went to Europe instead, visiting France, Germany, and Italy. In Germany he was enchanted by realism and the satiric nuance of the artists of the new objectivity, but also by the mastery displayed in drawing and the treatment of colors of the German masters such as Albrecht Dürer, Hans Holbein, and Hans Memling. In this way, taking the subject matter of life in rural American as his base, he created portraits and landscapes that used the colors and pure lines of 15th-century Flemish masters.

However, other works are sweet; he saw, with the innocence of a child, the most beloved landscapes of his youth. This delicacy contrasts with his harsher works. The years of the Great Depression awakened American nationalism, favoring the success of such images as *American Gothic*, by far Wood's best-known work. Unfortunately, after World War II, the public came to think of Wood's regionalist style as

- **1892** Born on February 13 on a farm in Anamosa, Iowa.
- **1901** Wood's father dies, and the family moves to Cedar Rapids, where, years later, Wood will become a member of the Art Association.
- **1910** On his graduation day, he goes to Minneapolis to study art with Ernest Batchelder, principal exponent of the arts and crafts movement in America.
- **1913** Moves to Chicago to study at the Art Institute while he works at a store.
- **1918** Enters the army.
- **1920** Travels to Europe with his friend Marvin Cone.
- **1923** Enters the Académie Julian in Paris.
- **1926** Exhibits at the Carmine Gallery in Paris.
- **1927** Commissioned to paint murals for restaurants depicting Iowa landscapes.
- **1928** Travels to Munich to supervise a stained-glass project he designed for the Veterans Memorial Building in Cedar Rapids. Sees new German painting and the works of the painters at the end of the Gothic era, such as Hans Memling and Albrecht Dürer.
- **1929** The stock-market crash and the Great Depression seriously affect American farmers. Wood starts painting in a regionalist style.
- **1930** Creates *American Gothic*, winning the bronze medal and a $300 prize from the Art Institute of Chicago. The entire United States will come to recognize this work.
- **1932** Founds the Stone City Art Colony, close to Anamosa.
- **1934** Named director of the Public Works of Art Projects in Iowa.
- **1935** Gives classes at the University of Iowa. Exhibits at Ferargil Galleries in New York. Writes his "Revolt Against the City" manifesto, in favor of genuinely American painting.
- **1936** Illustrates Sinclair Lewis's novel *Main Street.*
- **1940** Paints *Sentimental Ballad,* based on a John Ford movie. Is diagnosed with cancer.
- **1942** Dies in Cedar Rapids, Iowa on February 12.

reactionary. This did not prevent him from continuing to campaign for national painting—but in his last years, wearied, he tried to jump-start his career under a different name.

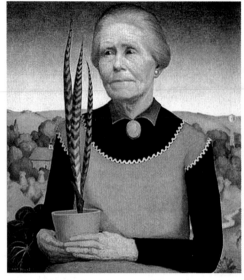

Woman with Plants

(1929)
oil on wood
20.5 x 17.9 in (52.1 x 45.4 cm)
Cedar Rapids Museum of Art,
Iowa

This painting of the artist's mother, Hattie Weaver Wood, marks the beginning of a new style of painting for Wood. During his visit to Germany, the painter had seen the masterworks of the Northern Renaissance painters and admired both the pictorial technique and their way of representing people. The psychological depth and great detail in the paintings, together with the use of light colors that allow all the details of the composition to be noted, have been incorporated in this portrait. Like Memling and other Flemish masters, Wood painted this portrait in oil on a wood panel.

Wood's mastery can be seen in the representation of the wrinkled skin of the woman's hands and the fabric of her dress. The elements—the wedding ring, the roughened hands— almost tell their own story, and they remind us that this woman raised her family alone after her husband died in 1901. The colors used are repeated in the landscape in the background: the blue eyes and collar of the dress are the same as the blue sky; the earth tones of her hands and face are the same as the land and houses, and the green of the plant is repeated in the Iowa landscape that unfolds behind her back. This is a portrait of an authentic pioneer at home, part of her landscape. This identification with the land is the point of Wood's painting as he developed his own vision of what national American painting should be.

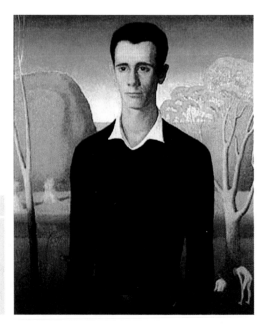

Arnold Comes of Age

(1930)
oil on wood
26.8 x 23 in (68 x 58.4 cm)
Sheldon Memorial Art Gallery and
Sculpture Garden, University
of Nebraska—Lincoln

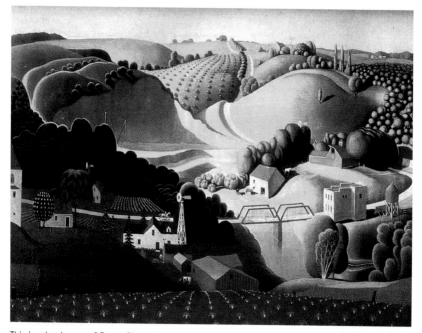

This is a landscape of Stone City, where the painter would later establish his art colony in order to search for a truly native, regional painting style. In his concept of the landscape, Wood could be considered a follower of Albert Bierstadt and Frederic Church, for the idealism that they portrayed. For Wood, the American landscape was the repository of all that was beautiful in the country, and he showed it like an Eden, perfect and immaculate. Similarly, the gentleness of the tones and the outlines of the geometric elements endow the work with a primitive air that seems to be capturing the artist's childhood memories.

Stone City, Iowa

(1930)
oil on wood
30.2 x 40 in (76.8 x 101.6 cm)
Joslyn Art Museum, Omaha, Nebraska

Wood had already observed this sharply defined drawing style in the works of new German objectivity, especially in Otto Dix's images. However, Wood had studied decorative arts in Minneapolis, which placed enormous importance on drawing, and therefore German artists cannot be credited entirely for his style. Here he adopts an unusual perspective, brought together by a wavy, soft horizon line that follows the outline of the hills surrounding the city. The effect achieved is one of a dreamscape, illuminated by clear, diaphanous light. These works were enormously successful during this era; the public saw in them an exaltation of the American identity. Wood's works were sought after by such well-known public figures as Katherine Hepburn and Edward G. Robinson.

Left: This portrait is another example of how Wood transferred the portrait style of the Flemish school of the 16th century to the American scene. It is a portrait of one of Wood's great friends, Arnold Pyle, in a front view with a landscape behind him. In this landscape, an allegory is developed, in the style of the Gothic painters. In the middle ground, just behind Pyle, are two trees. The first still has green leaves, while the other has already flowered; at its base, people prepare to bathe in the river. Two bundles of cut corn on the right-hand side have already been gathered. In the background are the enormous masses of foliage of two trees, the one on the right with summertime colors.

This is an allegorical painting representing the passage from youth to maturity, a highly stylized portrait. The man looks decisively toward the future that awaits him. Once again, the author has used a defined line for the outlines of the figures, emphasizing their volume through color and tonalities. The light, coming from an intensely blue sky, partially illuminates the scene, leaving the foreground in partial shadow to highlight the visual allegory behind. Similarly, the lighting of the youth's face symbolizes the passage to a new stage of his life. Wood often asked family and friends to pose for him so that he could try out the things that he had learned during his stay in Germany.

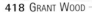

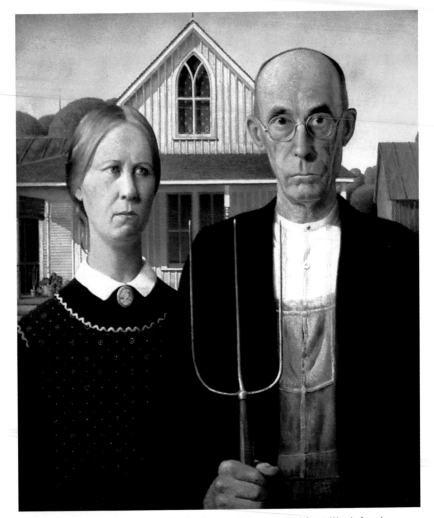

American Gothic

(1930)
oil on beaverboard
29.3 x 24.6 in
(74.3 x 62.4 cm)
Art Institute of Chicago

Undoubtedly the most famous work of Grant Wood, *American Gothic* won the bronze medal at the painting competition of the Art Institute of Chicago, along with a grant of $300. The meaning of this image of a farmer and his unmarried daughter in front of their rural home—and whether Wood meant it to be taken satirically—has been much discussed. Certainly the attitude of the man threateningly gripping his pitchfork, as if defending his property from strangers, does appear somewhat comic. (Perhaps we can read in the painting Wood's defensive feelings about the avalanche of foreign artistic styles.) Wood did intend to present the type of people who lived in middle America.

To do this, he asked his relatives and friends to pose for his work; the models here were his sister, Nan, and their family dentist, B.H. McKeeby. They stand below the triangle formed by the two sides of the steeply sloping roof of the house (constructed in a neo-Gothic style, inspiring the title), as if in the niche of a medieval altarpiece. Nothing in the farmer's expression augurs a warm welcome; indeed, he clearly disapproves of the intrusion of the viewer. Similarly, the farmer and his daughter do not seem to fear the opinion of others regarding their customs or lifestyle.

All the newspapers in the country reproduced this painting, created in a new style, and the artist enjoyed enormous fame. Wood always denied that this work was a satire of people in the Midwest—after all, he was from Iowa—and he simply said that it was a faithful representation of the essence of the inhabitants of this region. In 1932, he would found the Stone City Art Colony in order to promote this new regionalist style. During this period, Wood enjoyed great success as a painter, and even became the director of the Public Works of Art Projects and a professor at the University of Iowa, while also exhibiting in New York.

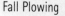

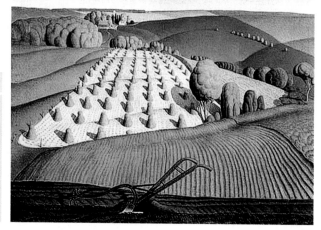

Fall Plowing

(1931)
oil on canvas
29.3 x 39.3 in
(74.3 x 99.7 cm)
John Deere and
Company Art
Collection, Moline,
Illinois

In this Iowa landscape, Wood shows the fruit of working the fields. Corn was the major crop in the Midwest. Here, cornfields are depicted in autumn, from an idealized and dreamlike perspective that ignores the hardships of farm work. The perspective moves in a straight line to the background, unfolding as a set of almost geometric elements. The cones formed by the heaps of corn, rhythmically arranged in rows, are idyllically in harmony with the wild countryside that extends over the wavy hills. There, the trees are pure spherical shapes, highlighting the delicate treatment of color and texture. They almost seem like cotton candy, dyed in soft reds and greens.

In the background, there is a red barn that can be reached by crossing the fields and taking the path in the distance. In the foreground, the plow used to turn the land lifts the grass as if it were a carpet. It is drawn precisely, with the eye of someone who has observed it closely, and is the protagonist of the landscape. Perhaps the artist wished to highlight its presence because it is an important tool of country life. Both the lines and the tonalities are delicate and smooth, while the afternoon light makes the colors glimmer.

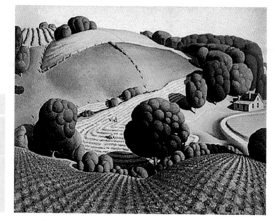

Young Corn

(1931)
oil on masonite
23.7 x 30 in
(60.3 x 75.5 cm)
Cedar Rapids Museum
of Art, Iowa

This work was painted in memory of one of the professors of the Wilson School in Cedar Rapids, and is a magnificent example of Wood's idyllic visions of the landscapes of his beloved Iowa. The state thought that the painting reflected the ideas of richness, peace, and prosperity so well that they later created a postage stamp based on this work. This sense of abundance and wealth comes from the composition: A high horizon line allows us to see more of the rolling hills, with their rich variety of greenery and textures. The lines of the crops cross one another before the viewers to impart an idea of abundance, as well as the lush, plump tops of the trees. The color—a deep, fresh green—contributes to the feeling of well-being and tranquillity. The people in the fields are totally in harmony with nature, and there are two typically rural characters: the man with his blue overalls and the woman in a pink dress, inspecting the corn.

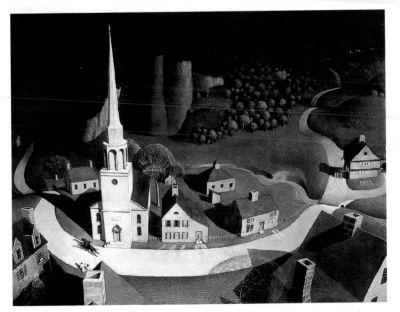

The Midnight Ride of Paul Revere

(1931)
oil on masonite
30 x 40 in (76.2 x 101.6 cm)
Metropolitan Museum of Art, New York

With a bird's-eye view, shrouded in mystery and adventure, the artist shows one of the most famous episodes in American history: the April night when Paul Revere, on horseback, announced the approach of the English to his countrymen. From our high viewpoint, we can see that lights are being lit inside the houses and some villagers are leaving their homes in alarm. The brilliant moonlight illuminates the landscape, and Revere's horse is the focal point of the composition. The meticulousness used to depict the characters, as well as the figures of the landscape, brings to mind the high detail of the Flemish artists. However, Wood has added his own signature brushstrokes in the geometric houses and trees; the shape of the church, with its almost impossibly tall steeple, is a perfect example. The viewer seems to be before a miniature town, populated by tiny, antlike people. Wood's description of nature at night is magisterial, and his primitive style adds drama to his representations of trees and mountains in rounded, softened shapes.

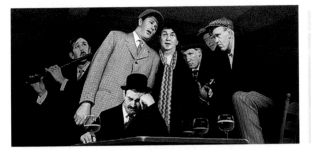

Sentimental Ballad

(1940)
oil on masonite
23.5 x 49.5 in
(59.7 x 125.7 cm)
New Britain Museum
of American Art,
Connecticut

This work was made during the decline of regionalism as a pictorial style; it was being pushed aside by abstraction. At this time, a movie producer, Walter Wagner, asked several important artists, among them Grant Wood, to paint scenes for his next movie, *The Long Voyage Home*, to be directed by John Ford. His intention was to have some good paintings to help promote the film.

This scene comes from the end of the movie, when seven sailors, euphoric with drink, are singing a beautiful song. The man in the light suit is John Wayne; like the rest of the group, he is shedding tears at remembering the old melody. It is almost certain that Wood painted *Sentimental Ballad* from photographs taken by the movie's production team during filming. Because of this, the artist has been able to portray the characters in great detail, while respecting the visual line of the movie camera.

CHARLES BURCHFIELD

Self-Portrait, 1916, watercolor, graphite, and conté crayon on paper, Burchfield-Penney Art Center, Buffalo, New York.

Many adjectives have been used to describe Charles Burchfield's work. But he always saw himself as a Romantic landscape painter whose main inspirations were nature, literature, and music. He was not interested so much in reflecting the nature of beauty, but in conveying its vitality. It was a very subjective way of painting, but it was quite expressive and poetic.

His belief that nature was the manifestation of God links him to the American landscape artists from the Hudson River School, although his is a more intimate version. Literature and music had a strong influence on Burchfield's work; some of his paintings can be related to medieval compositions and 20th-century works. This, in conjunction with his great expressiveness, puts him on the border of abstraction.

Burchfield painted not only landscapes but, in an intermediate period in his career, more realistic urban views that, because of his introspection, are comparable to the work of Edward Hopper. These works show the rural towns where Burchfield had always lived. In them, even the houses appear to have a life of their own, just like his landscapes.

The watercolor technique made it possible for the artist to paint quickly and with the same brilliance and color as oil, but without the characteristic problems of transportation, drying, and conservation. The artist, nevertheless, always tried to improve on his watercolors by retouching them.

- **1893** Charles Ephraim Burchfield born on April 9 in Ashtabula Harbor, Ohio.
- **1898** His father dies, and the family moves to Salem, Ohio.
- **1912** Studies at the Cleveland School of Art, where he has Henry Seller as a teacher. Goes to the modern art sessions that Seller directs at the Kokoon Club.
- **1913** His first contact with the European vanguard, thanks to the Armory Show in New York, where he gets acquainted with works of Pablo Picasso and Henri Matisse. Later, however, he expresses his rejection of the aesthetical colonialism of French painting in favor of American rural subjects.
- **1916** First individual exhibition at the Sunwise Turn bookstore in New York. Receives a distinction from the National Academy of Design.
- **1918** Fights in World War I. Makes the camouflage design.
- **1921** The Brooklyn Museum acquires one of his works.
- **1922** Works as a draftsman in the Birge Wallpaper Company in Buffalo. Marries Bertha Kenreich; they will have five children.
- **1924** Exhibits at the Montross Gallery in New York.
- **1929** Exhibits at the Frank K. M. Rehn Gallery in New York.
- **1930** Exhibits at the Museum of Modern Art in New York.
- **1936** Paints for *Fortune* magazine.
- **1938** Exhibits at the Carnegie Institute in Pittsburgh, Pennsylvania.
- **1943** Elected member of the National Institute of Arts and Letters.
- **1944** Retrospective at the Albright Art Gallery in Buffalo, New York.
- **1948** Harvard University and Hamilton College, in Clinton, New York, elect him *doctor honoris causa.*
- **1949** Teaches summer courses in Buffalo, Athens, and Duluth.
- **1956** The Whitney Museum of American Art organizes a retrospective in New York.
- **1960** Wins the gold medal of the American Academy of Arts and Letters in New York.
- **1964** Exhibits at the Pennsylvania Academy of the Fine Arts in Philadelphia.
- **1966** The Charles Burchfield Center is established at the State University of New York at Buffalo.
- **1967** Dies of a heart attack on January 11 in West Seneca, New York.

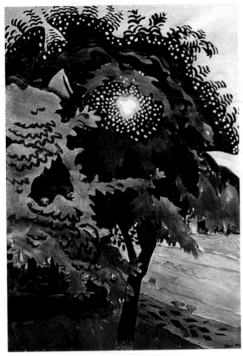

Luminous Tree

(1917)
watercolor on paper
22 x 14 in (55.9 x 35.6 cm)
Brauer Museum of Art,
Valparaiso, Indiana

As Burchfield wrote in his diary, 1917 was his "golden year." He painted over four hundred works of art that year. This is one of them; it depicts a tree next to a road. With this simple view, Burchfield reflects the sun's luminous effect filtering through the tree's foliage as well as the mysticism of nature. A focal point of light appears at the top of the tree, making the leaves vibrate in small points as if the light were the apparition of an angel. The artist mixed the white light with blue tones to increase its brilliance and purity, while the outline is yellow, just as it is in reality. The work has a transcendental and intimate quality. Burchfield studied in Cleveland, where he socialized with the most vanguard circle of local artists. One of them, William Sommer, invited him to participate in meetings at the Kokoon Club; there, the artist became familiar with watercolor and color theory. This technique let him work from the window of his house or in the easily reached outskirts of town. His work's motifs are simple, ordinary objects, like this tree. He transformed them into unique elements through his subjectivity, depicting the most mundane objects with tenderness.

Right: The artist painted not only natural landscapes, but also landscapes with people who had created new settlements and new ways of life. This work shows the humble houses of coal miners. It is winter, and the snow is covered with muddy, black soot from the mine. Two train tracks point toward the enormous entrance, dark as coal. Chimneys spew smoke, a sign that the residents are home. Perhaps the workday has ended and everyone is at home resting or dining. With a simple drawing and small suggestions, the artist stimulates the viewer's imagination to enjoy a slight and secret voyeuristic impulse. Burchfield's works with human elements combine his soft watercolor brushstroke with the secretiveness of the voyeur.

This view makes the coal mine the main protagonist, but focuses directly on the coalminers' windows, searching for some sign of life. In the background, the winter scene of dry trees devastated by human hands is lost in lead gray brushstrokes that accentuate the sadness of the sooty landscape. The artist turns his naturalist technique to the careful depiction of the metallic train tracks that lead into the mine.

Coal Mine—End of the Day

(1920)
watercolor on paper
17.2 x 30.9 in (43.8 x 78.4 cm)
University of Michigan,
Ann Arbor

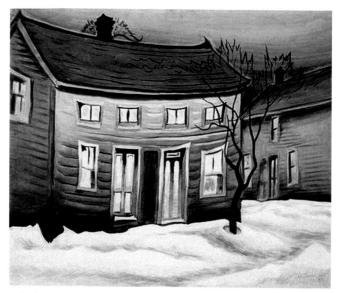

Cat-Eyed House

(1918)
watercolor with
graphite on paper
18.3 x 22.3 in
(46.36 x 56.52 cm)
Memorial Art Gallery,
Rochester, New York

In Burchfield's work, the houses have as much life as plants and trees. In this painting, the artist uses one of the architectural characteristics of houses in Ohio to enhance the sensation that this house has cat's eyes. Even today, there are older homes in Salem that have a "face" made up by the doors and windows. The windows in this painting even have a curve similar to eyelids.

For Burchfield, who painted in his room, the houses had eyes to see what was happening outside, just as people watch what is happening inside. This kind of voyeurism is present in many of the works of Burchfield's great friend Edward Hopper. However, in this house, the artist has noticeably deformed the lines to make it look more like a cat, which Hopper would not do.

After he painted this work, Burchfield served in the Army during World War I, and he was promoted to sergeant that year. Nonetheless, he confessed that he preferred to design camouflage than to give orders. In fact, he illustrated this with an anecdote: A commander ordered him to paint some pistols. For each one, Burchfield painted the entire weapon, even its firing mechanism, making it useless. When he showed his superior the results, the man, visibly upset, ordered him to clean them again. It took him all day.

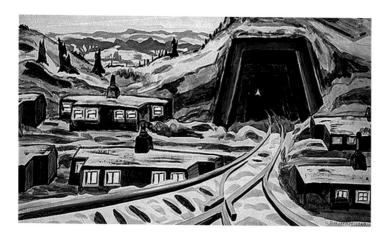

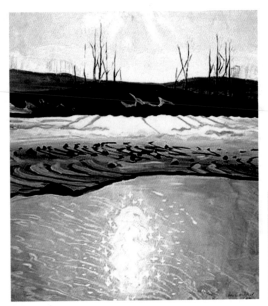

Springtime in the Pool

(1922)
watercolor and gouache on paper
21.1 x 18.6 in (53.66 x 47.31 cm)
Memorial Art Gallery, Rochester,
New York

Burchfield's main theme was always nature, particularly the change of seasons. The transformation of the landscape, particularly from winter to spring, was the artist's favorite motif. He captured this with great mastery and precision as a result of his expertise in watercolors. This work is interesting from a compositional point of view, since its main element is the reflection of the barely visible sun on the water. The brightness toward the rear of the pool inundates everything. It is concentrated in an enormous focus that vibrates with the ripples of the water. The sun itself has disappeared from the upper border of the painting, leaving a few rays as evidence of its presence. At this stage of his career, Burchfield was developing his trademark in watercolor: the use of warm colors and a restless brushstroke, as can be observed in the brilliance of the water in the pool.

The luminous glow of this painting is supernatural, a divine presence that comes from nature and is yet removed from nature. It has no form; it represents something immaterial and distant from earthly elements. The artist's very personal view sees and shares a manifestation of God in nature.

Right: All of Burchfield's skill in expressing nature's vitality is evident in this work. He has not limited himself to depicting the plants and trees in a realistic way. He has only drawn some lines to portray them, creating a nearly abstract view. The wind blows the figures, which nonetheless have great vitality. A lively color is used to illustrate the undergrowth, certainly different from its actual color. Some black-and-gray smudges represent the dust blown by the strong wind and the cold rain falling from the sky.

During the 1940s, the artist was interested in developing his technique, and this work is an eloquent example of his efforts. The brushstrokes are juxtaposed, using more solid textures for the figures and more transparency for the sky and wind. All this instills a washed, clear, and clean aspect, quite elaborate indeed, but not difficult to contemplate. On the other hand, Burchfield began to change his traditional technique by using drying paper and very little water on the brush, creating an effect similar to impasto in oil painting. This allowed him to make changes as he painted.

This work marks the beginning of a new stage in the artistic life of Burchfield, who, after a realist period, returned to a style full of the fantasy of his first compositions. At this time, he became interested in Finnish literature; from these writings, he made detailed descriptions of nature and the changing seasons.

**September
Wind and Rain**

(1949)
watercolor on paper
22 x 48 in (55.88 x 121.92 cm)
Butler Institute of American
Art, Youngstown, Ohio

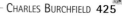

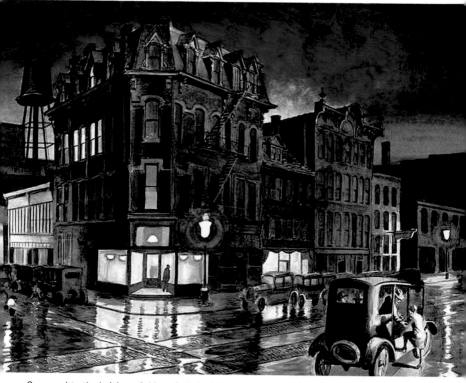

Compared to the lyricism of this artist's depictions of nature, there is a realistic vein in his urban scenes that has much of the silent introspection of the work of Hopper. In this street scene that portrays the streets of Buffalo after the rain, activity gradually wanes as night falls. Just a few lights are still on, perhaps a restaurant still open. At the lower right, a woman gets into a car, helped by a gentleman. The artificial lights turn everything grayish, concealing the true colors of hats, coats, and car.

Rainy Night, Buffalo

(1930)
watercolor over pencil on paper
30 x 42 in (76.2 x 106.7 cm)
San Diego Museum of Art,
California

Nonetheless, there are still cars in front of the restaurant, the glow of their headlights reflected on the wet pavement. All the houses are depicted very realistically, with effects that are quite similar to those of oil painting.

After he married, Burchfield lived in Buffalo, where the artist could not resist looking through the window to capture street scenes on canvas. He probably chose this time because of its silence and introspection. Life in the city will soon disappear for the night, with the lamp-posts the only silent and dull witnesses of empty streets.

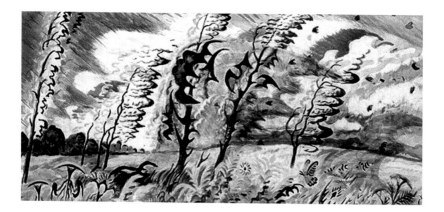

Orion in December

(1959)
watercolor and
pencil on paper
39.8 x 32.8 in
(101.2 x 83.4 cm)
Smithsonian American Art
Museum, Washington, D.C.

Burchfield was a modest but quite cultured man; he was familiar with the Impressionists and very excited about Van Gogh's work. Burchfield borrowed the sense of fantasy seen in Van Gogh's landscapes to paint landscapes in Ohio. Burchfield's work also has a childlike touch, no less expressive.

This work, which depicts the constellation Orion seen from a forest, is reminiscent of the work of the Dutch artist, who also painted lively stars in the middle of the night's darkness. Orion can be seen through the tall trees, which are no more than thick lines, similar to Chinese shadows. The artist's expressiveness is reminiscent of Hokusai, the Japanese artist greatly admired by Van Gogh. Burchfield adds a romantic tone to his nocturnal scenes, letting the viewer immerse himself in scenes from the artist's memory.

Golden Dream

(1959)
watercolor on paper
33 x 40 in (83.8 x 101.6 cm)
Private collection

Burchfield said that he did not search for paradise or the promised land: Everything was within his reach around his studio in Greenville, Ohio. Although he admired the great Italian painters such as Giotto, he affirmed that he did not envy the landscapes of Italy or France at all because he preferred those of his beloved Ohio. Burchfield did not long to paint what was far and unreachable, but what was near and accessible.

The artist's feelings about the landscape can be understood from his paintings. This work was the result of a story of his childhood years. When he was a child, he was caught in an apple tree on private property. Before he came down, he asked if he could catch a butterfly on a nearby branch. At home, he made several sketches of it in different positions. His interest in butterflies continued throughout his life, and here a group of them hang from the branches of a tree, as if they were resting from the summer heat, sleeping deeply.

MARK ROTHKO

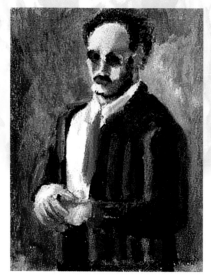

Self-Portrait, 1936, oil on canvas, 32.3 x 25.6 in (82 x 65 cm), collection of Christopher Rothko.

Mark Rothko is one of the icons of the so-called New York School, the name that refers to the group of painters in the United States who were Abstract Expressionists.

Although he studied at the Art Students League of New York at the beginning, most of his learning was self-taught. He began his long journey toward abstraction from figurative painting that was influenced by the European vanguard. Early in his career, he made a series of nude paintings and street scenes that, because of their subject matter, are reminiscent of the Ashcan School. Later he experimented with the techniques of the Spanish surrealist Joan Miró. This would affect the musicality of his strokes and the intricate symbolism of his paintings, which sometimes refer to classical myths.

Rothko's abstract period lasted from the end of the 1940s until his death. His work from this period is characterized by bands of horizontally arranged watery colors, which seem to concurrently advance and recede. From here, he evolved toward greater intensity and darkness, a result of his ever-deeper depressions.

This artist's work is a greatly simplified type of painting that explores the abstract qualities of color in order to create a spiritual and poetic art that exalts the viewer by directly targeting the unconscious.

- **1903** Marcus Rothkowitz born in Dvinsk, Russia (now Latvia) on September 25, son of a pharmacist, Jacob Goldin Rothkowitz, and his wife, Anna.

- **1913** Travels to Portland, Oregon, with his mother and sister to join Jacob, his father, who had settled there.

- **1921** Attends classes at Yale University, where he studies history, philosophy, and psychology.

- **1923** Drops out of the university and moves to New York.

- **1924** Attends classes at the Art Students League.

- **1929** Teaches children at the Academy of the Brooklyn Jewish Center.

- **1933** First individual exhibition at the Art Museum of Portland. Also exhibits at the Contemporary Arts Gallery of New York.

- **1934** Exhibits at the Gallery Succession, where he meets Adolf Gottlieb. Founds The Ten with other artists.

- **1935** First exhibition with The Ten.

- **1936** Makes murals for the Works Progress Administration, a program to promote employment among artists.

- **1940** Collaborates in the founding of the Federation of Modern Painters and Sculptors.

- **1947** Eliminates titles from his artwork and any remnant of surrealist imagery. Paints abstract work. Teaches with Clyfford Still at the California School of Fine Arts.

- **1954** Individual exhibition at the Art Institute of Chicago.

- **1958** His canvas colors start to consist of somber tones.

- **1961** Individual exhibition at the Museum of Modern Art in New York.

- **1964** Makes murals for the chapel at Texas Medical Center in Houston.

- **1968** Shrinks his palette to brown, black, and gray. Named member of the National Institute of Arts and Letters. Suffers a heart attack.

- **1969** Yale University names him a doctor of fine arts.

- **1970** Commits suicide in his studio on February 25.

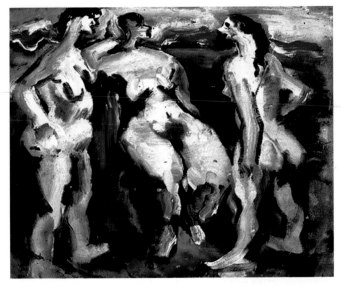

Untitled (Three Nudes)

(1933-1934)
oil on black cloth
15.9 x 19.9 in
(40.3 x 50.5 cm)
National Gallery of Art,
Washington, D.C.

This work depicts three nude studies. Although quite explicit for the American public, unaccustomed to this genre, this painting helped the artist develop his style from the influence of the European vanguard. Here, the artist displays the influence of Paul Cézanne, particularly in his way of portraying volume with a geometric appearance. Rothko became familiar with Cézanne's work, particularly his series of Bathers, during his studies at the Art Students League in New York. There, he studied with Max Weber, a very cultured painter familiar with trends in Europe, who guided his pupil on the road to modern aesthetics. The models' generous bodies are outlined by free and expressive black strokes, which imbue the figures with energy. One of them sits on a chair implied by two red strokes, while the other two are standing, one with her back toward the viewer. There is no clear background, nor any object that helps give context to the scene. The only concern appears to be the depiction of feminine bodies in vanguard style in the manner of the Impressionist painters. The influence of Henri Matisse's painting can also be detected in the importance Rothko gives color to highlight the figures' corpulence. The artist uses a violent gesture of the brush, a trademark that would dull in subsequent years.

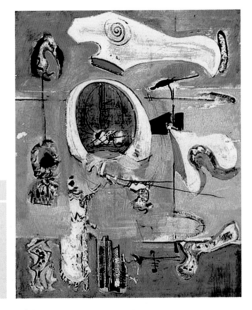

Sea Fantasy

(1946)
oil on canvas
44 x 36.2 in
(111.8 x 91.8 cm)
National Gallery of Art,
Washington, D.C.

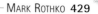

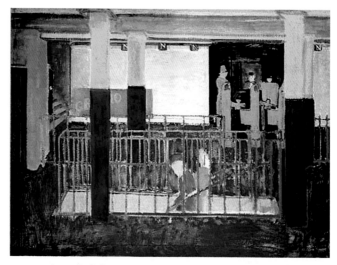

There has been commentary about the influence of the Ashcan School on this urban series due to the theme, although the treatment used by that group was somewhat more sinister and violent. Here, Rothko, who had experienced social ostracism during his childhood (he was Russian and didn't speak English), shows his extraordinary sensitivity as he depicts the loneliness in large cities.

Entrance to Subway

(1938)
oil on canvas
34 x 46.2 in
(86.4 x 117.5 cm)
Collection of Kathe Rothko

To do this, he chose a nearly deserted place that was visited daily by thousands of people. The subway seethes with strangers.

Anonymous faces descend the stairs that lead to the train. The anxious rush of the rhythm of life in the city, embodied in the subway station, can be observed here. In the background, the ticket clerk watches over the entrance from his booth.

The artist used a horizontal arrangement of color, joining related tones. Lilac is predominant in the upper portion and blue in the lower portion. This blue has two tones: a more intense one on the columns and a more liquid one on the floor. The figures are flat, as if they inhabited a two-dimensional space dominated by color.

Left: At the start of World War II, many European artists fled Nazi persecution. Many surrealists settled in New York, where Robert Henri had already opened the path to modern art at the Armory Show exhibition years before. Rothko was drawn to the lyricism of surrealist compositions and, especially, to the surrealist's unique way of painting. They used the so-called automatic method, which consisted of freeing the executing hand from all conscious thought and only obeying the rational impulses of their subconscious.

Here, Rothko portrays a symphony of figures that seem to have originated in childhood imagination or primitive art. The entire composition has a musical air, a result of the slight shapes and the lines that travel through the pictorial space. They refer to the dream world of the surrealist Joan Miró, although Rothko's colors here are more opaque. The fish and mollusks are barely distinguishable because of the figures' disintegration.

At this time, the artist began to turn to abstraction attained through automatic strokes, although he had not yet decided to abandon reality completely—his titles still refer to familiar realities. Words like "fantasy" lead one to think of a happy stage in Rothko's life. Nonetheless, he entered another, much more depressive stage in the 1960s.

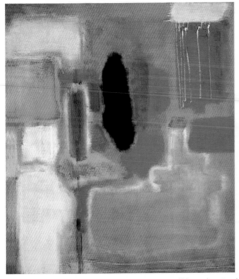

Number 9

(1948)
oil and mixed media on canvas
53.1 x 46.6 in (134.7 x 118.4 cm)
National Gallery of Art,
Washington, D.C.

This work is an example of the process of abstraction to which Rothko subjected all his work. It affected not only his canvases, but also their titles. The artist refused to give titles to his work, so that the viewer could concentrate on enjoying the painting's essence, without the need to pay attention to insignificant details. The use of numbers for titles had a much simpler objective: Rothko could organize his portfolio and remember what painting someone was talking about when they made a comment. *Number 9* portrays the basic characteristics of what would become the artist's definitive style.

On a fully painted canvas, there are a variety of misty-edged colors without any symmetry. Rothko obtained this aqueous appearance by using rags to apply the paint so no brushstroke could be seen. He also superimposed several tones of the same color, making the colors ascend and descend on the background. Thus, the viewer has the sensation of a gentle slow movement that transports and comforts him or her. Here, the tonal shades come from a main color, red, which eases into pink, orange, fuchsia, and violet. White is the counterpoint.

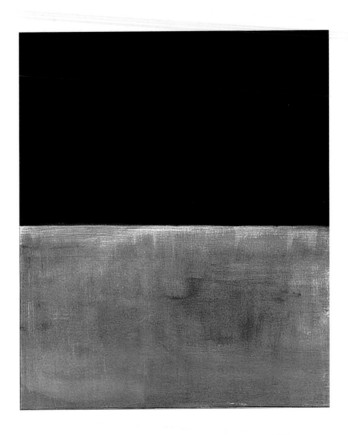

Untitled

(1951)
oil on canvas
44.3 x 37.4 in (112.4 x 94.9 cm)
National Gallery of Art,
Washington, D.C.

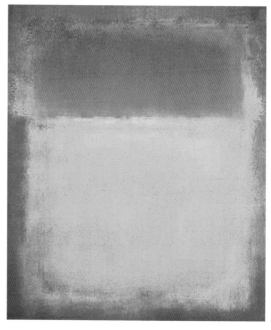

Yellow is predominant in this work. It suggests the sun, light, and summer warmth. The entire surface is painted in this color, except for the horizontal pink band. There is a second yellow band in the lower portion that is barely distinguishable because the tonal variation is very minor. It is the "border," the diffuse transition between fields of color. In fact, paintings of this type are called color fields.

This is a powerful image: The color, surface, proportion, and scale take the viewer to the knowledge of a philosophical truth, inseparable from the artistic experience. There is a mysticism that emanates from these color compositions that verges on the sublime. Rothko never bothered to explain his images; he believed the viewer could appreciate them directly, without the need for intermediaries or interpreters. His paintings refer to the human dramas that have existed throughout history, such as myths and ancient stories.

It is as if Rothko had discarded all the magical symbolism he displayed in his surrealist works to condense their essence in colors and the effects they produce when they are superimposed. Instead of depicting a myth with all its figures, the artist extracts the emotion, the soul, from the scene and captures it on canvas.

Left: Toward the end of the 1950s, Rothko's lively colors became darker and gloomier, culminating in a series of black paintings. It is the combination of opaque colors such as brown, gray, and black that conveys the sense of desolation. In this composition, even Rothko's characteristic floating bands have been eliminated. The gray band on the lower half of the black background lets the darker color glaze through. The artist's interest in black had already been observed in his chapel for the Texas Medical Center, where he had placed fourteen dark panels reminiscent of Christ's passion. Here, there is tension between the gray and the black's darkness. It is a battle of opposing forces. At the end, death, depicted here as the darkness, ends up winning against finite life.

Untitled (Black on Gray)

(1969)
acrylic on canvas
Guggenheim Museum,
New York

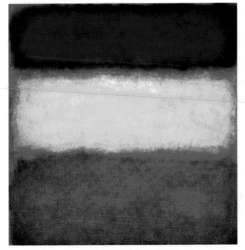

Violet Bar

(1957)
oil on canvas
68.9 x 66.9 in (175 x 170 cm)
Private collection,
Lausanne

The 1950s are considered the artist's classical period; that is when he developed his paintings with horizontal and aquatic bands arranged on a completely flat background. The colors he used during this period were extremely lively, like the violet, yellow, and red that appear here. Rothko attained these contours using old rags dampened in water to remove paint, as well as to add more color. He included the names of the predominant colors of the composition in the title because he was having difficulty remembering his works with just a number.

The artist chose enormous canvases to produce greater visual impact. He made sure that, in exhibitions, his paintings were placed in the smallest rooms, so that the work would not give the impression that it was merely decorating the ever-larger walls of museums. Although Rothko's color-field paintings do not reveal brushstrokes, the viewer can observe the irregular borders of the color rectangles. The artist wanted the viewer to think of the mental states that each tone on the canvas creates, individually and together.

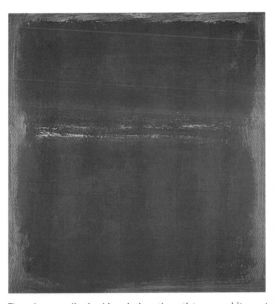

Untitled

(1970)
acrylic on canvas
60 x 57.1 in (152.4 x 145.1 cm)
National Gallery of Art,
Washington, D.C.

This work is one of the last that Rothko made before committing suicide in his New York studio. Depressed and sick, Rothko made a last series of paintings that stand out because of their intensity, as if he knew that his end would be violent.

This composition stands out because of the way the artist contours the red background with a lighter tone. There is sensuality in this painting; the artist caressed its contours. Rothko's use of a lively color is also surprising; he had developed the somber theme of death in his previous period.

This is what Rothko thought about life. Despite the certainty of death, he believed that irony and hope make life more bearable. The most important things in life are the emotions shared by all human beings.

WILLEM DE KOONING

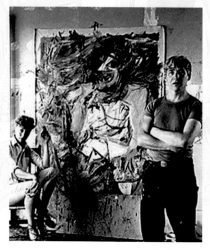

Hans Namuth, Elaine de Kooning and Willem de Kooning, *1953, gelatin silver print, National Portrait Gallery, Smithsonian Institution, Washington, D.C.*

Willem de Kooning was the greatest representative of Abstract Expressionism in the United States. His spirited and abstract style created the term action painting, which alludes to a violent brushstroke, a reflection of inner agitation.

Born in Europe, de Kooning came to America familiar with the geometric work of Piet Mondrian and Pablo Picasso, for which he expressed great admiration. In the United States, he became familiar with the surrealists and became interested in the unconscious and symbols.

His work is characterized by the synthesis of the figurative and the abstract through a wide, aggressive, and violent brushstroke that instills energy on the image and richness on the visual texture. This violent gesture can already be observed in his first work, highlighted by the use of few colors. In the 1950s, he used this impulsive gesture with feminine figures that have been the object of various interpretations because of their diabolical quality. They have large breasts and hips, reminiscent of divinities in primitive Greek art. They also have terrified expressions marked by enormous eyes and macabre smiles.

Later, the artist focused on purely abstract portrayals with wide strokes and thick impastos, which convey much more sensuality than his earlier, more apprehensive works. De Kooning's strokes became lighter and more fluid as the 1980s advanced. He was an internationally influential artist, but alcoholism ended up breaking his health. In his last paintings, his strokes become unclear in a whitish, ghostly atmosphere.

- **1904** Born on April 24 in Rotterdam.
- **1916** Studies at the Rotterdam Academy of Arts, where he becomes familiar with the work of Piet Mondrian and the Parisian cubists.
- **1926** Emigrates to the United States.
- **1927** Goes to New York, where he meets other artists such as Mark Rothko and Jackson Pollock. Makes geometric-style painting.
- **1936** Exclusively devoted to art, he paints several murals for the Federal Arts Project.
- **1938** Marries the artist Elaine Fried.
- **1948** First exhibition of drawings in black and white at the Egan Gallery of New York. His friend Arshile Gorky commits suicide. De Kooning becomes depressed, and his strokes become more violent.
- **1950** Paints feminine torsos that blend the figurative with the abstract. He is an important figure of Abstract Expressionism.
- **1954** Spends the summer on Long Island; the light and bathers inspire new themes for his series on women.
- **1955** Returns to abstract art and begins to make urban landscapes.
- **1964** Moves permanently to his workshop in East Hampton.
- **1968** Visits Holland, where there is a retrospective of his work.
- **1973** Leaves painting for a while and works on sculpting.
- **1975** Makes a series of very vigorous abstract paintings.
- **1978** Drinking results in concern for his health.
- **1980** Wins the Andrew W. Mellon prize with an exhibition at the Museum of Art, Carnegie Institute, Pittsburgh, together with the sculptor, Eduardo Chillida.
- **1982** His stroke becomes fine and linear.
- **1983** The Whitney Museum holds a retrospective.
- **1989** He is diagnosed with Alzheimer's disease, but continues painting.
- **1997** Dies on March 19 on Long Island.

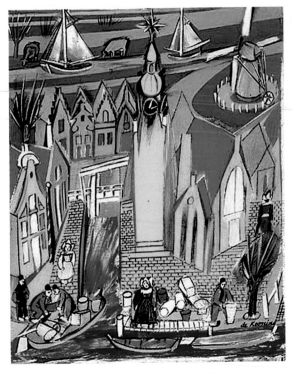

The Netherlands

(1944)
acrylic on board
12.6 x 10.8 in
(31.9 x 27.4 cm)
Smithsonian American Art
Museum, Washington, D.C.

This work is a view of Amsterdam in its daily bustle. People are going about their business, many working from small boats. The city is depicted fairly realistically, with its characteristic cobblestone streets and and its houses with triangular roofs. Farther out, windmills turn and cows graze. It is an idyllic view of the artist's native land, quite lively because of the intensity of colors. De Kooning here used primary colors flatly applied on the houses and people. They are the same tones that Mondrian, also Dutch, had already used to create geometric compositions; this work seems to honor him. De Kooning studied at the Academy of Fine Arts in Rotterdam. When he first went to the United States, he worked as a house painter to make a living. Only later was he was able to devote himself exclusively to art. His earliest work revealed his taste for violent brushstrokes. Here, the viewer can appreciate how he used free brushstrokes on the waters of the canals to depict motion, combined with the apparent control with which he painted the houses.

Right: This is the artist's largest work, and one of the first big paintings that he made during the 1950s, a happy time for him. He won an award of $2,000, and the painting joined the collection of the Art Institute of Chicago. *Excavation* was made with opaque colors and a few strokes in primary colors such as red, blue, and yellow. What stands out in the composition is the geometric synthesis based on Mondrian's cubism and suprematism, but revitalized with De Kooning's particular gesture and the apparent arbitrariness with which he applied touches of color. This gives the work a broken quality, creating the sensation that the artist has made his brushstroke jump without a definite order in an attempt to attain this effect. One can imagine that De Kooning's vital force emerges in the forest of black lines that make up the structure.

Excavation is something more than an abstract painting in the strictest sense of the word; it is thought of as a landscape that has been decomposed into infinite fragments, like a puzzle. In fact, the work has a definite "right side up"; if it is seen the other way around, there is a substantial change in the mood it conveys. Notice that the figures are increasingly compressed closer to the lower border.

Excavation

(1950)
oil on canvas
81.2 x101.3 in
(206.2 x 257.3 cm)
Art Institute of Chicago

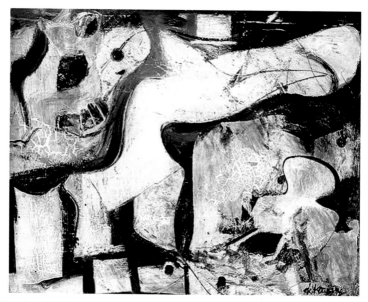

During his free time, De Kooning strolled the streets of New York to enjoy the city's nightlife. In this first period of living in the city, he made a group of paintings in white, gray, and black that reflect all the mystery of the night and the darkness. The artist plays with the viewer's imagination since the night theme is dominated by blackness. The viewer enters a fantasy, involved in scenes whose shape is not easy to define. Vague shadows could be smoke clouds, ghosts, or human figures that pass one another in the dark of night. Other, more solid shadows seem to be buildings or some type of structure. It is the profile and the form of a metropolis that changes its face at night. The artist used firm and expressive strokes for the figures' contours without worrying about the fact that the colors mixed, as this enhanced the sense of energy.

Night

(1948)
oil on canvas
23 x 28 in
(58.42 x 71.12 cm)
Private collection

In 1948, De Kooning exhibited his black-and-white drawings for the first time. They attracted the attention of the public and the critics, and the term "action painting" was used to classify his energetic strokes. By extension, this term would be used to define the work of those American Abstract Expressionists who focused their efforts more on giving the stroke vitality than color. De Kooning, however, would show the same concern for both compositional elements.

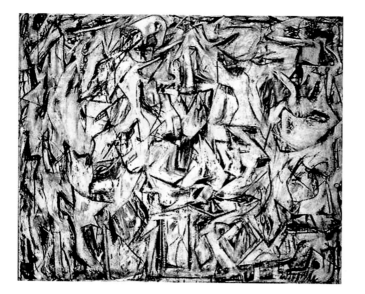

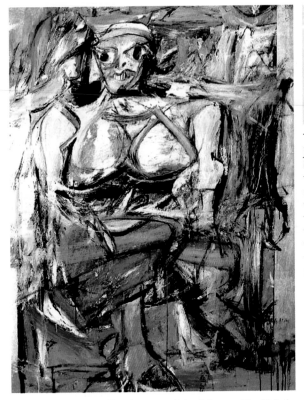

Woman I

(1950-1952)
oil on canvas
75.9 x 58 in
(192.7 x 147.3 cm)
Museum of Modern Art,
New York

The title of this work is just a starting point. More than a woman, this figure appears to be a real predatory monster, willing to rip the viewer's flesh with her horrible teeth. It is interesting that De Kooning stated that he was beginning his series on women by using the images of beautiful women as models. As the artist simplified the forms and filled them with his usual vitality, the young woman was transformed into a nightmare. Some said that the artist revealed an aggressive type of misogyny here. They interpreted the violence with which the artist appears to surround the figure literally. In reality, he is reflecting the effects of modern society on the image of women. Advertising and entertainment were making women into consumer products. Thus, the large pupils, mouth with perfect teeth, shapely curves, and prominent breasts—the ideal of beauty in the 1950s—are exaggerated in De Kooning's painting, taking on a monstrous quality. The suggestive lips are only slight lines that display a false and cadaverous smile. The breasts are so large that they take up the figure's entire chest. The woman appears to be seated, but instead of attractive legs, she has two limbs that look more animal than human. De Kooning has unveiled the deceitful tricks of advertising to reveal its true dehumanizing secret.

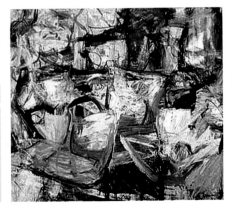

Saturday Night

(1956)
oil on canvas
68.7 x 79 in
(174.6 x 200.7 cm)
Washington University,
Saint Louis

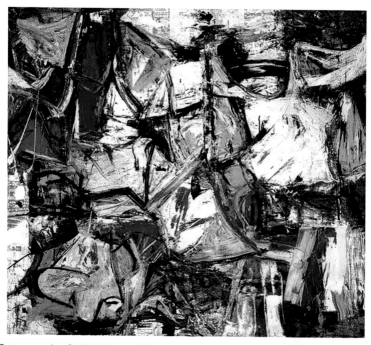

Just like Batman comics, De Kooning uses the name of Gotham to allude to New York City, where he lived. The title, *Gotham News*, could refer to two concepts, one a technique and the other purely a theme. De Kooning used newspapers to help the paint dry, and sometimes some pieces would be left on the canvas. There are still a few pieces stuck on the left-hand side of this painting. The artist liked this effect so much that he left the newspapers in place, and so named the painting. The newspaper is the reflection of life in this city through words. The artist wanted to depict all the aspects of the city: its dynamism, its diversity, the masses of people; in summary, its energy. There is nothing better than De Kooning's vehement strokes, spreading lively color on the canvas, to reflect all of New York's exciting everyday activity.

Gotham News

(1955)
oil on board
69 x 79 in
(175.26 x 200.66 cm)
Albright-Knox Gallery,
Buffalo, New York

This diversity affects the way in which viewers perceive the work, which meshes with the way New York City is perceived. It reminds some viewers of the city's most confusing and violent aspects; to others, it conveys New York's stimulating activity and excitement. De Kooning's technique is evident in the broad brushstrokes on the canvas, some applied directly from the tube and others scraped with a spatula. With this combination, a potent expressive effect is obtained.

Left: Urban landscapes were frequent in De Kooning's work, although they are entirely abstract. In this case, the title is not intended to explain the painting's content; rather, it complements the series of strokes and colors in the composition. The painter used two layers of paint that correspond to the two periods in which it was made. The first is thin layers of vibrant colors such as blue and white, and the second is impasto strokes that blend with one another.

It has been said that this rich surface is reminiscent of the baroque because of its squandering of artistic material and because of the intensity of color.

The work is exuberant in those areas where the colors blend without having dried. In others, sensuality gives way to angular, aggressive features made with a spatula and pieces of cardboard. The result is more balanced than previous paintings, since the weight of the composition is distributed throughout the canvas. The artist's favorite figure, the oval, also appears; it has been made with two curved strokes.

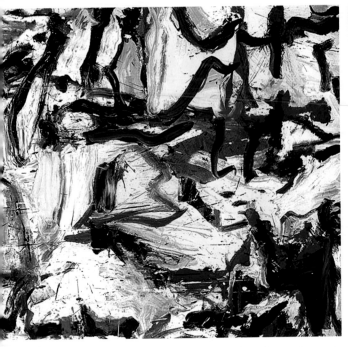

Whose Name Was Writ in Water

(1975)
oil on canvas
76.8 x 87.8 in
(195 x 222.9 cm)
Solomon R.
Guggenheim
Museum, New York

The title of this work refers to the epitaph on the tomb of the great English poet John Keats, who died in 1821: "Here lies one whose name was writ in water." De Kooning had visited the tomb during his visit to Rome in 1960.

Here, the painter reflects a philosophical approach to the transitory nature of life. The composition is open and simplified. The ochre, white, yellow, and blue capture the joyful vibration of light on water, without attempting to show its reflection as a fixed image. Once again, nature was a primordial theme for the painter, who saw water as its most representative element. Water was De Kooning's favorite natural element; he appreciated its fluidity and its changing movements. With a fluid brushstroke, the painter attempted to reproduce the qualities of water, and he foreshadows the simplification with which he will paint in the 1980s.

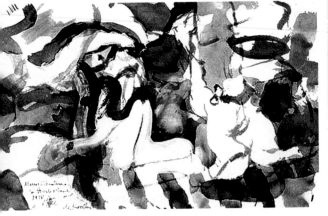

Untitled

(1985)
oil on canvas
77 x 88 in
(195.6 x 223.4 cm)
Smithsonian Institution, Washington, D.C.

The spiritual character of De Kooning's work in the 1970s became pure simplification in the 1980s, when the energy of his strokes transformed into absolute control over the brush, producing lines full of grace and innocence. He was so focused on the artistic task that he even refused to name his work. The artist appeared to have recovered the calm lost during his years of alcoholism, once he had also recovered his happiness with his wife.

His creative activity was such that he made more than 300 paintings during the 1980s and continued working after he was diagnosed with Alzheimer's. Here, the white background softly surrounds the brushstrokes, which are less aggressive than in earlier years. It is as if the painter had reconciled his brush with the paint; he peacefully arranges it on the canvas, creating a rhythm among orange, yellow, and blue. This is an intellectual painting in which the artist has finally been able to understand and accept the instinctive impulses of the subconscious.

ANDREW WYETH

Andrew Wyeth.

Andrew Wyeth, together with Edward Hopper, is one of the most outstanding 20th-century representatives of American realism.

The son of a very famous illustrator, N.C. Wyeth, he began studying art with his father and quite quickly became an independent artist after successfully exhibiting in Philadelphia and New York. His meticulous depictions of rural American scenes and people go beyond mere aesthetic representation; they are a moment of silence in which reflection dominates the painting and conveys calm to the viewer. Meditation about life and the imminence of death is the main theme of Wyeth's work. To encourage contemplation, Wyeth prefers clean compositions without frills to distract the viewer. The artist wants viewers to focus on the characters in his paintings and their emotions.

Quiet times stimulate the mind, and Wyeth has been able to concentrate all his energy into individual images. As America's consumer society was emerging in the 1940s and 1950s, Wyeth was concerned with portraying the link between man and nature, which he considered the only means of self-discovery.

- **1917** Andrew Wyeth born on July 12 in Chadds Ford, Pennsylvania. He is the fifth child of the famous illustrator N.C. Wyeth.

- **1932** Begins studying art in his father's studio.

- **1937** First watercolor exhibition, which was very successful, at the Macbeth Gallery in New York. Begins to concentrate on realism.

- **1940** Marries Betsy James, daughter of a newspaper editor from Maine. She introduces him to Christina Olson, who will appear in much of his work.

- **1941** Exhibits his first temperas at the Macbeth Gallery, and then at the Art Institute of Chicago.

- **1943** His work *The Hunter* is on the cover of the *Saturday Evening Post* and becomes nationally famous.

- **1945** Elected member of the National Institute of Arts and Letters.

- **1951** Exhibits for the first time in Europe, at the Cultural Festival of Berlin.

- **1952** The Institute of Contemporary Art in Boston organizes an exhibition of his most outstanding work.

- **1963** President John F. Kennedy gives him the Presidential Medal of Freedom.

- **1968** The Whitney Museum of New York organizes a retrospective of his work. Christina Olson dies.

- **1971** Makes a series of paintings using Helga as a model.

- **1977** Travels to Europe to become part of the French Academy of Arts. Before him, only John Singer Sargent had been accepted.

- **1978** Elected member of the Soviet Academy.

- **1980** First American artist to be elected member of the British Royal Academy.

- **1987** The National Gallery of Art exhibits his paintings of Helga, a friend of the artist. It is the first time that this institution has had an exhibition by a living artist.

- **1990** Receives the Congressional Medal of the United States. He is the first artist to receive this award.

- **1991** Exhibits in Tokyo.

- **1992** Exhibits in Bologna, Italy.

- **2002** There is an exhibition in the Julyn Art Museum, Omaha, Nebraska, of the Helga paintings.

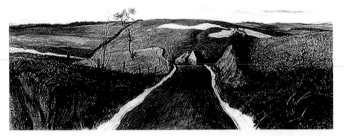

Road Cut

(1940)
tempera on masonite
16.2 x 35 in (41.2 x 88.9 cm)
Portland Museum of Art, Maine

This work shows a rural landscape divided by an asphalt road. It must be the end of winter, because the ditches are frozen and there is still some snow in the fields. Small wooden houses in the background are lost in the landscape that stretches to the horizon. Wyeth's interest in the relationship between the modern and the rural world can be observed here from the tension created by the dark gray road as it splits the landscape in two. The depiction is minute and realistic, the result of Andrew Wyeth's drawing lessons with his father. The scrub on the side of the path and even the traces of the passage of carts and automobiles on the road are minutely detailed.

The artist has arranged the elements of the landscape horizontally, placing the road vertically to highlight the sense of forward movement. Nonetheless, *Road Cut* is more than a simple portrayal; there is a sense of concentration and peace that makes the painting an ideal focus of introspection. This conception of the landscape as a natural environment for man is an idea that was quite successful before World War II; it is associated with American regionalist artists such as Grant Wood. Wyeth, however, believed in the progressive ideas of modern artists, which portrayed urban life much as he has depicted rural life.

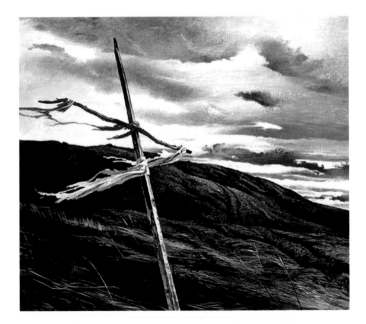

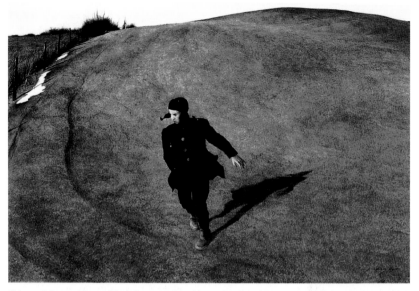

This work is autobiographical; it was painted just after Wyeth's father's death. The boy runs without any fixed direction through the hills, dressed in a thick coat and an aviator's hat. Wyeth said that this boy was himself searching for his own destiny (the raised hand was his soul, tempting fate). His face is expressionless; he is lost in the deepest thought.

Wyeth presents the human drama of death by alluding to the vacuum that the loved one leaves behind, rather than re-creating the most somber aspects, such as a coffin or a cemetery. According to the painter, the brown hill is the figure of his father—who had already returned to the earth, to nature—through which his childhood memory flows. The composition is quite simple and avoids aspects that might distract the viewer from contemplating the image. The perspective is downward, perhaps alluding to the father seeing his son's desolation from above, or perhaps to highlight his anxiety. The son has a lost gaze; it is impossible to know what he is thinking or to imagine his anxiety. The painting's brightness is achieved through tempera, a type of pigment made from egg white. The result is a brilliant color and a clear surface that combines quite well with the artist's talent for drawing.

Winter 1946

(1946)
tempera on wood
31.4 x 48 in
(79.7 x 121.9 cm)
North Carolina Museum
of Art, Raleigh

Left: His father's death was a hard blow for Wyeth, who made several paintings that relate directly or indirectly to this event. Here is a portrayal of a landscape in Westport, Maine, lashed by the wind. A cross hangs with rags; perhaps it is the wooden skeleton of a scarecrow. A storm is coming, judging by the clouds that fill the sky. Tractor tracks on the hill show that farmers pass through there. Perhaps they also refer to his father, who died in a tragic traffic railway crossing accident, because N.C. Wyeth did some farming, in addition to being an illustrator. The artist involves the viewer in a sense of solitude that blends with the storm's imminence.

Dodge's Ridge

(1947)
egg tempera on fiberboard
41.1 x 48.1 in
(104.5 x 122.3 cm)
Smithsonian American
Art Museum, Washington, D.C.

Through the landscape's appearance, the artist invites the viewer to reflect, to take time from the bustle of daily life. He calls for a moment of introspection, which can only be attained by approaching nature.

The forces of nature appear here in all their power. Their force and energy are felt in a silent setting, broken only by the murmuring wind. The artist uses blue and brown tempera to depict the clouds full of water and the dryness of the land. The lonely cross has a phantasmagoric appearance and religious overtones.

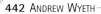

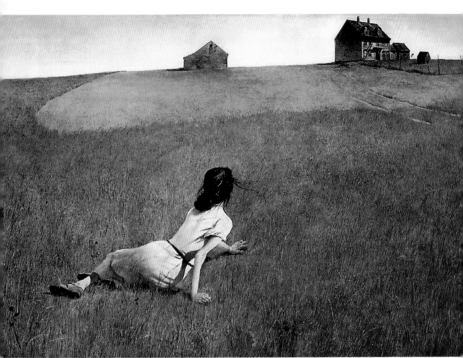

Christina's World

(1948)
tempera
32.5 x 47.8 in
(82.6 x 121.3 cm)
Museum of Modern Art,
New York

Christina Olson, a friend of Wyeth and his wife, had a degenerative disease. In young adulthood, she had lost almost all of her ability to walk, and it took her a long time to drag herself the 800 steps to the site of her parents' graves. (She had given up using a wheelchair, although her father had used one years before.) Wyeth depicts her here at 55, although he used his wife as a body model, so that the Christina in the painting has the body of 30-year-old Betsy and the wasted arms of 55-year-old Christina. She has dragged herself down the slope to visit the gravesite. Her house, located on a hill next to Hathorn Point in Cushing, Maine, is in the distance. Christina appears to be mustering her strength to return home, knowing that she will arrive quite tired: This is the world that Christina can handle. She did not allow anyone to feel sorry for her or help her or offer her the hated wheelchair.

Wyeth had married a friend of the Olsons, Betsy James, who introduced him to Christina. The artist was impressed by her energy. Christina Olson was an accomplished seamstress: The pink dress she is wearing is one she had made for the wedding of a nephew. When Wyeth exhibited the painting, it was so successful that everyone wanted to know who she was—something that was amusing to Christina Olson for a long time. The house that appears in the painting still stands and is now a tourist attraction.

Right: This is a seascape, shown from inside a quiet, abandoned house where an open window is lashed by the sea breeze. The palette is soft, as is common for Wyeth, who has favored ochre and yellowish tones. The lace curtains blow wildly at the mercy of the sea wind; the cloth blinds have holes, the result of storms and age. Through the curtains, depicted in great detail, we see a short coastline that ends where a forest of black pine trees begins. The light is intense, despite the fact that the sky is completely covered with yellowish gray clouds.

Once again, the silence of absence is present. Has someone just been here? Or has it been a long time since this window was last opened? There are no answers, only questions about an enigmatic view. The window is the frame for an extensive and solitary landscape. Two lines indicate that automobiles or wagons have passed through, and this is comforting, although it does not answer our doubts.

Wind from the Sea

(1948)
tempera
19 x 28 in (48.3 x 71.1 cm)
Private collection

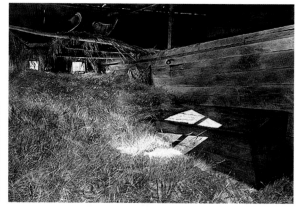

McVey's Barn

(1948)
tempera
New Britain Museum
of American Art,
Connecticut

This is the portrayal of a barn owned by one of Wyeth's neighbors in Chadds Ford; it was deserted when Wyeth painted it. The old planks are worn with age, and wild wheat grows on the barn floor. Above the beams, an old sled awakens echoes of a lost childhood. It seems as if the viewer can breath the dust and the musty smell and feel the sun's soft warmth. Inevitably, the viewer feels a sad sense of loss for the more innocent years before the war.

These sensations of time past, abandonment, mixed with the sadness of empty spaces that were previously filled, are what Wyeth has looked for. People were here once; they are symbolized by the sled, the wheat, and the chest. Nonetheless, although the artist presents such enigmatic elements as the chest illuminated by the ray of light, he never offers answers: It is the viewer who has to find them and fill the silence of Wyeth's work with the sound of his or her own thoughts. It is paradoxical that the artist presented reality in such a detailed yet mysterious way.

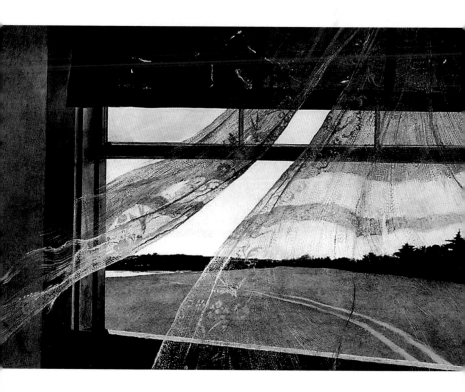

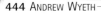

Anna Christina

(1967)
tempera
21.3 x 23.5 in
(54 x 59.7 cm)
Museum of Fine Arts,
Boston

Once again, Wyeth paints Christina Olson, but this time in a portrait. The appearance of this woman, who died shortly afterward, deceives the viewer; she seems somewhat scruffy and witch-like, and she has an inquisitorial look. In fact, she was quite generous and kind. In spite of all the misfortune that she had to bear, which is reflected in her face, Olson was an excellent aunt, a skilled seamstress, an intelligent student, and a woman with a great determination to keep on living despite the limitations forced on her by illness. Wyeth felt great esteem for her. Here, he depicts her with a neutral background, barely turned toward the viewer, as if she were calculating the distance that separates her from him. A palette of yellowish and ochre colors is used for the dress, while reddish colors are used for the skin.

Braids

(1979)
tempera
16.5 x 20.9 in
(41.9 x 53 cm)
Private collection

In 1971, Wyeth met a German woman named Helga Testorf, and he started to use her as a model. When Wyeth first met her, Helga was 32. She took care of a neighbor, Karl Kuerner, who was very old.

Testorf had come to Chadds Ford in 1961 and did many things: She took care of her family and her bakery; she taught music and cared for the sick, children, and the elderly. When she met Wyeth, she also became interested in art, and she painted and wrote poetry for some time. However, the long hours that she spent posing for Wyeth resulted in rumors about an amorous relationship. This affected her reputation, and she steadfastly refuted the rumors. Nonetheless, she continued working with Wyeth secretly. Wyeth's wife knew nothing about the paintings until the mid-1980s, when her husband decided to sell most of the series to a Japanese collector. Helga Testorf's relationship with the Wyeths has endured.

RICHARD DIEBENKORN

Richard Diebenkorn.

Richard Diebenkorn is one of the most important 20th-century California artists and the main representative of the Bay Area School, which promoted figurative painting that included landscapes painted outdoors and interiors with figures. These images were always painted in bright colors, with none of the concern for brushstroke gestures of the New York School. Far from participating in the stylistic disputes that agitated the New York scene at the end of the 1950s and beginning of the 1960s, Diebenkorn was always in tune with his native state; his paintings are full of brightness and calm.

An artist from a young age, Diebenkorn studied in Californian and Mexican universities, where he became familiar with Mark Rothko's work. He quickly went from Abstract Expressionism, which he was not happy with, to the figurative painting typical of the San Francisco Bay area, but always tending toward abstraction. Matisse, Paul Cézanne, Picasso, and Miró were influences that gradually led his aesthetic projects toward the depiction of the light and space of the coasts of California. It was in this stage that he painted his most famous series, Ocean Park. It is composed of almost 140 enormous oil paintings. In them, he captures all the essence of the coastal brightness and creates a manifesto in favor of art's compositional values. His health affected his activity in this field, opening the way to other types of artistic experiences with new techniques, materials, and themes.

- **1922** Richard Clifford Diebenkorn born in Portland, Oregon.

- **1943** Serves in the United States Navy, stationed in Quantico, Virginia. Takes advantage of this to visit the Phillips art collection in Washington, where he sees Henri Matisse's work.

- **1946** Returns to California, where he continues his education at the California School of Fine Arts. His friend David Park introduces him to the art of Joan Miró, Pablo Picasso, and Robert Motherwell.

- **1948** First exhibition of his work at the San Francisco Palace of The Legion of Honor.

- **1949** Graduates from Stanford University and the University of New Mexico.

- **1950** Professor of the California School of Fine Arts with Clyfford Still and Mark Rothko.

- **1951** Becomes familiar with the work of Arshile Gorky, who influences him. Becomes interested in aerial photographs of California fields.

- **1952** Teaches at the University of Illinois.

- **1953** Returns to Berkeley. Begins his series of paintings entitled Berkeley, influenced by Abstract Expressionism.

- **1954** *Life* magazine uses the term "abstract landscape" to define his paintings.

- **1963** Retrospective at the M.H. de Young Museum in San Francisco.

- **1964** Goes to Russia, where he sees Matisse's work again.

- **1965** Teaches at the University of California at Los Angeles.

- **1967** Paints his series of abstract paintings entitled Ocean Park.

- **1975** Exhibits at the Corcoran Gallery of Art.

- **1980** Paints his series of emblems in mixed media.

- **1988** Goes to the Bay Area, where he sets up a studio in Healsburg.

- **1989** Has a heart attack; doctors recommend that he rest. Stops painting large canvases and devotes himself to gouache, drawings, and etchings.

- **1993** Dies on March 30.

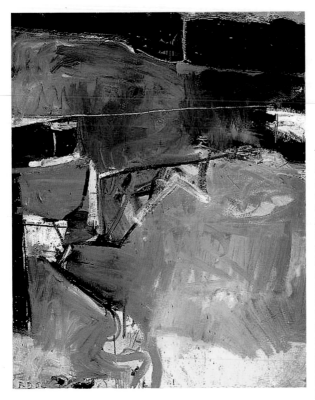

Berkeley, no. 24

(1954)
oil on canvas
38.7 x 57 in
(98.4 x 144.8 cm)
Norton Simon
Museum, Pasadena,
California

The series entitled Berkeley, which the painter made in the early 1950s, gives an idea of how far Abstract Expressionism had come as the most vanguard and groundbreaking style among American artists, including those on the West Coast. The painter has synthesized the two main directions of New York Abstract Expressionist artists here. On the one hand, he presents De Kooning's typical brushstroke gesture, seen in the way of applying oil paint to layers that are not dry yet. The colors blend, resulting in new tones: green blends with black and produces brown; white mixes with black and results in gray. The painting also displays concern for color fields and the tension among them, in line with artists such as Mark Rothko, whom the painter met when he taught at the California School of Fine Arts.

There is a struggle between these two concepts in the composition. On the surface, whether the brushstroke is painted in gray, green, or black, there is concern for the stroke and the expressiveness it portrays. A broken line that divides the composition in two parts accentuates the effect: The lower one is dominated by bright tones, and the upper one by dark tones. It is as if the shadow of the New York School weighed on the California artist, who considered color and light much more familiar.

Right: Diebenkorn painted much still life during his Bay Area period (so called, predictably, because at that time, the painter taught in California, near San Francisco Bay). *Bottles* shows a crystal bottle and an inkwell behind it. They seem to be on the painter's desk, which is an intense blue, applied with a dense impasto brushstroke. The crystal bottle has been made by outlining its contours in gray, although the reflections are in white and blue—the same blue that is used on the desk. In general, this work seems incomplete: More attention is focused on the application of vibrant color than anything else.

This use of bright, lively colors is what designates Diebenkorn as a Bay Area artist, although the artist did not like the name of a school applied to this trend. It is logical that in a land bathed by light and ocean the painter would find a whole series of vibrant clear tones, ideal for capturing on canvas. This painting uses all the colors of the ocean, including the white of the clouds and the yellow of the sand, whose texture appears in the canvas's upper portion. The two main elements are in the middle, surrounded by a great display of color that is the composition's true protagonist.

Woman and Checkerboard

(1956)
oil on canvas
59 x 55.6 in (149.9 x 142.2 cm)
Santa Barbara Museum of Art,
California

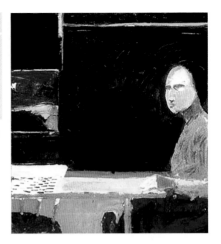

Matisse's paintings influenced the artist to turn
to figurative painting, which in turn initiated
the Bay Area period. In this period, Diebenkorn
made many scenes of solitary women in inte-
riors illuminated by the strong California light.
When one considers his artistic career, these
paintings contribute a documentary value to
the theories that defend Diebenkorn as an
abstract artist. Although this painting features
a woman and other recognizable elements, there is such insistence in the aesthetic value of the
work—particularly in the color and geometry—that it surely has as many abstract values as a non-
figurative painting.

The theme, a woman (Diebenkorn's wife, Phyllis) before a checkerboard, is what matters the
least: It is simply an excuse for the painter to develop a whole aesthetic discourse that is influ-
enced by Matisse and Cézanne, artists whose work he became familiar with during his formative
years. The woman's face is mostly absent; her eyes are two intense blue brushstrokes like the ones
that can be seen on her neck and under her nose. The figure is foreshortened against a neutral
black background, where several brushstrokes scratch the surface, giving it an incomplete look
reminiscent of Matisse. In terms of geometry, one only has to decompose the figure into rectan-
gles and ovals to appreciate Cézanne's influence and even that of Picasso.

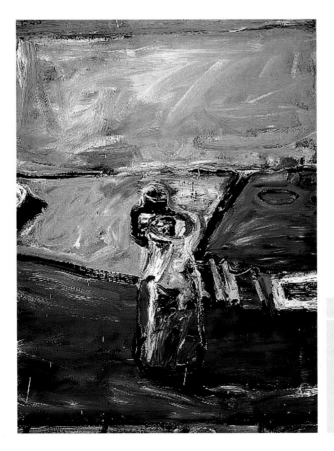

Bottles

(1960)
oil on canvas
34 x 26 in
(86.4 x 66 cm)
Norton Simon
Museum, Pasadena,
California

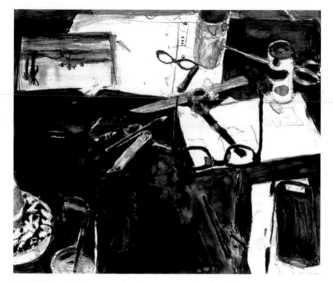

Still Life: Cigarette Butts and Glasses

(1967)
black ink, conté crayon, charcoal, and ballpoint pen on wove paper
13.9 x 16.7 in (35.2 x 42.5 cm)
National Gallery of Art, Washington, D.C.

Diebenkorn made black-and-white compositions of great abstract value. This still life shows a worktable, perhaps that of the painter himself. There are several objects: two pairs of glasses, several designs, markers, pencil sharpeners, scissors, and an ashtray full of cigarette butts, among others. Among them, there is a canvas with a landscape and palm trees, alluding to the artist's coastal landscapes. The painting has a broken appearance, perhaps because of the apparently disorganized arrangement of all the objects. There is a combination of round figures, more rectangular ones, and even pointed ones that convey concern to the viewer. Diebenkorn liked to play with the sensations that some geometric forms produced.

Nonetheless, although Diebenkorn thought of a future viewer, this modern still life contains something intimate and personal: It is the artist's table after an arduous day of work. Around this time, Diebenkorn began to be successful; his painting was considered a fresh answer to the Abstract Expressionists' violent gesture, which had led the American (and worldwide) scene in the 1950s. His concern with the tension among colors and the representation of a flat space, crossed by the viscosity of abstraction, began to be appreciated by the public and critics. Diebenkorn became internationally recognized as an excellent representative of vanguard American art.

Right: During the last stage of his life, Diebenkorn made a series of paintings inspired by emblems and heraldry. He used a mixed technique that included materials such as gouache (with which he obtained very bright colors), pastels, crayons, and graphite pencil on paper. In this composition, made in honor of the Spade Group, a club to which the painter belonged, red predominates, with white glazes and washes on its surface. This gives the painting an incomplete look, but also adds depth to the enormous red surface; it is broken by several white curved strips that appear to be in relief. This optical illusion is aided by the black line. It is thicker in the vertical band, so that it appears to rise from the surface. Following the patterns of some heraldry, Diebenkorn includes two groups of curvilinear figures.

Ocean Park 54

(1972)
oil on canvas
100 x 81.1 in (254 x 206 cm)
San Francisco Museum of
Modern Art

Ocean Park, a small town near Santa Monica, was familiar to Diebenkorn because he went by it every day as he walked to his studio on the beach. This painting appears to be an enormous window wide open to the ocean, showing the brightness of the blues in the sky and water. The artist picks up all the tonal shades with great tenderness and softness, without affecting the viewer's gaze.

This series depicts the pastel and bright tones of the ocean and sun in geometric representations influenced by the artist's plane trips. This group of paintings, however, also has something to do with the artist's investigation of painting itself. The lines that are presented are the first compositional lines that an artist uses to arrange elements and figures. For Diebenkorn, these imaginary lines, which Rembrandt and many other artists also used, are very important in the artistic process and, therefore, must be depicted. This was completely different from the proposals of Abstract Expressionism, which considered that the act of painting was only the moment when paint was applied to the canvas. This work is very elegant, not only because of the straightness of the lines and the use of clear and soft colors, but because it transmits a sense of completeness. The viewer's gaze does not flutter in violent convulsions, as is the case with De Kooning's Abstract Expressionism; it rests on the surface of clear colors. There is only one contrast—the use of darker tones in the upper right corner.

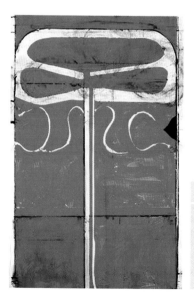

Untitled

(1982)
pastel, crayon, and graphite
on calendered paper
38 x 25 in (96.5 x 63.5 cm)
Museum of Fine Arts, Boston

Ocean Park 115

(1979)
oil on canvas
100 x 81.1 in (254 x 206 cm)
Museum of Modern Art, New York

The Ocean Park paintings are mostly large and vertical, to highlight the sense that the viewer is contemplating a landscape through a window. The vision rests on a soft balance between the surface, painted with vivid colors, and the depth, suggested by the geometric lines and the distribution of color. Here, the viewer is presented with a blue square central surface surrounded by a green band. In the upper portion, a rectangle the color of wet sand shares the segment with a small blue rectangle divided into two triangular areas, one lighter than the other. The uppermost band, separated by a black line, develops a last tonal exercise in sky blue that gradually dissolves to the point where it is a brilliant white. This composition, made in color planes, is reminiscent of Matisse's work, which Diebenkorn saw in the United States and in Russian collections. In his paintings, Matisse played with the expressive value of color by contrasting complementary colors. Diebenkorn learned the lesson, and here he presents a flat surface where colors simulate depth and create relief.

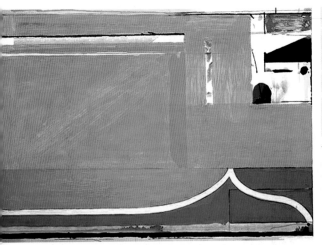

Ochre

(1983)
woodcut on Mitsumata paper
27.4 x 38.1 in
(69.53 x 96.84 cm)
National Gallery of Art, Washington, D.C.

This work depicts an emblem using a different technique: xylography, or wood engraving. In his childhood, the artist was interested in medieval heraldry, particularly the Bayeux Tapestry. In it, the main issue is depicted in the center, developing a whole series of parallel scenes that enhance the full story. The same idea is seen here, where ochre covers most of the woodcut's surface and the rest of the compositional elements are arranged around it. Just as Diebenkorn had done with Ocean Park, here he arranges the color so that it looks like attached squares, highlighting the work's geometric base. A curved white band opens a bracket to arrange the green surface in the lower area. Farther above, a white square opens up to other granite, blue, and black areas that have an incomplete look. Rather than considering the meaning or symbolism of this work, the viewer is encouraged to enjoy the aesthetic display that is offered.

ROY LICHTENSTEIN

Roy Lichtenstein.

Roy Lichtenstein was one of the greatest artists of pop art. His comic-book style paintings are the best-known pieces in his prolific production. Lichtenstein's work must be viewed within the context of a period when art had become a cult object for an erudite elite, unlike Abstract Expressionism, in which artists made an effort to capture emotion on canvas.

Lichtenstein's style, characterized by representing trivial or hackneyed subjects using commercial printing techniques, was something new and fresh in New York artistic circles, and he overthrew the established order. His works vulgarly portrayed stereotyped characters in a repetitive medium—comics—using cold lines, Benday or dot patterns, and a five-color palette, typical of commercial printing techniques.

The artist wanted his images to be as mechanical as possible, so that no trace of individual style remained—which was exactly the opposite of the goal of the Abstract Expressionists. Because of this, his figures, the only ones that seem to take their emotions seriously, have a removed, distant, stereotyped appearance. His works occupy the boundary between what is, and what is not, art, which was one of the looming questions that always greatly concerned the artist.

Finally, the importance of this artist rests in having removed American art from the dead-end street that it had reached with Abstract Expressionism. He forced art to return once again to look at reality in the form of popular culture.

- **1923** Born to a middle-class family in New York on October 27.
- **1940** Attends Reginald Marsh's summer painting class at the Art Students League. Enrolls at Ohio State University in the fine arts program, where he studies with Hoyt Sherman.
- **1943** Is drafted into the United States Army. Returns to U.S. in 1945.
- **1946** Creates works inspired by geometry and cubism. Earns B.F.A. from Ohio State.
- **1949** Earns a master's degree in fine arts from Ohio State University.
- **1951** Moves to Cleveland, where he will work as a graphic artist, decorator, and designer. Has solo shows in New York.
- **1957** Makes occasional drawings of comic-strip characters.
- **1959** Meets Allan Kaprow, a professor at Rutgers University, who later introduces him to the artistic world of Jim Dine, George Segal, and Claes Oldenburg.
- **1961** Creates his first pop paintings derived from commercial printing. The Leo Castelli Gallery in New York accepts some of his pieces.
- **1962** Has solo shows at the Leo Castelli Gallery and the Pasadena Art Museum.
- **1963** Exhibits at the Guggenheim Museum, the Ileana Sonnabend Gallery in Paris, and Il Punto Gallery in Turin. Moves to New York.
- **1965** Starts his series of paintings on brush strokes.
- **1966** Starts to make paintings using images from the 1930s. Stops usings words in his paintings.
- **1970** Moves to Southampton, New York, where he opens a studio. Paints works based on other artistic styles, like surrealism and futurism.
- **1973** Paints still lifes in a cubist style.
- **1979** Is elected member of the American Academy of Arts and Sciences.
- **1981** A retrospective of his work travels through the United States, Japan, and Europe.
- **1993** Complete retrospective of his work at the Guggenheim Museum; the show travels around the world until 1996. Does serveral nudes.
- **1997** Dies on September 29 in New York, of complications after having suffered pneumonia.

Girl with Ball

(1961)
oil on canvas
60.5 x 36.5 in (153.7 x 92.7 cm)
Museum of Modern Art,
New York

To make this work, Lichtenstein used an advertisement from a newspaper, highlighting the joys of spending your honeymoon in the Pocono Mountains. The artist took the image of the young woman holding a ball and copied it to the canvas in all its simplicity. Both her face and physical appearance, like all of his figures, are likenesses of models reproduced again and again in marketing. But what truly caught Lichtenstein's eye was how this advertisement had claimed ownership of emotions in order to stereotype them. It was precisely the falsity that these stereotypes portrayed that interested Lichtenstein, and he mocked the world of mass consumerism in this way—without criticizing it, just by showing it.

To do this, he separated the figure of the girl and placed it against a plain background, so that the viewers' eye is drawn to the artificiality of the girl's exaggerated, frozen expression. He also enlarged the size of the original to make this falsity more evident. Reducing the palette to a few bold colors heightens the potency of the original black-and-white image. Lichtenstein's colors are applied similarly to those in industrial printing, where few colors must work across the entire surface of the composition. Thus, blue is used for the hair (instead of black) and the bathing suit, and red for the ball and the young lady's lips, showing the humorous parallelism. The images that the artist selected for his first works had the mechanical, anonymous air of commercial art.

Drowning Girl

(1963)
oil and magna on canvas
68 x 68 in
(172.7 x 172.7 cm)
Museum of Modern Art,
New York

I Know, Brad

(1963)
oil and magna on canvas
66.5 x 37.8 in (168.9 x 95.9 cm)
Ludwig Forum für Internationale
Kunst, Aachen, Germany

In 1962, Lichtenstein sold all of his work by the day *before* the opening of his show at the Leo Castelli Gallery in New York. He had proposed a new type of fresh and irreverent painting that was even profitable. Because of this, he left his job as a professor and dedicated himself full-time to his painting.

The world of comic books had always interested the artist, who made drawings of Mickey Mouse for his children. Later, he found interesting subject matter in comic books starring Mickey Mouse and Donald Duck, and he re-created them in oil in a number of works. Following the advice of his friend Allan Kaprow, he began to work with more images from popular culture. Lichtenstein started to observe and to paint, gradually eliminating expressive lines and using the techniques of commercial printing, along with iconography and the language of comics, especially romances and war. In this example, a stunning young woman leans on a balcony, thinking about Brad (who is also mentioned in other works). Nothing shows the hand of the artist, who has used precise lines to define the figure. The colors are completely flat, concentrated in the blue of the dress and the blond hair of the woman. Lichtenstein used the solutions of commercial illustration to show the shadows of the figure, like the black on her neck, and white in the places where light would shine. The face, excessively perfect (classically idealized, vulgar because of the crassness of the media it comes from), seems absorbed, lost in thought, just like the heroine of a soap opera would be under the same circumstances.

Left: Brad appears once again in the thoughts of a young woman; this one cries disconsolately at the absence of her loved one. It is a snapshot of one moment selected by the artist. The instant is extremely tense and profoundly emotional, but, seeing it in isolation, the viewer cannot identify with the character. Lichtenstein separates the figure and blows it up to a gigantic size, which totally isolates it from its original context. Seeing from a distance how Lichtenstein's characters drown in their feelings is exactly what makes *Drowning Girl* humorous; it warns us of the ridiculousness of the melodramatic. In this work, Lichtenstein has used another convention from the comics: literally representing the narration of a scene. Here, the protagonist sinks in sadness, submerged in a sea of tears. Only the face, the erotically naked shoulder, and her hand jut out from so much water.

The waves are reinterpretations, according to Lichtenstein, of waves by the Japanese ukiyo-e artist Hokusai, whose works have been used as a basis for comics. Lichtenstein enjoyed taking the passionate scenes from illustrated romance comics to portray the reality around him. What most interested him was the homogenizing that emotions were submitted to through comics, the movies, and advertising, and the subsequent falsity of images. Because of this, he presented this reality by exaggerating the artificiality: Here, the face of the woman is monumental and gives the image greater impact. Nonetheless, the viewer contemplates the drowning girl's problems from a distance.

As I Opened Fire

(1964)
magna on canvas
68 x 56 in (172.7 x 142.2 cm),
each of 3 panels
Stedelijk Museum, Amsterdam,
Netherlands

In paintings based on the war comics favored by adolescent boys, Lichtenstein plays with his style in an extreme manner, mixing the simplicity of commercial design with the emotional force of the subject matter. This creates a tension that the comic resolves with stereotyped iconography, an interesting subject for the painter. The foreground of machine-gun fire prevents the viewer from really knowing what is happening. We "hear" (visually) the clamor of battle, but we do not know who is winning or losing, who is operating the weapons. The simplification of the image supports the idea that these war machines are functioning by themselves.

Lichtenstein's contemporaries, opposed to the Vietnam War, wanted to see a plea for pacifism in his work, but the truth is that Lichtenstein never thought about that. In fact, he always denied that his works contained social criticism, although it is true that there was a re-creation of the most common topics, vulgarized by the familiarity of repetition and massification (pop is objective, analytic art). He was more interested in studying the synthetic language of comic-book images, which achieved great expressiveness with little effort. For example, the sound of the machine guns is simulated by BRAT! and BRATATATA!, and the design of the words suggests the intensity of the sound. The depiction of the firing of the weapons is achieved by using three colors (red, yellow, and white), which would end up becoming something of a trademark for Lichtenstein. He also used the motif of explosions frequently, even when he created isolated sculptures.

The text of the narrator, where it is unknown who is speaking or what side they are on—are they the good guys or the bad guys?—is located in the upper part of each square, as in comics. The writing that Lichtenstein uses has an anonymous appearance, like the originals, in black within a yellow rectangular box. The appearance of these texts adds a disconcerting impression to the work.

Right: This is one of the sweetest images that Lichtenstein ever created. Two people in the foreground star in a candidly erotic scene, abandoning themselves to passion. Unlike many other pop artists, Lichtenstein did not neglect the background of his compositions; he used them to increase the commercial appearance of the work. Here, text accompanies the scene, narrating the ecstasy of the two characters. It is separated from the image by a panel and framed within a white rectangle.

Hesitation is represented by the ellipses separating the sentences. Grammar in the comics greatly interested the painter, who often used balloons or speech bubbles to show the thoughts of his heroes. The stereotyped emotions of Lichtenstein's comics are intensely lived by the characters, who, in turn, are also stereotypes. The women are always beautiful, but they have an air of innocence that makes them seem vulnerable. The women follow a prototype that had already appeared in the artist's earlier works; they are differentiated only by the color of their hair. Even with all the eroticism, Lichtenstein considers the viewer too intelligent to take scenes like this seriously.

We Rose Up Slowly

(1964)
oil and magna on canvas
68 x 92 in (172.7 x 233.7 cm)
Museum für Moderne Kunst,
Frankfurt, Germany

Crying Girl

(1964)
enamel on steel
46 x 46 in
(116.8 x 116.8 cm)
Milwaukee Art
Museum, Wisconsin

Not only did Lichtenstein use the cold lines and simple palettes of comic books, he also adapted Benday dot matrixes to his artwork so that no trace of the personality of the artist would remain. This discovery would be what would legitimize the artist within the artistic movement, within pop art, making his style truly unmistakable. Andy Warhol's comic-strip works were rejected when he showed them to Leo Castelli, a few weeks after the gallery owner had accepted Lichtenstein's works. When he saw Lichtenstein's Benday dots, Warhol understood that this terrain had already been taken, and he would always regret that he had not thought of it earlier.

These lines of small dots were used in commercial printing to show color gradations in lines and textures. The only concern for the illustrator was to outline the figures and indicate the areas that needed to be filled with Benday. When the reader of the comic looked at the image, he would not be aware of the small dots. However, in this work, Lichtenstein has enlarged the comic precisely to show the existence of these dots, used to color the skin of the young woman. This effect increases the contrast between the emotion of the crying girl and the totally commercial context that she is placed in.

In the beginning, Lichtenstein used a sheet with holes in it to pour the ink over the image; later he tried using wire gauze and rubbing above to imprint the dots. But he still could not achieve the even effect that he wanted for the works. Not until he combined the wire gauze with a lithography pencil did he achieve the desired results. Later, he hired assistants to do this part of the work; it was highly tedious.

Preparedness

(1968)
oil and magna on canvas
120 x 216 in (304.8 x 548.6 cm)
Guggenheim Museum,
New York

During the last years of the 1960s, Lichtenstein created paintings using imagery from the 1930s in his unique style. The influence of French art deco is obvious in this representation, mainly because of the painting's decorative nature and the use of grandiloquent lines. The artist also uses a cubist collage technique here to emphasize the idea of mechanization, so that even the soldiers seem to be war machines, as they have no expression—they do not have faces. Around them are shapes that bring to mind factories, industry, steam engines, and machinery. These images also show how the artist continued to study the possibilities of Benday dots; these lines of dots create shadowed surfaces on the yellow helmets of the soldiers, suggesting a metallic texture. In other areas, the lines of dots become lighter, to simulate the shine of the metal.

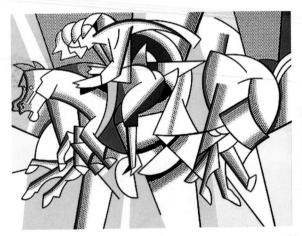

The Red Horseman

(1974)
oil and magna on canvas
84 x 112 in
(213.4 x 284.5 cm)
Guggenheim Museum,
New York

The European avant-garde of the beginning of the 20th century provided a source of study for Lichtenstein. This work is an interpretation, in his own style, of the futurist work *The Red Horseman* (1913) by the Italian Carlo Carrà. Lichtenstein criticized the excessive introspection of contemporary art, of the self-examination that turned its back on reality itself. Because of this, he took vanguard works—starting with paintings by Paul Cézanne, who, according to Lichtenstein, was the last painter to use reality as a model—and created his own versions of them.

If Carrà's original work is full of vigor created by the volume that conveys a sense of movement, Lichtenstein's work is a plane, integrated in its medium. The shadowed areas and volume are created by Benday dots that use the three basic colors of the original work, only this time without tonality, completely pure. The energy of the original work has given way to a study of the surface. The use of images from existing works of art leads us to ponder Lichtenstein's irreverence toward the concept of elitist art that fueled this period.

ROBERT RAUSCHENBERG

Robert Rauschenberg. Photography by Andy Warhol, (1981), VEGAP.

- **1925** Milton Ernest Rauschenberg born in Port Arthur, Texas, on October 22.
- **1947** Studies at the Kansas City Art Institute.
- **1948** Studies at the Académie Julian in Paris.
- **1949** Studies at Black Mountain College in North Carolina with Josef and Anni Albers. Meets composer John Cage and dancer Merce Cunningham there. Pioneers the use of electronics and lighting as part of representation.
- **1950** Attends classes at the Art Students League in New York.
- **1951** Presents his first exhibition, with works made for Happenings (artistic gatherings that combine theatre, visual arts and music, with participation of the audience).
- **1952** Travels to Europe and North Africa. Participates in Cage's theater production *Theater Piece Number 1.*
- **1954** Meets Jasper Johns, whom he will design windows with for Tiffany's. Creates his first combine paintings.
- **1962** Creates silk screens and long works based on his own photographs.
- **1964** Receives the Grand Prize of the Biennial in Venice.
- **1966** Is cofounder of Experiments in Art and Technology (EAT), dedicated to promoting collaboration between artists and engineers.
- **1970** Moves to Captiva Island in Florida.
- **1976** The National Collection of Fine Arts organizes a retrospective that travels throughout the United States.
- **1979** Shows interest in photography and collaborates with the Trisha Brown Company.
- **1981** Starts the *1/4 Mile Piece,* or *Two Furlong,* made up of 200 pieces that depict the history of his artistic career.
- **1985** Organizes the Rauschenberg Overseas Cultural Interchange to promote collaboration with craftsmen. Is elected Academician of the National Academy of Design in New York.
- **1992** Starts his Iris printer series based on photographs.
- **1998** The Guggenheim has a retrospective that travels throughout the European Guggenheim museums, in which for the first time the *1/4 Mile Piece* can be admired uninterruptedly.

Robert Rauschenberg has always been an independent artist. His uninterrupted, continual research into subject matters, styles, and techniques has made his career one of the most fruitful in art history.

Although he is best known for his combine paintings (which combine painting and sculpture), he has always worked in other fields, such as set design and photography, always surprising the public with the final outcomes. He was one of the first painters who, influenced by Marcel Duchamp, explored the boundaries between painting and sculpture (*Monogram,* from 1955, contained a stuffed goat standing on a painted board). This exploration of the border between art and life is precisely the field of work of this artist, whose art combines objects from daily life, found objects, and different techniques.

This early use of common objects to create his paintings is what led him to be one of the fathers of American pop art. He was one of the first to combine gestural brushstrokes with the mechanical nature of silkscreening; in other words, he combined the abstract with the figurative.

Despite the fact that, collectively, his work is a precursor to almost all postwar artistic movements, it has never been possible to pigeonhole his art into one specific style. Caring little for the opinions of others about his creations, he has always maintained that critics and museums are irrelevant institutions for art.

His commitment to art has led him to create different associations for exchanging ideas with other professionals, such as engineers and craftsmen, on both sides of the Atlantic. His biography, characterized by activities that are integrated in all senses, gives a good idea of how he has merged art and life.

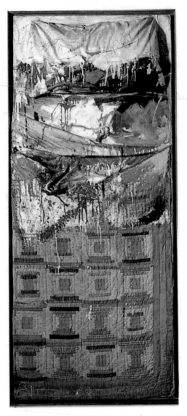

Bed

(1955)
oil and cloth on canvas
378 x 75.6 in (960 x 198.1 cm)
Leo Castelli Collection,
New York

In 1953, Rauschenberg had symbolically scribbled on a drawing by Willem de Kooning, who was a representative of Abstract Impressionism. Rauschenberg's action marked what would be a changing point in the history of American painting. With this act, the artist liberated art from path of Abstract Expressionism, which was centered around the expression of line and gesture. Rauschenberg demanded a return to reality, to analyzing the world that we have been born into—without completely rejecting all the research of the Abstract Expressionists.

This work depicts a bed—a daily object—and shows how gestural painting and recognizable objects can be combined into one piece. The sheets and pillows have stains made with brushes and dripped paint, giving the composition an untidy, disorganized appearance. But the bed is not a drawing of a bed; rather, the bed is constructed from fabric nailed onto the canvas—fabric that seems to have originally belonged to a real bed. Rauschenberg ponders the limits between painting and sculpture, and these works draw close to the concept of the latter in the most extreme manner. The visible result is an unmade bed, the same unmade bed that we climb out of every day.

This early love of representing daily objects—a reaction to the consumer society of 1950s and 1960s—is what distinguished Rauschenberg as a precursor to pop art. Nevertheless, art history has never been able to categorize this artist, because his works take from many different styles and, as a result, are unique and individualistic. In the same vein, while the works he made during the 1950s and 1960s are considered his most audacious, he still continues to surprise critics with infinite and impossible combinations.

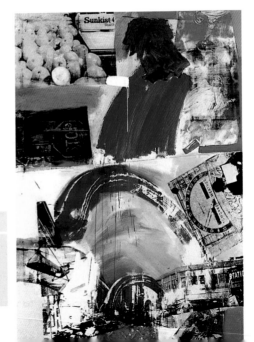

Harbor

(1964)
84 x 60 in (213.4 x 152.4 cm)
Museum Ludwig, Cologne,
Germany

Canyon

(1959)
oil, stuffed vulture, and
wood on canvas
81.7 x 70 x 24 in
(207.6 x 177.8 x 61 cm)
Sonnabend Collection, Paris

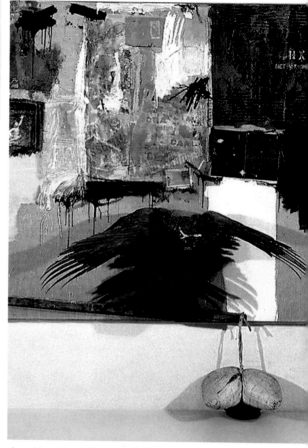

An ominous vulture joins a painting. How did critics classify this work—painting or sculpture?—when Rauschenberg presented it. The stuffed bird transgressed norms, but so did the use of other elements, such as wood. The composition, which has a sinister tone, uses the extended wings of the vulture as a motif that is repeated throughout the surface of the canvas with rapid and gestural brushstrokes. Other colors can be seen, ranging from browns, whites, and blues to the omnipresent black, apparently from one of the many cans Rauschenberg used to rinse his brushes.

As if mocking the end of Abstract Expressionism, the artist shows the multitude of expressive combinations that can be achieved through mixing diverse elements in a combine painting—a term coined by Rauschenberg, meaning a collage that includes objects attatched to the surface of the painting. Rauschenberg had already enjoyed his first commercial successes at this time, but he was openly public about his belief, inherited from the proud artists of Abstract Expressionism, in rejecting public life and the promotion of his work. Because of this, his relationship with Andy Warhol was never as smooth as might have been imagined between two artists of their caliber and renown. Warhol loved the fame and publicity he received, both for his work and about his personal life, while Rauschenberg thought of art as far removed from all the commotion. Furthermore, while Warhol dedicated himself to collecting and buying objects, Rauschenberg chose objects that would later become part of his works.

Left: This work displays how Rauschenberg uses a blend of several techniques and creates a collage with them. He arranges painted paper and ink and oil paint brushstrokes in intense colors, here violet, red and blue. These brushstrokes reveal that the artist, far from forgetting or negating the findings of Abstract Expressionism, incorporates them into his canvases: The apparently chaotic way of arranging the elements of the composition is expressionistic, as expressionistic as a brushstroke can be. Following the same concepts as his three-dimensional work, these combine paintings of the 1960s show the viewer trash the consumer throws in the garbage once its transient life ends. The labels and newspaper ads lose their meaning when the product has been used or consumed, becoming material lacking in content. For the artist, however, these discards have an artistic value that makes them expressive. Rauschenberg, like Jasper Johns, wants to free painting from the need for a motive. The painter can then concentrate on the artistic values that come from the brushstroke and the composition. What the viewer has before him is not a historical or mythological narration, but a carnival of visual impression, which is colorful and energetic and invades the spirit. This sensation is enhanced by the use of extremely large canvases.

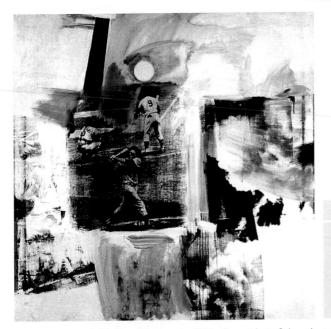

Brace

(1962)
oil and silkscreen
ink on canvas
60 x 60 in
(152.4 x 152.4 cm)
Private collection

Rauschenberg made his first silkscreens in 1962, after a trip to Cuba, where he had experimented with stamping. The author often used his own photographs or, as here, photographs from newspapers and other print media, transferring them to canvas. Using a new technique was a way of renewing himself, as his early combine paintings had left him somehow drained. Studying a new technique was something he did often, so as not to become distracted with problems about color composition, which he would tackle later.

One of Rauschenberg's favorite subjects—athletes—appears in this work, this time baseball players. As is common in his compositions, there is a combination of techniques and motifs: While the center of the canvas contains a silkscreen of a newspaper photo and alludes to a sporting event (repeated less clearly in other areas of the work), the gestural brushstrokes expand violently around this central point. The best aspects of abstraction and imagination meet in these works, to imbue them with a unique expressiveness. Rauschenberg subjected his pictorial material to all types of techniques: drops, sprays, impasto, horizontal brushstrokes, and washes upon the surface of the canvas itself. Rauschenberg began to use this industrial technique, using popular images, at the same time as other pop artists, such as Warhol, but not as an end in themselves. Instead, the image adds to the gestural touch to produce a truly unique piece.

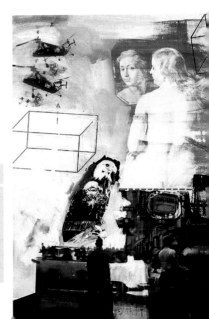

Tracer

(1963)
oil and silkscreen
ink on canvas
84 x 60 in (213.4 x 152.4 cm)
Nelson-Atkins Museum
of Art, Kansas City, Missouri

Estate

(1963)
oil and silkscreen ink
on canvas
96 x 70 in (243.8 x 177.8 cm)
Philadelphia Museum of Art

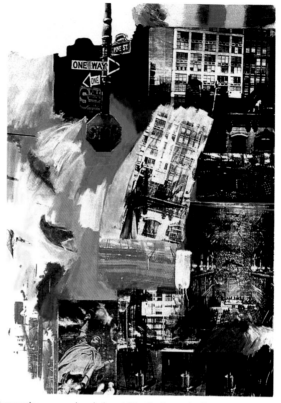

With a collage of images, concepts, and techniques, Rauschenberg created this mosaic of the reality of daily life in New York in the 1960s. Silkscreens of newspaper images showing well-known landmarks such as the Statue of Liberty or the street signs of New York are mixed with other silk-screens of the artist's photographs. Each of them appears to have been treated using a different technique. For example, the Statue of Liberty has been colored with pastel yellows and oranges, leaving the clouds and the sky and the series of photographs in black and white. The road signs, a collage of different routes and impressions, are colored almost identically to the Statue of Liberty. There are also normal apartment buildings. On top of this, Rauschenberg applies the gestural brushstrokes that normally complete his works, with long and carefully planned strokes.

The impact of works like this had already been tested in sets prepared for the modern dance performances of Merce Cunningham. Rauschenberg directed different colored lights toward the audience to make them interact with the work, closing a circle of creativity between the image and the audience. The artist was torn between becoming a dancer or a painter, but after completing his tour of duty in the Navy, he finally decided on painting. But he did not leave the dance world behind, and after working with Cunningham, he also worked with Paul Taylor. Perhaps it is this interest in dance that gives his works such a rhythmic and musical quality.

Left: Tracer includes some of the elements most typical of Rauschenberg's works: silkscreens and line drawings. This time, however, the lines have been measured and calculated. As the title itself suggests, these lines are the tracings of a drawing pen, geometric and carefully measured, characteristic of technical drawing. They are an answer to the liberal strokes of the Abstract Expressionists. To this, the author adds silkscreens, both from photographs and newspaper pictures. The bird this time is not stuffed nor wandering the borders of the work, but a bald eagle, the symbol of the United States. Above this, with some helicopters, is a silkscreen of a Renaissance work of art (the artist had studied art history and loved to place these references in his canvases), copying the original, as other pop artists were already doing. Rauschenberg has added a type of oil wash to the contours, giving a tonal change to the blue of the silkscreen. He has done the same with the bird of prey and the lower part of the work, which shows a busy street.

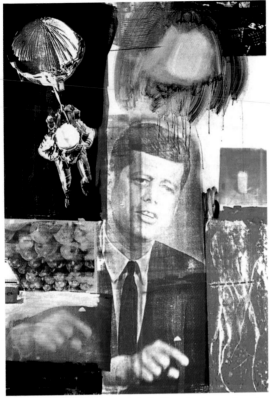

Retroactive 1

(1964)
oil and silkscreen ink on
canvas and objects
84 x 60 in (213.4 x 152.4 cm)
Wadsworth Athenaeum,
Hartford, Connecticut

This is one of Rauschenberg's best-known works, perhaps because it includes a silkscreen of a photograph of John F. Kennedy. The president's tie has been painted a shocking green, and he emphasizes a point with his finger, a gesture that is repeated on the left-hand side of the composition. This work speaks of the retroactive, of the recent past, and Kennedy points at the viewer, in a somewhat uncomfortable way. The festival of colorful silkscreens meshes with the abstract gestural brushstrokes. These figurative silkscreens are subjected to abstraction, which is one more element of the work. These works by Rauschenberg only make sense as a tribute to garbage, the remains of a consumer society. In this way, President Kennedy is nothing more than this, an image that stays in our memories.

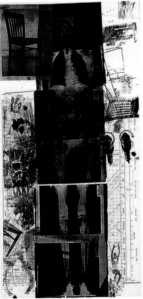

Booster

(1967)
color lithograph
72 x 35.6 in
(182.9 x 90.5 cm)
National Academy of
Design, New York

Rauschenberg had to present a work to the National Academy of Design in New York in order to become a National Academician. This happened in 1984, and Rauschenberg submitted a work he had made in 1967. It shows an entire human skeleton, perhaps his own, through x-rays, arranged in an orderly way and depicting the complete anatomy. Images of athletes and other objects on both sides frame the central figure. The work could be interpreted from the artist's point of view—he humorously offers an x-ray of his insides so that "the academicians can study it"—or from the viewpoint of an artist who is taking an x-ray of contemporary society, as if it were a clinical analysis.

Whether or not these speculations are correct, Rauschenberg has never lacked a sense of humor in his work. The artist has never stopped researching the possibilities of his works, and today his artistic career can be viewed in an enormous mural almost a quarter-mile long. Although he finished this project in 1994, he has always been concerned about the mixture, as it represents the vitality and heart of his work.

ANDY WARHOL

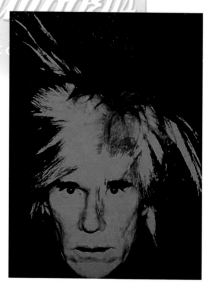

Self-Portrait, *1986, silkscreen ink on synthetic polymer paint on canvas, 106 in x 106 in (269 x 269 cm), Guggenheim Museum, New York.*

Andy Warhol is synonymous with pop art. He is considered the greatest artist of this movement. His work is a critical reflection of consumer society, influenced by advertising and mass media. He wanted to be part of this production chain and became an art-producing machine, even naming his studio The Factory. There he had a series of collaborators who, always under his guidance, made artwork in series. The work featured figures and elements from popular culture and popular consumption.

These images are a continuation of the European portrait and still-life tradition, although a modern version. Furthermore, the themes that fascinated him—fame, death, and money—are the same as the still lifes that focused on superfluous elements in life. They helped Warhol denounced the meaninglessness of objects outside of their advertising context and the deceit of the superstars' poses. Serializing these images denounces the banality and emptiness of these icons, aesthetically interesting but lacking any content. Warhol depicted overly enlarged objects, enhancing their attractiveness to such a point that the appetite for consumption wanes.

It is ironic to see how his work and persona also became objects of consumption. It is also paradoxical to see how the artist, who had always dreamed of having the striking death of a star such as James Dean or John F. Kennedy, died almost anonymously in a huge New York hospital.

- **1928** Andrew Warhola born in Pittsburgh on August 6 to a family of Czech immigrants. It is unknown if this was really the date of his birth, but the artist celebrated his birthday on that day.

- **1941** Makes a self-portrait imitating the pose of Truman Capote, one of his idols.

- **1945** Begins to study at the Carnegie Institute of Technology in Pittsburgh, today Carnegie Mellon University.

- **1949** Graduates and goes to New York. Appears in the illustration credits of *Glamour* as Andy Warhol; uses the name from then on.

- **1952** La Hugo Gallery of New York exhibits Warhol's illustrations concerning Truman Capote's writings.

- **1956** Travels to Europe and Asia.

- **1960** Begins painting by using comic-strip characters (Popeye and Superman).

- **1962** Exhibits at the Ferus Gallery of Los Angeles. Has a solo exhibition at the Stable Gallery. Makes his first Campbell Soup cans.

- **1963** Begins his series of silkscreens, working with collaborators. Directs and produces his first films. Exhibits at the Guggenheim Museum in New York.

- **1965** Begins working with the Velvet Underground and musical groups such as Duran Duran and Blondie.

- **1968** Valerie Solanas, founder and sole member of SCUM (Society for Cutting Up Men) shoots him in the chest.

- **1969** The first issue of his magazine, *Interview*, appears.

- **1970** Begins to paint using brushes. Makes large portraits of famous people such as Marilyn Monroe and Mao Tse-Tung.

- **1972** Exhibits in Germany.

- **1975** Publishes his autobiography, *The Philosophy of Andy Warhol: From A to B and Back Again.*

- **1979** The Whitney Museum has a retrospective of his portraits from the 1970s.

- **1980** Publishes *POPism, the Warhol's Sixties.*

- **1987** Dies in a New York hospital on February 22.

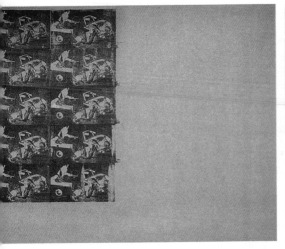

Orange Car Crash, Ten Times

(1963)
acrylic and Liquitex on canvas
two sheets, 131.5 x 81.1 in
(334 x 206 cm) each
Ludwig Collection, Museum
Moderner Kunst, Vienna

One of the products of modern society is the way in which events are rendered banal by the mass media. This car crash, which in itself is tragic, is depicted up to ten times, as in a daily newspaper. It creates saturation in the viewer as the image is repeated again and again. Warhol cut out these photos from newspapers to use them in his work, completing them with the use of complementary colors and striking headlines to create the greatest drama in the composition. Warhol wanted to completely anesthetize the viewer, so that he feels nothing regarding this horrible accident. *Orange Car Crash, Ten Times* is the denouncement of modern consumer society, which devours the news like popcorn.

There is another interesting aspect of this work: the artist's interest in death. Warhol depicts death here in a modern way: It is a car, a coffin of steel, and the photograph is of the car crash that killed James Dean, one of Warhol's idols. Modern death had to come unexpectedly from a lethal machine or chemicals, like Marilyn Monroe's barbiturates. This kind of dramatic death transformed a mere star into a real superstar, a cult figure made into a myth such as James Dean, Jackson Pollock, Marilyn Monroe, or John F. Kennedy.

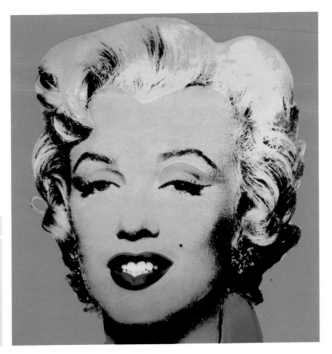

Marilyn

(1964)
silkscreen
on canvas
40 x 40 in
(101.6 x 101.6 cm)
Tate Gallery,
London

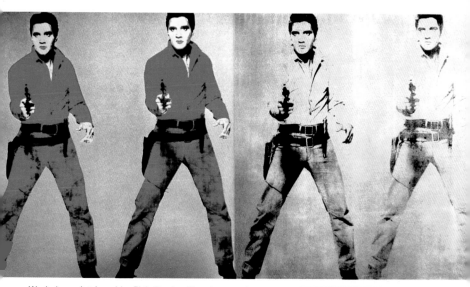

Warhol was intrigued by Elvis Presley. The singer and actor, hysterically adored by millions of fans, was the prototype of the American dream in modern society: Originally a truck driver, he became a rock-and-roll star and the object of desire for millions.

The flat plane of the work alludes to the consumer society, which fills its emptiness with unreal and dreamlike figures, illusory figures lacking any significance deeper than what they are assigned by the media. In this work, Elvis is reduced to a mere empty image that, after the initial impact, is diluted as he is repeatedly copied. In the first panel, Elvis aims a brightly colored pistol; in the second, he begins to be diluted; he lacks color and looks almost like a stain.

This fading also alludes to the destiny, sometimes tragic, of the stars of America's consumer society: oblivion. Elvis's popularity faded until his early death; fame also faded for the stars of Warhol's Factory. After their allotted 15 minutes had ended, they reproached Warhol's fame and power: In 1968, after shooting Warhol, Valerie Solanas, once a part of The Factory, said that the artist "controlled her life." Warhol had become the master of ceremonies of modernity, skillfully orchestrating his steps to stay in the forefront.

> ### Elvis I and Elvis II
>
> (1964)
> silkscreen on acrylic (Elvis I);
> silkscreen on aluminum
> paint on canvas (Elvis II)
> 82 x 82 in (208.3 x 208.3 cm)
> each panel
> Art Gallery of Ontario

Left: In August 1962, Marilyn Monroe was found dead from an overdose of barbiturates and alcohol. Such a modern death, because it was unforeseen and violent, fascinated Warhol so much that he predicted that she would rise to the peak of American goddesses. He would use her image again and again in his works; this picture is the first of many. Warhol depicted Marilyn Monroe as she looked in the film *Niagara*, predicting that she would be made into an icon by the consumer society—although the collective unconscious of the time still considered Rita Hayworth the reigning sex symbol.

He depicts her here in a blue background, highlighting her sexual allure by coloring the silkscreen's surface. The social vacuum grabs hold of a new icon to consume: a vulgarized and standardized sex symbol. Marilyn's bleach blond hair is a surface of color, like the skin, the drooping eyelids, and the lips that are simply stains on the silkscreen. He depicts what is only a decontextualized image, the trap of the everyday object or image. Colors, the ornaments of fantasy that are evident here because of their artificiality, are placed over the black silkscreen. Even the star's pose is exaggerated; the artist has suspended her in time so that we can clearly see how she is playing a part.

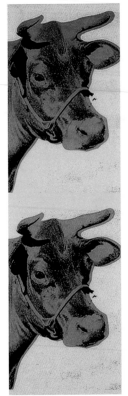

Cow Wallpaper

(1966)
silkscreen on paper
47.9 x 30 in (112 x 76 cm)
Ludwig Collection, Neue
Gallerie, Aquisgrán

Warhol used this design to cover the gallery of Leo Castelli, a great promoter of pop art, during one of his exhibitions. Leo Castelli believed in this new type of art from the very beginning; pop art was completely different from the Abstract Expressionism of the decade before. Castelli made sure the exhibitions were great social events, and the imagination of the artists guaranteed that the openings would be very entertaining. In addition to pop artists, The Factory's large, diverse group of collaborators also attended these gatherings.

In this work, the artist completely bypasses established artistic norms and makes ordinary wallpaper a work of art. A cow becomes an object of consumption, just like Marilyn Monroe. For Warhol, everything was aesthetic; everything was worth taking a picture of, and thus it could possibly become famous. Although Warhol obviously highlights what is aesthetic and glamorous (even in a cow), the painting appears fairly straightforward, inviting the viewer to reflect on how society can make anything into an icon.

In many pictures Warhol used a distant, unassertive background. This time the background is yellow and flashy, highlighting the intense fuchsia that covers the black silkscreen. Warhol seldom used animals as protagonists; this work can be compared with works by masters of art history such as Francisco Goya. In his etchings, the Spanish artist sometimes used animals—for example, donkeys governing or teaching—to denounce society's stupidity.

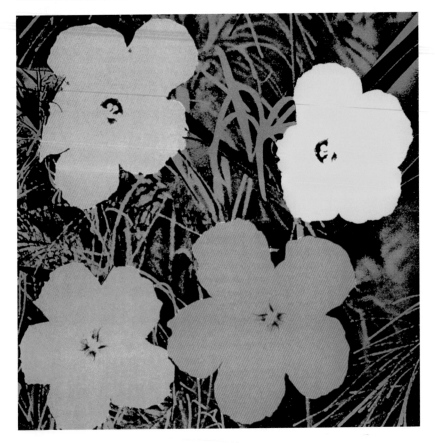

Campbell's Soup I

(1968)
silkscreen
31.7 x 18.4 in (80.5 x 46.7 cm)
Ludwig Collection, Neue
Gallerie, Aquisgrán

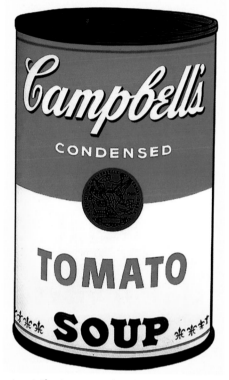

This is probably Andy Warhol's most famous image. The artist made several versions of the Campbell's Soup cans, starting in 1962. This example comes from a portfolio of ten silkscreens that show ten different varieties of soup available from Campbell's. Nonetheless, the product is not depicted in the same way as it would be in the supermarket, where the design and merchandising help attract the customer. Rather, the can is portrayed in the opposite way: the artist has isolated it to such a point that one sees only the aesthetic impression of the container and the solitary label. The image does not appeal to the hunger of the viewer, as would be the case in a TV commercial or in the supermarket. The cold outline shows the hard metal form of the can. The labeled can ceases to be perceived as a container for food; there is no temptation to consume tomato soup. Warhol once again denounces how society fills its existential void through consumption for consumption's sake, the acquisition of things to meet basic needs and the absurd loyalty to commercial brands. The perfection of the drawing and the simplicity of the design enhance its effect in silkscreen, saturating the viewer's senses and calling attention to what the product really is: a can with a carefully designed label.

Left: Warhol discovered this floral image in a botanical catalog while he was preparing his exhibition in Paris at the gallery of Ileana Sonnabend (her husband was Leo Castelli). Warhol, who had always believed that everything could be painted, chose flowers to refer to the work of French Impressionists. Nonetheless, an amateur photographer recognized the photograph as hers and sued Warhol for copyright. It is ironic that, although anything can be depicted or captured by anyone, the public acknowledges only the famous artist.

On this occasion, Warhol improvised, in a silkscreen, a floral still life from a photograph. This technique debunked all the oil-painting tradition that, as far as Warhol was concerned, was stagnant and out of date. After studying design and technology, the artist had chosen silkscreening as the best new technique to create his work. In addition, using silkscreening made it possible for him to keep a productive workshop much like that of Renaissance painters. More than 2,000 works were made in The Factory in New York in the 1960s, all under Warhol's supervision. In the middle of this activity, the artist was able to organize efforts, select the best works, and add a last touch (just as Michelangelo or Raphael would have done). Afterward came the "most important" part of artistic creation, the "true art": selling the work. Warhol, through television, his magazine, and his discotheque, sold the image that people wanted to buy. His marketing was part of the underlying philosophy of his artwork. Even nature is artificial, its variety of colors intended only to deceive.

Flowers

(1970)
silkscreen
36 x 36 in (91.5 x 91.5 cm)
Ludwig Collection, Neue
Gallerie, Aquisgrán

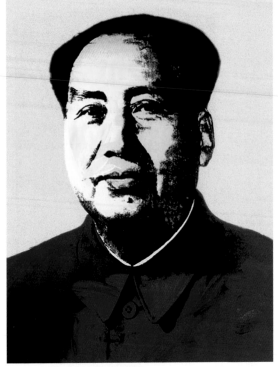

Mao

(1972)
silkscreen, acrylic, and
oil on canvas
81.9 x 61.8 in (208 x 157 cm)
Thomas Ammann Collection,
Zurich

To Warhol, Mao Tse-Tung was more than an important political figure. His portrait was omnipresent in offices, businesses, and even private homes in China. His words had become ubiquitous through millions of copies of "little red books." He had become an icon of modern society.

As such, his myth was based on an image that was incessantly reproduced until it became part of the collective unconscious. In order to depict this image and not just paint the portrait of Mao, the man, Warhol used silkscreen. This method, since it copies the outline in a blurry way, is distanced from any expression, so that the artist gives an objective view of reality. That is why Warhol stayed away as much as possible from brushstrokes, which are subjective. He only added color with a brushstroke on a few occasions, and only to highlight the lie that conceals the underlying truth.

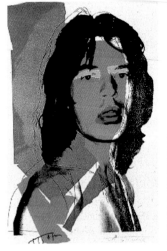

Jagger

(1975)
silkscreen
46.1 x 28.7 in (117 x 73 cm)
Ludwig Collection, Neue
Galerie, Aquisgrán

One of superstars who occupied Warhol's world in The Factory was Mick Jagger, the lead singer of the Rolling Stones. This work is part of a portfolio with ten silkscreens, edited down from at least 250 samples. Starting from a photographic silkscreen, the artist composes a portrait of the singer in which he highlights the sensuality of his voluptuous red lips.

Warhol had started to make a series of commissioned portraits of famous people at this time. There were so many requests that he always carried his camera with him. Many of the portraits, like this one, have the appearance of an everyday snapshot with some added glamour. Nonetheless, although the pose and "makeup" undoubtedly have aesthetic value— the lie of the myth created by society—ultimately, *Jagger* is nothing but the empty trace of a photograph. Behind the painting, as Warhol himself said, there is nothing but the wall.

JASPER JOHNS

Jack Shear, Jasper Johns.

The role of this painter in the history of art in the United States is crucial, as he was the first American artist whose work was different than that of the Abstract Expressionists, the dominating artistic current in the New York of the mid-50s.

In 1955, Jasper Johns, who had been working in window design, had a dream where he saw himself painting a flag. Intending to break with everything he had created until then, he burned all his pictures, an act of self-purification that allowed the artist to hurl himself into the creative process.

His first flag was only the beginning of a prolific career that would establish the basis for what would become American pop art, for the use of trivial objects and paradox, and for minimalism and his love of geometricizing. His objective is to make art an object in itself, and to achieve this goal, he chooses everyday objects (flags, numbers, letters, targets) that have little meaning on their own; they are the starting point from which the artist performs his aesthetic experiments. The subject of the work is not the objects or figures within the pictorial space, but the entire work itself as an object (canvas, frame, paints). His work moves between abstraction (bull's-eyes, letters, flags, and numbers are, ultimately, abstractions) and figuration.

His work comprises a philosophical investigation that seeks the liberation of the creative forces of art, a probe that Johns continues today.

- **1930** Born on May 15 in Augusta, Georgia. Spends his childhood in South Carolina after his parents separate.
- **1947** Enters the University of South Carolina.
- **1949** Studies commercial art in New York.
- **1954** Meets Robert Rauschenberg and, later, musician John Cage. Works with Rauschenberg as a window designer for clothing stores and Tiffany's. Moves to Fulton Street.
- **1955** Burns all his pictures. Makes his first flag, first bull's-eye, and first numbers.
- **1956** Paints his first alphabets. Starts to incorporate objects into his paintings. Exhibits at the Jewish Museum in New York in a group show. Leo Castelli takes an interest in his work.
- **1958** Exhibits at the Leo Castelli Gallery. The director of the Museum of Modern Art in New York, Alfred Barr, buys several of his pieces. Exhibits at the Biennial Exhibition in Venice.
- **1959** Exhibits at the Biennial Exhibition in Pittsburgh and wins the Carnegie Prize. Meets Marcel Duchamp.
- **1961** Makes his first maps of the United States.
- **1963** Creates the Foundation for Contemporary Performance Art.
- **1965** Exhibits in Pasadena.
- **1967** Moves to Canal Street. Paints for the first time using flagstones and tiles. Participates in the Montreal World's Fair. Serves as artistic advisor to the dancer Merce Cunningham.
- **1972** Presents his first works with cross-hatching.
- **1973** One of his works sells for $240,000.
- **1975** Illustrates the book *Fizzles* by Samuel Beckett at a Paris workshop.
- **1977** The Whitney Museum organizes a retrospective with more than 200 of his works.
- **1980** The Whitney Museum buys one of his works for a million dollars.
- **1988** Wins the grand prize for painting at the Biennial Exhibition in Venice for *The Four Seasons*.
- **1997** Works near Sharon, in Connecticut, where he can enjoy one of his hobbies, bee-keeping.

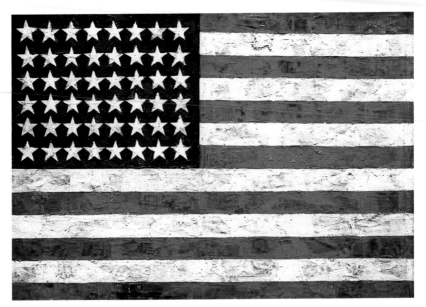

Flag

(1955)
encaustic, oil, and collage
on canvas
42.2 x 60.5 in (107.3 x 153.8 cm)
Museum of Modern Art,
New York

Jasper Johns reportedly painted this work after having a dream in which he saw himself painting a flag. Soon afterward, he destroyed all his previous work, renouncing them to start a new stage of his artistic career. In 1954, he had met the painter Robert Rauschenberg and the musician, philosopher, and experimental artist John Cage, who had introduced him to New York artistic circles. The freedom he breathed at the Happenings and experimental concerts gave wings to Johns's creative spirit. Here, the artist presents the flag stripped of all mystical feeling, of all meaning whatsoever, in order to concentrate on the act of painting itself. The American flag had already been designed long before, and so it did not need to be created by the artist; the focus is on the pictorial investigation. (Indeed, Johns once stated that he did not like drawing.) This distanced him considerably from the subjectivity of the brushstrokes of Abstract Expressionism, and the end result is a painting with a cold appearance that freezes emotions, the same objectivity that pop artists would subsequently display. The flag appears immobile, totally geometric and simple with its pure colors. It is simply a representation, not The Flag. This has a parallel in Johns's contemporaries, anesthetized by the abundance of consumer goods. The vision of this flag forces the viewer to confront himself and to recognize in some way the coldness within him. Johns would reinterpret this motif many times, creating a unique work of art with each of his flags.

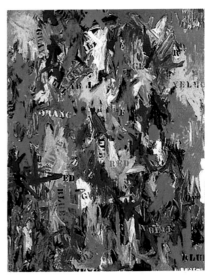

False Start

(1959)
oil on canvas
67.3 x 53.9 in (171 x 137 cm)
Newhouse Collection, New York

Target with Four Faces

(1955)
encaustic on newspaper
over canvas
33.6 x 26 x 3 in
(85.3 x 66 x 7.6 cm)
Museum of Modern Art,
New York

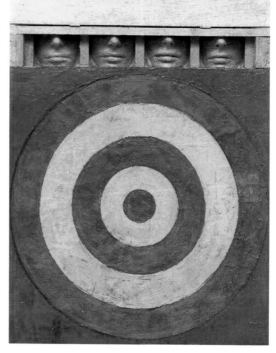

One of the motifs that Johns used and repeated throughout two decades was the target. The gallery owner Leo Castelli said that when he first saw the targets by this painter, he didn't know if he was before an abstract painting or a figurative painting, because, as the title clearly states, the work is a target; however, its appearance—a surface covered in ochre—indicated that he was in front of an abstract picture. In addition, the artist concentrated, above all, on the pictorial surface (the target is an excuse), so the confusion of the important gallery owner must have been enormous. He offered to exhibit those works in his gallery. Johns had dared to paint common objects in such a way that they appeared to be museum pieces.

In this work, he gives a humorous wink to the critics: Before the art-loving public that observed the work (Jasper Johns conceived of artwork as something that must be contemplated), the critic aims at the work. The target returns his inquisitive glance, mockingly. In this work, one of Johns's first targets, he develops the geometric motif—only the title reminds us of what the object really is—totally covering the canvas through a technique combining encaustic (a technique using wax) with papier-collé (glued newspaper). This gives the surface an uneven appearance that distributes the color in different directions, giving life to the surface.

Appreciating the modulations is a great aesthetic pleasure. In this work, Johns starts to practice and play with the juxtaposition of three-dimensional objects in his paintings; in this case, four faces where the eyes cannot be seen and are, thus, totally inexpressive. They surely allude to art critics—only mouths and not eyes that know how to see.

Left: During the year 1955, Johns had already become a star in New York. The Museum of Modern Art had bought three of his works (through a third party, as the museum was, not sure about the political correctness of Johns's flags) and he had been recognized at the Biennial Exhibition in Venice. American art was gradually entering the European circuits, although the innovations proposed by artists like Johns faced some rejection. During this period, the artist experimented with colors that he spread explosively over the canvas. At the same time, he introduced humorous games, characteristic of paradox and contradiction.

In this work, the white, red, blue, and yellow create, like fireworks, an abstract mosaic where the colors reign in an almost festive atmosphere. The names that appear are the colors on the canvas, although they don't correspond to the fields that they occupy. Apparently, this is a contradiction, but what would happen if they were placed in their corresponding fields? Clearly, they would not be visible. In any case, Johns' intention is not to discover where the colors are, but to contribute to their degree of contrast. The contradiction itself is what unites the compositional harmony. This painting could have its roots in Piet Mondrian, as it uses primary colors to return to the origin of painting, but this time the colors are distributed jubilantly upon the canvas. This energetic work contains no falseness.

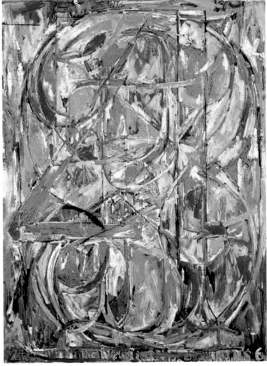

0 Through 9

(1961)
oil on canvas
54 x 41.3 in
(137.2 x 104.8 cm)
Tate Gallery, London

The author had started to create his numbers, his figures, in 1955. Figures interested him for several reasons. First, they are so common in daily life that they did not distract his intellect (nor that of the viewer), and second, they have an abstract component; they symbolize quantity, while alone they have no meaning. Finally, they have a certain symmetry; starting from that, Johns could draw the spectrum of numbers from zero to nine. Johns did not have the least interest in mathematics, and only wanted to pictorially investigate the surfaces of digits. Therefore, any symbolic interpretation lacks meaning and does not make sense. The result is that, as in this work, the numbers all appear together, in such a way that the viewer stops seeing the figures and focuses on the color modulations that the artist has created. Johns has made an effort to inhibit the intellect by fusing all the numbers together, making them unrecognizable. The viewer becomes submerged in a dense sea of color where there is no room for the neutrality of the figure, the numerals that have given the work its shape.

The figures, according to Johns, are simply those that he saw every day on packaging boxes, and indeed, their format had no importance to him, because the picture is not made up of the numbers, but of painting. The author created many works with figures, grouping them together, as in this case, or in a series. Numbers symbolize something that cannot be perceived by the senses; they are an ideal element for the starting point of an artwork. Once they are placed on the canvas, their function becomes something new and different. Decontextualized, figures become simply an aesthetic pleasure, without further meaning besides what the author's brush grants them. Therefore, the mind stops the intellectual process that seeks to identify what it is seeing, and so our capacity to enjoy the purely aesthetic is awakened.

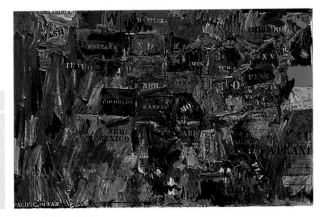

Map

(1963)
encaustic and
collage over canvas
60 x 93 in
(152.4 x 236.2 cm)
Private collection

Field Painting

(1964)
oil and objects on canvas
72 x 36.6 in (183 x 93 cm)
Jasper Johns Collection

One of Jasper Johns's innovations was introducing objects into his paintings. The artist had always felt great admiration for Marcel Duchamp and his ready-mades. Duchamp collected everyday objects and, after altering them very slightly, elevated them to the status of works of art, serialized for large-scale consumption. In this way, art used real objects to allude to reality, without needing to copy them on the canvas. Johns had had the opportunity to meet Duchamp in person, after reading the books that had been written about him.

Johns applied Duchamp's discoveries to his own work, but followed his own particular style. The objects in this work (cans, letters, and more) are only an excuse to investigate the pictorial surface. The objects are fastened in a crevice in the middle of the work, so that they project their silhouettes on both sides—as if their profiles had been copied when the painting was "closed." Nevertheless, if there is something that sets him apart from Duchamp, it is having used, besides objects from everyday life, abstract letters that are midway between drawing and painting.

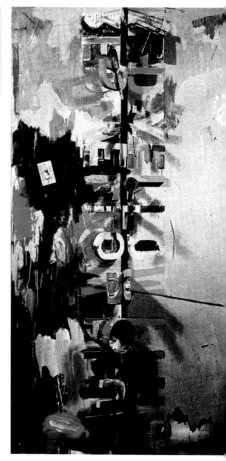

Left: This work was created while the artist was composing his color symphonies with figures. It is surprising that he could use red, yellow, and blue so violently at the same time as he was using such a dull palette for other works.

The map of the United Sates is only a base over which the artist lays on the textured color, applying it with encaustic. This technique, used centuries before by Greek and Roman painters, mixes melted wax with the color; the tones brighten as the wax dries. Encaustic was largely unknown among American painters of this era, but Johns used it to give more texture to his works. The map is a surface, and a territory over which to spread color. Games of contrast are created by the placement of the names of each state, in their correct places, as Johns sensitively varies the tonality of the letters. The names remind us that we are not seeing something imagined by the painter. His typology is the same for all, but his final goal is to refer to the character of the brushstroke, the flourish of color in harmony with the composition. The primary colors he has used—blue, yellow, red—are posed like witnesses on the upper right-hand side of the work. The transparencies allowed by encaustic expose some dense, very modulated textures, which the artist created using a caulking spatula (more rigid than a brush) with papier-collé to give a greater sensation of thickness. The result is a bluish surface, with the colors that are spread underneath showing through. It is something like an abstraction in perspective, the opposite of the traditionally flat abstraction.

Untitled

(1972)
oil, encaustic, and collage
over canvas and objects
72 x 191.9 in
(183 x 487.5 cm)
Museum Ludwig, Cologne

The motifs of daily life inspired Johns's paintings. The cross-hatching (made with small sticks) that appears in the first panel of this work originated in an announcement for a Mexican barber shop, painted simply on a tree. The turtle shells in the two central sections are the result of the artist's liking for both orderly and capricious shapes, which he then filled in with primary colors. The panels show a kind of symmetry between the red and black paving stones, and Johns added a touch of pink to the right-hand side. He enlivened the surfaces of his works without totally covering them, using simple, efficient motifs. The artist's paintings achieved, in this way, an almost musical or poetic rhythm (it is interesting to note Johns had wanted to become a poet). On the far right, a collage constructed of wood seems to show a completely different perspective than the other panels—and yet it is related to them. It is as if the viewer had zoomed in very, very close to the crosshatching weave.

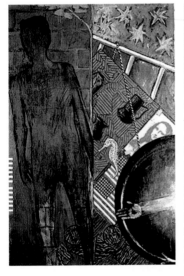

Summer

(1985)
encaustic on canvas
75 x 50 in (190.5 x 127 cm)
Philip Johnson
Collection

The ordered, schematic, structured, symmetrical and repetitive, linear, and extremely modern style has been a permanent feature throughout the pictorial career of this artist. Thanks to this work, part of a set of four pieces called The Four Seasons, Jasper Johns cemented his worldwide fame as one of the most important living artists in the world. The artist himself is the human shadow that appears on the canvas. One of his friends traced the silhouette of the painter onto a base, which was reproduced in the four works. It is a reinterpretation of the theme of the ages of man—birth, youth, maturity, death. The hand of a clock in the lower right-hand corner revolves, marking the inexorable passing of time, while around the figure, the elements that have formed part of the work are grouped: flags, starfish that complement the seahorse, a ladder holding down a crosshatching picture that reproduces part of a work by Grünewald that Johns admired, the *Mona Lisa*, some earthenware vessels by the potter Ohr, and other objects. This is the painter surrounded by the elements that contributed to his fame.

476